ORIGINS OF THE AMERICAN FILM

Gordon Hendricks

ARNO PRESS & THE NEW YORK TIMES

New York · 1972

This volume was selected for
THE ARNO PRESS CINEMA PROGRAM
by George Amberg, Ph.D.,
Professor of Cinema,
New York University

Reprint Edition 1972 by Arno Press Inc.

LC# 74-169345
ISBN 0-405-03919-0

THE ARNO PRESS CINEMA PROGRAM
See last pages of this volume for titles.

Manufactured in the United States of America

Contents

Introduction

I began the first book of this volume, *The Edison Motion Picture Myth,* about fifteen years ago. I still believe that previous accounts of American film beginnings contained (and contain) considerable error. Too much credit has been given Thomas Edison and too little to his employee, William Kennedy Laurie Dickson, who did most of the work in developing an effective motion picture camera and exhibitor. Aside from eliminating a number of adverbs, some italics and a few errata,* I would change little. There should have been a Chronology: I have added one to this edition, and have arranged the three books themselves in their proper chronological order, with the Biograph book last.

The Edison Motion Picture Myth, together with *The Kinetoscope* and *Beginnings of the Biograph,* was the first — and is still the only full account of American motion picture beginnings since Terry Ramsaye's *A Million and One Nights.* I therefore published a fuller documentation than would otherwise have been necessary. Ramsaye's intelligence and enthusiasm, and, above all, his close, consistent contact with pioneers — as uncritical as he was and as chauvinist as they were — made his history a landmark in its area. But he was biased for his favorites: Edison and Thomas Armat, and biased against others: Eadweard Muybridge, Dickson and C. Francis Jenkins. And his conclusions were largely unaccompanied by the sources that would allow a reader to appraise their accuracy.

My own intention has been to present what I thought to be the relevant documents so that my conclusions could be compared with my sources.

<div align="right">

Gordon Hendricks
New York City
May 16, 1971

</div>

*P. 33: 32 and 1 should be reversed; p. 77: "Salchen" should be "Salcher"; p. 140: "1899" should be "1889"; p. 153: "00" should be "74."

Chronology

(Numbers in parentheses refer to pages in each book.)

The Edison Motion Picture Myth

William Kennedy Laurie Dickson joins Edison: April? 1883 (150)

Ottomar Anshutz' motion picture work published: June 4, 1887 (85)

Eadweard Muybridge visits Edison (and Dickson?) and discusses motion pictures: February 27, 1888 (11)

First Motion Picture Caveat: October 8, 1888 (14)

Dickson starts "Daguerrotype experiment," apparently first motion picture work at Edison laboratory: November 28, 1888 (22)

Second Motion Picture Caveat begun: February 3, 1889 (29)

Third Motion Picture Caveat begun: May 20, 1889 (36)

Dickson buys John Carbutt celluloid film: June 25, 1889 (37)

Edison leaves for Paris and visits Jules Etienne Marey, and evidently discusses Marey's motion picture work: August 3, 1889 (51,52, 171)

First commercial Eastman celluloid film: August 27, 1889 (58)

First photographic building at laboratory built: September-October 1889 (79)

Fourth Motion Picture Caveat begun: November 2, 1889 (81)

First cylinder motion pictures; "Monkeyshines" produced: November 1890 (99)

Edison announces motion picture work, describing it as an "improvement" on his phonograph: May 1891 (105)

First public exhibition of motion pictures, in the Kinetoscope, at laboratory: May 20, 1891 (111)

Edison files three motion picture patent applications: for method and apparatus for photography, for method for photography and exhibition, and for apparatus for exhibition — the Kinetoscope: August 24, 1891 (130)

Vertical-feed camera apparently underway; plans for World's Columbian Exposition exhibition: June 1892 (138)

Frames from four motion picture subjects achieved by a rapid, inter-
mittent movement of film driven vertically published; the latest
possible date for the completion of an effective camera at the
Edison laboratory: October 1892 (140)
Camera patent issues: February 21, 1893 (137)
Kinetoscope patent issues: March 4, 1893 (133)

The Kinetoscope
The "Black Maria" completed: February 1893 (23)
Prototype of commercial model of Kinetoscope produced: April 1893
(35)
First official public demonstration of the Kinetoscope, in Brooklyn:
May 9, 1893 (36)
Kinetoscope at World's Columbian Exposition: not later than July
21, 1893 (41)
First motion picture copyrights: October 6, 1893 (47)
First motion pictures made in anticipation of opening of first Kineto-
scope parlour: February? 1894 (51)
Eugene Sandow and Carmencita photographed for the Kinetoscope:
March 1894 (53, 55)
William Gilmore begins work for Edison: April 1894 (70)
World's first Kinetoscope parlour opens, on Broadway: April 14, 1894
(57)
San Francisco Kinetoscope parlour opened: June 1, 1894 (59)
Chicago Kinetoscope parlour opens: May 1894 (60)
First Latham Kinetoscope production: possible first attempt at arti-
ficial light for motion pictures: June 14, 1894 (75, 77)
First known film censorship: July 1894 (77)
First outdoor subject: July 25, 1894 (76)
Edison contract for Kinetoscope exploitation, with Raff and Gammon:
September 1, 1894 (79)

Corbett-Courtney fight: September 7, 1894 (100)
Maguire and Baucus plan foreign exploitation of the Kinetoscope:
September 1894 (111)
Kinetoscope parlours opened in Washington, Philadelphia and Lon-
don: October 1894 (75, 77, 112)
Kinetoscope parlour opens in Paris; Charles Chinnock motion picture
camera produced; Gilmore-Dickson relationship deteriorates,
foreshadowing Dickson's departure from laboratory: November
1894 (112, 163)
Robert Paul copies Kinetoscopes for European sale: December 1894
(115)

Kinetoscope parlour opens in Mexico City; Chinnock Kinetoscope public exhibition (?): January 1895 (66, 166)

Kinetoscope-phonograph combination produced — the Kinetophone: March 1895 (123)

First known stop-motion, in *The Execution of Mary, Queen of Scots:* August 28, 1895 (138)

Kinetoscope sales, with novelty worn off and screen machine anticipated, fall off severely: September*ff* 1895 (142)

Beginnings of the Biograph

Herman Casler builds the Mutoscope in Syracuse, New York: November 1894 (7)

Mutoscope patent application filed: November 17, 1894 (9)

Casler begins works on the first Biograph camera, to take subjects for the Mutoscope: December 1894 (9)

First Biograph camera completed: March 2, 1895 (11)

Casler and partner, Harry Marvin, move to Canastota, New York; June 1895 (16)

Dickson, having left Edison and having helped Casler evade the Edison patents in the Biograph camera, visits Canastota, and, with Elias Koopman and Marvin and Casler, establishes a working relationship that results, in December 1895, in the American Mutoscope Company: September 1895 (18)

Mutoscope patent issues: November 5, 1895 (24)

American Mutoscope Company moves into 841 Broadway, New York: January 1896 (31)

American Mutoscope Company motion picture production begins: April? 1896 (32)

The American Mutoscope Company's motion picture projector, the Biograph, makes début in Pittsburgh: September 14, 1896 (40)

An American Mutoscope Company cameraman, Billy Bitzer, photographs William McKinley in Canton, Ohio: September 18, 1896 (41)

The Biograph opens in Philadelphia and Brooklyn: September 1896 (43, 44)

The Biograph opens in New York City, at the Grand Opera House: October 5, 1896 (44)

The Biograph opens "officially" at Hammerstein's Opera House: October 12, 1896 (46)

The Biograph has outclassed other American motion picture projectors: December 1896 (51)

The Mutoscope enters commercial production: January? 1896 (60)

The Edison Motion Picture Myth

The Edison Motion Picture Myth

By

Gordon Hendricks

Berkeley and Los Angeles, 1961

UNIVERSITY OF CALIFORNIA PRESS

UNIVERSITY OF CALIFORNIA PRESS
Berkeley and Los Angeles, California

CAMBRIDGE UNIVERSITY PRESS
London, England

© 1961 BY THE REGENTS OF THE UNIVERSITY OF CALIFORNIA
LIBRARY OF CONGRESS CATALOG CARD NUMBER 61–7532
PRINTED IN THE UNITED STATES OF AMERICA
DESIGNED BY MARION JACKSON SKINNER

To the memory of

William Kennedy Laurie Dickson

"YOU MAY SHARE THE LABORS OF THE GREAT,
BUT YOU WILL NOT SHARE THE SPOIL" (Aesop)

And to *Guido Castelli* and *Kenneth Macgowan*

Preface

I INTEND THIS BOOK TO SERVE TWO PURPOSES: (1) TO BE A BEGIN-
ning of the task of cleaning up the morass of well-embroidered
legend with which the beginning of the American film is
permeated and (2) to afford some measure of belated credit
to the work done by W. K. L. Dickson.

Although research in original sources is axiomatic for stu-
dents of the history of other arts, in American film history
it is rare, and whatever exists has been often submerged in
trade-paper journalism. As someone has said in a review of
one volume of film "history," it is too often "inverted alchemy
. . . the process of taking the richest materials and turning
them into dross." Romances have thus been built around the
work of the pioneers—romances to which the pioneers them-
selves have added not a little. The advantage is held by the
man who lives the longest: as the years pass, fewer and fewer
of his colleagues remain to gainsay his extravagances.

With too few exceptions these romances have been left
undisturbed. And no set of motion picture claims has become
more firmly entrenched in the American mind than those of
Thomas Alva Edison—claims made by himself, his chroniclers,
and writers in other fields who have taken "specialists" at their
word.

Although this investigation has been as impartial as I have
been able to make it, impartiality has not always been easy to

sustain—particularly in the face of the immodest claims of Edison himself:[1]

> . . . when I invented the modern motion picture in the Summer of 1889 . . .
> . . . in 1887, when I was able to perfect the motion-picture camera . . .
> . . . there was no co-invention . . .
> . . . the kinetograph [is] entirely my work . . .
> . . . Paul, Lumière, Jenkins & others . . . introduced only minor details . . . they all use my original movements. . . .
> Of course the public can't understand these things, and it permits fakirs . . . to claim the invention of the movies by merely a change in a minor detail.
> . . . it was our machine . . . [i.e., the Jenkins' Vitascope].

Surely, as Julian Hawkins said in the *Electrical Engineer* of November 18, 1891: ". . . if Mr. Edison would quit inventing and go in for fiction he would make one of the greatest novelists this country ever saw."

Being thus tempted, I have tried to exclude all interpretations from this work which might permit a feeling that it was "anti-Edison." Even when virtually convinced that an "anti-Edison" theory was considerably more than theory, I have refrained from setting it down.

The task of sifting history from myth has been enormously complicated by the fact that, far from merely not recording what actually happened, Edison and the Edison interests made determined and sustained efforts to obscure it—and indeed built careful structures of fiction.

The powerful American tradition of hero-worship has furthermore not helped matters, and such investigation as I have undertaken may be considered disrespectful. One thinks of nothing so much as Mencken's remark: "If you are against labor racketeers, then you are against the working man . . . If you are against trying a can of Old Dr. Quack's Cancer Salve, then you are in favor of letting Uncle Julius die."

[1] These are quoted, in order, from: *Moving Picture World*, 1909, p. 293; *Munsey's*, March, 1913; Edison laboratory letter book E1717, 4/13/94–8/27/95, p. 413; *Electrical Engineer* (British), November, 1894; unpublished notes in the West Orange archives, made in 1925 during an effort of the Edison junto to persuade the Franklin Institute not to credit C. Francis Jenkins for the phantascope as a significant motion picture invention; and Equity #6928 (see page 3), Complainant's Record, p. 115.

In this task of sifting history from non-history I have been helped by the men to whom this book is dedicated and, almost beyond description, by many other persons who agreed with me that facts are worth recording. First among these are the members of the staff of the West Orange laboratory. It was in this rich monument of the past that I was first inspired to write this account. From the first day, and the first conversation with Mr. Norman Speiden, supervisory curator, I was assured of the most helpful coöperation. Through the several years that followed, this helpfulness was sustained in the fullest fashion, and was often the cause of considerable embarrassment to me—since I soon began to realize that my account must fly in the face of what had gone before. It is a fine measure of the stature of Mr. Speiden and his colleague, Mr. Harold Anderson, that even after they realized my changing viewpoint their coöperation diminished not at all. Their natural loyalties in no wise interfered with what they considered to be their duties: helping me in my free research in whatever laboratory documents were available.

Cheerful coöperation was also given by Miss Kathleen Oliver of the staff, who must often have dreaded to see me come, since she knew that it would mean the additional crowding of an already crowded schedule.

When the laboratory became a National Monument in 1956 and was taken over by the National Park Service, additional members of the staff—Mrs. Alberta Appleby and Mr. Melvin Weig, superintendent—cheerfully continued this coöperation. (For the benefit of those who may be interested in knowing exactly what archives materials I examined in my study, a list of these materials may be seen at the Edison museum, the George Eastman House, and the library of the Museum of Modern Art. It should be noted here for the benefit of other researchers that many of the dates noted on photographs and documents in the West Orange archives are necessarily inaccurate. And where no information was available to determine these dates, estimates therefor have sometimes been produced. It should also be recorded that the method used to mark these dates *as* only estimates is contrary to both logic and accepted archivist practice: they are enclosed in parentheses, indicating an aside. In no case that I can recall has the customary question-

mark been used. A case in point is a photograph of a horse and rig in front of a laboratory building. The photograph is signed "W. K. L. Dickson," but beyond knowing that it was taken between the fall of 1887 when the building was built, and April, 1895, when Dickson left the laboratory, there is no justification whatever for the "(1893)" written on the reverse.)

Next my gratitude must go to Mr. Beaumont Newhall, Director of the George Eastman House in Rochester, New York, who from the first heartily applauded and encouraged my efforts to research the motion picture beginnings of America. I am also grateful to Mr. Newhall for his reading of the manuscript, and for his eloquent endorsement of it.

I am grateful to Mr. Ernest Callenbach, of the University of California Press, for his efforts in bringing this book into print—efforts more difficult because there is so little precedent for a serious work of film history.

I am grateful to the Misses Allene and Elsie Archer, of Baltimore, Maryland, and Richmond, Virginia, for many exceedingly pleasant hours spent talking about their great-aunt, the first Mrs. Dickson, and for their many favors in the preparation of this book.

I am grateful to Miss Kathleen Polson, of Twickenham, Middlesex, whose kind and intelligent efforts in behalf of my work resulted in more than one interesting discovery; and to her friend Miss Storey, who accompanied us on a memorable visit to Dickson's grave in Twickenham. Miss Polson's gift of a valuable collection of glass negatives has enriched my research.

I am also grateful to Dr. R. A. Albray of Newark; to Dr. Elizabeth Baker, Professor Emeritus of Economics, Barnard College; to Mr. A. Barclay and Dr. S. E. Janson of the Science Museum, London; to Miss Geraldine Beard, Mr. Arthur Carlson, and Dr. James Heslin of the New York Historical Society; to Miss Mabel Bishop of the Virginia Bureau of Vital Statistics, Richmond; to Mr. Willi Borberg of General Precision Instruments, with whom I had many a pleasant lunch; to Mr. Wyatt Brummitt and Mr. Glenn Matthews of the Eastman Kodak Company, Rochester; to M. Maurice Daumas, Conservateur du Conservatoire Nationale des Arts et Métiers,

Paris; to Sarah Dennen, Jessie Carter Duncan, and A. H. Carter for their intelligent kindnesses in my Friese-Greene research; to the Devonald family of East Orange, New Jersey; to Miss Lotte Eisner of the Cinémathèque Française, Paris; to Mr. Ellstadt, of the Bausch and Lomb Company, Rochester, New York; to Mr. James Flexner; to Miss Bess Glenn, the gracious and intelligent head of the Justice and Executive Branch of the National Archives, and to Mr. Cummings, Mr. Leisinger and Dr. Rheingold of the National Archives; to Dr. Alfred Goldsmith for his valuable opinions on the Edison caveats; to Mr. Sylvan Harris, former editor of the *Journal of the Society of Motion Picture Engineers*; to Dr. Thomas Harvey of Orange; to Mr. John Melville Jennings of the Virginia Historical Society; to Miss Grace Mayer, Mr. Bernard Karpel, and Mr. Rolf Petersen of the Museum of Modern Art; to Dr. John Kintzig and Mr. Charles Young of the Photographic Division, Mr. Joseph Mask of the Main Reading Room and Miss Dawn Pohlman of the Science Division, of the New York Public Library; to Mr. Bradley Leonard of the Newark Public Library; to Mr. Robert Lovett of Baker Library, Harvard University; to Mr. Macartney of the Copyright Division, and to Colonel Willard Webb, Chief of the Stack and Reader Division, of the Library of Congress; to Mr. Don Malkames for many pleasant conversations; to Mr. Jack McCullough of the Motion Picture Association; to Mr. George Pratt of the George Eastman House, Rochester; to Miss Georgia E. Raynor of the Orange Free Public Library; to Mr. Charles Reynolds of *Popular Photography*; to Mr. T. V. Roberts, Borough Librarian, Borough of Twickenham, England; to Dr. R. S. Schultze of Kodak Limited, Harrow, England; to Mr. Bud Schwalberg; to Mrs. Sedgewick of Twickenham, England; to Miss Miriam Studley of the Newark Public Library, and Mr. Fred Shelley, formerly of the New Jersey Historical Society and now of the Library of Congress, both of whom helped me with rare good will and rarer intelligence; to Dr. Louis Sipley of the American Museum of Photography, Philadelphia; to Mr. Ed Wade of *Infinity* for an illuminating analysis of the technical side of the Archives seven-frame strip; to Dr. Alexander Wedderburn of the Smithsonian Institution; to the Twickenham lady who was Dickson's housekeeper during his last days; to my correspondent at the Royal Geographical Society; to the

friendly staff of the Engineering Societies Library, New York; and to all others whose names I may have inadvertently omitted from this list.

In addition, I am grateful to the following for allowing the reprinting of copyrighted material:

Appleton-Century-Crofts for a quotation from Faulkner's *American Political and Social History*, 1957;

Doubleday & Company for a quotation from Smith's *Two Reels and a Crank*, 1952;

Callaghan and Company for a quotation from Hopkins' *The Law of Patents*, 1909;

The Columbia University Press for a quotation from Eder's *History of Photography*, 1945;

E. P. Dutton & Company, Inc. for a quotation from Tate's *Edison's Open Door*, 1938;

The *Encyclopædia Britannica* for quotations from their 1956 edition;

The General Alumni Society of the University of Pennsylvania for a quotation from George Nitzsche in their *General Magazine and Historical Chronicle*, Vol. LIV, No. 1;

Lewis Jacobs for a quotation from his *The Rise of the American Film*, 1939;

Marsland Publications for a quotation from Allister's *Friese-Greene: Close-Up of an Inventor*, 1951;

McGraw-Hill for quotations from Josephson's *Edison*, 1959;

The G. & C. Merriam Company for quotations from their dictionary, 1959;

The Museum of Modern Art, for a quotation from Newhall's *The History of Photography*, 1949;

The *New York Times*, for a quotation from the *Times* of October 3, 1935;

Charles Scribner's Sons, for a quotation from Burlingame's *Engines of Democracy*, 1940;

Simon and Schuster, for quotations from Ramsaye's *A Million and One Nights*, 1926;

The Society of Motion Picture and Television Engineers, for quotations from their *Journal*, 1928 and 1933;

The University of Rochester for quotations from Ackerman's *George Eastman*, 1930;

and James T. White & Company for a quotation from their *National Cyclopedia of American Biography*, Vol. IX, p. 193.

On the debit side, I cannot refrain from commenting upon the many librarians and library assistants who proudly told me that *their* newspapers were on microfilm—and when I asked them what had become of the old, were only able to say, "But

Mr. Hendricks, they were *falling apart!*" Few of these failed to ask me why I wanted the original volumes—a question no one who has done serious research would find it necessary to ask. From such enemies within the gates history also has much to fear.

G. H.

Contents

Illustrations

Introduction

"OFFICIAL" MOTION PICTURE HISTORY HAS GIVEN THE LION'S SHARE of credit for invention to Thomas Edison. There has been an occasional backward glance at Edison's employee, W. K. L. Dickson, but Edison's prominence in American life has made the attribution to him easy, and historians have been loath to change it. The most prominent historian of the early period of the American film, Terry Ramsaye, had continuous cordial personal contact with Edison during the preparation of his history, and although he has occasionally and upon details gainsaid Edison claims, Ramsaye's work is far too indulgent to go unchallenged.

Since the Ramsaye history has been virtually the only treatment of this period—and the only extensive one—historians of the film, not being inclined to do research on any particular period of their history, have rerecorded Ramsaye, although they must have wondered more than once about his reliability. Edison did not like Dickson; Ramsaye liked Edison and shared his dislike of Dickson. This disapproval was not lessened by Dickson's many errors. (See Appendix C.) The George Eastman biographers have aided the aggrandizement of Edison in the process of claiming for *their* hero some of the glory which shone from the "Wizard of Menlo Park." The most anyone has done is to attribute a small part of the credit to Dickson. Writers of reference books, as is their wont, have merely followed the "authority" of the field. As a result, en-

1

cyclopedias, almanacs, and text-books ascribe most or all the invention of the American film to Thomas Edison. Few of these so much as mention the work of W. K. L. Dickson.

The work with which this volume is concerned began in 1888 and ended in 1892 with the achievement of the "modern" motion picture at the West Orange laboratory. Dickson, who had been hired for his electrical interests and ability, was particularly interested and skilled in the whole subject of photography; when the motion picture work began, he became its natural mentor, and continued the work to its culmination in the fall of 1892. He was twenty-three years of age when he entered Edison's employ, had come to America four years previously, and like many young men of the time, had his own share of hero-worship for the famous electrician-industrialist. He was given successively more important jobs to do, and when the motion picture swam into the Edison ken, he was given this matter to "handle"—although he was consistently refused the time and coöperation necessary for its best fulfillment.

Edison and his men at West Orange tried everything. Nothing was too trivial or obscure. If it occurred to them they proposed to try it (although much that they proposed to do never got done). "Motion photography" was no exception. Everyone was talking about it in 1887 and for some time previously—but chiefly after the Muybridge publications in 1887 and the Marey publications of the same year—and Edison was not one to encounter this new problem without wanting to solve it himself. The story of this solution by one of his men, derived from the first systematic examination ever made of the laboratory records and other original sources, constitutes the present history.

1 · *The First Stimulus*

THE CHIEF CREDIT FOR WHAT IS GENERALLY KNOWN AS THE EDISON motion picture work must rest with Edison's employee, W. K. L. Dickson (see Appendix A for biographical sketch), but for whose interest, perseverance, and mechanical and inventive skill none of this work would have been accomplished. If this study is rather an account of the work of Dickson than an account of the work of Edison, it is because it is the work of Dickson which is the "Edison" motion picture story. Much error, concerning the work per se, his relations with Edison, and his own claims to accomplishment, can be laid at Dickson's door (see Appendix C), but it is nevertheless true that what was accomplished was accomplished because Dickson was there, and the conscientious historian must confine Edison's contribution to his sponsoring of Dickson, and to the intelligence and energy which made the West Orange laboratory the scene of the commercial preparation of so many of the ideas of other men.

There is no evidence that motion pictures of any kind were produced at the Edison laboratory until the fall of 1889, or that they were produced on what we know as "film" until May, 1891: this in spite of the sworn testimony of Edison himself and many of his men to the contrary and frequent averments by nearly everyone else.[1]

There is furthermore no evidence that the motion picture was

[1] E.g., "Complainant's Record," Equity 6928, the United States Circuit Court of the Southern District of New York.

3

even thought about in terms of an Edison project until November, 1888; or that when work was begun it was done by Edison himself; or that Edison had, indeed, any interest at all in the project until he began to realize that it had publicity value; or that even then he did anything toward making the project practical; or that any single part of any of the so-called Edison motion picture inventions actually contains any Edison invention; or that he even made any serious claim to the invention of motion picture photography until the vitascope of C. Francis Jenkins became, in 1896, a means to recoup the tremendous loss of time and money Edison had incurred in the previous five years by a combination of misjudgment and stubbornness in the ore-milling business.

From the first work to the vitascope debut in 1896, and with the exception of the 905 kinetoscopes produced by the Edison Manufacturing Company before the vitascope debut,[2] Edison merely permitted others to do what *they* could with motion picture work—both developmental and exploitation, and this only over protest.

When Eadweard Muybridge lectured in Orange, New Jersey, on February 25, 1888, at the invitation of the New England Society,[3] the fact that Edison's laboratory was in the same city was only coincidence. In retrospect, and with the knowledge we now have that the work of Muybridge was important in stimulating motion picture work at the Edison laboratory, it may seem that these two facts are interdependent. But even a slight study of the period will convince us that Hartford, Albany, Boston, Cincinnati, or any of hundreds of other American cities could have invited (and often did invite) this famous authority on animal locomotion to lecture.

Orange was the principal member of a four-town group of Newark suburbs, the others being West Orange (to which Edison's laboratory came in 1887), South Orange, and East Orange, this latter perhaps the most fashionable of the four. In 1890 Orange's population was 18,844.

[2] A file of selected legal miscellany including notes by the Edison attorneys lists kinetoscopes manufactured. See number E190-0.292-2.1 to 2.47 in the Edison archives.
[3] *Orange Chronicle,* March 3, 1888.

4

During the ascendancy of the wet collodion process there was widespread interest in so-called "instantaneous" photography. Such photography, however, was only infrequently achieved. ("Infrequently" is only appropriate here when it is considered in relation to the many more such photographs possible after the gelatino-bromide process was discovered. The word "instantaneous" itself, as a contemporary wrote, was "as elastic a term as the expression 'long and short,' " [4] yet it clearly represented all short exposures at the beginning of the era. Exposures of less than a second were so called, and soon it became possible to reduce exposures to $\frac{1}{25}$ of a second and beyond. One writer referred to "instantaneous" as meaning, in 1888, "exposures made by hand, of a quarter of a second or less." [5]) In general it may be said that the wet collodion process by its very nature excluded such photography. As Eder says:[6] "The introduction of 'instantaneous' photography was hastened by difficulties of the wet collodion process." But after 1871 the Maddox invention of the gelatino-bromide process made possible dry-plate "instantaneous" photography—exciting, sharp-edge glimpses of life. Although W. H. Harrison had used gelatin as a binding agent for silver bromide his images were useless because his emulsions were too rough. Dr. Richard L. Maddox, as Eder says (op. cit.), "succeeded in obtaining the first satisfactory images on gelatine silver bromide." Maddox's first notice of his new process is dated September 8, 1871. Eder also names Poitevin (1850) and Gaudin (1853) as other early experimenters in the process.

The new process was particularly suitable for fast exposures because it was a dry process: the sensitive silver could now remain sensitive after its suspending agent (gelatin in the new process, collodion in the older) had dried. Indeed, it was found that ripening the emulsion some days or a week increased its rapidity, whereas in the wet process the exposure had to be made in a few seconds. (See the Newhall quotation, page 20.) And the gelatin emulsions were from ten to a hundred times more sensitive than collodion-bromide.

According to most authorities, however, the dry-plate process

[4] Theodore Skaife, *Instantaneous Photography* (Greenwich, 1860).

[5] *Anthony's Photographic Bulletin*, June 9, 1888.

[6] Joseph Maria Eder, *History of Photography*. (New York: Columbia University press, 1945.) Hereafter cited simply as "Eder."

of "instantaneous" photography did not become generally used until the early 'eighties. This is indeed self-evident from the popular periodical literature of the time.

With the wide distribution of the Eastman flexible film and the Eastman stripping film, beginning in 1884, many thousands of amateurs began trying to catch life motions on film.[7]

The classic work of Eadweard Muybridge—still to be outmoded in spite of the curious rancor of at least one historian (see below)—was then and is now the transcendent tour de force of life motion photography.[8] Muybridge had been lecturing widely and with considerable artistic and commercial success for many years, had been heard in and around New York many times, and was a figure of national interest through magazine articles on his work. It was only natural that the chief lecture-sponsoring group in Orange should have invited him to visit.

For reasons which seem to have originated from a combination of journalistic sensation-seeking and his obviously favorable impression of John D. Isaacs (whom he "found" in Massachusetts) Terry Ramsaye seems to have been "out to get" Muybridge. No one close to the facts will fail to recognize this feeling in the following lines from *A Million and One Nights*:[9]

> Now the photographer from California was acclaimed and on the road to greatness. He hastened to London in his native England to bask in glory. He lectured with large profundity and tooting astuteness before the Royal Institution. John D. Isaacs, busy railroading in faraway California read about it and grinned. . . . Everything that developed [i.e., the relation of his work to the motion picture. One wonders here what a "motion picture" was to Ramsaye] was . . . the sheerest coincidence. He was engaged solely in stopping the horse on the plate, by methods handed to him for the purpose.

[7] Eder mentions Melhuish and Spencer (1854) as Eastman's predecessors in the roll-holder type of camera, and Warnerke (1875) as a predecessor in coating (and later stripping) paper with silver in gelatin. Milmson (1877) and Ferran and Pauli (1880) were others who coated paper with the new dry emulsion. In 1884, however, all these were overshadowed by the wide availability of Eastman's paper film, from which the emulsion could be stripped and used.

[8] A projected monograph will discuss Muybridge's work, which seems to me to be the chief stimulus for the mechanical invention upon which the American motion-picture is based.

[9] New York: Simon and Schuster, 1926. Pp. 41–42. Herafter cited simply as "Ramsaye."

Ramsaye continues by comparing Muybridge's fame to that of the "Boer farmer who was using a giant Kimberly diamond for a door weight when a mining expert called," discounting entirely the tremendous amount of careful and imaginative work done by Muybridge.

Since this work is intended to deal with facts, detailed treatment of the famous statement by Edison that he began work in 1887, the year before Muybridge's lecture, and the later one by Dickson that "In the year 1887, Mr. Edison found himself in possession of one of those breathing spells. . . . It was then that a series of experiments was entered upon at the Orange Laboratory . . ." seems inappropriate.[10] Edison's *Century Magazine* statement, repeated by Dickson in an article in *Cassier's Magazine* in December, 1894, supplementary to his long series titled "The Life and Inventions of Thomas Alva Edison," and later published in book form, is only a repetition of error.

This series was begun in *Cassier's* in November, 1892, as the lead article of the issue. The frontispiece of this issue was the photograph reproduced later on page 31 of the Dicksons' biography of Edison. The series ran through November of the next year. Its airy persiflage contained a run-down of most of Edison's life to date—with the customary aggrandizements. It was later published in book form in both America and England in 1894 as *The Life and Inventions of Thomas Alva Edison*, although Dickson seems to have gotten little or no remuneration for it.[11]

Judging by Dickson's other and soberer writings, the book's objectionable style stems principally from his sister Antonia, who fits well into Thomas Beer's definition of a late-nineteenth-century "author": "a dreadful person who likes to write books." Dickson himself no doubt warmly acquiesced in these often mawkish wanderings, which were so exaggerated that more

[10] From the *Century Magazine,* June, 1894; reprinted in Antonia and W. K. L. Dickson's *History of the Kinetograph Kinetoscope and Kineto-Phonograph* (New York: Albert Bunn, 1895); reprinted also in Dickson's article in the December, 1933, *Journal of the Society of Motion Picture Engineers* (hereafter cited simply as "Dickson's 1933 article"): "In the year 1887, the idea occurred to me that it was possible to devise an instrument which could do for the eye what the phonograph does for the ear . . ."
[11] See a January 3, 1894, letter from Dickson to Dyer and Seely in the document files at the West Orange laboratory.

than one reviewer—even in a day famed for romantic exaggeration—was moved to satire. For example, the British *Electrical Review*[12] said:

> This series has been in progress during the last eight months . . . Each seems more likely "to be continued in our next," than the last.
>
> We are generally prepared, in the month of June, to make allowance for excesses of fine feeling, as Byron did; but even in June it requires a specially wrought individual to bestow a deep enthusiasm upon the glow from an electric lamp. The June number of *Cassier's* begins thus: "The breathings of Marsyas's flute which trenched upon the golden harmonies of Phoebus Apollo, and the flowing fabric of Arachne which outvied the textile intricacies of Pallas Athene; the spell of Arion which smoothed the wrinkled brow of ancient Oceanus, and the magic strains of Orpheus, at which the basaltic gates of Hades rolled suddenly back on their adamantine hinges, all these endangered the attributes of Olympus, and the gods themselves became ashamed of their earthly children. But the majesty of heaven entrenched itself in the mysterious and deadly arsenal of the skies, in the thunder-bolts of Zeus, the steel-blue Aegis of the sheet lightning, the forked spears and chains of deadly fire."
>
> By a more or less natural sequence this florid language leads to the contemplation of the voltaic arc . . .

Both Dickson and Ramsaye, in point of fact, even claimed 1886 for such a "breathing spell" as Dickson described.[13] But anyone who examines the Edison archives will doubt that 1887 contained such a "breathing spell." It is difficult to credit that, according to normal standards, Edison took such a break in any of these years. The Dicksons' florid description of this time in their *History of the Kinetograph Kinetoscope and Kineto-Phonograph* fails to convince: "The great issues of electricity were satisfactorily under way. The incandescent light had received its finishing touches; telephonic telegraphic devices were substantially interwoven with the fabric of international life; the

[12] August 18, 1893.
[13] Ramsaye, page 50; Dickson, in a letter to Glenn E. Matthews, in the Matthews collection, Rochester. (See also Matthews letter of August 7, 1933. Also in a letter to Meadowcroft, Edison's secretary, of April 21, 1928, in the historical files of the Edison archives at the West Orange laboratory, "Mot. Pic. Hist. Dickson Articles and Letters."

phonograph was established on what seemed to be a solid financial and social basis . . ."

And in fact there is no evidence that anyone at the West Orange laboratory gave motion pictures a thought until October 8, 1888, the time of the first motion picture caveat (see page 14). In any case, the matter does not seem crucial since many others both in the United States and abroad had given innumerable thoughts to motion pictures long before this. The crucial matter is what was *done* about these thoughts, and we have direct evidence, as I will show, that little was done at the West Orange laboratory until some years later.

The documents files of the Edison archives contain, for 1887, only one item classified (albeit improperly) by the laboratory staff as a motion picture item. This is a letter from the Scovill Manufacturing Company dated December 17, 1887, in which Edison is asked to confirm "memorandum invoice of goods selected by Mr. Wm. K. L. Dickson." (Matthew Josephson, in his recent biography of Edison,[14]—see Appendix F for an analysis of errors in this work—mentions this, but, properly, does not ascribe this visit to motion picture work, as the laboratory cataloguers have done.)

The 1888 motion picture and Muybridge files contain many items improperly ascribed to motion picture work. Of the twenty-six items so filed only the following twelve appear relevant to motion pictures:

(1) A sketch of a cylinder machine.

(2) A sketch of a cylinder machine.

(3) A sketch of a cylinder machine.

(4) A letter from Eaton, Edison's attorney. Edison had sought a name for the apparatus described in the first motion picture caveat, October 10, 1888.

(5) Another such, from Daniel Chamberlain, same date.

(6) Another such, from Lewis, Eaton's partner, same date.

(7) Ten handwritten pages of the first motion picture caveat. (See Appendix B.)

(8) Letter from Muybridge, dated May 12, 1888. (See page 27.)

(9) Letter from Muybridge, dated November 28, 1888. (See page 28.)

[14] Matthew Josephson, *Edison*. New York: McGraw-Hill, 1959. Page 385. Hereafter cited simply as "Josephson."

(10) A brochure *re* the Muybridge plates, apparently enclosed with the May 12 letter.

(11) A card introducing Edison to the Muybridge publishers, also apparently enclosed with the May 12 letter.

(12) A carbon copy of an Edison letter asking Muybridge to select the plates for him.

A strong case is thus made for the position that the only motion picture activity at the Edison laboratory up to the end of 1888 concerned the Muybridge material and the first motion picture caveat.

It is possible that both Edison and Dickson attended this February 25 lecture by Muybridge. Edison's reason for going would have been two-fold. In the first place he had already, after twenty-two months as a West Orange citizen,[15] established a policy of what was then and is now known as "civic-mindedness." There is little to suggest that he ever supported a "worthy cause" in those days from any inner conviction of his own, or that any social group such as the New England Society that sponsored the lecture would ever have involved him if it had not been for the inclinations of his new bride.[16] But belonging to and attending the affairs of this Society was clearly "the thing

[15] As of January 28, 1887, the laboratory property purchase was being negotiated (letter book E1730, 10/12/86–2/21/87, page 260). A Josephson error, page 309, says that it had been bought by the previous year. On May 5 Edison wrote that he would want nothing for his new laboratory for another two months. (Letter book E1730, 2/21/87–6/14/87, page 426.) On June 18, the *Orange Journal* announced that "ground will be broken in a few days." On July 5, ground *was* broken (*Scientific American*, September 17, 1887). By July 12 the foundation was in (letter book E1730, 6/21/87–10/22/87, page 25). By September 14 the laboratory "had not been completed" (letter book E1730, 6/21/87–10/22/87, page 92). On about November 1, Edison appears to have established himself at the new location (Edison archives document files "Edison El. Lt. Co. 1887"). On November 8 he said "My laboratory will be ready" on December 1, (letter book E1730, 8/29/87–10/15/88, page 33). On Thanksgiving Day, according to Fred Ott, they moved in; but on December 21 Edison was still saying that the laboratory would be "completed" in about two months. (Letter book E1740, 8/29/87–10/15/88, page 89.)

[16] Mina Miller, of Akron, Ohio, daughter of Lewis Miller, called the "father" of the Chautauqua idea by Dyer, Martin, and Meadowcroft (*Edison, His Life and Inventions*. New York: Harper and Brothers, 1929. Hereafter cited simply as "Dyer, Martin, and Meadowcroft.") whom he had married two years previously and concerning whom there is every indication that she was socially minded. (See, for example, descriptions in the Orange newspapers of many social affairs, of which the May 20, 1891, reception—see chap. 15—is a case in point.)

to do" in those lecture-ridden days of the late nineteenth century when much of America felt that Culture was something to be acquired as one would acquire a "Queen Anne" house, or would go to the shore on the first of July to spend as much of the next two months as possible in an elaborate "cottage."

There is also no doubt that Edison, because of his consistent and vigorous interest in all scientific matters, would have been more than ordinarily interested in this lecture. It would perhaps be fair to say that Mrs. Edison might have had less trouble than usual in persuading him to go—although he was a man whose actions frequently belied his avowals of contempt for social affairs. In any case he appears to have readily agreed to see Muybridge the Monday following the lecture. (February 25, 1888, the date of the lecture, was a Saturday.) If he went, he may have met the lecturer personally after the program—as Muybridge must have himself been eager to meet the Oranges' most famous citizen—and either volunteered the invitation or readily acceded to a proposal of a visit.

Dickson, with his lively interest in all things photographic, and with so much interest being had in these days by all photographers in the "instantaneous" photography of life, may also have attended the lecture. We cannot rule out the social side of the matter with Dickson also. He would have felt that such an Orange social affair would be the sort of thing he "ought" to attend, although he had not yet moved there with his socially minded wife and sister. (See Appendix A.)

We can be sure also that the Monday visit was about the idea of joining the phonograph with pictures of motion.[17] Edison was even more famous for his phonograph than Muybridge was for his photographs, and such a discussion was natural. Both men were anything but blind to the publicity values of such a visit—whether or not either had any serious idea of such a motion picture-phonograph combination as both afterward claimed.

Of this interview there can be no doubt, and no more doubt

[17] The angle of displacement, although sometimes so small as to be imperceptible to the eye, is nevertheless always existent in photographs of moving objects. We therefore see moving objects actually "in motion" whenever we view photographs taken while this movement occurred, although the image on the plate may seem perfectly sharp to us. ". . . One high authority," says *Anthony's Photographic Bulletin* of March 26, 1887, places the amount of displacement allowable for sharpness at $\frac{1}{250}$ of an inch.

that they talked of joining photographs to the phonograph—although this was later denied, in characteristic fashion, by Edison.

In the preface to *Animals in Motion*, 1899, Muybridge said: "It may be here parenthetically remarked that on the 27th of February, 1888, the author . . .consulted with Mr. Thomas A. Edison as to the practicability of using [the zoöpraxiscope] in association with the phonograph . . ."

In the margin of the Ramsaye manuscript now at Harvard University, opposite the Ramsaye remark that Muybridge had "wanted to interest Edison in uniting this device with the phonograph" Edison has noted: "No—Muybridge came to Lab to show me picture of a horse in motion—nothing was said about phonogph." In characteristic fashion, and again without checking the unsupported statements of pioneers, Ramsaye "improved" Edison's remark, excised all such claims from his history, and said, on page 44, "It makes a handsome paragraph, but it does not fit the unaggressive Muybridge pattern." Yet Ramsaye has been at pains elsewhere to establish precisely Muybridge's aggressiveness. As for the Edison remark, shortly after the visit occurred he himself stated in specific, unmistakable terms that the topic of this conversation *was* the joining of these two inventions.[18] Josephson (page 384) repeats the fiction that this visit was two years earlier.

Muybridge was not the only life-motion photographer who stimulated motion picture work at the Edison laboratory. The work of Ottomar Anschütz, for example, is also significant.[19] It has been stated categorically by at least one writer that the

[18] *New York World*, June 3, 1888.
[19] Anschütz was born in 1846 and died in 1907. He made single instantaneous photographs in 1882 but was not well known until 1884 when his photographs of birds in flight became famous for their unprecedented sharpness. From 1885 onward he worked in photography of animals and human beings in a continuous series of photographs. Eder (page 513) says that he made 24 exposures in ¾ second, and that he was "far more successful and more precise in obtaining the optical synthesis of these serial photographs into 'moving pictures' than all his predecessors." His tachyscope, of which many were installed in America in the few years following 1889 (see page 84 ff.), was apparently introduced in early 1887 (see page 85), although there is some reason to believe that it belongs to an earlier date. The *Photographic Times* of April 22, 1887, mentioned a "recent" exhibition in New York City. Among very interesting biographical material on Anschütz, the reader is directed to Eder's *Jahrbuch für photographie*, 1887, page 107.

Anschütz work was the *most* influential,[20] but there is no evidence to support this position. It is certainly true, however, that things German interested Edison preëminently, and more particularly he admired the achievements of the German scientists, especially Helmholtz.[21] He subscribed to more German publications than those in any other foreign language,[22] although he did not read German himself—not even enough to obtain the gist of what was said, in spite of many statements to the contrary.[23]

The first prominent notice of the Anschütz work that I have found in American publications is one in *The Philadelphia Photographer* of June 4, 1887 (see chap. 11 for a fuller discussion of Anschütz' work): "The photographer, Anschütz, of Lissa, has an apparatus . . . for the most perfect stroboscopic combination of the motion pictures produced by him . . ."

It is clear that men the whole world over, such as Marey in France and Anschütz in Germany, were stimulated by the work of Muybridge, but it seems likely that it was the rapidly increasing pace of the public notices given to all these men which stimulated Dickson to start the ball rolling in his "spare" time at the Edison laboratory.

But on February 27, 1888, Dickson was deep in ore-milling experiments[24] and Edison was deep in setting up his new laboratory and in scores of other claims on his time. This preoccupation with other matters continued until the next year, with

[20] For example, Zglincki (*Der Weg des Films,* Berlin, 1957) on page 203 quotes Liesegang, a prominent German writer on photography, as saying that Edison "found the starting point" for his kinetoscope in Anschütz' *schnellseher.*

[21] This admiration of Helmholtz reached an almost touching *pointe acérée* on September 18, 1889, when Edison, visiting Helmholtz in Charlottenburg, presented the German scientist with several phonographs. (Edison archives document files "Synopses etc., 1889.")

[22] The order of April 22, 1889, establishes this. On this date twelve technical periodicals were subscribed to for the library of the new laboratory. Four of these were French (including the *Comptes Rendus* of the Academy), three were English, and five German. (Letter book, E1717, 4/8/89–5/21/89, p. 174. This letter book is improperly titled 6/7/88–5/21/89.)

[23] Letter book E1730, 6/21/87–10/22/87, page 51. See also Dyer, Martin, and Meadowcroft, page 745.

[24] The Dickson note book, for example, #870610 in the Edison Museum, West Orange, New Jersey, lists February 1, 4, 13, 27, 29; March 1, 3, 7, 10, 12, 13, 14, 15, 16, 20; April 27; May 1, 3, 4, 5, 6, 8; June 15 as ore-milling experiment days. Considerable additional correspondence—for example a June 11, 1888 letter from Dickson in the document file "Edison Ore-Milling Company" adds weight to this opinion.

Dickson giving only very occasional attention to his work as the official laboratory photographer—a considerable job in itself.[25] It is further substantiated by the fact that in a list of 104 "Things doing and to be done," dated January 3, 1888, from an Edison notebook (N-880103.2), motion pictures are not even obliquely mentioned, in spite of the fact that this list contains everything else we know to have been part of laboratory experiments and a number of items that were never tried—at least visibly.

2 · The First Motion Picture Caveat

THE FIRST MOTION PICTURE ITEM IN THE EDISON WEST ORANGE laboratory is dated October 8, 1888. This was the date upon which Edison wrote his famous Motion Picture Caveat I, beginning: "I am experimenting upon an instrument which does for the Eye what the phonograph does for the Ear . . ." This document, given in its original form in Appendix B (published here for the first time), is extremely revealing of the man who wrote it: his methods, his personality, and his knowledge of mechanics in general and of photography in particular. It also reveals the most advanced extent of motion picture thinking at the West Orange laboratory as of October 8, 1888.[1] It deserves, therefore, detailed consideration here. It is not widely known; few historians have discussed it.[2]

[25] The pressure to which Dickson was exposed in connection with this work is often shown in the archives material. For example, items dated August 6, 1887 (document file "Photos Electric Light Early"), August 12, 1887, (ibid.), March 31, 1889 (document files "Phonograph 1888"), April 2, 1888 (ibid.)—in which Edison wrote that Dickson was too busy with ore-milling to take the photos requested. On May 28 and again on June 7, the Electrical Review asked for photos and was not answered until August 6. On July 14, the Scientific American asked for photos but did not receive them until August 21. All these references are from the document files.

[1] I cannot imagine why a man writing such an account of his work would set down in a secret place ideas which he no longer possessed.

[2] I do not believe the word "caveat" appears in Ramsaye—let alone a discussion thereof. Dyer, Martin, and Meadowcroft spend four pages (591–594) discussing the Edison caveats but do not refer to those concerning motion

To begin with, a caveat, as defined by Webster's Dictionary of that year, 1888, is: "A description of some invention, designed to be patented, lodged in the office before the patent right is taken out, operating as a bar to applications respecting the same invention, from any other quarter." And the law itself reads (4902, R.S.U.S.):

> Any person who makes any new invention or discovery and desires further time to mature the same may, on payment of the fees required by law, file in the Patent Office, a caveat setting forth the design thereof and its distinguishing characteristics and praying protection of his right until he shall have matured his invention. Such caveat shall be filed in the confidential archives of the office and preserved in secrecy, and shall be operative for the term of one year from the filing thereof; and if application is made within the year by any other person for a patent with which such caveat would in any manner interfere the Commissioner shall deposit the description, specification, drawings, and model of such application in like manner in the confidential archives of the office and give notice thereof by mail to the person by whom the caveat was filed. If such person desires to avail himself of his caveat, he shall file his description, specification, drawings, and model within three months from the time of placing the notice in the postoffice in Washington, and with the usual time required for transmitting it to the caveator added thereto, which time shall be indorsed on the notice.

Edison obviously filed caveats regularly to gain the benefit of the "give notice" clause of the law.[3] His attorneys, however, as we shall see later (Appendix D), in spite of the great dissimilarity between the apparatus described in these caveats and the apparatus described in the Edison motion picture patent applications, and grasping at a last incredible straw to prosecute his

pictures. Byran (*Edison: The Man and His Work*. New York: Alfred A. Knopf, Inc., 1926), makes no mention of any such caveat. I have not found the word in any Dickson writing, in Quigley (*Magic Shadows*. Washington: Georgetown University Press, 1948), in Talbot (*Moving Pictures*. London: Heinemann, 1912), Bardèche and Brasillach (*The History of the Motion Pictures*. New York: Norton and Company, 1938), Rotha and Griffith (*The Film Till Now*. London: Vision, 1949), Knight (*The Liveliest Art*. New York: Macmillan, 1957), Jacobs (*The Rise of the American Film*. New York: Harcourt Brace, 1939), etc., etc.

[3] Although I have not made a study of this matter, Dyer, Martin, and Meadowcroft say on page 591 that Edison filed altogether one hundred and twenty caveats. If we consider that many of these embraced dozens of items each, we can readily conclude that his intention was to circumscribe from other workers fields of endeavor which he could not possibly exploit himself.

application to issue, cited these caveats as proof of priority of invention.[4] These citations were soon abandoned, however, by Edison's attorneys and disregarded by every judge who ever sat upon the litigation which arose as a result of the issue of this patent.[5] (For a discussion of the beginning of the complicated course of this application through to its controversial issue, see chap. 18.) Patent law authorities agree—without any exception that I have found—that the law excludes the use of a caveat to carry back the date of invention unless it "adequately describe[s] the invention of the subsequent patent"—the adequacy being moot. (61 Fed. Rep. 655, 671.) As the standard legal text, Hopkins' *The Law of Patents*,[6] says on page 272: "It will be seen that the purpose of the section was to secure an opportunity to have questions of priority between rival inventors determined before the issue of a patent."

The language of the law also limits the operation of the notice to within a year of the date of filing of the caveat, so the caveator could not expect to be notified of what had happened in this line before the date of his filing, or after the end of a year. Edison, incidentally, seems to have filed the three additional Motion Picture Caveats to "keep alive" his original filing, since the two caveats next ensuing (of February 3, 1889, and May 20, 1889—see chaps. 3 and 4) sketched the originally described mechanism as well as the improvement which was ostensibly the specific occasion for the new caveat.

The language of court decisions on this matter is extensive and interesting. This language makes it clear that an apparatus described in a caveat was not to be regarded as having been perfected. Indeed, there has been a nearly complete unanimity upon this point: only one case being an exception. (For typical

[4] Motion Picture Caveat I, October 8, 1888; Motion Picture Caveat II, February 3, 1889; Motion Picture Caveat III, May 20, 1889; Motion Picture Caveat IV, November 2 *et seq.* 1889. These dates are the dates upon which they were written. The dates upon which they were officially filed are, respectively, October 17, 1888; March 25, 1889; August 5, 1889; and December 16, 1889. (Complainant's Record, pages 348–359 both inclusive, Equity 6928, U. S. Circuit Court, Southern District of New York.)

[5] In his argument and briefs on appeal to the United States Circuit Court of Appeals of the Second Circuit, Parker Page, the American Mutoscope and Biograph Company counsel, stated that the Edison attorney (who had referred to this caveat in *his* argument) did not realize that the 1888 caveat had been abandoned in the appeal to the same court in 1902. (Equity #8289 in U. S. Circuit Court, Southern District of New York.)

[6] Chicago: Callaghan and Company, 1911.

interpretations see 61 Fed. Rep. 655, 671; also 6 McLean 303, Fed. Case 225; 1 Bond 212, Fed. Case 1247; 4 Fisher 170, Fed. Case 7140; 12 Fed. Rep. 111, 116; 1 McArthur 52, Fed. Case 2929. For the single exceptional case, see 1 Fisher 351, Fed. Case 7411.)

In Elges vs. Miller, 46 O.G. 1514, the court said:

> The filing of a caveat does not give the caveator the standing of an applicant with respect to what is called "Constructive Reduction to Practise." [The caveat] contains no declaration or purpose on the part of the caveator that he will ever complete or finish his invention or give it to the world. The statute does not contemplate that a caveator shall stand as an obstruction to the diligent efforts of other inventors in the same field of art.

In the same case, the court also said:

> The statute authorizing the filing of a caveat does not intend to confer upon the caveator any right as an inventor, nor to save him from the effect of negligence or give him any advantage over any other inventor who has conceived the invention and prosecuted his application with diligence. It is not intended as a stimulus to prod and drive him to perfect his invention, nor is it intended to extend the time in any manner within which he may complete the invention . . .

In Ex Parte Ward, 46 O.G. 1513, the court said: "[A patentee] ought not be delayed in the issuance of his patent by a caveator who is under no obligation to be diligent or to file his application for patent." As we will see, Edison, in all his caveats, had in no case achieved "Constructive Reduction to Practise," nor had he in any sense achieved what the courts understood as a "perfection" of his invention. Indeed, Caveat I describes a completely inoperable apparatus, and nearly all its sections range variously from the extremely unlikely on one hand to the fabulous and impossible on the other. Without attending to the claim in the first sentence that the instrument was "in such a form as to be both cheap practical and convenient," which we cannot accept as having been ever achieved with the apparatus described (or with any Edison motion picture apparatus ever made) we are made quite incredulous in the third by: "In the first production of the actual motions that is to say of a continuous Opera The Instrument may be called . . ."

17

In June of this same year (see chap. 1, note 18) Edison had claimed a similar fanciful capacity for his phonograph. On June 3, the *New York World* said in the article cited above:

> I have also a talking clock, which, instead of striking the hour, speaks it. At dinner time a voice issues from the clock which says 'dinner-time'; also 'One o'clock,' 'Two o'clock, &c., as the case may be. Another device which I am perfecting [a word which came easily to Edison's lips] in connection with the clock is that of a female face which I purpose to set in the face of the clock. The lips of this figure will move at the hour, the head will bow, and the fictitious lady will say, 'Good evening, ladies and gentlemen, it is bedtime.' . . . I can make an instrument which is capable of being hidden away in a parlor and which will record all the conversation carried on there. Imagine the consternation of a loving young couple when all their billing and cooing is reproduced by the mother of the young lady who has placed the phonograph there for that purpose! To unnumbered purposes can this instrument be put.

He had elsewhere claimed that *Nicholas Nickleby* could be entirely reproduced on four cylinders[7] and that *Ermine* (a musical which had a long run at the Casino in New York) could also be "taken" in its entirety on his motion picture machine.

Two years later, in the process of a collaboration with George Parson Lathrop (see *Harper's Weekly* article, June, 1891, etc.) on a science fiction book he also proposed "Kinetoscope operas with phono . . ." In the *Century Magazine* article above cited, he had quieted somewhat in his predictions, but they were of the same genre, and still claimed fantastic possibilities for his apparatus: "I believe that in coming years . . . that grand opera can be given at the Metropolitan Opera House at New York . . . with artists and musicians long since dead." In the Lathrop work, at least, he confines this idea to its then proper role as fiction, but in the present caveat he proposes it as an actual capacity of the cylinder apparatus which he describes.

[7] *Scientific American*, December 31, 1887. As his contemporaries knew, hyperbole was a facile métier with Edison. The *East Orange Gazette* spoke (on June 14, 1888) of experimentations "on a flying machine . . . commissioned by the Spanish government . . . revolving fans . . . power [from wires to] an electric dynamo on earth." Edison himself referred (in a letter of May 9, 1890) to his "very successful experiment . . . of eliminating uric acid from the finger joints by the use of lithia, forced in and out of the finger by electrical osmose." The *Metropolitan Magazine* of March, 1896, spoke of Edison's belief that light reflected from the retina could be registered on a photographic plate.

He describes an apparatus capable of starting and stopping 25 times per second and recording the actions occurring during 28 continuous minutes. This is achieved by the intermittent movement of a ratchet and pawl [8] of such a size as to make anything more than a start and stop of more than two or three times a second for a period of two or three seconds quite out of the question. His apparatus would also have to have had a ratchet containing 180 teeth on a circumference of about 4½ inches, arrested and released by a pawl with teeth correspondingly small. This would enforce a distance of about $\frac{1}{40}$ of an inch from point to point in the teeth of the ratchet gear, and a corresponding size in the teeth of the pawl. At this small size, an intermittent starting and stopping would have to occur 25 times per second!

The Edison establishment customarily ordered its gears from the outside, and on more than one occasion from the Boston Gear Works, which figured prominently in the later Latham apparatus. A contemporary catalogue of the Boston Gear Works —furnished to the writer through the kindness of Mr. E. P. Williams, Internal Sales Manager of the concern—lists all the ratchet wheels offered by that company. For ratchets of this diameter the greatest number of teeth on any Boston Gear Works gear was eighty.

The point should also be made that the description in the caveats need not have necessitated any except the most casual effort, since many Edison developments had described mechanisms closely similar in more than one respect. For example, the first Edison patent, U. S. #90646, showed an intermittent movement with ratchet and pawl achieved by electromagnetism. His stock printer also shows such a movement. (See Dyer, Martin, and Meadowcroft, page 822.) This later apparatus shows a similar intermittent movement achieved by a ratchet and pawl activated by a commutator wheel.

An example of the photographic experience of the writer of this caveat may be seen in the following remarkable periphrasis.

[8] This movement is said by Goodeve (*The Elements of Mechanism*, 1876) to have been devised by Robert Hooke, Newton's bête noir, who died in 1703. It is most commonly seen in clocks. Usher (*A History of Mechanical Inventions*. Boston: Beacon Press, 1959) ascribes it to Clement. Berthoud (*Mésure du temps*, vol. 1) dates it in 1680. It consists of a circular wheel with usually angular teeth; a pawl either imparts movement to it or prevents it from moving backward.

The first line indicates that the writer either does not know the difference between a negative and a positive or does not care that the reader should think he knows the difference:

> The collodion or other photographic film may be flowed over it just as if it was an ordinary flat photo plate, a positive being taken, but if it is desired to produce a negative series of photographs a glass cylinder is used—surface of the cylinder or shell is flowed & the records taken. The cylinder or shell being exceedingly thin say of mica is slipped over the regular cylinder to be used in practice whose surface is sensitized and printed from the negative by light in straight lines without reflection from side surfaces. A positive may be taken & reproduced on another cylinder just as one photograph may be taken from another.

Does anyone doubt that if any sensitive surface is exposed to light that anything else than a negative impression of the object reflecting the light results? Yet Edison has said "A positive being taken . . ." Even more fanciful is the line "The collodion, may be flowed over it [i.e., the cylinder] just as if it was an ordinary flat photo plate." Let this be proposed to anyone who has ever flowed collodion over even a flat plate. And let those who might suspect that a cylinder once "flowed" (which has probably never been accomplished in the whole history of photography) could be either exposed in the way described in this caveat, or, once exposed, processed, read the following excerpt from page 56 of Beaumont Newhall's *The History of Photography* (New York: Museum of Modern Art, 1949):

1. A piece of glass was placed in a vise and thoroughly cleaned and polished.
2. Holding the cleaned glass by one corner, enough of the viscous collodion (to which an iodide and often a bromide had been added) was skillfully flowed over the surface to form a smooth, even coating.
3. In the subdued orange light of the darkroom the coated plate, while still tacky, was *excited* [italics in original], or made light sensitive, by soaking it for about five minutes in a bath of silver nitrate. When it had become creamy-yellow it was taken out, drained and put, *still wet* [italics in original] into a light-tight plate holder, or shield.
4. "Place the cap on the lens . . . ; let the eye of the sitter be directed to a given point; withdraw the ground-glass slide; insert the plate holder; raise or remove its slide; atten-

tion! One, two, three, four, five, six! (slowly and deliberately pronounced in as many seconds, either aloud or in spirit). Cover the lens. Down with the slide gently but with firmness. Withdraw the plate-holder and yourself into the darkroom and shut the door."

5. The plate was removed from its holder and over its surface a solution of pyrogallic acid or ferrous sulphate was poured. In a few seconds the image began to appear, increasing rapidly in brilliance. When it was judged to be fully developed, the plate was rinsed in clean water.

6. Hypo or potassium cyanide in solution was now poured over the developed plate to dissolve the remaining unaltered silver salts. The plate was then well washed under running water.

7. Over a gentle flame the fixed plate, held between thumb and forefinger, was rapidly moved until dry; while still warm it was varnished.

Newhall adds: "The process required experience and skill of hand; a mistake in any one operation spelled failure. The photographer was chained to his darkroom, for all these operations had to be done rapidly, before the collodion dried or else excess silver nitrate would crystallize out and spoil the image . . ." The impossibility of Edison's proposal is specifically stated by Vogel in *Anthony's Photographic Bulletin* of September 26, 1891: "When collodion photography with glass plates came into use the production of cylindrical plates [of even only a half circle] *was not possible.*" [Italics mine.]

If anyone believes that Edison's Caveat I was written by a man who was experienced in photography (or who cared to convey that impression) let him also read the sentence next following the paragraph quoted above: "The permanent cylinder may even be covered with a shell and a thin flat film or transparent tissue sensitized by wrapped around it which after being filled with images . . ." Even the Dyer and Seely translation of this line leaves confusion: "The permanent cylinder may be covered with a shell and a thin flat film or transparent sensitized tissue wrapped around it, and this after being filled with images . . ."

Important also, as we will show later (see pp. 71–73), was what "a thin flat film" could have been on October 8, 1888. Such an item could not have been so manipulated at this date, since a "film" in 1888 even among professional photographers meant

only the *emulsion* which formed the coating of a base. The Eastman "stripping film" is a case in point.

In spite of this, Josephson (page 387) has called Edison a man with "instinctive knowledge and discernment [of photographic] materials." He also says, in spite of the careful rates described here, that these were "still to be determined" late in 1889.

The start-and-stop mechanism of this caveat could not overcome the inertia of a metal cylinder 9″ long and 3″ in diameter; it could not, for that matter, even overcome its own inertia. To be made operable, the diameter of the cylinder would have to be considerably increased, the number of teeth considerably reduced, the driving mechanism considerably modified, and the rate of taking considerably slowed up: all of which is exactly what happened later, when Dickson produced the "Monkeyshines" pictures on such a cylinder. (See chap. 5.)

In addition to all this, no fair-minded man who was also familiar with shop practice would concede that such parts as these could have been constructed. This caveat, like others which where to come after, reveals a man who knew nothing about and had done nothing with either motion pictures or photography of any kind whatever. He was now merely using his wide general knowledge of mechanics and electricity to circumscribe, wherever possible, these fields from others. As Dr. Alfred Goldsmith[9] in a letter to me said, ". . . the equipment would have no practical significance . . . would have produced only very small, low-detail, non-projectable pictures . . . was inevitably of no significance in the actual development of the motion-picture art."

This caveat, however, although having within itself proof that no motion picture work had been done and that no motion picture work could be done unless there were a considerable advance in methods therefor, is nevertheless a sure indication that Dickson was beginning to think about the matter. We have no indication that he *did* anything about it until he went to New York on November 28 to "get all ready for the Daguerrotype Exp." (see page 28).

[9] Associate Professor of Electrical Engineering at City College of New York, past-president of the Institute of Radio Engineers, past-president of the Society of Motion Picture and Television Engineers, Fellow of the American Physical Society, Fellow of the American Institute of Electrical Engineers.

3 · The First Motion Picture Work

THE FALL AND WINTER OF 1888–1889 WITNESSED NOTHING WHICH can be described as extensive work on motion pictures. The work which Dickson himself later described as having been antecedent to his motion picture work appears to have been covered in the following lines from his 1933 article:

> Before making the drum I made a small micro-camera, using various objectives or lenses taken from one of my microscopes to produce pin-head photos. [Edison's idea had been to cover the drum "with pin-point micro-photographs which of course must synchronize with the phonograph record." *Ibid.*] In this micro-camera I tried Daguerre's process on highly polished bits of silver and developed in the usual way. The subject I used was a lantern slide of Landseer's stag for all these comparative single still pictures.
>
> The time of exposure was about three-quarters of a minute. Of course, this method was soon abandoned. Next I tried silver nitrate on wet collodion, using an exposure of 10 seconds, which was finally shortened to 5 seconds . . .

Dickson, recalling his motion picture work after forty-five years, has elided much of it into extraneous material. The work he described here for the *Journal of the Society of Motion Picture Engineers* in 1933 included also his microphotographic work, which very much concerned Dickson, Edison, and Edison's attorneys at this time. He may also very well be confusing the "Magic Lantern Experiment," which was begun at this time, and which was spuriously used in the American Mutoscope suit (Equity 6928, U. S. Circuit Court, S.D.N.Y.)—although in the private notes of the attorneys the magic lantern work and the kinetoscope work were carefully distinguished. In any case, there can be no question that only the viewing of photographs is spoken of here: the $\frac{1}{100}$-second exposure necessary for motion photography is far in the future. And considerably more

than one such exposure (to say the least) is needed to qualify for motion picture camera invention.

In the first place, wanting to produce "pin-head photos," [1] Dickson would probably have antedated the arrival of the elaborate Zeiss microphotographic outfit, since he describes nothing here which could not have been accomplished with greater smoothness on this later apparatus. This outfit was not in working order at the Edison laboratory until late in 1889.

Both Dickson and Edison were proud of this apparatus. It was first ordered from the importer James Queen and Company on September 21, 1887. (Document files "Correspondence West Orange Laboratory Equipment, 1887.") Fifteen months later, on December 22, 1888, Queen and Company said that the photomicrographic apparatus would be finished "in the course of a fortnight." (*Ibid.*, "Motion Pictures, 1888"—although improperly filed there.) On February 21, 1889, Edison wrote sarcastically: "When may I expect to receive the micro photo outfit of Zeiss ordered from you a long time ago?—before 1890?" (Letter book 1717, 1/30/89–4/8/89, page 326.) By March 18, the apparatus had arrived but was in bad condition; Dickson claimed that the wooden elements were green and this had caused warping. Dickson told Tate that Queen and Company "shd make some reduction in bill." (Document files "Motion Pictures, 1889"—improperly filed.) Queen and Company replied on May 30 that a 5 per cent reduction was all right (*ibid.*). It was then decided to make repairs on the apparatus at the laboratory and send Queen and Company the bill for these repairs (*ibid.*). By June 27, these repairs had not yet been completed (letter book E1717, 6/21/89–8/3/89). Apparently they had not been made up to the time Edison went to Paris, but Dickson suggests that the apparatus was ready for business by the time Edison returned. (Edison archives, Dickson letter to Charles Edison, March 8, 1933. See also Eder, *Jahrbuch für Photographie*, 1889, pp. 260, 261.)

Laboratory receipts of collodion at this time are perhaps inconclusive, since this substance was used regularly in Dickson's work as laboratory photographer as well as for many other laboratory purposes. It may be fair, however, to assume that the distinction made in the receiving book for October 10 of that

[1] In *The Century Magazine* article, June, 1894, he says "pin-point."

year suggests that previous shipments of collodion had not been for photographic purposes:

8 lbs. Collodion 4 lbs. negative [collodion]

A similar distinction was made in describing the shipment received on October 17.

(It is interesting to note, incidentally, that on September 15, 1888, 10 yards of "Blue Process Paper" were received at the laboratory, with the inference that this new photographic work —there is no record of any previous such shipment—must also have added to Dickson's later confusion in separating the still and motion photography work. We know that this blueprint paper was not just something that was to remain "on hand," since immediately after he got this paper he went to work on it.[2])

On October 11, a single slide was received from McAllister. We know that McAllister was the largest slide manufacturer and distributor in America, and that he made and distributed a 3¼" x 4" glass slide of Landseer's famous "Stag" under the name "Monarch of the Glen."[3] Although the Edison laboratory used hundreds of slides in these years, the receipt books show none previous to this date, and none possibly answering this description until January 15, 1889.[4] On this latter date, however, 582 views were received from McAllister, including several from the Louvre. The Landseer may well have been among these 582, though it was not in the Louvre in 1889, or apparently at any other time. This very slide is now in the West Orange laboratory, where it is accession #E175-1. In any case, we apparently have, in October 11, a first possible date for the Landseer work, although the January shipment is much more likely. As we will see, experimentation with it did not begin until six weeks later. (See page 28.)

October 19 records the receipt of arc light carbons—the first I have found, suggesting again that the Magic Lantern Experi-

[2] Edison archives document file "Phonograph Sketches and Notes 1888."
[3] McAllister catalogue in the Bella C. Landauer Collection, New-York Historical Society.
[4] On December 11, 1888, the Edison archives receiving book records:

100, 13, 102, 2, & 2 micro. objects; epigram; 5 micrometers; slide Lord's Prayer in 1/17000 of an inch. McAllister

and no other entry for this time. None of these could have been the Landseer.

ment was about to get under way. We have seen that indeed it was, since the first charge to this account was made the next month. On November 9, the first receipts I have found of calcium gas were recorded,[5] and on November 22 a magic lantern "sheet" was received.[6] On December 15, further tanks of gas were received.[7] These shipments of illuminating gas continued almost throughout the years Dickson was at the laboratory.

On December 8 we have a note which may suggest the first laboratory experimentation with celluloid:[8]

1 lb Gum [sic] cotton . . . Chas. Cooper & Co.

But on December 24, *et seq.*, we have the following:[9]

1 gal amyl acetate
1 lb. soluble cotton

which makes it possible for us to believe that the gun cotton received on December 8 was unsatisfactory or that more was wanted.

There is no evidence, however, that this celluloid was used for photographic work. More likely, it was used for the celluloid eartubes with which phonographs were sometimes fitted. That there had been no celluloid of any kind at the laboratory until this time is suggested by the fact that the next March the Celluloid Varnish Company of Newark wrote in regard to Edison's touted claim to have "every known substance," saying that they did not see celluloid on the list. Edison's reply was a request for information as to prices, etc., suggesting that up to the next March, at least, ready-made celluloid was not at the laboratory.

The Celluloid Varnish Company was associated with the

[5] Page 230, Edison archives receiving book entry for this date.
[6] Page 241, Edison archives receiving book entry for this date. See also page 23. The point must be made, however, that all expenses for the regular lectures that were held at the laboratory were actually charged to this magic lantern "experiment." Which is another case of obscuring regular operating expenses under an "experiment" camouflage. (See page 32 *et seq.*)
[7] Page 259, Edison archives receiving book entry for this date:
one cylinder each. Hy. [drogen] & Ox [ygen]
[8] Page 252, Edison archives receiving book entry for this date.
[9] Page 263, receiving book entry for this date. Celluloid is made principally of soluble gun-cotton and camphor. The addition of amyl acetate and fusel oil was considered a patentable distinction by the patent office when they awarded Reichenbach, Eastman's chemist, his U. S. #417202. The *Scientific American* of January 29, 1887, contains an interesting account of the American Celluloid Company.

Celluloid Manufacturing Company, and told Edison that they could supply celluloid only $\frac{1}{200}$ of an inch in thickness.

Irrelevant to the matter described by Dickson as having been his pre-drum motion picture work, but much more important to our history is the notice of the receipt on November 15, 1888, of

Plates of Animal Locomotion. Photo Gravure Co.

The Photo Gravure Company was the agency for Muybridge's photos;[10] Edison had ordered these and had asked Muybridge to make the selection for him.[11] The account books record the payment of $100 but, significantly, do not apply this cost to any established account, but simply to "Edward Muybridge." [12] When these plates came, they were greeted with much enthusiasm. They were taken from their folder and put up in the library for easy viewing. They remained thus conspicuously displayed for some time. There appears to be little question that they were significant in initiating motion picture work at the Edison laboratory.

W. S. Mallory, an Edison associate in those days, wrote on February 1, 1939, that:

> I have a distinct recollection that in the spring of 1889 someone sent Mr. Edison a set of photographs of running horses which were taken by Meyerbridge [sic]. The pictures were mounted on boards and set up in the library for Mr. Edison's inspection and they were there for some months. It was these pictures which again started him working on the development of the moving picture machine . . .

Mallory is in error here about the date, as we have seen, but it is impossible not to believe that these photos were treated in the manner described. (See also W. J. Hammer's remarks quoted by George E. Nitzsche in chapter 11.) Ninety of these

[10] And also the printer, according to the brochure published in connection with their distribution. (Archives, University of Pennsylvania, Philadelphia, Pennsylvania.)

[11] On May 12, Muybridge sent Edison a catalogue of the "Animal Locomotion" plates on which Edison noted

Tell him to make the selection for me. E.

(Edison archives document file "Motion Pictures, 1888.")

[12] Edison archives "Journal/No. 5/Laboratory/T. A. Edison/Orange, N. J." Page 132.

plates are still in the library at the West Orange Laboratory.[13]

Equally interesting, and distinctively related to what Dickson describes above as work preliminary to the kinetoscope, is the receipt book entry for November 23:[14]

Hand Book Daguerrotype. Scovill Mfg. Co.

This entry is conclusive when taken in connection with an intralaboratory note in Dickson's hand dated November 27, 1888, which I found in the ore-milling files at the Edison laboratory: "Having waited unnecessarily long for the silver plates I thought it the best plan to go over first thing Wed. morning [it was now Tuesday] to NY & see what I could get all ready for the Daguerrotype Exp. hoping this may meet with your approval, I remain, etc." If there was any thought that the receipt of a daguerreotype handbook on November 23, did not necessarily indicate that daguerreotype work had not been done before, the note by Dickson on November 27 establishes this beyond doubt. Here we have also reference to silver used in photography, as it commonly was in daguerreotype work. Surely we have here the process described above: "In this microcamera I tried Daguerre's process on highly polished bits of silver . . . Landseer's stag . . ."

So far as my work has shown, this trip to New York on November 28, 1888, is the first actual work at the Edison laboratory on what we can fairly call motion pictures. The Muybridge plates had lately arrived, and were the object of much admiration. A daguerreotype handbook was soon ordered and on November 28 plans were undertaken.

On the same morning that Dickson went to New York to "get all ready for the Daguerrotype Exp.," Muybridge wrote Edison a letter saying that he had sent his "animal locomotion" plates to Orange "about two weeks ago." Obviously the laboratory had written to ask why they had not come and Muybridge was replying after the arrival of the plates had made such an inquiry no longer pertinent. Again we see the eagerness and interest with which these photos were regarded.

(Regularly and throughout all this period various items concerning photographic work were appearing in public print, and

[13] Dewey number 591.47M. The Mallory letter is in a miscellaneous letter file on the second floor of the library.

[14] Page 242, Edison archives receiving book entry for this date.

many of them had a bearing on the work that Dickson was doing. But since this literature is so extensive I will refer to it here only insofar as it seems to have been directly influential on the Edison laboratory work. The reader is invited to read Appendix D for a résumé of such work.)

On February 3, 1889, Edison wrote his Motion Picture Caveat II (see Appendix B). This was a multisubject caveat, and adheres to an Edison practice later described by himself in testimony in the case cited above, on page 105 of the Complainant's Record:

> Q. [By Richard Dyer, Edison's attorney.] Has the date of the caveat any immediate relation to the date when you made the experiments . . . ?
> A. No. My habit was to collect a great number of notes from time to time, and when I got enough of them I put them in the form of a caveat.

This particular caveat is claimed to have been partly conceived on January 11, 1889. In the infringement suit heretofore referred to, six small sketches on as many pages bearing the familiar "From the Laboratory of Thomas A. Edison" letterhead, were presented (Complainant's Record; presented, page 107, printed on pages 410–415). These sketches represent elements of the cylinder machine described in Motion Picture Caveat I (see page 19), but *do not illustrate that part of the apparatus which distinguishes Caveat I from Caveat II*. All these sketches are signed:

> Kinetoscope
> Jany 11 1889
> T A E
> J. F. Ott

The "J. F. Ott" is John F. Ott, Fred Ott's older brother and for a long time foreman of the precision room at the laboratory.

The character of these signatures make it impossible, in my opinion, to believe that they were made on the day on which the sketches themselves were made. Even a cursory examination of the Edison notebooks will turn up many such instances, suggesting strongly that the dating was either part of an honest recall, or a part of an effort designed to achieve an end not supported by the facts. A case in point is one page which is

dated October 5, 1889—upon which date Edison was still on the high seas one day out of New York on his way back from Paris.[15] It is possible to think that he had the notebook with him, but it is much easier to believe—especially when one has the notebook before him and notices the differences in pencil, strength of marking, illogical location on page, etc.—that this date, like many others, was entered at a time considerably later than the time which was claimed for it. As we shall see later, much of the testimony at this trial can be shown to have derived from the "incorrect" memory or claims of men with important axes to grind, namely, establishing priority to the Friese-Greene disclosure on February 28, 1890.

The only distinctive change in the apparatus from that described in Motion Picture Caveat I, and now described in Motion Picture Caveat II, is that improvement which was proposed to prevent the pictures from being thrown out of focus by the roundness of the surface of the cylinder. This difficulty was described by Dickson more than once; for example, in the *Century Magazine* article of June, 1894, he wrote: "The pictures were then taken spirally to the number of two hundred or so, but were limited in size, owing to the rotundity of surface . . ." and in the 1933 article he repeated that "These pictures, when viewed through a low-power microscope, were fairly good in spite of the curvature of the drum. A disk was tried next, to avoid the difficulty arising from the curved drum surface . . ." In neither case, however, does Dickson refer to the expedient described in Motion Picture Caveat II.

On page 182 of Edison's notebook (see page 29) which may be seen at the Edison museum in West Orange alongside the Dickson notebook hereinafter referred to, a sketch headed also

<div align="center">

Kinetoscope
Jay 11 89

</div>

but neither signed by Edison nor countersigned by John Ott shows an arc of a cylinder containing several flattened surfaces. It is accompanied by the following notes: "If ⅛ photo taken on 3 inch cylinder Then there should be 72 paralell [sic] flattened places longitudinally along cylinder so that all parts of photo

[15] This date may be seen on pages 47 and 55 of the Edison notebook at present in the museum of the Edison laboratory in West Orange. This notebook is catalogued there as N-870902.

30

be in focus— . . . glass strip could be pasted along side each other but this is perhaps unnecessary a varnish might be used collodion etc enamel etc."

The intermittent movement of this cylinder, like that described in Motion Picture Caveat I, would again have to be accomplished by the movement of a ratchet gear containing over 180 angular teeth evenly spaced along a periphery of approximately 4½ inches.

Everywhere these photo-cylinders are referred to as being the same size as those used for the phonograph work. Such cylinders were introduced in evidence in the infringement case, and referred to in the attorneys' private notes (see page 4) as similar in size to the phonograph cylinders. In the Edison note above he calls them "3 inch" cylinders. Assuming 3-inch cylinders, and assuming a ratchet diameter of half this (as is shown in all the sketches), a circumference for such a ratchet would be four and a half inches. Acting upon this ratchet there again would have to be (as in the first caveat) a pawl with arms coming to points sufficiently small to enter such a ratchet as above, and made of such a substance as would not batter out of shape while being actuated at the rate of 15 to 20 times per second: surely an impossible condition. The technical difficulties attendant upon cutting and pasting glass strips $\frac{1}{32}$ inch wide and 9 inches long firmly and with mathematical precision upon the face of a cylinder are also prohibitive.

We may fairly assume that between November 28, 1888, and the days soon following February 3, 1889, when this second caveat was begun, the motion picture cylinder work had reached the point where Dickson had discovered, by actual work, that the photographs taken on a cylinder surface needed to have their sharpness improved. He communicated this need to Edison, and Edison, in this caveat, proposed an altogether impracticable solution. Only a very slight amount of work would have been necessary to meet this impasse—possibly just the right amount of work to explain the opening of the account late in January, 1889, and the small charge made to it. There is no indication, however, that these photographs were either rapidly taken or taken with a sufficiently short exposure to classify as "motion pictures."

4 · The First Advance

WITH FEBRUARY, 1889, A SERIES OF CHARGES TO THE KINETOSCOPE account began which was to continue uninterruptedly for sixteen months.[1] I believe it probable, however, for reasons I will show, that little work was done on the kinetoscope during most of this period, and that the account was largely or only a cover for unknown charges—possibly laboratory overhead.

To begin with, in the infringement case with the American Mutoscope Company, and in testimony taken at the laboratory on February 3, 1900, John F. Randolph, Edison's bookkeeper submitted "the original time sheets from which the schedules put in evidence . . . were prepared." These time sheets showed, for the month of February, a total of $33.73 spent on labor for the kinetoscope account, and a total of 116½ hours (at an average wage of about 28 cents an hour) by six men: a pattern maker, a blacksmith, a blacksmith's helper, and three machinists.[2] For March, this total was 77.43, with 284½ hours spent (an average wage of 27¢ per hour) by six men: five machinists and a pattern maker. In April, a total of 39.47 with 148 hours (with an average wage of 26¢) by one man only, a machinist. In May, a total of 52.68 is shown covering 197½ hours by three men: a machinist, a blacksmith, and a blacksmith's helper.[3]

We have then, for February, March, April, and May, total

[1] The charge for February was $103.52; March, $226.94; April, $126.87; May, $166.61; June, $142.39; July, $921.27; August, $813.55; September, $463.33; October, $470.34; November, $308.70; December, $241.34; January, $248.32; February, $150.48; March, $314.93; April, 402.34; and May, $303.69 (Edison archives "General Ledger No. 5 Jan/88–June/90," pages 806 and 560).

[2] These sheets are presented to the defendant's counsel on page 163 of Complainant's Record, Equity number 6928, U. S. Circuit Court, Southern District of New York, and are printed on pages 360, 361, and 362 of this record. I have also examined the originals: with very minor exceptions, they correspond to the printed record.

[3] Since the week ended, for Edison laboratory accounting purposes, on Thursdays, it has been difficult to accord to the weeks including month ends and beginnings the exactly proper amounts of these charges—since the Randolph time sheets give only weekly totals. But since, on a monthly basis, these differences do not exceed more than a few days, I do not consider this difference significant.

time charges of $33.73, $77.43, $39.47, and $52.68, respectively. And during these four months, 116½, 284½, 148, and 197½ hours. (I disregard materials charges for the sake of this demonstration, because in answer to a later question, Randolph said that up to January 1, 1890, in a total of $3,984.86, spent on this account, only $57.70 was for material—in other words, only about one-seventieth.)

Yet the Edison account books themselves show that the charges to the kinetoscope account for these months were respectively, $103.52, $226.94, $126.87, and $166.61.[4] The differences, then, between what were actually charges to the kinetoscope account and the amount which we can explain with payroll costs, were: $69.79, $149.51, $87.40, and $113.93. In each case these figures represent approximately two-thirds of the total actually charged, with the inescapable conclusion that two-thirds of what was charged to the kinetoscope account in these four months was *not* kinetoscope work. This discrepancy cannot be explained by the suggestion that Edison himself did not fill time sheets but nevertheless had his time charged to this account, because during the months of August and September, 1889, when we know he was in Europe, the same wide disparity between what was actually spent and what was charged continues.

When we add to this the fact that none of the ten men who are shown on these time sheets as having been engaged in this work prior to Dickson's coming into it in the week ending June 27, 1889, was called as a witness (in spite of the fact that, according to the private legal file above noted, at least one—the draftsman, who dated his work in 1890—lived no farther away than the Orange Y.M.C.A.), we are inclined to feel even more strongly that little work *was* done during this time. The precision room book item (see page 34) is the only proof we have that *any* work was done. Since Edison was basing a large part of his case on Dickson's claim to have projected motion pictures for him on his return from Paris in October, 1889; and since this projection would have necessitated a considerable amount of work by Dickson before this time—even, as I will show, *before* Edison went to Paris; and since Dickson was a member of the defendant's firm and the defendant's lawyers could scarcely

[4] In the ledger cited in note 32, page 1.

have attacked this Dickson claim without prejudicing their case (even if they had not believed that he had done all this work when he said he did, before and during Edison's trip to Paris) all parties refrained from disputing Dickson's work on the kinetoscope at this time.

In addition, when we consider the fact that an exhaustive study of *everyone's* claims in this cylinder work up to the work ending June 27, 1889, turns up a grand total of only a few cylinders; and when we place these products alongside the alleged fact that the following hours were spent on the construction of these few devices:

1. pattern maker East	15½	hours
2. pattern maker Ludecke	2	hours
3. blacksmith Hepworth	6	hours
4. blacksmith's helper Gilmore	6	hours
5. machinist Grabicsy	59	hours
6. machinist Wheelwright	50	hours
7. machinist Harburger	14	hours
8. machinist Riebe	38	hours
9. machinist Morlet	5	hours
10. machinist Neubert	550½	hours

with this latter working full time for a full nine weeks *with no one else working on the experiment*—and all this time spent *without a single charge for an experimenter or a draftsman* to tell the machinist what to machine, we are sure that at least a large part of the work claimed was spurious.

In addition to the inferences made on page 23ff. from Dickson's memory and the inference made from the description of the flattened surfaces in the second caveat, there are only two items in all the tens of thousands of documents in the Edison archives which establish that any work at all was done at this time on motion pictures—excluding, of course, the inconclusive accounting records. One of these is a note in Edison's hand which, although itself undated, appears to accompany pages dated August 1, 1889. This is a memo for John Ott: "Help Dixon on ~~ph~~ [change in original: "phonograph" was begun] Kinetoscope."

The second item is from John Ott's Precision Room notebook dated January 31, 1889 (Edison laboratory #E190-0-2.12) for "Kinetoscope 262." The "262" is a shop order number. This date

34

coincides with the first charge to the kinetoscope account (see page 32) and appears to establish that *something* was done at this time. This book contains *no other such entry*, however, until the next year. If there had been other kinetoscope work done at the laboratory, I do not understand how it could have failed to be noted in this book. Since it was not noted, how can the historian believe that such work *was* done?[5]

This doubt is strengthened by a contradiction in the legal file mentioned on page 4. Item 2.10 of this file attributes a reflector bought on voucher #853 in August, 1889, to the kinetoscope account, yet item 2.11 in a group of three items two of which are obviously extraneous to kinetoscope work,[6] does not identify this reflector with such work. This leaves us with the clear impression that the attorneys, scraping the bottom of the accounts' barrel to find documentary proof of their pre-Friese-Greene thesis, seized upon this reflector as a possible kinetoscope purchase. What an 8" reflector could have been used for in the cylinder work is obscure, and such an item would fit into more than one other laboratory experiment. If the attorneys were trying to ascribe it to the peep-hole kinetoscope, then why did they not produce vouchers for other peep-hole parts, such as the sprocket wheels and the spools for the spool-band—which would have had to have been ordered for this device? Moreover, the appropriate receiving book makes no mention of this reflector, suggesting strongly that it was part of a shipment for another laboratory experiment.

It may be further stated that unless the Edison attorneys had clear proof that Dickson *did* spend the weeks beginning at this time on the kinetoscope work, they were laying themselves open to possible proof by Dickson himself that this date was too early

[5] In all their writing about the "Edison" motion picture invention the Edison junto have consistently failed to note the fact that this precision room book, (E190-0-212) covering the whole period from February, 1889, when the first kinetoscope charge is noted, to 1900, and having a *complete* record of all shop orders from #1 to #1242, *makes only two additional kinetoscope notations in all our history up to October, 1892:* (1) about October, 1890, "Experiment on Kinetoscope—462," and (2) about June 1, 1892, "Making New Model for Kinetoscope Nickle in slot. 626."

[6] "Voucher 73—Jan 90—2 Tin cylinders 7¾ x 24" and "Voucher 372—Apr. 90—13 pieces dipped/36 punchings as sample/E. P. Wks. [Edison Phonograph Works]—2 cylinders japanned Jan 9/90." The reference to the Edison Phonograph Works proves that the "Jan 90" cylinders were bought for the phonograph work.

(he was always accused of taking his notes away with him) and that he did not do any work until after Edison had left for Paris —thus prejudicing Edison's own case for invention but still making reasonable Dickson's claim for a projection on Edison's return.

Meanwhile, on May 20, Edison had written his Motion Picture Caveat III, with specifications as fanciful as either of the two before: "A reflector X throws the light of the spark [from a Leyden jar!] on the moving object AA′ . . ." (AA′ being the object to be photographed). He proposed to take these photographs at the rate of 15 per second on a sensitive surface. As one authority has said optimistically, "the chances are about a million to one." No such light is conceivable from a Leyden jar, which, although the power of its discharge depends upon the power of its charge, must nevertheless be of a size concomitant with the power of its action. A Leyden jar of the capacity needed here would be a monstrous object utterly beyond anything in the history of physics.

Edison, as though feeling that this was too bald an exaggeration even for a man noted for his exaggeration, goes on to say that an intermittent sunlight or arc light might be created by the use of a shutter. His sketches, however, show an object some feet away from the light source being photographed by means of the few candles of Leyden jar spark. And this in a day when only the approximately hundred billion quintillion candles of the sun itself would suffice to produce images on such photographic materials as were then available.[7]

Edison's closing remarks reach new heights of fancy. He proposes that this same spark should be inserted within a cylinder of small diameter, be intermittently produced, directed through the glass of a transparent cylinder, through negatives on the surface of the drum, through a lens, and onto a screen![8] To begin with, any such light as would achieve this projection would

[7] This estimate of the sun's candle power is by C. E. Kenneth Mees, and was made at a meeting of the Society of Motion Picture Engineers. (*Transactions, SMPE*, September, 1925.)

[8] It will be seen (see pages 114, 189) that negatives were referred to elsewhere, when such a reference could only mean a lack of empirical knowledge or, at best, the failure to achieve the positives which would be appropriate.

then, as now, instantly melt the glass of the carrier itself—not to mention the film.

The two sketches in this caveat are dated (in the manner to which Edison is accustomed—cf. page 29) June 19—a full month after they could possibly have been made—since the text, dated May 20, refers explicitly and specifically to these sketches. Although this June 19 date appears to have been scratched out on the second of these two sketches, it remains on the first. It also shows us the extreme carelessness with which these dates were set down, and shows Edison's unscrupulousness in entering them, since legal action depended upon them. The impression that Equity 6928 was perfunctorily prepared is reinforced. This caveat, incidentally, although written on May 20, was not filed until August 5. We may thus presume that it was felt by both Edison and his attorneys to represent his latest pre-Paris thinking in the matter of motion pictures. Unlike Caveat II, it contains no indication that the impasse reached when the cylinder photographs were thrown out of focus in enlargement had been surmounted.

During these months and until the end of June Dickson was much engaged with ore-milling and, it bears repeating, could take only spare time for anything else, even his work as the official laboratory photographer.[9] It is interesting to note, also, in connection with Dickson's notes re the use of celluloid (see page 71) that on May 16 the Zylonite Company ("zylonite" or "xylonite" was an early equivalent for celluloid[10]) offered celluloid to the laboratory, and on May 7, Seed and Company had also announced a celluloid base for positives. (*Photographic Beacon*, May, 1889.) On June 3, the Zylonite Company, having apparently been written for information concerning their celluloid, told Dickson that if he wanted "to bend into any shape the material left" (here we have proof that celluloid was

[9] See, for example, E190-0.282-2.14; letters of February 9, February 19, February 21, March 4, March 6, March 23, April 22, May 22, May 24. (Letter book E1717, 1/30/89–4/8/89, page 148.) See also document files "Ore-Milling 1889 General"; document files "Laboratory West Orange W. K. L. Dickson."

[10] See *Scientific American* for January 29, 1887, page 69. Also *Webster's International Dictionary*, 1890 edition: "Xylonite: see Zylonite," "Zylonite: celluloid." Although this definition cannot be found in the current edition of Webster's, it was still being given as late as 1926.

at the laboratory as of June 3, 1889) to let them know and they would tell him how.[11]

On May 30 the Phonograph Works had asked the Eastman Dry Plate Company for quotations on a Kodak camera and a "reloading camera." Carl W. Ackerman (*George Eastman*. New York: Houghton Mifflin, 1930) says on page 64 that Edison had purchased such a camera "in the summer of 1889"—which he assumes only from the fact that Edison had asked for a *quotation* on this camera on May 30. We know from the receiving book that no such camera was received until November 23.

Wilson's Photographic Magazine for June noted that Eastman had "succeeded in making" transparent flexible film—although no one saw any of it until later—and on June 8 the Eastman Dry Plate and Film Company sent out the announcement of its new film to the trade press. I will show in chapter 7 what happened to it.

5 · *The Carbutt Film*

ANY DISCUSSION OF EASTMAN'S CELLULOID-BASED FILM IS, HOWever interesting (see chap. 7), only academic so far as the Dickson motion picture work of these months is concerned. The influence of the Eastman film on this work was nonexistent until 1891, but the celluloid-based film developed by John Carbutt of Philadelphia—already on the market for some months by June, 1889—had an influence from the cylinder days in 1890.

John Carbutt was a well-known photographic materials manufacturer whose "Keystone" plates were widely used throughout the world.[1] He deserves a prominent place in the history of American photography and in the story of the American motion picture. Since he supplied Dickson with the film means to develop his first cameras, his place, often usurped by Eastman

[11] Edison archives document files "Laboratory quotes for equipment, 1889."
[1] For biographical facts on Carbutt see *Journal of the Franklin Institute*, December, 1905, page 461; *Photominiature*, volume 4, page 9; *Philadelphia Photographer*, page 40, volume 7; *ibid.*, page 437, volume 9. Also an interesting account of Carbutt's western adventures beginning on page 277 of Taft, *Photography and the American Scene*. New York: Macmillan, 1942.

through the deplorable tendency to ascribe famous contributions to famous people, is in front of any other film supplier.[2] Following the tremendous desire of all photographers—and especially amateurs, whose work so often took them out of the studio—for a lighter, more portable film carrier, Carbutt's scientific and manufacturing resources were brought to bear upon the problem, and on November 7, 1888, he announced his celluloid-based film to the Photographic Society of Philadelphia, of which he was a permanent member.[3] By November 12 he was able to write, in a paper read to the Franklin Institute on November 21: (*Photographic Times*, Dec. 7, 1888)

> The substance I have the honor to bring to your notice tonight is this sheet celluloid, manufactured by the Celluloid Manufacturing Company.
>
> It is some three or four years since I first examined into this material, but the manufacturers had not then perfected the finish of it to render it available, and it is only during this year that it has been produced in uniform thickness and finish, and I am now using at my factory large quantities of sheet celluloid $\frac{1}{100}$ of an inch in thickness, coated with the same emulsion as used on glass, forming flexible negative films, the most complete and perfect substitute for glass I believe yet discovered on which to make negatives and positives, and without a single objection belonging to the substances previously enumerated.
>
> Its weight, as compared with glass, is as follows: Twenty-four 5 x 8 flexible films weigh seven and one-half ounces, while twenty-four glass dry plates weigh from 110 to 120 ounces, and its great merit does not alone lay [sic] in its lightness, toughness and flexibility, but in that its treatment in development, etc., is precisely that of a glass plate—there is absolutely no after-process required . . . owing to its thinness, can be printed from the reverse side . . .
>
> I have here several negatives made on the films and prints from them, that members can examine at close of meeting.
>
> I will now show on the screen lantern transparencies from film negatives, both contact and reduced in the camera.

[2] As Eder has pointed out (page 786), the word "film" originated in the Anglo-Saxon word "filmen," i.e., "the scum which forms on boiled milk." As noted in Appendix D, Edison did not coin this word. Mrs. Dickson's remark, reported in her husband's *New York Times* obituary on October 3, 1935, that Dickson ". . . Took his first motion picture film to Mr. Edison, who observed that it was 'filmy,' according to his widow, and from that remark the name took rise" discredits Dickson, Mrs. Dickson, *and* the *New York Times*.

[3] The original handwritten minutes of the society, now in the collection of the American Museum of Photography in Philadelphia, list Carbutt as a member.

As Carbutt says, his celluloid was produced by the Celluloid Manufacturing Company. It is also pertinent to note that Carbutt was not the first to use celluloid as an emulsion base in the United States: the Reverend Hannibal Goodwin had applied for a patent on this process the previous year (U. S. #610861, application #236780) and was even now beginning his long trials in the Patent Office.

Because his was a relatively small firm with little attention given to the sort of publicity which later established the Eastman Company's reputation of having *invented* celluloid-based film, Carbutt's talks in Philadelphia received little attention in any but trade journals.

The extravagant claims of the Eastman Company had already begun at a Boston convention of photographers in August. (See chap. 7.) In a talk delivered at that meeting, G. D. Milburn of the Eastman Company said (*Anthony's Photographic Bulletin*, August 24, 1889, as quoted on page 380 of the complainant's record of Equity 6928): "The Eastman Company are pioneer workers in flexible-film photography. They have, as you all perhaps know, introduced first negative paper; second, the American films; and now the very best of all their transparent films."

(Similarly, one Harry Davis some years later claimed America's first nickelodeon; since no one was interested enough to dispute his claim, Davis was able later to point to the *report* of this *claim* as *authority for the truth of the original statement!* In fact, dozens of buildings were constructed for motion picture projection before 1900; yet many writers have followed Davis' false claims, not being interested in searching original sources, and have given Davis' claim for America's first nickelodeon credence merely because "he himself has said it." Thus many film historians have credited the Eastman Company with the "invention" and/or "introduction" of celluloid-based film. Without bothering to list others even before Carbutt—see Carbutt's reply to Milburn below—we know that none of this is true. Eastman's contribution was improvement of manufacturing methods, and not inventive novelty.)

Milburn's clear implication—if not direct statement—that the Eastman Company had been the first to introduct celluloid-

based film in America, was answered in the following words by Carbutt, who was in the audience: (*Ibid.*, page 377)

> Some three or four years ago my investigations in celluloid commenced. And since I have become a manufacturer of the article I have learned that I was antedated one or two years. So that I have to disagree with the gentleman who preceded me in the statement that Mr. Eastman was the first to produce the transparent film [for that matter, Eastman himself did no such thing, since all records—including contemporary statements by Eastman himself, ascribe this "production" to Henry M. Reichenbach]. I was shown, in New York, in the office of Messrs. Anthony, a film said to have been made some five years ago on celluloid. And I have no reason to dispute that as being a fact.
>
> Early in this year I had a piece of film submitted to me over thirty feet in length, of precisely the same nature as is now brought on as being the invention of Mr. Eastman. I have some of that film at my house; I haven't here . . .
> E.]

The Scientific American, for example, which had a regular photographic department discussing most of the recent photographic developments, failed to mention the new film at this time. By July of the next year, however, it was beginning to reach many American amateurs, and large shipments were being sent abroad:

> We allude to Mr. John Carbutt, whose quite recent introduction of Flexible Films for negative purposes is already so well and favorably known . . . In a conversation with Mr. Carbutt recently, we learned from him that he had just made a shipment of thirty-four hundred dozen celluloid films to one dealer in London . . .

These words, appearing in *Wilson's Photographic Magazine* of July 6, 1889, accompany an ad listing many Carbutt flexible film sizes, their degrees of sensitivity, etc., which had also appeared in the *American Amateur Photographer.*

By the time of the Boston convention Carbutt had introduced his positive films, both tinted and plain. These films, we have reason to believe, were the ones referred to by Dickson in his notebook as "pink +." (See page 71.) Edison laboratory records show us that on June 25, 1889,

1 doz. Em. no 1298 Carbutt 11 x 14

were received.[4] A careful search in many sources[5] did not reveal what "Em. no 1298" was. But in the excellent collection of the American Museum of Photography in Philadelphia there is an empty pasteboard container 5⅞" x 8¾" x ⁷⁄₁₆". Its label reads:

One doz. Carbutts
Flexible Negative Films
A Perfect Substitute for Glass
ECLIPSE . . .
Emulsion No. 5199. Sensitometer No. 27
The Eclipse Films are Extremely Sensitive
and Specially Intended for
Quick Studio Exposures Detective Cameras
Instantaneous Views and
Magnesium Flash-Light Photography

The inference is obvious: the "Em. no 1298" that the Edison laboratory received on June 25, 1889, refers to the actual batch or lot number which Carbutt gave to emulsions as he applied them, so that both he and his customers could keep close check on the quality, effectiveness, etc., of each new "flowing" as it came from his factory. Thus, the film package in the American Museum of Photography belongs to a later time than June 25, 1889, and the June 25, 1889, film received at the Edison laboratory is from the twelve-hundred-and-ninety-eighth batch of flexible film emulsion produced by Carbutt.

It is also interesting to notice that the price of the "Em. no 1298" was higher than that for the Keystone B plates. This difference in cost was an important reason why the Carbutt films were soon outdistanced in popularity by the Eastman films. Curiously, the word "plates" was left off the notation of the June 25 shipment. All entries for previous shipments from Harvard and other suppliers had contained the word "plates." The label of the American Museum of Photography item substantiates our belief that this June 25, 1889, receipt was a lot of films. That these films *were* films is also confirmed by the fact that according to the private notes of Edison's attorneys in the case against the Mutoscope Company heretofore referred

[4] Edison archives receiving book entry for this date. Josephson, who ascribes the use of celluloid to the first part of 1889 (page 387), apparently did not examine any of these receiving books.
[5] The George Eastman House, the Bella C. Landauer Collection of the New-York Historical Society, the Smithsonian Institution, the Library of Congress, and all the photographic periodicals herein referred to.

42

to (note 2, page 4) there is a notation that a voucher for July 29, 1889, records the purchase of

<div align="center">1 doz 8/10 Key Ecl Films</div>

Here the word "films" is used, making certain that what is referred to is celluloid and not glass. We have also "Eclipse" films, which we know were for "instantaneous" work.[6] As Carbutt had said in the paper read to the Franklin Institute on November 21, 1888 (*Journal of the Franklin Institute*, December, 1888):

> I am frequently asked, are the films quick enough for instantaneous work? In reply, I say, most assuredly, yes. A short time ago I made some 8 x 10 negatives of the New York and Philadelphia Express going at the rate of forty miles an hour. I was on the shadow side, but the negatives were fully timed and showed remarkable detail in the deepest shadows. The train was perfectly sharp, and the driving rod of the engine plain and distinct.

The general position that Dickson used Carbutt celluloid is well established, for example, by the following quotation in his 1933 article already referred to:[7] "My second batch of emulsion was light struck, owing to the night watchman's bursting in at 2 A.M., which so disgusted me that I just slotted the aluminum drum and wrapped a sheet of Carbutt's stiff sensitized celluloid over it . . ." And again, on page 440, 441, and 442 of the same piece, he refers to

> sheet of Carbutt celluloid on light alum [i.e., aluminum] slotted drum [accompanying sketch].
>
> looking forward some day to getting decent lengths or strips of film from Blair or Carbutt . . .
>
> My next attempt . . . was to proceed with narrow strips of Carbutt celluloid . . .
>
> John Carbutt short strip celluloid [accompanying an illustration]
>
> single row of sprockets to fit the newly punched Carbutt strips
>
> the pictures were taken horizontally, but were only ½ inch in size—on Carbutt celluloid strips.

[6] The Carbutt advertisement in *Wilson's Photographic Magazine* of July 6, 1889, lists these "Eclipse" films as being the Carbutt item sold for instantaneous work. These were said in the same place to have a sensitometer number of 27.

[7] The December, 1933, article in the *Journal of the SMPE*.

In a letter to Meadowcroft, Edison's secretary, in 1928, Dickson wrote of "then sheets of John Carbutt sensitized celluloid used . . . John Carbutt short strip celluloid" [accompanying sketch]. Ramsaye (page 59) agrees: "From John Carbutt . . . Dickson obtained some heavy celluloid sheets coated with a photographic emulsion." Ramsaye's information is otherwise incorrect, however; he asserts that "Only very short bands or strips of this material were obtainable," whereas we know that "short bands or strips" were not "obtainable" in the sense implied here since Dickson *cut* these strips from Carbutt 8 x 10 or 11 x 14 celluloid films. And after describing this work Ramsaye follows the crowd in the wake of a famous man by writing, in a caption opposite page 57: "George Eastman, whose solution of the kodak's problem of 'roller photography' with film in 1889 produced the material which Edison needed for the motion picture."

Others have followed this error.

It furthermore appears that the well-known "Monkeyshines" subjects were shot on this Carbutt celluloid. The "Monkeyshines" subjects are so called because of Fred Ott's testimony in the case cited above. In answer to direct question 12 on page 129 of the record already cited he says: "We had white cloth wound around us and then a little belt to tie in around the waist so as not to make it too baggy—look like a balloon, and then tied around my head, and made a monkey out of ourselves." This remark, quoted here verbatim, was made more grammatical by Ramsaye (page 58) in his customary fashion of "improvement." (Josephson, page 386, identifies this subject with *John* Ott!)

In the legal files cited above, note 2, page 4, the item marked 2.30 contains a list headed "Film," which includes, among other items,

1. Film 2½″ x 13⅝″ with ¼″ pictures
2. 2 pieces of film for same mch. with larger pictures ¾″ films

These clearly contain the exhibits described in the 1898 infringement case as Cylinder Strips Nos. 1, 2, and 3: Cylinder Strip No. 1 being a piece of No. 1 above and Cylinder Strips Nos. 2 and 3 being No. 2 above. "Larger" here refers not to the frames themselves, which are of the same size, but to the sub-

ject—another example of the ignorance or carelessness with which this case was prepared. The cylinder strips presented in connection with the December 21, 1896, affidavit (see page 180), when placed end to end in accordance with the subject-matter, equal exactly 13⅝″. This earlier strip can also be identified with the one in the 1898 case. Therefore, since this strip—containing the same subject matter in both cases—was originally 13⅝″ long, allowing for a shrinkage of ⅜″ in a 14″ original length, and allowing for similar shrinkage and possible slight loss in cutting 11 x 14 sheets vertically into four pieces, we can be sure that such an 11 x 14 sheet corresponds exactly to these cylinder strips. As I have shown on page 41 such celluloid sheets were received at the laboratory on June 25, 1889. On page 42 I have also identified these films with Carbutt. Therefore, since Dickson used Carbutt celluloid-based sheets, we can only conclude that the cylinder strip "Monkeyshines" subjects represented by these Cylinder Strips Nos. 2 and 3 of the 1898 case were (1) taken on the Carbutt 11 x 14 celluloid base and, (2) taken *not earlier than June 25, 1889* (see also page 102).

It will be seen that Ott clearly included at least one other person in his testimony. This circumstance is upheld by Dickson in his 1933 article when he refers to a "sunny natured Greek," Sacco Albanese, as being put through "weird antics" (see page 101). Dickson's association of these "Monkeyshines" with the strip mechanism is clearly in error.[8] (See page 101 for the dates of the "Monkeyshines" subject.) A strip introduced in the December 21, 1896 affidavit (see page 180) also contains a "Monkeyshines" subject which cannot be identified with Fred Ott—agreeing with Dickson's statement that it was Albanese who had such pictures taken. Moreover, a careful examination of these "Monkeyshines" subjects tends to disassociate them from Fred Ott. Ott's prominent mustache can-

[8] Dickson says on page 444 of this article, after having described his graduation from cylinder mechanisms: "To take these photographs or strips . . . Sacco Albanese . . . was one of my earliest victims, figuring mostly in the ¼-inch and later in the ½-inch pictures. Draped in white, he was made to go through some weird antics. (See Fig. 4)" Fig. 4 is the illustration of a cylinder subject taken bodily from Ramsaye (opposite page 56). There is, therefore, a contradiction, since Dickson is talking about *strip* photography and Fig. 4, with which he illustrates his talk, shows *cylinder* photography. Mr. Glenn Matthews, who edited the article in 1933, has told the writer that Dickson read the article for error before it was published.

not be definitely distinguished in any of the subjects, and in certain frames can be almost as definitely excluded.

Using Cylinder Strip Number 3, possibly the clearest of these photographs, as an example, and lettering the vertical rows of figures A to J inclusive, and numbering these columns from top to bottom, 1 to 23, to include only whole figures, I disassociate Fred Ott from the following examples among many:

A: 12, 16, 17, 18, 19
B: 16, 23
C: 19, 20, 22
F: 17, and 18.

Of these A 17 and 18, and F 17 seem particularly conclusive. There is also a probability that such violent body and leg movement as is shown in B 6–12 should not be associated with a man of Fred Ott's temperament, whereas for the Maltese Albanese it is much more likely. It is of course quite possible that Ott did pose for "Monkeyshines" no longer extant.

These subjects have been frequently reproduced, beginning with an article in *Cassier's* in December, 1894, and later in the Dicksons' *History of the Kinetograph Kinetoscope and Kineto-Phonograph* of October or November, 1894, in Ramsaye opposite page 56, and on page 440 of Dickson's 1933 article. I have made a careful study of all such "Monkeyshines" subjects and have reached the following conclusions: (1) None of these subjects ever approached a taking rate of 46 per second.[9] (2) All can be identified with "Cylinder Strips Nos. 2 and 3" of the 1898 case above cited (see page 3) and none with "Cylinder Strip No. 1" in this case. (3) Cylinder Strips Nos. 2 and 3 of this exhibit are parts of the same strip, which was in turn a strip cut from either a piece of Carbutt 11 x 14 celluloid-base film or a later, similar film from another manufacturer.

We can be sure that these "Monkeyshines" subjects, and the cylinder work of which they are a logical part, were not taken *before* June 25, 1889, and indeed there is every reason to believe

[9] This will be obvious to anyone who is accustomed to translate body movements into motion picture terms. Let us assume, for example, that it may take a man moving with normal rapidity not less than ⅛ to ¼ of a second to remove his hat and stretch out his arms diagonally as in A7 to A10. This action is accomplished here within three or four exposures; in a 40 or 46-per-second rate more than twice as many exposures would have resulted.

that they were shot seventeen months later. (See page 100.) Surely the character of Dickson's language suggests that the Carbutt celluloid he seized in disgust was something he had lying around, and not something he had just gotten in.

Furthermore, as I have said in connection with Edison's Caveat I (page 22), these "Monkeyshines" were apparently shot on a considerably enlarged version of the apparatus described then. How the intermittent movement was achieved remains obscure, but the approximately 180 teeth of the gear and the enlarged diameter of the cylinder now in the Edison museum (accession #E5512) would correspond to the dimensions I indicated then as essential to a successful operation of this apparatus. Another cylinder apparatus in the museum (accession #E5511), upon which it has been suggested that there is still a trace of photographic chemicals (Complainant's Record of case cited), was chemically examined at my instance and found to be free of any such.

I have been unable to find an example of this early Carbutt film. (Josephson, page 386, implies that the original celluloid is still at the West Orange laboratory!) Dickson describes it as being "stiff," although he remembers it, naturally, only in contrast to the film to which he had become accustomed throughout the previous forty years. Ramsaye, following his trade-journal instincts, embellishes Dickson's adjective "stiff" with one of his own and adds "heavy"—although "heavy" seems scarcely the word to describe an 11″ x 14″ sheet weighing 1.2 ounces—even though one writer expressed doubt that it was quite that thin.[10] This quotation may seem academic, however, considering the fact that we know Carbutt got his film from the Celluloid Manufacturing Company, and that this company manufactured celluloid down to $\frac{1}{200}$″ thick.

The Eastman film, soon to be standardized, was said to be $\frac{3}{1000}$ of an inch thick (*Scientific American,* July 6, 1889; see also page 58), or approximately $\frac{3}{5}$ of what was available to Carbutt from the Celluloid Manufacturing Company at this

[10] The Carbutt November 21, 1888 talk (*Anthony's Photographic Bulletin,* December 8, 1888) gave the weight of two dozen 5″ x 8″ films as 7½ ounces. A simple calculation shows that one 11″ x 14″ film would weigh about 1.2 ounces. *Anthony's Photographic Bulletin* of November 10, 1888, says: "It is claimed that this support is only one one-hundred of an inch in thickness; but we think it is somewhat thicker."

time. This was a promise only, however, so far as I have been able to determine: no periodical that I have seen said that it *was* this thick.[11] But Eastman's film throughout 1889 and 1890 and beyond (the May, 1891, film shows frilling) was almost unusable because of its frilling, cockling, and static electricity markings.[12]

6 · *Edison Goes to Europe*

APROPOS THESE CARBUTT STRIPS, AND TO SHOW THE LENGTH TO which a man with a commercial ax to grind will go in the matter of sharpening that ax, the contradictory, confused testimony of Edison and his three men in 1900 is interesting.[1] Eager to establish a strip machine antedating his trip to Paris on August 3, 1889, and having Dickson's statement in his 1895 booklet (see page 88) that he had achieved projection immediately after this trip (and logically, therefore, an advanced camera) Edison says:

(1) A number of views were taken of moving objects and recorded on a film twenty to fifty feet long [before I went to Paris] [answer to question 39]

(2) [In October, 1888] we could not get strips, but we could cut strips from square pieces and paste them together [answer to question 103]

(3) I think the first that we were able to get the continuous strips was in the summer of 1889 [answer to question 104]

(4) I don't think [the celluloid base, gelatin emulsion film] was on the market in 1888 [answer to cross-question 134]

(5) No, sir; I never remember of any paper [answer to cross-question 137]

(6) . . . the first, I think, we bought from the Eastman Company [answer to cross-question 139]

[11] Eastman's patent specifications (U. S. #441831) said more than once, concerning the *emulsion*, "I have found a thickness of one one-thousandth of an inch for this film when dry satisfactory; but this may vary."

[12] See 1933 article above cited. Also Ackerman (*op. cit.*, pages 67–68) for an ambiguous account of the static electricity trouble. Was the static electricity problem solved in April, 1892, or "immediately before the first of January," 1892?

[1] The Complainant's Record in Equity 6928 U. S. Circuit Court, Southern District of New York.

Now in the testimony of Fred Ott we read:

(1) Well, the strips at that time [i.e., when Edison went to Paris] were made twenty-five feet long [answer to cross-question 55]

(2) [They were made of "pieces of film pasted together"] [answer to cross-question 56]

(3) [The length of the pieces of film] I could not remember [answer to cross-question 57]

(4) [While Mr. Edison was away the film was] not exactly of a single piece, possibly made up of two strips to give the twenty-five feet [answer to cross-question 62]

(5) [The length of the strip was not more than 25 feet] [answer to cross-question 63]

(6) Well, I think they bought them, about five-foot strips, or somewhere in that neighborhood [Answer to cross-question 67]

(7) [When "Edison came back from Paris they were still using the strips made up of sections and fastened together end to end."] [Answer to cross-question 81]

And in the testimony of C. A. Brown, another Edison employee (bracketed passages are paraphrases of lawyer's questions, to which Brown often replied simply "Yes" or "No"):

(1) [We used Kodak celluloid film on the '89 strip machine] before Mr. Edison went to Paris [Answer to questions 63, 64, and 70 and cross-question 113]

(2) They were short strips [before Mr. Edison went to Paris] because we did not want to waste the material [Answer to question 71]

(3) [Up to January of 1890 the length of the strips was ten to fifteen feet] [answer to questions 21 and 95]

(4) [The first films used on the '89 kinetoscope were shorter than 15 feet] [Answer to question 98]

(5) [At first there was no joining in the strips used on the '89 kinetoscope] [answer to question 101]

(6) [The strips of film first used in the '89 strip kinetograph were 2 or 3 feet long] [answer to cross-question 119]

(7) [We began to paste them together while Mr. Edison was in Paris] [answer to cross-question 121]

(8) [We did not paste together the 15 foot strips at any time] [answer to cross-question 135]

Although only testimony dealing with nothing but film has been chosen from the record, we can discern that: (1) Edison's first answer disagrees with both the facts as we know them

and with Ott's numbers 4, 5, and 6—also with Browns numbers 2, 3, 4, 6, and 8. His second answer disagrees with his own answer 4, and with the facts as we know them.[2] His answer 3 disagrees with Ott's numbers 2, 4, and 6, and with Brown's numbers 2, 4, and 6.[3] His fifth answer shows (to be the kindest possible) remarkably poor memory.[4] (2) Ott's first and second answers disagree with Brown's numbers 3, 4, 5, 6, and 8. His answer 3 disagrees with his own answers 4 and 6. His answer 4 disagrees with his own number 6. (3) Brown's answer 1 disagrees with the facts as we know them.[5] His answer 3 disagrees with his own answer 6.

In this welter of contradiction, even Edison's attorneys found only confusion.[6] In it we ourselves must find intentional distortion. The reasons for this distortion we will see later when, in the prosecution of the patent application, the Edison attorneys decide that they must antedate the Friese-Greene references. (See pages 76, 177, 180.)

In a memo made by Tate, laboratory office manager, for Insull on June 30 and July 1 before he (Tate) left for Europe to prepare things for the Edison visit, among 20 items listed, no mention is made of kinetoscope affairs. (Tate went to Europe on July 2, Insull taking his place at the laboratory.) On July 19,

1 box patterns Microphotograph . . . C. Scott

was received at the laboratory.[7] This is the only laboratory re-

[2] As we have seen on page 41 no such "square pieces" were available until the next year.

[3] Compare this with Dickson's notebook comment re the Eastman paper film (see page 71). I cannot believe that commercially produced paper-based gelatino-bromide film, with which the country was flooded at this time, would not have been used for .these purposes when Dickson was coating his own celluloid with home-made emulsions. (Cf. page 73.)

[4] A man may say "I think" and escape all moral opprobrium for anything "inaccurate" he might have said. Yet we know the *first* film used in a kinetoscope was Carbutt's, or even, possibly, the Scovill Company's Ivory film. (See page 46.) If Edison knew so little of what was going on in his photographic department he should either not have been on the witness stand, or should not have claimed supervision of the work that was being done there.

[5] It is obvious from the Dickson letter of September 2, 1889 (written a month after Edison went to Paris), if from no other source that no such film had been used before; if kodak film was being used, Brown's answers 2, 3, 4, 5, 6, 7, and 8 are improper.

[6] The private legal file cited above in note 2, chap. 1. This particular reference is to the item marked 2.22.

[7] Edison archives receiving book entry for this date.

50

ceipt which can possibly be fitted into a charge made to the Magic Lantern account for this month.[8] This charge was also referred to by Edison's attorneys in preparing their case in the American Mutoscope Company's suit.[9]

When one recalls all the activity described by the witnesses in this latter case it is also interesting to read the following letter, sent by Insull to Tate on July 30, 1889:[10]

> Laboratory. There is nothing particularly new to report in connection with the Laboratory. There has been no correspondence of any moment referring to any business of importance. Every thing goes on in a hum drum kind of way, Mr. Edison giving little or no attention to experimental work. The order of the day now is "I will take that in hand when I return from Europe."

On August 3 Edison sailed on the steamer *La Bourgogne* for Le Havre. In laboratory records of many scores of cables sent back to the laboratory no reference is made to the kinetoscope work, and for that matter no cable at all was sent to Dickson. This bears out Dickson's later disavowals of such communications:[11]

> . . . and as our enemies slanderously stated that Mr. Edison got much data from Prof. Marie in Paris & sent me weekly long cables of such acquired data—I was forced to say among other things that I got my instructions *BEFORE* he left—& that I received NO communication from Mr. Edison either by cable or letter during his absence—that will put your father right.

And in the 1933 article already referred to:

> It has been said that Mr. Edison sent me long, weekly cables and letters during his absence, to instruct me further as to what information he had gathered when in Paris from others working on these lines; which, of course, was absolutely incorrect. I wish to emphasize the fact that Mr. Edison never during his absence communicated with me either by cable or letter.

[8] Edison archives "Journal/No. 5/Laboratory/T. A. Edison/Orange, N. J.," page 217. There is also reason to believe that this "Magic Lantern Exp.," to which $79.62 was charged this month, may have later obscured such projection experiments as were referred to by Dickson as part of the kinetoscope account. Surely it was never Edison's idea in those days to project the synchronous pictures, but merely to make them synchronous.

[9] Private legal file cited in note 2, chap. 1. This reference is to the item marked 2.10.

[10] Letter book E1717, 6/21/89–8/3/89, page 451.

[11] Letter to Charles Edison, May 14, 1933, in the Edison archives.

03358

We know that Edison visited Marey while he was in Paris (see Appendix D, page 171). We also know that what he learned from Marey he applied as the "new ideas" of his fourth motion picture caveat. There appears furthermore little question (see page 169) that Dickson kept up with the Marey work through the prominent periodical references and possibly through the *Comptes Rendus* regularly bought for the laboratory, since he read French fluently.

Considerable additional laboratory correspondence suggests that work was largely quiescent at the laboratory while Edison was away.[12] Even if kinetoscope work had been among the important projects at the laboratory we may judge that it would have suffered from neglect at this time.[13] Furthermore, since Motion Picture Caveat III appears to have represented Edison's most advanced pre-Paris kinetoscope thinking, and since we have shown that the device described in this caveat was inoperable, we cannot see how much if anything was done on this matter at this time. There is much laboratory documentation also to suggest that whatever work Dickson was doing was mostly concerned with ore-milling—with which business, as Insull said, Edison was "intoxicated." [14]

Again, as in the period of February to May, 1889, we have a fantastic amount of charges which we are expected to explain by a few small pieces of apparatus. The time sheets shown by Edison's own bookkeeper (in the above case) ascribe 4082 hours to this account for this period, and again this figure accounts for only about one-third of the actual charge.

The total charges to the kinetoscope account for all the months from the opening of the account in February, 1889, to

[12] For example, in a letter dated August 19, Charles Batchelor, Edison's chargé d'affaires, listed six laboratory projects, none of which was photographic. (Edison archives document files "Laboratory of TAE. W.O., 1889.")
[13] Letter book E1717, 8/3/89–10/7/89, pages 7, 8, 14, 18, 39, 115, 417 ("In the course of a month or so, when we have resumed active work at the Laboratory,"), 445, 446, etc. A letter of September 23 says: "I do not wonder that you are getting disgusted at the way things are dragging. This would not happen if Mr. Edison was home." (Letter book E1717, 9/13/89–6/19/90, page 23.)
[14] Edison archives document files "Ore-milling 1889 General"; letter book #1717 8/3/89–10/7/89, pages 7 and 107 and pages cited in note 13 above; case cited in note 1, page 48 above: Randolph time sheets. Also letter to Tate, July 30, 1889 (letter book E1717, 6/21/89–8/3/89, page 451).

the end of May, 1890, was $5,404.62.[15] Conceding that two-thirds of this amount was a hidden charge, possibly to cover laboratory overhead, we still have an amount of work to explain that can only be described as incredible.

7 · The Eastman Flexible Film

AT THE JUNE 11 MEETING OF THE SOCIETY OF AMATEUR PHO-tographers of New York, a member had said:

> I received Monday [it is now Tuesday] a couple of papers and a circular mailed from Rochester on Saturday [i.e., Saturday, June 8], announcing that the Eastman Company have perfected their transparent film. It is a celluloid film. I know that they have been, for the last two or three months, trying to perfect this film . . . will immediately build a factory . . . [the film] is perfectly flexible . . . I expect to have at the rooms, from the Eastman Company, some of their celluloid films for examination. They will be here at any time if any of the members wish to see them. [*Anthony's Photographic Bulletin*, August 10, 1889.]

It is impossible for even the most cursory reader of contemporary photographic trade periodicals to believe that it was not such men as the speaker of these words who were the first to receive such notice.[1] The whole photographic world was led by these "amateurs." Amateur photography in the '80's did not have the derogatory connotations it began to assume later

[15] I set this month for reasons which will become apparent later. In May, 1890, the kinetoscope work closed until the next fall. (See pages 93–99.)

[1] I have read the following: *Anthony's Photographic Bulletin, The Philadelphia Photographer* (also called *Wilson's Photographic Magazine* and later *The Photographic Journal of America*), *The Photographic Times* (American), *The Photographic News* (British), *The Photographic Beacon, The St. Louis and Canadian Photographer, The American Amateur Photographer, The International Annual of Anthony's Photographic Bulletin, Photographic Mosaics* (The annual of *The Philadelphia Photographer*), *The Photo-American, The American Journal of Photography, The Photographic Globe, The Optical Magic Lantern Journal and Photographic Enlarger, Jahrbuch für Photographie, 1887–1896*.

53

when so many thousands began to use portable cameras, and "a contemporaneous magazine article" quoted by Ackerman (*op. cit.*, page 23) said:

> Men who would not be seen handling a box or dusting a shelf in their own store, boast of fingers and linen stained with nitrate of silver and odoriferous chemicals, and are not ashamed to carry their tents and other apparatus upon their backs up and down through the country, with dusty faces and perspiring brows, even at the risk of having country children taking them for a hand-organ man and clamoring for music!

In the year in which these words were spoken, nearly all amateur photographers were men of social position, more than common education, and—of necessity—considerable financial resources. Even if we begin only with Maddox in 1871, whose work led to the gelatin dry plate, and end this year of our history 1889 with the Reverend Hannibal Goodwin (who pre-dated both Carbutt and Eastman with his use of celluloid as an emulsion base) the list of what was known in these years as "amateur photographers" was long and distinguished.

The Society of Amateur Photographers of New York was the most illustrious of the photographic groups in New York City. (The Photographic Section of the American Institute appears to have been less significant at this time; the Photographic Society of the Brooklyn Institute and the Brooklyn Camera Club were also less remarked upon, and the New York Camera Club, which, as I will show, Dickson confused with the Society of Amateur Photographers, had been founded only the previous December.) Its officers and members were all men of standing, and often men of real contribution. It was at this society that "the first public demonstration in the East," of the new Eastman film was given on July 30. (*American Amateur Photographer,* September, 1889.)

Aside from what we can infer as the meaning of the invitation to the members of this society to examine the films which (see page 53) "will be here *at any time*" [italics are mine] other references make it clear that such samples *were* "here at any time" after the editorial deadline of this issue.

By June 15, just after the meeting of the Society of Amateur Photographers on June 11, the editor of *Wilson's Photographic Magazine* had gotten ". . . a piece of [Mr. Eastman's] new

Kodak film . . . we shall at once put it to the test . . . It is as thin as a blister and as clear as glass." On this same date, June 15, the following announcement by the Eastman Company was made:

> The announcement is hereby made that the undersigned have perfected a process for making transparent flexible films for use in roll holders and Kodak Cameras.
>
> The film is as thin, light, and flexible as paper, and as transparent as glass. It requires *no stripping* and it is wound on spools for roll holders.
>
> It will be known as *Eastman's Transparent Film*, and will be ready for market on or about July 1st. Circulars and samples ready and will be sent to any address on receipt of four cents in stamps.

This message was not, however, published until July 1, the promised date for commercial availability of the new film.[2]

On June 21, the *Photographic Times* said: "The specimen sheet which we have seen seems to be all that Mr. Eastman claims for it; certainly, the negative . . . is all that could be desired." The use of the word "sheet" does not seem to be applicable to the small sample that Dickson apparently received later, again suggesting, as I will show, that what Dickson got was somewhat later than these prodigal first samples to trade publication editors. It does seem to agree, however, with what the editor of the *Photographic Beacon* got: (June, 1889)

> Transparent films for the roll holder seem to be now an accomplished fact, at least a telegram from the Eastman Dry Plate and Film Company says so . . . just as we are about to go to press . . . are promised a roll for experimental purposes . . . as soon as possible . . . [the 15″ square] sample is very beautiful, perfectly structureless, transparent as glass . . . weighs only 17 grains.

In the issue of July, 1889, the *American Amateur Photographer* said:

> As we go to press [this is a monthly magazine] information is received that a new transparent film has just been perfected by the Eastman Dry Plate and Film Company, flexible enough to be used in a roll-holder, like paper, with none of the disadvantages of the latter. We have not been apprised of the

[2] *The American Amateur Photographer*, for example, published the advertisement on page 13 of its advertising section in the issue of July, 1889.

nature of the film, but presume it may be an improved celluloid film, as we have recently been shown some specimens of this material which were certainly very near meeting all the requirements of a flexible, transparent film.

I find no particular significance in the fact that after two weeks the editor of this publication had yet to receive a sample of the new film, since it was the first issue of this magazine, and "going to press" for this editor must have been a project somewhat ahead of what would be the regular deadline for a monthly magazine. If any tendency is here it must surely be on the side of the argument for a June, 1889, debut of the new film—and not for an earlier.

Although the meeting on July 30 of the Society of Amateur Photographers of New York was called "the first public demonstration of the film in the East" a negative made from the film had already been seen, as we mentioned above (page 55) by the editor of the *Photographic Times*. Such a negative was also shown to the Photographic Society of Philadelphia by a member:[3]

> Mr. J. M. Walmsley exhibited a negative made in [sic] the new Eastman Flexible Film. In reply to a question as to the use of the film in cut sheets, he said that difficulty would be found in using them in that way, and he thought the manufacturers had announced that the films should only be used in continuous sheets in the roll-holders.

Like the negative shown to the editor of the *Photographic Times*, Mr. Walmsley's negative appears to have come to him from another place than his own camera. This report also clarifies the above quotations in *Anthony's Bulletin* of July 27 and the *Photographic Times* of July 26—both of which stated that negatives were shown.

By his editorial deadline for the July 6 issue, the editor of *Wilson's Photographic Magazine* had not yet tried the new film, although he gave the first exact data I have found for its thick-

[3] This excerpt is quoted from the original handwritten minutes of the Philadelphia Photographic Society, now in the collection of the American Museum of Photography, Philadelphia, and made available to me through the Museum's Director, Dr. Louis Sipley. The laboratory received much Walmsley optical merchandise: for example, the receiving book for March 15, 1888, records

4 microscope stands with one objective ea.———$35.00

from Walmsley.

ness—celluloid $\frac{4}{1000}$ of an inch and $\frac{1}{2000}$ of an inch for the emulsion, i.e., a total thickness of $\frac{9}{2000}$ or about $\frac{1}{200}$ of an inch. As I will show later, there was disagreement about these measurements, even among the internal authorities of the Eastman Company.

In its July 13 issue, *Anthony's Photographic Bulletin* made no further mention of the new film, suggesting that there still had been no trial, although the next issue, that of July 27, noted the presence of the film at the July 3 meeting of the Photographic Society of Philadelphia.

(*Anthony's Bulletin*, however, as a policy, may be said to have not exactly "rushed into print" with all new developments in the photographic world. It was not until the issues of July 27 and August 10 that it reported the June 11 meeting of the New York Society of Amateur Photographers noted above, and not until August 24 that mention was made of the Eastman representative's having shown the film to the Chicago Camera Club on July 29. It is from *Anthony's Bulletin*, however, that we are able to find conclusive evidence that the "New York Camera Club" mentioned by Dickson [see page 65], was confused with the Society of Amateur Photographers. In the issue of October 12, 1889, *Anthony's* tells us that the New York Camera Club had not met all summer, but held its first meeting since the previous spring on Wednesday, October 9.)

Other claims were made by the Eastman Company to be "able" to manufacture the new film in fifty-foot lengths. These claims were published, among other places, in *Wilson's Photographic Magazine* on June 15 and in a Rochester, New York, newspaper (unidentified) as quoted by the *St. Louis and Canadian Photographer*, July, 1889: ". . . after four months of experimenting and preparation by Mr. Eastman [and Reichenbach] . . . Mr. Eastman and his associates have overcome all difficulties and can now manufacture sheets of absolute uniformity of thinness fifty feet in length and three one-thousandths in thickness. This enables them to apply their new transparent film to both their roll holder and their Kodak . . ." The close similarity of the language in *The Photographic Times* of June 21 makes it clear that each editor speaks from an Eastman release and not from experience: "The Eastman Company now announce that it has overcome all difficulties and can

57

manufacture sheets of absolute uniformity of thinness fifty feet in length and only three one-thousandths of an inch in thickness. This enables them to supply their new transparent film to the roll-holder and the Kodak . . ."

So far as the internal records at Eastman are concerned, we have the testimony of Eastman himself quoted by Taft,[4] that the film was first commercially produced on August 27, 1889— which, as we will see, coincides with the Seth Jones statement of July 29, 1889,[5] and the *Photographic Times* of August 16. It excludes, of course, the various samples sent out before August 27. Other records agree with the facts as we understand them concerning Dickson's work (see pages 69–73) and with the records of the Patent Office (see Taft, *op. cit.*). For example: (1) The Ackerman record, *op. cit.*, of the flexible film beginnings; (2) the Glenn Matthews statement in a letter to Dickson on August 7, 1933: "The final successful experiments leading to the production of Eastman film began sometime in December, 1888, and continued through the spring of 1889, the first patent application being drawn up in March, 1889"; (3) *Kodak Milestones* published by the Public Relations Department of the Eastman Kodak Company in 1957; (4) *The Encyclopaedia Britannica*, Volume 15, page 853: "In August 1889, George Eastman of Rochester, N. Y., began the manufacture of film on a nitro-cellulose base"; (5) C. E. Kenneth Mees in *Photographic Society Journal*, December, 1950.

When all these facts are considered alongside the unsupported statements of Eastman's biographer Ackerman,[6] and

[4] Taft, *op. cit.*, gives this date on page 396, and in note 415, page 507, gives its source as being Eastman himself in testimony in the Goodwin *versus* Eastman suit, *Complainant's Record*, Volume 2, page 325.

[5] Made to the Chicago Camera Club that "the company hoped to supply the dealers in about two weeks." This quotation is from the *Photographic Times*, August 16, 1889. See also *Anthony's Photographic Bulletin*, August 24, 1889.

[6] Of the nine "firsts" which Ackerman claims for Eastman *op. cit.*, page 69, only three are accurate: (1) Eastman invented the first film, a coated strip of paper, the coat, or pellicle of which was stripped after exposure and developing, making a transparent photographic negative. [See pp. 6, 71.] (2) Eastman was the first to begin experiments with nitro-cellulose as a possible base for film. [The judges of the United States Circuit Court of Appeals who said on March 10, 1914, that Eastman "cannot use a patented invention because he has improved it," and supporting Goodwin's application for "nitrocellulose as a possible base for film" would certainly disagree with this.] (3) Reichenbach obtained the first patent on transparent, flexible, nitro-cellulose film, which he made by discovering the importance of camphor, fusel oil and

58

Dickson's statement of forty-five years later out of a blue sky (he had made no such claim in any of his several previous accounts—even those of a few weeks previous) when he asked the Eastman Company for a pension as a reward for *his helping Eastman "invent" celluloid film* (!) we can only decide that contemporary records and not the wishful thinking of a man who wants a pension or the adoring statements of a hero worshipper must tell us the truth. What this truth is, is obvious: as of July, 1889, at least, no celluloid base film had yet been produced by the Eastman Company in any except experimental form, and the small samples distributed—even if we assumed that Dickson got them along with the editors (which he did not)—could have in no wise been used for the motion picture work at the Edison laboratory.

A Dickson statement in an August 16, 1933, letter in the Matthews collection reads thus: "Again Mr. Eastman says under [sic] his own signature when I wrote him "Do you remember the date or year of our first meeting?"—he replies 'Yes, I well remember when you came in *1888*'" [Dickson's stress]. This appears to be the basis for claims by Eastman specialists that such a meeting did occur in 1888. A loyal Eastman man could, indeed, scarcely do otherwise than try to set back the date of this product and at the same time link Eastman's name with

amyl acetate. [Reichenbach may have obtained the first United States Patent on such a process but the work of Parkes (1856), Hyatt (1869), Fortier (1881), Goodwin (1887), and Carbutt (1888) contravene the claim that he discovered "the importance of camphor, fusel oil and amyl acetate."] (4) Eastman invented the machinery and process for making film. [Surely Eastman invented some of this machinery, but if we say he "invented the machinery" how can we account for the products of other manufacturers?] (5) The Eastman Company was the first to manufacture and sell both kinds of film. [Carbutt antedated him in the celluloid base and Vergara in the paper base. It is a tribute only to his industrial facilities that Eastman was the first to manufacture and sell *both*.] (6) This company created the market for film by developing the Kodak which was the first great consumer of film. [Certainly the market for what men for decades before the appearance of the Kodak had been crying—a flexible portable film—cannot be said to have been "created" by the kodak.] (7) This company made the first film for Edison's Kinetoscope. [As we have shown on page 39, Carbutt antedated Eastman by some time.] (8) Eastman was the first to eliminate electricity from film which had caused marking in cold weather. [This may be true, but if so it is scarcely a distinction since so far as we know Eastman was the only one who *had* such markings on the new flexible roll film.] (9) He was the first to produce, manufacture, and market film in continuous strips, or reels. [Balagny, for one, antedated Eastman in this. What Eastman did in this line is again a credit to his manufacturing facilities—and not to his inventiveness.]

Edison's at a time when Edison was one of the world's most famous men—even though this letter has never been produced and its text bears the signs of on-the-spot manufacture. Moreover, the alleged Eastman answer is not psychologically proper for the question asked; it certainly does not sound like a natural response to Dickson's question. Against these claims we must, of course, place all statements made by Eastman protagonists before they were given the opportunity to claim this new priority.

Eastman's own statements, made both by his agent on September 7, 1889 (see page 62), and two years later by Eastman himself (see Ackerman, *op. cit.*, page 67) bear this out, and prove false what many (e.g., Josephson, page 387) have said: that Eastman improvements were largely the result of Edison's motion picture needs. Finally, in the legal file noted above (page 4) the item marked "2.22" is headed "Note for Eastman Co. trip." It is a list of questions asked by the Edison attorneys in the case above cited on a trip to Rochester. This list includes the following: "What bearing did Kinetoscope invention of Edison have on these changes [i.e., changes between July, 1889, and February, 1890, on Eastman film lengths, widths, transparency, sensitiveness, etc.]? to which the Eastman man answered, "None."

This should finally set at rest all claims that Edison stimulated Eastman to improve his film.

Ramsaye, the only historian of the American film of this period, tended to credit without serious questioning the claims of pioneers—particularly those of note. Rarely did he research the statements that they made. His work is immensely valuable to any present-day historian because he had an interest in these matters and bothered to set down much valuable data; and all of this at a time when memories, although often inaccurate, were nevertheless fresher. But he was a man, unfortunately, who hated to be found wanting. He was unwilling (except rarely) to set forth what facts he had found and go no further in presenting a solution than what these facts permitted. Often he assumed conclusions—particularly when the matter was crucial in his history and when it involved crediting a famous name with invention or priority.

One of the more unfortunate of these assumptions is his state-

ment that the note sent by Dickson to Eastman on September 2, 1889, was an order for motion picture film. There is nothing to suggest that this is so. He presents this letter (see illustration opposite his page 64) with more than one error in his "translation," calls it "the first motion picture film order, from Edison to Eastman," and quotes it as follows:

> Eastman Dry Plate Co. Sept. 2nd '89
>
> Dear Sir:
>
> Enclosed please find sum of $2.50 P.O.O. due you for one roll Kodak film for which please accept thanks—I shall try same today & report . . . it looks splendid—I never succeeded in getting this substance in such straight long pieces.
> > Sincerely yrs.
> > W. K. L. Dickson
>
> P.S.—Can you send me some rolls with your highest sensitometer—please answer

On page 62, Ramsaye comments: "Having heard of the new Eastman film Edison dispatched Dickson to Rochester for information and a sample. The first Edison purchase memorandum remitting for a prior delivery of the first motion picture film in the world is still in the files of the Eastman Kodak Company at Rochester, under date of September 2, 1889." There are two especially interesting errors in the Ramsaye version of this letter: (1) What Dickson spelled "Kodac" is changed to "Kodak," and (2) What Ramsaye has called "P.S." is actually "9/7." Other errors—making "Sirs," 'Sir"; a dash changed into three dots; "Wm. K. L. Dickson" made "W. K. L. Dickson"—are not significant for our purpose, although they do illustrate the bravura with which Ramsaye handled facts.

When Dickson wrote this letter the Kodak camera of George Eastman had already had considerable excursion; yet here we have Dickson misspelling it, which can mean only that he had not seen the word often enough to know how to spell it. That he was careless about spelling is not borne out by any other information that I have found. Surely, if he had actually had such a camera (which, in spite of Ackerman, he did not—see page 38), this misspelling would not have occurred.

Mistaking "9/7" for "P.S." is more serious. If Ramsaye had looked further into the Eastman files, as Ackerman did some years later (*op. cit.*, p. 66), he would have found the following:

"We have no film of higher sensitometer now on hand, but occasionally have it considerably quicker. Should we have some of its kind, we will try to bear you in mind." This letter is dated September 7. Clearly the "9/7" at the bottom of Dickson's letter is the routine notation of a date upon an original order signifying that on this date, September 7, Dickson's request for a film of "higher sensitometer" had been attended to. The check mark on the "$2.50" in the text of Dickson's letter is routine verification that the amount mentioned by Dickson had actually been sent. The figure at the top of the letter, "379," with the two holes on either side, indicates that this order was #379 and that this order, like all the others, was impaled on some sort of order board. This number, by the way, is quite appropriate to the Eastman statement noted elsewhere (see page 58) that he began the commercial production of his new celluloid base film on August 27, 1889.

The tone of the September 7 answer to Dickson's letter (as I have said on page 60) is in direct opposition to all statements that Eastman, along with all the other film manufacturers, worked madly in these days trying to accommodate Edison's needs for the kinetoscope work. (Josephson, page 387, says that Eastman produced these fifty-foot lengths "under Edison's prodding.") Few, however, can reconcile such a remark as "we will try to bear you in mind" with such statements as Dickson's:[7]

> [Eastman] showed considerable enthusiasm . . . Mr. Eastman was at all times ready to concede to my wishes, supporting me in . . . my great purpose for Mr. Edison . . .
>
> A few weeks elapsed before I saw Mr. Eastman again and explained our difficulties, which were remedied principally by reducing the coarseness of the silver bromide. [Imagine Eastman changing the formula for his already vast celluloid film market for the buyer of only a few rolls—however notable that buyer was!] . . . [Later] I had to ask Mr. Eastman whether he could make his base tougher and less brittle, which he did . . .
>
> This caused me to apply to Mr. Eastman for a less sensitive product or emulsion . . . which we . . . received . . .
>
> Mr. Eastman, however, managed to overcome this [frilling] difficulty in part.

[7] The December, 1933, article by Dickson in the *Journal of the Society of Motion Picture Engineers*.

Both C. A. Brown and Edison himself have perpetuated this fiction. Brown, in the case cited above (note 1, chap. 6), said in answer to question 95: "I know there was quite a lot of strife between the Scoville [sic] people and the Eastman people to see which could get the best strips for us." Edison's remarks, in the same vein, are in answer to direct questions 77 and 78 and re-direct questions 183 and 184 in the same case.

Ackerman also made this error, wanting to establish both Eastman priority in motion picture invention and an early Eastman-Edison association—although he contradicts it baldly in another location (*op. cit.*, page 866): "It is a remarkable coincidence that neither of these men knew of the experiments of the other . . ."

The answer is obvious. When Eastman began to supply Dickson with motion picture film it was some time after this, as is clear from the following letter here published for the first time. Dickson himself neatly eliminates the possibility of his film work at this time being apropos kinetoscope experiments:

> #166 Cleveland St.
> Orange, New Jersey
> Nov. 89
>
> Eastman Co.
> Dear Sirs—
> Kindly send me a cut roll of your Kodac [sic] transparent film ¾" wide and as long as possible—I have made all my astronomical experiments on the samples & am ——— [word illegible] anxious to finish it now. You spoke of 54 feet long—tis well, but if you can make it double do so—if not just send the 54 feet length say ♂ [sic] 6—54 feet lengths ¾" that won't frill—& oblige yrs truly
> W. K. L. Dickson

And along the side he put an afterthought: "Have you a good method to suggest for slowly developing the strips?" This letter, apparently sent the week beginning November 10, indicates that the film that Dickson got from Eastman was for astronomical experiments and not for motion picture experiments.[8] There

[8] The November 20 letter was apparently received on November 21, when the original order was filled—possibly as a result of the immediate stimulation of the later letter. On this order are several markings: (1) the dates "11/20" and "11/21." (2) the number "3498," and (3), two large checks—on the ¾" width asked by Dickson and on the "6—54 foot lengths" asked.

is no reason why Dickson should conceal from the man who is supplying him with a sensitive surface the purpose for which this sensitive surface is wanted: there is, indeed, urgent reason for exactly the opposite. Further, the word "slowly" in the postscript is appropriate for astronomical work, whereas it is not appropriate for motion picture work. The faint images likely in photographs of the heavens would have to be slowly developed, since this development might quite possibly have to be arrested at an early stage to avoid the bringing out of extraneous imperfections, etc., in the film itself. These would be scarcely distinguishable—particularly by such an amateur in the field as Dickson—from the impressions of the heavenly bodies themselves.

We are also sure from other sources that astronomical work of substance was being carried on at the laboratory at this time. There is at present in the Edison archives at West Orange a Fauth and Company astronomical telescope (accession #E4198), which had been purchased in November, 1887.[9] The archives also has a photograph apparently of this instrument taken some years later in the galvanometer room, i.e., "building number one" (negative #4653).

The *Cosmopolitan Magazine* article of April, 1889, elsewhere noted, contains the following line: ". . . and emerge once more to take a peep at the ten-feet-long astronomical telescope, which has its little observatory all to itself, set up in a convenient part of the grounds."

The fifty-four-foot length matter is also interesting. In a letter of April 11, 1959 to Mr. Wyatt Brummitt of the Eastman Kodak Company, I made the following proposal in explanation:

(1) Kodak #1 had 100 exposures 2⅝″ in diameter
(2) Kodak #2 had 100 exposures 3½″ in diameter
(3) 100 x 2⅝″ is 21.875′
(4) 100 x 3½″ is 29.16′
(5) If we allow 3/16″ between frames (which, judging from what I've seen of these early Kodak frames, appears to be about the right

Since Dickson said on November 20, "some days ago," I do not believe he could have referred to a time *less* than *three* days, and probably not more than ten days, previous—otherwise, he would have referred to a period of a "week" and not "days." Hence I would place the date of this letter within the week of November 10–17, 1889.

[9] Document files "West Orange Laboratory Equipment, 1887."

amount) Kodak #1 would have an additional circa 18¾" to accommodate these 99 or 100 in-between spaces, and

 (6) Kodak #2 would likewise have to have c 18¾"
 (7) 21.875
 29.16
 1.5 (approximate)
 1.5 (approximate)
 54.035

It should be noted that Dickson, said to have gotten a Kodak some months before, still cannot spell the word correctly. The use of the word "samples" is appropriate to our former idea that Dickson's memory elided much of his other work into what he thought was an account of his motion picture work; we have already shown that his microphotographic work, for example, became confused in his memory with his kinetoscope work (see page 23ff.). Again we see that since he wrote of having "made all my astronomical experiments on the samples" and was eager to get more film, that he must be confused when he says in the 1933 article (page 7) that "He [i.e., Eastman] then took me into another room and gave me many experimental samples wrapped in red and black paper for my tests."

Dickson had said that he went to a meeting of the "New York Camera Club" in 1888, and spoke to the "Eastman representative" demonstrating the new Eastman celluloid-base film, and was given a two inch by four inch sample of this film —the only such sample the representative had.[10] Next day, continued Dickson, he went to Rochester and was given the samples noted above. (Cf. Brown testimony cited in note 1, chap. 6—page 151, Q. 93.)

We are sure, however, that the "New York Camera Club" meeting which he describes was a meeting of the New York Society of Amateur Photographers. And that the meeting he attended was the one held on Wednesday, August 21, of that year. To begin with, the New York Camera Club was not established until December, 1888, according to more than one periodical reference (e.g., Anthony's Photographic Bulletin, December 8, 1888) and as we have shown above, the fact that an

[10] This according to a Dickson letter to Matthews, August 16, 1933. (Matthews collection.) It is also implied in the 1933 article cited above which refers to "The 2 by 4 inch sample." [Italics mine.]

Eastman representative showed the new Eastman film at this meeting makes such a meeting possible only after July 30, 1889. Dickson, however, later remembered other details. In the August 16, 1933, letter to Matthews he said: "This representative had 5 or 10 minutes to show a scrap of the new film 2" x 4"— and *gave no* explanation of the process—he gave me that scrap . . . The Camera Club meeting was, I *think* to show off a developing *daylight* box—glass bottom and inside red light— which may help place the date." According to the *American Amateur Photographer* of September, 1889, the meeting of the Society of Amateur Photographers of New York on August 21 included a short talk by Eastman representative G. D. Milburn on the new film but "The chief demonstration of the evening was then given, consisting of the development of plates by the aid of white light without a darkroom." This apparatus, U. S. Patent #409618 to Charles Spiro, is described in the same periodical for October, 1889, as having a bottom of "a ruby sheet of glass," below which was a mirror, reflecting the red light upward for observing development. No other such apparatus was demonstrated in any of those meetings for any of these months.

Dickson again elides facts and says that he showed this piece of film to Edison, who said [11] "That's it—we've got it—now work like hell," although Dickson, writing his 1933 article for the *Journal of the Society of Motion Picture Engineers,* says it went like this: "When I showed Mr. Edison my new find his smile was seraphic; 'Good,' he said, 'we can now do the trick —just work like hell.' "

Such quotation of conversation, in the context of such writing on the motion picture as we have had, only offends the scholar who is hesitant about quoting even a short phrase after the passage of twenty-four hours. Whether or not Edison said what Dickson said he said, or what Ramsaye said he said,[12] it was indeed a neat trick to have shown Mr. Edison anything at this time, or to have gotten either a smile *or* a remark from him, since at this time he was in Paris. (Josephson, page 387, says that Edison "dispatched Dickson to New York to get a sample.")

[11] Ramsaye, page 63.
[12] Ramsaye may have gotten his version from Dickson, with whom he was in correspondence during the preparation of his book. See page 118 of Ramsaye.

Dyer, Martin, and Meadowcroft's entire exclusion of Dickson from their account of the "Edison" motion picture work cannot in fairness be said to have been objective. (See page 95.) Edison's rancorous feelings about Dickson (in the Ramsaye manuscript above cited, page 12, he noted twice that Dickson had "Double X"-ed him) appear to me to have been influential here. Tate in his *Edison's Open Door* (Dutton & Company, 1938, page 204) mentions Dickson only as "an excellent amateur photographer." On a letter of January 19, 1926, in which Dickson asked Edison to say that he (Dickson) had never been disloyal, Edison, still grudging the man who had done most of his motion picture work for him, noted "He was disloyal. I think we better not answer—file."

On November 20, Dickson, not yet having gotten his fifty-four-foot film lengths, wrote Eastman again. This letter is also quoted for the first time, by the courtesy of Mr. Wyatt Brummitt of the Eastman Company:

> I wrote some days ago asking you please send me *six* ¾″ wide strips 54 feet long or more & would add that I shd like if possible to get you to see that it is clear ¾″ (full). *no less.* I shall require a considerable number of these rolls shd my experiments turn out O.K.—
>
> I am especially anxious to secure from you a non frilling film which I dont doubt but that your present film proves to be . . .

It is to be noted that Dickson addresses no one in particular at the Eastman plant. This again suggests that so far as he was aware at this time there was no particular personal interest in his problems by anyone at the Eastman plant. The letter adds to our doubt of the likelihood of Eastman himself bothering about Dickson's needs; and in any event we may conclude that no possible Dickson-Edison pressure could have forced him to go any faster in developing his film than he was already going—all records point to his bending every effort in this line for many months previously. (See page 53ff.) Dickson continues, congratulating the Eastman Company on its development of "so transparent and light substitute for celluloid . . . now that acetate of amyl is used by you for a solvent and have so perfectly succeeded in getting up a process for producing these

long sheets I consider you have a magnificent thing." [13] He ends
with another post script: "Please send me this preliminary order
at yr earliest convenience."

It seems quite possible that Dickson did *not* travel to Roch-
ester in these months, as he said later. These letters indicate
no personal correspondent at the Eastman plant, such as would
certainly have been the efficient thing to establish from the
business point of view, putting aside the fact that Dickson was
the sort of man who made a point of establishing these per-
sonal contacts in all his relationships. So far as the samples are
concerned, these could easily correspond with those of the 1891
visit to Rochester, when Eastman gave Dickson a sample of
film.

The fact that the Rochester papers did not note Dickson's ar-
rival may or may not be significant.[14] But it *is* significant to
note that although Dickson describes fully a conversation with
Eastman during which he received the samples, Eastman, like
Edison, was himself in Europe.[15]

8 · *The Dickson Kinetoscope Notebook*

AN ENTRY IN THE DICKSON NOTEBOOK MAKES CLEAR HOW FAR
film work had gone at this time so far as Dickson and his kineto-
scope work were concerned: "Try how sensitive the paper is

[13] As Ackerman says, *op. cit.*, pages 60 and 61, Reichenbach by December,
1888, had produced a film of nitro-cellulose dissolved in wood alcohol, to
which he later added camphor to strengthen and soften the substance. The
camphor, however, crystallized and made opaque spots. He achieved success
by March 3, 1889, the date of the patent application, by using a 60% solution
of camphor and adding fusel oil and amyl acetate, and drying the solution with
a steady, even heat.

[14] As we shall see on p. 123 one Rochester paper, at some time later than
this date but before Dickson's 1891 visit, began to list hotel arrivals. Rochester
was a city of 133,896 at this time, and although Dickson was the representative
of one of the most famous men of the time and would himself not have been the
one to play such an association down, such notes as these only very infre-
quently appeared in any Rochester daily.

[15] The *Rochester Post-Express* of July 8, 1889; the *Rochester Morning-Herald*
July 8, 1889.

. . . (roll Eastman) in other machine—& trial machine." This is an obvious reference to the emulsion-coated paper film which had been prominently before the public since 1885, and which was well known to amateurs and professionals alike both in America and abroad.

The problems of this notebook, which at the time of this writing may be seen displayed in a glass-topped museum case at the Museum of the Edison Memorial National Monument in West Orange, New Jersey, have yielded to study.[1] It is titled, in Dickson's hand: "See large book/Wm Kennedy-Laurie Dickson/ June 8th/87/fully entered up." The "large book" referred to here is Edison accession #E2610, into which Dickson copied a carefully revised version of the rough work of the earlier book. The ambiguity in the dating on certain of the pages in the smaller book is explained by the larger. Before he began preparing the larger book, Dickson enlarged upon his notes in the smaller, recalling—sometime after the date of the event—what had happened, so that he might make the new record complete and accurate. The entries in the small book were made at or very soon after the time of the original work.

The first entry in these books is an example of these changes, made at the time of the preparation of the larger book for what may well have been presentation to the attorneys in their preparation of the Dickson-Edison patent application (application #337523, U. S. patent #434588), or possibly just as a record by Dickson himself of what both he and Edison regarded at the time as his most important work.[2]

In the smaller book the first date occurs as follows: "Commenced June 10th '87 after construction-Magnetic Ore Separator Experiments." And in the larger, this date is edited to read: "Magnetic Ore Separator Experiments/Gold and Iron/—commenced June 5th/87" either to comply with a better memory

[1] Edison laboratory serial #870610. This notebook has been rebound and laminated by the Library of Congress on the occasion of its forming a part of a motion picture exhibit at the Library in 1954. It contains 92 mechanically numbered pages plus end papers and is about 5″ x 8″ in size. It has also been microfilmed by the Edison laboratory, and a copy of this microfilm is available to other Government agencies.

[2] For some years, chiefly between 1890 and late in 1895, it was also regarded by Edison himself as his most important work. This will be obvious to anyone who studies this period; he did little else for five whole years. Bryan (*Edison, the Man and His Work*. New York: Knopf, 1926) says nine years. See also Dyer, Martin & Meadowcroft, page 501.

or to designate the date upon which the "construction" noted in the first entry began. (Certainly any experiment may be properly said to have been begun on the date of the beginning of the construction of apparatus therefor, and not on the date upon which such apparatus began to be used.)

In this notebook, preceding the three pages containing kinetoscope notes and sketches, I have found fifty-one specifically dated entries. These begin, as I have said, with June 10, 1887, and run consecutively through to June 15, 1888. Each corresponds to an entry or entries (interesting in themselves although irrelevant to this history) in Dickson's hand concerning the chronological progression of his ore-milling and ore-plating work.

There is a hiatus between November 15, 1887, and February 1, 1888. On the last of November, 1887, the move was made into the new West Orange laboratory (see note 15, chap. 1) and the ore-milling work which had been carried on at the Harrison, New Jersey, laboratory was moved to the new location.[3]

The notes accompanying the last of these dates, June 15, 1888, end opposite page 44. (The notebook has numbers on right-hand pages only.) Then blank pages occur until opposite page 47, where sketches appear relating only to ore-milling. Although they are superficially similar to those on page 47, these sketches contain unmistakable indications of their ore-milling application. One contains several "Ns" and "Ss" arranged on diagonal bands around a cylinder; another contains, clearly, the word "ore" with a bracket containing the sketch and the word "iron" at the base of a sketch. Furthermore, and

[3] For many months a staff of experimenters had been employed at the Harrison, New Jersey, plant (letter book E1717, 4/22/84–12/31/88), and since the closing of the works at 104 Goerck Street in New York City on December 18, 1886 (according to the bookkeeper Ernest J. Berggren, historical files "Pioneers. Edison. Applications."), whatever work was being done at Goerck Street and was not moved to Schenectady was moved to Harrison.

According to letter book E1730, 2/21/87–6/14/87, page 23 Randolph (see page 32) earned $146.96 for Goerck Street work during the period from December 24, 1886, to February 12, 1887. This latter date, which appears otherwise arbitrary, suggests that this was the final accounting for 104 Goerck Street. By May 25 ore-milling experiments were in progress in Harrison (letter book E1730 2/21/87–6/14/87, page 461) and, as we have shown on page 69, by June 5 the construction of the Dickson-supervised apparatus had begun.

characteristically, these sketches appear to have been made with the notebook upside down, as we will see was also true of the material on the pages following page 84. It is plain that this book was used casually and without care as to form—albeit its chronology, edited before reëntry into the larger notebook, appears to be exact.

On page 47, sandwiched between ore-milling notes, the first kinetoscope notes appear. The drawings seem to be ideas as to how sensitive paper might be wrapped about a cylinder. The notes read:

> Try reproduce in copying camera smaller picture ~~by~~ [change in original] from larger kinetoscope on colodo albumenized celluloid
>
> Make up a stereoscopic illustration of fight to be separate from phonograph. try this
>
> Get black mask & white eyes Exp. against white screen
>
> Try how sensitive the paper is—(roll Eastman) in other machine—& trial machine

These are *the only direct evidence* that we have concerning the detailed nature of Dickson's motion picture thinking at the Edison laboratory.

On opposite page 48 we find

> Kinetoscope
> Try larger lense
> & single lense no eye piece

along with a note or two explaining the sketches—see illustrations. Then on page 48: "Make a fine picture of Edison home on pink+/Get ore milling case in Library/Is the chemical force the same as the retinal/make observation/Get long pipe ready/ Write to Harry" and opposite page 49: "give Kennelly his picture/get picture ready for English/get slide cover to spark phonograph/order parabolic mirror or projecting reflector for arc lamp." The sketches and notes on page 49 clearly relate to the plating experiments discussed earlier in the notebook on pages 41 *et seq.*

A number of these notes are suggestive. The reference to Eastman paper places them before September 1, 1889, at the probable latest, as I have shown.

The reference to "pink+" appears not to have been possible

much before August 1, 1889.[4] The word "kinetoscope" could not have been used before October 10, 1888.[5] "Order parabolic mirror or projecting reflector for arc lamp" is not easily datable; it appears irrelevant to kinetoscope work.[6] "Get black mask & white eyes Exp. against white screen" may be an idea ancestral to the "Monkeyshines" subject.

The first note on page 47, "Try reproduce in copying camera smaller picture from larger kinetoscope on colodo albumenized celluloid," is one of the most interesting in the series. In the first place, we must assume the word "colodo" to be an approximation of "colloid"·with a combining form: a coining to accommodate a limitation of the two words that follow, "albumenized celluloid." In Webster's Dictionary of 1888 only the word "colloid" appears. It is probable that the one "L" was—to a man to whom the spelling of "collodion" was by now quite familiar—not the result of carelessness, but the result of a rapid confusion as to whether or not to give the new word one or two L's.

"Colodo albumenized celluloid" is a description of celluloid—not at the laboratory until after June 3 (see page 38)—prepared

[4] On August 2, 1889, the *Photographic Times* said of Carbutt's positive celluloid that one grade was "a delicate seashell pink." It is natural that Dickson would have used a plus sign for "positive," since this is the sort of symbol any experienced electrician would use. Since the famous "ivory" films were also manufactured in a pink version it is perhaps more likely that Dickson was referring to these.

[5] As we have seen on page 9, Edison had asked his attorneys to suggest a name for his motion picture apparatus. They answered him with several suggestions on October 10. On this letter Edison noted that he had found a word in the dictionary and wrote "kinetoscope-moving view" at the top of the letter. That he had not yet found such a name as of October 8 is obvious from the handwritten copy of Motion Picture Caveat I, dated October 8, which left a half-line blank. This was later filled in with "Kinetoscope 'moving view.'" (Document files "Motion Pictures 1888" in Edison archives. See also Appendix B.)

[6] Arc lamps were consistently used by Dickson in his regular capacity as the laboratory photographer. The laboratory receiving books show many entries for arc-lighting items. Arc lamps were used also in an important ore-milling experiment, and since Dickson was heavily involved in this work we may suspect that this notebook entry is irrelevant to the kinetoscope work. In the legal file cited (note 2, chapter 1), item 2.10 lists "voucher No 853 reflector" under "Kinetoscope" for August, 1889. This classification does not really agree with Dickson's note here: "for arc lamp" is much too broad a reference. More conclusively, such a reflector would be enormously too large for the tiny reflector necessary for the kinetoscope lamp. Nevertheless, the attorneys' dating of this item corroborates the August, 1889, dating of these notebook pages. (Cf. page 74.)

for photography with a layer of albumen between the supporting celluloid and the emulsion, a silver-bearing collodion. This was frequently done in those early days of experiments with celluloid as a film support. As the *Photographic Times* of August 21, 1891 said, some years after collodion as a carrier of the silver salts had been abandoned and gelatin substituted:

> Q. Will you kindly tell me how I can coat celluloid with gelatine emulsion? I have tried it several times, but the celluloid seems to be greasy and the emulsion won't run over it.
>
> A. Try a substratum of diluted albumen; or rub the celluloid plate with a weak solution of sodium water glass till dry.

At the time of Dickson's note he was still experimenting with collodion as the means for carrying the sensitive silver nitrate. The fact that he was still coating his own celluloid is indication that, in spite of the already familiar and soon to be widespread use of gelatin for this purpose, he began work by exhausting the old means before he tried the new: his work in the laboratory had taught him that it is upon the familiar that the scientist must base his understanding of the unfamiliar.

The fact that celluloid was not at the laboratory until shortly before June 3, 1889, and that Dickson was already possibly trying to conceive it as being bent around a cylinder (see the language of Xylonite Co. letter, page 37), suggests that in his precious "in-between-times," he was already giving thought to "extraneous" matters. The Edison attorneys, however, although straining to force back a date of invention for this apparatus, could not see the way clear to suggesting that Dickson had done any actual *work* before the week ending June 27, 1889.

The arrival of this celluloid (see page 37) again proves that not until June, 1889, could celluloid have been used in any possible kinetoscope experiments and that, therefore, it was appreciably later (as I will show) that commercially coated celluloid was used. This disproves the testimony of Edison and his co-workers, Brown, Ott, and Kayser in 1900, not to mention recent fanciful claims of Eastman partisans who base their ideas on the curious letter written by Dickson 45 years later in which he asks financial remuneration from the Eastman Company for the "help" he gave George Eastman in developing the celluloid film in 1888. (See page 166.)

Indeed, none of these notes seems to have been possible before the week ending June 27, 1889.[7] The other notes refer either to work done after this week or to activities possible within a range of several months. "Write to Harry," incidentally, may well refer to Harry Marvin, with whom Dickson had become friendly. They had spent a week's vacation together the previous August in Clifton Springs, New York.[8] This friendship was to have far-reaching significance for the whole early motion picture story in America.

It would seem clear then, that these kinetoscope notes belong to July or August, 1889; I incline to the latter, since it seems likely Dickson may have done motion picture work after Edison had gone to thhe Paris Exposition on August 3. They appear to be certainly before the new Eastman celluloid-base, film, which was in Dickson's hands by September 2, 1889.

The pages following these three kinetoscope pages in the notebook are either blank (for example, the pages opposite 61 to 75 are all blank) or contain irrelevant material. The page opposite page 79 contains what I consider proof that these latter notes were done in recall, and preparatory to their entry into the larger notebook. A date is given as October 20, 1888. The " '88" is crossed out and an " '87" is substituted. It is not credible that anyone writing as late in the year as October would continue to write the previous year in error. It is therefore certain, it seems to me, that this note was being written in 1888; but as the ensuing entries indicate (opposite page 81 and page 82) the work described was done in 1887.

Among these latter pages, for one interested in Dickson's psychology, are sketches on page 80 of a devil or an imp, and on page 91 of a seascape with accompanying "poetic" comment: "At last doth/The morning sun arise/on the ruined turrets/of the golden age." Both the quotation and the drawings suggest much. They also remind us that Dickson was a man who had a reputation among his friends as an artist and himself agreed with this estimate of his gifts. It is difficult for us to share this opinion.

[7] In this week, according to the source cited in note 1, page 3, Dickson did his first work on the kinetoscope account. See also page 33 for a discussion of why this was probably his earliest possible time.

[8] *Clifton Springs Press*, August 16, 1888. See also Appendix A.

9 · The "Photograph Building"

DICKSON'S STORY WAS THAT EDISON GAVE HIM A LAST-MINUTE direction for work on the kinetoscope as he departed for Paris (*Journal SMPE, loc. cit.*): "In the midst of this work Edison went abroad. . . . As the boat glided out I saw Mr. Edison leaning over the railing, his fists to his eyes to imitate the viewing of the pictures in our experimental kinetoscope." To me this has the feeling of credibility. It must, however, be placed alongside the Ramsaye story (page 63) that Edison's ship glided out of the harbor with Edison at the rail holding a phonograph under one arm which had been delivered to him at the last moment. If Dickson's account is to be believed, then we have another indication that the kinetoscope was at this time still only in the microscopic-peep-hole stage—and that stories about strips, pictures taken intermittently on these strips, and the projection of these pictures, are woven from whole cloth. (Josephson, however, page 395, sees "no doubt" that Edison and Dickson tried to produce a five-foot projected picture in 1889. Considering the fact that in 1889, apart from the tachyscope (see p. 87), the only motion picture apparatus they had was a cylinder about the size of a phonograph cylinder, this seems somewhat naïve.)

Claims for the construction of what was known as "the photographic building" (see description below) during Edison's absence abroad are proper[1] but this fact is *not* an indication that kinetoscope work was going on apace, or indeed that it was going on at all. Consistent claims that this building was built because of the necessity of getting into a place where the kinetoscope work would not be jarred by the machinery have from the first rung untrue.

In the legal record we read: "We had trouble with the ele-

[1] General Ledger/No. 5/January 88–June 90." Page 236.

vator there; we had to stop it everytime we wanted to take any pictures, because it would jar the room so that we could not, and that was the reason Mr. Batchelor gave his permission or had the building built for us." (C. A. Brown, answer to cross-question 142, Equity 6928.)

An article in the *New York Herald*, February 2, 1890, entitled "To Catch A Speaker's Gestures," [2] said: "But a new difficulty arose. The slight, imperceptible tremor of the room in which the experiments were conducted, caused by the motion of the machinery and dynamos in another part of the building, was sufficient to destroy the sharpness and value of the photographic images. This was overcome by erecting a special building . . ." The same press release was used as the basis of similar articles in the *Orange Chronicle* of February 1, 1890, the *Newark Evening News,* and the *Newark Daily Advertiser.* Both the *Evening News* and the *Daily Advertiser* claimed exposures of from $\frac{1}{250}$ to $\frac{1}{1000}$ of a second at a rate of from 8 to 10 per second. The intelligent reader will need no other proof that all these "motion picture" photography claims are spurious. In stroboscopic photography the film is placed within a dark space and uncovered. It is exposed by a flash of light which falls upon the object to be photographed. This flash is so short (as in the tachyscope: see chap. 11) that the object to be photographed, while bathed in light, appears to be motionless. To think that any shutter arrangement like that described could effect stroboscopic photography, is improper. If nothing else, there would be so much displacement within $\frac{1}{250}$ or $\frac{1}{1000}$ of a second that the bullet would be merely a streak. Edison's "perfect image" (see following) is as unlikely as his ratchet and pawl intermittent.

The answer to this difficulty we find in the same *Herald* article. The change was not made to accommodate the taking of motion pictures, but because ". . . an elaborate system of experiments was begun to try if possible to photograph a rifle

[2] The reader is recommended to the whole article, which is not repeated here for lack of space. The "Sunday feature" quality of the piece will be apparent, as will the desperateness which led Edison's attorneys to clutch at so slight a straw by which to pre-date Friese-Greene. This "Sunday feature" quality is further substantiated by the fact that no other New York paper—the *Sun,* the *World,* or the *Times*—all of which showed considerable eagerness in reporting Edison's "latest," made any mention whatever of this "invention."

bullet in its passage through the air . . . weeks of careful experiment brought a solution in a new combination of sensitizing chemicals by which even this infinitesimal period of time sufficed for a perfect image."

If we are to concede that such "an elaborate system of experiments" was carried out at all (and there is much to discredit this when we consider that this was not a news item but a Sunday Supplement feature story) then we must also concede that the principal point here was that kinetoscope work was not involved. The photography of a rifle bullet is not something upon which a man trying to record the motions of human beings would spend time. Furthermore, the photography described here is stroboscopic: experiments of a type which was already occupying much interest at the time.

Interesting also is an article in the *Scientific American Supplement* of January 4, 1890, which is a translation from a German piece entitled "The Photographing of Artillery Projectiles Travelling Through the Air at a High Velocity," in which Anschütz's work on this problem was described. The reader is also referred to the following item from the *Scientific American* itself, of January 25, 1890. (Note the significant correspondence of the date with that of the Edison article!)[3] "Rifle bullets are now photographed in their course by means of an electric spark. The camera is taken into a dark room, which the bullet is caused to traverse. As it passes the camera it is made to interrupt an electric circuit and produce a spark . . ."

An article in *Anthony's Bulletin* of this same date is also interesting in this context. It describes in considerable detail the microphotographic work of Zeiss in Jena, Germany, and

[3] The reader is also referred to many interesting articles in the various Eder *Jahrbücher,* in which photography by stroboscopic means is frequently described, including photography of the air compressions in the path of the projectile. I make special reference to: E. Mach and J. Wentzel, *A contribution to the mechanics of explosions,* Minutes of the Vienna Academy, XCII, Volume II, Part II (1885), page 625. E. Mach and P. Salcher, *Photography of changes in air produced by rifle-bullets (projectiles), ibid.,* Vol. XCV, Part II, page 764. E. Mach and P. Salchen, *On the ballistic-photographic experiments carried out in Meppen and Pola, ibid.,* Vol. XCII, Part II, page 41. E. Mach and L. Mach, *Further ballistic-photographic experiments, ibid.,* Vol. XCVIII, Part II, page 1310. E. Mach and P. Salcher, *Optical investigation of air currents, ibid.,* Vol. XCIII, Part II, page 1303. E. Mach and L. Mach, *On interference of sound-waves of great extension, ibid.,* Vol. XCIII, Part II, page 1333. E. Mach and L. Mach, *loc. cit., Concerning longitudinally progressing waves in glass, ibid.,* Vol. XCVIII, Part II, page 1327.

says, among other things: "Dr. Zeiss works in an isolated and uninhabited dwelling house, in the ground floor of one of the rooms of which he has sunk two large foundation stones." If the reader will begin by reading the *Herald* article, then the *Scientific American Supplement* and *Anthony's Bulletin* articles, and consider that it was Edison's habit to turn out sensational stories like a nickel-in-the-slot machine (he could not endure having anyone do anything scientific without having it known that he had done the same thing long before and better) he will have little difficulty in deciding that no such experiments occurred.

Two more decisive items should be noted. First, *Wilson's Photographic Magazine* of April 5, 1890: "The article in your last number [*Wilson's* had reprinted the *Herald* article] on 'To Catch a Speaker's Gestures'—copied from the New York 'Herald' —is a 'fake.' One of our members wrote to Mr. Edison a month ago about it, and received answer that no such experiments had been attempted." These experiments described "an ingenious piece of mechanism by which photographs of the speaker are taken . . . with enormous rapidity . . . from one-eighth to one-twentieth of a second [and] sent to any desired point and . . . thrown on a screen . . ." Since the West Orange laboratory was never known to claim *less* than reality, it is difficult to consider that they were telling anything but the truth on this occasion. Secondly, there is no charge whatsoever made to any such account or work in any of the Edison account books nor any mention made of any such work in the tens of thousands of contemporary documents that I examined.

The "photographic building" may be seen in an article in the *Photographic Times* of January, 1895.[4] It is described by Dickson himself in some detail in his 1933 article: ". . . an

[4] I have presented a copy of this photo to the Edison Museum. At the time of this writing it hangs in that corner of the library at West Orange which has come to be designated as "Charles Edison's Room." It may also be seen at the extreme right of negative number L6015 of the Edison laboratory archive numbers. Its outline may be seen on various tax maps examined by the writer in Orange, West Orange, and Newark. For example: (1) Page 147 of "Standard Fire Map/of/Essex County/New Jersey/Volume IV/Corrected to/ . . . /May 92" in the Orange Free Public Library. I have also presented a copy of this to the Edison museum. (2) 1890 "Atlas of Essex County" in the County Register's Office, Newark. (3) 1904 map in the West Orange City Engineer's Office—although the building is not certainly identifiable here.

outside studio to my specifications, combining a sliding glass roof to let in the sunlight unobstructed. . . . Attached to this room, which was about 18 x 20 ft. in size, were two darkrooms — . . . Above these darkrooms I had another room for projecting tests . . .

This 18′ x 20′ studio is illustrated on page 449 of the 1933 article. It is also illustrated on page 7 of Dickson's *History of the Kinetograph Kinetoscope and Kineto-Phonograph*. Against its east wall were taken innumerable photographs in the course of Dickson's regular job as the official laboratory photographer.[5] The controversial Kayser photo was also taken in it (see pages 182–183). It was begun in September, 1889, and finished the next month (see note 1, page 75).

This building may have been modeled after the description of such a studio in Carey Lea's famous *Manual of Photography*, a copy of which I found in the West Orange Edison library, bearing evidence of considerable use. On page 107, under a section entitled "The Glass Room," three sketches and some description of a suggested studio are given. These pages appear to have been much used, with pencil additions, etc., and the dimensions given are close to those of the Edison building.

10 · *The French Influence*

WHEN EDISON RETURNED FROM PARIS ON OCTOBER 6, HE DID NOT, as all others have said, go "immediately" to the laboratory.[1]

[5] For example, the famous Edison-with-microphotograph-apparatus photograph, Edison archives negative nos. L40–L42, reproduced in: (see chap. 3) (1) *Cassier's Magazine*, October, 1893. (2) *Century Magazine*, June, 1894. (3) The Dicksons' biography, *The Life and Inventions of Edison*, largely a reprint of the *Cassier's* series, in which it appears opposite page 300.
[1] Ramsaye titles his chapter 4, "It Moves—October 6, 1889." I get the impression, however, in reading Ramsaye, that he believed that such a projection may not have occurred. In his account in the *Encyclopaedia Britannica*, Volume XV, page 853 of the 1956 edition, although he errs (as we have shown) in saying that a "sample strip 50 ft. in length [was purchased by Edison] for $2.50" he carefully avoids committing himself to a projection at this time, and speaks only of "the demonstration of the Edison *kinetoscope* at West Orange, N. J., on October 6, 1889 . . ." [Italics mine.] Furthermore, in the *SMPE Transactions*, Volume XII, No. 35, 1928, he said: "It was undoubtedly a peep show . . . We now know [the projection machine] could not have been there." Josephson (page 388) follows the October 6 error.

As a matter of fact, he did not go until the next day, which was a Monday, when he appeared bright and early.[2] He probably did not, as described in a confusion of reports (see pages 88–91 for an analysis of this) see a motion picture projection, although he may have seen a small device built by Dickson for viewing the microscopic pictures taken by Dickson on the cylinder machine.[3] As we have seen, Edison may have left West Orange with the indication to Dickson that he wanted such an apparatus ready by the time he returned and had asked John Ott to help Dickson with it (see page 34). Since it appears that microscopic pictures of motion may already have been achieved at the laboratory, it is natural that Edison would have wanted to see these, just as he would have wanted to see what had been done in all departments while he was gone.

When he got back he immediately plunged into the phonograph work. This was to result in the famous note to Jesse Lippincott on October 17:[4] "Experimental machine finished & turned over to factory last night. It's a daisy. Edison."

In the week beginning October 20 he worked "steadily" on the ore-milling machine concerning which Mallory had complained. During this time and beginning rather sharply with his employer's return from Paris, Dickson's time was charged to the ore-milling account, leaving the impression that Edison may well have had an "enough of this nonsense now let's get to work" attitude when he got back.

[2] *The Orange Journal*, October 12, 1889. He returned to West Orange ill, moreover, a circumstance making a day of rest at home more likely than any "remembering of the Sabbath day to keep it holy" would have made it. In a letter written on October 9, he says: "Eight days on the ocean have failed to repair the damage done to my digestion by a series of French dinners which it was impossible to avoid—I bore up bravely . . . like a plain American citizen." This quotation is from letter book E1717, 10/7/89–11/11/89, page 82. This predilection for "plain Americanism" is further shown in a letter of May 29, 1889, in which Edison wants to know if a particular firm of attorneys are "born Americans."

[3] In 1900, in testimony from the case cited in note 1, page 3, in answer to question 131, Edison says "But there was no screen as Mr. Dickson says." In the Motion Pictures Patents Company litigation of some years later (I quote Ramsaye here, page 67) Edison said again, "dryly," "There was no screen," but later, in a marginal note of the Ramsaye manuscript now at Harvard, he said: "the facts are that Dixon & I had a machine projecting on a screen 5 ft sq at the time we were making peep machines." Since these "peep machines" were not manufactured until beginning late in 1893, and were continued until at least 1899, this Edison remark is inconclusive.

[4] Edison archives document files "Thomas A. Edison Handwriting 1889." Also letter book E1717, 10/7/89–11/11/89, page 152.

Beginning on November 2, Edison wrote his Motion Picture Caveat IV, a long multisubject document. (See Appendix B.) For the first time he envisioned something else than a cylinder surface for receiving the photographs: "The sensitive film is in the form of a long band passing from one reel to another." And, for the first time, he mentions perforations: "on each side of the band are rows of holes exactly opposite each other & into which double toothed wheels pass . . ." (Sprocket wheels were, of course, far from being new. Among others, see the Reynaud patents.) He sticks with the Leyden jar as a means of projection: "The Leyden jar spark illuminates back & by means of a lense the image is projected on a screen" and repeats the possibility of a continuous light intermittently interrupted by a shutter: "Instead of a leyden spark a continuous light with revolving shutter may be used."

He specifically restricts, moreover, the photographic operation to a microphotographic process: "in front of the apparatus where the film is exposed the Microphotographic apparatus is placed" and accomplishes the intermittence by the familiar impossible escapement: "on the sleeve is a release escapement with fork connected to the tongue of a polarized relay. This polarized relay is reciprocated by means of a break wheel alternating currents through it . . . The band is advanced one step for a photograph 10 times in one second . . ." For the first time he delineates his $\frac{1}{10}$ to $\frac{9}{10}$ ratio: "but of this $\frac{1}{10}$ of a second $\frac{9}{10}$ths of the $\frac{1}{10}$ the band is still with $\frac{1}{10}$ of the $\frac{1}{10}$ of a second the band is moving." He contradicts all positions taken before in now deciding that ten images a second are all that are necessary to achieve persistence of vision: "taking 10 photographic images per second most perfect results are obtained." He reiterates his idea of synchronizing this apparatus with the phonograph: "The break wheel which controls the polarized relay may be connected to the screw shaft of the phonogh hence there will be a positive connection & all the movements of a person photoghd will be exactly coincident with any sounds made by him."

To former impossibilities Motion Picture Caveat IV has added new ones:

(1) A sensitive band as narrow as that shown in the sketch (assuming the shutter opening a close accommodation for the

photos, and this opening being approximately half the width of the film) made to accommodate microphotographs, was then and is now a practical impossibility. A "low-power" microscope is one with a magnifying power of from 50 to 75 times. Assuming even a low-power microphotograph, the band would have to be not more than approximately $\frac{1}{25}$ of an inch wide. Into *each side* of this band of "sensitized film" there would have to be punched a row of holes sufficient to accommodate sprocket wheels.

(2) Such a film could not possibly endure the stress incumbent upon a rapid-forward movement for $\frac{1}{100}$ of a second, ten times a second.

(3) Sprocket wheels of the size necessary to fit into the microscopic holes punched on each side of this band are impractical, just as the tooth gear and pawl of the former apparatuses were also impractical.

(4) No practical means for driving the wheels is described, either the supply or the take-up wheel. The use of a sleeve and friction contact is impractical at the speed described: the inertia of even such microscopic parts (granting that they could have been built) would exclude this.

The theoretical leap forward in this caveat—specifically the replacement of a cylinder by a band, the addition of perforations, the slower rate of taking—is clearly the result of the contact with Marey (see Appendix D for a further discussion of the Marey work). For some months Marey had been using film bands for his motion picture work, and had been propelling these bands along intermittently. No serious student will believe that Edison, when he saw Marey's projection in Paris, would not have been curious to find out how the photographs were made—or that Marey would have been reluctant to disclose such information. In both England and France, serious scientists placed the dissemination of knowledge above any material gain that might accrue therefrom, and had for generations been giving their latest developments to their respective scientific societies.[5] With Edison secrets were carefully guarded.

[5] In England to the various Royal Societies; in France to the various divisions of the Academy of France. In America, however, Edison's secrecy was by no means unique.

Marey for months had been disclosing the latest results of his work to his fellow members of the Academy of France.

Marey's book, *Le vol des oiseaux*, in which he described his methods in detail, was seen at the West Orange laboratory during the time at which this fourth motion picture caveat was being written. According to letter book E1717, 11/11/89–12/9/89, Edison acknowledged the gift on November 12. Since this caveat had not been finished until shortly before November 27 (see correspondence files) we can be sure that Edison had the Marey book while writing this caveat. Even leaving aside the Paris visit, he now had at hand more than enough to account for all the advances in the new caveat.

Motion Picture Caveat IV covered 45 pages and 78 sketches —far more than would be possible to set down on the single day which dates the beginning of this caveat, November 2. The many differences in ink, handwriting pressure, and so on, the complexity of the subject matter, Edison's busy schedule, and his own testimony on his method of preparing these caveats (see page 29) add to this impression. The Marey book was acknowledged on November 12, and we know that such acknowledgments were habitually made within approximately a week, depending upon the illustriousness of the donor. We also know that the revised caveat was not returned by Dyer and Seely until November 27, which is an exactly proper time if we assume that Edison had finished writing it even as late as the tenth or the twelfth of the month.

This last caveat confirms my position that at least up to this point no *rapid* motion photography had been achieved—else why, in this secret place, did Edison not describe a practical method for doing it? Up to this time, the "kinetoscope" work at the laboratory, slight as it was, concerned chiefly a viewing apparatus, and only a cylinder, microphotographic one. So far as Edison himself was concerned, any suggestions he might have given Dickson in his work would have been of no help, since there is nothing in his writing up to this point (as there was nothing in it up to October 8, 1888) to suggest that he had learned anything about such work.

11 · The Lenox Lyceum Projection

I HAVE WRITTEN ABOVE OF A "TACHYSCOPE" THAT WAS BUILT AT the laboratory at this time. I infer this from repeated accounts by Dickson. First in the *Century Magazine* of June, 1894:

> . . . it was resolved to abandon that line of experiment, and to revolutionize the whole nature of the proceedings by discarding these small photographs, and substituting a series of very much larger impressions affixed to the outer edge of a swiftly rotating wheel, or disk, and supplied with a number of pins, so arranged as to project under the center of each picture. On the rear of the disk, upon a stand, was placed a Geissler tube, connected with an induction coil, the primary wire of which, operated by the pins, produced a rupture of the primary circuit, which, in its turn, through the medium of the secondary circuit, lighted up the Geissler tube at the precise moment when a picture crossed its range of view. This electrical discharge was performed in such an inappreciable fraction of time, the succession of pictures was so rapid, and the whole mechanism so nearly perfect, that the goal of the inventor seemed almost reached.

This paragraph was repeated word for word in the *Cassier's Magazine* article of December, 1894, and again on pages 9 and 10 of Dickson's *History* of later the same year. It was also referred to by Dickson in his article for the *Journal of the Society of Motion Picture Engineers* in December, 1933, page 439: "To obtain full illumination it occurred to me to rig up a small Geissler spiral tube without a shutter . . . A disk was tried next, to avoid the difficulty arising from the curved drum surface."

Let this description be compared with that of the Anschütz tachyscope in a front-page article in the *Scientific American* of November 16, 1889—an edition which contains on its front cover a detailed drawing of such an apparatus:

This instrument (which is shown in our large engraving) is known as the "electrical tachyscope." It consists of an iron wheel of sufficient diameter to hold an entire series of these pictures on its periphery. This wheel is arranged upon a rigid standard, and provided with a series of pins, which register exactly with the pictures. Upon the standard, behind the wheel, is located a box containing a spiral Geissler tube which is connected with the terminals of a Ruhmkorff coil. The primary wire of the coil is provided with a contact maker and breaker adapted to be operated by the pins projecting from the wheel, so that every time a picture comes before the Geissler tube, it is illuminated by an electric discharge through the tube. This discharge being instantaneous shows each picture in an apparently fixed position, and these pictures succeed each other so rapidly that the retinal image of one picture is retained until the next is superimposed upon it, thereby giving to the observer the sense of a continuous image in constant motion.

The Anschütz tachyscope, as we have seen on page 12, was announced to America as early as June 4, 1887, when the *Philadelphia Photographer* (page 328) carried an article entitled "Anschütz's Motion Pictures and the Stroboscopic Disk." This article contained the following lines:

I come now to the special description of Anschütz's apparatus. As in the ordinary stroboscopic disk, so here the successive series pictures are arranged circularly upon a steel disk of large diameter. These are diapositives [i.e., positive transparencies] of high finish . . . and a diameter of 10 cm [i.e., about 4 inches]. From fourteen to twenty-four of these are placed together in a vertical circle according to the motion to be represented. At the highest point of these is a circular .opal glass disk 10 cm [i.e., about 4 inches, the same as the photos] in diameter, likewise behind which is placed a Geissler tube wound spirally to a circular face of the same diameter. At the moment when the picture, being set in motion, finds itself directly in front of the disk, a strong induction current is let through this tube, and then broken after $\frac{1}{1000}$ to $\frac{1}{2000}$ of a second, so that the tube sends out only for this short time its beautiful light. If the room is now darkened, and the disk made to rotate fast enough, so as to let the pictures follow one another in about $\frac{1}{30}$ of a second, then the opal glass disk begins to shine with a seemingly continuous light; in front of and before it the motion, which was represented in the series picture, can be perceived; it appears to pass along in elegant measure and excellent completion.

On November 19 of the same year the same periodical had a detailed article on the same subject, entitled "Photography on 'The Go'" and containing, incidentally, examples of the same series of pictures which were produced in the November, 1889, *Scientific American* article.

On August 17, *Wilson's Photographic Magazine* ran another article entitled "The Instantaneous Apparatus of Mr. Anschütz," containing a description of Anschütz' camera. On October 8, at the regular meeting of the Society of Amateur Photographers of New York (whose meetings Dickson apparently often attended) Anschütz' "beautiful animal pictures were passed around . . . and excited general admiration."[1] In the *American Annual of Photography*, the preface of which was dated November 1, 1889, the U. S. Photographic Supply Co. of New York City offered the Anschütz camera (!) for sale—"manufactured in best style."

On the same day as that upon which the *Scientific American* carried its article concerning the Anschütz tachyscope, *Wilson's Photographic Magazine* had as its frontispiece a montage of Anschütz pictures. On November 29, 1889, the *Electrical Engineer* (British) took cognizance of the Anschütz activities. On February 7, 1890, the magazine *Science* also published 12 Anschütz photos.

And on December 5, 1889, to the Edison laboratory came

24	3½ x 4" transparency plates
24	3½ x 4" glasses for lantern slides
50	—— mats
50	—— borders

—items never before received—from the Scovill and Adams Company.[2] It appears more than coincidence that what was received at this time was exactly what was needed to build such an apparatus as was described by Dickson, even to the *number* of transparencies described as having been regularly used in an Anschütz tachyscope.

If we examine Dickson's original statement in the *Century Magazine* of June, 1894, we find him saying—after having described extended experiments in which only microphotographs were used:

[1] *American Amateur Photographer*, November, 1889.
[2] Edison archives receiving book entry for this date.

86

The bromide of silver haloids, held in suspension with the emulsion, showed themselves in an exaggerated coarseness when it became a question of enlarging the pin-point photographs to the dignity of one eighth of an inch . . . Each accession of size augmented the difficulty, and it was resolved to abandon that line of experiment, and to revolutionize the whole nature of the proceedings by discarding these small photographs and substituting a series of very much larger impressions . . .

Here was an advance indeed! Whence came these "very much larger impressions"? Is not this the goal for which the whole work strove? Granted that he himself had been able to produce such "very much larger impressions" was it not time to call the kinetoscope experiments to a halt and write them off as successfully finished?

The only answer is that these "very much larger impressions" were not taken by Dickson. Either they were motion photos taken by someone else—possibly Anschütz or Muybridge—or photos taken by Dickson with a still camera. We know that the laboratory had a series of Muybridge photos. (See page 27.) We also know that Dickson used a "copying camera" in his kinetoscope work. (See page 71.) The photos used in the tachyscope may well have been the result of such a procedure: it is difficult to identify the Lenox Lyceum exhibition (see page 92) with photographs produced at the laboratory by means of a motion picture camera.

It is also relevant to draw attention to the fact that W. J. Hammer was quoted by George E. Nitzsche in *The General Magazine and Historical Chronicle*, Volume LIV, no. 1, published by the University of Pennsylvania, as saying that Edison used "Muybridge's motion photographs of running horses . . . [as] his first continuous movie on a strip film."

When I first read this sentence I was inclined to classify it as one of the more fanciful of pioneer "memories." But when I realized that the Muybridge photographs may well have been used in the tachyscope, that this tachyscope was probably the projection apparatus at the Lenox Lyceum exhibit, and that W. J. Hammer was personally in charge of arranging the apparatus for the exhibit, I began to regard it as illuminating.

Eugene Lauste also specifically remembers an Anschütz tachyscope in the 1889 photographic building: "It was here that he

one day saw a demonstration of the Tachyscope, the invention of Anschütz. This consisted of a series of successive photographs arranged in sequence around the margin . . ." (This quotation is from an unpublished biography of Lauste by Merritt Crawford, number 4051 in the Lauste Collection of the Smithsonian Institution.)

On Monday, February 10, 1890, Edison left for the South for the purpose of looking at ore-milling properties. On the Saturday before he left he had arranged with Hammer and De Frece what the Lenox Lyceum exhibit would consist of.[3] On February 13, 17, 21, 26 and March 1, 7, and 11 Tate sent reports of the laboratory work to him.[4] On the afternoon of March 18 Edison returned to the laboratory. During the time that he was away about half of Dickson's time had been charged to the kinetoscope account.[5]

Dickson, having built—or bought—a tachyscope probably not earlier than December 5, 1889 (see page 86), and eager to show progress with his work (an eagerness not so apparent in the Paris absence during which no such regular reports were filed), apparently did attain a projection like that he described in 1894 (page 19, *History of the Kinetograph Kinetoscope and Kineto-Phonograph*):

> The crowning point of realism was attained on the occasion of Mr. Edison's return from the Paris Exposition of 1889, when Mr. Dickson himself stepped out on the screen, raised his hat and smiled, while uttering the words of greeting "Good morning, Mr. Edison, glad to see you back. I hope you are satisfied with the kinetophonograph."

This occurred when Edison returned on March 18—if it occurred at all. Such a projection of a tachyscope series would

[3] W. J. Hammer was the man who had had charge of the Paris Exposition Exhibit and to whom Edison left the arrangements for the Lenox Lyceum Exhibit. (See also Dyer, Martin, and Meadowcroft, pages 224, 273, 336, and 417.) De Frece was the man at the Edison General Electric Company office at 44 Wall Street who acted as liaison between the Ladies Committee of the Women's Exchange, Villard, and Edison. He was "General Commissioner" of this exhibit. (Edison archives document files "Exhibitions. 1889.")

[4] These were reports of Fessenden, Atwood, John Ott, Aylesworth, and Dickson—all heads of departments at the laboratory. References to these reports are made in letter book E1717, 1/31/90–2/25/90, pages 300, 362, 439, 474 and letter book #1717, 2/25/90–3/22/90, pages 38, 96, 173, 216, and 244.

[5] The legal file cited in note 2, chapter 1 above. The particular reference here is to the item marked 2.15.

have been just as natural at this time as a zoopraxiscope projection was in the first years of the Muybridge work and before.

Dickson's own accounts of this post-Paris projection are tedious and confused. In an account written for Meadowcroft in 1928 he says:[6] "The subject of the film was: self entering thro' door advancing and speaking—'Welcome home again, hope you had a good time & now like the show—or something to this effect—raising and lowering my hands & counting one to ten at each gesture to prove synchronization."

For the first time since 1894, he adds sound synchronization. If there were no other difficulty, there is *great* difficulty in accommodating such a long action in any such length of film claimed by anyone for this time.[7] The phrase "counting one to ten *at each gesture*" (the italics are mine) may possibly be ascribed to carelessness. But when we also consider that the action includes "self coming thro' door advancing etc.," we are faced with almost insuperable problems of lighting, etc., in a kinetoscope experiment in which only a small area of intense light was ever used for illumination.

In 1928 Dickson sent another and slightly different account to Meadowcroft—this time conceding no possibility of poor memory:[8] "The subject for the occasion was self—entering through a door and speaking—"Welcome home again, glad to see you back again, and hope you like your kinetophone" raising and lowering my hands and counting one to ten at each gesture to prove its perfect synchronization."

In the 1933 article the account has expanded into a romance, with much new conversation "remembered" after the manner of old-timers with pioneering to prove:

> Mr. Edison's return to his laboratory took place October 6, 1889. Within the hour I had him by the arm and led him to the new studio and kinetophone exhibit, on which we had been working day and night. On seeing the studio, Mr. Edison asked, "What's that building?" I explained its necessity. "Well, you've got cheek; let's see what you've got." We went in. Gradually his face lit up, the clouds of disapproval were dis-

[6] The so-called "historical files" for this year, i.e., 1928, in the Edison archives.
[7] I have timed all of these versions of what happened and cannot fit this action into less than 15 to 20 seconds. Even at only 16 frames per second this would enforce a greater length on the film than we know was possible.
[8] The "historical files" cited above, note 6.

sipated and finally dispelled. I had placed him in a chair in the upper projecting room to witness his first "talkie," or exhibit, of the kinetophone. For a wonder, the exhibition was good. No breakdown of the film occurred nor did the Zeiss arc lamp sputter. There was much rejoicing. Edison sat with the eartubes to the phonograph. My assistant started the arc lamp and removed the metal sheet between the arc and the film. The phonograph motor controlled the projecting kinetograph.

I was seen to advance and address Mr. Edison from the small 4-foot screen: small, because of the restricted size of the room. I raised my hat, smiled, and said, "Good morning, Mr. Edison, glad to see you back. Hope you like the kinetophone. To show the synchronization I will lift my hand and count up to ten." I then raised and lowered my hands as I counted up to ten. There was no hitch, and a pretty steady picture. If the pictures were steady in the taking, why not in the reproduction on the screen?

It can be shown that (1) "Mr. Edison's return to his laboratory" did not occur on October 6, 1889 (see chap. 10 for local paper report), (2) the word "kinetophone" was not used for some years after the event described, and (3) neither Dickson nor anyone else worked "night and day" on the kinetoscope while Edison was in Paris (see pages 75, 80). The idea that the screen was *only* four feet large because the room was small is fanciful when we consider that any projection at all was to be wondered at.

(It is this sort of "remembering" by old-timers, and the addition of more and more detail, said with increasing certainty as the years go by, that obfuscates history. It is motivated by an impulse each of us knows well: the unwillingness of most of us—and particularly experts—to say "I do not know" or "I do not remember." We know that Dickson was largely responsible for the development of what is commonly known as "Edison" motion picture invention. How much simpler would have been the task of establishing Dickson's contribution if he had not tried to help! [see also Appendix C].)

We have seen that projection by the cylinder apparatus was not possible. We have noted also how the Dickson version of the Anschütz tachyscope was assigned to a period after the first cylinder experiments and before the introduction to the cylinder of a commercially manufactured celluloid-based film. We have also seen how this tachyscope was built (or, possibly

more likely, bought) probably not before December 5, 1889. How, then, since Edison came back to the laboratory on October 7, 1889, could projection by any means at all have occurred?

If there appears to be error in this reasoning, then let us consider the matter of the Lenox Lyceum projection, which is noted here for the first time since it occurred in 1890, and which must have been the first Edison-sponsored (although, like all other motion picture projections, not Edison-invented) public motion picture projection. It antedates the Latham projection by five years and the Jenkins' Vitascope projection at Koster and Bial's by six—each of which has been called the "first" many, many times.[9]

The Lenox Lyceum was the former Panoramic Building at the southeast corner of Madison Avenue and Fifty-ninth Street in New York City. In it Edison had arranged (through Henry Villard, a man he always wanted to please, but who later "betrayed" him by organizing the Edison General Electric Company and reducing a $250,000 annual income to $83,000 [10]) for the Edison Paris Exposition exhibit to be shown in New York for the benefit of the New York Exchange for Women's Work, in which Mrs. Villard was interested. These arrangements had been projected long before, had been completed just before Edison left for the South on February 10, and were now, with Edison's return, taking much attention at the laboratory.

This exhibit opened on the Monday after Easter, April 7, 1890. It was fully described in the *New York Herald*, April 7, 1890, the *Sun*, April 8, 1890, the *World*, April 8, 1890, and a number of weekly and monthly magazines.[11] But far the most significant for our story was the report of the correspondent

[9] For example, (1) Ramsaye, page 233, says it was the "true" introduction of the motion picture to Broadway; (2) Jacobs, *op. cit.*, page 3, says "the moving picture as we know it today was seen for the first time in America . . ."; (3) Iris Barry in a footnote to *The History of Motion Pictures* cited above, page 15; (4) Mayer and Griffith on page 3 of *The Movies* (New York: Simon & Schuster, 1957) say that it was the first public one under Edison's patronage.

[10] See *New York World* for May 17, 1888, for biographical sketch of Villard. The source of the Edison income information is a letter from Edison to Villard dated February 8, 1890. (Letter book E1717, 1/31/90–2/25/90, page 199.)

[11] For example, *Harper's Bazar*, May 10, 1890, and *Frank Leslie's Illustrated Newspaper*, May 3, 1890.

of the *Western Electrician,* published April 12, 1890: "The effects produced are indeed wonderful, and in splendor outrank anything ever seen in this country. *A magic lantern of almost unimaginable power casts upon the ceiling from the top of the tower such pictures as seem to be the actual performances of living persons.* From this tower . . . wide aisles stretch out . . ." [Italics supplied.] Here we have what was surely a tachyscope projection by Dickson.

Since an exhaustive search has discovered no other reference to this projection, and since the language of the remainder of the report makes it clear that this reporter was writing about something he had actually seen ("Every afternoon a special performance . . . is given"), we can assume that such a projection occurred probably Monday afternoon. Likely, it was a press preview, and in any case it would have had to occur early enough in the week for the *Western Electrician* man to mail his report to Chicago in time for the issue of the following Saturday. That it was not considered worthy for the public is indicated by the following sentence in the *New York Journal* of May 29, 1891: "It was intended to exhibit it [i.e., the kinetograph, etc.] at the display of electrical inventions at the Lenox Lyceum a year ago, but although the screen for the reproduction was even made, a hitch in the apparatus itself prevented it at the last moment." [12]

It is interesting to note also that *Wilson's Photographic Magazine* for March, 1890, had suggested a tachyscope projection: "With an arrangement like the electrical Tachyscope the little pictures might be projected in succession on the screen . . ."

12 · The Summer of 1890

WITH THE COMING OF THE SUMMER OF 1890, ACTIVITY AT THE laboratory diminished. The phonograph recording room had

[12] The Misses Devonald, daughters of Fred Devonald, the Edison storekeeper in those days, recall their mother making a screen for motion picture projection. This screen (if it can be accurately ascribed to this time) may have been the screen described by the *Journal.*

been closed since January 25 [1] and on April 26 chemical experiments were stopped.[2] Though Edison said on May 12 that he had "a hundred experimenters requiring close attention," the laboratory records reveal that this was rather a device to keep correspondents from bothering him and more of his usual exaggeration.[3] Beginning with July Dickson spent much of his time at Ogden at the new ore-milling works which was to take so much of Edison's time and temper for the next years: a project into which he was to keep pouring much of his own and his associates' money—with diminishing hopes, as the months and years passed, for recovery of these investments.

After the close of the first week in May, nothing was done on the kinetoscope work until the next fall, when the week ending October 16 records the reopening of this account. For April the charge was $401.44, and for May, $303.69.[4] The May entry substantiates further the nonkinetoscope character of most of these charges since, according to the Randolph time sheets cited above (page 32), work on the kinetoscope account was done only the first week of this month.

Dickson had been much preoccupied with ore-milling through the time following the beginning of the previous May, but now the Ogden business had started in earnest. We know that he was at Ogden on July 7, 12, 14, 23, 24; August 8, 25, 26, 27, 29, 30; September 1, 2, 3, 4, 5, 7, 10, 11, 12, 16, and 19. He engineered the installation of the ore-separators there and there is every indication that his judgment in this area was much respected by Edison.[5]

[1] Edison, in a letter of this date, wrote: "I have today closed my music room & discharged the staff lately employed there." (Letter book E1717, 1/11/90–1/31/90, page 335.)

[2] Edison archives document files "Edison Handwriting 1890."

[3] Laboratory records (document files, "Laboratory Payrolls, 1890") indicate that for the week ending February 6, 1890, there was a total of 84 men working at the laboratory. Of these 84 only 23 were listed as "Experimenters."

[4] Edison archives "Journal/No. 5/Laboratory/T. A. Edison/Orange, N. J.," pages 326 and 342.

[5] The reader is directed to the long series of letters from Dickson (at Ogden) to Edison (in West Orange and elsewhere) in the summer of 1890, and ending on September 16 with the note referred to herein on page 96. For example a letter of March 23, 1891, in which Edison in Ogden asks Dickson to come as soon as possible and bring a microscope (document files "Laboratory of T. A. Edison. W. K. L. Dickson. 1891"); a letter of June 25, 1891, in which he plays the part of a trouble-shooter for the works (letter book 4/23/91–7/31/91, page 625); also a June 27, 1891 letter (letter book E1717, 6/13/91–8/24/91, page 172).

On August 19, United States patent #434588 was issued: "T. A. Edison & W. K. L. Dickson Magnetic Ore Separator"— a patent which had been applied for the previous January 20. Edison also wanted patents taken out on "the invention referred to in the enclosed application of himself and Mr. W. K. L. Dickson in all Australasian countries, Spain, Canada, Chili [sic], Mexico and India." [6] We have seen earlier (see page 69) how Dickson had begun this work even before the West Orange laboratory was opened, and how he had continued it throughout the period since. And this with only sporadic let-ups— chiefly when Edison was not around. It was the ore-milling business that was closest to Edison's heart in these years. We may easily grant that the various phonograph improvements took his time and interest at intervals and that the electric light litigations also involved him frequently. But the phonograph work was largely predetermined by the necessity of making exactly such improvements as were dictated by competition, and the electric light litigation was largely paper work—which was not Edison's proper métier, although he showed a lustful perspicacity for law suits. (See pages 96–97.) The *Electrical Review* (British) of November 5, 1881, early discerned Edison's patent methods:

> . . . the young man who keeps the road to the Patent Office hot with his footsteps . . . His plan appears to be to patent all the ideas that occur to him, whether tried or untried, and to trust to future labors to select and combine those which prove themselves the fittest. The result is that the great bulk of his patents are valueless in point of practicability; but they serve to fence the ground in from other inventors.

The *Electrical Engineer* (U. S.) of February, 1888, on the occasion of Edison's attacking the patent law:

> The unthinking and unintelligent members of the body politic who are clamoring for the overthrow of our patent law . . . have received a notable recruit to their ranks in the person of one of the principal beneficiaries of the system which it is proposed to destroy . . .
> An old proverb bids one to speak well of the boat that has carried one safely across the stream. It was not many years ago since Mr. Edison was earning, by diligence and industry, a modest stipend of some three dollars per diem as a telegraph

[6] Letter book E1717, 1/11/90–1/31/90, page 110.

94

operator . . . Today he occupies the finest estate in the vicinity of the metropolis, and if he is not twice a millionaire [at this time he was actually five times a millionaire], it can be for no other reason than that like too many of the rest of us, he has found it less easy to keep money than to get it . . . had it not been for the patent law, which he now decries, Mr. Edison would . . . be "pounding the brass" [i.e., operating a telegraph key] . . . at this moment, although it is doubtful if, in the absence of inventions, which the patent law has fostered, anybody could afford to pay him more than $1.25 per day . . .

The ore-milling business started with the development of the apparatus from the beginning, the setting-up of the business organization and, what Edison most liked, the application of the newly developed apparatus to manufacturing on a commercial scale.[7]

The installation at Ogden was enormous. It involved the construction of many large buildings, the excavation of much difficult land, and the management of strenuous means of transportation.[8] Before he was through, Edison was to invest $2,000,000 of his own and his employees' money in this project (see Dyer, Martin and Meadowcroft, p. 504): a project which returned to him only such pleasure as he took in the work, caused much strife between him and many of his valuable workers, and probably established the climate for his rift with Dickson.

The ore-milling patent was the result of a joint effort by Dickson and Edison. It is difficult to assess how much should be credited to each man. If we may judge from the Dickson notebooks and the fact that Edison rarely permitted joint patent applications for work which was even entirely and only the

[7] On October 14, 1887, a preliminary agreement to develop the apparatus was signed (letter book E1717, 2/25/90–3/22/90, page 170). A statement dated January 2, 1890, of the "Edison Ore-Milling Company Limited" records a general account as of this date of $21,310.90 (*ibid., loc. cit.*). I say "developed" because I have not made a study of the ore-milling patents issued in Edison's name. How much was invention and how much adaptation of the work of other men, I do not know. I know that Dickson, according to his notebook, appeared to have started from the bottom in his work (see page 69 *et seq.*), but I do not know how much of this "bottom" was based upon work that had gone before.

[8] This matter is discussed in Dyer, Martin and Meadowcroft, in their chapter beginning on page 473. The reader is referred to this—although it must be remarked again (see page 67) that these writers contradicted the facts when they failed even to *mention* Dickson's important role in this work.

result of the work of his employees, Dickson had more to do with this development than Edison. (At a later time Edison denied that Dickson had *anything* to do with this patent—which we know is absurd.[9])

After September 1, when he returned from a visit to Schenectady, Edison shuttled back and forth between Ogden and West Orange.[10] On September 16, Dickson's work at Ogden seems to have been completed: ". . . a grand success. No. 1—72.4!!!" [11]

By the first of October Dickson had returned to the laboratory to stay and Edison himself appeared to have felt that fewer visits to Ogden were needed. On or about the first of October Edison found time to take a long, searching look at his patents and patent applications and instruct his attorneys as to a long list of proposals: "Get it out," "Is this infringed," "I think it is infringed," etc.[12] Since his attorneys were on a substantial retainer he did not need to restrain himself in suggesting actions which otherwise he would have hesitated to initiate—since many of the actions which were taken do not appear justifiable. Thus his attorney, Maj. S. B. Eaton, wrote to him on October 2, 1891: "As a lawyer, I cannot say that he may safely do this; but he, as a business man, may conclude to do it and take his chances." (Document files "Legal Correspondence, 1892"—sic.) And again, on March 4, 1892: "It is probable that if competent experts were to carefully look into all of our pending applications for patents, it would be found that some are not worth the money they are costing." (*ibid.*) (Major S. B. Eaton, according to Dyer, Martin and Meadowcroft, pages 364 and 365, was "the leading member of a very prominent law firm in New York" and also president of the Edison Electric Company.)

[9] In a letter dated February 5, 1895 (letter book E1717, 4/13/94–8/27/95, page 413), Edison says: ". . . there is no co-invention in the Ogden business with Dickson or anybody else." The United States Patent Office, for one, disagrees—see U. S. #434588. *The Electrical Engineer* of September 3, 1890, described the apparatus in an article entitled "The Edison-Dickson Magnetic Ore Separator," and said: ". . . Mr. Edison, in connection with Mr. Wm. K. L. Dickson, has designed the ore-separator . . ."

[10] As of August 26, Edison was in Schenectady. A letter from Edison to Insull dated May 21, 1891, suggests that during this visit he first examined Harry Marvin's electric rock drill (U. S. #395575) which he planned to market and call his own. (Letter book E1717, 4/14/91–6/13/91, page 425.)

[11] Document files, "Ore Milling, W. K. L. Dickson, 1890." The "72.4" is apparently the percentage of pure ore achieved by the separator.

[12] Letter book E1717, 9/10/90–10/20/90, page 247.

There is also a letter of January 24, 1890 (letter book E1717, 1/11/90–1/31/90) and a letter from Dyer and Seely of December 29, 1890 (document files "Patent Correspondence, 1890"), in which they said that Edison was wrong to think that "A prejudice exists against [him] in the Patent Office, or that [he] has not been effectively represented in [his] electric light interferences." To this Edison replied on December 31 (same source): "I again remark that when the issue is of any *value* I get beaten of course I get justice where there is nothing gained by deciding against me." In a letter written on June 21, 1891, Edison again wrote: "I have 500 patents not one was ever sustained. Law expenses $600,000. Patents have ceased to give any protection in this country. It's cheaper to steal them." On June 20, 1893, he told a correspondent that "My Patent Office business hereafter wouldn't pay your office boy's salary. I'm through with patents." (Document files: "T. A. E. personal.")

That Dickson was well regarded at the laboratory at this time appears certain. He was called "Mr. Edison's chief assistant in the metallurgical department" when the "metallurgical department" was the principal activity and interest at the laboratory. He had been more than once previously called head of the ore-milling department.[13] He was also highly regarded for what we would call today his public relations ability— particularly when these public relations required finesse. When the 500 members of the Iron and Steel Manufacturers Institute took a special train and visited the laboratory on October 3 of this year they were met at the station by Dickson and escorted through the establishment. This was easily the largest as well as the most important group of visitors the laboratory had in the years covered by this study.[14]

Experiments at the laboratory were at such a leisurely pace on October 6 that on that day Edison, having agreed to collaborate with George Parsons Lathrop on what we would today call a "science-fiction" novel, made many pages of notes therefor. The construction and installations at Ogden had been made.

[13] For example, in a letter dated February 9, 1889, A. O. Tate writes: "Mr. Dickson, in addition to his work as Laboratory Photographer, runs our ore-milling department . . ." This is from letter book E1717, 1/30/89–4/8/89, page 148. See also the *East Orange Gazette* of October 8, 1890.
[14] See *East Orange Gazette, loc. cit.*, the *Electrical Engineer* of October 8, 1890, and *Frank Leslie's Weekly* of October 18, 1890.

It now remained to hire a force of men and commence operations—a task, according to laboratory records, with which neither Edison nor Dickson was immediately concerned.

George Parsons Lathrop, who had written a *New York World* article of May 12, 1888, describing Edison's new phonograph, and who will enter this history again as the author of a *Harper's Weekly* article of June 13, 1891, was a prominent late-nineteenth-century writer and the son-in-law of Nathaniel Hawthorne. "His prose style is strong, nervous and careful, possessing a directness that is pleasing in this period of bewildering rhetoric." [15] (This is an estimate those of us unsteeped in "this period of bewildering rhetoric" will have trouble justifying.)

Although Lathrop apparently made a good start on this work, it was never published. Lathrop wrote on August 10, 1891 (document files "George Parsons Lathrop 1891") that he must see Edison on September 1 or give up the project of collaboration. That he did not see Edison on September 1 is clear from a November 18, 1891, note from Edison (*loc. cit.*): "I am still at Ogden cannot set date yet." Lathrop had been trying to get these ideas from Edison for some time, but only now did Edison feel that he had the time for such frivolity. That he felt this is a measure of the great pressure that had been felt all summer apropos ore-milling, and the correspondingly great relief when the initial stage of planning and installation at Ogden had ended.

In several pages of notes which Edison made for the Lathrop-Edison novel there are several that interest us: (these are from the document files, "Edison. Personal. Lathrop Science Fiction Book")

> Photography of the bottom of the sea[16]
> Photographs were taken of objects in absolute darkness by means of radiant heat being those rays beyond the red end of the visible spectrum small lenses of Rock salt being used in the camera. The plate is sensitized by ———[17] Radiant light

[15] The *National Cyclopedia of American Biography*, Vol. IX, page 193.
[16] This was, of course, not a new idea. The Frenchmen Bonfante and Massoneuve, for example, had been using incandescent light to photograph sunken vessels on the floor of the sea for some time. (*Anthony's Photographic Bulletin*, April 23, 1887.)
[17] This space was left blank to be filled in later. A small note here is undecipherable but is clearly a note of the source where Edison expects to get

reflected from an object produces more or less decomposition of a silver salt . .

Kinetoscope operas with phono every family wealth

Photography colors

Photography of surface sun by iron salts in an alternating field.

Phono publishing houses kept star cos of actors & stage and produced for family use Kinetographic phonograms of whole Dramas and Operas. No theatres with actors in vogue.

Although insofar as motion pictures are concerned Edison's predictions for fiction differ little from his claims for reality (see page 104) we may perhaps excuse these ideas because they are presented as fiction. But his claims for motion picture *accomplishment* must be ascribed to what was often recognized in those days as Edison's passionate love of sensational publicity.[18]

13 · The Fall of 1890

FOR THE WEEK ENDING OCTOBER 16, 1890, THE EDISON ACCOUNT books show the first charge to the kinetoscope account since the first week of the previous May. Dickson is said to have spent, in these three weeks in October, one-half week, one-fourth week, and one-fourth week respectively on the kinetoscope account.[1] At this time and until the week ending November 6 his only helper in this work was William Heise, listed in the laboratory records as a machinist.[2] So when we find in the

this information. Again we have indication of a man unversed in the chemistry of photography. (See discussion of Motion Picture Caveat I on page 14.)

[18] As *The Independent* of October 22, 1891, said: "[He] cannot be at work on any new application of electricity without having it announced that he has invented something that will revolutionize industry . . ." *The Electrical Engineer* (U. S.) said on November 18, 1891: "Mr. Edison today is unfortunately just as free and unconfined in the expression of his hopes and beliefs and opinions as when he was a humble operator; and he is just as fond of turning over in his mind all sorts of extraordinary projects as the day when he made his first invention." See also pages 18 and 104.

[1] The private legal file cited in note 2, chapter 1, *q.v.* The particular reference here is to the item marked 2.15.

[2] This is the man who was Dickson's right hand during the 1894 Black Maria production season. He appears, probably, in negative #6570 as the third person from the right; in the well-known July 31, 1893, group of laboratory

private legal file (see note 2, chap. 1)—private because it contains information not used by Edison's attorneys since the introduction of much of its contents would have served to prejudice their case—the following note, we at once recognize it as one of the most specific and significant in all this chronology:

"Note: Job 462 Kinetoscope began Nov. '0."

It can be shown that Job 462 could not have begun until comfortably after September 1.[3] For the ensuing weeks the legal file shows the following charges to the kinetoscope account:

week ending	Nov.	6	mch.	5.65
"	"	"	Dickson	15.00
"	"	" 20	Heise	12.89
"	"	"	Dickson	7.50
"	"	" 27	Heise	16.52
"	"	"	G. Sacco Albanese	1.50
"	"	"	Dickson	10.00
"	"	Dec. 4	Heise	5.63
"	"	" 11	Heise	13.65
"	"	" 18	Heise	11.21
"	"	" 25	Heise	15.54
"	"	Jan. 1/91	Heise	10.18
"	"	"	H. Campbell	.60

This list of workers contains one very interesting name, that of G. Sacco Albanese. In his 1933 article for the *Journal of the SMPE,* Dickson writes:

> To take these photographs or strips, our camera or kinetograph had to be carried down[4] to a small improvised platform placed

workers opposite page 284 in the Dicksons' biography of Edison he is the man immediately behind Dickson's left shoulder; and he is obviously the man at the camera in the famous Outcault and Meeker drawings of the Maria interior. (*The Electrical World,* June 16, 1894, and the *Century Magazine,* June 1894.)

[3] See also file cited in note 1, above, the item marked 2.11. This is the date of the first Eastman film receipt since the six rolls received on December 4, 1889, which Dickson used in his astronomical experiment or in his tachyscope work. (These data are from the Eastman Company, and by courtesy of Mr. Wyatt Brummitt.) But since the laboratory receiving books record no such material—as they also do not record a similar shipment on March 12—it is possible that these were sent to Dickson's home.

[4] Dickson's use of the work "down" here suggests what I have often felt, namely that the so-called "photograph building," built while Edison was in Paris, was soon preëmpted for ore-milling work, and much of the kinetoscope work even after this building was completed was still carried on in the photographic room of the main laboratory building. An excellent tax map in the

against our ore-milling outhouse.[5] A bright sunny-natured Greek [actually Maltese], Sacco Albanese by name, was one of my very earliest victims, figuring mostly in the $\frac{1}{4}$ inch and later in the $\frac{1}{2}$ inch, pictures. Draped in white, he was made to go through some weird antics. (See Fig. 4.)

In my search through laboratory records I found the following letter, dated February 18, 1890: (Letter book E1717, 1/31/90–2/25/90, p. 388.)

Mr. G. Sacco Albanese
Fitter Apprentice
HM's Dockyard
Malta
Dear Sir:
In reply to your letter under date 15th January, Mr. Edison regrets that there is no position at present vacant in his Laboratory to which you could be appointed. Your application has been filed for future reference.

But on September 5 of the same year we find a letter from a Vincenzo Sacco in which Edison is thanked for employing his son—proving that as of that date the man whom Dickson identified was nevertheless at work at the laboratory. (Document files. "Lab. personnel. 1890")

Albanese's first work with Dickson on the kinetoscope,[6] however, was in the week ending November 27, according to the time sheets in the private legal file noted above. This gives us a first possible date for the cylinder photographs described by

Orange Free Public Library seems to corroborate this. (See note 4, chap. 9.)
[5] The reader may identify this "Ore-Milling Outhouse" with either of two buildings: (1) The one referred to in the Edison accounts "General Ledger/No. 5/January '88–June '90" page 796 as "Ore Milling Building" and built in January–March of 1889 at a cost of $982.66; or (2) Building 4, the easternmost of the one-story laboratory brick buildings referred to by Dickson as the "Ore Milling Outhouse" in document files "Edison Ore Milling Co. 1888. Dickson, W. K. L." In the same reference Dickson refers to "Room 22" as being that part of the "Ore Milling Outhouse" which had received the changes that were the purpose of this notation. He also speaks of having bolted and fastened the door between this "Room 22" and the laboratory blacksmith shop. These facts, taken in conjunction with the night watchman's list of January 24, 1888, in which Room 22 is called the "Metallurgical Room" must lead us to the conclusion that so far as Dickson was concerned as of November 24, 1888, the "Ore Milling Outhouse" was that part of the easternmost of the laboratory one-storied buildings closest to the main laboratory building.
[6] His last work was eight months later. The Edison archives show (letter book 2/27/91–4/14/91, page 369) that he was given a reference then because he was leaving the Edison employ. We thus have a first and last date for these "Monkeyshines."

Dickson. If we accept Dickson's identification of the subject of this "Monkeyshines" film, and our own virtual certainty that what remains with us (whether or not it is of Albanese) is *not* a motion picture of Fred Ott, then we must conclude that as of November 27, 1890, cylinder apparatus was still in use at the laboratory. To believe that this work continued after the introduction of the strip-feeding mechanism is stretching our credulity. It is unlikely that a strip-feeding mechanism of any sort was achieved until May, 1891, when Edison, not a man to let a new sensation lie fallow, pulled it out of Dickson's hat. (See page 111.)

For the first month of the new year the Edison account books show $212.81 charged to the kinetoscope account; for February $286.88; for March, $514.87; for April, $303.19; for May $227.03; for June, $494.48; for July, $493.00.[7] Although we feel certain that the "hidden" policy was continued with the kinetoscope account during these months (cf. p. 32), we nevertheless know that some work was done on this account in these months, since the private legal file shows various vouchers:[8]

Jan.	91	E.P.W. [i.e., Edison Phonograph Works]	42 sundries
Jan.	91	N.Y.C.L. Co. [i.e., New York Calcium Light Company]	92 gas
Febry	91	E.P.W.	178 sundries
Mch.	91	Lamp Works	277 sundries
"		E.P.W.	280 sundries
May	91	E.P.W.	480 sundries
"		Lamp Works	491 sundries
June	91	E.P.W.	556 sundries
"	91	Eimer and Amend [a chemical firm]	557 sundries
"		J. N. Lindsley	584 sundries
July	91		629 express
"		McNab and H. Mfg. Co.	670 piping and
"			696 telegrams
"		Yale and T. Mfg.	702 locks

On March 18, the only film possibly suitable for kinetoscope work in these first six months of 1891 was bought from a firm called Merwin Hulbert. (Letter book 1/30/92–8/31/92, page

[7] "Journal/No. 6/Laboratory/T. A. Edison/Orange, N. J.," in the Edison archives in West Orange. Pages 118, 123, 130, 131, 140, 148, 149, 150, 167, 175, 177, 180, 189, 192, 199 and 203.

[8] File cited in note 1 above. The item here is marked 2.10.

32.) The price of $4.25 is appropriate for a 50′ length of coated celluloid of the #2 Kodak size. Trow's 1894 Directory lists a "Hulbert Brothers and Company, phot. materials" at 26 West Twenty-third Street, doubtless the same firm. Quite possibly Dickson was trying out another manufacturer's film, made exposures, sent them to the Eastman Company for processing, and charged the expense to the kinetoscope account. (See also page 124.) Although Blair & Co. film was not regularly supplied to the laboratory until consistent subject production got under way two years later, there is much to suggest that this may have been Dickson's first use of Blair film. According to the Edison memory, in answer to question 139 in the case cited—given credence here because it is irrelevant to an ulterior purpose— Blair film was used in the *early* stages of motion picture work. According to Dickson also, in his 1933 article, Blair film was used in these early stages. Blair & Co. were at this time beginning to produce such film *for the first time,* according to *American Amateur Photographer* for May, 1891 and June, 1891. (See also *Anthony's Photographic Bulletin* of April 11, 1891.) Dickson, seeking constantly the latest and best film, would surely have wanted to try this new manufacturer's product: the Eastman film, he wrote in the 1933 article, was quite unsatisfactory.

Dickson spent a considerable amount of time at Ogden during these months, where the ore-milling works had started up on about February 10.[9] As of March 26, 29, 30, and April 11 we know he was there.[10] During much of the rest of the time he was preoccupied with ore analysis and similar matters.

14 · *The First Press Stories*

IN MAY, BEGINNING WITH PUBLICATION OF THE *World's Columbian Exposition Illustrated* for that month, a flurry of activity

[9] A letter written January 9 says "Ogden will not start until about Feb. 10." This was from letter book E1717, 12/5/90–1/20/91, page 376. In a note written the previous December 20, Edison said it would be opened "in two months." (Document files, "Ore Milling Ogden, N. J. 1890.")

[10] Document files "Edison, Thos. A. Personal, 1891," and letter book E1717, 3/31/91–8/31/91, page 114.

commenced. This report began a mass of exaggerated publicity concerning Edison's "latest" and confused photography with telephotos or television. That Edison was hard put to produce a "latest" is obvious from the strained quality of these reports. He was so preoccupied with ore-milling that he was forced to scrape the bottom of the barrel to satisfy a public that was accustomed to getting new sensations from him as regularly as they would put a nickel in a slot.

> I hope to be able by the invention to throw upon a canvas a perfect picture of anybody, and reproduce his words. Thus, should Patti be singing somewhere, this invention will put her full length picture upon the canvas so perfectly as to enable one to distinguish every feature and expression of her face, see all her actions and listen to the entrancing melody of her peerless voice . . . I have already perfected the invention so far as to be able to picture a prize fight—the two men, the ring, the intensely interested faces of those surrounding it— and you can hear the sound of the blows—And when this invention shall have been perfected . . . a man will be able to sit in his library at home, and, having electrical connection with the theatre, see reproduced on his wall or a piece of canvas the actors, and hear anything they say.

As early as 1879, the *Punch Almanac* had described Edison's "telephonoscope." On July 6, 1889, Insull had squelched another notice, ascribing such reports to "the fertile imagination of some newspaper correspondents." [1] And as recently as April 22, 1891, in a letter to a man in Belgium, a correspondent was told that newspaper accounts apropos a "far-sight" machine were inaccurate.[2] Previously, on October 19, 1899, Edison was quoted in the *Scientific American* as saying: "I am studying on a device for a telephone, so that you can see the man you are talking to." This of course is an instantaneously transmitting apparatus, and bears no relation to such *recording* of life as is the function of photography. The confusion was still apparent in the *New York Times* of May 13, whose report was repeated in the *Electrical Engineer* (U. S.) of May 20 and in the *Photographic Times* of May 22:

> Thomas A. Edison [was] asked [says the *N. Y. Times* report from Chicago] if he had an electrical novelty in store for the

[1] Document file "Motion Pictures. 1889"
[2] Edison archives letter book E1717, 4/14/91–6/13/91, page 113.

104

Columbian Exposition, he said: Well, I have a thing in view, but the details are somewhat hazy. My intention is to have such a happy combination of photography and electricity that a man can sit in his own parlour and see depicted upon a curtain the forms of the players in opera upon a distant stage, and hear the voices of the singers. When the system is perfected, which will be in time for the fair, each little muscle of the singer's face will be seen to work, every color of his or her attire will be exactly reproduced, and the stride and positions will be as natural as and very like, those of the live characters. [The *Times* report ends here.] To the sporting fraternity I will state that ere long this system can be applied to prize fights. The whole scene, with the noise of the blows, talk, etc., will be truthfully transferred. Arrangements can be made to send views of the mill [i.e., the fight] a la stock and race ticker.

It will be seen at once that the substance of this report, although similar, is somewhat embellished over that of the *World's Columbian Exposition Illustrated* of May. We now have color photography added—a fanciful concept in 1893 and for many years thereafter. Again, the arrangement described involves not only the *recording* of impressions by the photographic medium but also the instantaneous *transmission* of such by a television-like apparatus. Such an apparatus was only fiction for many years to come.

On May 23 the *Western Electrician* reported on this same fancy:

The distinguished visitor told the reporters that he was working on a new electrical invention to be known as the kinetograph. It appears to be a device for reproducing photographs of moving objects on a screen at a distance from the scene portrayed at the time the scene is transpiring or at a later date. Mr. Edison is reported as having given this description: . . . It will register the looks and gestures of any person and then reproduce them at any future time and place . . . One that I have now in my laboratory reproduces the scene of a prize fight, and shows every blow and motion . . .

Here, however, the reporter places his finger on two crucial points: (1) "It appears to be a device for reproducing photographs . . . at the time the event is transpiring or at a later time," and (2) "Mr. Edison is reported as having given this description."

Such a device as would photograph an event could not, we

know, reproduce it "at the time the event is transpiring." And any nonphotographic device that would accomplish this end was far ahead of science in 1891. The reporter, with the objectivity we might expect from a technical publication, clearly identified the comment as a press release.

On May 20, the *Electrical Engineer* (U. S.) has something to add. After quoting verbatim the *Times* dispatch the writer goes on to say:

> Speaking of this the other day in Brooklyn, Mr. Edison said: "I make forty-six photographs a second on a moving sheet and by exhibiting this sheet moving at the same speed the scene is reproduced. I had a man sing into the phonograph the other day and I photographed him by this process as he was singing. Then I gave a concert. The phonograph reproduced the singing and the kinetograph reproduced all his motions and gesticulations."

This report shows that between the time Edison returned from Chicago on May 18 and "the other day in Brooklyn"[3] he was thinking for the first time in terms of his famous 46-per-second rate. Although he had already (in Motion Picture Caveat IV) decided upon a theoretical proportion between the periods of rest and of movement of $\frac{9}{10}$ to $\frac{1}{10}$, this is the first time he expressed himself on the 46-per-second rate of taking the photographs.

If we will look at the patent application with its specifications signed on July 31, 1891, and in preparation by the previous June 16 (see note 24, chap. 17), we will find this 46-per-second rate stipulated: "and said forward movement is made to take place thirty or more times per second, preferably *at least as high* [the italics are mine] as forty-six times per second." This 46-per-second rate is not claimed as invention, but intervals of less than $\frac{1}{30}$ of a second *are:* "4. The method of producing an impression as of a moving object by means of photographs, which consists in taking photographs of a moving object at intervals of less than one thirtieth of a second . . ."

[3] Considering the editorial deadline of a weekly dated May 20, the fact that neither the *Brooklyn Eagle* nor the *Brooklyn Times* for any of these days carried any such reports, and the fact that Edison returned from Chicago on May 18, the phrase "the other day in Brooklyn" must have been more of Pooh-Bah's "corroborative detail."

As C. Francis Jenkins remarked some time later: (The *Photographic Times*, July, 1898)

> These picture ribbons "are passed before the eye at the rate of forty-six pictures per second," presumably to commemorate the number of years which had passed over the head of the inventor [Edison was born in 1847: at the time of the patent application he was 44 years of age. Jenkins was undoubtedly thinking in terms of the date of the patent *issue*, 1893], as there would seem to be no other good reason for it.

Indeed, there would seem to be no good reason for it. This rate was far above any rate necessary for gaining the benefits of persistence of vision, and far beyond the rates previously indicated:

> Caveat I, 25 per second
> Caveat II, 15 or 20 times per second
> Caveat III, 15 per second
> Caveat IV, 10 times per second.
> *Herald* 2/1/90 report, 8 to 20 per second.

It is also possible that the rate was lifted bodily from Helmholtz, Edison's particular idol, who said in his *Physics:* "Using a disk with black and white sectors all of the same width and illuminated by the strongest lamplight, the author finds that the transit of black does not take more than about one forty-eighth of a second for all flicker to cease . . ." We must not fail to recognize the significance of the word "about," and indeed both a 47-per-second rate and a 48-per-second rate were claimed for Edison.[4] Josephson (page 386), relying on unspecified sources, says that this rate was settled upon in 1889, with the building then (he says) of the 1891 machine. We know, however, that up to the end of 1889 the $\frac{1}{10}$ to $\frac{9}{10}$ proportion was the only rate yet determined. (See discussion of Motion Picture Caveat IV on page 81.)

If we consider the kinetoscope apparatus in operation not later than May 20 (see page 111), with which Dickson logically would have made his trials of such rates if he made any at all,[5]

[4] *The World's Columbian Exposition Illustrated*, for example, had said 47 per second.

[5] I believe we can assume that all the information for the patents was sent to the Edison attorneys by Dickson since Edison had little time for anything but ore-milling and knew little about photography; more than one reference

we realize that two arrangements of the revolving shutter are suggested at this time. First, in the patent application, "This shutter has one or more openings—near its edge," and second in the *Harper's* article of June 13 "Now in the circular shutter there are four openings . . ."

If we are to assume that 46 of these pictures must be presented to the eye each second (many statements establish that they are to be shown at the same rate at which they are taken—the kinetoscope application, for example, says: "with a speed sufficient to bring the opening centrally over a picture at intervals practically equal to the intervals between exposures in taking the pictures . . .") then we must assume that in the case of a 4-opening shutter something over 11 revolutions per second of this shutter would be necessary. And in the case of a single-opening shutter, 46 per second. It is the single-opening shutter that was used by Edison. All known mechanisms show only one opening, including the apparatus which was later photographed and used in connection with the reopening of the camera case in the Patent Office in December of 1896.[6] This is the apparatus illustrated opposite page 65 of Ramsaye, where it is called "Kinetoscope No. 1," despite the fact that everyone concerned called the earlier cylinder apparatus "kinetoscopes." Even if we are to assume that Ramsaye, by "Kinetoscope No. 1" means "Floor model No. 1" we may still disagree with him. (See page 109.)

Ramsaye (page 73) has also said [his italics]: *"It is provable that there is not now and never has been subsequent to the year 1888 any motion picture film machine whatsoever of any relation to the screen art of today that is not descended by traceable steps from the Kinetoscope."* In spite of this hyperbole, we do not feel inclined to include the "subsequent to 1888" work of Marey, Friese-Greene, Demeney, Rudge, Mortimer Evans, etc., among these steps which Ramsaye so enthusiastically finds "traceable . . . from the Kinetoscope." As for the

in the Edison archives specifically indicates that the technical material for the patent applications was supplied by Dickson. (See page 129.) I speak here of "the kinetoscope apparatus" as being the box-like structure about three and one-half feet high as distinct from any small table model cylinder machine, such as was called a "kinetoscope" in the laboratory up to at least late in 1890.

[6] See the file wrapper of the application in the Industrial Records Division of the National Archives in Washington.

italics, and for Ramsaye's Edison partisanship, it may be appropriate here to quote from Burlingame (*Engines of Democracy.* New York: Scribner's, 1940) that it is nevertheless true that [Burlingame's italics]: "... *no basic part of the kinetoscope was original with Edison and that the reason the screen art of today derives so much from it is that Edison by his patents was able to dominate the whole American industry in its infancy.*"

In any event this mechanism was evidently brought forward in 1896 (see page 108) and then dated as 1889. It appears to have been at least partially manufactured for purposes of the litigation which began at the later date. The clean, new-looking wood shown in a photograph in the legal record (see page 426 of Complainant's Record, Equity 6928) does not accord with what would have been a necessary age of eleven years: eleven years, moreover, of what would certainly have been very careless handling—even putting aside (which we cannot do) the extreme unlikelihood of the apparatus having endured intact for all these years in a place such as the Edison laboratory, where it was common practice to dismantle apparatus freely as soon as it had served its purpose. This "1889" kinetoscope would have served its purpose as soon as the "new model" of 1892 had been built. (See page 139.)

It is also obvious that the peep-hole device of the 1896 photograph has a hole in its top considerably larger than the "inch in diameter" of the *Sun* account or the "size of a silver dollar" of the *Herald* account. The *Sun* reporter saw a lens; the *Harper's Weekly* reporter described one but apparently did not see one. Furthermore, we cannot credit Edison's remark (see below) that a lens was once here but was now missing, since the *Sun* reporter said the lens was fitted *into* this "inch in diameter" hole, and the chiseled opening of the 1896 photograph shows no sign of such a fitting.

The matter of sprockets is also very interesting and illuminating. As the *Scientific American* reporter said: "This feature is of vital importance, for the holes must move the film with such regularity as to make each separate impression when reproduced coincide exactly . . . with the position and expression . . ." What the *Sun* and *Herald* reporters saw could only have been accomplished without sprockets if there had also

been no shutter. Both shutter and sprockets were described in the *Harper's Weekly* and *Scientific American* articles, and both were described in the patent application. However, neither of these reporters indicates that he has actually seen the machine with the shutter and sprockets he describes. The *Scientific American* reporter,· as a matter of fact, fails to mention the kinetoscope at all, and refers only to the entirely theoretical projection machine.

The patent application states that "The means for advancing the film and for operating the shutter to expose the pictures may be the same in all particulars as in the apparatus for taking pictures. . . ." This is on page 4, line 8 of the original application now in the Archives. We must therefore assume these means to be sprockets and synchronized shutter, since these were described in the other application.

Therefore, since no sprockets are shown in the alleged "1889" kinetoscope produced in 1896 for the reopening of the patent application, and a shutter *is* shown; and since a shutter could not have been used without sprockets, we must assume that the apparatus shown in this photograph could not have operated to exhibit pictures. To argue that the old sprockets were merely missing from the machine is impossible since Edison himself said that except for "the lamp for giving the light, and the lenses" it was intact. (This inoperability, which must have been obvious to the Mutoscope Company lawyers at the time, was not attacked, since the kinetoscope patent was not in issue.) And since it could not have been operated to exhibit pictures, it could not possibly have been the apparatus of either "1889" or of 1891.

It was, we know, a practice of the Edison forces to manufacture evidence as the need arose. In a later suit, Equity 8289, U. S. Circuit Court, Southern District of New York, a witness for Edison produced a camera which was designated by the Edison attorneys as the "complainant's exhibit Old Edison Camera of the Patent in Suit." The Edison witness testified that it was on this camera that a number of the 1894 motion picture subjects were shot. Yet the Edison correspondence of the time shows that a camera was being built for purposes of the law suit (see page 189). And in the margin of the record at present in the Engineering Societies Library in New York there is a

notation by Edison's attorney, J. Edgar Bull: ". . . film on reconstructed old camera." It is clearly this reconstructed camera which is now in the collection of the Ford Museum in Dearborn, Michigan.

No serious student however, in either the case of the Ford Museum "Black Maria" camera (parts of which, at least, were not yet in existence when the "Maria" was torn down) or the "1889" kinetoscope, would take the position that both were entirely spurious. We have shown that much of what was alleged to be original was not; it is therefore tempting to dismiss the whole apparatus. But there is no reason to think, in spite of the literally incredible testimony in the law suits, that such items as the alum-water tank or the shutter or the spools of the kinetoscope, or the heavy iron baseplate of the camera (as Mr. Spieden of the West Orange staff has said) are not original parts. Our purpose here is only to examine the claims made for the machines, and to show the way Edison wrested the law to his purpose.

15 · The Kinetoscope's Public Debut

ON THE AFTERNOON OF MAY 20, THE DELEGATES OF THE CONVENtion of the National Federation of Women's Clubs, having been entertained by Mrs. Edison with an elaborate lunch at the Edison home, "Glenmont," visited the laboratory just down the hill, and saw the kinetoscope in what was, so far as we know, its public premiere. As the *Orange Chronicle* of May 23, 1891, said:

> . . . after the close of the entertainment a large number of the ladies were, by special invitation, driven down to the laboratory, where Mr. Edison himself was present and exhibited to them the kinetoscope, the new invention that he is about perfecting, by which the gestures of a speaker are accurately reproduced, while the spoken or sung words are reproduced by the phonograph.

111

The Phonogram of May, 1891, reported this event as follows:

> The first exhibition of this latest discovery was given before the Convention of Women's Clubs of America—147 members were present.
>
> They saw, through an aperture in a pine box standing on the floor, the picture of a man. It bowed and smiled, and took off its hat naturally and gracefully . . .

Although its edition of May 22, which recorded the luncheon at "Glenmont," failed to mention the visit to the laboratory (as did both the *Herald* of May 22 and the *World* of the same date) on May 28 the *Sun* reported the laboratory visit as follows:

> A little while ago there was a great convention of the women's clubs of America. Mrs. Edison is interested in women's clubs and their work and she decided to entertain the Presidents of the various clubs at the Convention. Edison entered into the plan and when 147 club women visited his workshop he showed them the working model of his new kinetograph, for that is the name he had given to the most wonderful of all his wonderful inventions.
>
> The surprised and pleased clubwomen saw a small pine box standing on the floor. There were some wheels and belts near the box, and a workman who had them in charge. In the top of the box was a hole perhaps an inch in diameter. As they looked through this hole they saw the picture of a man. It was a most marvelous picture. It bowed and smiled and waved its hands and took off its hat with the most perfect naturalness and grace. Every motion was perfect. No wonder Edison chuckled with the effect he produced with his Kinetograph.

What was seen by these ladies was the only such device in existence; claims for a television-telephoto-photographic device were self-contradictory and obviously described an apparatus that did not exist. (Josephson, incidentally, page 391, calls "the first vague newspaper accounts" those of the *Sun* of June 3— where no mention whatever is made of any of this matter— and *Harper's Weekly* of June 13, which in the generally accepted sense of the word, is scarcely a "newspaper.")

The next big publicity for the kinetoscope came on May 26 when Edison was in court all day "during the argument of his counsel for an injunction to restrain the United States Electric Light Company from making incandescent lamps." This item, reported by the *New York Sun* (*loc. cit.*), also contained the in-

formation that during the day a *Sun* reporter had asked Edison "What else is new?" and Edison—not a man to fail to produce something new even when something new did not exist—spoke of his television-telephoto-photographic device. This time, however, with an actual visit to the laboratory by trained observers in the offing, he cautiously reduced his previous claims to one only, i.e., a device for taking photographs and reproducing them on either a screen or in a viewer. Actually, a peep-hole viewer was the only thing he had to show: such a camera as he had he was not going to expose—at least until the patent application had been drawn. Letting down gently a public which had read about his television-telephoto-photographic apparatus was indicated.

> . . . Yesterday morning [i.e., Wednesday, May 27] the reporter found Mr. Edison at the laboratory, and showed him a copy of the Chicago interview [i.e., the *Times* account quoted above]. Edison read it and laughed.
>
> "Yes, it's true," he said, "you can sit in your parlor and look at a big screen and see Chauncey Depew come out just as if he was introducing Stanley at the Metropolitan Opera House [Henry M. Stanley, the famous explorer, was at present in the news. He had recently been given a triumphant reception in New York. Chauncey Depew was, of course, the famous U. S. Senator and New York Central Railroad man.]. He will walk up to the front of the stage and bow and smile and take a drink of water and start off with his oration. Every time your eyes see him open his mouth your ears will hear what he says, that is if he says anything."

The next paragraphs are a series of claims for performances of musical comedy, opera, and plays, together with typical fanciful claims for production:

> . . . I will get the company to give a dress rehearsal for me. I place back of the orchestra on a table a compound machine consisting of a phonograph and a kinetograph with a capacity of thirty minutes' continuous work. The orchestra plays, the curtain rises, and the opera begins. Both machines work simultaneously, one recording sound and the other taking photographs at the rate of forty-six photographs per second. Afterward the photographic strip is developed and replaced in the machine, a projecting lens is substituted for the photographic lens. . . . Then, by means of a calcium light, the effect is reproduced, life-size on a white curtain . . .

113

Here we have a specific claim for projection by the same machine that took the pictures along with claims for a 46-per-second rate, capacity for a whole opera, etc. As in the patent applications (this was pointed out later by the Mutoscope lawyers as proof of the inoperability of the patent-described machine) no mention is made here of a *positive* film. In fact a positive film is specifically excluded and a *negative* film described for the projector! In the patent application, with every word weighed for its suitability, we cannot ascribe this error to anything but lack of experience with positive film. At the time of the writing of the patent application obviously the only film achieved was a negative film.

The *Sun* reporter goes on to say: "The accompanying sketch is from a drawing of the compound machine made by Mr. Edison himself at his laboratory yesterday." (See also page 120, where George Parsons Lathrop says that his sketches were made by Edison himself.)

The sketch itself shows—as other such sketches also show—(see pages 116–117) the unmistakable signs of imagination. Clearly such a photograph-taking apparatus did not exist except in the imagination of the artist. Details of the tables, the mounting, the horn, etc., also suggest that either this apparatus was whisked about with incredible celerity from one arrangement to another or that it was, as appears certain, drawn from the imagination.

After talking at some length (and attacking all former efforts to produce motion photographs as inferior) Edison belabors the necessity of the 46-per-second rate, and refers to "gelatine film" a number of times:

> To illustrate what he had said, Mr. Edison took one of the rolls of gelatine film which had been through the kinetograph and showed it to the reporter. On it was photographed one of the boys in his laboratory. The photographs were about half an inch square and were taken in the film at intervals of about one inch. They represented the boy in the act of taking off his hat and bowing . . .

Then followed an intensely interesting account of what was actually *seen* by the *Sun* reporter: "When you get your base principle right [continued Edison], then it's only a question of time and a matter of details about completing the machine.

The details can all be worked out after you get the germs. Come upstairs and see the germ work." The conversation had been occurring in the library on the ground floor of the main laboratory building, where the reporter had been given the sketch mentioned above. Now they go upstairs:

> He ran up stairs with the step of a boy and easily headed the procession to the spot where the "germ" was expected to prove that the reproduction of motion by photography was an established fact. It is a question which part of the kinetograph Edison himself regards as the greatest part of his invention, the arrangement for taking the photographs or the contrivance for reproducing them. It was the reproducing contrivance which he showed to the reporter as the "germ."
>
> To outward appearance the "germ" is nothing but a pine box, which looks very much as if it had been originally intended as a packing case for shoes or boots. It stood on end in front of a lathe, and the open top was nearest to the lathe. In the upper end was cut a hole about an inch in diameter, and in this hole was set a lens. On the bottom of the box was arranged a series of wheels and spindles. A roll of gelatine film was placed on a spindle on one side of the bottom. The end of the gelatine strip was then carried over one of the wheels and past the lens in the hole in the top of the box to another spindle on the other side of the box bottom and fastened. A small belt ran from the lathe to the shaft, on which was set the spindle, to which the end of the gelatine film was fastened. When the motor was turned on the roll of gelatine strip was transferred from the first spindle to the second, and in the transfer passed under the lens.[1] When it was run at the highest speed [the significance of this "highest" cannot fail to be noticed: this "highest" speed, which represents the capacity of the kinetoscope, must, according to the careful language of the patent application, equal the taking rate] the reporter saw a young fellow waving his hands and touching his hat . . .

What the *Sun* reporter saw was the spool-bank device which is later familiar to us as the kinetoscope. This was described the next month in the patent application. The *Herald* account of May 28 makes this plain:

[1] The reader cannot fail to note that although "a series of wheels and spindles" was seen by the *Sun* reporter, these are specifically excluded from the operation of the machine. Although Dickson had 50-foot rolls of film his camera was incapable of exposing more than several inches of this at a time. The strip was made into a loop for the *Herald* man: ". . . photographed on an endless strip."

Mr. Edison has not yet a perfected machine at work. He has an experimental one rigged up in his workshop, covered by a wooden box. It is a regular photographic machine impelled by an electric motor. In the top of the box was a hole about the size of a silver dollar. The machine was started and I looked through the oriffice. What I saw was the form of a man about an inch in size bowing and raising his hat. The motions were natural and continuous and no break could be detected between them. The picture I saw was only a negative, *photographed on an endless slip* [the italics are mine] . . .

The *Sun* article closes with more extravagant claims by Edison:

"I can put a roll of gelatine strip a mile long into it if I like," said the inventor yesterday. The work it will do in half an hour is something astonishing. Taking 46 photographs per second, in half an hour there would be 82,800 photographs on the gelatine strip. If the photographs were half an inch square and half an inch apart, the strip of film used in taking a thirty-minute act of opera would be 6,900 feet long, and Mr. Edison would need something more than his "mile of gelatine."

This somewhat cynical closing indicates that even in the days when "yellow journalism" was rampant, such papers as Charles Dana's *Sun* were not entirely without objectivity, let Pulitzer's *World* say what it might. Edison, however, adjusted quickly and easily to this sarcasm. As long as the matter is only imagination anyway, it is just as easy to claim *two* miles for the gelatin strip as *one*; so in the *Morning Journal* of the next day, May 29, the following quotation appeared: "In the small box camera, as shown in the cut the inventor places a roll of gelatine film about three-quarters of an inch wide and as long as desired—*two miles if necessary*" [the italics are mine].

The *Morning Journal* reporter, as is clear from his accounts, had not actually made a trip to the laboratory but the *Herald* reporter had and was given another sketch, varying in such details from that of the *Sun* as would not have been possible if the sketches had been made from an actual machine. The *Journal's* sketch, however, is closely similar to the *Sun's*, with the only difference being the addition of shadows on the floor, which might have been made by the engraver. In both the *Sun* and the *Journal* explanatory letters A, B, C, and D appear, although the *Journal* text does not refer to these—suggesting

again that the *Sun* sketch had been given to the *Journal* reporter.

The *Herald* sketch, on the other hand, must have been separately prepared—like the *Harper's Weekly* sketch of June 13. The proportion of the table is widely different; the base of the phonograph horn support is different; the proportion and shape for what we must assume (for lack of any other reasonable explanation) to be a reel casing, but which is in the wrong plane to be one, is different from the same structure in the *Sun* and *Journal* sketches. This is also true of the lens at the front of the camera. The battery and the supply wires thereto are also different in the *Herald* sketch. Furthermore, in the *Herald* sketch, the two instruments are placed on a thick base which is itself separate from the table upon which the whole apparatus rests. Conclusively, not one of these sketches shows a lamp housing, although projection ability is claimed for the apparatus. Everything in all these four sketches points in only one direction, i.e., imagination.

Each of these two latterly published papers contains the familiar extravagances: a 46-per-second rate, thirty-minute "takes," life-size projection, "gelatine" films, etc. Both make references to only negative films being used in the projection, and the *Herald* reporter, who actually saw the apparatus—presumably at the same time as the *Sun* reporter—was specific in his remarks. "The picture I saw was only a negative . . . ," he wrote, "photographed on an endless strip." What the *Sun* reporter called "wheels" were the spools of the familiar spool-bank apparatus of the patent specifications. As we will see shortly, the *Harper's* article writer was given a description and a sketch of a reel-mechanism.

Although this apparatus contained a spool-bank, the two sprocket wheels were sufficient to carry across the lens the short piece of film used. Dickson was only raising and lowering his hat, and, as in *Fred Ott's Sneeze*, only a relatively short piece of film would have been necessary to record this operation. In the *Sneeze* there were only about 100 frames shot.[2] There appears to be no good reason why this action would have been

[2] See, in this connection, my analysis of *Fred Ott's Sneeze* in *Film Culture*, No. 22–23, Summer, 1961.

repeated beyond the apparently two times it was shot (see page 121). The repetition described by the *Sun* reporter could have easily been accomplished by looping the film and passing it again and again across the lens.

16 · *America's Rarest Film*

GEORGE PARSONS LATHROP (SEE PAGE 98), THE WRITER OF THE *Harper's* article, had been in Orange "a whole month" as of June 24, and during this month had only "15 minutes conversation" with Edison. He had now become disgusted with the chances for the science-fiction collaboration (see page 97) and left his room at the Windsor Hotel in Orange to go home.[1] Since he had already been at the laboratory many times and since he was alert to all such possibilities, he made a story of the kinetograph matter, contracted for by *Harper's*, the only one of the six principal "prestige" magazines of the time that covered the device.[2]

On May 29 Lathrop asked that the strip be kept exclusive with *Harper's*, but was told that it was too late—the *Scientific American* man had already gotten his strip. (See illustration section for cut of this strip.) On this same day, the editor of the *Phonogram* asked for a cut of the kinetograph. She was told "There never have been any cuts made of this apparatus."[3]

On May 30 both Orange papers, the *Chronicle* and the *Journal*, covered the story. Both confined themselves to the claims for prowess we have already seen, with the *Chronicle* (which got Edison's printing business[4]) giving it half a column, and the *Journal* (which did not get this business) giving it a single

[1] Document file "George Parsons Lathrop 1891."
[2] Faulkner, for example (*American Political & Social History*. New York: Appleton-Century Crofts, 1957), lists "the distinguished, dignified, and at the same time well-illustrated *Harper's*, *Scribner's*, and *Century* . . . [and] the *Atlantic Monthly*, the *North American Review*, and the *Forum*, which catered to much the same intellectual level . . ."
[3] Letter book E1717, 4/14/91–6/13/91, page 604.
[4] An Insull letter in the Edison archives asks in effect, "What's the matter with the *Chronicle?*" and threatens withdrawal of the laboratory's printing business.

paragraph at the bottom of the page.[5] On June 1, the *New York Herald* printed a short strip of the photos in a line cut. By June 3, George Hopkins' article for the *Scientific American* had been looked over by Edison and pronounced O.K.[6] On June 5, the *Photographic News* reported on the kinetograph, quoting verbatim from the *New York Sun.* On the same day, the *Electrical Engineer* (British), with the objectivity which foreign periodicals had in those days about Edison's claims, said:

> As yet it is hardly possible to say exactly in what "Edison's latest" consists. It is a combination of phonograph, photography, and lantern work to reproduce the vocal sounds and visible sights upon an operatic or other stage. So far as phonography is concerned, Edison may claim all the credit, but so far as the photographic reproduction is concerned we are inclined to the opinion that Mr. Rudge, of Bath, has prior claims which will hardly be disputed. Mr. Rudge has quite recently perfected an electric arrangement which greatly assists in giving a faithful reproduction upon a screen of what we may term continuity of action . . .

On June 12, the *Photographic Times* paraphrased the *New York Sun* as saying that "The kinetograph is nothing more or less than a photographic camera arranged in a new way to do new work." [The *Sun* had said "photograph camera": the *Photographic Times* now says "photographic camera."] And on June 13 the Lathrop article for *Harper's Weekly* appeared. This is perhaps the most quoted of all the contemporary writings on this 1891 kinetograph flurry.[7] It appears that although he was given sixteen frames of motion pictures (see page 121) Lathrop did not see the kinetoscope—let alone the camera. The familiar Edison claims are again set down, but this time these are clothed in the sententious style characteristic of this writer and of so many others of his time. For example, referring to the close relationship of the phonograph and the "taking" apparatus, he cannot simply say that they are like Siamese twins, but must say: "The original and unique birth of one brain, they are linked as closely as the Siamese Eng and Chang, not by a band of flesh, but by a

[5] *Orange Chronicle* May 30, 1891, and *Orange Journal* of the same date.
[6] Letter book E1717, 4/14/91–6/13/91, page 578.
[7] I do not believe that the *Sun, Journal,* and *Herald* articles, etc., have ever been noted before in a history of these early days of motion pictures. Quigley (*Magic Shadows.* Washington: Georgetown University, 1848) follows chiefly the Ramsaye errors, and has noted the *Harper's Weekly* piece on page 135.

bar of steel, viz., the shaft that rotates the phonograph cylinder . . ." As I have said above, sketches of the kinetoscope showing reel-feeds are here, and, as Lathrop says, "both of these sketches, by-the-way, were made by Mr. Edison for this article . . ."

Elsewhere the article contains the old claims for the 46-per-second rate, the taking of a whole opera, etc. It also contains specific information about other workers in the field—either researched by Lathrop or supplied by the Edison organization —which is quite inaccurate:

> Muybridge's pictures of different phases of movement, on the other hand, had the benefit of a much longer exposure than Edison's,[8] and accordingly were much easier to take . . . and Muybridge, photographing a bird in flight, had to set up twelve cameras in a row, while Edison's kinetograph can capture any required number of pictures in a rapid series, and uses *only one camera.* [The italics are not mine.]

The drawing of Lathrop's "Siamese twins" on a table is apparently a modification in "elegant" style by the *Harper's* artist of such a sketch as was given to the newspapers—with interesting additional detail added to the phonograph part. On June 20 the article which George Hopkins had written for the *Scientific American* appeared. Little new had been added. For the first time, however, the film had become "celluloid" instead of gelatin. This was apparently a change enforced by the scientific mind of the writer, who could not accept Edison's claims for a gelatin strip. Another detail is added, apparently from the Edison end: "To secure enough light for the production of a good image in so short a space of time, a special camera lens of large aperture had to be constructed, at a cost of $600." When we note that at no time in the two years since the cylinder experiments began had as much as $600 been spent (even on paper) on the whole kinetoscope account, then we will understand why this particular lens was kept *sub rosa.* The *Scientific American* also reproduced the 15-frame strip it had gotten by May

[8] Analysis of these Muybridge exposures must wait for a later study. There appears to be disagreement. For example, *Anthony's Photographic Bulletin* for March 26, 1887, said 1/500 of a second; Taft (on page XI of *The Human Figure in Motion*, Dover, 1955) is indefinite; Eder says the earlier California photos were at 1/25 of a second; Newhall, *op. cit.*, says 1/5000 of a second.

120

29. It was called: "Photo-engraving of a portion of the strip negative of the Kinetograph (actual size)."

In looking through the original file wrapper of the Edison camera and kinetoscope applications (Industrial Records Division of the National Archives) involved in the file of the application which later became the kinetoscope patent (application #403536, patent #493426), I found the following letter from Dyer and Seely to the Examiner, dated November 23, 1891: "We find that the sample of a film, on which are a series of photographs, referred to in our communication of November 20th. was not sent therewith as intended, and it is enclosed herewith." Also found in the file by an alert Archives employee[9] was this seven-frame strip, which had become detached. This strip was easily identified as the same subject which had been reproduced so many times in the periodicals of June, 1891. It must certainly qualify for the distinction of being called America's rarest motion picture film. The file wrapper of the kinetoscope patent, application #403536, indicates that this is the strip which was sent to the patent office on November 23, 1891 (see illustration section).

There were eight frames in the *New York Herald* of June 1; sixteen in *Harper's Weekly* of June 13; fifteen in the *Scientific American* of June 20; and seven in the Archives strip. All were clearly shot at the same time and were a part of the same taking: lighting, distinctive background, body angles, and arm movements all establish this. The action was repeated once in the apparent second of time in which the machine was in operation:[10] once a movement outward from the shoulders with the fingers more closely bunched, and again a movement outward from the neck.

[9] Dr. Nathan Rheingold, formerly of the Industrial Records Division of the National Archives, and now of the Library of Congress, to whom I am indebted for courtesies in the preparation of this work.

[10] No other frames of this subject are known to exist, nor have any others been referred to in any laboratory document. Furthermore, the seven-frame Archives strip was produced by the attorneys *five months* after the others. (The Eastman sample—see page 67 of Ackerman, *op. cit.*—was apparently from a trial considered unworthy of display.) Since this makes a total of forty-six frames, it is not too much to suggest that the Dickson machine was capable, up to at least November of 1891, of only one second's operation. It is also quite possible that this very action was the base for the establishment of the 46-per-second rate, first noted in the *Electrical Engineer* of May 20, 1891.

121

There is also a possibility that all these frames are but a series of still photographs, separately posed, and then transferred to film. Although this may seem far-fetched, I have found no explanation for the white streaks in the Archives strip other than that they were caused by halation—a condition excluded by the use of film for the original photography, but quite possible if glass plates were used.

17 · The Summer and Fall of 1891

AFTER A MONTH OR SO OF TROUBLE-SHOOTING AT OGDEN, DICKSON'S work in this line appears to have let up a little, although on June 30 Edison himself had gone to Ogden "to stay." A laboratory letter noted, "It is impossible to say when he will return." [1] Many correspondents were told (for reasons with which we are now familiar) that the kinetograph details are "not yet sufficiently advanced" [2] for discussing. More than once they were referred to the *Harper's* article for information.

By July 15, the Gundlach Optical Company of Rochester had sent Dickson a catalogue which, as we know from *Wilson's Photographic Magazine* of July 18, 1891, contained a lead article by Ernst Gundlach on "A New Photographic Objective," a new triplet lens which "[completely] encloses the flint-glass with crown-glass] . . . thus its yellowish tint [is] made imperceptible [also] the flint-glass lens is completely protected against oxidation and mechanical injuries." [3]

We note elsewhere that Dickson placed much faith in the Gundlach Company,[4] and on July 17, a wire was sent to Rochester.[5] (On July 17, incidentally, the *Photographic Times* re-

[1] Letter book E1717, 6/13/91–8/24/91, pages 206 and 215.
[2] For example, letter book E1717, 6/13/91–8/24/91, page 247.
[3] Flint-glass is so called because it contains pulverized flints. It was valuable for optical instruments because of its dispersive power. Crown-glass contains potash and lime.
[4] See December, 1933, article in *The Journal of the SMPE.*
[5] Letter book E1717, 1/30/92–8/31/92, page 53.

printed the *Scientific American* article of the kinetograph reproducing the fifteen-frame strip.)

On July 20, the following letter was sent to a correspondent in France:[6] "With reference to your letter of 8th instant addressed to Mr. Edison, with relation to his Kinetograph, I beg to inform you that we no longer make our own emulsions for use in connection with that apparatus, and consequently have stopped using gelatine in any form." This makes clear what we already knew, i.e., that gelatin was used as a film base only by those who used home-made emulsions, or who applied the commercially prepared emulsions themselves. And by this time "gelatine film" could not have been used for such purposes as were described in the press releases previously referred to. What *was* used, of course, was a celluloid film (see *Scientific American* article) with an emulsion in which the sensitive salts of silver were suspended in gelatin: the familiar gelatino-bromide emulsion.

On July 20 another wire was sent to Rochester from the laboratory[7] and on July 22 Dickson went to New York, wired to Eastman that he was on his way, and boarded a sleeper for Rochester.[8] He had his supper and breakfast en route (these two meals together cost him $1.35) which he later charged to laboratory expense.[9]

He registered at the Livingston Hotel in Rochester,[10] and immediately plunged into negotiations with Eastman and the optical companies Gundlach and Bausch and Lomb.[11] He remained in Rochester from July 23, the day he arrived, until July 29, when he may have gone over to Clifton Springs, New York—a favorite spot with him (see Appendix A)—to begin a week's vacation.[12] On August 5 he returned to Rochester, stayed overnight, and the next evening boarded a train for home.

Meanwhile, in preparation since at least June 16 (see note 24 in this chapter), the patent specifications were signed by Edison on July 31 and filed officially on August 24. On July 31

[6] Letter book E1717, 6/13/91–8/24/91, page 363.
[7] Letter book E1717, 1/30/92–8/31/92, page 53.
[8] *Ibid.*
[9] *Ibid.*
[10] *Rochester (N. Y.) Union & Advertiser*, July 23, 1891.
[11] See Ackerman, *op. cit.*, page 67.
[12] *Ibid.*

the Eastman Company sent to the laboratory 4 rolls of 1" x 50' film ordered by Dickson personally.[13] This was the first such film received at the laboratory (if we except the one roll received March 18 from the Merwin Hulbert Company—see page 103) since the previous December, when six rolls of film had been received for the astronomical work. Ackerman (*op. cit.*, page 67) is interesting in this matter.

There is no doubt that all this was kinetoscope business, because all these charges were made to that account in the laboratory books. In addition we have the following specific note from the laboratory to a correspondent on August 6: "[Thomas] is busy with Mr. Edison at the Ogden mine, and [Dickson] is now visiting the photographic supply houses in Rochester on business connected with the Kinetograph."[14] On August 10 two lenses were received at the laboratory from Bausch and Lomb, marked "no bill required," indicating that Dickson had ordered them personally while in Rochester, and had at that time gotten the bill (receiving book entry).

On October 2, the Eastman Company sent Dickson an intriguing bill:[15]

Bill The Eastman Company	Oct 2/91	
Dev. & Ptg. #2 Transp. 55 @ 12^2		6.88
Express		.16
		7.04

Apparently Dickson had sent the Eastman Company 55 separate celluloid-base films of the Kodak #2 size for developing and printing. He had bought such film on March 18 (see page 103), but so far as we know he did not have such a camera. He charged this item to the kinetoscope account: (*ibid.*)

O.K. W.K.L.D.
462—Kinetoscope

which demonstrates that he was working on the viewing apparatus, or was again making such pictures as he did for the June publicity, or the Lenox Lyceum projection. These are obviously cut films from the March 18 purchase and the indication is that he was again experimenting with such transparen-

[13] It was mailed from the Eastman Company, according to item 2.11 in the private legal file above cited, on July 31.
[14] Letter book E1717, 6/13/91–8/24/91, page 556.
[15] E190-0.292.2.11 in Edison archives. (See note 2, chap. 1.)

124

cies as he used before in his version of the Anschütz tachyscope (see page 88).

During the month of September several items arrived at the laboratory which could well be ascribed to the kinetoscope work. For example, on September 8, 2 sheets of red glass 12″ x 14″ and 2 sheets 30″ x 36″ were received.[16] On September 7, Dickson received a box from Rochester by express, but apparently returned it on September 9.

Another occurrence this month corroborates the view that camera work was in progress this fall. On September 29, U. S. Patent #460492 was granted to Hayden—a patent which I discovered in the Edison archives. This patent describes a particular intermittent movement referred to by Dickson in his 1933 account of his intermittent movement trials. This is an unusual movement, and the idea that its being on hand at the laboratory might be only a coincidence—on top of the indications we already have that such work was in progress at this time—seems unlikely.[17]

On October 9, Dyer and Seely, having gotten Dickson's assignment to Edison of "An Improvement in the Art of Photography," ask Edison for $15 to file this application. This application later became #408340 in the U. S. Patent Office. (See page 128.)

We should note that on November 24 the laboratory received what was apparently its first shipment of aluminum. This was received in sheets .020″, .010″, $\frac{3}{32}$″, $\frac{1}{16}$″, .028″, and .046″ in thickness.[18] That Dickson was still working on the cylinder apparatus at this time is indicated by the following excerpt from his 1933 article which describes work begun immediately after the work we cited on page 23:

> Then I had a light drum made and produced a few spirals of pictures on a dead slow shaft. These even with ammonia ac-

[16] Receiving book entry for this date.

[17] It involves the movement of a band or strip by means of a two-pronged fork or pawl acting upon teeth cut into the upper edge of the strip.

[18] That it was the first such appears from a careful search of the receiving books of this time. On March 27, 1890, after having received only "samples" (letter book E1717, 2/25/90–3/22/90, page 396) a letter said (letter book E1717, 3/22/90–4/12/90, page 114): "Mr. Edison has never worked in Aluminum."

celeration, proved a failure[19] so I increased the size of the *aluminum* [my italics] drum and of the pictures, and coated the drum with bromide of silver gelatine emulsion [as we have seen above, on page 73, the use of bromide of silver gelatin emulsion must surely be dated after at least August, 1889]; and would have obtained a fairly good result but for some chemical action which took place between the *aluminum* [my italics] and the emulsion. That made me try a glass drum and a one-opening rapid shutter.[20]

My second batch of emulsion was light struck, owing to the night-watchman's bursting in at 2 A.M., which so disgusted me that I just slotted the *aluminum* [my italics] drum and wrapped a sheet of Carbutt's stiff sensitized celluloid over it.

Later, on page 440, accompanying a sketch of this drum, he has noted: "Sheet of Carbutt celluloid on the light *alum.* [italics mine] slotted drum."

Although such aluminum was not mentioned in the 1894 accounts[21] or in the 1928 account,[22] the use of the word "aluminum" four times in the 1933 account is suggestive. We know that as late as the patent applications the cylinder mechanism was still offered as invention[23] and that it was this synchronization—apparently more immediately possible with the drum ap-

[19] For a discussion of the use of ammonia in developing, see Eder. It was not a usual process in the United States (see *Photographic Globe*, November, 1890) and demonstrates again the extremities to which Dickson found it necessary to go to get any photos at all.

[20] The glass drum work was apparently a thing of the past as of August 31, 1891, according to the following letter to N. A. Jennings, of Dallas, Texas (letter book 8/24/91–10/21/91, page 112): ". . . your ideas with respect to moving photographs are, in general, correct. The glass cylinder idea would not, however, be practicable, on account of the great difficulty of stopping and starting 40 times in a second, which is necessary to take a complete picture." This, incidentally, is the first instance I have found in which a lower than 46-per-second rate is described after the stand for the higher rate had once been taken in May, 1891. Forty per second is, actually, approximately the rate at which most of the 1893–1898 subjects made by the Edison Company were shot.

[21] In the *Century Magazine* article of June, the *Cassier's* article of December, or in the booklet written by Dickson and his sister Antonia in the latter part of this year—presumably after the *Cassier's* editorial deadline—*History of the Kinetograph Kinetoscope and Kineto-Phonograph* (New York: Albert Bunn, 1895).

[22] Dickson's "A Brief History" sent to Edison, who agreed with Meadowcroft's suggestion that it would be a good thing to have. (Historical files, 1928.)

[23] File wrapper of application #403536. Original application, page 3, lines 10, 11, 12, 13, and 14. (Industrial Records Division, National Archives, Washington.) See page 127 for this quotation.

126

paratus than with a strip mechanism—that was Edison's chief goal in all this Dickson kinetoscope work. At least until projection became general in the United States he regarded his kinetoscope work as just an "improvement" on the phonograph.

In the Edison patent application #403536, one of the three filed on the official date of August 24, 1891 (but having specifications in preparation by the previous June 16)[24], the following lines occur: "In my application No. [25] I have described an apparatus in which an electric spark is formed at the proper moment to illuminate the pictures, which instead of being on a tape are or may be on the surface of a drum." There is nothing more apropos a drum apparatus in any of the specifications filed at this time, although each of these refers to at least a reproducing apparatus.

But in this application, which later was issued as U. S. Patent #493426, on March 14, 1893, there is described a drum reproducing apparatus with intermittent illumination accomplished by the use of a revolving shutter (*vide* page 3, line 7). The only item necessary to a sketch in the private legal file (see note 2, chap. 1) to qualify it to accommodate the requirements of this application is the addition of such a revolving shutter, interposed between the picture surface and the light source. Pencil additions to sketch number 7 accomplish this purpose.

It seems logical then, that Dyer and Seely, casting about (in the Edison manner) for the means of claiming all apparatus which could possibly be construed as falling within the claims of this patent, used this pencil drawing as the basis of a separate application, the one which Dickson filed on October 10, 1891—

[24] On June 16 a letter was written to a Long Island man who had written to suggest that such pictures as are taken by the kinetograph should be stereoscopic: "It is Mr. Edison's intention to give a stereoscopic effect to the pictures taken in connection with the Kinetograph, and a long and extensive series of experiments have been conducted thereon at the Laboratory, very good results being obtained. This has all been incorporated in the patent . . ." These patent incorporations refer, of course, to claims 21 and 22 of application #403535 and to several claims in the kinetoscope application, #403536. Again, however, we are faced with imagination being presented as fact: we know that such stereoscopic photos were *never* achieved in a so-called Edison invention. It will be seen further that this letter also states that of this date the patent specifications had been drawn. (Letter book 6/13/91–8/24/91, page 47.)

[25] This space is blank in the original application.

127

#408340.[26] In claim numbers 2, 3, 4, 5, 6, 8, 10, 11, 13, 17, 18, 19, and 20, specific provision is made for "The combination, in a picture exhibiting apparatus, of a *film or surface*" [the italics are mine]. A drum apparatus is thus enclosed within the patent claims. The fact that at the time of the drawing of these specifications there was not yet an official number for this "Edison" application fits easily into the idea that the Dickson application was being contemplated but had not yet been filed.

The filing of this application would have necessitated the removal of the finished ink drawing of this cylinder apparatus done at apparently the same time as the other apparatus described in this same file, i.e., the film cutter, slitter, and perforator. This is exactly the case: the finished drawings of these other devices remained in the attorneys' records, unfiled, whereas the drum device, filed, is accompanied by no such finished drawing. The cutting apparatus had not yet been built as of late July. (See Ackerman, *op. cit.*, page 67: "His idea is to make a slitter of his own.")

Details concerning this application could be readily ascertained if it were not for the unfortunate fact that all Patent Office applications for patents which have not been issued have been destroyed. Only in rare cases are we able to examine unissued applications, and this is when the file wrapper contents have been placed in the records of a suit at a time previous to their destruction.[27]

An interesting document found in the so-called "private legal file" sheds light on the extent to which Dickson was responsible for both the development of the motion picture apparatus produced at the Edison laboratory in these years and the extent to which he had a hand in drawing up the specifications for the patents. According to a letter written on January 3, 1894, some months after the kinetoscope had been patented, Dickson found that what was the then present (i.e., January, 1894) version of this machine had specifications which were not covered by the

[26] Patent applications numbers are assigned serially in the order of their receipt in the Office. This application was #408340: #408334 and #408378, enclosing the former application, were both filed on October 10, 1891. We know of this application through a letter dated October 30, 1891, in the document files "Motion Pictures 1891."

[27] I was told by more than one source in the National Archives that the file wrappers of applications which did not issue have been destroyed. P. J. Federico, an Examiner-in-Chief in the Patent Office, concurred in this.

patent. He therefore sent to the Edison lawers a sketch and description covering the new specifications. He had prepared this description on April 26, 1892. Because this latter date is well within the period covered by this history, I quote excerpts:

> When Mr. Pelzer called at Lab the other day we went over the Kinetoscope very thoroughly & while doing so I found that no specifications had been drawn up covering the *present* [not my italics] nickel slot viewing part—so send it now which can be added to same patent I suppose—its only another way to the same end, only infinitely better. The alum tank has been done away with, besides greatly simplifying same.

We will see (page 133) that the Patent Office Examiner was persuaded to accept the alum tank feature of the kinetoscope application only after Dyer and Seely had specifically stated that it was not invention *per se* but was only the first application of this feature to motion pictures. And by now the alum tank had disappeared from the kinetoscopes being manufactured by Edison in preparation for what was to be the mechanism's April 14, 1894, debut. This made useless the previous Dyer and Seely insistence on the alum tank, and indicates also that had the attorneys kept in close touch with Dickson's laboratory developments they might have saved themselves trouble.

There is enclosed with this letter a separate sheet of notes on the laboratory letterhead, dated April 26, 1892:

Kinetoscope
Nickel slot
Viewing Device

Specification to be added to Kinetoscope nickel slot viewing detail—

An incandescent light placed in the foci of a converging reflector—at said convergence or crossing of rays a narrow slotted shutter is placed—the opening just large enough to admit the rays which cross & fully illumine the travelling band of 1″ pictures . . .

Points gained:—

Film protected from heat rays—by interposing shutter—alum water tank done away with and greater simplification of construction.

Sincerely yrs
W. K. L. Dickson

129

There are included two sketches illustrating these specifications —sketches which accord with all models of the kinetoscope which we know.

18 · The Patent Applications

MEANWHILE THESE THREE PATENT APPLICATIONS, IN PREPARATION as of June 16, had begun their tortuous course through the Patent Office (#13 of the original file wrapper): "the first case No. 403534 . . . covering the method of taking the pictures and subsequently reproducing or exhibiting the same; the second case, No. 403535 covering the method and apparatus for taking the pictures; and the third case, No. 403536, covering the apparatus for reproducing the pictures in an exhibiting machine." The above, from the "Brief for Petitioner" written by Frank Dyer and filed some years later in an appeal to the Commissioner of Patents anent the reopening of the first application after it had been declared abandoned, is a clear statement of the purposes of the three 1891 applications. Although the specifications of these patents were signed by the official applicant, Thomas Edison, on July 31, 1891, we can nevertheless be certain that their content had been decided upon by the previous month (see note 24, chap. 17), and in consultation chiefly between the attorneys and Dickson.

(Josephson, page 391, again trying to force facts into his theory that Edison decided not to bother about projection from 1891 onward for some time, says that projection claims were dropped from the "1891 application." Clearly the kinetoscope application and the third application of the three filed at this time were not taken into consideration. That one of these applications was rejected by the Patent Office is irrelevant to Edison's intentions at the time of the application. The projection claim in the kinetoscope application, as impractical as it was, was actually allowed and now forms part of the printed patent.)

The first action on any of the three applications was taken on the last, #403536, the exhibiting apparatus, on November 13, when the Examiner rejected claim numbers 1, 2, 3, 6, 10, 11, 12,

13, 14, and 15 on U. S. #93594 to Brown.[1] Claim 4 was rejected on the same patent taken in connection with U. S. #230322 to Molera and Cebrian.[2] Claims 7, 17, and 18 were rejected on U. S. #36395 to Dayton and Kelly.[3] Claims 8, 9, and 19 were rejected on U. S. #13106 to Southworth and Hawes, and on U. S. #26912 to Loyd.[4]

On November 20 Dyer and Seely wrote the Examiner that:

> The Brown patent does not disclose in any manner the necessity of having a large number of pictures, having the successive pictures substantially alike, and moving them with great rapidity before the eye. [We now know, considering chapter 16, note 10, that claims for "a large number of pictures" were fraudulent.]
>
> In the Molera patent there is nothing between the light and the single picture being examined except ordinary lenses.
>
> . . . Dayton and Kelley show an endless belt passing over two rollers and having on it ordinary stereopticon pictures, said pictures having no connection with each other except that they are successively brought into sight.
>
> Southworth and Hawes and Loyd do not meet claims 8 and 9 since they show merely hand operated mechanism for bringing ordinary stereopticon pictures one after another into view.

On December 5, the Examiner answered:

> The slightness of difference between the successive pictures may give a more perfect result, but it does not involve a novel or a different "method."
>
> The 4th 5th and 6th claims are rejected in view of the well known use of heat absorbents in this class of instrument and that it involves no invention broadly to apply these to Brown's instrument.

[1] Brown described means of intermittently bringing a transparent picture series before a projecting lens through which light was intermittently thrown onto a screen through a two-aperture, revolving circular shutter. Brown's intermittent, moreover, was a Geneva Star modification. (The recurrent phrase "rejected on . . ." means "rejected because of priority of . . ." in Patent Office terminology.)

[2] Molera and Cebrian described an apparatus intended to intermittently present for examination by magnifying lenses "matter previously reduced to a microscopic scale by photographic apparatus."

[3] Dayton and Kelly described an apparatus "in which the pictures or photographs are so arranged as to form a continuous sheet and admit of being brought consecutively in front of the lenses by the turning of a shaft."

[4] Southworth and Hawes' invention consisted in arranging apparatus to give stereoscopic pictures "a panoramic motion into and out of the field of vision." Loyd described a series of stereoscopic plates fastened on an endless belt and passed before viewing lenses.

Claim 7 was rejected on Potter, U. S. #390396, which described an apparatus in which could be exposed such pictures as were described in the application—particularly since the Edison claim did not "limit the applicant to his peculiar pictures." Claim 8 was again rejected on U. S. #36395, Dayton and Kelly, for the same reason as the rejection on Potter. The Examiner also made the point that " 'rapidly' is only a relative term and does not point out any real distinction." He also pointed out that "in the present state of the art the substitution of an electric light for any other ordinary light in a magic lantern does not involve invention."

On February 29, 1892, Dyer and Seely asked the Examiner to cite references re his rejection of a heat-absorbent, and to cancel claims 1, 8, 13, 14, and 17. In his reply of March 14, the Examiner cited page 6 of Laudy's *Magic Lantern and its Applications*, published in 1886 by E. and H. T. Anthony. He withdrew his objections to Claim 7.

On April 30 Dyer and Seely, having seen the alum water reference cited them by the Examiner, asked the Office to insert the following in the application:

> I am aware that a heat absorbent, such as alum water, has been used in connection with microscopes between the object being examined and the lens to protect said object from the effect of heat concentrated thereon by said lens. I do not, therefore, claim broadly the use of such heat absorbent, but only the use thereof in combination with the moving film having pictures thereon and certain elements of my apparatus, as hereinafter defined in the claims.

They reiterate the differences from Brown, saying that his "pictures are not arranged on a flexible tape but on a circular plate. This is objectionable, mainly, because it is impossible to employ a large number of pictures." On May 12 the Examiner answered that Brown still anticipated because "applicant [has not limited] himself to a 'film' as in his argument, but includes broadly a 'surface.' " He persisted that the addition of a heat-absorbent to Brown's apparatus was old, and instructed the applicants as to how to "patentably distinguish from Potter before cited."

On June 3, Dyer and Seely argued the difference from Brown as to the heat-absorbent. On June 9, the Examiner repeated his rejection and said that this was a final rejection. On October 31

(possibly a significant date since it looks like a revival) Dyer and Seely said that they interpreted the last letter from the Examiner to mean that if they limited the heat-absorbent to a film, the claim would be acceptable. On November 15, the Examiner said that the last Dyer and Seely suggestion did not properly claim the benefit of the inference they had made from his letter, "and they are rejected on the same reference as before. Brown's series of pictures are practically the equivalent of a 'band.' The case stands finally rejected since June 9."

On November 21, Dyer and Seely wrote to say that the word "band" was changed to "in the form of a tape." This satisfied the Examiner, and on December 8, Dyer and Seely were sent their notice of allowance. On February 22 the final fee of $20 was paid. On March 4, 1893, the patent was issued as U. S. #493426.

Meanwhile, on January 2, 1892, the first action on application #403534 had been taken, the Examiner rejecting all the claims: "The claims are anticipated by patents to Le Prince 376247, Jan. 10, 1888; Donisthorpe, 452966, May 26, 1891, and British patents to Greene, 10131, June 21, 1889 & Dumont, 1457, June 8, 1861 (cameras), and they are therefore rejected."

This rejection stood as final to the end of the period with which this history is concerned—Dyer and Seely taking no action on it until December 29, 1893, when they presented a new set of claims. Being advised that these claims were aggregations and therefore not patentable, they again took no action.[5] Therefore, on October 18, 1895, the claims were finally rejected. After having waited until April 18, 1896, the last day allowed in which to make an appeal, they filed an appeal and a set of substitute specifications.

The appeal finally ended after Edison had sworn to new matter, and after what the American Mutoscope Company later called fraud in the Patent Office, with the issuance of the fa

[5] An aggregation according to patent law, is: ". . . thing or assemblage bringing together the action of two or more parts or functions which are availed of independently of each other and not so as to constitute a patentable *combination.*" [By permission. From *Webster's New International Dictionary,* Second Edition, copyright 1959 by G. & C. Merriam Co., Publishers of the Merriam-Webster Dictionaries.]

mous Edison motion picture camera patent, U. S. #589168,[6] scaring the little entrepreneurs in the motion picture business *out* of that business, but stimulating the American Mutoscope Company to contest the infringement suit and finally obtain a decree.

The first action on application #403535 was taken on January 4, 1892, when the Examiner rejected claims 1 to 6 inclusive on U. S. #376247 to Le Prince;[7] U. S. #452966 to Donisthorpe and Crofts;[8] British #10131 of 1889 to Friese-Greene (see page 176); and British #1457 of 1861 to Dumont.[9] Claims 8, 9, 10, 12, and 20 were rejected on Le Prince, Donisthorpe and Crofts, and Claim 13 on Donisthorpe. Claims 15, 16, and 17 were rejected because they were for a different device (see below for the outcome of this). Claims 18 and 19 were rejected on U. S. #337963 to Lewis[10] and U. S. #408451 to Barker.[11] Claim 22 was rejected as an alternative. Claims 21 and 22 were also said to have been met by the patents cited, "In view of the fact that it is old to take pictures stereoscopically," and rejected on British patent #1588, 1865, to Bonelli,[12] and French patents

[6] In his "answer" to the original Bill of Complaint which opened litigation in the infringement case (Equity No. 6928 in the U. S. Circuit Court of the Southern District of New York), Harry Marvin, vice-president of the defendant company, makes this charge in paragraph XI.

[7] Le Prince described rows of lens to overcome the shock of intermittency; refers to 960 per minute as a "slow speed"; says (on page 4, lines 37 to 42 of his specifications) "I am enabled to take negatives . . . as may be wanted, attaining several thousand per minute"; describes metal-reinforced positives and "an endless sheet of insoluble gelatine coated with bromide emulsion, or any convenient ready-made quick-acting paper, such as Eastman's paper film."

[8] Donisthorpe and Crofts (British #12921, August 15, 1889) describe a strip moving constantly before a lens.

[9] Dumont (Belgian #11130, July 3, 1861) describes a rack and pawl to secure intermittent movement of a sensitized surface; a shutter; a sensitive band continuously moving but only intermittently exposed by this shutter. Dumont could have used only wet plates, he was, therefore (as Main said in the case cited above, note 6), "in advance of the time in providing a mechanical and optical device which could not then be supplied with suitable photographic material." He must in no wise, however, be deprived of credit for *invention*.

[10] Lewis describes "A light-tight box having a light-tight passageway for the movement of the paper sheet into or out of the box, and which is light-tight both when the sensitized sheet is wholly within the box and when it is being moved in or out of the same."

[11] Barker described a roll-holder for "sensitized paper or tissue" in which are used "removable light-tight cases or boxes for carrying the sensitized paper and for supplying and taking up the exposed portions of the film."

[12] Bonelli describes the application of the thaumatrope or phenakistiscope to microscopic photography by "making a series of successive microscopial pic-

#169144 to Groult (3rd Series, Vol. 55) and Chevalier, #20884 (2nd Series, Vol. 63).[13] Brown was again cited as ground for the rejection of claim 23.

The Examiner closed this encouraging letter with: "All the claims except the 14th are rejected."

On March 16 Dyer and Seely reiterated their feeling that a rapidly moving film rendered their application patentable; and that the proportion between the period of rest and the period of movement also made their claims new. They asked that the stop device be retained (the Examiner had rejected the claims covering this device on the ground that it was a different invention). On March 26, the Examiner insisted that the stop device must be divided from the other claims, and that "This formal question of division must be settled before further action can be had on the merits of the case."

On March 29 Dyer and Seely wrote Edison:[14]

> . . . the Examiner has required division between the claims to the photograph apparatus and the claims to the detent or stop device . . .
>
> Our recollection is that you considered this one of the novel and important parts of your machine. Do you consider it of sufficient importance to warrant the filing of a divisional application?

To which a reply was made the next day:[15] "Please file a divisional application to cover this device, and oblige." Accordingly, on March 31, Dyer and Seely excised the stop device claim from the original set of claims and filed a new application for it. We will see later what became of that application.[16]

The Examiner on April 13, meanwhile, reiterated his idea *re* the remaining claims that "to take such pictures of moving objects on a film rapidly advanced" involved no invention, and further that "All the claims except the 8th & 9th are fully anticipated by the references of record, and as the amendments made

tures, and in placing these pictures upon a small disk, by causing the disk to rotate . . . A barrel with spring wheels and pinions is used to impart the required motion."

[13] Groult describes a "pistolet photo-stéréoscopique" which, by the operation of a trigger, takes two instantaneous views simultaneously on glass plates.

[14] Document file, "Motion Pictures, 1892."

[15] *Ibid.*

[16] *Ibid.*

to some of these claims are immaterial, these claims are finally rejected and the case closed before the Primary Examiner."

On May 5 Dyer and Seely asked that the Examiner point out the pertinent parts of the references cited against their claims and repeated their idea that their way of moving the film—a motor "constantly tending to move the film" with a stop-motion in connection—made their device patentably different from the references cited.

On May 20, the Examiner suggested (with possibly a bit of sarcasm) that "If the references were not understood, it would seem that the proper time to ask further explanation was after the first rejection." But he did cite the relevant parts of the Le Prince patent and the British patent to Friese-Greene. The application of the motor and stop device he again said was anticipated by Friese-Greene and also Donisthorpe. He closed this letter with

> In reply to the statement "The amendment to these claims was not therefore immaterial, and it is thought that the final rejection in the Office Letter of April 13 should not have been made, and we desire further consideration of the application," applicant is informed that the application has been given the further consideration desired. The action made by the prior Office Letter is repeated, and the case is now in condition for appeal.

To this letter Dyer and Seely did not reply until October 19 when they wrote to say that before taking final action they wanted to "obtain a literal translation of those portions of the French patents cited which bear directly on the invention," and again asked the Examiner to refer them to the pertinent parts of these patents.

Again, as in the other application, there had been a hiatus until October. (Cf. page 132.) It appears that both these applications may have been thought abandoned but that developments at the laboratory stimulated a revival (see also page 140).

When this last application had been divided, on March 31, the claims for a stop device were filed in the Patent Office under the official number 428614. Four claims were made in this application. On June 18 the Examiner rejected the first three of these on U. S. #205829 to Blackburn and Moeslein;[17] U. S.

[17] Blackburn and Moeslein describe a rib concentric with a disk and at right

136

#215810 to Eaton,[18] and U. S. #303621 to Colburn.[19] He rejected the fourth claim on the ground that such a connection as the one shown between the stop device and the motor was "very common." On July 20 Dyer and Seely made minor changes in wording and belabored the point that *their* application described a driving power *tending* to turn the wheels, and that this differentiation was crucial and therefore patentable. They changed "motor" to "driving shaft," hoping thereby to make this driving force an integral part of the device of the application.

The Examiner replied on July 26 that "If there is a patentable difference between applicant's device and those shown in the references, the claims fail to develop it. The claims are again rejected—finally if desired." But Dyer and Seely by no means "desired" this final rejection. On August 5 they wrote making several changes in phrasing. They again pointed out differences, including the lips which are adjacent to the notches in their device. The Examiner replied on August 17 and again rejected claims 2 and 3. He also said that Claim 4 must be more carefully described. He closed saying that "Upon the proper correction, as to the features above alluded to, claims 1 and 4 will be allowed." On August 18—*the same day upon which they received the last letter*—Dyer and Seely replied with amendments which they felt would "distinguish [claims 2 and 3] from the references." The Examiner acquiesced in this and on August 25 notified them that the application would be allowed. It was not until January 27, 1893, however, that Dyer and Seely paid the final fee, allowing the patent U. S. #491993 to issue on February 21, 1893.

angles to the axis of a wheel into which are cut three teeth at an angle of 45°. This is acted upon by four groups of three teeth each to "convert a continuous rotary motion into an intermittent rotary motion."

[18] Eaton describes a broken cam-wheel acting upon a spiral cam to produce intermittent motion from a continuous rotary motion.

[19] Colburn describes "a radial-toothed crown or bevel gear wheel with an oblique or spiral toothed wheel in such manner that said radial-toothed wheel may mesh with it and operate two or more oblique or spiral-cut wheels" and does not, therefore, describe an intermittent motion.

19 · The First "Modern" Motion Pictures

MEANWHILE, DICKSON'S WORK ON THE KINETOSCOPE, ALTHOUGH not heavy (because he was kept busy with ore-milling), had been nevertheless steady. So that by the end of June, 1892, plans were under way to market the instrument.[1]

It seems likely that this decision would not have been made unless a supply of film subjects for the device had been assured by advances made in the development of the motion picture *taking* apparatus. And although we cannot be sure of the stage of development here, by the time it was decided to manufacture a nickel-in-the-slot kinetoscope—probably by June, 1892—the fundamental necessities had been met: a rapid, intermittent movement and a sufficiently tough, sensitive film. Exactly what apparatus had been built we cannot know. A vertical-feed camera was probably under way.

During all this time correspondents were consistently told that although "the kinetograph [the kinetoscope] is not yet ready to be placed before the public [nevertheless] Mr. Edison hopes to have it in operation at the World's Fair."[2] It was this prospect of World's Fair business which permitted Dickson to take enough time in his kinetoscope experiments to achieve the apparatus necessary for such a presentation. Various persons were already approaching Edison for this concession, and by the time the summer was out definite arrangements had been made.[3]

[1] Zglincki (*op. cit.*) again produces an impossible date: that of February 20, 1892, for the first kinetoscope. That this is quite improper may be seen from the fact that a kinetoscope as we understand the word—a device with endless film on a spool bank passed before a magnifying glass and lighted by light reflected at intervals through a shutter—was seen not later than May 20, 1891, when Mrs. Edison's Women's Clubs Convention guests got into their carriages and were driven all of two blocks down a gentle slope to Mr. Edison's laboratory. (See page 111.)

[2] This reference is from letter book E1717, 3/9/92–6/16/92, page 646. For others see *ibid.*, page 405, *ibid.*, page 687.

[3] Among others George Parsons Lathrop (see page 98) on February 20, 1892 (document files "George Parsons Lathrop 1892").

Edison's secretary, A. O. Tate—a considerable entrepreneur in his own right, as many such men around Edison were—had arranged with Thomas Lombard and Erastus Benson to join him in such a company.[4] Tate secured the World's Fair concession from Edison and as a result the kinetoscope project at the laboratory had a constant stimulus.

Tate, Lombard, and Benson were each to supply one-third of "the preliminary expense which must be incurred in the transportation and installation of [the kinetoscopes intended for the World's Fair], employment of help and other necessary and appropriate incidentals."

This was to be in return for one-quarter each of the stock of the Chicago Central Phonograph Company which had been formed to exploit this World's Fair concession. Edison was to loan this company $10,000 in return for which he got controlling interest (801 shares out of a total of 1,600) and was to be paid back from the first proceeds. Thereafter he was to retain 400 shares, or one-fourth of the total stock. (Document files "Motion Pictures. 1893.")

The laboratory account books show a charge to the kinetoscope account in June, 1892, of 20¢ for carfare.[5] In view of the next month's developments we may assume that on this occasion Dickson took a trolley to Newark to arrange with a John Valentine, "Pattern and Model Maker," of 15 Alling Street, to build "one cabinet for Kinetoscope" which was received at the laboratory on July 14.[6]

In the meantime the apparatus which was to go inside this

[4] Thomas Lombard (see Ramsaye, page 78 et seq.) was vice-president of the North American Phonograph Company and was perhaps the leading force in the reorganization of that company after Edison had forced the ailing Jesse Lippincott into bankruptcy. Benson was an Omaha banker who had a phonograph concession from the North American Phonograph Company.

[5] Edison archives "Labor and Material Sub-Ledger No. 6," page 340. I infer the "carfare" from the amount of this entry and the July activity.

[6] Valentine's letter is interesting: (Doc. files "Lab. T.A.E. equip. and supplies. Jan.–Feb. 1891 [sic]").

Mr. Dickson
Dear Sir. I am Sorry to Say that I have not got it done but well advanced 3 of My men have bin of for two or three days & I am mutch put out with them that I have to disapoint you & others by not getting the work out
if they do not disapoint me again I will have it done by tuesday morning next

Yours Resptfuly,
John Valentine

The holiday [Fourth of July] makes the trouble

cabinet had already been built (see p. 35). The account books show expenditures to the "New Model for Kinetoscope Nickel-in-Slot" of $16.22 and $88.66.[7] The entire kinetoscope account charge for the month of June was $404.30 (see *ibid.*, beginning on page 43) although this charge may still have concealed extraneous charges. (Cf. p. 32.) There is, as a matter of fact, reason to believe that since the General Electric Company had reduced its support of the laboratory experiments from one-half to one-third, the "hidden" proportion of these charges was increased. But since a vertical-feed motion picture camera and a new nickel-slot kinetoscope came into existence at this time, we may suppose that at least a part of such charges was real.[8]

As we saw when Edison's attorneys received the Patent Office Examiner's letter of August 17 they were uncharacteristically precipitate both in conceding the changes requested and in answering the letter. It also appears that the October 19 letter (see page 136) may have been significant, and indicated that the attorneys now thought it desirable to reactivate the application. The October 31 letter also seemed to indicate a similar revival of interest. (See page 132.)

Given (1) these Patent Office actions, (2) the knowledge that the nickel-slot kinetoscope model was well under way, (3) the inference that to make such a mechanism meaningful, motion pictures of some sort must have been realized, and (4) the knowledge we have that various men interested in the commercial development of the kinetoscope were in a position to command action (e.g., Tate and Lombard), the conclusion seems reasonable that in these months the first Dickson vertical-feed motion picture camera was built.

Our present history ends with October, 1892, and the publication in the *Phonogram* of several frames from each of 4 vertical-feed motion picture subjects—obviously achieved by a rapid intermittent movement of film driven forward on sprockets by means of a double row of perforations. These are

[7] Edison archives "Labor and Material Sub-Ledger No. 6."
[8] For July the charge was $358.33; for August, $233.51; for September, $292.50; for October, $311.47; for November, $526.83. For December the amount was $1,320.32—which included most of the expense for the building of the "Black Maria." (Edison archives "Labor and Material Sub-Ledger No. 6," pages 143 and 144.)

the first such pictures published, to my knowledge, and are here noted for the first time in a motion picture history. Obviously here is a latest possible date for the completion of an effective camera.[9] Considering the patent application urgency in October, their appearance must be more than coincidence.

The camera was, however, still to be improved. Its capacity was to be enlarged and its working made smoother. In December, beginning with the building of the famous "Black Maria," plans for the extensive production of subjects were implemented. Although the new nickel-slot kinetoscope was not available in time for commercial use at the Fair, action was taken soon to commence its manufacture, and before long it was to have its official debut in New York City. Thus would begin the stimulation of the commercial development of the motion picture the world over.

It appears certain that although the only motion picture work at the laboratory resulting in practicable apparatus until May, 1891, concerned a cylinder-viewer, a strip motion picture camera had been developed by October, 1892. It also appears certain that this development was helped by the knowledge of the work of other men—principally Marey and Friese-Greene. But it took a man with interest in the matter and skill in utilizing both his own ideas and those of others to achieve such an apparatus. That Edison had little or no interest in this development seems clear from the internal records of the laboratory, and particularly from the naïveté of his expressions on the subject. He encouraged its development (i.e., permitted Dickson to spend time on it) only when he was persuaded by the men about him that the device had a financial future. As the *Electrical World* of September 8, 1889, said: ". . . with all due credit to his inventive genius, it is yet permissible to think that his greatest art is that of coining money through the collective work of others."

No one will gainsay the imagination, energy, intelligence,

[9] The *Phonogram*, a monthly, was not always on schedule in its dates of issue. Its February, 1891, issue, for example, had been sent to the laboratory on February 23. Since the Edison establishment was one of the first places to get this publication, we can infer that it may have been issued at any time during the month of dating. Similarly, the October, 1892, issue should be placed at any time within this month. (See also page 112, in which the May issue of the *Phonogram* reports an event occurring on May 20.)

and colossal ambition which made this sponsorship of Dickson possible. And no one will deny that because Edison lived and worked, society has had much benefit. But no careful student will fail to see that the kindly old man of the Shinn and Miller photos, the Allen and Silvette paintings, the Hafner bas-relief, and the 1928 medallion of the Society of Arts and Sciences is not the Edison we know from our study. Nor will he fail to see that the motives toward these benefits to mankind showed little love therefor, or much more than a drive toward self-expression, the accruing of wealth and fame, and the controlling of the actions of others.

It is to the young Scotsman who came from Virginia in 1883 to seek his fortune in the great city that the American film owes more than to any other man. Stimulated by Muybridge and Anschütz, aided in important details by Friese-Greene and Marey, he was the center of all "Edison" motion picture work during the crucial period of its technical perfection, and when others were led to the commercial use of the new medium, he was the instrument by which these others brought it into fruition. Soon he was to bring his enthusiasm and experience to the American Mutoscope Company as the most significant member of a quartet whose integrity, acumen, and high standards set the pace for the headlong, rushing growth of the new industry.

William Kennedy Laurie Dickson's death twenty-five years ago brought an end to an "unsteady," priggish, conventional, snobbish man. It also brought peace to a life full of harrowing family responsibilities (always freely accepted), constant financial worries, and, most of all, the frustration a man must feel who knows that in spite of all he has done, little has been acknowledged. It is for us to begin that acknowledgment.

142

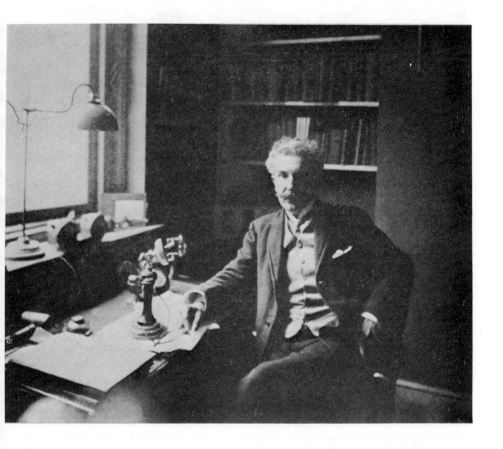

W. K. L. Dickson in his London office, July, 1908. After leaving the motion picture business, Dickson set up an experimental laboratory in London. This photograph is from the effects of the second Mrs. Dickson and is by courtesy of the Science Museum, London, and the West Orange archives. Heretofore unpublished.

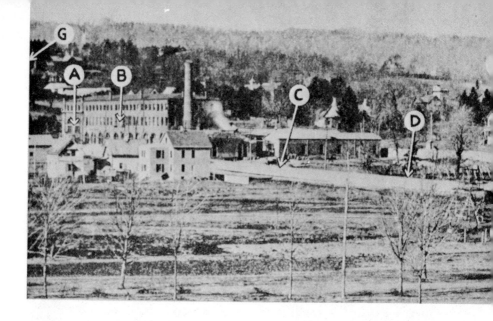

The West Orange laboratory, January, 1889. The two-story library of the main laboratory building may be seen at *A*, on the corner of Lakeside Avenue (which lies directly this side of the white board fence) and what was then Valley Road—but is now Main Street. About half-way down the second-story row of windows, at *B*, are the photographic rooms (see page 184): one may almost imagine seeing window equipment here for sun-printing, which Dickson used often. *C*, just beyond the fence, is the site of the photographic building (see page 75) to be erected the next fall, and *D*, a close approximation to the site of the Black Maria, to be erected in December, 1892, some time after the pond *E* had been drained. At *F* is a house which appeared more than once in the background of an early motion picture, and Edison's home, "Glenmont," is just out of the picture to the left, at *G*. This is an enlarged detail of a photograph in the *Newark Sunday Call* of December 27, 1931, and is here reproduced by courtesy of the *Newark News* and the West Orange archives. Heretofore unpublished in an Edison or motion picture history.

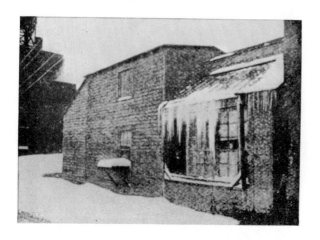

The 1889 photographic building (see page 75). From *The Photographic Times,* January, 1895, which had a deadline of December 15, 1894. Unpublished since that date.

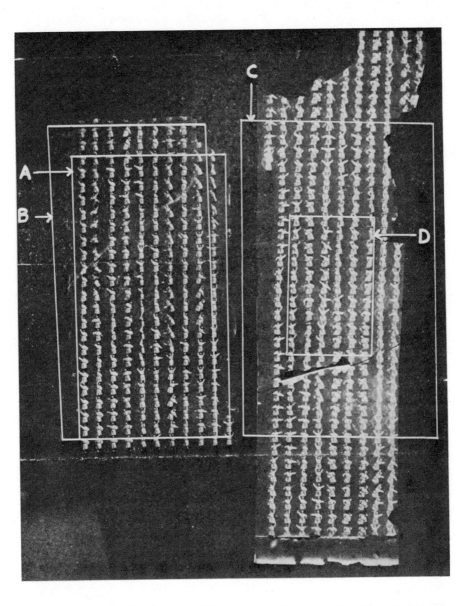

The "Monkeyshines" subject (see page 44). From the 1896 affidavit (see page 181) by courtesy of the National Archives. Heretofore unpublished. Excerpts from these "Monkeyshines" indicated by outlines have been published several times before:

A—in the 1894 booklet (see page 7) and in *Cassier's,* December, 1894;
B—on page 428 of the Complainant's Record, Equity #6928 (see page 3);
C—on the same page, *ibid.;*
D—opposite page 56 of Ramsaye.

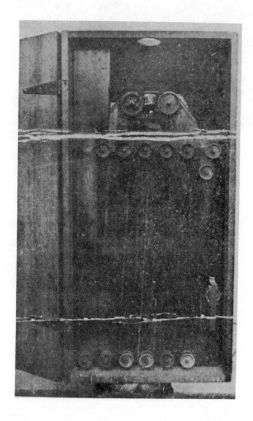

Kinetoscope No. 1" (see page 10
From the 1896 affidavit (see p
181) by courtesy of the Natio
Archives. Heretofore unpublished

"America's rarest film" (see page 118). From the Gordon Hendricks collection an
by courtesy of the National Archives. Heretofore unpublished.

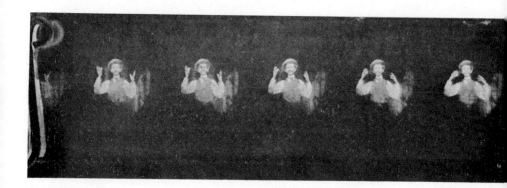

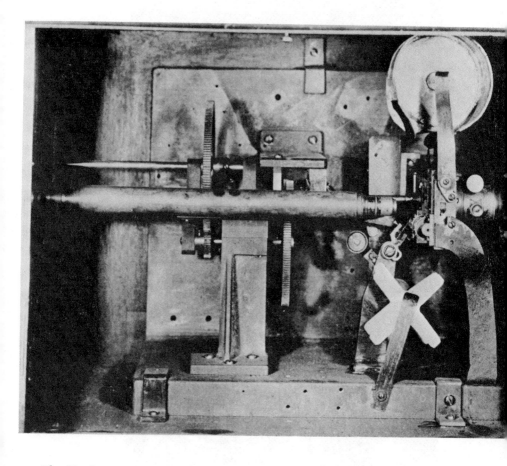

The Ford Museum camera (see page 111). By courtesy of the
West Orange archives. Heretofore unpublished.

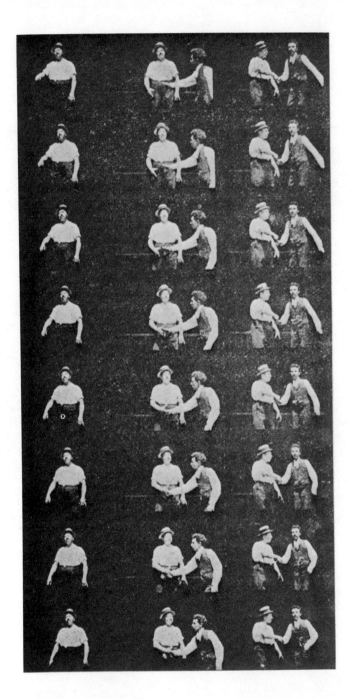

The first "modern" motion picture in America (see page 140). This subject shows Dickson and Heise, and was first published in *The Phonogram,* October, 1892, along with two others called "Wrestling" and "Fencing." Published here by courtesy of the Smithsonian Institution Library for the first time since its original publication.

W. K. L. Dickson and Jules Etienne Marey (see page 82) taken by Eugene Lauste (see page 87) in Paris, apparently in 1898. By courtesy of the Smithsonian Institution. Heretofore unpublished in the United States.

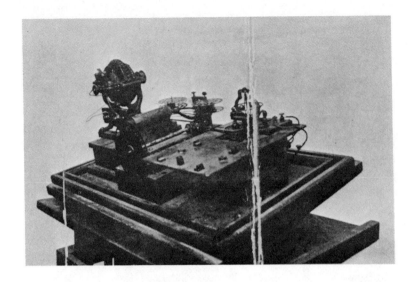

The "May, 1891" horizontal-feed camera as it appeared in 1896 (see page 181). This is the earliest known photograph of this instrument, as the photographs of the "Monkeyshines" subject and the "Kineto-scope No. 1" are the earliest known of those items. From the 1896 affidavit (see page 177) by courtesy of the National Archives. Heretofore unpublished.

The Kayser photograph (see page 182). From the copy negative at the West Orange archives, and by courtesy of the archives. Unpublished since 1922.

APPENDIX A · *A Biographical Sketch of W. K. L. Dickson*

William Kennedy Laurie Dickson was born in August, 1860, in the Brittany town of Minihic-sur-Rance.[1] His father, James Dickson, was said to have been "a distinguished English painter and lithographer . . . [a descendant of Hogarth]" and his mother, Elizabeth, "a descendant of the Lauries of Maxwellton, immortalized in the celebrated ballad "Annie Laurie," and the Robertsons, of Strowan, connected with the Earl of Cassilis, the Duke of Athol, and the Royal Stuarts." [2] The family's claims to wealth and distinction (despite the fact that these were never exactly played down by the son) were of doubtful substance. A photograph of "my birthplace, St. Buc" suggests this.[3]

We know little of Dickson's life until February 17, 1879, when he wrote Edison for a job. We do know that he had by this time two sisters: Antonia, born in 1858, and Eva, born in 1862. Antonia became a child piano prodigy and Eva a singer of apparently some success.[4] The follow-

[1] I have not investigated the local birth records, but the marriage license in 1886 and the death certificate in 1935 both agree on 1860. The letter written February 17, 1879 gives August as his birth month.

[2] This quotation is from the biographical paragraphs at the end of the 1895 booklet, frequently referred to herein. I have not examined these pedigrees: that James Dickson was a sketch artist of only moderate amateur ability appears from a sketch he made of his daughter Antonia in 1862, now in the writer's possession, a gift of Miss Kathleen Polson, of Twickenham, Middlesex.

[3] A number of original glass negatives of Dickson's have come into the writer's possession. One of these is labeled "My birthplace, St. Buc." It is apparently a small building attached to the chateau.

[4] Antonia was said to have been twenty-six in 1882; Eva eighteen the same year. Antonia's musical precociousness was frequently remarked upon, e.g., the *Richmond and Twickenham Times* of October 3, 1935, and the Orange papers of 1894–97. Eva was said to be "singing with success in the United States" at the time of her brother's death in 1935. (*Richmond and Twickenham Times, loc. cit.*) Since few singers are singing at all at the age of seventy-two, we have supposed that even the modest claim "with success" is more of the Dicksons' straining after effect.

ing letter—here quoted for the first time—and apparently written from a London boarding house when Dickson was eighteen and a half years old—gives us some hints:

<div align="right">

c/o Mrs. Aubin
2 Tregunter Road
West Brompton
London.W.
Feb. 17th/79

</div>

Dear M^r Eddison

May I beg that you will not throw this letter aside, but give it a patient reading, as my future prospects may depend upon your kindly consideration. I have read a sketch of your life with the deepest interest, and the lesson it has taught me of hopefulness amid difficulties, of firm endurance and determination to vanquish apparent impossibilities,—will, I trust not be soon forgotten. I have not your talents, but, I have patience, perseverance, an ardent love of science, and above all a firm reliance on God. I have no pride, and would willingly begin at the lowest rung of the ladder, and work patiently up, if by doing so, I might hope to attain independence, and repay my widowed mother for the care and affection which she has lavished on me for so many years.—I have proved like many others that with reverses of fortune, friends fall away, and I would rather solicit the help of an utter stranger like yourself, upon whom I have only the claim of a common nationality, (my mother being like your own, a Scotchwoman) than be dependent upon their aid, so coldly and grudgingly offered. I am sure you will not have cause to regret holding out a helping hand to a friendless and fatherless boy.

I shall be nineteen in August, have had a good English education, can speak French and German, being born on the Continent, have a fair knowledge of accounts, and draw well. For all these things, I have certificates from the Cambridge Examiner, and can give ample testimonials to my integrity and assiduity. If you will try me, I will take the lowest place in your employment, until you find me worthy of something higher, so passionately do I love your noble profession. I am neathanded and inventive, and have already constructed, or attempted to construct, the following articles; but I have very little opportunity for cultivating these tastes in England. An electric bell, worked by two Bunsens, two Micro Telephone transmitters, a couple of switches, four Leclanches, etc. I also gained a prize for the best model of the Tabernacle in the Wilderness at school last year.

If you will consent to give me a trial, I can pay my way to New York, and having been brought up with the strictest economy,

Antonia died on August 29, 1903. (*Orange Chronicle*, September 12, 1903.) Research on Eva is difficult since, although she is known to have married by 1894 (letter dated Dec. 12, 1894, in the Edison archives), there is no record of this marriage in Orange for any of these years. The New York City Health Department records cannot be searched. The above letter mentioned "Mr. D's nieces." Since Mrs. Dickson's relatives are certain this cannot refer to distaff relatives, Eva is indicated as the mother of these nieces. Antonia never married.

and with an abhorrence of anything like debt, my wants would be few and easily satisfied.

<div align="right">

Believe me, dear Sir
Yours respectfully
William Kennedy Laurie Dickson
</div>

P. S.
May I beg you to give me
an early reply as ~~to~~ [sic]
my final decision must be
made within two months.

This letter suggests a boy out of school rather than one still in. We see that he has gotten certificates from the "Cambridge Examiner" and that he was possibly in some sort of church school the year previous. His father had died and left his mother in the all too familiar "reduced circumstances." It appears possible that by this time he was at least the partial support of this mother and two sisters. It appears also that he may have come honestly by a certain prodigality or unsteadiness which we infer from his later life. There will be some, indeed, who will see an impractical nature in the very fact of his writing this letter.[5]

This letter brought a prompt response:

<div align="right">

Menlo Park, N. J.
March 4, 1879
</div>

William Kennedy Laurie Dickson,
Care of Mrs. Aubin,
2 Tregunter Road. London. W.
Dear Sir,
Your favor of the 17th ult. has just been rec'd.
I cannot increase my list of employees as I have concluded to close my works for at least 2 years, as soon as I have finished experiments with the electric light.

<div align="right">

Very truly,
T. A. Edison
</div>

This letter is reproduced in Dickson's 1933 article (see page 7). I have not found it in any letter book in the Edison archives. It became the basis for Dickson's adding his own name to the long, unlikely list of men who wouldn't take no for an answer. He claimed that

> in spite of this, I persuaded my mother and sisters to pull up stakes, and after a stormy crossing we landed in New York and

[5] The maturity of the handwriting and the probability that his mother was with him at this time suggests that this letter may have been written by his mother: its stress on the financial condition, etc., of his mother, may or may not support this theory, depending on the reader's viewpoint. (I have never seen an authenticated example of his mother's handwriting.) I have not determined his father's death date and so have not established how long before this the "reverses of fortune" which probably began with his father's death had begun. It is obvious, of course, that Dickson wanted Edison to think that the handwriting was his own, else he would have at least signed his own name. (I found this letter in the document files.)

continued down to Richmond, Virginia, by the Old Dominion S. S. Line. After residing there for two years, we youngsters made for New York City early in 1881. I took my book of credentials etc., to show Mr. Edison at his office at 65 Fifth Avenue, in case I should be lucky enough to gain an interview.

My reception was unique.[6] "But I told you not to come, didn't I?" said Mr. Edison. I agreed, but told him I couldn't have done otherwise after reading about the work in which he was engaged. He watched my face while turning my testimonials over, until I had to remind him please to read them. He only replied, "I reckon they are all right; you had better take your coat off and get to work." I had won.

Dickson was soon to be married (see page 152) and his wife, although not herself from Richmond, had relatives in that place.[7] Although the implication is clear that the Dicksons left England soon after the receipt of the March 4, letter ("However, in spite of this, I persuaded my mother and sisters to pull up stakes . . .") by any fair standard the Edison refusal can scarcely be said to have been a whetting of Dickson's appetite. By his own admission Dickson waited two years to approach his hero, and I will show that it was actually *four* years later that they first met.

I have been able to determine the exact day upon which the Dicksons arrived in Virginia from this "Old Dominion S. S. Line" trip. The "Manchester and Vicinity" section of the *Richmond Daily Dispatch* (Manchester was a locality in Chesterfield County until 1911, when it was incorporated into the city of Richmond) of Friday, May 30, 1879, said: "A family from England arrived at the Chesterfield Hotel yesterday and will spend the summer at that place." A family tie was responsible for the choice of Chesterfield County, Virginia, and indeed of the United States. Petersburg cemetery records read: "Elizabeth Kenedy [sic] Dickson . . . Born Chesterfield Co., Va." We can also fairly assume that the migration to America had been decided upon when Dickson wrote his February 17 letter, and that he was then only trying to make the best of a bad situation by making this shot in the dark *re* Edison. How many other letters he must have written to prospective American employers will remain perhaps undisclosed.

But the tie that brought the Dicksons to Virginia was soon to be loosened, for on July 1, 1879, the same paper carried the following item:

Death of a Foreigner—Mrs. Dickinson, a lady from Scotland, who recently resided in the vicinity of Chesterfield Courthouse,

[6] How depressingly *un*-unique is such a reception—if we are believe the long list of those who have said it happened to them! To believe, as Dickson later claimed, that Edison would have remembered the February 17, 1879 letter in April of 1883—a letter which was so routinely answered and which was only one of many hundreds of such—is even more unlikely.

[7] For example, the *Orange Chronicle* of May 4, 1895, carried the following social note: "Mrs. William K. L. Dickson left yesterday for Richmond, Va., where she will spend three weeks in visiting her brother Colonel Alexander W. Archer."

died last Saturday afternoon after a long illness. She came to this county a few weeks ago in company with her daughter, who is said to be a musical prodigy, having won a medal in the international contest several years ago in Europe for being one of the best performers on musical instruments.

The *Register of Deaths/Within Petersburg Va.* (which I examined in the Virginia Bureau of Vital Statistics in Richmond) corroborates June 28, 1879, and adds the further information that she died of "gastric fever"—which, in 1879, could have meant anything abdominal. Her age was given as 56 and her parents as "M [sic] & Kennedy Lewis [sic]." Her place of birth was Scotland, her occupation "none" and her marital status "widow."

The fact that the death occurred in Petersburg is also interesting. Possibly Mrs. Dickson died at the home of the Petersburg relative at whose instance the family came to Virginia. The later reference (see item below) to Antonia's being "of Chesterfield" we must take at face value, since the Manchester correspondent of the Richmond paper was reporting, and would not have been likely to err here. No Richmond directory of the time (which I have examined at the Virginia State Library in Richmond), though including Manchester residents, lists any of the family. The *Index of Grantees of Deeds/1749–1913* indicates no property purchase; the *Index to Wills/1749–1947* indicates no estate left by Mrs. Dickson.

The only copy of any Manchester paper in existence (all others having been lost in the eagerness of librarians to "clean up" the place) for 1879 carries no Dickson reference. So for our present purposes, we must assume that the two girls and their brother were resident in Chesterfield, Virginia, at least some months after their mother's death. That they remained there at least until October is shown by the following from the same paper of October 4, 1879: "Miss Dickson, of Chesterfield, was introduced to the audience [of the Beethoven Society of Manchester] . . . She rendered two excellent selections—piano solos—and was handsomely applauded."

I have been unable to determine the exact date of the family's removal to Petersburg, but that this had occurred by April 28, 1882 is obvious from a notice in the *Petersburg Daily-Index.* On this evening Antonia played and Eva sang at a concert. Antonia, "ill for several days came from a sick bed rather than disappoint the audience." Petersburg papers preceding September 1, 1881, were not available to me, but to that date, and after the October 4, 1879 reference in the *Richmond Daily Dispatch,* I have no direct information.[8] Since the Dicksons were not the sort to hide their respective candles under bushels, it may be fair to assume that they remained in the Richmond vicinity until shortly before April 28, 1882. Conclusive information must await further research.

[8] I examined carefully the local papers in the collection of the Petersburg Public Library. The first note of this far from inconspicuous group from abroad was taken on April 28, 1882.

The family quickly became involved in the social life of the town. By June 7, in spite of their less than opulent condition, they were already entertaining quite elaborately, and in a manner which local society, although charmed, must have found somewhat bizarre:

> Tableaux Vivants. The friends of the Misses Dickson and their brother, enjoyed a very delightful little entertainment last evening, at their residence, Strawberry Hill . . . The evening was in every way a delightful one . . .

By now they had probably become connected with the Petersburg Grace Episcopal Church (although Dickson later became a Swedenborgian), and had become friendly with the Archer family—probably the leading family socially, who were also neighbors and fellow church members. Lucy Archer's uncle, Fletcher H., had led the Petersburg citizenry in a defense of the town during the Civil War. (As mayor of the town he had also sentenced a ten-year-old Negro boy to twenty stripes at the whipping post for purse-snatching, and was reported to have saved the youth "from the full penalty of the law" only because of "his extreme youth." *Petersburg Daily-Index*, Feb. 28, 1882.) Lucy's father, Allen L., was "bookkeeper" for a local department store, A. Rosenstock & Co., in a day when a "bookkeeper" was company comptroller, treasurer and auditor all rolled into one.[9]

By August the Dicksons were taking the inevitable summer-in-the-mountains: (*Petersburg-Daily-Index*, August 14, 1882.)

> PERSONAL. A correspondent of the "Dispatch," writing from Mountain Lake, in Giles County, says: The Misses Dickson and brother are here from Scotland, though natives of France. The senior sister, only twenty-six years old, has given piano concerts in Great Britain, Germany and France, and has received honors from celebrated musical institutions of Europe. Miss Eva, eighteen years old, has a superb voice, and expects soon to make her *debut* in New York. The brother accompanies his sisters with a fine tenor, and is also given to the pencil art.

Although in residence in Petersburg for some time they are still "from Scotland" and "natives of France." This straining after social effect characterizes the whole Dickson career and, so far as we know, the lives of his sisters also.

Although "a fine tenor, and . . . given to the pencil art" Dickson had become known locally as the head of the family. The Petersburg City Directory, which was canvassed after January 1, 1883,[10] lists only:

Dickson William K L, h Friend nr Folly

[9] The Petersburg City Directory for 1882–1883, 1884, etc.

[10] Petersburg was being canvassed on January 16, 1883, for what was later entitled *The 1882–3 Directory*. (*Petersburg Daily-Index* of that date.) Only one directory in two years was produced, with the fair assumption that whoever was listed in January of 1883 could be assumed to have been, technically at least, in residence in both 1882 and 1883. I saw this directory in the Petersburg Public Library.

148

Between the time of the canvass for this directory and not later than March 28—and probably not later than some days *before* that date—the three Dicksons had come to New York City and had taken up residence at 255 West 24th Street. I found in the Edison archives a letter from a Raymond Sayer, dated March 28, 1883, which establishes that by this time Dickson had not even met Edison:[11]

> This will introduce to you my friend Mr. W. Kennedy Laurie Dickson, who is a talented young man speaking German and French fluently & has studied electricity, he is desirous of getting a position of some kind in your establishment, he brings with him from abroad fine testimonials, and has applied to you from London by letter a short time ago [actually four years ago]. I can recommend him very highly, and am sure if given the opportunity, would be of good service, and do credit to himself, anything you will do for him will be greatly appreciated.
>
> [signed] Raymond Sayer

With this letter of introduction Dickson included one of his own to Samuel Insull, who was then Edison's secretary:

> 255 West 24th. St.
> New York City
>
> Mr. Insull
> Dear Sir
> Having called several times & finding you out I take the liberty of writing you to ask you to make an appointment with Mr. Edison for me so that I can present a letter of introduction & have an interview with him some day this week that he may have a few moments of leisure.
> Awaiting your reply—
> I remain yrs truly
> Wm. Kennedy Laurie Dickson

We have here—in spite of many statements to the contrary—evidence that as of March 28, 1883, and later, Dickson had yet to meet Edison, much less enter his employ.

In a short biographical sketch appended to the 1895 booklet Dickson claimed to have become "superintendent of the testing and experimental department at the works in Goerck Street, New York." In his 1933 article he made a similar claim:

[11] Raymond Sayer was an artist who made a wash drawing of the Edison Lamp Works, presumably on the occasion of its opening, in 1882. The original, with the name clearly inscribed, may be seen now in the office of Mr. Harold S. Anderson in the West Orange laboratory. It is most appropriate to Dickson that he should have been introduced to Edison by an artist friend. It is also interesting that in spite of all of Dickson's apparently real claims to highly placed friends that he knew no such highly placed person among Edison's acquaintances. That Sayer was not so highly placed is obvious from the fact that his name does not appear in a nearly exhaustive card index of the Edison archives.

He [i.e., Edison] then gave me a note to Mr. Charles Clark, chief mathematician, and another to Mr. W. S. Andrews, superintendent of the Goerk St. testing and experimental department of the Edison Electric Works . . . The following year, with Mr. Edison's approval, Mr. W. S. Andrews gave me his place while he travelled through the United States planning and erecting electric light and power stations.

We know from laboratory records that as of at least the following June 8 Dickson was not yet in charge of such an experimental department, although that he was working there in some capacity not later than May 26 is certain.[12] The character of this work appears to have been similar to that claimed by him in the 1933 article:

My tests and experiments under Mr. Edison's direct instructions were indescribably interesting. We attempted to arrive at a fixed standardization of all electrical apparatus for home and power stations, such as type of dynamo, motors, lamps, meters, *etc.* One test or series of experiments stands out very clearly in my mind. I had the good fortune to help Mr. Edison to determine the meaning of the "Edison effect," or first concept of the famous "valve" used now in radio apparatus.

That Dickson worked on this standardization matter seems logical, but that he "help[ed] Mr. Edison to determine the meaning of the 'Edison effect' " appears less certain—although it is likely that his work at least involved this matter. (Few writers would agree that Edison himself ever "determined the meaning" of the so-called "Edison effect." [13]

By September 8 W. S. Andrews had gone on the road supervising local plant establishments, and I see no reason to doubt—considering Dickson's certain skill—that when Andrews left he actually did arrange to have Dickson placed in charge of the testing and experimental department of the Goerck Street works, as Dickson claimed. It is also possible that Dickson did not actually take charge of this department until the next year. In a letter dated June 4, 1884, he is addressed as "Supt. Testing Room." [14] By the following September 15 there is reason to believe

[12] A letter from Insull dated May 26 addresses Dickson at the "Edison Machine Works, City." (Letter book E1730, 10/11/82–5/29/83, page 480.) A letter on June 8 suggests that as of this date a "Mr. Edgar" was in charge of the testing department. (Letter book #1730, 5/29/83–1/3/84, page 99.)

[13] The phenomenon known as the "Edison effect" is discussed by Dyer, Martin, and Meadowcroft, page 579 *et seq.* This account also makes it clear that no one at this time "explained the meaning of this phenomenon"—least of all Edison, who left such theory to those he later called "the Bulged headed fraternity of the Savanic [sic] world." (Historical files, estimated date of letter, December, 1884.) That he was jealous of this fraternity seems obvious. More than once a parent was advised "Don't send [your son] to college." (E.g., letter book 12/5/90–1/20/91, page 213.) Crowther (*Famous American Men of Science.* New York: Norton, 1937) and Josephson are interesting in this respect.

[14] Letter book E1730, 4/8/84–6/22/84, page 347.

that he had already become Edison's "official" photographer, and was thus set upon the road that was to lead logically to his assignment to the kinetoscope work in 1889. In a letter dated September 15, 1884, Tate writes:[15] "Mr. Edison desires me to . . . state that he has a man in his Laboratory who does all the photographing he requires." Since Dickson is the man logically referred to here, and since all my study has turned up no other possible name, I believe that it can be assumed that reference is made to Dickson, and that it is evidence that he had become Edison's "official" photographer. Photographic portraits by Falk, however, continued to be regularly supplied whenever one of the frequent requests for an Edison photograph was made.

Before the close of the next year, 1885, Dickson had also (1) done considerable work in connection with the Edison Electric Tube Company's project of laying electric conduits under the streets of New York and Brooklyn;[16] (2) become somewhat more a man of affairs in the Edison organization; and (3) had moved—apparently still with his sisters, although there is a possibility that his younger sister Eva had gotten married by this time and had established a household of her own (see note 4 to this appendix)—to 49 West 24th Street, New York: a letter of October 1, 1885, is addressed to Dickson at this address.

Dickson claimed in the 1933 article that he started to work in the "Newark" laboratory in 1885:[17] "In 1885 Edison took me away from the Electric Works at Goerk St. to assist him in his private laboratory at Newark, N. J., where I was given research problems to work on." This must be made to accommodate the fact that he was probably not in Edison's New Jersey plant until February of 1887 (see note 3, chap. 8). It is likely that this memory was based on the belief that he began work with Edison in 1881 and that "the next year" became superintendent

[15] Letter book E1730, 1/4/84–10/16/84, page 373.
[16] The 1895 booklet said that Dickson was "charged with the office of laying the first telegraphic and telephone wires underground in New York City [and was] chief electrician in the Edison Electric Tube Co., of Brooklyn." A study of the Brooklyn papers indicates that what was apparently the first Brooklyn underground work began in Joralemon Street on Dec. 10, 1884, and that several different systems were tested at this time. Edison's conductors were iron pipe, about 16 feet long, each with a copper rod and a plastic insulating material forced between the copper and the iron. These frequently leaked current. (*The Electrical Engineer* (U. S.) has an excellent article entiled "The Edison System of Underground Conductors" in its March, 1885, issue.) The first Edison Electric Light Company underground mains in New York City itself were earlier. By November, 1881, for example, about three miles in a ¾ square mile area south of Spruce and east of Nassau streets had been laid (*Scientific American*, November 19, 1881). So if Dickson was "first" in any of this work, it must have been in Brooklyn late in 1884. It was during this work, apparently, that he first met Harry Marvin. (See pages 151 and 153.)
[17] The laboratory was then in the Lamp Works in Harrison, New Jersey, often confused with East Newark even today. Dickson is again incorrectly remembering the location: possibly he remembered "Newark" from a mistaken impression of *East* Newark.

of the Goerck Street testing department where, as he later remembered, he worked for two years before going to New Jersey.[18]

Our next fact is a quaint and somewhat poignant note written on April 18, 1886, by the father of Miss Lucy Agnes Archer of Petersburg, now in the town hall in Petersburg:

> This is to certify that my Daughter Lucie Agnes Archer marries Wm K. Laurie Dickson—with my full consent, and approbation —and that there is no lawful impediment to the marriage. She is of age.
>
> [signed] A. L. Archer
>
> Sunday April. 1886—18th Day of month.

We remember that Dickson had become acquainted with this family in his Petersburg sojourn of the previous years. In the marriage license now in the Clerk's Office in Petersburg, Dickson gave his occupation as "electrician," his birthplace as St. Buc, France, and his age as twenty-six. By May 6 the newly-weds had landed in Cobh on their wedding trip; they visited many European cities and the pianist Rubinstein at his home in Peterhof, Russia, on August 27.[19]

Many will see a certain sadness in this cultivated daughter of the South, possessing an education (according to local legend) beyond her surroundings and already past an age considered marriageable, seizing (if we may use the word) upon this opportunity to achieve what surely must have seemed to her a glamorous position. That she was actually forty years old at the time of her marriage and that she gave her age as the same as that of her new husband, add to this impression.

Lucy Agnes Archer had considerable literary accomplishments. She had translated the "Rosa von Tannenburg" stories from the German, and in March, 1895, a *Frank Leslie's Popular Monthly* article she wrote on Anton Rubinstein gives us an additional impression of a true daughter of the nineteenth century. Her adulation of Rubinstein at this visit— ". . . I found myself on my knees before him, covering his hands with tears and kisses, and murmuring, brokenly: 'Master, master, you have played us into heaven!' "—reminds us of the Countess d'Agoult at the feet of Liszt.

Meanwhile the "Edison laboratory" had moved to the Lamp Works in Harrison, and there is reason to believe that Dickson returned to New York from his extended wedding trip, worked at the Goerck Street shop for a time before it was closed at the end of 1886, and then went to Harrison to work on his "research problems" in the week beginning February 19, 1887.

[18] Shortly after July 10, 1886, and before August 18, 1886, what was then known as "the Edison laboratory" moved to the Lamp Works in Harrison, New Jersey. (Letter book E1730, 6/23/86–9/14/86, pages 24 and 168.)

[19] *Daily-Index* reports the *Richmond State* as saying on May 6, 1886: "The following Virginia party have landed at Queenstown [i.e., Cobh]: Mr. W. Kennedy-Laurie Dickson and wife (née Archer) of Petersburg . . ." The *Frank Leslie's Popular Monthly* article (see below) describes the Rubinstein visit.

As of the following May 25 he was not yet in charge of the ore-milling work in the Harrison establishment, although by June 5 he had begun to work on this project, and by the following fall was more deeply in it than anyone else in the Edison organization.[20] His work, once he arrived at the West Orange laboratory, has already come under our observation, so it would seem appropriate here to discuss only such spare information about his private life as we possess.

As of May 1, 1888, the Dicksons had not yet moved to Orange, although there is some reason to believe that this move may have occurred shortly thereafter. The Orange Directory, adjusted to the regular May 1 movings, did not list Dickson in Orange as of May 1 of this year. Yet a note from his wife written from 189 High Street in Orange was found in such a place in the Edison archives as to suggest that it was written in June, 1888; since it would have been logical to move to Orange as soon as possible, I assume that such a move was made.

There is also a possibility that when Dickson returned to New York late in 1886 he may have taken residence, with his new bride, at 2 West 21st Street. In the fly leaf of the Dickson notebook previously mentioned (see chap. 8) this address, together with the name of a "Cornelia Cook" appears. "Cornelia Cooke" is listed in the New York City Directory of the time as a boarding-house keeper.

By July 5, 1888 (and quite likely some time before) Dickson had earned the dislike of Samuel Insull, just as he was later to earn the dislike of A. O. Tate, Edison's secretary for many years. In a note written on this date Insull—himself an Englishman, a member of a minority ethnic group, and a member of what Dickson must not have refrained from making clear was a somewhat inferior social stratum—wrote to Tate (document files "Edison Machine Works. 1888"):

> I have your several leters about the hand of Mr. Edison's bust[!]. I have written to Mr. Marks suggesting that he have the hand made. I have also suggested that he might get you to have a photograph of Mr. Edison's hand made for the artist to work from. I think if you will ask the Right Honorable William Kennedy Laurie Dickson to make a photograph, he will only be too happy to do so, if he can get Mr. Edison to hold his hand steady long enough.
>
> Yours very truly,
> [signed] Saml Insull
> General Manager

On August 10, Dickson, taking a well-earned vacation, registered at the Sanitarium in Clifton Springs, New York.[21] This countryside was to become a favorite with the Dicksons. The next day Harry Marvin, with whom Dickson had become acquainted while working on the underground

[20] A letter of October 12, 1887, states that an E. Thomas was actually in charge of this work. (Letter book E1730, 6/21/87–10/22/87, page 262.)
[21] *Clifton Springs Press*, August 16, 1888. See also page 00.

system in New York, also registered at this hotel.[22] The two friends spent a week together; a week which included photography on a fairly serious level, since a wire in the Edison archives records that Dickson asked that a complete photographic outfit be sent him.

On or about October 24, after some time as the center of activity in the ore-milling department, Dickson became its chief, and as the head of an important laboratory department had claim to much Edison attention.[23] On January 31, there is indication that he had managed to displease another Edison man.[24] There is also much to suggest that the very fact of Edison's recognition of Dickson sparked some of this feeling. There was considerable jealousy among the laboratory men as to who was to have most attention, etc.[25]

By May 1 the Dicksons had moved from a relatively humble dwelling at what was then 189 High Street (now 261 High Street, in Orange) to a relatively luxurious one on the northeast corner of Hawthorne and Cleveland in Orange.[26]

The next years were years of social success in Orange and a position in town affairs befitting a man who was known to be high in Edison's regard. As I have shown earlier, Dickson had become co-inventor (to say the least) with Edison in an important ore-milling patent, and ore-milling was to be the chief laboratory interest for all the years remaining to Dickson in Edison's employ. That Dickson's public relations ability was well thought of we have also seen earlier.

For lack of any specific place to record this information, and because the possibility exists that it may have been apropos the ore-milling work (in which Edison said there was "no co-invention") I record here that Edison paid the following amounts to Dickson over and above his salary: on February 2, 1891, $300.00; on February 27, 1892, $300.00; on March 7, 1894, $1,500.00; on July 31, 1894, $73.10.[27] Although we may ascribe the last amount to advances for expenses, what the first three payments were for I leave to the reader's imagination to decide. Dicksons' salary, incidentally, was thirty dollars per week. Ramsaye says, in a letter to a New York newspaper, that Dickson got the "equivalent"

[22] *Ibid.*

[23] On October 24, 1888, E. Thomas, whom we have seen to have been head of the ore-milling department, was given a letter of reference. (Letter book 6/21/87–11/5/88, page 262. This letter book is improperly titled "6/21/87–10/22/87" since it also contains late 1888 letters.)

[24] This was Tate. The reader is invited to consider letter book E1717, 1/30/89–4/8/89, page 59; also letter book E1717, 1/20/91–2/26/91, page 155. (See also page 67.)

[25] For example, the Lauste biography (see page 88) is convincing in its statement that John Ott was of this jealous nature. See also the Dickson letter in the legal file above noted, note 2, chapter 1. Dickson was preparing a composite photograph of Edison and his workers and complained to Dyer and Seely that he was getting "a shower of abuse from those placed in their own estimation *too far* from Edison.

[26] Orange City Directory, May 1, 1889, page 43. These houses are still standing and in good repair.

[27] Accounts payable/sub-ledger No. 6, page 208.

of this $30 per week from Edison for the last 20 years of his—Dickson's —life. When we consider that Edison was convinced up to the end of his days that Dickson had "double X'd" him (see page 67), and that he was clearly not a man of sentiment in his business, this pension was rather more likely the corruption of witnesses than a case of conscience. But in either case, our thesis that Dickson did most or nearly all the motion picture work at the Edison laboratory is certainly not weakened.

That Dickson was no exception to the practice among Edison's men (see the Ott and Brown testimony on pages 49–50) of permitting their loyalty to inhibit their sense of morality may be seen from the matter of the Wheeler-Chinnock interference. A Patent Office Interference had been declared between an application of Edison's, an application of Wheeler, and an application of one of those several men who felt that they had been cheated by Edison: Charles E. Chinnock.[28] By October 28, 1891, this interference had already been declared [29] and on the following April 21 Dickson gave testimony in the case which reflected nothing but dishonor upon himself and upon the employer-employee relationship which countenanced such an action.[30] What he swore to on this occasion is plain from the opinion of the Patent Office Examiners-in-Chief, delivered on March 28, 1893, and sent by Dyer and Seely to Edison on April 19:[31]

> Edison does not set up any date of conception in his preliminary statement, but both in his statement and in his deposition he asserts a first use of the invention in March, 1883, "which was recorded in a note-book of one of my assistants, W. K. L. Dickson, between March 25 and 29, 1883."
>
> . . . His assistant and witness, Dickson . . . testifies to other experiments conducted at Goerck St., N.Y., prior to June 1, 1883 . . . Dickson also testifies in regard to a sketch in his notebook made between the dates of March 25 and 29, 1883 . . .
>
> The Examiner finds two objections against the force of this evidence for Edison; first that Edison is not sufficiently connected with them as inventor, and secondly, that the sketches are not dated. As to the first objection, however, Dickson is testifying for Edison and in behalf of his inventorship. He lays no claim to any inventorship of his own, but expressly swears that he was merely the agent and assistant of Edison, carrying out his orders and suggestions, as he was employed to do . . .
>
> As to the second ground of objection that the sketches do not bear date, it is sufficient to say that the sketches by themselves do not impress us as evidence, and a date upon them would

[28] This Chinnock was prominent in the Edison hierarchy in those days and was later to be an important witness in the Motion Pictures Patents Company litigation, when he produced a motion picture camera which he made in the fall of 1894 and which he utilized in the production of several motion picture subjects.
[29] Letter book 10/21/91–12/31/91, page 39.
[30] Letter book 1/30/92–8/31/92, page 275.
[31] Document files "Electric Light. Lamps and Filaments. 1893."

not add to their impressiveness. It is the positive testimony of the expert Dickson concerning them and what they indicate and when they were produced that impresses us, and we do not see our way to a conclusion in face of it that Edison was not the inventor of this matter in controversy in the early summer of 1883 as he claims . . .

We have seen on page 149 that Dickson was, at the time he swears to have been in Edison's employ and to have made notebook notes and sketches, i.e., March 25–29, 1883, *not yet in Edison's employ, and had not yet even met Edison.* We cannot assume that Dickson did anything else than swear to what he must have known was not the truth: a truth he must have known from Edison office records if not from his own memory.

That Dickson was also not above manufacturing "evidence" and that other Edison men were not above using such evidence we can see from another item. At Christmas, 1892, he gave Edison a photograph of himself—Edison—in the cab of the Menlo Park locomotive. This photograph is negative #6374 in the Edison Museum collection, and is reproduced on page 180 of the Dicksons' 1894 biography and opposite page 462 of Dyer, Martin, and Meadowcroft. It will be obvious to anyone who makes a close study of this photograph that it was actually a "fake" and that the figure of Edison was added at a later time—presumably immediately before Christmas of 1892.[32] What is supposed to be Edison's hand on the controls is obviously much too far away to *be* Edison's. No shadow falls on Edison's face as it would certainly do if he were under the hood of the cab as the photo shows him to be. And the photograph bears in other areas the unmistakable sign of retouching.

Meanwhile, Dickson and his sister Antonia were flourishing in local musical and social affairs. For example, in one of many such appearances, he played the violin in a concert on February 11, 1892.[33] On October 13, 1892, he was represented by several slides in the annual slide exhibition of the fashionable Orange Camera Club, of which he was a prominent member.[34]

The remainder of Dickson's stay in Orange and his employ at the Edison laboratory was characterized by a continuation of this considerable social activity—in which his sister Antonia played an important

[32] Historical files "Photos. R. R. Electric." This photo bears an inscription not yet included in any reproduction:

<div align="center">Compliments of W. L. Dickson Xmas /92</div>

[33] The *Orange Chronicle* of February 16. Dickson was said to have taken part in this concert with two others of apparently considerable technical ability —his sister Antonia and Theodore Lehmann, a fellow worker at the Edison laboratory.

[34] The *Orange Chronicle* of October 15, 1892.

part.[35] He left Edison's employ on April 2, 1895,[36] aided the Lathams materially in their competitive efforts, and subsequently became very important to the fortunes of the Biograph Company. In spite of all this Josephson (page 397) says that after he left Edison "he achieved virtually nothing." He, his wife, and his sister Antonia sailed for Europe on May 12, 1897.[37] In London Dickson established himself as a supplier of European motion picture subjects for the booming business of the Biograph Company. He took many sensational subjects, including motion pictures of Pope Leo XIII in the summer of 1898 and the Boer War in 1899 and 1900.[38] The following years were checkered and appear to be outside the scope of this account. He was made a Fellow of the Royal Geographic Society in 1908.[39] His wife Lucy died about 1910.[40] He married a Scotswoman[41] about 1915 and settled in Twickenham, England, for the rest of his life, with occasional sojourns in Jersey, the Channel Islands. At some time previous to 1925 he adopted a son. According to reports that I have not found useful to verify, this son was killed in action in the Second World War.

Dickson himself died of carcinoma of the prostate in Montpelier House, Montpelier Row, Twickenham, on September 28, 1935.[42] He was buried in the Twickenham Cemetery.[43] His tombstone inscription—with something less than sparkling originality—reads:

> And so beneath His shadow I abide
> For when I wake I shall be satisfied

[35] The reader must realize, of course, that the part of this sketch following October, 1892 (the closing date for the main text of this book) contains only the highest highlights of Dickson's career, and only a very small percentage of the information which has been gathered concerning it. A planned study of the beginnings of the Biograph Company will detail his life up to about 1911, when his last significant contact with this company seems to have occurred.

[36] He himself said (Equity 5-167, U. S. Circuit Court, Southern District of New York) April 2, 1895. The *Orange Chronicle* of April 27, 1895, said merely "has resigned." Raff and Gammon, writing to Erastus Benson on April 29 said merely that Dickson had by that time left Edison's employ. (Baker Library, Harvard University.)

[37] *Orange Chronicle*, May 15, 1897.

[38] The Leo XIII pictures made a considerable stir at the time and were a great boost to the Biograph fortunes. Dickson's Boer War adventures are recounted in his *Biograph in Battle* (London: Unwin, 1901).

[39] According to a letter from the Society to the writer.

[40] According to her grand-nieces, the Misses Archer of Richmond, Virginia, and Baltimore, Maryland.

[41] According to Mrs. Sedgwick, the present resident of Montpelier House, Twickenham, who had considerable to do with both Dickson and his second wife.

[42] According to the death records in Somerset House, London.

[43] Visited by the author on May 11, 1959.

APPENDIX B · *Original Texts of the Four Motion Picture Caveats*

[I have adhered as closely as possible to the original spelling in my transcription of the texts of these caveats. Where self-evident errors in grammar or spelling occur, I have, of course, not altered these. Where changes occur in the original they are faithfully indicated. In all other cases I have used my own judgment as to what was intended. (For example, when writing a "v," Edison made this letter the same way in both capitals and lower case, varying only in size.) In such cases I have allowed the sense of the context to be the governing factor—although, as the reader will plainly see, there was much carelessness about the beginning of sentences, periods, etc. If errors occur, it is hoped that these will not be regarded as crucial.

[The original handwritten copies of all these caveats are in the document files of the Edison laboratory in West Orange: the reader is recommended to these originals for further study. —G.H.]

MOTION PICTURE CAVEAT I

Handwritten original:

Seeley

Rush this I am getting good results Edison Caveat 110 Filed October 17th. 1888

Orange N.J. Oct 8 1888

I am experimenting upon an instrument which does for the Eye what the phonograph does for the Ear, which is the recording and reproduction of things in motion, and in such a form as to be both Cheap practical and convenient. This apparatus I call a Kinetoscope "Moving View" In the first production of the actual motions that is to say of a continuous Opera The Instrument may be called a Kinetograph but its [sic] subsequent reproduction for which it will be of most use to the public it is properly called a Kinetoscope The invention consists in photographing continuously a series of pictures occuring [sic] at intervals which intervals are greater that [sic] Eight per second, and photographing these series of pictures in a continuous spiral on a cylinder or plate in the same manner as sound is recorded on the phonograph At the instant the chemical action on the cylinder takes place the cylinder is at rest and is only advanced in rotation a single step which motion takes place while the light is cut off by a shutter. Thus there is a practically continuous rota-

158

tion of the cylinder but it takes place step by step and at such times as no photographic effect takes place. For illustration say the The cylinders ~~which I propose to use~~ [crossed out in the original] may be about the same size as the phonograph the number of threads to the inch on the feed screw is about 3$\cancel{3}$2 [change in original; "33" was written first, then changed to "32"] This will give a photograph image about $\frac{1}{32}$ of an inch wide. giving about 180 photographs per revolution or 42000 for the whole cylinder It is probable that $\cancel{1}$25 will be sufficient to give the illusion of as if looking at the actual scene with all its life & motion this will therefore record & reproduce all the motions or scenes occuring [sic] during a period of 28 minutes.

By gearing or connecting the Kinetograph by a positive mechanical movement, ~~The~~ a continuous Record of all motion is taken down on the Kinetograph & a continuous record of all sounds are taken down by the phonograph. and by substituting the photograph recording devices on the Kinetograph for a Microscope Stand & objective it becomes a Kinetoscope & by insertion of the listening tubes of the phonograph into the ear The illusion is complete and we may see & hear a whole Opera as perfectly as if actually present although the actual performance may have taken place years before. ~~by these means~~ [sic]

i\cancel{f} [sic] I prefer to use the cylinder form instead of a plate with volute spiral. A continuous strip could be used but there are many mechanical difficulties in the way while the cylinder with the microphotographs taken on its surface in continuous spiral permits of the use of very simple mechanism The cylinders which are hollow shells slip onto a taper cylinder permanantly connected to the instrument just as in the phonograph.

The shells may be of any substance which will preserve its shape such as plaster paris and other mouldable bodie's [sic] The Collodion or other photographic film may be flowed over it just as if it was an ordinary flat photo plate, a positive being taken, but if it is desired to produce a negative series of photographs a glass cylinder is used —— [undecipherable mark-out] surface of the Cylinder or shell is flowed & the records taken, The cylinder or shell being exceedingly thin say of Mica is slipped over the regular Cylinder to be used in practice whose surface is sensitized & printed from the negative by light in straight lines without reflection from side surface's. A positive may be taken & with proper ~~micros~~ lenses' reproduced on another cylinder just as one photograph may be taken from another.

The permanent cylinder may even be covered with a shell and a thin flat film or transparent tissue sensitized by wrapped around it [sic] which after being filled with images may be detached from the shell and use as a negative to print many positive [sic] on sheets which are permanently pasted on shells for actual use, perfect alignment and no eccentricity of the surface must be had as the focus of the observing objective will be changed ~~If it~~ Although a presser foot might move the objective & thus keep it in focus even if the surface of the cylinder did not run true.

In figures 1 . 2 . & . 3. I illustrate diagramatically the principal feature of the apparatus.

W fig 2 is the drive pulley preferably run by a belt from an Electro-motor,

V The break wheel. ~~best shown in fig 2~~ [sic]

P is the feed screw as in the phonograph

7 a friction connecting the drive pulley & break wheel with the Screw p micro

and attached Apparatus 3, the traveller arm for Carrying the photo-graphic apparatus while recording and the observing Microscope when reproducing

5 is the Arm Carrying the above a shutter with two openings see fig 3 is vibrated by double magnets G. &. F. between the surface of the cylinder and the recording or reproducing apparatus.

M. The lever of the vibrator is pivoted at h. When the lever is to the right or to the left the Aperture is opposite the objective but when in the act of moving the line of vision between the Cylinder & objective is Cut off by the space between the two holes in the Shutter

When the Shutter is at Either the left or right limit and still the cylinder is also in a state of rest and no movement of the cylinder takes place ~~except~~ while an aperture is opposite the objective, hence in recording and reproducing the photographic surfaces are in a state of rest, the in-termittant [sic] rotation of the cylinder takes place by means of an Escape-ment. O & fork T reciprocated by the double magnets Q. &. R. The reciprocation of the shutter as well as the Escapement being controlled by magnets and the break wheel V & springs 20 & 22 One spring being in contact with the metallic part of the wheel. (see fig 1) while the other is in the space between—on a further rotation of the break wheel the opposite effect occurs and the spring which was previously in insula-tion now comes in electrical contact with the wheel & the other set of magnets are energized thus advancing the cylinder $\frac{1}{32}$ of inch only at the time the shutter has closed the vision between objective & cylinder as the speed of w should be much greater than p The break wheel V need have but few breaks—this insures greater rapidity of advancement of the cylinder during the interval when the shutter closes the light beam off—The Motor should be governed so as to produce even results, Of course in practice the mechanism will be considerably changed from that shewn as the figures are merely diagramatically [sic] so as to simplify the Explanation of the g——— [?] of the invention

A Tuning fork with break might control the magnets, the fork being kept in continuous vibration by a magnet & automatic make & break con-tact, The levers T & the shutter lever may be Reeds or tuning forks them-selves their magnets being in one circuit & controlled by a Mosler fork or Reed electrically operated or by a self make & break attached to one of them The break wheel V might be run by a governed motor or mecha-nism ~~& b~~ Independent of the motor driving the main devices—The levers T & shutter may be operated mechanically by means of a undulating

160

[sic] surfaced rotating wheel which reciprocates a lever which not only serves to release the Escapement O but works the shutter, a strip paralell [sic] to the cylinder & between the objective & surface of cylinder may be reciprocated up and down two continuous aperatures [sic] are in the strip, The whole of the shutter is then detached from the travelling arm rendering the images free from blurring due to any movement or vibration of the arm, A plate machine with feeding mechanism say a volute spiral or worm or multiplying gearing may be used and flat records taken instead of using cylinders but I do not think this form is so practical.

By using very large transparent shells the pictures may be even projected on the screen as in microphotographic projection or enlargement, the cylinder being revolved & the source of light inside of the cylinder, negative records being only recorded—

<div align="right">Thos A Edison</div>

MOTION PICTURE CAVEAT II

Handwritten original:

Caveat No. 114 Filed March 25th 1889
Recd Feby 5 89 H. W. Seely

<div align="right">Orange Feby 3 1889</div>

Dyer—I am putting several inventions in this Caveat. merely want to get it in patent office for dating purposes—

. . . Fig 19̶ 54 [sic] Is a Kinetoscope ———— [?] for recording & reproducing moving objects photographically—14 is the cylinder The cylinder is not round but paralell [sic] with its length are a number of flat places about $\frac{1}{32}$ wide. This gives a flat face for the photographic record from the microscope & the picture is not thrown out of focus as it would be if the cylindrical surface was round, especially on very small cylinders which it is necessary to use on a commercial apparatus.

19 is a motor. 17 a friction. 18 a pulley 16 a belt. 15 a pulley on the cylinder shaft. 25 a [sic] escapement wheel worked by escapement. Connected to lever 23 & escapement 21 & 22 limiting stops to lever 23. 20 is the extended shaft of cylinder provided with a leaf or key 12 is the thread or screw part, having about 25 threads to the inch 13 the screw nut which engages in the threads on 12. 1 . 2 . 3 . 4 i̶s̶ are [sic] a similar magnet to 24 with lever limiting stops & escapement & wheel—a shaft 6 carries the revolving shutter 7 in front of the objective 8 6 is pivoted at 9 on a bridge 10. 27 is camera etc. The two magnets are arranged in two circuits provided with break & contact wheels both on one shaft. so that any definite movement one related to the other can be obtained. These break wheels are rotated by a governed motor. The action is as follows: the cylinder stands still. The shutter advances & opens the shutter while the cylinder is still the photographic effect takes place on the flat of the cylinder; the shutter closes then the cylinder advances another notch but such advance only takes place while the shutter closes off the light. These

actions takes place [sic] continuously at the rate of 15 or 20 times per second. 26 shews the cylinder with flattened parts . . .

Motion Picture Caveat III

Handwritten original:

> Phonograph
> Caveat May 20 1889
> No. 116 Filed Aug 5th 1889.

. . . Fig 51 & 52 Shews an improvement on the Kinetoscope. N is the rotating cylinder of glass covered with the photographic film; K the Lenses AA′ the object to be photographed with all the motions P is a break wheel which closes & opens the circuit of an induction coil g with Leyden jar H: a Reflector X throws the light of the spark on the moving object AA′ The break wheel breaks are so arranged that there will be say 15 breaks per second [sic] allowing ⅛ of inch of space on the cylinder for each photogh; owing to the instantaneous character & high actinic power of each spark a ——— [?] shutter cutting of [sic] & on the lenses from the cylinder as in my first device is unnecessary. At every spark a photograph is taken always at definite intervals & as the spark is infinitely quick the continuous movement even of the cylinder does not blur the photograph. of course a shutter through which a powerful arc light beam or sunlight passes to the object may be controlled positively by a lever worked by the machine & thus instead of continuously illuminating the subject to be photoghd & the use of a vibrating shutter, the light itself is intermitted.

Fig. 51 shews the manner of reproducing the picture on a screen the microphotoghs instead of being looked at through a microscope are projected very much magnified by using a lens on K & inserting inside of the rotating glass cylinder spark points controlled by the break wheel, the spark being given at the exact moment when the Negative is exactly opposite a hole leading to the lens∉; [sic]

Motion Picture Caveat IV

Handwritten original:

Nov 2 1889

Caveat

. . . Fig 46 is a Kinetoscope. The sensitive film is in the form of a long band passing from one reel to another in front of a square slit [the Edison attorneys read this word as "slot"] as in fig 47. on each side of the band are rows of holes exactly opposite each other & into which double toothed wheels pass an [sic] in the wheatstone automatic telegh instrument. This ensures a positive motion of the band. The ——— [?] film being transparent.

The Leyden jar spark illuminates back & by means of a lense the image

is projected on a screen Instead of a leyden spark a continuous light with revolving shutter may be used

The operation of photographing is as follows—in front of the apparatus where the film is exposed the Microphotographic apparatus is placed. A Motor preferably an Electric Motor drives a shaft at great velocity on this shaft is a sleeve carring [sic] double toothed wheels engaging in the holes of the band of photofilm The connection between this sleeve & shaft is a friction one, on the sleeve is a release escapement with fork connected to the tongue of a polarized relay. This polarized relay is reciprocated by means of a break wheel alternating Currents through it or by an alternating small dynamo The time is so arranged with these Currents that The band is advanced one step for a photograph 10 times in one second the escapement working of course 10 times in a second but of this 1/10 of a second. 9/10 ths of the 1/10 the band is still with 1/10 of the 1/10 of a second the band is moving In other words if there were but one photograph to be taken in 10 seconds. The band would be shifted in 1 second & stand still 9 seconds, and this proportion holds good up to any number of photographs per second until the mechanism fails to act, by thus causing the band to be in a state of rest 9/10 of the time yet taking 10 photographic images per second Most perfect results are obtained & the great necessity of a shutter is modified.

The break wheel which controls the polarized relay may be connected to the screw shaft of the phonogh hence there will be a positive connection & all the movements of a person photoghd will be exactly coincident with any sounds made by him—

fig 48 gives rough idea of positive feed mechanism of course this principle can be applied to cylinders covered with the photo material as well as in bands—

When a leyden spark is used the break wheel is arranged that it takes place while band is in state of rest or if shutter used reciprocating or revolving It is to be released by ~~a p~~ [sic] the same devices that release ~~the~~ [sic] & move the band and the shutter so devised that light only passes to the image while projecting it on the screen when in a state of rest.

APPENDIX C · *Fifty Representative Dickson Errors*

[The following errors show the extent to which Dickson himself, in his many statements, wandered far afield from the truth. It is intended to demonstrate the necessity for careful checking of the statements of pioneers, who frequently contradict even themselves. Errors such as these, however, are particularly interesting to the researcher, since it is always

illuminating to discover their source, and the search often uncovers new truth. —G.H.]

(1) On April 3, 1914, Dickson claimed only the *week* after Edison's return from Paris, later he claimed the *day*. Later he claimed October 6, and still later he "proved" this latest date by dating the microphotograph/Edison photo four years earlier than, according to copyright records, it was actually taken. (Letter to Charles Edison, Edison archives. See also page 89.)

(2) On April 3, 1914, he claimed a synchronous projection in "early 1889. Can anyone beat that?" (Letter to Charles Edison, Edison archives.) Later he claimed October 6, 1889, as the first such.

(3) Placed his "fighting for the film" also in "early 1889" (*ibid.*) whereas we know this was not the case (see page 61). Twenty years later he claimed 1888 for this. (Correspondence with Glenn Matthews in 1933, page 58.)

(4) He claimed a 25′ length for his "early 1889" film whereas he says that he used Carbutt film before he used Eastman film, and we know that Carbutt film could not have been used before June 25, 1889. (See page 41.)

(5) He said he "entered Mr. Edison's employ in 1881" and regularly printed on his business cards "Late with Edison 1881–1897." We know, however, that he was still in Petersburg, Virginia, in 1883, and as of March 28, 1883, had not yet entered Edison's employ. (See Appendix A.)

(6) In 1928 he claimed 1886 for Edison's disclosure of the zoetropic motion picture idea, whereas in 1894 and again in 1933 he claimed 1887 for this disclosure. (Edison archives historical files, "Motion Picture History. Dickson Articles and Letters.")

(7) He claimed "Rapid initial or fundamental data was obtained—year 1887" in Room 5 of the West Orange Laboratory, whereas we know this room was not in operation until 1888. (*Electrical Review* January 27, 1888. Also note by Hayes, the laboratory night watchman, dated January 23, 1888 in document file "Laboratory, West Orange. Construction. 1888.")

(8) He claimed that "various drum apparatus" was constructed in 1887, which we have shown on page 28 could not have been true.

(9) He said in the 1928 article (Meadowcraft item cited in chap. 11) that ¼″ pictures were the first cylinder photographs, whereas in 1933 he claimed several smaller than even ⅛″: at one point "pin-head" photos, at another "pin-point."

(10) He said in the same article that the first Eastman strips were 50 feet long whereas five years earlier, in the 1928 article, he had claimed 25 feet. (We have seen on page 53 ff. that neither was true.)

(11) He said that George Eastman himself exhibited the new film at "N. Y. Camera Club," which we know was a function Eastman never performed. Furthermore, Eastman was in Europe at this time. (See page 68.) In the 1933 article he said "The Eastman representative."

(12) He ascribed first use of the word "film" to Edison, whereas we know that it was in use for 30 or 40 years previously. (See Eder, and thousands of earlier usages in periodical literature.)

(13) He claimed that the "photograph building" was in use in August of 1889, whereas we know it was only so two months later. (1928 account written for Meadowcroft and page 126.)

(14) He made multitudinous and varying claims apropos projection. (See pages 88–91.)

(15) He claimed 1″ film in 1889, whereas we know that 2 years later only ¾″ film was still being used.

(16) He claimed recognition and distinction for his father. (See page 143.)

(17) He made 4 (out of a possible 19) improper kinetoscope subject identifications in his December, 1933, list.

(18) He gave kinetoscope shutter dimensions which we know are improper for the May, 1891, apparatus: 10″ diameter and ⅛″ slot. These were actually 11½″ and ⅜″—the latter being particularly crucial.

(19) He claimed Carbutt celluloid use in 1887, whereas we know Carbutt's first celluloid film did not appear until very late in 1888. (See page 39.)

(20) He claimed printing and developing methods and apparatus for 1889 and 1890 which we know were not yet in existence in May, 1891, at the earliest. (See page 117.)

(21) He claimed "in or about 1891" and "'90–91" for the Sandow motion picture subject, whereas we know this subject was shot in 1894. (1928 article and a notation on an eight-frame strip—negative #1897 of the Museum of Modern Art Film Library, and the George Eastman House Collection.)

(22) He claimed in 1930 to have become superintendent of the Goerck Street experimental testing department in 1882, whereas he was still in Petersburg, Virginia, in this year. (See Appendix A.) This claim was made in a letter to Merritt Crawford who was then writing a biography of Eugene Lauste. (See page 88. A copy of this letter was also sent to Meadowcroft—see source cited in item 6 above.)

(23) He claimed responsibility for camera, film perforator, etc., for himself in December 12, 1933, letter to Crabtree of the SMPE. He had frequently claimed these for Edison previously (Matthews correspondence above cited).

(24) He dated the Carmencita subject as 1889–1891, whereas we know it was shot in 1894. (See negative number 1898 in the Museum of Modern Art Film Library for this claim.)

(25) He dated the Kodak after his visit to the "N. Y. Camera Club" in a letter to Oscar Solbert of the Eastman Kodak Company, December 10, 1932. (Matthews correspondence.)

(26) He said that he used Blair celluloid films in 1888, whereas we know that Blair produced no such film until 1891. (Matthews corre-

spondence; Blair reference, *American Amateur Photographer,* May, 1891; and *Anthony's Photographic Bulletin,* April 11, 1891.)

(27) He said he showed the new film to Edison the next day after the "N. Y. Camera Club" meeting and then went immediately to Rochester and saw Eastman, when we know (see p. 68) that both Eastman and Edison were in Europe at the time.

(28) The Dickson letter of December 10, 1932, to Oscar Solbert cannot be reconciled with the Dickson letters of September and November, 1889.

(29) Dickson's remarks apropos Eastman experiments in this December 10 letter cannot be reconciled with the facts as we know them and as even Eastman's most extreme partisans have recorded them. See Ackerman, *op. cit.,* page 70 *et seq.*

(30) He described, in this December 10 letter, a building as being in existence in Rochester in 1888 which was not built until the middle of 1889. (See Ackerman, *op. cit.,* page 62.)

(31) In this letter Dickson requested a copy of his "early in 1889" telegram to Eastman saying "Eureka." This copy was never supplied, apparently, and there is no record anywhere of the Eastman people ever agreeing that such a wire existed.

(32) Dickson quoted Eastman as saying, "I ought to remember you in my will." In juxtaposition to the last paragraph of this letter, in which Dickson asked the Eastman company for "a slight acknowledgment in the form of a grant" we find the former claim difficult to credit.

(33) The contradiction implicit in the February 12, 1933, letter to Matthews: "I justly and emphatically say that both Mr. Eastman and Edison were jointly responsible for Kinematography—which would not have come into existence at that time but for my persistency . . ."

(34) His letters to Charles Edison, March 8, 1933: "All the 'takings' or experiments dating from 1888 were made on Eastman samples or base" contradicted the claims for Carbutt film which he had made in the 1928 and the 1933 articles. (The Charles Edison letter is in the Edison archives, *loc. cit.*)

(35) Dickson letter to Charles Edison May 14, 1933, in the historical files in the archives: "I have been forced to take out a formidable affidavit . . . that the Exhibit I gave your father on his return from Paris took place November 6, 1889 [sic] . . ."

(36) In the same letter a "completed kinetograph" was claimed for 1888; in previous remarks (e.g., April 3, 1914—see 2 above) 1889 is claimed.

(37) He said, in a letter to Earl Thiesen of July 5, 1933, that "his successor" at the laboratory reprinted his 1895 booklet under another name, whereas we know it was not such a "successor" (whoever that could have been) but Raff and Gammon, and that it was done in preparation for the vitascope premier of April-May, 1896. (Letter, gift to me from Kenneth Macgowan, November 7, 1958.)

(38) He called the "Black Maria" photo reproduced in this 1895

booklet one taken upon the "Maria's" completion, whereas we know that it was one showing alterations made some time after the "Maria's" completion—probably about 18 months later. (*Ibid.*)

(39) He dated the "Maria's" "day of completion 1892," whereas we know it was 1893. (*Ibid.*)

(40) He claimed a single-perforation camera for 1888, whereas even Edison and his employees, with all their exaggeration, claimed only 1889. (See page 49.) This claim was made in a letter to Matthews on July 12, 1933 .

(41) He placed the 1888 Camera Club talk "Later . . . the following year *after patent* [not my italics] application" in his letter to Matthews of August 16, 1933. (Matthews collection.) We know, however, that this application was made on March 3, 1889—making this remark a three-way contradiction.

(42) He said, in the same letter, that Eastman corroborated his next-day-after-Camera-Club visit—which he did not, corroborating only, according to Dickson elsewhere, merely a visit in 1888.

(43) He said in the same letter that the kinetoscope and the kinetograph each "took me a few months using Eastman film to arrive at," yet he had elsewhere claimed the kinetograph for 1888 and now said it was used to project pictures for Edison on October 6, 1889, immediately upon completion.

(44) It is fantastic to presume that anything like the enthusiasm imputed to Eastman concerning the Dickson work could have occurred in a man whose organization wrote the September 7, 1889, letter. (See page 62.)

(45) It is likewise fantastic to assume that Eastman would have given Dickson "many samples" months before even his *application* for a patent on March 3, 1889. Dickson made this claim in the August 16, 1933, letter above cited.

(46) Dickson misquoted Matthews in his postscript to the August 16 letter as saying that the new Eastman film was "patented—exhibited—and sold" on June 15, 1889. This was far from what Matthews had actually said in the August 7 letter: "Our records show that one of the first advertisements for our film is dated June 15, 1889."

(47) He claimed February, 1892, for the *building* of the "Black Maria," in a letter to Matthews of October 2, 1933. We know from Edison records that the "Black Maria" was begun in December of 1892 and finished by February 1893.

(48) He claimed 124 [sic] articles for *Cassier's Magazine* whereas we know (see page 7) that this number was only 13. He made this claim twice: first in a letter to Matthews of October 2, 1933, and again in a letter to Matthews on November 5, 1933.

(49) He claimed 1897 for his *The Biograph in Battle* whereas this book is a series of reminiscences of a war that did not commence until December, 1899.

(50) He said *Harper's Weekly* in the November 5, 1933, letter above cited when he wrote no such article.

APPENDIX D · Selected References to the Work of Other Men

[Although it may be fairly said that Dickson did most or nearly all of the West Orange laboratory work on the motion picture, it may also be said that what he did was strongly influenced by his knowledge of the work of contemporaries in the same line. In accordance with other historians, I take the view that in France, England, and the United States, developments were being made in this period which culminated in motion picture invention. I have selected the following references because these have seemed to me to be the most significant. —G.H.]

As the expert for the Defendant said in Equity 6928, there was "no principle in this art . . . which had not been fully explained in various publications and patents," and many investigators had long before established the laws which govern the persistence of vision.

Desvignes (French #537, 1860) used endless bands vertically; placed slits between pictures—having the effect of a revolving slotted shutter; and used an electric spark for illumination.

Shaw (British #1260, 1860) used photography and a revolving slotted shutter.

Ducos (French #61976, March, 1864; Certificate of Addition December, 1896) took pictures instantaneously at short intervals; proposed the use of the camera as a projector; suggested the use of his camera from a travelling carriage or vehicle; mounted photos on a continuous band of paper or fabric; used magnified images viewed through a slit in a band and reflected in a concave mirror; used, as an alternate, lenses moving along with the band; suggested time lapse photography; slow motion; reversal; astronomical photography.

Both Lincoln (U. S. #64117) and Linnett (British #925, 1868) patented "thumb books." Van Hoevenbergh (U. S. #259950) patented substantially the same thing.

Johnson (British #1443, 1868) patented a device for taking and exhibiting animated microscopic photographs on a slide, with the change effected by a button and spring; the period of vision was, therefore, longer than the period of change.

Brown (U. S. #93594) described a magic lantern in which the intermittent movement of the pictures was effected by a Maltese variation

168

and in which the light was intermitted by a revolving shutter, the openings of which were made to coincide with the film during the time in which the pictures were at rest.

Dyer and Seely thought so much of the significance of the Brown data that they wrote Edison on December 1, 1896 (document files "Motion Pictures, 1896"), that it "seems to me that it goes far towards making success in the kinetoscope patent doubtful."

Donisthorpe (British #4344, 1876) described photos on a continuous strip of paper equal distances apart, wound from one cylinder to another and viewed by either the zoetrope or the phenakistoscope. (See also page 171.)

Reynaud (British #4244, 1877) described continuous illumination by reflection. Reynaud (British #2295, 1889) described picture bands of indefinite length, supply and take-up rollers, toothed to effect positive movement and exact coincidence of pictures. As Gaston Tissandier, prominent French writer, said in *La Nature* of November 4, 1882, these were "very clear pictures . . . with the greatest of ease projected moving pictures . . . using simply an every-day lamp."

The *Scientific American Supplement* of August 9, 1879, reprinted an article by Fairman Rogers in *Art Interchange* in which Rogers said that Wachter, in 1862, showed ten drawings of a galloping horse in the phenakistoscope.[1] Rogers made a large zoetrope for these: "The idea was [says Rogers] of course, a very natural one, and it had already occurred to Gov. Stanford and Mr. Muybridge ["already," we assume, by the time Rogers had made his zoetrope, not by the time Wachter had made his device] who had independently done the same thing." [2]

Any *Scientific American* (of June 5, 1880) report of the Muybridge projection in San Francisco (as recorded in the *San Francisco Call* of May 5, 1880) may also have been noticed by Dickson, who was an avid reader of scientific periodicals.

(I have not discussed the Coleman Sellers and Henry Heyl work in this line, because these inventions have been treated in both Ramsaye and Quigley, *op. cit.*)

Two long, detailed, profusely illustrated articles on the work of Marey,[3] in the *Scientific American Supplement* of February 5, 1887, and February 12, 1887, must surely have been read with interest by Dickson. The *Scientific American Supplement* of January 10, 1891, also carried a translation of a *La Nature* article in which Marey's latest apparatus was described for what I believe was the first time in an American periodical. This apparatus contained a continuous, sensitive surface—paper-based

[1] A fuller discussion of these "pre-history" devices must wait for a later study. The reader is referred, for example, to the writings of Plateau quoted by Helmholtz, *op. cit.*

[2] It may be interesting to note here that on some occasions Muybridge gave a small tap with a hammer at the moment at which each foot appeared to strike the ground.

[3] See also discussion of Marey on page 79 ff., *et seq.*

film, which he had been using since 1888 [4]—moved intermittently before a slotted shutter from a continuously moving feed roller *with a loop to avoid jerking.*

(Marey's patent may or may not have been seen by Dickson by the time of the *Scientific American Supplement,* January 10, 1891, description. It is perhaps more likely that he saw it later, since bound volumes of the patents were received by the Astor Library in New York City several months after publication, and the Edison laboratory copies appear to have come about the same time.)[5]

On the fifth of January, 1889, *Wilson's Photographic Magazine* published a translation of a paper which had been read by Marey before the French Academy of Sciences the previous October 29. Because it represents the stage which had been attained by foreign workers in the field, and because it was so much noticed in the Edison litigation, I reproduce it here.

> To complete the researches which I have communicated to the Academy at recent sessions, [i.e., October 15 and 22, 1888] I have the honor to present today a band of sensitized paper upon which a series of impressions has been obtained, at the rate of twenty per second. The apparatus which I have constructed for this purpose winds off a band of sensitized paper with a speed which may reach 1m, 60 per second, as this speed exceeds my actual needs I have reduced it to 0m, 80.
>
> If the impressions are taken while the paper is in motion, no clearness will be obtained, and only the changes of position of the subject experimented upon, will be apparent. But if, by means of a special device, based upon the employment of an electro-magnet, the paper is arrested during the period of exposure, $\frac{1}{5000}$ of a second,[6] the impression will possess all the clearness that is desirable.
>
> This method enables me to obtain the successive impressions of a man or of an animal in motion, while avoiding the necessity of operating in front of a black background. It seems moreover destined to greatly facilitate the studies of the locomotion of men and animals.

This excerpt was quoted by the American Mutoscope Company as part of their evidence in the suit brought by Edison for infringement of his U. S. #589168.[7] Well it might, for here we have explicit proof of photographs of motion having been taken intermittently on a continuous band of film from a single point of view at a rate that easily accommodated persistence of vision. (Josephson—page 384—would have us believe

[4] The Balagny films were mass-produced by the Lumières in Lyons, and very popular in France as of May, 1888, and before.
[5] Receiving book entries for March 24, 1890; April 29, 1892.
[6] I have not yet made a study of Marey's exposures; this time seems short.
[7] Equity 6928, United States Circuit Court for the Southern District of New York, Defendant's Record. The quotation is from the *Comptes Rendus* of the French Academy of Science, Vol. 107, pages 677 and 678.

that Marey's work was limited to "a series of dry plates revolving on a wheel.")

Previous Marey publications had already reached America, and the work of this man was certainly well known to Dickson and even to Edison in spite of the fact that he had little interest in photographic matters. He could not very well have missed the many prominent articles on Marey's work that had appeared in American publications—chiefly his favorite *Scientific American*. If any more proof were needed, the fact that Edison visited Marey the following fall and saw his work during a visit crowded with social and scientific activity would suffice.

Edison said that he saw Marey's work in the case cited above—page 109, answer to question 126. Marey confirmed this in a statement made in 1892 on the occasion of the first International Exposition of Photographers in Paris: "J'essayai dès lors d'obtenir avec des images chronophotographiques la synthèse des mouvements au moyen du zootrope ou du phenakisticope [sic] de Plateau. Un appareil de ce genre figurait à l'exposition de 1889, où je le fis voir à M. Edison." [8] I have been given a photographic reproduction of this account by M. Pierre Nogues, a long-time associate of Marey himself. In "Nouveau Developpement de la chronophotographique," a paper from the *Revue des travaux scientifiques*, published in Paris in 1892, Marey similarly said:

> De mon côté, aussitôt que j'eut réalisé la chronophotographie sur pellicule mobile, je plaçai de longues series d'images positives dans un zootrope et j'obtins de la sorte des résultats assez satisfaisants. M. Edison, à qui je les montrai à l'exposition de 1889, s'en inspira sans doute pour créer son kinetoscope qui, vers 1893, fit son apparition en France.[9]

Similarly, Albert Smith says:[10]

> . . . Some time later Edison was to tell me of a visit in Paris with E. J. Marey, the distinguished French physiologist . . . For some time Edison had been experimenting with the possibility of photographing moving pictures on a cylinder similar to that used in his phonograph. Departing for Paris, he instructed his assistants to keep hard at the experiment. In Paris, Marey took him into his shop and there revealed his motion-picture camera, utilizing pictures in sequence, one under the other as they are today. "I knew instantly that Marey had the right idea," Edison told me. On the return trip aboard ship, he said, he penciled

[8] "I have been trying since then to obtain with the chronophotographic images a synthesis of movements by means of the zootrope or Plateau's phenakistiscope. An apparatus of this sort was at the 1889 exposition, where I showed it to Mr. Edison."

[9] "On my part, as soon as I had gotten chronophotographs on flexible film, I put a long series of positive images in a zootrope and I obtained in that way fairly satisfying results. Mr. Edison, to whom I showed them at the 1889 exposition, was no doubt inspired by them to create his kinetoscope, which, toward 1893, made its appearance in France."

[10] *Two Reels and a Crank*, Doubleday, 1952, page 80.

out a mechanical draft of a machine and immediately upon his arrival at Orange he ordered a halt on all work on the cylinder idea and the new project was launched. Out of that brief visit with Marey came the famous kinetoscope.

These statements are explicit and accord well with the rather sudden change from cylinder apparatus to perforated strips described in the last motion picture caveat (see page 81) and with the strong impression we get from reading these caveats that they were carelessly set down. It is furthermore difficult to see just how Smith would have gotten his information if not from Edison: he was not exactly the man to have known of Marey *or* the Dickson cylinder work.

Edison constantly received visitors at his residence in Paris, the Hotel du Rhin, 4 Place Vendome. (Document files "Edison. Personal. 1889.") He was photographed while in Paris by M. V. Daireaux. (Document files "Phonograph. U. S. Misc. American Companies. 1892.") On August 18, Gaston Tissandier, the editor of *La Nature* (see above), called on him. (Edison archives photos, "Photos Portraits" contains M. Tissandier's calling card, dated August 18.) On the next day he attended the fiftieth anniversary of the Daguerre invention where he was introduced by Janssen, the astronomer who had made motion pictures of the transit of Venus in December, 1874, in Japan and who was now head of the French Observatory at Meudon.[11]

Newspaper interviews were published in *L'Industrie* on August 24 and in *Le Petit Moniteur Illustre* and *La Vie Populaire* on August 25. (Historical files "Publications.") On September 4 the Ministry of Commerce gave a dinner in his honor. (Document files "Phonograph Talking Doll. 1889.") On September 9, the City of Paris also gave him a dinner. (*Ibid.*) On September 10 he ascended the Eiffel Tower in the company of Eiffel himself. (Document files "Thomas A. Edison. Personal. Handwriting. 1888 [sic].") Marey's invitation to Edison may well have been issued at the Daguerre dinner on August 19 and so the visit may have been after that date. The fact that the interviews published on August 24 and 25 contain no references to such a visit may or may not be significant. Dyer, Martin, and Meadowcroft, pages 740–747, have an interesting account of this Paris visit.

On April 3, 1891, the *Photographic Times* discussed Marey's 50-per-second photos with exposures from $\frac{1}{2000}$ to $\frac{1}{3000}$ of a second—although on January 10, as we have seen, the *Scientific American Supplement* had already had a detailed, well-illustrated article on the same subject.

The Anschütz publicity we have already noted (see pages 84–86).

Le Prince (British #423, 1888) described a camera and a projector; flexible film, both positive and negative; an intermittently moved strip and an intermittently operated shutter. This camera was later built by Herman Casler and used for taking pictures—which resulted in a fa-

[11] Document files, "Edison. Personal. 1889" gives the text of this Janssen introduction.

vorable court decision. In spite of this Josephson (page 396) says that this camera "is known to have been completely inoperable."

Donisthorpe and Crofts (British #12921, 1889) described a long negative band, printed later on a similar band; intermittent movement in projection; intermittent projection light at about seven illuminations per second. This patent also established that such a series of seven per second was sufficient to accommodate persistence of vision. The film band itself regulated these intermittent light flashes; the pictures on the band touched but did not overlap, were stationary during exposure, and were carried forward in a dark period of not more than $\frac{1}{12}$ or $\frac{1}{16}$ of a second.

Varley (British #4704, 1890) was described in the *British Journal of Photography* for December 5, 1890, in which Varley described his improvements on Friese-Greene: a film held taut against the film gate by pawls, and moved intermittently by a "displacement roller." Varley also discussed Friese-Greene in the following interesting way:[12]

> [Friese-Greene] also proposed to use a camera to take the varied movements and the play of features at the same moments that an operator was talking into a phonograph, and devised an apparatus so that when the sound was reproduced in the phonograph the image of the speaker would change, because the mechanism controlling the phonograph also controlled the changing slides of the lantern. You thus not only hear him talking, but see him also at the same moment moving his lips &c, as the play of features corresponds with the words spoken into the phonograph . . . I only mention the subject of the unison working of phonograph with the camera, and the reproduction of the two kinds of impression—one due to sound and the other to light—because somewhat recently Mr. Edison has been credited with inventing such a machine, and it is only right that we as Englishmen should look after the laurels due our own countrymen.

On January 8, 1891, the Mortimer Evans patent (British #3730 of 1890) was issued. Evans had been the co-patentee with Friese-Greene. Evan's description chiefly involved improvements on the Friese-Greene apparatus. As he says: "The objects of the present invention are to simplify the means by which the successively adjacent or following portions of a sensitized strip . . . are caused to be presented in position for exposure, arrested in position . . . and removed from position . . . so as to allow . . . the strip to be more gradually advanced. . ." He effected this by causing "the advance of the strip to be effected directly from the main shaft . . . in lieu of . . . intermittently operating escape devices independently and momentarily operating when released from the control of such shafts . . ." The intermittence which Evans then described is brought about by: (1) An intermittency of the take-up roller,

[12] This quotation is from *The British Journal of Photography* of December 5, 1890. The "somewhat recently" may refer to such English reports as the previous February 3 reference in the *Pall Mall Gazette* (London) to the *New York Herald* report of February 2, 1890. (See page 76.)

(2) An intermittency of the "wind-on" roller, and (3) An intermittency effected by the addition to the take-up roller of two additional rollers which receive their intermittency from rocking arms upon which they are mounted.

Surely, as William Main, the expert witness mentioned above, said:

> previous to August, 1891, the art had received a high degree of development, and . . . all its principles, so far as they are known today [i.e., 1900] had been fully explained in various publications and patents. [Edison's work is] rather . . . the perfection of minor mechanical details, the use of improved photographic materials or possibly a more judicious selection of subjects for exhibition calculated to please the public fancy.

As the judges of the United States Circuit Court of Appeals, sitting in judgment on the appeal taken by the American Mutoscope Company from an unfavorable decision in the United States Circuit Court for the Southern District of New York, said on March 10, 1902:

> It is obvious that Mr. Edison was not a pioneer in the large sense of the term, or in the more limited sense in which he would have been if he had also invented the film. He was not the inventor of the film. He was not the first inventor of apparatus capable of producing suitable negatives, taken from practically a single point of view, in single-line sequence upon a film like his, and embodying the same general means of rotating drums and shutters for bringing the sensitized surface across the lens and exposing successive portions of it in rapid succession. Du Cos anticipated him in this, notwithstanding he did not use the film. Neither was he the first inventor of apparatus capable of producing suitable negatives and embodying means for passing a sensitized surface across a single lens camera at a high rate of speed and with an intermittent motion, and for exposing successive portions of the surfaces during the periods of rest. His claim for such an apparatus was rejected by the patent office, and he acquiesced in its rejection. He was anticipated in this by Marey, and Marey also anticipated him in photographing successive positions of the object in motion from the same point of view.
>
> The predecessors of Edison invented apparatus, during a period of transition from plates to flexible paper film, and from paper film to celluloid film, which was capable of producing negatives suitable for reproduction in exhibiting machines. No new principle was to be discovered, or essentially new form of machine invented, in order to make the improved photographic material available for the purpose. The early inventors had felt the need of such material, but in the absence of its supply, had either contented themselves with such measure of practical success as was possible, or had allowed their plans to remain on paper as indications of the forms of mechanical and optical apparatus which might be used when suitable photographic surfaces became available. They had not perfected the details of apparatus especially adapted for the employment of the film of

174

the patent, and to do this required but a moderate amount of mechanical ingenuity. Undoubtedly Mr. Edison, by utilizing this film and perfecting the first apparatus for using it, met all the conditions necessary for commercial success. This, however, did not entitle him under the patent laws to a monopoly of all camera apparatus capable of utilizing the film. Nor did it entitle him to a monopoly of all apparatus employing a single camera.

This decision summarizes well, I believe, the inappropriateness of the Edison patents. It does not, however, take into consideration what we now know and what the court may have known then: that Edison had not completed an apparatus described as "the first apparatus utilizing" the new film in 1889. As this decision says elsewhere, the court held that this matter "was not in dispute." It was not in dispute because Dickson, now a prominent member of the defendant's firm, had already made dispute impossible by claiming projection years before, in a time when his continued trouble with Edison's new manager, W. E. Gilmore, made him begin to see the end of his Edison association. (Dickson made his first claim for the October, 18ᶠ ∂, projection sometime between the *Cassier's Magazine* deadline for December, 1894—this claim was not made in *Cassier's*—and the deadline for his *History of the Kinetograph Kinetoscope and Kinetophonograph*, where he first made this claim. This deadline, as I have established elsewhere,[13] was apparently around December 17, 1894.)

Even if Dickson had told the defendant's attorneys that this projection was a series of photographs taken by the still camera and projected through an Anschütz tachyscope (an admission which he did not make to the day of his death—indeed he may not have remembered that it *was* an Anschütz tachyscope, although in describing it he gave himself away), to have begun their case with an admission that this claim was false would have prejudiced their case beyond hope of recovery. They were justified in their confidence that such a straightening-out of the record was not necessary and that they would win their case anyway. And as we have seen they were not mistaken—although the judge of the lower court, in a decision remarkable for its carelessness and lack of understanding of the testimony, must have made them anxious for a while.[14]

[13] *Image*, published by the George Eastman House, Rochester, New York, September, 1959.
[14] For example, (1) The use of the phrase "persistence of the eye" does not appear to be one which would be used by a man who understood what persistence of *vision* was. (2) The use of the word "things" to describe the apparatus alleged to have been infringed is frivolous. (3) The recurrent identification of the phenakistoscope as being Marey's would not have been made, it seems, by one who had actually *read* the original account in the *Scientific American Supplement* of June 18, 1892, where *Plateau's* phenakistoscope was referred to. (4) The use of the word "learnedly," to me, suggests sarcasm, whereas William Main's description—the one referred to here—was certainly learned. (5) The Court rests heavily on the decision of the Examiners-in-Chief who allowed the patent to issue in 1897, and not upon a fresh look at the

As I have said above, the Friese-Greene matter is of special interest. Much has been said and written concerning the problem of whether or not Friese-Greene was "the inventor of the motion picture." It seems proper here to discuss the Friese-Greene and Dickson relationship and to delineate the extent to which Friese-Greene affected Dickson in this work. A discovery that I have made among the Edison documents appears to settle the claims of Friese-Greene's biographer at least.[15] The excellent work of Georges Sadoul, chiefly his *Histoire générale du cinéma,* (Paris: Denoël, 1946 *et seq.*) and Raymond Spottiswoode will need to be reappraised. Spottiswoode, for example, in his careful summary in the *Hollywood Quarterly,* Spring, 1955, could naturally take no cognizance of the enormous mass of new material available to me, and assumed 1889 for the West Orange strip-film attainments.

On June 21, 1889, Friese-Greene applied for a patent on an "Improved Apparatus for Taking Photographs in Rapid Series." With this application Friese-Greene left a "Provisional Specification." [16]

According to British law:[17] "The application must contain a declaration to the effect that the applicant is in possession of an invention, whereof he . . . claims to be the true and first inventor, and for which he desires to obtain a patent, and must be accompanied by either a provisional or complete specification." The Provisional Specification is kept secret in the Patent Office until such time as the applicant files a Complete Specification. The Comptroller may require suitable drawings at the time of the acceptance of the Provisional Specification. The applicant has nine months in which to file his Complete Specification with a possible extension of one month. After ten months the application becomes void.[18]

On March 13, 1890, well within the time allotted by law, Friese-Greene left his Complete Specification. At this time the law provided (*Ibid.,* page 59): "On the acceptance of the complete specification the comptroller shall advertise the acceptance; and the application and specifications with the drawings [etc.] shall be open to public inspection." The applicant who has had complete specifications accepted—Friese-

facts presented. (6) Although the Court said that "the claim is not limited to negatives," if it had read the original application presented in evidence in the file wrapper, it would have seen that only negative film was within the experience of the applicator. (7) Many proofs are not remarked upon in this short, effectively 4-page decision. The Appeals Court used $11\frac{1}{2}$ pages of careful analysis after an opening $4\frac{1}{2}$ pages in which it stated a clear premise for its subsequent reasoning. The judge of the lower court found only four pages necessary, and in these he leaned heavily on direct quotation of both the language of the claims themselves and opinions of the Patent Office.

[15] Ray Allister, *Friese-Greene* [:] *Close-Up of an Inventor.* (London: Marsland Publications, 1951.)

[16] I am not concerned here with what happened before that. The earlier Friese-Greene work, although interesting, is outside the scope of this history. I agree with the opinion of the Friese-Greene protagonists that this patent is the crucial one so far as Edison is concerned.

[17] See *Patents and Designs Acts 1907–1932,* Sweet and Maxwell, Ltd., London, 1933, page 55.

[18] *Ibid.,* page 57.

Greene did on March 13, 1890—is protected from the date of the Provisional Specification. So we see that as of March 13, 1890, the Friese-Greene specifications were made public by the Patent Office, although Friese-Greene was protected from the date of the provisional specification.

But meanwhile, Friese-Greene, with what some may call a certain prodigality, had released the details of his invention to the public press. He may have been already officially assured by the Patent Office that his Complete Specification would be accepted—as indeed it was shortly afterward—and he may thus have felt free to divulge the contents of his patent, knowing that in any disagreement that might arise his Provisional Specification would protect him in the matter of priority.

His "official" means for this public announcement was *The Photographic News* (British) of February 28, 1890. This issue contained a detailed description of his apparatus together with an exterior view of the camera and two interior engravings so complete that there could be no doubt to a technician as to exactly how the inventor achieved his ends. The apparatus provided, among other things:

> . . . the paying out and the rolling up rollers . . . a continuous motion . . . a film, during its exposure to the light . . . at rest . . . a drum . . . draws the loop of fresh film which has been gathering into the exposure position and at the same time passes forward the already exposed film into the form of another loop in readiness to be wound up on the winding cylinder.[19]

(To quote the Dyer and Seely letter accompanying the Edison affidavit of December 21, 1896, reopening his abandoned camera application—now that it looked as if it could be a money-maker: "For the purpose of these affidavits, we have taken as the earliest pertinent reference the description of the Friese-Greene apparatus published in the 'Photographic News' for February 28, 1890.")

In its November 15, 1889, issue, the *Optical Magic Lantern Journal and Photographic Enlarger* (British) had had a notice concerning the Friese-Greene camera, but the description was only a précis:

> This instrument is pointed at a particular object and by turning the handle several photographs are taken each second.
> These are converted into transparencies, and placed in succession upon a long strip, which is wound on rollers and passed through a lantern of peculiar construction (also the invention of Mr. Friese-Greene), and by its agency projected upon a screen. When the reproduction of speech is desired this instrument is used in conjunction with the phonograph.

The Friese-Greene biographer, with a carelessness for facts that we must wonder at, said:[20] "The following issue of the *Optical Magic Lantern*

[19] Thus we have another loop, claimed as invention by so many others—one of the most unlikely being that of Enoch Rector, whose claim is supported by Ramsaye.

[20] *Op. cit.*, page 56.

Journal carried an illustration and technical description of the camera." If she had read this "following issue" she would have found: "Just before going to press we have been particularly requested by Mr. Friese-Greene to delay publishing the description of his camera until after its exhibition at the Royal Society, by which time all patent arrangements will have been completed." In the February issue of this magazine the editor was still hoping for Friese-Greene details "by our next issue." A search of this next issue and many subsequent issues has revealed no such details.

The April 11 issue of the *Photographic Times* (American) discussed this camera. And in its issue of April 19, 1890, the *Scientific American Supplement* carried a description of the camera which was practically a reprint of the *Photographic News* piece noted above. In the same month the *St. Louis and Canadian Photographer* also carried a description. In addition, several other non-specialist periodicals referred to it briefly.[21] Thus we know that a complete technical description was widely available as of February 28, 1890.

Even assuming that Dickson did not see the February 28 issue of the *Photographic News* (and we cannot assume this since we know he was a frequent visitor to the Astor Library in New York City, that the laboratory subscribed to many foreign publications, and that he himself must have seen both at home and at the Orange Camera Club many additional photographic publications) we can be sure that after the *Scientific American Supplement* of April 19, 1890, he had become familiar with exactly what Friese-Greene had done in this line.

During my search among the Edison archives I made a very interesting discovery. Between the pages of letter book E1717 (4/12/90–8/13/90) in the Edison archives, I found inserted a letter in Friese-Greene's own hand which had been written to Edison on March 18, 1890, and which is now published for the first time:

> T. A. Edison
> Dear Sir
> Have sent you by same post a paper with description of Machine Camera for taking 10 a second which may be of interest to you.
> Yours faithfully,
> Friese-Greene

Inserted in the same place was a note apparently made by whoever had read the letter (possibly Thomas Maguire, Tate's stand-in); obviously at Dickson's instance:[22] "Get the paper then turn it over to Dickson." At the top of the letter is noted "answered April 15, 1890."

Turning to this latter date I found: "The paper, description of Machine Camera for taking ten a second, mentioned in your letter of 18th ultimo, addressed to Mr. Edison, has not yet come to hand."

[21] *Cassell's Family Magazine,* for example, noted the matter on page 254 of its March, 1890, issue.

[22] On May 7, 1921, Dickson wrote Edison: "How is it that Freese Green [sic] when he wrote you in 1890 (you showed me the letter) described what he was doing . . ."

178

Whether or not this paper ever "came to hand" is unknown. No such paper has been found in the Edison archives. But by this time, its interest to Dickson would have been only academic, since he would already have seen the *Scientific American Supplement*'s detailed description on April 19, and would see the patent itself in a few weeks.

(Incidentally, the text of a letter from Friese-Greene to Edison of February 10, 1890, is claimed by Will Day to have been a part of his *Historical Collection* offered for sale in the early 30's.[23] I have been refused access to this letter and so am unable to present it here. But the March 18 letter above quoted makes certain that this February 10 letter contained no crucial matter, since only at the latter date did Friese-Greene actually appear to send his camera details. Likely, the earlier letter—if it exists—was one from Friese-Greene asking Edison if he would *like* to have such details, with the March 18 letter merely confirming that such details had been sent.)

The idea that the April 15 letter may have been written after the Friese-Greene details had already been recived appars fanciful. There would have been no possible motive at this time for such a deceit.

In the Friese-Greene biography (page 53) the claim is made that Friese-Greene had sent such a letter to Edison in June of 1889:

> describing in minute detail the construction of his camera and the projector designed for use with films taken by the camera . . .
> Friese-Greene prepared the letter carefully, making several drafts. His secretary helped. He read the drafts to his chief operator, Mr. Scott Alexander . . . Mr. Alexander suggested alterations for the sake of clarity, and when the final letter went off both men agreed it gave an exact account of the Friese-Greene invention . . .
> The letter to Edison brought only a formal acknowledgement from Edison's laboratory and a request that Friese-Greene should send full drawings of his camera . . .
> The drawings made for the patent were available. Within five days they had been sent off to Edison. That was completely and utterly the end of the matter—for twenty years. In 1910 Edison stated in an affidavit that he had never received such a letter.

I have examined carefully the letter books covering the entire month of June, 1889, at the Edison laboratory (i.e., 5/21/89–6/21/89 and 6/21/89–8/3/89) and have found no such "formal acknowledgement." I have not, moreover, found any other relevant letter from Friese-Greene to Edison except the one mentioned for March 18, 1890.[24] Obviously,

[23] Will Day, a pioneer English motion picture operator, offered this collection of memorabilia for sale and published a catalogue of this collection. This catalogue can be seen in both the New York Public Library and the library of the Museum of Modern Art in New York.

[24] Only one other letter of any kind has been found. On May 9, 1892, Friese-Greene wrote Edison—here published for the first time:

> I wrote to you some time ago, asking if you could find a situation for me in America [this letter, if it ever existed, is now lost]. Could you not find

since the same patent was involved, and since we know that Friese-Greene offered to send—and may have sent—drawings of this patent (now lost) the next year, the 1889 letter was confused with the 1890 letter and the former never existed. Certainly, it is difficult to understand why *two* such letters, offering the same thing, would have been written.[25]

APPENDIX E · *The Horizontal-Feed Camera in the ·Edison Museum*

Much has been made in many contemporary sources of a horizontal-feed motion picture apparatus. This apparatus, now to be seen in the Museum of the Edison laboratory in West Orange,[1] New Jersey, is approximately such a machine as might have taken the Dickson motion picture strip of the May, June, 1891, publications noted elsewhere (see page 103 *et seq.*). As I have said, it first entered history on December 21, 1896, when Edison, straining to overcome the priority claims of Friese-Greene, claimed:[2] "For the purpose of these affidavits, we have taken as the earliest pertinent reference the description of the Friese-Greene apparatus published in the "Photographic News" for February 28, 1890." Although it was dated by Edison and his attorneys as an 1889 apparatus, and is so dated in the museum, there is no evidence that it existed, as shown, before the preceding summer, i.e., 1895, and much to suggest that it was manufactured for legal purposes in, possibly, 1896.

something remunerative that would suit me at the Chicago Exhibition. If so, I should be so much obliged for I am sick of Patents & Companies in England & people here imagine anyone can complete an invention while they are talking.

<div align="right">Yours very respectfully
[Signed] Friese-Greene</div>

Trusting you won't mind my writing.

To this Edison replied (after an accustomed manner) on June 7: "Mr. Edison regrets that he is unable to offer you a position—He has nothing to do with appointments at the Chicago Exhibition." One cannot help thinking by how much American motion picture developments would have been speeded if Friese-Greene had joined forces with Dickson at the Edison laboratory at this time!

[25] The Zglincki statement (*op. cit.*, page 204) that Friese-Greene offered Edison a roll of photos (!) in December of 1890 appears as arbitrary as other statements by this writer. (See my review of his book in *Film Culture*, November, 1957.) In any case, such a roll of photos could not have been significant since how they were produced had already been known at the Edison laboratory since the previous February.

[1] Edison museum accession number E5477.

[2] File wrapper of application #403534 (U. S. Patent #589168) in Industrial Records Division of National Archives, Washington, D. C.

Accompanying the above statement by Edison's attorneys an affidavit by Edison dated December 21, 1896, contained the following:[3]

> Subsequent to the making of the machine above referred to [i.e., a cylinder apparatus designed to take motion pictures on a spiral] and prior to the month of February, 1890, I constructed and used other machines for photographing objects in motion, one of which was a machine for taking pictures on a sensitized film in the shape of a long, narrow strip . . .
>
> This machine is in all essential details identical with the machine illustrated in the drawings accompanying my above-entitled application, and comprises a microscopic lens; a sensitized surface in the shape of a long, narrow tape carried by a reel and adapted to be wound on a driven reel; the tape being provided with a series of perforations along one edge, with which the projections of the so-called "stop-wheel" engage; a stop mechanism for arresting the rotation of the stop-wheel to arrest the forward movement of the film, a shutter for exposing the film to the lens, a constantly running motor for driving the feed and stop mechanism and the shutter; and a yielding driving connection between the motor and the mechanism referred to. This machine was repeatedly used for photographing objects in motion prior to February, 1890, and I attach hereto a photograph of the same, marked "Exhibit C" . . .

As the affidavit says, this apparatus, chiefly because of its horizontal-feed feature, corresponds somewhat to the apparatus described in the patent application. Because of this horizontal-feed feature, it is, as a matter of fact, the only possible apparatus which would accommodate this specification of the patent:[4] "Figure 1 is a *plan* view of the apparatus for producing the picture, the top of the case being removed" [the italics are mine]. (The reader must recognize that a "plan" is a drawing of a horizontal slice of anything.) The patent drawing shows reels on opposite sides of an intermittent-feed mechanism. This horizontal-feed feature in the application was ignored by the Edison attorneys when they produced the exhibit called "Old Edison Camera of Patent in Suit"

[3] This was apropos #403534, the first of the three 1891 applications and the one finally settled upon by the Edison attorneys in 1896 (see page 133) when it was clear that the motion picture business was going to be a *big* business and one that was passing Edison by. This business would be eminently worth tying up, if possible, through patent infringement suits. Therefore, although these two camera applications—#403534 and #403535—had been to all practical purposes abandoned, there was still no harm in resurrecting one and trying to prosecute it to issue. As subsequent events not covered by this history were to prove, such a prosecution was successful, and for the next 4½ years, the most crucial in the establishment of this new industry, Edison was able to directly control much of the American production of motion pictures, and to harass—often into death—that part which he did not control.

[4] Page 2, beginning line 15, of original application in the file wrapper noted above.

in their case against the American Mutoscope and Biograph Company, Equity #8289, thus quite excluding the possibility of any other known mechanism than that described by Edison in the December 21, 1896 affidavit. Dickson also, in his several accounts, failed to mention any such apparatus.

The photograph presented in the 1896 affidavit was a photograph of the camera at present in the Edison museum in West Orange. Details vary; but so many significant and casual ones are identical that there can be no question of an identity. This camera was again presented four years later in the infringement case against the American Mutoscope Company instituted in 1898 (Equity #6928, page 96 of the complainant's record).

It is also illustrated in the intensely interesting Charles Hugo Kayser photo presented as evidence in this same case.[5] This photo was purported to date the camera not later than the spring of 1890: (*Ibid.*, page 127)

Q. Do you recall when that photograph was taken?
A. Yes, sir; that was taken in the spring of 1890.

This photograph is negative #662 in the collection of the Edison Laboratory National Monument in West Orange. The negative is a copy negative made from a lost original print. Although the negative was masked there is evidence to suggest that the original was taken on the celluloid base film supplied by Eastman and other makers. This particular photograph may have been taken on one of the Eastman Kodaks.

The print appears to be an enlargement from the original; crude retouching in several areas of the original print is obvious in what must have been creases in this print. Assuming an enlargement of a circular frame cut from a roll of film—obvious from an examination of the negative in the Edison archives—a Kodak in the hands of an amateur appears likely. And since it was probably taken by an amateur its quality is in sharp contrast to all other photos we know to have been taken by Dickson. There are many scores of these in the Edison archives and in many publications.

It was alleged to have been taken by Dickson: (*Ibid.*, page 125)

Q: Who is the man shown in the photograph?
A: Well, that is myself; that is, at the machine. After a test I took it apart or took the cover off, and Mr. Dickson happened to want to test a camera and was looking around for something to take, and I said, "Take me with the machine," and he did.

The same testimony tells us that it was taken in the 1889 "photograph building," and the evidence of our own eyes corroborates this. For example, the light source is from above and toward the viewer; windows partly covered with board to exclude light are in the left background— these would open onto Lakeside Avenue; a windowless wall is at the back;

[5] Page 125, paragraph 500, complainant's record of case cited.

182

a partly opened door is at right rear; the flooring is identical with what we know (e.g., negative #L40) to have been in the building; the equipment —camera, screen, etc.—is such as we know to have been in this building; the set of drawers on the left is in a position appropriate for this building; the drawer pulls and the drawers themselves are identical with those which can be discerned in the photograph of this building in the Dicksons' 1895 booklet.

For us, however, the most pertinent question concerning this photograph is the dating given by Kayser as the spring of 1890. Apart from the fact that there is no *occasion* for such a photo, exterior evidence points to a later date for this machine and therefore for an earliest-possible date for this photo. There is also indication within the photo itself that such a date is unlikely: (1) The Lalande battery cases upon which the apparatus is supported,[6] (2) The presence of the cane chair at the right rear of the photo,[7] (3) The general appearance of disuse of the room in which the photograph was taken—a disuse not possible within four or five months of construction,[8] (4) The position of the sewing machine base close against the set of drawers at the photograph's left,[9] and (5) The condition of the connecting wires on the phonograph motor in the machine's left side.[10]

Given the fact that the whole purpose of the suit was to prove prior invention, and given also the many instances of self-evident contradiction in this same testimony concerning other matters in the case, I am sure that what is at present in the Edison museum called an "1889" machine was in fact constructed at least two years later. There is also much specific difficulty in the testimony regarding this machine, as we have seen difficulties in the same testimony regarding the film which was used therein:

[6] These cases show unmistakable signs of considerable use—an amount of use unlikely for the spring of 1890, since it was only this very season that the Lalande batteries (which required distinctive wooden cases for their cells) were first produced.

[7] This set of chairs had been bought by the laboratory workers for Edison's 1889 birthday. They were much admired and not inexpensive. It is incongruous to the whole laboratory state of mind that such a chair would have been permanently a part of such a place as this. It is more likely that it was placed here on the occasion of the photograph—possibly for an attorney.

[8] We know that the building was finished for occupancy in October, 1889 (see page 79). The general appearance it presents in this photo is not that of a workroom in regular use, but rather that of an attic or storeroom.

[9] Assuming that the building was in use, it is entirely unlikely that the drawers under what we know was a workbench would have been so obstructed, nor, for that matter, the workbench itself. It is more likely that this sewing-machine-based perforator was simply pushed to this position for purposes of this photograph; and if not, was merely stored here—an idea entirely inconsistent with a spring, 1890, date.

[10] The frayed condition of the wires suggests considerably more use than only a few months. In such a workroom as the Edison laboratory wires used would have been newly gotten from the storeroom, or, in any case, not in such a condition (as seems likely here) as to possibly interfere with the proper functioning of the parts.

(1) The machine is incapable of taking the forty-per-second pictures attributed to it in the testimony.[11]

(2) A viewing apparatus to accommodate the pictures taken by this machine was said to have been built *before* two weeks before Edison went to Paris, i.e., before about July 15, 1889. Much evidence is against this.[12]

(3) The conclusive fact that although the film on this machine was activated by means of the escapement described elsewhere as having been built later that fall by Kayser, the time sheets presented by Edison's own bookkeeper Randolph show no Kayser charge for any date before the week ending October 3—long after the time at which the apparatus was said to have been built.

(4) The "several times longer" proportion between the periods of rest and the periods of movement, said by Edison in this testimony (page 99, Complainant's Record) to have been used on this machine was not, as we have seen elsewhere (see page 81), formulated until the time of Motion Picture Caveat IV, which was dated in November of this year— four months after the time this machine was said to have been used.

(5) The forty-per-second rate later settled upon as a compromise for the forty-six-per-second rate considerably post-dated the first claim for a forty-six-per-second rate. We know that this claim was not made until May, 1891, or *two* years after the date given by Edison here as the rate used in July, 1889.[13]

(6) The remarkable statement made by Edison that *in addition* to this machine, there was *also such a one driven by hand.*[14]

(7) The fact that photographs were claimed to have been made by this machine in the so-called "room #5" in the main laboratory building which, considering its position, would have necessitated the use of arc lighting. Arc lighting would have been completely inadequate for photos taken in this time of slow emulsions.[15] (Many periodical

[11] This rate is attributed to this machine in the case cited in note 1, chapter 1. The reference is to Edison's answer to direct question 75. For a discussion of this rate see chapter 14.

[12] See case in note 1, chapter 1: page 99 of Complainant's Record, answer to direct question 62. The Dickson notebook sketches, which we have ascribed to 1889 (see page 74), obviously describe an apparatus far from realized. The June–July, 1891, drawing (see page 71) is vacillatory in its claims and indicates an apparatus inoperable for the same reasons cited in the discussion of the caveat.

[13] All known Edison cameras are physically incapable of this range. Of the dozens of subjects known to have been taken in these early days, none was shot at this rate.

[14] Answer to Dyer's question 66 in the case cited above. Page 99 of the Complainant's Record. Since the reels of the machine now in the museum and the machine of the patent are practically inoperable, and since we have seen that the 1891 camera was apparently incapable of taking more than 40 or so exposures at a time, this remark may be significant.

[15] Particularly rapid exposures. The cycle of exposure, movement and exposure would have had to have been completed in $\frac{1}{40}$ of a second. Allowing only $\frac{1}{10}$ of this fortieth part of a second for the movement of the film, i.e.,

references place the photographic room on the second floor, i.e., the first floor above the ground floor. For example, the *Cosmopolitan* article of April, 1889, says: ". . . up still higher we mount [from "the photographic studio"] and come to a large, airy, well-lit room directly over the library." Since there were only three floors in this building, the fact that the reporter went *up* to the room over the library—which we know to be on the top floor—indicates that he had been on the second floor in the first place. The *Scientific American* (in *Orange Journal,* September 24, 1887) said: "On this floor [i.e., "upon the second floor"] there will also be a room devoted to photography." The laboratory night watchman's list of January 23, 1888 (document files, "Laboratory, West Orange. Construction.") also places the "photograph room" in juxtaposition to the lamp testing room, which we know from other sources was on this second floor.)

(8) The statement by Kayser (in answer to cross-question 27 page 128, C. R. 6928) that the "earliest date of which [he] had any knowledge at which this machine . . . was operated practically for the taking of a series of pictures was . . . in the fall of 1889"—post-July 15 by anyone's standards, and an explicit contradiction of points 2 and 5 here.

(9) The statement by Fred Ott (answer to direct question no. 25, p. 131, C. R. 6928) that he built this apparatus in "the latter part of February," 1889, whereas the complainant's own time sheets showed Ott's first work to have been in the same week that Dickson did *his* first work, i.e., the week ending June 27, 1889.

(10) Ott's statement that the exhibiting machine for viewing the pictures taken on this machine was built while Edison was in Paris, whereas Edison had said it was built two weeks *before* he went to Paris.[16]

(11) The statement by Ott that long, continuous strips were used on this machine in the summer of 1889, which we know could not have been the case. (See pages 63–67.)

(12) The statement by Ott that the rate then current was 30–35 per second—a crucial difference if we are to regard much other testimony here as valid.[17]

(13) The confusion Ott felt regarding the dimensions of the pictures taken on this strip machine. First he is certain about their being $3/4$ inch in diameter; then, after measuring, he changes his statements to $1/2$ inch.[18]

$1/400$ of a second (a fantastic rate), we are left with circa $1/40$ of a second for the stopping of the film, the moving of the shutter aperture to and away from the gate. We have no way of knowing during what part of this $1/40$ of a second the film was actually exposed. Some have said $1/150$ of a second; Edison himself said (document files "Motion Pictures, 1893") that the time of exposure was eight-tenths of one forty-sixth of a second; Dickson in the 1895 booklet (page 13) said one one-hundredth of a second.

[16] Ott's statement was given in answer to direct question 39, page 132 of 6928; Edison's was an answer to direct question 42 on page 97 of *ibid.*

[17] E.g., the Edison answer cited above, which insists on a rate not less than 40-per-second. Ott's statement was in response to cross-question 68, page 135.

[18] In case cited above, 6928, answer to cross-question 70 on page 136.

His testimony stresses his knowledge of the machine, yet he doesn't know the size of the pictures it takes—also crucial apropos the film size available.

(14) Ott's acceptance of Page's statement that Kayser had *made* the stop motion, elsewhere said to have been only *adjusted* by Kayser.[19]

(15) Ott's confusion as to which machine was used for his "Monkey-shines" subject. (Answer to cross-question 85, *et seq.*, 6928, page 137.)

(16) Ott's confusion about how much he knew *re* film lengths, etc., and his clumsy explanation—under re-direct questioning by Dyer trying to rescue his statements from the muddle into which Page's cross-questioning had thrown them—of the reason for this confusion. This directly contradicts his answer to previous questions in which he had averred close contact with this work.

(17) Brown's statement that this machine was built "just before Mr. Edison went away to Paris," i.e., August 3, 1889, although Edison had said it was built appreciably *before* about July 15, 1889, and Ott had said it was built in the latter part of February.[20]

(18) The statement by Brown that only Kodak film was used on this machine, before Edison went to Paris—which we know could not have been true.[21]

(19) Brown's statement that a viewing apparatus to accommodate pictures taken on this machine was built while Edison was in Paris. (Answer to question 79, C. R. of 6928, page 150.)

(20) Brown's refusal to admit the early existence of any other machine besides a microscopic viewer, such as claimed by other witnesses.[22]

(21) His later vacillation.

(22) Brown's statement that Kayser's work adjusting the stop-motion was done after Edison got back from Paris and upon Edison's instance. The only work Kayser did, according to his own testimony, was in adjusting this stop-motion, but the time sheets show that Kayser's work was done the week ending October 3—too early for Edison to have brought it about.[23]

(23) Brown's statement that although only Kodak film was used on this machine, this film was only two to three feet long. (Answer to cross-

[19] In case cited answer to cross-question 78, page 137. There is also much to suggest that this movement was an adaptation of a well-known intermittent movement shown in Hiscox, *507 Mechanical Movements,* which was received at the laboratory on February 14, 1890. This further suggests that the Edison/Kayser device post-dated this. The reader is invited to consider this device as only a variation on Movement 364 of these "507 Mechanical Movements."

[20] Answer to question 56, page 146 of Complainant's Record of case cited.

[21] We know that the first "kodak film" was supplied on August 27, 1889, and the first received at the laboratory was shortly thereafter. (See page 61.)

[22] Case cited, pages 143, and 146, answer to direct questions 29 and 53.

[23] Brown's statement was in response to direct question 89, page 151 of this case: Kayser's statement was in answer to question 8, page 125; the time sheets are printed on pages 360, 361, and 362 of this record—page 361 recording Kayser's work of the week ending October 3, 1889.

question 119, C. R. page 154.) We know that the Kodak film was 30 feet long at this time.

In addition to these difficulties in the legal testimony itself, we must not overlook the following: ·

(1) The likelihood that this photo was crudely retouched before a copy negative had been made—placing it after Dickson's departure from the laboratory in April, 1895. It would probably have been done by Dickson if it were done while he were there. This would make it unlikely that Dickson had done the retouching: he was an excellent photographer and Kayser said that Dickson had shot it. This would make it probable that this photo, which was not referred to in the 1896 affidavit, was resurrected from somewhere (or possibly even taken) for use in Equity 6928 in 1898 or afterward. The creases in the original, plain in the prints from the copy negative, are deeply uncharacteristic of Dickson's habits, and characteristic of only amateur photographers in the way we now understand the word "amateur."

(2) The unlikelihood of anyone taking a picture of any kind—and particularly one as casually taken as this "to try out a camera"—never permitted before patenting, and not often *afterward*.[24]

(3) The unworkability of this camera in reference to the claims made for it, its speed, etc. and the significant qualities in which it departs from the apparatus described in the patent application.

There would appear to be little question by anyone who examines this apparatus that the horizontal-feed camera now in the Edison museum in West Orange (accession #E5477) could not attain such a rate. In general, its parts are much too light for the violent jarring which we know must of necessity occur when such a rate is approached. (See *New York World* April 26, 1896.) A motion picture of this apparatus ("reconstructed" for operation by the Edison laboratory photograph expert in 1954) in action (produced by the United States Navy in the same year and called *The Origin of the Motion Picture*) clearly suggests that the speed shown in this film is the speed for which the apparatus was intended. Attention, in this regard, is drawn particularly to the governor, which appears to be going at a rate beyond which it would lose its efficiency, and to the single row of tiny perforations in the film— six to a frame—which would have been quickly torn out if required to drag film without a loop-making device which this apparatus does not have.

In addition, there are many other differences. For example:

(1) The motor in the patent specifications is in a position to directly drive the central shaft which in turn activates both the shutter and the film feed. In the other apparatus there are two motors, one driving the shutter and the other the film.

[24] Kayser's answer to direct question 12 on page 126 of the Complainant's Record: ". . . Mr. Dickson happened to want to test a camera . . . and I said, 'Take me with the machine,' and he did."

187

(2) In the patent specification the notched gear of the detent or stop device is on a central axis driven by an electric motor directly. In the other apparatus it is on the axis driving the shutter and connected with a motor by a friction belt.

(3) The lens in the patent specification is both enormously larger and of a type entirely dissimilar to the lens of the other apparatus.

(4) The take-up reel is positively driven in the patent specification. In the other apparatus it is not driven at all. Indeed, one may wonder if the film could have been other than pulled by hand. Josephson says that it was "rewound automatically"! (Page 388, *op. cit.*)

(5) The governor in the patent specification is adjusted to regulate a speed of operation by control of the shutter and the intermittent feed— not by control of the motor itself (an unusual, impractical function). In the other apparatus it is fixed to the central shaft of the motor itself, and there is no such device at all affecting the operation of the film shutter, etc.

(6) The patent specification shows a reel drive device, whereas there is no such device at all in the other apparatus.

(7) The patent specification shows a screw regulator for focussing the objective lens, whereas no such arrangement exists in the other apparatus.

(8) The patent specification describes reel accommodation for "100s and even 1000s" of feet of film. No such accommodation is made in the other apparatus, which, because of the lack of a loop-forming device, would probably not be capable of using more than a few feet of film.

(9) The patent specification describes 1″ pictures, the other apparatus is capable of only ½″ pictures.

(10) The patent specification describes film boxes or casings. In the other apparatus the film is not enclosed except by the cover of the whole camera.

(11) These film casings act upon the film itself in the patent specification. In the other apparatus the film is free.

(12) The patent specifications describe beveled gears, whereas there are none such in the other apparatus.

(13) The patent specifications describe no such hinged film gate as in the other apparatus.

(14) In the patent specifications the operation is started and stopped by a spring gate set in the reel casing acting upon the film itself and operated by a string pull. In the other apparatus the action is stopped and started by a shaft acting directly on the intermittent.

Granting that the date given in these sources for the horizontal-feed strip motion picture camera is incorrect, it remains to propose a date for this apparatus.

Since it is the only Edison motion picture camera we know containing the following features of the apparatus described in the patent application of 1891 (a horizontal feed, the "Kayser adjusted" stop-motion (see page 186), a series of friction drives, film with one row of perforations,

and constantly driven film and intermittent movement by a governed motor), we may logically feel that either the patent specifications were drawn with this apparatus in mind, or this apparatus (for some purpose) was built to comply with the patent specifications. That such a compliance would of necessity contain only part of the patent specifications is obvious from the fact that the apparatus described in the patents can never have been made to operate.

In addition to such differences between the apparatus described in the patent specifications and the horizontal-feed strip kinetograph as already listed in above (which must have been intended to achieve an operable mechanism and at the same time adhere as closely as possible to the patent specifications), the following additional inoperabilities of the mechanism described by these specifications appear: (1) The casing would probably not be lightproof. (2) Impossible—at that time and possibly even today—"hundreds and thousands of feet." (3) No loop-forming device is provided for. (4) The movement of *reels* is described as intermittent—actually an impossible function. (5) At a forty- or forty-six-per-second rate the detent spring or pawl in the specifications would quickly ruin the teeth of the gear. (6) The $9/10$ to $1/10$ proportion is impossible. This proportion should be close to *even*—or not more than 3 to 1 at the extreme. (7) The greater-to-lesser proportion statement does not accord with the facts. (8) A continuously moving film "within my invention" impossible here—and possibly anywhere else. The patent officer examiner shared our astonishment at this statement. In the margin he noted "???" (9) The use of *negative* film only.

We can see no reason why such an application, describing many details not contained by this machine or possible to have been contained in any operable machine, would have been deliberately drawn to vary so widely from the facts of the machine now in the Edison museum—assuming, of course, that the museum machine dates from 1891. We can only assume that the application was intended, like the caveats, to fence off areas from other inventors. Since at least a second's operation of a motion picture camera had been achieved by Dickson by May, 1891, it may be logical to assume that elements of the museum machine date from 1891.

There is also evidence that it was built considerably later, during experiments designed to put kinetoscope pictures on the screen, or even in the process of preparing evidence for litigation. (See pages 110, 181.) Considering the easy way with facts which we have seen elsewhere we cannot exclude this possibility.

There is distinct evidence that a $3/4''$ strip camera of some sort was in existence in the summer of 1895.[25] This is supported by the fact that

[25] Letter book E1717, 7/31/94–7/1/97 carried, on page 240, the record of charges from a firm called Maher and Flockhart on July 1 and 5 of 1895 for "Iron Backs on Printing Machine for ¾" strip during July, 1895"; see also "Labor and Material Sub-Ledger No. 6," page 247. Since our first look at this horizontal-feed device was in December of 1896 (see page 108) the possibility

the "prize-fight" subject claimed as a product of this machine was almost certainly shot in the "Black Maria," which was not ready for action until February, 1893.[26] The fact that as of November 20, 1891, Dyer and Seely still did not have any other product of this machine to use in their patent negotiations (see page 121), and the fact that the cylinder experiments were still in progress late in 1890 (see page 101), are also pertinent.

These considerations force us to the position that so far as credible evidence is concerned, .no part of the "1889" horizontal-feed motion picture camera now in the Edison museum was constructed before 1891, and certain elements now there were not in the machine until 1895 or later.

APPENDIX F · *Matthew Josephson's* "*Edison*"

Matthew Josephson's biography, *Edison* (New York: McGraw-Hill, 1959), is quite partisan, but much less so than all previous biographies of Edison. Most of these (Dickson; Dyer, Martin, and Meadowcroft; Tate) were written either by employees or ex-employees with axes to grind. My own work has pointed out examples of this prejudice. (See pages 67, 95.) Because of its less partisan viewpoint the Josephson work may be considered (by those who do not make a close study of the matter) an objective history. It will also be given an authority because of the reputation of the author as an expert on late-nineteenth-century America, and because of the form of the book—relatively copious notes, its publishing aegis, and a use of documentary material unprecedented in Edison biographies. As the author has said in his preface: ". . . much new knowledge and an immense amount of documentary material has accumulated, making necessary extensive revisions of earlier accounts . . . It is mainly from direct study of these materials that this book has been written." My own study of the West Orange laboratory work in motion pictures—covered in Josephson's chapter 19—was necessarily more extensive than Josephson's, since his task was to cover all aspects of Edison's life, and I concentrated on the motion picture work alone.

Because of this concentration I have been enabled to view Josephson's

that it may then have been not *more* than a year and a half old, is real. Surely there is nothing in the Kayser photo to exclude this later date (see page 000 et seq.).

[26] A close examination of this subject will show that it was taken in front of a platform such as we know was in the Maria (see negative #6570 for example) and nowhere else at the laboratory. Moreover, a shadow in the left of the frame corresponds exactly with such a one as would have been produced by the raised roof of the Maria.

190

chapter 19 with something more than an average reader's penetration. It is this viewing that has led me to believe that with very few exceptions—and none of these crucial—Josephson has followed former writers of this subject, chiefly Ramsaye, and has therefore found himself speaking about the motion picture work from a point of view closely similar to those who have gone before, whose views are clearly false. This is the view that Edison, although helped considerably by Dickson, was nevertheless largely responsible for the motion picture work at the Edison laboratory and that ". . . it would be absurd to say, as some have done, that on the motion picture [Dickson] did "most" of the work credited to Edison." (Josephson, page 397.) Josephson supports this view from words of Dickson himself, but, here as elsewhere, he ignores or suppresses crucially relevant data. In this case, he fails to note the many instances in which crediting to Edison was both contradictory and equivocal, and that during the entire time in which he made these attributions Dickson was receiving either a salary or its "equivalent" from his former employer. Other errors, both of fact and of opinion, are numerous. Out of approximately one hundred and thirty or forty such that I have found in the twenty-three pages of Josephson's chapter 19, I present a representative half:

(1) To say that motion pictures surpassed the phonograph in interest for Edison (page 383) is like saying a man likes steak better than he does meat, since it is impossible to exclude "steak" from "meat." In an exactly similar relationship did Edison always regard the motion picture work—as only an improvement on his beloved phonograph.

(2) On page 384 he says Muybridge's cameras were arranged along a race track, whereas these cameras were alongside a track specifically laid out for photographic purposes, and never used for races.

(3) On page 384 he says that these Muybridge pictures were "a dozen or so," whereas we know that they were consistently twice this.

(4) They were never projected through a "device much like the wheel-of-life" as he says on page 384, but through a praxinoscope variation. It is difficult to believe that he ever saw a "wheel-of-life," since the Muybridge apparatus was so different.

(5) He says on page 384 that Muybridge visited Edison in 1886. I have shown (see page 11) that this was 1888.

(6) We have seen on page 170 how improper it is to say that Marey's work was limited to "a series of dry plates revolving on a wheel," as Josephson has done on page 384.

(7) On page 385 he locates the "1887" Dickson-Edison conversation in West Orange, whereas we know that this conversation (if it took place at all) took place in Harrison, New Jersey.

(8) His entire chronology for Dickson's microphotographic work is taken bodily from Dickson's account, whereas we have seen (pages 23–38) that this was mistaken.

(9) Like Ramsaye, he persistently "corrects" quotations in a manner which should be anathema to a scholar. On page 386 "occuring" is made

"occurring"; on page 392 "Kinetograph" is made "Kinetoscope," without explanation; on page 395, "Marie" is made "Marey." His justification for changing, on page 391, ". . . acting and talking with a vigor which leaves him totally unprepared for its mysterious vanishing" into ". . . acting and talking then mysteriously vanishing" is even more obscure.

(10) After referring to the fourth motion picture caveat on page 386 he says that the rate of taking was "still to be determined," whereas this caveat is specific in its description of this rate.

(11) On page 386 (to accommodate, apparently, the position that this rate was still undertermined) he says that Edison "first fixed on about forty pictures a second," whereas we know that on October 8, 1888, Edison had decided on 25 per second and that this was his "first" thinking.

(12) He says on page 386 that "the Edison Laboratory has a sensitized sheet of celluloid" containing the "monkeyshines" subject. We know this not to be true. This item is paper—a crucial difference.

(13) He calls these pictures of John Ott on page 386, whereas it was actually Fred Ott.

(14) He ascribes the "getting results" remark to the attorney Seely (page 387) to the time after the "Monkeyshines" subject, whereas this remark was affixed to the October 8, 1888 document—a full two years before the "Monkeyshines" subject was made. (See pages 100–102.)

(15) To say, as on page 387, that Edison had an "instinctive knowledge and discernment of [photographic] materials" is to belie the colossal ignorance which would cover a cylinder with collodion, and which did not know a negative from a positive. (See pages 19–22.)

(16) On page 387 he pulls an entirely new date from the hat when he ascribes the first Carbutt sheets to "the first part of 1889." We have shown that this was six months later (see page 41). The remark that Carbutt was "from New York" (same page) is also quite incorrect.

(17) As we have seen, strip photography could not possibly have begun as early as "the late spring of 1889" (see page 183).

(18) Forcing history into the fiction that Edison took a close interest in this work he says on page 387 that "Edison . . . dispatched Dickson to New York to get a sample [of the new Eastman film]." We know (see pages 53–66) that the first sample Dickson ever saw was while Edison was in France.

(19) Again, as on page 387, to say that Eastman produced 50-foot lengths of film "under Edison's prodding" is absurd. Eastman's normal production was geared to this length from the beginning of the transparent base distribution. (See page 64–65.)

(20) Although we may assume that a man who has not looked into the matter may date the horizontal strip camera in 1889, no one yet has said that the film it carried was "rewound automatically," as Josephson has done on page 388.

(21) He equates, on page 388, "an escapement" with a "Geneva

mechanism," whereas we know that a great many "Geneva mechanisms" are far from being escapements.

(22) On page 388 he gives the laboratory "machines" in the early summer of 1889. Although some have said there was one, no one—even the most avid Edison fan—has attributed several such to anything like this early date.

(23) He pulls a truly marvelous item from his hat on page 388 and says that motion pictures of twelve seconds' duration were ready for Edison when he returned from Paris.

(24) He repeats the October 6 error on page 388, whereas we have shown this is improper. (See page 80.)

(25) On page 388, in perhaps one of the most significant of these errors, and an "error" which some may feel cannot be explained except as a conscious or unconscious suppression of facts to fit a preconceived position, he excises the words "Edison's veterans" from his quotation of the *Century Magazine* article and substitutes merely "Edison."

(26) He places the peep-hole of the kinetoscope in *front* of the cabinet instead of the top, where we all know it was. (Page 388.) His error possibly stems from the entirely fictitious figure 3 of the kinetoscope application—a description never seriously considered in practice.

(27) He places the large vertical-feed camera in 1890, whereas no one has ever so dated it. My own work has placed this camera in 1892.

(28) He says, on page 389, that four men worked on the motion picture job in its early period. Who are these four? Ott, Kayser, Brown and Dickson? We know that these men worked on it. And if so, where is Edison? Edison's own testimony, accepted elsewhere without question, names twenty-five: East, Hepworth, Gilmore, Grabicksy, Wheelwright, Harburger, Riebe, Neubert, Morlet, Ludecke, Ott, Dickson, Brown, Friskhorn, Birney, Lauste, Westring, Allen, Leonard, Niekan, Wolke, Arnot, Kayser, Thrige, and Spengler.

(29) Who are the "two . . . photographic assistants" who left to work for competitors? (Page 389.) Dickson may be thus described—Dickson, but not Lauste, who had left Edison some time before he went to work for the Lathams.

(30) He attributes the "discovery of a mechanical principle" to Marey and Muybridge on page 389. Who can define such a mechanical principle in the work of these two men? Everything important in the "principle" line had been discovered decades if not centuries before either of these men.

(31) To say, as on page 390, that Edison's contribution was the single point of view is only to contradict the dozens of patent references we have seen. What a "single point of view" is is also quite relative, and incapable of so hard and fast a definition.

(32) On page 390 he changes his mind (and contradicts his sources in the West Orange museum curatorial staff) by dating the horizontal-strip machine in "1889–1890."

193

(33) He says on page 390 that the Le Prince camera "is known to have been completely inoperable," and fails to note that such a camera was actually built and used to take pictures. Who "the English" are who give priority to Le Prince remains obscure.

(34) The kinetoscope cannot properly be called either a "little" box or a "black" one or "a first exhibiting mechanism that used positive film in rapid movement seen through an eyehole," since it was neither "little" nor "black" nor "first": among others, Demeny's phonoscope predates it.

(35) Although (page 390) some may call the kinetoscope the "inescapable link" between the past and the present, it is perhaps the commercial link, but certainly not the inventive. As Burlingame has said (*Engines of Democracy*, Scribner's, 1940): ". . . no basic part of the kinetoscope was original with Edison and . . . the reason the screen art of today derives so much from it is that Edison by his patents was able to dominate the whole American industry in its infancy."

(36) The statement on page 390 that Richard N. Dyer was permitted to witness a private exhibition of the kinetoscope is unfounded, and based, we may presume, on the false assumption that because Dyer was the chief attorney, and the kinetoscope was patented, *ergo,* Dyer saw the kinetoscope in operation. This bit looks rather like the "corroborative detail" of which we have spoken before, and for which Edison himself showed such talent.

(37) He identifies (on page 391) "the first vague newspaper accounts" as the *New York Sun* of June 3, 1891, and *Harper's Weekly* of June 13, 1891. Putting aside the fact that *Harper's Weekly* was not a newspaper in any commonly accepted sense, neither of these was the "first" such, as we have seen on pages 103–122. Furthermore, the *New York Sun* of June 3, 1891, carried no notice whatever of either Edison or his inventions.

(38) On page 391 Edison's "patent application of 1891" is referred to, and it is stated that picture projection was dropped from that application. There were, of course, two camera applications, one of which very carefully claims such projection as is here described as "dropped." Furthermore, projection is also claimed in the kinetoscope application. This alteration seems deliberately intended to force facts into the theory that Edison gave up the idea of projection to concentrate on the kinetoscope.

(39) Conversation is quoted in this chapter and throughout the book without restraint. On page 391 Edison is quoted as saying that foreign patents on his motion picture devices were not "worth it." The facts are that Edison at this time and for some time later took out foreign patents consistently in even such remote countries as Portugal, Australia, etc.

(40) He dates (on page 392) the "friendly note to the aged Muybridge" as 1893, whereas a very little examination would have shown this date to be February 21, 1894. The fact that he says "probably" in the notes does not lessen the effect on that vast majority of readers who refuse to fumble for notes in the back of a book.

(41) His claim on page 392 that John Ott did "an Arabian skirt

194

dance" for the motion picture camera is quite new, and as unfounded as it is new.

(42) On the same page he attributes the well-known *Fred Ott's Sneeze,* as he had the "Monkeyshines," to the wrong Ott—John. Furthermore, there was never any idea, in the case of the sneeze, to use sound-effects.

(43) On page 393 the "shorts" of the 1893–94 season (in another of those miraculous bits of exact information we have noticed) are described as running "about a minute and a fraction." We know that these vaudeville skits did not run beyond twenty seconds until years later.

(44) On page 393 the spurious tradition about the Corbett partner is repeated and embellished, whereas we know that no one other than Pete Courtney was ever intended as a partner. Here we have again the overwhelming urge to introduce "comic relief"—facts notwithstanding. (Dyer, Martin, and Meadowcroft had said—page 543—a "dark-un." The extra Josephson touch here is that this Newark "dark-un" was terrified of the "lugubrious stage setting" as well as of Corbett.)

(45) The rates for acts given on page 383 are from whole cloth, and quite exaggerated. As I have shown elsewhere (*Image,* September, 1959), the whole Buffalo Bill Wild West show, including horses and riders, were not so well paid.

(46) There were no "French ballet girls" as is said on page 393, or "knife throwers" either.

(47) The Ramsaye fiction about Edison picking up "the beautiful Mae Lucas" in New York and persuading her, "the leading lady" (which she was not), to be "taken for the camera, is repeated in page 393, whereas we know that such a circumstance never occurred. "The Gaiety Girls" opened on Monday, September 17. Ramsaye's "next Sunday" after Mae Lucas' "September" evening would have been perforce either September 23 or September 30, whereas we know that this subject was shot a full month later, on November 1. (*Orange Chronicle,* November 3, 1894.)

(48) On page 394 Josephson confuses an 1897 subject with one taken many years later.

(49) On page 394 he says that although the April 14, 1894 showing was the first public showing, "There had been a few illustrated lectures previously." This vague statement, apparently garnered from an equally vague memory by the West Orange curatorial staff of what I had told them, may refer to the Brooklyn Academy lecture of the previous year. But surely that was the only such "illustrated lecture."

(50) On page 394 he follows the Ramsaye error in saying that the *Leonard–Cushing Fight* contained ten rounds, whereas we know (*Orange Journal,* June 21, 1894, and *New York World,* June 16, 1894) there were no more than six.

(51) To say, as Josephson says on page 395, that there is "no doubt" that Dickson and Edison tried to project five-foot pictures in 1889 is more of the omniscience we have noted elsewhere. Surely there can be little doubt that projection was attempted with the horizontal-feed ma-

chine, but this machine was not in existence until two years later. Any claims of projection by means of the cylinder apparatus we must ascribe to the realm of pure fiction.

(52) We may wonder what "a screen projection camera" is, on page 396, unless it is a camera that also projected, but this is not what Edison was being urged to produce.

(53) On page 396 he states that Raff and Gammon "were selling a lot of peep-show boxes" at the time Edison was pressured for a screen machine, whereas we know that exactly the opposite was true, and that the chief reason for the urgency about the screen machine was the fact that the kinetoscope sales had fallen to a very low mark.

(54) To complete his picture of Dickson as an eccentric (and, therefore, by implication, less worthy of credit), he says on page 397 that Dickson had a waxed mustache, whereas we know that since 1886 he did not.

(55) He also implies (page 397) that thirty dollars a week is a low figure for a salary in the 1890s, whereas we know that according to recognized authorities it was the equivalent of $125 to $150 today—not a high salary, but certainly somewhat above the average for today, and at least three times the average at the laboratory at that time. (Cf. pages 32–33.)

(56) In one of the most exaggerated statements of the whole chapter, he states, on page 397, that "After Dickson left West Orange, he achieved virtually nothing during the next forty years of his life." Nothing, that is, except to bring to the Latham efforts the skill and inventiveness they needed to perfect their projector and camera, and thus force Edison into action concerning a projector of his own. Nothing, that is, except to join with Herman Casler in the construction of a camera and projector (in which it can be shown that Dickson had the larger hand)—a camera which became the basis for the American Mutoscope and Biograph Company's fortunes, and upon which nearly the whole art of the American film and half its industry are founded.

(57) Says on page 397 that Lauste was a "photographer," which he was not, and that he was "lured away" from Edison by the Lathams, which he was not—having left Edison some time before and having in addition been refused a reference by Edison when he was attempting to set up a shop of his own.

(58) Without exception, Josephson spells Mutoscope as "Mutascope."

(59) He calls, on page 397, Mutoscopes "peep-hole kinetoscopes," whereas they bore no resemblance whatever to the kinetoscope.

(60) Wanting to force a bad conscience onto Dickson, he says, on page 397, that Dickson left for England when the "Mutascope and Biograph" company was sued for infringement by Edison, whereas we know that Dickson went to England on May 12, 1897 (see page 157), and the infringement suit did not begin until February 14, 1898, when the bill of complaint was signed.

(61) He says patronizingly, on page 398, that Edison was "really quite fond of Dickson" when we have seen (see page 67) that as late as

the last few years of Edison's life he called Dickson a double-crosser and ignored his letters.

(62) He says, on page 398, that "someone at the Lathams' laboratory, hit upon the *reel*" (Josephson's italics), whereas we know that a reel had been used years before by many others.

(63) He follows the absurdity of Ramsaye and ascribes all vitascope work to Armat (he even fails to mention Jenkins, who did most of this work) on page 398.

(64) The films shown at the laboratory were shown on Friday evening, April 3. The time may have been "frosty," but it was not "morning."

(65) To say, as on this occasion, that the press "mistakenly" publicized the projector as Edison's is rather stretching it, since this is exactly the information all the reporters were given.

(66) The Koster and Bial show of April 23 was not, as he says, the "introduction of living pictures to Broadway," since "living pictures" in 1896 were something quite different from photographs.

Index

Ackerman, Carl W.: Kodak purchase, 38, 61; date of static electricity solution, 48; quoted, 54; re flexible film beginnings, 58; analysis of his Eastman "firsts," 58–59; on Eastman influence by Edison, 60, 63; Reichenbach experiments described by, 68; re Eastman samples, 121; re Eastman film, 124; re Dickson film slitter, 128; re Dickson error, 166
Aggregation, 133
Albanese, G. Sacco, in "Monkeyshines," 45; kinetoscope work, 100–102; father's letter to Edison, 101; as "Monkeyshines" performer, vis-à-vis Fred Ott, 100–102
Alexander, Scott, 179
Allen (portrait artist), 142
Allen (worker on kinetoscope account), 193
Allister, Ray, 176, 177–178
Alum tank, 111; 129; 132–133
Aluminum, use of in cylinder apparatus, 43, 126; first shipment of, 125
American Amateur Photographer, notes Carbutt celluloid-base film, 41; quoted re Eastman celluloid-base film, 54–56; quoted re Society of Amateur Photographers of New York, 66; account of Anschütz' photos in, 86; re first Blair celluloid-base film, 103
American Annual of Photography, 86
American Celluloid Company, *see* Celluloid Manufacturing Company of America

American Journal of Photography, read by author, 53
American Museum of Photography, 39, 42
American Mutoscope and Biograph Company, vs Edison in Equity 8289 (q.v.), 16; vs Edison in Equity 6928 (q.v.), 23; testimony of Randolph against, 32; reference to magic lantern account in suit of, 51; points out inoperability of Edison patent machine, 114; calls Edison patent office relations fraudulent, 133–134; presents Marey work in Equity 6928, 170; Edison suit against, 182
American Mutoscope Company. *See* American Mutoscope and Biograph Company
American Political & Social History, 118
Ammonia acceleration, 125–126
Amyl acetate, in laboratory experiments, 26; in celluloid-base film, 59, 68; in Dickson letter of November 20, 1889, 67
Anderson, Harold S., 149
Andrews, W. S. 150
Animals in Motion, 12
Anschütz, Ottomar: influence of on motion picture invention, 12; biographical sketch of, 12; tachyscope of, 12 ff., 75, 84–92, 125; stimulation by Muybridge (q.v.), 13; work described in *Scientific American Supplement,* 77; camera of, 86;

199

Edison biography by, 7; letter to Dyer and Seely, 7; claims for an 1886 "breathing spell" by, 8; letter to Glenn E. Matthews, 8; letter to Meadowcroft, 8; Scovill Manufacturing Company letter concerning, 9; possibly at Muybridge lecture, 10; preoccupation with ore-milling of, 13–14; notebook of, 13, 68–74; as official laboratory photographer, 14; produces "Monkeyshines," 22; preparation for Daguerreotype experiment of, 22, 28; microphotography by, 23; use of Zeiss apparatus by, 24; letter to Charles Edison from, 24; use of blue process by, 25; use of Landseer's "Stag" by, 25; receives Daguerreotype handbook, 28; difficulty with curved surface of drum of, 30; first advance in motion picture work of, 32–39; first work on "official" kinetoscope account of, 33; claims for motion picture projection by, 33; February–July, 1889, ore-milling preoccupation of, 37; gets information from Zylonite Company, 37; uses Carbutt celluloid-base film, 43; description by, 47; statement on projection by, 45; description of Carbutt celluloid by 47; statement on projection by, 48; notebook comment of re Eastman paper film, 50; letter of, to Eastman Dry Plate and Film Company, 50; denies cables re Marey work, 51; confusion re New York Camera Club, 54; gets Eastman celluloid-base film samples, 55, 65; Matthews letter from, 59; September 2, 1889, letter of, 61; gets letter from Eastman Dry Plate and Film Company, 62; order of for 54-foot length of film, 63; astronomical photography of, 63; misspells "Kodak", 65; claims for trip to Rochester of, 65; memories of, about daylight developing apparatus, 66; derogation of, in Tate: *Edison's Open Door*, 67; letter November 20, 1889, of, to Eastman Dry Plate and Film Company, 67; E2610 notebook of, 69; reference to Harry Marvin by, 71; friendship for Harry Marvin of, 74; use of arc lamp by, 72; in Clifton Springs with Harry Marvin, 74; as an artist, 74, 148; photography in "photograph building" by, 78; may have shown Edi-

son a cylinder viewing apparatus, 80; sees *Le vol des oiseaux*, 82; Marey influence on, 82–83; responsibility of, for Motion Picture Caveat IV, 83; attendance at Society of Amateur Photographers of, 86; possible seeing of Anschütz photographs by, 86; possibly bought/built a tachyscope, 88; projections claims in 1894 by, 88; reports to Edison by, 88; confused projection accounts of, 89–90; tachyscope projection by, 92; at Ogden, 93; ore-milling patent of, 94; ignored by Dyer, Martin, and Meadowcroft, 95; completes Ogden ore-milling work, 96; prominence at laboratory, 97; recommences kinetoscope work, 99–103; shoots "Monkeyshines," 101–103; uses Blair film, 103; preoccupation with ore-analysis, 103; supplies patent information, 107; as subject in *Harper's Weekly* and *Scientific American* film strips, and "America's rarest film," 118–122; gets Gundlach Optical Company catalogue, 122; goes to Rochester and Clifton Springs (?), 123; visits Bausch and Lomb, orders lenses, 123–124; sends films to Eastman Dry Plate and Film Company for processing, 124; gets box from Rochester, sheets of red glass, 125; work on cylinder apparatus, 125; uses aluminum in kinetoscope work, 125–126; uses ammonia as an accelerator, 126; writes "A Brief History," 126; to make film slitter, 128; improvements on kinetoscope of, 129–130; work on kinetoscope of, 138; begins work on vertical-feed kinetograph, 138; has "new model" kinetoscope made, 139; summation of role of, in motion picture work, 141; influence of Muybridge, Marey, Friese-Greene, and Anschütz on, 142

—— *biographical sketch of:* birth, presumed ancestry, 143; claims to social position, 143; letter to Edison, 144; Edison answer, 145; migration to America, 145; moves to Petersburg, Va., 147; entertains in Petersburg, 148; takes summer in Giles County, Va., 148; said to have a "fine tenor" and to be "given to the pencil art," 148; moves to New York City, 149; letter to Insull, 149;

commences work for Edison, 150; claims to work on "Edison effect," 150; becomes Edison "official" photographer, 151; works for Edison Electric Tube Company, 151; moves to 49 West 24th Street, New York City, 151; possible first meeting with Harry Marvin, 151; marries Lucy Agnes Archer of Petersburg, Va., 152; takes wedding trip, 152; visits Anton Rubinstein, 153; returns to U.S., 153; begins ore-milling work, 153; moves to Orange, New Jersey, 153; earns dislike of Samuel Insull and A. O. Tate, 153; goes to Clifton Springs, spends week with Harry Marvin, photography, 153; becomes chief of Edison ore-milling department, 154; moves to finer Orange home, 154; public relations ability (see also page 97), 154; "mysterious" payments from Edison, 154; said to have gotten salary "equivalent" for last 20 years of his life, 154–155; questionable professional morality re Wheeler-Chinnock Interference, 155; Menlo Park locomotive photograph retouching, 156; social and musical life in Orange, 156; in Orange Camera Club exhibit, 156; leaves Edison employ, 157; aids Latham efforts, 157; joins American Mutoscope Company as partner, 158; goes to Europe, 157; photographs Pope Leo XIII, 157; photographs Boer War, 157; writes The Biograph in Battle, 157; made Fellow of the Royal Geographic Society, 157; remarries, 157; settles in Twickenham, with sojourns in Channel Islands, 157; adopts son, 157; dies September 28, 1935, 157; buried in Twickenham Cemetery, 157; errors of: see Appendix C; influence of others on, 168; influence of Muybridge on, 169; influence of Marey on, 171; trouble with Gilmore, 175; influence of Friese-Greene upon, 176; re Friese-Greene letter to Edison, 178; May 7, 1923, letter to Edison of, 178; fails to mention horizontal-feed kinetograph, 182; said to have taken Kayser photograph, 182; first work of on kinetoscope account, 185; statement of re time of exposure, 185; Josephson errors concerning,

191–197; helps Herman Casler build Biograph apparatus, 196
Donisthorpe, 133, 136, 169
Dry plate process, 5, 6
Ducos, 168
Dumont, 133
Dyer, Frank L., 10, 130
Dyer, Richard N., letter to, 7; re Motion Picture Caveat I, 21; letter to Edison of, 97; letter to patent office examiner of, 121; letter to Edison of, 125; re 1891 patent applications, 127–129; 130–137; letter to Edison of, 155; letter to Edison of, re Brown patent, 168; tries to predate Friese-Greene, 177; examination of Fred Ott by, 186; re production of film, 190; Josephson error concerning, 194

East (kinetoscope worker), 193
East Orange, New Jersey, 4
East Orange Gazette, 18, 97
Eastman Dry Plate Company, 38
Eastman, George, reflected glory on, 1; flexible film of, 6; stripping film of, 6; preceded by Melhuish and Spencer, 6; preceded by Warnerke, 6; re film in Motion Picture Caveat I, 22; celluloid film of, 26; Kodak film of, 50 ff.; testimony of re first production of celluloid-base film, 58; Ackerman claims for "firsts" of, analyzed, 58–59; Dickson claims for letter to, 59; improper claims for stimulation of, by Edison, 60, 63, 67, 73; letter to Reichenbach of, 65; in Europe, 68; Dickson errors re, 165, 166, 167
Eastman celluloid-base film: 6, 26, 38, 41, 44; thickness of, 47, 57; frilling, cockling, electricity markings of, 48, 62; alleged use of, in horizontal-feed kinetograph, 49, 186; for Kodaks, 50, 57–58; announced, 53; received by Wilson's Photographic Magazine, 54; received by Photographic Times, 55; received by Photographic Beacon, 55; shown to Chicago Camera Club, 57; claims for length of, 57; first commercial production of, 58, 62; Dickson order for, 63; lengths of, analyzed by author, 64–65; first receipt of since December 4, 1889, 100; Dickson errors re, 164, 166–167; use of, for Kayser photograph, 182; Josephson error re, 192. See also

Balagny, Blair and Company, Carbutt, Ivory, Seed and Company
Eastman Dry Plate and Film Company, Dickson letter to, 50; announce celluloid-base film, 53, 55; letter of, to Dickson, 62; send film to laboratory/Dickson, 124; is sent film for processing, 124. *See also* Eastman Dry Plate Company
Eastman Kodak Company, 64, 165
Eastman stripping film: 6, 50; Dickson notebook reference to, 71; reference to, in Motion Picture Caveat I, 159. *See also* Balagny, Blair and Company, Carbutt, Ivory, Seed and Company
Eaton, S. B., 9, 96
Eaton, T. W., 137
Edgar, 150
Eder, Josef Maria, quoted, 5; apropos Anschütz (*q.v.*), 12; description of Zeiss microphotographic apparatus by, 24; discussion of "film" by, 39; description by, of stroboscopic photography, 77; on ammonia acceleration, 126
Edison, Charles, Dickson letter to, 24, 51, 164, 166; photograph of "photograph building" in room of, 78
"Edison effect, the," 150
Edison Electric Company, 96
Edison Electric Light Company, 151
Edison Electric Tube Company, 151
Edison Electric Works, 150
Edison General Electric Company, 88, 91
Edison/His Life and Inventions, 10; re Edison's knowledge of German, 13; discussion of caveats in, 14–15; discussion of Edison stock printer in, 19; exclusion of Dickson from, 67, 95; re Edison preoccupation with ore-milling, 69; re W. J. Hammer, 88; discussion of ore-milling in, 95; on S. B. Eaton, 96; on the "Edison effect," 150; Menlo Park locomotive photograph in, 156; error of re Corbett–Courtney fight, 195
Edison Lamp Works, 102
Edison Machine Works, 150
Edison:The Man and His Work, see Bryan, George S.
Edison, Mrs. Thomas A. (#2) (Mina Miller Edison), 10–11, 111, 138
Edison Ore-Milling Company Limited, 95, 101
Edison Phonograph Works, 35, 102

Edison's Open Door, see Tate, A. O.
Edison, Thomas A., false claims of, vii, viii; credit to for motion picture invention, 1; tries everything, 2; testimony of in Equity 6928, 3; as having only a commercial interest in motion pictures, 4; claims for 1887 of, 7; letter from Eaton to, 9; letter to Muybridge from, 10; at Muybridge lecture (?), 10; construction of West Orange laboratory of, 10; moves into new laboratory, 10; possible disinterest in social affairs, 11; sees Muybridge at laboratory, 11–12; inability of to understand German, 13; interest in things German, 13; admiration of Helmholtz, 13; notebook N-880103.2 of, on "Things doing and to be done," 14; purpose of, in filing caveats, 15; claims of, for phonograph capacity, 18; claims of, for motion picture capacity, flying machine, "electrical osmose" to cure uric acid ailments, and photography by reflection from retina, 18; U.S. patent #90646 of, 19; stock printer of, 19; photographic ignorance of, 19–21; pride of, in Zeiss microphotographic apparatus, 24; letter from Celluloid Varnish Company to laboratory of, 26; orders Muybridge photographs, 27; eagerness of, for Muybridge photographs, 28; writes Motion Picture Caveat II, 29; sketches by, for Motion Picture Caveat II, 29; dating of sketches of Motion Picture Caveat II by, 29; dating of sketches of notebook N-870902 of, 29–30; personal charges to kinetoscope account, 33; trip to Paris of, 33–34; "confused" testimony of, re film, in Equity 6928, 48–50, 62; lack of motion picture experiments knowledge of, 50; sails for Europe, 51; visits Marey in Paris, 52; "intoxication" of, by ore-milling, 52; false claims for stimulation of Eastman by, 60, 63, 67, 73; re the "work like hell" remark, 66; persistent rancor toward Dickson of, 67; in Europe, 68; business of, at 104 Goerck Street, 70; laboratory of, in Harrison, New Jersey, 70; facile press stories from, 78; microphotographic apparatus photograph of, in "photograph building," 79; returns from

204

Paris, 79; goes to laboratory, 80; probably does not see projection, 80; note of, to Jesse Lippincott, 80; work of, on ore-milling, 80; "100% Americanism" of, 80; sees Marey projection in Paris, 82; leaves for south, 88; sent laboratory reports, 88; income of, 91; closes phonograph room, 93; stops chemical experiments, 93; ore-milling patent of, 94; on patents, 94–95; disclaims any Dickson ore-milling invention, 96; urges lawsuits, 96; correspondence of, with Dyer and Seely, 97; collaboration of, with Lathrop on science-fiction novel, 97–99; Vincenzo Sacco letter to, 101; claims of, for television, 104; claims of, for telephotos, 104; shows kinetoscope to club women, 111; in court for electric light litigation, 112; claims of, for sound motion pictures of opera, 113; said to have made *Harper's Weekly* sketch, 114; goes to Ogden "to stay," 122; divides patent application #403535, 135; summation of role of, in motion picture work, 142; portraits of, 142; answers Dickson letter, 145; the "Edison effect" of, 150; "bulged headed fraternity" remark of, 150; photo of, by Falk, 151; payments to Dickson, 154; in interference with Wheeler-Chinnock, 155; influence of Marey on, 171; sees Marey work in Paris, 171–172; Paris activities of, 172; said to be anticipated by Friese-Greene, 173; said, by Equity 6928 appeal court, to be fully anticipated, 174–175; re Dickson letter of May 7, 1921, 178; said to have been sent letter by Friese-Greene, 179; disclaims power to employ Friese-Greene at World's Columbian Exposition, 180; tries to predate Friese-Greene, 180; affidavit of re horizontal-feed kinetograph, 181; "birthday chairs" of, 183; claims of, for hand-driven viewing machine, 184; statement of, re time of exposure for motion pictures, 185; Josephson errors concerning photographic knowledge of, 192
Eiffel, [Gustav], 172
Eiffel Tower, 172
Eimer and Amend, 102
Electrical Engineer (British), quoted, viii, 86, 119

Electrical Engineer (U.S.), quoted, viii; quoted re Edison and patents, 94–95; description of "Edison-Dickson Ore Separator" in, 96; account of visit of Iron and Steel Manufacturers' Institute to laboratory in, 97; quoted re Edison exaggerations, 99; reports Edison Chicago claims, 104; quotes *New York Times* and Edison "in Brooklyn," 106; statement of 46-per-second rate in, 121; article on Edison underground tube system in, 151
"Electrical osmose," 18
Electrical Review (British), quoted, 8; asks for photos, 14; quoted re Edison and patents, 94; re Dickson error, 164
Electrical World, 100, 141
Elements of Mechanism, see Goodeve
Elges *vs* Miller, 17
Encyclopædia Britannica, 58, 79
Engineering Societies Library, Equity 8289 records in, 110
Engines of Democracy, see Burlingame, Roger
Equity 8289, United States Circuit Court, Southern District of New York, abandonment of caveats in, 16; Ford Museum camera described in, 110–111; "Old Edison Camera of Patent in Suit" in, 182
Equity 5–167, 157
Equity 6928, United States Circuit Court, Southern District of New York, quoted, viii; Edison testimony in, 3; dating of caveats in, 16; spurious use of "Magic Lantern Experiment" in, 23; cited re Edison's method of writing caveats, 29; testimony of John Randolph in, 32–33; perfunctoriness of preparation of, 37; confused, false testimony in, 48–50, 62; "private legal file" in, 51; testimony re "photograph building" in, 76; "Kinetoscope No. 1" in, 109; Marey paper quoted in, 170; decision of appeal judges in, quoted, 174; casualness of first court's decision in, 175; horizontal-feed kinetograph presented in, 182; Kayser photograph presented in, 182; testimony in, concerning horizontal-feed kinetograph, 184-187
"Ermine," 18
Evans, Mortimer, 108, 173
Ex parte Ward, 17

claims abandoned, 130; improper derogation of Dickson post-Edison work, 157; says Casler Le Prince camera replica is "completely inoperable," 173; improper claims for automatic rewind in horizontal-feed kinetograph, 188
—*Errors in the* Edison *of: see* Appendix F
Journal of the Franklin Institute, 38, 43
Journal of the Society of Motion Picture Engineers, 7; Dickson in, re microphotography, 23; Dickson quoted from, 43, 62, 66, 75; tachyscope reference in, 84; Dickson projection account in, 89–90; quoted re Sacco Albanese, 100; quoted re cylinder work, 125; Dickson account of migration to America in, 145; Dickson Goerck Street claims in, 149; Dickson claims to replace Andrews (*q.v.*) in, 150; Dickson claims re "Newark" work beginnings in, 151

Kayser, Charles Hugo, testimony of, in Equity 6928, 73; "photograph building" photograph of, 79, 182–183; testimony of, concerning photograph, 182; date of work of on escapement, 184; testimony of, concerning horizontal-feed kinetograph, 185–187; retouching of photograph of, 187; Josephson error concerning, 193
Kennelly, A. E., 71
Kinetographs,
—*Horizontal-feed:* re Paris claims for, 48; Eastman celluloid-base film for, 49; first achievement of, 102; in *Western Electrician,* 105; rates of, 106–107; *Phonoscope* asks for cut of, 118; various periodical accounts of, 119; patent applications for, 130–137; Dickson errors re, 166–167; analysis of, 181–190; date of, 180, 189–190; Edison affidavit concerning, 181; not mentioned by Dickson, 182; controversial Kayser photograph of, 182–183; rate of taking of, 184; Equity 6928 testimony concerning, 184; time of exposures in, 185; Brown testimony concerning, 186; Ott testimony concerning, 186; impossibility of 46-per-second rate on, 187; differences of, from patent specifications, 187–

189; purpose for building of, 188–189; Josephson error concerning, 192–193
—*Vertical-feed:* first achievement of, 2; as the Ford Museum camera, 110–111; work on, 138; as "Old Edison Camera of Patent in Suit," 181; Josephson errors concerning, 193
Kinetophone, 90
Kinetoscope, 905 manufactured by 1896, 4; name for, 9, 72; operas with phonograph, 18; work for distinguished from "Magic Lantern Experiment," 23; precision room work on, 34; Edison attorneys attempt to ascribe work on, 35; spurious use of reflector in, 35; Dickson notebook notations and sketches for, 71; as a cylinder-viewer, 80; extreme perfection of as of Motion Picture Caveat IV, 83; work on reopened, 99–103; as "job 462," 100, 124; references to, in caveats, 159–163; Dickson errors concerning, 167; use in, of photographs by horizontal-feed kinetograph, 184; Edison claims for hand-driven version of, 184; C. A. Brown's testimony concerning, 186; Josephson errors concerning, 193–194
—*"Kinetoscope No. 1":* latest possible date for, 107; description of, 107–110; shutter of, 108; rate of operation of, 108; as described by Ramsaye, 108; possible spuriousness of, 109; patent specifications for, 110; public debut of, 111–118; seen by members of National Federation of Women's Clubs, 112
—*"New model":* 35, 139–140; Dickson improvements on, 128–130; April, 1894 debut of, 129; patent applications for, 130–137; renewal of interest in, 136–137; marketing plans for, 138; Dickson errors re subjects for, 165
—*Account of:* opening of, 32; first charges to, 32; February, 1889, to June, 1890, charges to, 32; materials charges to, 33; charges to as obscuration for laboratory overhead, 34, 52, 53; Edison's time charges to, 34; charges to in summer of 1890, 93; 1890 charges to, 99; charges to, in 1891 and 1892, 102–103, 140
Knight, Arthur, 15

210

214

Spieden, Norman, 111
Spiro, Charles, 66
Spottiswoode, Raymond, 176
Stanford, [Leland], 169
Stanley, Henry M., 113
Stereoscope, 131
Stock printer, of Edison, 19
"Strawberry Hill," 148
Stroboscopic photography, see tachyscope, and photography of projectiles

Tachyscope, of Anschütz, 12–13; as 1889 motion picture apparatus, 75; stroboscopic illumination in, 76; Century Magazine account of, 84; Cassier's Magazine account of, 84; The Philadelphia Photographer's account of, 85; History of the Kinetograph Kinetoscope and Kineto-Phonograph account of, 85; Scientific American account of, 84–85; Wilson's Photographic Magazine account of, 86; Society of Amateur Photographers discussion of, 86; sale of, by U.S. Photographic Supply Company, 86; American Amateur Photographer account of photographs for, 86; Electrical Engineer (British) account of, 86; possibly bought outright or built by Dickson, 88; Dickson projection by, 92; film for, 100
Taft, Robert, Carbutt biographical sketch by, 38; cites Eastman film testimony, 58; on Muybridge exposure rates, 121
Talbot, F. A., fails to mention caveats, 15
Tate, A. O., memo to Insull, 50; goes to Europe, 50; letter to Insull of, 51; letter to, 52; author of Edison's Open Door, 67; letter of to Dickson, 97; interest of in kinetoscope for World's Columbian Exposition, 139–140; describes Dickson, 153; Thomas Maguire stand-in of, 178
Tax maps, 78
"Telephonoscope," 104
Telephotos, 104
Television, 104
Thrige (kinetoscope worker), 193
Tissandier, Gaston, 169, 172
Thiesen, Earl, 166
Thomas, 124
Transactions of the Society of Motion Picture Engineers, The, 79
Trow's Directory, 103

Two Reels and a Crank, see Smith, Albert

Underwater photography, 98
United States Electric Light Company, 112
United States Navy, see Origin of the Motion Pictures
U.S. Photographic Supply Company, 86
Usher, Abbott Payson, 19

Valentine, John, 139
Van Hoevenbergh, [H.], 168
Varley, 173
Vergara, 59
Vie populaire, La, 172
Villard, Henry, 88, 91
Villard, Mrs. Henry, 91
Vitascope, the invention of C. Francis Jenkins, viii; debut of, 4; by Jenkins, 91
Vogel, Hermann, 21
Vol des oiseaux, Le, 83

Wachter, 169
Walmsley, J. M., 56
Warnerke, 6
Webster's International Dictionary, 37
Webster's New International Dictionary, 133
Wentzel, J., 77
West Orange, New Jersey, 4
Western Electrician, The, 92, 105
Westring (kinetoscope worker), 193
Wet collodion process, the, excludes "instantaneous" photography, 5; description of, by Beaumont Newhall, 20–21; in Motion Picture Caveat I, 20 ff., 159
"Wheel of life," 191
Wheeler-Chinnock Interference, 155
Wheelwright (kinetoscope worker), 193
Williams, E. P., 19
Wilson's Photographic Magazine, announces Eastman "success in making" celluloid-base film, 38; quoted re Carbutt celluloid-base film, 41; Carbutt advertisement in, 43; gets Eastman celluloid-base film 54; gives thickness of Eastman celluloid-base film, 56–57; quoted re "photograph building," 78; tachyscope account and photographs in, 86; tachyscope projector described in, 92; Ernst Gundlach article in, 122; report on Marey's work in, 170

The Kinetoscope

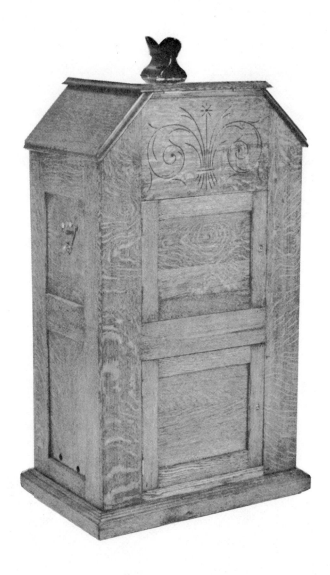

The most typical of all Kinetoscope models. This model is now in the Ford Museum. A rheostat for regulating the current is at the left, as well as the two holes discussed on page 13. (For mechanism see page 9ff and Illustrations 1, 2 and 17). Photograph courtesy of the Henry Ford Museum. Previously unpublished.

THE KINETOSCOPE

America's
First Commercially Successful
Motion Picture Exhibitor

by

Gordon Hendricks

The Beginnings of the American Film

G. P. O. 2552
NEW YORK, NEW YORK
1966

Printed in Brooklyn, New York, by
THEODORE GAUS' SONS, INCORPORATED

TO

GUIDO CASTELLI

Preface

The Kinetoscope is the third monograph in a series intended, to quote the preface of the first, *The Edison Motion Picture Myth*, "to be a beginning of the task of cleaning up the . . . legend with which the beginning of the American film is permeated". The second, *Beginnings of the Biograph*, told the story of what happened to W.K.L. Dickson after he left Edison in 1895 until, with his aid, the Biograph Company became established. The present work goes back a few years and takes up the story where *The Edison Motion Picture Myth* left off. It details the work at the Edison West Orange laboratory from the accomplishment of an effective camera to the beginnings of the decline of the earliest exhibitor of the product of that camera. This exhibitor was the peep-hole, nickel-in-the-slot machine called the "Kinetoscope."

Again I have tried to present as many sources as possible, partly so that a reader less privileged with access to original data than I have been, may see how I have established my narrative. If error is found, I hope that the whole work will not therefore be derogated. *The Edison Motion Picture Myth* has been called "anti-Edison", or prejudiced in favor of Dickson. But I have not yet had my attention drawn to error in the book that might support such opinions. I hope that if such error does, indeed, exist, that the book may still continue to be useful.

I would myself point out two differences in the Edison book. First, the quotation from page 2 of the preface, "there was no co-invention", concerned ore-milling invention, and not the motion picture, as the context clearly implied. Second, the

statement in footnote 10 of Chapter 16 that since only 46 frames of "America's rarest film" were known to exist, it was therefore "not too much to suggest that the Dickson machine was capable . . . of only one second's operation". This conjecture is altered by the fact that additional frames of this subject have been found in the Batchelor notebook at the West Orange laboratory.

To replace the modest statement "there was no co-invention" I quote another equally modest, which Edison made to *The Scientific American*[1]: "[Mr. Edison] wishes me to tell you that it was he who invented the motion picture camera, which is the foundation upon which the whole motion picture art rests". And the discovery of additional frames from "America's rarest film" does not reduce the impropriety of the claimed *rate-of-taking* of the early camera, but only takes away support for the one-second-capacity theory.

In *Beginnings of the Biograph* I have found one difference. Note 2 of Appendix B should read "burial record" instead of "gravestone". This matter was stated properly in *The Edison Motion Picture Myth*, but in *Beginnings of the Biograph* it slipped through.

I am indebted to many for help with *The Kinetoscope:* Miss Mary Abernethy, Mr. Harold Anderson, Miss Alberta Appleby, Mr. Fred Bielaski, Mr. Sandy Black, Mr. William Brower, Sr., Miss Carole Carlson, Mr. Guido Castelli, Mrs. M. P. Clark, Mr. Charles Clarke, Mr. Frank Davis, Mr. P. S. M. Dew, Mrs. Frank Florin, Mr. George Freedley, Mr. Guido Gramaglia, Jr., Mr. Baldwin Guild, Mr. James Hilbrandt, Mr. Bernard Karpel, Miss Rosalind Krokover, members of the staff of the Library of Congress, Mr. Robert Lovett, Mrs. Robert McCormick, Mr. Gerald MacDonald, Mr. Kenneth Macgowan, Mrs. Kathleen Oliver McGuirk, Sr. Mauriçio Gomez Mayorga, Miss Caroline Milheim, members of the staff of the National Archives, members of the staff of the New York Public Library, Mr. Beaumont Newhall, Miss Violet Peterson, Mr. George Pratt, Mr. Gerald Rickard, Miss Ruth St. Denis, Mr. Ed Schuller, Mrs. Barbara Seabrook, Miss Betty Shannon, Rev. Leonard E. Smith, Mr. Norman Speiden, Miss Miriam Studley, Mr. Jack Vorisek,

1 From letter file 608 E1712 in the West Orange archives.

Mr. Gregory Walley, Mr. Melvin Weig, and Sra. Jovita Zubaran.

In closing this preface I would again add my small voice to what I hope will soon become a swelling chorus of lament for the arrogant speed with which irreplaceable newspapers and other primary sources are being harmed—or quite destroyed—in the machine-age rush to get *everything* on microfilm. The exasperating difficulty of seeing even the best microprint, the frequently poor microfilming, the 8 to 10 positive physical movements necessary for *each page* of an average newspaper, the frequent poor condition of readers, the frequent over-lighted or crowded positions of the readers—all these result, in my experience, to early fatigue. And fatigue inhibits or eliminates the eagerness with which such contemporary records should be approached and systematically searched. Work with original sources, already scarce enough, must, if this headlong activity is not slowed or more judiciously controlled, soon disappear altogether.

GORDON HENDRICKS

Contents

Illustrations

Introduction

EARLY IN 1894 THERE APPEARED IN THE AMERICAN MARKET PLACE a peep-hole picture machine known as the "Kinetoscope." It stood on the floor to a height of four feet. Through an eyepiece on the top a customer could, upon application of the coin of the realm, cause the machine to whirr briskly and show motion pictures of dancing girls, performing animals, etc. The vast majority of these customers were enormously excited by the exhibition, came back again and again to see it, and told their friends about the new wonder. Some were impelled to build machines of their own; others, more significantly, devoted themselves to the task of projecting the pictures on a screen —so that many more than one viewer at a time could see the show. From the work of these latter came America's first projectors, and the subsequent rich burgeoning of the industry in 1896 and afterward.

The Kinetoscope was the source of their inspiration, and at the same time supplied them—by stimulating public interest —with a market. It must therefore be given more than a small share of credit for the beginnings of the American motion picture industry. It is to tell the story of the design, production and exhibition of the Kinetoscope, its camera and motion pictures that this book has been written.

To West Orange, New Jersey, in 1887, came a young Scotsman named W.K.L. Dickson, whose contribution to this work has been overshadowed by the illustriousness and aggressiveness of his employer, Thomas Alva Edison. Dickson was much interested in photography, and brought this interest—and the

excellent facilities of the Edison laboratory—to bear upon the problem of a camera and the Kinetoscope. By the end of 1892 he had produced both. I have described the preliminary work in *The Edison Motion Picture Myth* (Univ. of Calif., 1961) and left, in that work, the story in October 1892, with the production of the camera.

The present book details the ensuing events to the end of 1895, when the Kinetoscope was losing its lustre, and the camera was beginning to furnish motion picture subjects for the screen.

1 · The Camera

THE "BLACK MARIA" CAMERA WAS THE FOUNTAINHEAD FROM which flowed all West Orange motion pictures. Every subject known to us up to May 1896 was shot by this instrument— and many of those afterward. It was probably with this camera that Edison re-entered the motion-picture-taking business in the fall of 1896, and with its patent specifications tied up the whole industry for years. It is thus as important as any other camera in the history of the business.

For all this significance, however, the details of its construction are not clear. Patent specifications are frequently ambiguous and conflicting claims profuse. Central among these conflicts is Dickson's claim for a Geneva intermittent[1]—although, if we may judge from some of his statements, he intended us to think that such an intermittent was used on an earlier camera.

The first Dickson claim for a Geneva intermittent that I have found was in "A Brief Record of the early days of Moving photography" written in 1928:[2]

> Early in 1889—we had produced—a sprocket wheel—with the teeth to fit the perforations punched on one side only— a geneva stop movement was used attached to the sprocket wheel as a stopping & starting mechanism . . .

On December 1, 1930 Dickson sent Meadowcroft, Edison's secretary, a copy of this account as he had abridged it for

[1] The Geneva movement was developed by Swiss watchmakers—thus the name —to prevent over-winding by means of a five-faced Maltese cross. It is now widely used in motion picture projectors.

[2] From "Motion Picture History. Dickson Articles and Letters" in the West Orange archives.

Merritt Crawford, who was then engaged in an effort to bolster Eugene Lauste's claims for motion picture priority and a less praiseworthy effort to bolster those of Jean LeRoy.[3]

On October 26, 1932 Dickson wrote Earl Thiesen:[4] "The Kinetograph had a Geneva Stop motion which I always came back to . . ." On November 27, 1933 he sent Charles Edison a sketch of the stop motion he used and again it was a Geneva.[5]

In the December 1933 article in *The Journal of the Society of Motion Picture Engineers*, often quoted in *The Edison Motion Picture Myth*, he places the Geneva movement prior to the horizontal disc escapement, and intermediate between that escapement and the ratchet and pawl escapement of the drum apparatus:

> The escapement movement then in use was soon found to be much too slow to satisfy persistency of vision in the stopping and starting which we found imperatively necessary in the endeavor to get a quick change and a long rest period. So we adopted the Maltese cross [i.e. the Geneva escapement], and after some modifications found it to answer our purpose very well . . .
>
> A little later, about a year, I fancy, Mr. Edison devised an ingenious stopping and starting device, which took the place of the Maltese cross or Geneva movement for a time.[6]
>
> A horizontal 1½-inch disk with one slot at its edge was centered on a shaft to run continuously. A disk of similar size with a nose or pin projecting and running vertically was driven forward on a slip collar. The nose rested and slid along the slotted horizontal disk; and as the vertical disk revolved, the nose or pin in the horizontal disk would fall rapidly through the slanting slot . . .

This chronology has also been indicated in "A Brief Record":

> clock escapement [i.e., the ratchet and pawl of the cylinder apparatus] stop motion to prove a principle—i.e. stopping & starting action—followed by—The Geneva movement

3 *Ibid.* I will discuss Lauste's claims in a forthcoming work on Latham (see Chapter 10) projection begininngs, in which he had an important inventive part. Jean Acme Leroy's claims are a tissue of the romance and inflation in which some newspapermen revel. They were given an imprimatur by a National Board of Review accolade in the early thirties.

4 This is quoted by courtesy of Mr. Thiesen.

5 "Motion Picture History. Dickson Articles and Letters."

6 To say that "Mr. Edison devised" this disc escapement is absurd, so unrelated is such a discovery to Edison's natural talents. I have shown on page 185 of *The Edison Motion Picture Myth* that this intermittent was well-known in mechanics at this time.

... [then the horizontal disc escapement.] Improved Edison stop motion for Higher speeds

We cannot concern ourselves here with when—or whether —the Geneva movement was ever used in a Dickson motion picture camera: the horizontal disc escapement (see Illustration 47) was used in Black Maria production within the range of this history. The operation of this mechanism is again clearly described by Dickson in testimony in Equity 5/167,[7] in his answer to cross question 164:

> ... the construction of the feeding mechanism used in [the commercial work of taking pictures for the Edison Kinetoscope was] a horizontal continuously travelling disk, containing one slot adjacent to a vertical 3 toothed disk, one of the teeth resting on the first mentioned horizontal rotating disk slipped through said mentioned slot giving an impulse to further mechanism controlling the film on a sprocket wheel. The 3 toothed vertical slotted disk was kept in tension in a forward direction while resting [on] one of the teeth on the first mentioned horizontal slotted disk.

A later exchange was as follows:

> XQ 241 In your answer to XQ 164 you described the feeding mechanism of the camera used in the commercial work for producing pictures for the Edison kinetoscope. Was the horizontal continuous travelling disc you speak of arranged like the disc 25 of the Edison patent 12037, except that it had one slot instead of six and was the vertical three toothed disc arranged like the disc 23 of that patent with relation thereto except that it had three teeth instead of six . . ?

> A My explanation or description as given in my answer 164 is purely from memory, some 22 years ago [it is now 1911 and Dickson is somewhat in error, since the horizontal disc escapement did not come into use until about 1891], was broadly a description of the action of such a machine. What I described doubtless was sufficiently correct for the purpose and perhaps one of the modifications we made at that time. The patent drawing entitled "T.A. Edison Kinetoscope No. 12037" shows such a modification and looks quite correct; showing more teeth on the vertical disc with a corresponding additional number of slots, in the travelling horizontal disc. The terms horizontal and vertical do not as closely apply to this drawing as in my rough description from memory, although the action is the same.

[7] U.S. District Court, Southern District of New York.

The description of this operation in *The New York Sun* of June 16, 1894 is unspecific and free with fact:

> The manner of making the pictures is simple. A gelatine film 150 feet long and about 1½ inches wide, with its ends joined together into a band, is wound around rollers until it is all stretched out. A row of holes in one edge of the, band fits into the teeth of a sprocket wheel like those used to drive the chains of bicycles. This wheel is driven by an electric motor.
>
> The band of film is thus passed rapidly along behind the camera tube. The front of that tube is a circular shutter having a slot in one side. The motor drives this also. It turns around forty-six times a second, and every time the slot comes around it allows a picture to be made on the, film. These pictures are about an inch square and close together . . .

The ends of the film in the camera could not have been "joined together". It is also clear that since the early days of the horizontal-feed camera of 1891 (see, for example, Appendix E in *The Edison Motion Picture Myth*), there was a double row of sprocket holes in the film, and *The Sun* gives only one edge of the film such holes.

The rate of taking was not forty-six frames per second. Despite many varying claims, the camera was run regularly, 1894-*circa* 1898, at about forty per second. Many authorities stated this categorically (see my article in *Image*, September 1959) and Dickson himself said in his Equity 5/167 testimony that the camera was run "about 40 to the second." In an April 3, 1914 letter in the West Orange archives he said the rate was 25-46. But assuming his memory to have been correct (which it often was not) he must have been referring to extremes of speed and not the regular practice.

I selected eighteen subjects from my own collection to show the rate-of-taking of the Black Maria camera between January 1894 and January 1897. These are all subjects of which I know the exact shooting dates—with three exceptions, two of which I know within a week and another within three days. I discovered that:

> 1, In no case did the Maria camera operate as high as 46-48 frames per second;
> 2, It frequently operated at about 30 frames per second;
> 3, It sometimes operated at approximately 18 frames per second;

4, It sometimes operated at approximately 25 frames per second;

5, It was sometimes operated at speeds varying as much as 15 frames per second within a single day's shooting;

6, Its average rate, judging from the 18 subjects viewed, was 38-40 frames per second.

I projected the fastest-shot of the 18 subjects on special apparatus and found that none of these, covering a shooting range from January 1894 through December 1896, exceeded this 38-40 per second rate. I also found that the Sandow and Toyou Kichi subjects were shot at what was to become "silent speed" for a time, i.e. *circa* 16 frames per second, and that Annie Oakley, "Buffalo Dance" and the "Black Diamond Express" were shot at approximately sound speed, i.e., 24 frames per second. The list of subjects examined, with their shooting dates and my best estimate of their rates-of-taking, is as follows:

Title	*Date*		*Rate*		
1. Fred Ott's Sneeze	1/1/-8/94	c. 40	frames	per	second
2. Sandow	3/7/94	c. 16	"	"	"
3. Carmencita	c. 3/11/94	c. 40	"	"	"
4. Juan Caicedo	7/25/94	c. 40	"	"	"
5. Corbett-Courtney Fight	9/7/94	c. 30	"	"	"
6. Glenroy Brothers	9/13/94	c. 30	"	"	"
7. Buffalo Dance	9/24/94	c. 24	"	"	"
8. Sioux Indian Ghost Dance	9/24/94	c. 40	"	"	"
9. Bucking Broncho	10/16/94	c. 40	"	"	"
10. Toyou Kichi	10/18/94	c. 16	"	"	"
11. Annie Oakley	11/1/94	c. 24	"	"	"
12. Princess Ali	5/9/95	c. 40	"	"	"
13. Execution of Mary, Queen of Sots	8/28/95	c. 40	"	"	"
14. Irwin-Rice Kiss	4/16-18/96	c. 30	"	"	"
15. Newark Fire Department	11/14/96	30-40	"	"	"
16. Newark Fire Department	11/14/96	30-40	"	"	"
17. Black Diamond Express	12/3/96	c. 24	"	"	"
18. First Sleigh Ride	12/24?/96	30-40	"	"	"

This regular rate of 38-40 frames per second is further supported by entries in an A.E. Kennelly notebook.[8] Kennelly tested the Kinetoscope in February of 1893 and his notebooks

[8] A.E.Kennelly was the principal mathematical and electrical expert at the West Orange laboratory. He left Edison and later went to the Massachusetts Institute of Technology. I found seven of these notebooks, uncatalogued, in the Vail Library at the Institute and was instrumental in having them restored to the West Orange archives.

8

indicate that he used four speeds: 41.66, 38.33, 33.33 and 37.5 frames per second in his testing. Since the Kinetoscope was run at the same speed as the camera, and these were apparently the only motor tests made by Kennelly (the notebooks seem exhaustive within their time range), the suggestion is strong that one of these rates—or possibly an average of them—was used in the camera. This 40-per-second rate is further corroborated by a model variable-speed Kinetoscope constructed at the George Eastman House, through the imagination and enthusiasm of its director, Mr. Beaumont Newhall.

The best idea we have of the external appearance of the Black Maria camera may be the sketch by the artist E.J. Meeker.[9] The sketch by "EA" in the *Frank Leslie's Popular Monthly* article of February 1895 (see page 25) may be slightly more interesting: certainly this later sketch shows signs of direct observation,[10] whereas the Meeker sketch may have been done at least partly from photographs. I reproduce both these sketches as illustrations. A Dickson sketch[11] is virtually worthless, since it appears to have been merely roughly copied from the Meeker sketch. What is clearly the handle for carrying the camera (see Illustration 48) is identified by Dickson as the "Stop & Start"!

[9] Meeker was an exceedingly popular sketch artist for the "better" magazines. He was a first-class draftsman. His sketches for such periodicals as *The Century Magazine* show a skill in perspective that was unsurpassed even by Joseph Pennell.

[10] The studding inside the right wall of the Maria seems too specific not to have been eye-witnessed. This is also true of details of the doors, roof pulley position, etc.

[11] In a note of May 1, 1921 in "Motion Picture History. Dickson Articles and Letters."

2 · *The Kinetoscope*

JOHN RANDOLPH, EDISON'S BOOKKEEPER, SAID IN HIS TESTIMONY in Equity 6928, that as of December 8, 1899 there had been 973 Kinetoscopes manufactured.[1] Laboratory records show that as of the time of the Vitascope debut of April 23, 1896 there had been 905 manufactured. This manufacturing began in the summer of 1893 with the signing of the contract agreement with James Egan. But Egan was unable to fulfill his obligation and the initial machines were completed early in 1894 by William Heise.[2] The Edison-Egan contract, signed on June 26, 1893, is an interesting document:[3]

Orange June 26/93

James Eagan [sic] agrees to make 25 Kinetographs[4] Complete except Motor, Mirror & Lense of glass & Nickel slot device and assemble the whole in the Case tested Satis-

[1] More Kinetoscopes were manufactured after this Randolph testimony—possibly to replace worn-out machines. The record shows that only 28 were made in 1897, one in 1898, and only one for at least the first several months of 1899. The Science Museum (London) Kinetoscope is numbered 509, the Ford Museum apparatus 1018, and the Eastman House 1026. The serial number of a phonograph designed for use in the Kinetoscope now in the West Orange archives is "K1404" and a Science Museum Kinetophone phonograph is numbered "1268". This may suggest 1, that Edison expected to equip all his Kinetoscopes—at least of later manufacture—with phonographs, and, 2, that these phonographs were manufactured in advance of their need. Possibly serial numbers were started beyond zero: I cannot believe that a substantial number beyond the Eastman House and Ford Museum machines were manufactured. (See page 11)

[2] According to John Ott's Precision Room book (see page 34 of *The Edison Motion Picture Myth*). Heise finished Egan's contract some time between January 1 and January 5, 1894. The legal record indicates that these Kinetoscopes were the last manufactured until January 12, when two more were made. Edison wrote Eadweard Muybridge on February 14 that by that time 25 had been made. Charges to the Kinetoscope account for lenses, cabinets, wire, glass and lamps during the first months of 1894 (in *Labor and Material Sub-ledger No. 6*) may or may not corroborate this. These items could all refer to adjustments in the Kinetoscope itself, the camera, or to motion picture production, which was getting under way at that time.

[3] "Motion Pictures, 1893"

[4] Edison and many others—even Dickson on one occasion—confused "Kinetograph" with "Kinetoscope," often saying "Kinetograph," (as here), when they meant "Kinetoscope."

factorily for Thirty Eight dollars each I agreeing to allow him one week to make tools—Tips & dies to be furnished by Edison.

Thos A Edison
Jas Egan

The model that Egan used in his first work seems to have been the "New Model Kinetoscope" made at the shop of John Valentine, pattern maker, of 15 Alling Street in Newark, immediately following the Fourth of July, 1892. It may be the instrument illustrated at the left of the photograph of the photographic studio in Antonia and W.K.L. Dickson, *History of the Kinetograph Kinetoscope and Kineto-Phonograph*. Illustration 38 is the title page of this booklet; the photograph is Illustration 6. Although heavily retouched, the cabinet at the left of the photograph has a design unknown in later cabinets. It can be explained in no other way than that it was the "original" model—excluding, of course, the "Kinetoscope No. 1" of the May 1891 demonstration (see *The Edison Motion Picture Myth*). Even assuming heavy retouching of outlines, areas in this apparatus have values inexplicable except that they were in the original negative. This photograph probably dates from late in 1894 and was possibly taken at the same time as the exterior view of this studio in *The Photographic Times* of January 1895 (see illustration in *The Edison Motion Picture Myth*).

The Kinetoscope on the right of the photograph, with its three oblong-shaped outlines in wood on its broader side, seems to correspond with the newly-made Kinetoscope of Egan-Heise workmanship of January 1893 - April 1894. An excellent photograph of this instrument is in a "production still" of the "Hear Me, Norma" subject—which dates from pre-June 1894.[5] The three oblong-shaped outlines supplanted the design of the ear-

[5] We know it dates from pre-June 1894 from the fact that frames from it appeared in the *Century Magazine* June 1894 article, placing it before the deadline for the June issue of that magazine. It was so-called from a line in the Dicksons' booklet, page 18: "The organ-grinder's monkey jumps up on his shoulder to the accompaniment of a strain of Norma." Another production still of this subject, with the head of the adult sharply defined, is reproduced on page 26 of the booklet. This subject was apparently not popular with Raff and Gammon customers, or perhaps may not have been distributed by them at all, since I have found only two references to its being used in the Kinetoscope. One was in *The Atlantic City Daily Union* of July 21, 1894, and another was in *La Nature* of October 20, 1894.

lier, left-of-photograph instrument, and were themselves re-
placed in 1894 by the cabinet design with which we are most
familiar. This latter design was apparently regular throughout
later manufacture. This cabinet underwent only minor varia-
tions—the eye-piece, the door-framing, vent holes, etc. It may
be seen with perhaps its most typical details in the Eastman
House Kinetoscope (Illustration 1).

The six "pure" Kinetoscopes known to me—as differentiated
from the Kinetoscope-turned-Kinetophone (see page 123) and
the R.W. Paul copy (see page 133)—as the only machines
extant among the thousand-plus which were made,[6] are all of
this design. Two panels are on each of the four sides, with a
stylized floral design on the upper part of the wider side. The
Eastman House Kinetoscope is, overall, 18" x 27" x 48½"—
these dimensions including the base and the eye-piece. Kineto-
scopes, incidentally, were packed in crates measuring 21" x
30" x 49",[7] indicating that the eye-piece was attached later.

The drawing of the 1155 Broadway parlor, on page 53 of
the Dicksons' booklet (see Illustration 36), shows the two-
section side of the Kinetoscope cabinets with a floral pattern
in both of these two sections. This is possibly license, or indi-
cates that the 1155 parlor instruments had been supplanted

[6] I have examined five of these six. These five are: the George Eastman
apparatus (Illustrations 1 and 2), the Ford Museum Kinetoscope, the Science
Museum Kinetoscope, the Charles G. Clarke Kinetoscope, and the Academy of
Motion Picture Arts and Sciences Kinetoscope. I do not reckon the instrument
in the Conservatoire des Arts et Metiers in Paris in this number since I exam-
ined this instrument in June 1959 and discovered that it was one of those
copied by Paul for European sale (see page 133). The Kinetophone of the
Science Museum, Illustration 49, was apparently built as a Kinetophone and
does not qualify as a "pure" Kinetoscope. A sixth "pure" instrument appears
to be in the Will Day collection, said (by *Cinema Studies* of September 1962)
to have been acquired by the Cinematheque Française. Repeated inquiries have
failed to elicit any further information from the Cinematheque, and examina-
tion of the Will Day collection while it was still in possession of his son was
denied me in London in 1959. A photograph of this Cinematheque Kinetoscope
may be seen, however, on page 9a of the catalogue Will Day issued. This cata-
logue may be seen in the library of the Museum of Modern Art in New York
City, the West Orange laboratory and the New York Public Library.

It may be well to state here, also, that a seventh Kinetoscope is now in the
Smithsonian Institution—but this is a replica made by the George Eastman
House from the Science Museum apparatus. Another replica has been re-
cently built at Eastman House. Considering the sturdy oak construction of
the machines and the fact that a thousand-plus were made, it is remarkable
that more are not known.

[7] According to the dimensions in the September 29, 1894 invoice described
on page 112.

by the new version by the time of the booklet—the fall of 1894 (see *Image,* September 1959).

We have thus in focus two important early stages of Kinetoscope development: first, on the left of the photograph, the Kinetoscope as it appeared up to the beginning of regular manufacture in 1893, and second, on the right of the photograph, the Kinetoscope as it appeared up to the spring of 1894. The design of this right-hand Kinetoscope appears to have extended through the Egan-Heise Kinetoscope manufacture. This machine appears to have been installed in only three places: 10 in the 1155 Broadway parlor, 10 in the Chicago parlor (see page 60) and 5 in the San Francisco parlor (see page 71). These were referred to in invoices as "the original twenty-five." Some of these were given, curiously, serial numbers 197 to 202, both inclusive, when they were used in the opening of a new Chicago parlor about October 9, 1894.[8] Serial numbers 195 and 196 were billed to Boston on October 3, 1894, number 183 to Baltimore on October 3, and number 219 to 223, both inclusive, to Cleveland on October 13. Assuming that the serialization of the "original twenty-five" was correct, then either Boston, Baltimore or Cleveland received some of the original twenty-five machines. None of these "original twenty-five" are, therefore, so far as we know, extant. Will Day has said that his Kinetoscope—and therefore, by inference, the Cinematheque's Kinetoscope—was number 69.

The later version of the Kinetoscope is also shown in "The Kinetoscope in the Bowery," (Illustration 40) in Antonia Dickson's article of February 1895 in *Frank Leslie's Popular Monthly.* It is also a part of the Columbia Phonograph Company's installation illustrated on page 453 of C. Francis Jenkins' article in *The Photographic Times* of October 1896, and Peter Bacigalupi's San Francisco parlor at 946 Market Street (Illustration 41).[9] It is also illustrated in the October 20, 1894

8 Baker Library collection.

9 Edison laboratory negative #6177B, a detail of which is also a Museum of Modern Art negative. The San Francisco parlor view also indicates that the five original San Francisco Kinetoscopes were later replaced. The peep-hole machine at the far end of the Kinetoscope row in this San Francisco parlor may have been used as a Kinetophone, since ear tubes appear to extend from the base. But there are, even excluding this machine, six machines exactly alike, which suggests that Bacigalupi's machines were replaced with later models.

La Nature article referred to above. Holes in the lower section, noticeable in the Eastman House, Ford Museum, Academy of Motion Picture Arts and Sciences, Clarke and Bacigalupi Kinetoscopes, may have been, as Mr. Harold Anderson of the West Orange laboratory suggests, vent holes. I show in Chapter 13 that this accommodation could not have been made until April 1895.

The cast iron eye-pieces are the same for all Kinetoscopes except those in the two instruments shown in Illustration 6. Laboratory records[10] suggest that the later eye-piece may have come into existence about May 18, 1894.

At this same time the nickel-in-the-slot attachment, although dispensed with at the 1155 Broadway parlor,[11] may have been a standard feature of the Kinetoscope. Estimates for 20 boxes and tubes, possibly for the Kinetoscope, had been received by Dickson by March 17, 1894.[12] And on May 18, according to the Ott notebook, a pattern for these coin boxes was either made or charged to the account. The funnel leading to the coin boxes is described in the Eastman House instruction sheet (see page 15). The mechanism for the nickel-in-the-slot device finally made standard in the Kinetoscope was built according to the patent issued to J. Henry Ling on November 4, 1880, U.S. #495557. This is clear from the Ford Museum Kinetoscope.

Many entries in the Edison archives indicate that Kinetoscopes sold for $250 in the spring of 1894, although Bacigalupi claimed to have paid twice this (see page 60). As of June 5, 1895 (see page 132) this price had been reduced to $127.50. Later in 1895 second hand Kinetoscopes were selling for $100 to $150, including film and batteries.[13] Ramsaye, from sources he does not indicate, says on his page 219 that by (presumably, since Ramsaye gives no dates) the end of 1895, Edison had reduced his price to Raff and Gammon to $70 and intended that they should sell the instrument for $100.

10 Page 117 of John Ott's Precision Room notebook, for example.

11 On April 2, according to the Ott Precision Room notebook, attachments were made for the 1155 Broadway Kinetoscopes to make them work without a nickel. The attendants switched the instruments on and off for customers who had paid their twenty-five cents. This arrangement may be seen in the Dicksons' booklet.

12 "Motion Pictures, 1894"

13 *New York Clipper* advertisements of July 27, August 24, and November 16 and 30, 1895.

14

Herman Casler's description of the operation of the Kinetoscope is clear and authoritative. I reproduce the two paragraphs of this description:[14]

> . . . A ribbon of transparent film carrying the pictures is laced up and down over idle spools at the lower part of the case. The ends of the film are joined, forming an endless, band passing over two guide drums near the top of the case. One of these drums is driven by motor and feeds the film along by means of sprocket teeth which engage with perforations along the edges of the film. Just above the film is a shutter wheel having five spokes[15] and a very small rectangular opening in the rim directly over the film.[16] An incandescent lamp[17] . . . is placed below the film between the two guide drums, and the light passes up through the film, shutter opening, and magnifying lens[18] . . . to the eye of the observer placed at the opening in the top of the case.
>
> The film had a continuous motion, and, I believe, showed the pictures at the rate of forty per second.[19] The shutter was probably about 10″ in diameter[20] and, judging from the photograph, the opening must be about ¾″ wide. As the shutter made one revolution for each picture, the

[14] In a lecture of *circa* 1909 in Syracuse, New York. Casler's typescript copy of this talk and the glass slides illustrating it are in my collection.

[15] This five-spoke matter is interesting. Casler showed on the screen at the time he was speaking these words, a 3¼″ x 4″ glass slide of "Kinetoscope No. 1", as photographed in about 1899 for Equity 6928. This is the same machine (but a later photograph) reproduced in *The Edison Motion Picture Myth*. This Kinetoscope had five spokes, but a six-spoked shutter was standard for later Kinetoscopes, and, if we may judge from the *La Nature* illustration of October 20, 1894, sometimes only four spokes were used.

[16] The opening in the shutter in the West Orange laboratory, presumably of the 1891 Kinetoscope, is about ⅜ inches, but this may well have been enlarged for use in the Columbia College projection experiments with the Lathams (see Chapter 10) in the fall of 1894. The Eastman House Kinetoscope has a slit about 3/16 inches wide. The Academy of Motion Picture Arts and Sciences Kinetoscope has one about ¼ inch wide.

[17] Dickson said in Equity 5/167 that this was a four or five candlepower lamp.

[18] Dickson said in *ibid.* that the magnification was two and a half times. Others gave somewhat varying estimates. The diameter of the viewing lens on the Eastman House machine is about 2 5/8 inches.

[19] Casler is correct here. Armat, Jenkins, Dickson, *et al.*, as well as the evidence of our own eyes (see page 7) indicates that this was true of phototographs reproduced in the Kinetoscope. Unless they were reproduced at the rate at which they were shot, the action would have been unnatural. I have discussed this matter on page 108 of *The Edison Motion Picture Myth*.

[20] I have said in *The Edison Motion Picture Myth* that Dickson himself said that the shutter was 10 inches in diameter, and with a ⅛ inch slot. I measured the five-spoked shutter wheel at the West Orange laboratory and found it to be 11½ inches in diameter and with a ⅜ inch slot. 11½ inches is also the diameter of the Eastman House Kinetoscope shutter.

length of exposure would be between 1/1600 and 1/1700 part of one second.

The length of the film used varied from 25-30 feet in the earliest Kinetoscope (see *The Edison Motion Picture Myth*) to from 42 feet to 48 feet in the later.[21] Varying film lengths could, of course, have been easily accommodated by varying the number of spools in the spool bank and by adjustment of the spring-arm spool (see Illustration 17).

A remarkable—and apparently unique—instruction sheet in the George Eastman House for "Setting up and Operating the Edison Kinetoscope" describes the process thoroughly. At a later date the spool bank itself was removable and customers could change films by turning a thumb screw and replacing the bank itself—already threaded with film. This is clear from a letter of February 17, 1896 in the Baker Library collection. The Eastman House instruction sheet is as follows:[22]

DIRECTIONS FOR SETTING UP AND OPERATING THE EDISON KINETOSCOPE.

Open top and right hand side of Cabinet, take sheet iron shutter from side and drop it over centre shaft of Kinetoscope mechanism at point "A."

Place sheet iron shutter on centre shaft of Kinetoscope mechanism with marked side down, tighten the nut (with washer *under* the nut) and screw down temporarily.

TO PLACE THE PHOTOGRAPHIC STRIP

Place a sheet of clean paper on the floor on right hand side of Cabinet, then open the tin box containing the film, loosen and take out the tin tube, which will leave a film loop in your hand. Great care must be taken to avoid scratching of Photographic strip during this operation.

Unwind the film entirely and keep the end in your *left hand, dull side up*—the head of each picture pointing towards the right.

Pass the film under top cross piece of Cabinet and temporarily over reels "BB," while the film is brought over reel "C," this with particular care, avoiding bending or cracking of the film. Now pass the film under "BB" and over "D."

Return to the left and bring film down and up over each reel, as shown.

When all the reels are filled, hook on the spiral string

[21] Testimony in Equity 5/167 said that later it was "about 48 feet" but never *more* than 48 feet. Film shipments suggest that it was often 46 feet.

[22] Reference should be made, in reading these instructions, to Illustration 17.

"F" to tension lever "G" and bottom screw, and if there is too much tension, take the next screw.

Great judgment should be exercised in avoiding *over strain* or *slackness* of film, as both are equally bad—when too tight the film is apt to tear, when too slack the film is apt to ride up on reel edges and tear, besides, being liable to slip on reel "C" which would [?]²² automatically stops the machine from operating.

<div align="center">TO SET SHUTTER TO CORRESPOND WITH PICTURES</div>

[?] one Photographic strip around by means of the shutter (under no circumstances by pulling the strip itself) until single picture fits the opening exactly, then loosen shutter and turn same until slot in shutter is at centre of picture, and then tighten shutter nut.

<div align="center">TO SET LAMP AND REFLECTOR</div>

Loosen reflector nut "H," which lowers the reflector, giving room to screw the lamp into socket "I," then loosen screw on lamp holder "J" and see that the carbon spiral of lamp is in the centre of the square opening. Then raise up reflector to lamp as close as possible without touching same.

Connect your battery wires to binding posts in battery compartment and then start the machine. Now adjust the lamp by turning the lamp tube "K" until the best light is obtained.

A further adjustment can be had by moving up or down the reflector. During this operation the picture should be viewed through lens.

Now place the cone shaped funnel, *small end down* over the square hole.

Should the picture show an edge of the next, the shutter must be reset, a very little ahead or back according to which edge of picture appears.

Light and speed of motor can be controlled by putting in more or less resistance in lamps or motor circuit—in other words, by changing the position of the brass contact strip from under the wire resistance coil.

As soon as the light and speed commence to go down, immediately detach the leading wires from binding posts, and have batteries recharged.

In oiling, care must be taken to avoid getting any oil on film. Oil each oil hole, also worm wheels and centre worm shaft.

Machines should be oiled before shutter is put on, in order to reach the centre worm shaft.

Belt should not be too tight nor too loose. In case of the belt getting too slack, cut out a small piece of same and rewire it as before.

²³ Here, as in the following bracket, the type is obliterated by damage to the original.

Oil up motor and wipe off commutator with oily cloth
or vaseline to prevent brushes from cutting.

Should the brushes spark, see that they are set exactly
opposite each other vertically, and that the tension is not
too great, (pressure of brushes on commutator).

Binding posts for the connection of battery are set in
top of battery closet next to door hinge. Heavy insulated
wire should be used for this purpose.

THE KINETOSCOPE COMPANY

3 · The Black Maria

GRANTING THE EXISTENCE OF AN EFFECTIVE CAMERA AND AN
effective device for the exhibition of the product of that camera,
the first substantial step in the establishment of the American
motion picture industry was a proposal to Edison on October
31, 1892. This date, the reader of *The Edison Motion Picture
Myth* will remember, is exactly appropriate to the date I have
set as that at which Dickson had achieved his camera. This
proposal was for the exploitation of the Kinetoscope in the
World's Columbian Exposition in Chicago. A.O. Tate (see
Illustration 30), Edison's right-hand man after Samuel Insull
had left and before W. H. Gilmore came, telephoned Edison
from Chicago and urged him to conclude the deal. Edison was
to loan the Chicago Central Phonograph Company (which was
to manage the Fair business) $10,000 and was to receive, in
return, 801 shares, or one-half-plus-one—a controlling interest.
He was to be paid back out of the first proceeds from Fair
Kinetoscopes. After he was repaid he was to retain 400 shares
of the company, or one-fourth—equal with Tate, Lombard and
Benson.[1]

[1] "Phonograph.N.A. Phonograph Co. 1892". Thomas R. Lombard was asso-
ciated with the North American Phonograph Company, which was concerned
with the use of the phonograph as a dictating machine. Ramsaye's caption for
a photograph showing Lombard in his Fair office gives him credit for being
"the first man to see commercial opportunity in the motion picture machine
he had discovered in Edison's laboratory," but this not correct. Erastus A.
Benson was an Omaha banker who had made considerable investments in the
phonograph. He was at this time president of the Chicago Central Phonograph
Company, which distributed phonographs in Chicago. He was thus a logical
man for this enterprise.

The next day Lombard and Tate, meeting in Chicago and needing financial support for the venture, agreed to share their Kinetoscope Fair prospects with Benson:[2]

> November 1st 1892.
> For good and valuable consideration, the receipt of which is hereby acknowledged, the subscribers Thomas R. Lombard and A.O.Tate, agree to permit Mr. Erastus A. Benson to participate to the extent of one-third in any interest which they now have or may hereafter acquire in the earnings of the invention of Thomas A. Edison known as the Kinetograph during the term of the exhibition of this instrument at the World's Columbian Exposition, and to the same extent in any ownership in the said instruments and appliances therefor so exhibited which they hereafter may acquire. It being understood and agreed that the said Erastus A. Benson will pay when called upon to do so one-third of the preliminary expense which must be incurred in the transportation and installation of the said machines, employment of help and other necessary and appropriate incidentals.

> (THOMAS R. LOMBARD
> :
> (A.O.TATE
>
> (SIGNED)
> I agree to the above
> (SIGNED), E.A.BENSON

Benson agreed to supply one-third of the needed capital and the three men were to share the profits equally.

(Tate also planned to install a number of weight machines at the Fair. In a letter of November 11 he urged the Phonograph Works to hurry with these[3] and in a letter of February 18, 1893 complained that even the model, ordered two months before, was not yet finished.[4] Tate, frustrated on all sides, apparently never got his weight machine. His relationship with Edison was deteriorating rapidly and Edison was not disposed to do anything for him with alacrity.)

A November 14 note urged Edison to hurry with the Kinetoscopes:[5]

> Mr. Edison.
> The World's Fair opens on the 1st of May next. In order that there may be no delay in placing Kinetographs

2 This was inserted with a letter from Tate to Edison of February 10, 1893 in "Motion Pictures. 1893."
3 "Phonograph. N.A. Phonograph Co. 1892."
4 "Phono. U.S. Ed. Phono. Works 1893."
5 "Exhibitions. 1893 [sic]".

[i.e. Kinetoscopes], would it not be well to take this matter in hand at once? We will have to have a good many "records" for these machines. I am not familiar enough with the instrument to know whether there is going to be any trouble in getting these; but it seems to me we ought to start at once. I wish we could get the Christmas Pantomimes which are given in London each year. Would this be feasible?

Lombard, in the Chicago office of the now bankrupt North American Phonograph Company, represented the affairs of the Lombard-Tate-Benson Kinetoscope *entente* in the Ways and Means Committee of the Fair. A letter of November 15 discusses this:[6]

> My dear Tate.
> I have received your telegram in regard to the concession for Kinetographs, and find that the concession has not yet been acted upon, owing to the great pressure of business before the Ways and Means committee. I shall push the matter forward as fast and as soon as possible. I wired you this morning to that effect.

On November 24 Tate wrote John Barrett, the Fair's Chief Electrician (a man much impressed by Edison), that the Kinetoscope would be at the Fair.[7] This may have been one way of influencing a prompt decision.

But on December 3 the concession had still not been acted upon, although Tate, in Chicago, wrote Edison that he thought it would be acted upon that week:[8]

> It was to have been acted upon Tuesday last, but Mr. Lombard had to be in New York upon that day on some personal business, and the matter was postponed until the latter part of the week. I enclose herewith a memorandum showing where the Kinetographs are to be placed at the Fair.[9]

On December 9 Tate, back in the East, was told by Lombard that the Ways and Means Committee wanted 33% of the gross, but that he, Lombard, hoped to reduce it to 20%. We will see that a compromise was reached at 25%.

6 "Motion Pictures. 1892."
7 "Exhibitions. 1893 [sic]".
8 "Motion Pictures. 1892."
9 This memorandum is now lost. Although apparently no more than one Kinetoscope was ever "placed at the Fair," such a plan would have been interesting. "Kinetographs" here, as often elsewhere in this correspondence, means "Kinetoscopes."

A month later, on January 9, 1893, the concession still had
not been secured:[10]

> While I was in Chicago [wrote Tate to Edison] I saw the
> Secretary of the Ways and Means Committee and told
> him that if we had to give up 33⅓% of the gross receipts
> to the Exposition people, we would decline to install the
> instruments, as we could not make a living under those
> terms. Afterwards I called upon Prof. Barrett and ex-
> plained the situation to him and he has taken the matter
> personally in hand. He is going to see a friend of his, the
> Chairman of this Committee, and he assures me that the
> terms will be arranged to our satisfaction. We are trying to
> get it down to 15%.

This letter also mentioned that the only electric current at the
Fair would be Westinghouse alternating, and that therefore
Tate and his associates would need to lease storage batteries
from the North American Phonograph Company for their
Kinetoscopes.

On January 18 Benson asked Tate if the shares had been
worked out, "Also, whether any of these machines have been
actually built and tested [,*viz.*] the nickel-in-the-slot attach-
ment."[11] Tate replied on January 26 that he would advise
Benson as to this "in the course of a few days."[12]

The camera patent application, meanwhile, although its final
issue and the details covered thereby are outside the scope of
this history,[13] was pursuing its course. On December 6 Edison
was told that two of its most important claims, although re-
jected, could be "soaked," until May 20, 1894. "Let it soak,"
he replied. He then began the course which was to lead him,
in August 1897, to the issue of the notorious motion picture
camera patent, by which he harassed the whole industry for
years.

The Kinetoscope application was allowed on December 8,
1892. On December 31 Dyer and Seely, in no precipitate haste,
leisurely "cleaned up" the language of the Kinetoscope claims,
only to have them mauled about by the harsh strictures of the

10 "Motion Pictures. 1893."
11 *Ibid.*
12 *Ibid.*
13 This may come within the scope of a sequel or sequels to the present book.
This sequel will make a survey of the enormously complicated material de-
scribing the establishment of the industry and its effulgence in the nickelodeon
era.

Examiner.[14] On the same day Edison was told of the allowance and that the case could lie dormant in the Patent Office for six months after December 8—if he so desired.[15] At first he seemed so inclined, and wrote at the bottom of the letter "Let it lay as long as possible." But he changed his mind, crossed out the directions to delay, and wrote "Take it out".[16] This Dyer and Seely did by paying the fee on February 22, 1893. The Kinetoscope patent issued on March 14, 1893 as U. S. #493426.

Meanwhile, for the months of October and November 1892, substantial amounts—$311.47 and $526.83 respectively—had been charged to the Kinetoscope account. Explanatory vouchers for these charges included orders for chemicals and other film material, and suggest motion picture activity.[17] According to the same laboratory records, charges totalling $789.03 for December 1892 comprised the first charges for the Black Maria.

This "revolving photograph building"[18] was under construction from December 1892 to January 1893. It has often been called the world's "first" motion picture studio. This is incorrect: the 1889 photograph building at the West Orange laboratory, if no other, predated it considerably.[19] But if we were to call the Black Maria the world's first studio specifically built for motion picture production, we are on firm ground: I have found no earlier.

The Black Maria was felt to be necessary as soon as motion picture plans for the Fair began to outgrow the 1889 building. The stage area of that building was small, and the skylight lighting insufficient. So Dickson set about designing a larger, lighter, more flexible stage. Many new subjects would have to be taken to supply the Fair Kinetoscopes, and they would have to be taken quickly. A new studio was indicated. Tate had written on November 14 that he thought "we ought to start at once," and soon the Black Maria was begun.

14 From the case file in the National Archives in Washington.
15 Ibid.
16 "Motion Pictures. 1892."
17 Labor and Material Sub-Ledger No. 6.
18 Ibid. This was the bookkeeper Randolph's language.
19 This building (see Hendricks, The Edison Motion Picture Myth) was built in the fall of 1889. In it were shot, for example, the four Phonogram subjects of October 1892.

The first intimation of this revolutionary new studio is in the John Ott Precision Room book. Page 101 of that book has a notation dated September 12, 1892 for shop order No. 654 for "Building Revolving Photo Building." We can thus be sure that the summer of 1892, as well as producing an effective camera and viewer, also produced the first plans for the studio where the camera was to be operated so successfully for a period of several years.[20]

Perhaps the September 12 entry was for a blueprint for a drawing for the Maria. Possibly this plan was unlike the Maria as we know it: certainly nothing seems to have been done about carrying out such a plan—if a plan it was—until December. But on the 10th of December a large order of lumber was received from the Newark lumber dealers Swain and Jones.[21] This lumber clearly suggests the framing of the Black Maria. I have changed the language slightly to conform to modern usage:[22]

6 —	1½ x 6″	20′	Hemlock
1 —	1½ x 6″	12′	"
4 —	6 x 12	28′	Spruce
1 —	6 x 12	26′	"
1 —	6 x 12	22′	"
1 —	10 x 12	22′	Yellow Pine
1 —	2 x 10	12′	Hemlock
7 —	2 x 10	14′	"
2 —	2 x 10	18′	"
2 —	2 x 10	20′	"
2 —	6 x 6	18′	Spruce
9 —	3 x 4	14′	"
5 —	3 x 4	12′	"

On December 12, 27 and 30 additional shipments were received, each shipment comprising material logical to the advancing construction of the Maria:[23]

20 The exact extent of Black Maria production awaits further study. The Maria was regularly used, I believe, for the shooting of motion pictures, or processing them, through 1897 or 1898—and possibly the beginning of the new century. At that time the Edison studio on East 21st Street in New York City came into being. For some time before its final destruction—which, according to laboratory sources I have not closely examined, was about 1905—the Maria had been used only for storing or processing.

21 In the 1892 Orange Directory: "Swain and Jones, lumber dealers, 46 River, Newark."

22 Receiving book 1/1/92 - 12/31/92.

23 Ibid.

```
554'   1 x 4½ #3 Pine flooring
 28'   2" x 4" x 10' hemlock
  9'      "     12'    "
  2'   2 x 10 x 18'     "
1966'  ½ x 10 planed pine
 20'   2 x 8" 14' spruce
215'   shelving
100'   1" dressed pine.
```

I have had an analysis of these shipments made by a specialist and reproduce this analysis as Illustration 3. This analysis gives, for the first time I know, an exact demonstration of the Black Maria dimensions, which has been a source of some controversy.

Various vouchers to "Rev. Phot. Bldg." appear in laboratory accounts for the first months of 1893.[24] The account books are explicit in their record of the cost: December 1892, $366.70; January 1893, $218.25; February 1893, $7.77; March 1893, $3.75; April 1893, $16.88; and May 1893, $28.39. There is a credit of $5.85 for December 1892, and this makes the total cost of the Maria $637.67. This agrees exactly with John Randolph's testimony.

The earliest known photograph of the Black Maria (see Illustration 4) was shot possibly by Dickson[25] for the drawing made by James R. Outcault[26] for the June 16, 1894 *Electrical World* article. It was also published in *The Photographic Times* of January 1895. It is at once both the most interesting and the most revealing of all Black Maria photographs and drawings. It establishes to within a few feet the location of the Maria, a problem which vexed workers for some time before the *Electrical World* article was found. The original photographic model of the Outcault *Electrical World* sketch was found in the West Orange archives by Norman Spieden, Supervisory Curator. Mr. Spieden and I also arrived at an approximate location for the Maria. If the present day visitor to the West Orange laboratory will start at the southwest corner of

24 These are recorded in the account book cited above and in Randolph testimony in Equity 6928.

25 The size of the print is 4½" x 7½", from negative #6570 in the Edison archives.

26 James R. Outcault is the artist who later became famous as the creator of the "Yellow Kid" illustrations of *The New York World*. *The World* for February 10, March 10 and March 17, 1895 has good examples of Outcault's work.

Building No. 21 and walk directly to the down-spout of the water tower, when he arrives at a point midway between the building corner and the down-spout he will, it appears, be standing approximately at the pivot point of the Black Maria. Work with 1888-89 photographs was also helpful in this determination.

In addition to the easily credible idea that this photograph was taken for the *Electrical World* June 16, 1894 article (and would therefore likely have predated June 1, 1894) the photograph itself is full of details enabling us to determine the date more closely:

1, The trees at the right and the left are leafless, suggesting a pre-spring shooting;

2, The condition of the snow, particularly on the roof, suggests a shooting within the first several days ' of March 1894;[27]

3, A close examination of a sign seen through the open door of the Maria reveals the legend: "The/ Latest Wonder/Shave & Hair Cut/ for a Nickel." This is a subject we know was in existence as of March 11, 1894.[28] Thus the photograph was taken while this subject was in production and probably not later than March 8, 1894, which agrees admirably with our weather conclusions;

4, The cock fight, although obviously in production at the time the photograph was taken (the rooster is being held by Fred Devonald, who owned it),[29] is less conclusive than the barber shop information and the weather data. But we nevertheless know that this subject was one of those shown at the April 14, 1894 opening of the Kinetoscope parlor at 1155 Broadway.

[27] This snow is clearly a comfortably measurable fall—and no fresh fall—after a thaw. A study of the weather reports in *The Orange Chronicle* is illuminating. Many sleighing parties were held at the end of this February. And on April 7:

Only twice in the course of the last fifty years has March failed, as it did on this occasion, to bring snow in measurable quantities . . . On the 15th and 17th we had insignificant flurries.

The Fifth Annual Report of the Board of Directors of the New Jersey Weather Service, of 1894 in the Newark Public Library corroborates an early March shooting for this photograph. The data compiled by Professor Sonn of Newark (and made available to me at *The Newark News* on March 3, 1960) also supports this date.

[28] We know this from a *New York Tribune* account of this date. The subject is also mentioned in *The New York World* of March 18, 1894. To have been taken and processed in time for the *Tribune* account, the subject logically would have been in existence not later than March 8. (See also the 40 frames of this subject in the *Century Magazine* June 1894 article.)

[29] According to his children, to whom I have spoken.

We therefore know how the Maria exterior looked as of about March 5-8, 1894.

Another Black Maria photograph (see Illustration 5) is not so decisive.[30] Again, it was shot after the leaves had fallen, i.e., late in October, and in cool-to-cold weather, if we may judge from the clothing of the men in it. It seems to have been made for a frontispiece for the Dicksons' *History of the Kinetograph, Kinetoscope and Kineto-Phonograph*, the text of which I believe to have been completed by about December 17, 1894.[31] But considering that the photograph was a frontispiece for that work and that the Library of Congress did not get its copyright deposits for the book until February 2, 1895[32] it seems that the latest possible date for this photograph would be some time in January of 1895. This would allow a week or so for printing. Dickson himself is in this photograph, and along with him there are three other young men, at least two of whom may be said to have a jaunty, young-man-about-town look. This description would fit the Latham boys, Otway and Gray admirably, although Gray spent much of this season in Boston—according to records in the Baker Library. Unfortunately there is not sufficient detail to positively identify these men, although I believe that the age is appropriate for the Lathams.[33] A pre-late-January 1895 deadline is also appropriate for a Latham visit to West Orange, since the Latham-Dickson relationship was at its height late in 1894 and early in 1895.

It is also obvious that the Maria had been recently somewhat enlarged at the time this photograph was shot. That it was not so enlarged on September 8, 1894 is obvious from a sketch made by the artist of *The New York Sun* on the occasion of the Corbett-Courtney fight (see page 100). That it *had* been thus enlarged by the deadline for *Frank Leslie's Popular Monthly* of February 1895 is clear from the illustration in an article in that issue entitled "Wonders of the Kinetoscope" (see Illustration 8). This article also has a remarkable drawing of the Maria interior, showing (as I noted in Chapter 1)

30 Negative #6543 in the Edison laboratory archives.

31 See *Image,* September, 1959, also page 10 herein.

32 According to a letter to me from the Library.

33 Gray Latham would have been 28 years of age and Otway 27 (see Appendix B.)

the camera and the Maria details hitherto unknown, e.g., apparently two doors on the far side (see Illustration 9).[34]

Beside those I have mentioned, a sketch of the Black Maria in *The National Police Gazette* of September 22, 1894 is frivolous.

Additional interesting interior details may be seen in a laboratory negative (Edison laboratory #6566B) which may well have been taken for the use of either Outcault (for his *Electrical World* drawing) or E.J. Meeker (for his *Century Magazine* article—see Illustration 7). Surely the weather was not cold at this time and the Maria was still unenlarged. The occasion is also proper: there is nothing "arty" or posed-looking about it; it shows no notables—or even carefully chosen nonnotables.

Various motion picture subjects within this perod also show interesting details of the Maria interior. For example, the "Heap Fun Laundry" and Corbett-Courtney production stills, (Illustrations 20 and 54) the "Sioux Indian Ghost Dance," and the serpentine dancer of *The New York Evening Journal* of January 13, 1937. "Alcide Capitaine" and "Mexican Knife Duel," illustrated in the Dicksons' booklet, are also interesting in this connection.

The Black Maria was presumably 48' x 10'-14' x 18' overall, although certain contemporary records are vague.[35] It was lined at least partially with black tar paper[36] although it was said more than once to have been painted black inside.[37] This lining was not entire. It covered, so far as I have been able to determine, that part of the Maria surrounding the shooting

[34] I do not believe the presence of these doors is due to artistic license. It is the logical explanation for the fire hose stream playing off-screen right in the "Fire Rescue Scene". There is no other place for this water to go.

[35] According to *The Orange Chronicle* of March 10, 1894 it was 50' x 13'. *The New York Sun* of September 8, 1894 said that the Corbett-Courtney ring was 14' square—which is appropriate to Illustration 54, and the width Mr. Brower has settled upon in Illustration 3. *The New York World* of September 8, 1894 reported that the building was 15' wide, and *The World* of June 16, 1894 reported that the ring for the Leonard-Cushing fight (see page 000) was 12' square. *The New York Times* of the same date agreed with *The World*.

[36] For example, *The Orange Chronicle*, March 10, 1894.

[37] For example, in *Frank Leslie's Weekly* of July 17, 1894 and *The New York Sun* of September 8, 1894. This tar paper is obvious in the Corbett-Courtney photograph (Illustration 54) and in the production still of "Heap Fun Laundry" (Illustration 20) as well as exterior photographs.

area or stage. This area, the outer confines of which were some-
what altered to conform with the late-1894 alterations, was
delineated at first by a raised platform[38] and later by chalk
marks,[39] wooden barriers or otherwise limned space.[40] For the
Corbett-Courtney subject the walls of the shooting space were
padded:[41]

> The ring was 14 feet square. It was roped on two sides,
> the other two being the heavily padded walls of the build-
> ing. The floor was planed smooth and covered with rosin.

The New York World of September 8, 1894 reported that the
sides were "heavily padded up to a height of six feet." No
barriers, chalk marks or platform are visible in "Princess Ali"
(see page 137 and Illustration 28) where the entire stage area
appears to be draped off. This technique was apparently used
in both early and late Maria production. A letter from Raff
and Gammon in the Baker Library collection at Harvard asks
the return of the "portieres that were left there when Dolorita
was taken."

The Black Maria swung suspended on a central vertical axis
over a graphite pivot[42] to accommodate the need for sunshine,
although as a matter of practice nearly all Maria subjects seem
to have been shot close to noon. This would have made the
pivoting less important.[43]

The Maria was further supported by rollers less and less

[38] This slightly raised platform may be seen in the experimental sound film
described on page 122. It may also be seen in Illustration 4. A "stage" was
frequently remarked upon, however, at times when no *raised* platform existed.

[39] In the *New York World* April 26, 1896 account of the "Irwin-Rice Kiss,"
for example, it was said that "Rings had been drawn on the floor about the
chair legs, so that they could not be moved an inch." And a Maguire and
Baucus "Annabelle" shows chalk lines at the rear of the stage.

[40] These barriers are frequently plainly visible, beginning with the Carmen-
cita film (Illustration 12) and the 1894 Annabelle films. They are fronted by
newel posts, and appear to be, possibly, halves of the balustrade background
of the 1892 *Phonogram* subject (see *The Edison Motion Picture Myth*). When
the stage area was enlarged—a crucial development—these balustrades were
supplanted by the rough barriers seen in the small Maria interior of Illustra-
tion 7. These barriers are also visible in such subjects as the 1895 Annabelle
dances (of *The New York Evening Journal* of January 13, 1937), "Sioux
Indian Ghost Dance," "Heap Fun Laundry" (Illustration 20), etc.

[41] *The New York Sun,* September 8, 1894. See also Illustration 00.

[42] *The Century Magazine,* June 1894.

[43] We know, for example, that the Corbett-Courtney fight and the Barnum
and Bailey subjects of May 1895 were shot near noon. And judging from
the angle and length of the shadows in many other subjects, they were also
shot about noon.

used as time went on.[44] These rollers were necessary, along with the iron trusses, to support the Maria's considerable end weight. They are shown in an exaggerated form in the *Century Magazine* June 1894 sketch by Meeker. This sketch, in spite of a certain artistic license (the iron truss nearest the viewer is missing, the tar paper strips are fewer, the rose-window of the camera-room is multi-paned), is an interesting study.

The Black Maria camera was mounted on steel tracks. These were described and illustrated in various periodicals.[45] It was drawn in and out of the small room facing the stage for loading and reloading.

4 · Building the First Model

THE BLACK MARIA WAS NO MORE THAN FAIRLY COMPLETED WHEN Dickson had a nervous breakdown and went south for a ten weeks' rest. Plans to have Kinetoscopes ready for the Fair's opening had to be abandoned, and it was not until May 2 that Tate felt that it was time to order the first lot of machines with the hope that they would be ready before the Fair closed.

We know exactly when Dickson left for Florida. His friend Theodore Lehmann[1] accompanied him, and Lehmann, then working at the Ogden ore-milling works, wrote on February 3:[2]

> I am going to the southern part of Florida tomorrow, together with Mr. Dickson of the Laboratory, to spend a few weeks of vacation there, hunting. Mr. Dickson is seriously ill, and we having always been good friends, we decided to take our holiday together.

[44] Illustration 5 suggests that by that time the Maria may no longer have been swung on its axis. The iron trusses essential to this action had been removed and the rollers blocked.

[45] In the Meeker and Outcault drawings, for example. See also the description of the camera in Chapter 1.

[1] Lehmann was, the reader of *The Edison Motion Picture Myth* will remember, like Dickson, a string player. Laboratory records also tell us that he was lately from Europe.

[2] "Laboratory of T.A. Edison, W.K.L. Dickson, 1893."

I do not know any address as yet as we shall in all prob-
ability not stay in one place very long . . . Will you write
me Theo. Lehmann, 166 Cleveland St., Orange, N. J.[3]

Dickson and Lehmann, therefore, left the Orange vicinity on
Saturday, February 4, and traveled south to below Fort Myers,
Florida, for a hunting and vacation trip. That Dickson was an
eager and probably adept hunter is clear from other sources.[4]
But neither his illness nor his hunting prevented him from tak-
ing photographs for use in the Edison biography which he and
his sister Antonia were then preparing for *Cassier's Magazine*.[5]
The language of the *Cassier's* text, for all its inflation, never-
theless suggests first-hand experience—particularly (for me)
the first mention of the Calahoutchie River on page 333. There
can be no doubt, also, that the photographs on pages 332 and
335 were taken by Dickson during this trip. This is clear from
the credits. He stayed at Fort Myers for five weeks of this trip
(see page 33).

Lehmann had said that Dickson was "seriously ill," and *The
Orange Chronicle* of February 11 said that he was "much
affected by brain exhaustion." Edison himself said, in a letter
to H.E. Dick of February 17, that it was an "alarming sick-
ness," which convinces us that Dickson was indeed "seriously
ill"—since Edison was alarmed by few things. It is fair to say
that Dickson's "alarming sickness" was what we might call
a "nervous breakdown."

Edison advanced Dickson $225 when he left and, in addition,

[3] This is Dickson's home address. It should be recorded somewhere in this
work that Dickson may have done film processing in his home. I visited this
house (after an adventure involving endless negotiation with the Newark
archdiocese office, Orange parish priests, the present owners of the house—
and finally two members of the Orange police force!) and found, in a lean-to
off the kitchen, a double sink of apparently nineteenth century vintage. This
sink would have been quite appropriate for film processing. I was told at this
time (although in a way that left me far from satisfied) that these were the
only such sinks in the house.

[4] *The Orange Chronicle,* March 20, 1897, said that the Winchester Arms Com-
pany gave him two "handsomely engraved" guns "as an expression of their
admiration for his fine workmanship" in breaking twenty out of twenty clay
pigeons in trap shooting.

[5] Both *Cassier's* and *The Life & Inventions of Thomas Alva Edison*—a re-
print of the *Cassier's* series—reproduce such photographs. See, for example,
the photographs on pages 332 and 335 of the book. Edison had an elaborate
summer house in Fort Myers which the two men apparently made their head-
quarters. This house and its adjoining laboratory may still be visited. Edison
correspondence occasionally called this place "Fort Myer" or "Fort Meyers."

instructed his bookkeeper John Randolph to pay Mrs. Dickson her husband's salary during his absence. A letter of February 10 from Tate, with Randolph's response, makes this clear:[6]

> . . . Please send a check for $34. to Mrs. W.K.L. Dickson . . . I will give you a bill for this amount and explain it in the course of a few days . . . Tate.

> Mr Tate [replied Randolph] Before sending the above check I beg to advise you that Mr Edison advanced Mr Dickson when he went away $225.00 and we send each week to Mrs. Dickson while Mr Dickson is away $30.00 . . . do you wish me to send the above check

From this $225.00 Dickson was expected to pay his traveling and living expenses. But the amount that he was advanced when he left and the salary that his wife was given while he was away were not gifts. When the final rupture with Edison came and a final accounting was made, he was charged for the entire amount: his salary at $30.00 a week for apparently ten and a half weeks, the $225.00 cash advance, and half the Fort Myers grocery bill.[7]

Kinetoscope affairs, meanwhile, although practically stopped during Dickson's absence, were the subject of considerable negotiation. Several days before Dickson left, apparently on or about January 27,[8] H.E. Dick, brother of A.B. Dick whom Edison regarded as a good and faithful servant,[9] had visited the laboratory and told Edison that *he* wanted a Kinetoscope concession in Chicago. He received assurances that he would have this—in spite of the fact that Tate considered that such a concession was his. Dick returned to Chicago and wrote Edison on February 4:[10]

> Please send me a contract on lines we agreed upon for the Kinetograph and also kindly say when you think it will be possible to send me a sample [of film] . . . I have the refusal [for slot-machines] . . . I am arranging my affairs so as to be able to handle almost any number of [Kinetoscopes] . . .

[6] "Laboratory of T.A.Edison, W.K.L. Dickson, 1893."

[7] Page 172 of letter book E1717 7/31/94 - 7/1/97 charges Dickson with $55.50 for "½ of Bill for Living Expenses while at Fort Myers, Florida."

[8] A Tate letter of February 10 said "about a fortnight since."

[9] On June 7, 1892 Edison had written: "This young man, Dick, seems to be doing pretty well with the little one-horse trap that he has." (Letter book E1717 3/9/92 - 6/16/92.)

[10] "Motion Pictures, 1893."

Edison's reply again confirms the position that Dickson's absence slowed up the Kinetoscope project considerably:[11]

> Dixon [sic: Edison only rarely spelled Dickson's name properly] has been taken with an alarming sickness & has gone to florida he will be back in 2 months—the model is about finished but I am afraid that without you come on & hustle things personally . . . that nothing can be done as its impossible for me to give it attention just now . . .

It is only natural that Tate, having assumed this right over an extended period of negotiation should be incensed by these dealings, although he tactfully blamed Dick for the trouble and not Edison. He wrote to Lombard on February 10:[12]

> I learned a few days ago that Mr. H.E. Dick . . . was at the Laboratory about a fortnight since and made, or attempted to make, some arrangement with Mr. Edison for the exhibition of the Kinetograph in the City of Chicago. Mr. Dick did not call upon me, and it was only in ordinary routine that I made discovery of the fact. Mr. Dick was aware that you and I had this matter in hand, and his attempt to forestall us is a piece of sharp practise which I will long remember . . . Of course he had a perfect right to try and make a contract so far as general commercial ethics are concerned; but the favors which I have personally extended to Mr. A.B. Dick in the past make me feel that he should at least have had the courtesy to consult me before approaching Mr. Edison, knowing, as he did, that I was engaged in the same line of work. He will find that a Diamond can cut a Diamond . . .

(Tate, irritated by such treatment by Edison—of which this was only a typical example[13]—was soon to leave Edison's employ after years of service. Like many Edison men, however, he was eager to forget all this later in life and was responsible for one of the most saccharine tributes that Edison ever received.[14])

But so far as our history is concerned, who got a Kinetoscope concession is academic, since only one Kinetoscope was ready for operation by the time the Fair closed. This was in

11 *Ibid.*
12 *Ibid.*
13 For another, after making a contract with Norman C. Raff and Frank R. Gammon (see pages 51, 57 and 61) for the exploitation of the Edison-sponsored projector in 1896, and agreeing not to enter the market in competition, Edison specifically violated nearly every point of this agreement. Many others experienced this treatment.
14 In his *Edison's Open Door,* Dutton & Company, 1938.

spite of Edison's agreement to furnish 150 machines to the Tate-Lombard-Benson combination:[15]

> . . . Mr. Edison has made the following arrangement with us. He will build 150 of these machines and deliver them to us at the Edison Phonograph Works. All further expense for the transportation, installation and operation must be provided by us. We must also provide battery power . . . of the first proceeds Mr. Edison is to be reimbursed for the cost of the Kinetographs [i.e., Kinetoscopes] . . . One half of the net receipts are to go to Mr. Edison, and the other half to you, Lombard, and myself. [Tate is writing to Benson.] The deal is made for the City of Chicago and the World's Fair, and for the period covered by the latter . . .

On the same date Tate had his first solid doubts about the Fair opening date:[16] "I doubt very much if we can have these instruments in place before the 1st. of May . . ." It appears that as of this time and until possibly as late as April 12 or thereabouts there was not even one complete commercial model of the Kinetoscope in existence. Edison told Tate on February 17 that "the model is about finished," to a man with whom subterfuge would be useless—though he may have understood, as we do, why Tate would have wanted to keep the impatient Benson pacified.

A Tate letter of February 23 to *The New York Sun* said that "I will inform you when the [Kinetoscope] is in operation . . . in about a month."[17] But meanwhile he was pressed with other business and was perhaps becoming resigned to disappointment. He went south on March 9 and did not return for some time.[18] When he got back he was forced to write a prospective customer that the model would still not be ready for "about a week or ten days."[19] And on April 9 Edison wrote the Fair surrendering the concession:[20]

> We [the Committee] are in receipt of your communication of April 7th surrendering concession awarded you for permission to establish Kinetographs in the Exposition.
>
> The Committee very much regret that you are obliged to do this, but desire to thank you for giving it due notice at the earliest practicable date.

15 A letter of February 14, 1893 in "Motion Pictures 1893."
16 *Ibid.*
17 Letter book E1717 2/4/93 - 7/2/93.
18 *Ibid.*
19 *Ibid.*
20 "Motion Pictures, 1893."

But Tate, although despairing of opening the Fair with Kinetoscopes, did not despair of having at least some installed before it closed:[21]

> I would like to place an order immediately [he wrote Edison] for Twenty five Kinetographs. Will you please authorize me to do this by O.K'ing this note, if the same meets with your approval.

To this Edison replied:[22] ". . . first I want to see the model finished & pronounced ok by Dickson & ourselves 2nd I want an Estimate . . . as to Cost." Tate had reduced the Fair's demand for 33 1/3 percent of the profits to 25 percent,[23] and was eager to make the most of a situation made almost untenable by Dickson's absence and Edison's preoccupation.

Dickson returned to the laboratory on April 25, 26 or 27, after about ten and a half weeks in the south. We know this from the laboratory wage record. He immediately took photographic matters in hand, although a letter sent to his laboratory friend Thomas Maguire on February 24 indicates that he was much ·concerned with the matter even while he was away. It also indicates that he contemplated not being able to return at all:[24]

> Will Mr. Maguire please undertake this correspondence during my absence of 2 months—it is of the utmost importance—we wish to decide on some film—I have written to a certain Mr. Holwede[25] who may take my place as photog. —he is to give us the address of a new film party in Rochester—This new party was Eastmans head chemist who left them & starts a rival biz—*write please* to this party immediately on receipt of the address. asking them what they w^d furnish us with film for in large quantities say per 100 rolls 50 feet long by 1 9/16 *inches* wide—we will pay $10 for a slitting machine—we shall want about 1000 rolls in all at present—Want immediately 50 rolls fast— & 50 rolls slow for transparency work—as an experimental

21 *Ibid.*
22 *Ibid.*
23 *Ibid.*
24 "Laboratory of T.A. Edison, W.K.L. Dickson 1893." Here and elsewhere in this book I have, for printing expediency, italicized all words that were underlined in manuscript or typescript originals. For the same reason I have eliminated the two short lines that Dickson regularly placed under the second letter of his "w^d"s, "sh^d"s and "y^r"s.
25 George Holwede wrote to the laboratory on March 21 from a Hoboken, New Jersey address, asking for a job. But the reply on March 23 (in "Laboratory of T.A. Edison. Applications for Employment, 1893.") stated that Edison was "not in need of an assistant photographer."

34

lot—how soon could they furnish it after order—& to send
us immediately one 50 foot 5 inches roll to cut up—or any
convenient size—we want it tougher than Eastmans & if
they have Experimented further & gotten it more leathery
or tough we sh^d be glad to deal with them—Heiss [i.e.,
Heise] will get you to write to Blair people if necessary—
& when an order goes out please incorporate the following
stipulations:—

Film coated with an emulsion of proper thickness or
consistency & speed to take instantaneous impressions—
samples sh^d be sent to us for test & approval—and order
to when filled to be in accordance with samples furnished
—the basis or support to be of an even thickness & as
[sic] not too brittle—

On March 6 Maguire responded: [26]

Your letter of the 24th ultimo, which was accompanied
by a communication from George Holweide [sic], a can-
didate for employment . . . was duly received by Mr. Edison
. . . He thinks it best not to do anything just yet in regard
to the Kinetograph . . .

The Kinetograph model is, I understand, all but com-
pleted, and manufacture of the instrument can soon be
commenced. In this connection I hear that one of the Dick
brothers is coming in shortly from Chicago to 'hustle'
things. Mr. Edison's attention is so much absorbed by Ore
Milling affairs that he cannot devote much time to other
matters. Unfortunately, the 'other matters' suffer because
of this. Dick's presence may have a good effect Kineto-
graphically . . .

I sincerely hope that your sojourn at Myers is benefitting
you . . . How have you been since your arrival in Florida?
. . .

Please give my regards to Mr. Lehman [sic].

As of March 6 the Kinetoscope model was not finished and
Edison was inclined to let the matter go. But with Tate's
constant prompting he agreed to engage James Egan, a labora-
tory employee, to build the 25 Kinetoscopes. The following
agreement (which I have already quoted) was drawn on June
26, with the Fair already far advanced. It was a placebo for
Tate, who could not now hope, even under the most felicitous
circumstances, to have more than only a few Kinetoscopes
ready in time: [27]

26 *Ibid.*
27 "Motion Pictures, 1893."

Orange June 26/93

James Eagan [sic] agrees to make 25 Kinetographs complete except Motor, Mirror & Lense of glass & Nickel slot device and assemble the whole in the Case tested satisfactorily for Thirty Eight dollars each I agreeing to allow him one week to make tools—Tips & dies to be furnished by Edison.

Thos. a. Edison.

Jas. Egan

A laboratory legend states that Egan found it difficult to stay sober long enough to fulfill the contract.[28] This appears to be substantiated by a watchman's report that Egan apparently wanted to "sleep off" a drunk one night at the laboratory —and the watchman wanted to know, "Shall I let him in?"[29]

But one still wonders at this perfunctoriness. Nearly two months had passed before Egan was set to his task. Tate had ordered his 25 machines on May 2 and Edison said that he wanted these "pronounced ok" by Dickson and cost-estimated by the phonograph works. Both Dickson and a man from the phonograph works were on the scene and, to all appearances, available to do what was expected of them. That the "model was finished," as Edison noted on May 2, is apparent by the time of the Egan agreement. With Dickson back it is difficult to understand why such an agreement was not made before June 26. We can only conclude that in spite of Tate, Edison was very casual about Fair Kinetoscopes, and that Dickson was either still too ill to press the business or, for some reason presently obscure, did not concern himself with pressing it.

Barnett Phillips of *Harper's Weekly*[30] visited the laboratory apparently shortly after May 3, 1893 and saw the Kinetoscope.[31] And between April 19 and 25 George Hopkins of *The Scientific American* examined the machine in preparation for demonstrating it on May 9 at the annual meeting of the Department of Physics of the Brooklyn Institute of Arts and Sciences.[32] This

[28] Quigley *(Magic Shadows,* Georgetown University Press, 1948), for example, airs this tradition.

[29] "Lab. W.O. Inter-Office Correspondence. 1887"

[30] See also page 71. This is the Barnett Phillips of "Fred Ott's Sneeze" fame whose connection with this film I have discussed in *Infinity,* December 1960 and *Film Culture,* Summer 1961.

[31] A letter of May 3 in reply to one from Phillips of April 27 invites Phillips to come "any day."

[32] An account of this meeting appears in *The Fifth Yearbook of the Brooklyn Institute of Arts and Sciences,* 1893, page 183.

meeting was called "the first time that the Kinetograph had been exhibited outside of the Edison laboratory in Orange, New Jersey, where it was invented and manufactured."[33]

In a letter of May 1 Edison supplied Hopkins with information for his Brooklyn talk. This was referred to in a letter of April 25 on which Edison made notes for a reply:[34]

> How many impressions on a strip?—[Edison notes:] about 700
>
> Are these taken at the rate of 46 per second?—yes[35]
>
> Is the time of exposure one eighth of this?—8/10s of 1/46 of a sec.[36]
>
> What is the aperture of the Photo lens?—dont[37]
>
> What is the duration of each image seen in the Kinetograph?—½ of 46th sec[38]
>
> Have you successfully shown it on the screen in connection with the phonograph? Yes[!]
>
> Will it be shown in this way at Chicago?—No didn't have time to perfect

Hopkins also asked Edison for a "piece of a broken strip of Kinetograph pictures . . . to show in the lantern" and Edison notes: "Ask Dickson for a short length of new strip & send to him."

On May 9 the new manufacturer's model of the Kinetoscope was taken over to the Brooklyn Institute, set up on the stage, and there given its first "official" demonstration.[39]

[33] *Ibid.*

[34] "Motion Pictures, 1893."

[35] All the publicity claimed this rate, yet we know from actual observation that this was not true (see page 7).

[36] The *Harper's Weekly* article of June 13, 1891 had said, for example, that "the strip is at rest during nine-tenths of the second." See also page 000.

[37] The aperture of the photographic lens is, of course a crucial matter, whether or not Edison knew that it was. The reader has a choice between whether this "dont" is a contraction for "Don't know," or whether Edison is directing his typist to "don't tell." It is odd that Hopkins' request for information would have been referred to someone who did not know the answers. But it is just as odd that the lens information should be kept secret while other important details were revealed.

[38] Or 1/92 of a second, which does not agree with the exposures referred to elsewhere by, for example, Herman Casler (see page 14).

[39] We have seen how the Kinetoscope had been given another showing in May of 1891 (see *The Edison Motion Picture Myth*, page 111). But the 1891 machine was only experimental. The Brooklyn machine was, apparently, the prototype of a long line of commercial Kinetoscopes.

This Brooklyn demonstration was noted in *Anthony's Photographic Bulletin* of May 13, *The New York World* of May 10, *The Brooklyn Standard Union* of May 10, and in George Hopkins' own paper, *The Scientific American*, on May 20. The *Anthony's* and *World* reporters apparently did not attend, but the *Standard Union* and, of course, the *Scientific American* reporters did. These eye witness accounts, though confused, are an interesting source of information. *The Standard Union* lamented that the sound motion picture promised was not forthcoming and that

> The Instrument which was exhibited, however, only presented the moving picture without the noises accompanying. But even in this form it was startling in its realism and beautiful in the perfection of its working.

After quoting long sections of the Hopkins talk the *Standard Union* report closed thus:

> After showing in the lantern two or three sections of the kinetographs, to give an idea of how they looked, the kinetograph was opened for use and the audience passed up the right of the stage, took a view of the scene presented and passed on. Mr. Hopkins stated that the present instrument, among a number of others, was going to Chicago, there to be exhibited in the Fair grounds as a penny-in-the-slot [sic] machine. W. Kennedy Dickson, the expert who brought the machine from the Edison laboratory, has been engaged in perfecting, under Edison's direction, for five years [sic]. The pictures taken by the camera can scarcely be distinguished from one another, so slight is the difference between successive views. This explains the continuity and unbroken character of the scene as presented in the kinetograph.

The Standard Union—and *The Scientific American* with no significant variation—gave the following account of the blacksmith shop subject shown in the Kinetoscope. *The Scientific American* said:

> The picture represented a blacksmith and two helpers forging a piece of iron. Before beginning the job a bottle was passed from one to the other, each imbibing his portion. The blacksmith then removed his white hot iron from the forge with a pair of tongs and gave directions to his helpers with the small hand hammer, when they immediately began to pound the hot iron while the sparks flew in all directions, the blacksmith at the same time making intermediate strokes with his hand hammer. At a signal

from the smith, the helpers put down their sledge hammers, when the iron was returned to the forge and another piece substituted for it, and the operation was repeated [apparently the film was looped. G.H.]

This subject almost certainly had been shot after Dickson's return from the south on or about April 25, and was, therefore, appropriately "new" when Edison directed that Hopkins should be given "a short length of new strip." It is possible—perhaps even likely—that on May 1 this subject was only being planned or only just taken, and still not processed. 27 frames of this blacksmith subject may be seen in *The Photographic Times* of April 6, 1894 (see Illustration 19). It was very popular throughout most of 1894. It must not be confused, incidentally, with a "Horse shoeing Scene" which Dickson himself seems to have confused with it, and which shows Dickson with his hand on the back of a horse (see Illustration 18).[40] "Horse Shoeing Scene" or "Blacksmith [#2]" must be the same as the "New Blacksmith Shop" shot by Raff and Gammom when "Blacksmith Shop [#1]" wore out late in 1894 (see page 134).

The Brooklyn talk, if accurately reported, must have given the "more than 400 scientific people" who attended it a confused impression of the rate-of-taking:

> This camera starts, moves, and stops the sensitive strip which receives the photographic image forty-six times a second, and the exposure of the plate [sic] takes place in one-eighth of this time, or in about one-fifty-seventh of a second. . . There are 700 impressions on each strip, and when these pictures are shown in succession in the kinetograph the light is intercepted 700 times during one revolution of the strip. The duration of each image is one ninety-second of a second, and the entire strip passes through the instrument in about thirty seconds. . .

Even allowing no time for the film to move from one picture to the next and the sensitive surface to, 1, come completely to rest, 2, receive the light, and 3, move again "one-eighth of this time" (assuming "this time" to be 1/46th of a second), the *Scientific American* calculation is enormously wrong. One eighth of 1/46th is 1/368th. Assuming

40 The reader may see "Horse Shoeing Scene" on page 443 of *The Journal of the Society of Motion Picture Engineers* of December 1933, and on page 2 of the Deems Taylor, *et al,* book, *A Pictorial History of the Movies* (Simon and Schuster, New York, 1950).

"this time" to be a whole second, 1/8th is merely 1/8th of a second—which again allows, as above, *no time* for the film to move, stop and be exposed. And if we assume "this time" to mean an unstated period during one of the 46 movements of the film and shutter per second, the "one-fifty-seventh" has no meaning whatever.

Furthermore, if we allow 700 photographs in a strip and "one-ninety-second" of a second for each exposure or "duration of each image," about 7 seconds would be required to expose 700 photographs—and nothing like the 30 seconds described by Hopkins. Edison had told Hopkins 700 images, i.e., 1400 per minute and 23-plus per second, which is a direct contradiction of the 46-per-second rate discussed on page 000. He also told him that 1/92nd of a second was the duration of each image in the viewer. But when he said that the time of exposure was 8/10ths of 1/46th of a second he was being specific, and was saying that the exposure was about 1/80th of a second. It was then and is now a practical impossibility for a film in such aparatus to 1, start from rest, 2, move rapidly, 3, stop completely, and 4, be exposed—all within 2/10ths of 1/46th of a second, or about 1/180th of a second.

But in spite of Edison's elaborate obfuscation (or ignorance) and the *Scientific American's* "editing," the Dickson camera *worked*. And soon its product was to burgeon throughout America, for whomever had a nickel to spend, and was daring enough to spend it.

5 · *The Kinetoscope at the World's Columbian Exposition*

IN SPITE OF PERSISTENT, POIGNANT CRIES, TATE AND HIS ASSOciates never got their World's Fair Kinetoscopes. Nevertheless, apparently one machine made its way to the Fair, and before the season closed was installed in the second floor of the Electricity Building (see Illustration 32) for all and sundry to see. The *Brooklyn Standard Union* account of the May 9 exhibition had said that "the present instrument . . . was going to Chicago." *Anthony's Photographic Bulletin* had said that the Kinetoscope "was one of many made for the World's Fair." *The Scientific American* had merely said that "a number . . . had been made for use at the Columbian Exposition at Chicago."

A number of writers have said that the Kinetoscope was shown at the Fair, and these opinions must have sometime been based on memories of the one Kinetoscope that was apparently there. At other times they have been based on hearsay or assumption. The most celebrated of these hearsay accounts is Ramsaye's in *A Million and One Nights* (page 85):

> It has been stated repeatedly by all of the writers of screen beginnings that the Edison peep show pictures were shown at the Columbian Exposition, and several pioneers have recollected and described the machines and the fair building in which they say they saw them in Chicago. But these statements are none the less incorrect. The Kinetoscopes were not yet completed. Raff was in Chicago waiting for them.

Pioneer memories are often mistaken, and Ramsaye's experience is far from unexpected. But the pioneer memories here decried by Ramsaye may nevertheless have been based on experience. A Kinetoscope, apparently the one shown in Brooklyn, was probably demonstrated to thousands at the World's Columbian Exposition.

I have found the following in support of this position. First, *Science* of July 21, 1893:

> It will be remembered that some years ago Mr. Edison brought out the kinetoscope. In this instrument a combination was made of the well-known zootrope and the phonograph, so that at the same time that the motions of the moving object were seen, the accompanying sounds were heard. The apparatus was exhibited at some of the charitable entertainments in New York through the influence of Mrs. Edison,[1] but since then comparatively little has been seen of it. It has now been more fully developed and forms a part of the Edison exhibit in the gallery of the Electrical Building.

Again in *The Scientific American* of October 21, 1893:

> In the southern end of the gallery [of the Electricity Building] are Edison's phonograph exhibits and his latest invention, the "kinetograph." He photographs the face at the same time one talks into the phonograph. By this method the sound and the motion, of the lips in producing it are accurately reproduced.

It is obvious that either 1, the *Science* and *Scientific American* reporters are describing something they have not seen, or 2, a Kinetoscope was rigged up with a phonograph in the Electrical Building at the World's Fair. I incline to the latter of these two positions. These periodicals—and particularly the long-established *Scientific American*—had a large and devoted readership among serious-minded scientists, scholars and the mechanically-minded. Just what was seen by the reporter would have been of specific interest to these readers, and over many years *The Scientific American* had established a reputation for seriousness and reliability. And since connecting the Kinetoscope and the phonograph would have been a simple matter (we will see in Chapter 13 *how* simple it was), it appears likely that the motor of the Kinetoscope was attached to the phonograph, and as visitors to the Edison exhibit peered into the eye-piece they heard music. We cannot believe, of course, that they heard "the sound and the motion, of the lips," as described by the *Scientific American*. Nor can we know whether they heard this music through the ear tubes connected as in the Kinetophone (see page 123) or merely through a nearby speaker.

[1] This appears to fit neatly into the May 1891 exhibition I described in *The Edison Motion Picture Myth*.

At what time during the exhibit the apparatus made its appearance is less certain. *The Brooklyn Standard Union* had stated that "the present instrument among a number of others was going to Chicago." The use of the phrase "the present instrument" is unequivocal, and the character of the article in *The Standard Union* suggests that it was not casually written. *The World* had merely said that "Mr. Edison proposes to send several of these instruments to the World's Fair." *The Brooklyn Eagle* said[2] that the instrument shown was "one of many Mr. Edison had made for the world [sic] fair," and *The Scientific American* reported that:

> The kinetograph [i.e., the kinetoscope] in this form is designed as a "nickel in the slot" machine, and a number of them had been made for use at the Columbian Exposition at Chicago.

There seems to be no reason why the instrument referred to by *The Standard Union* as the "present instrument" should have remained in the laboratory throughout the summer. The Egan agreement was signed on June 26, and it may have been thought desirable to have a Kinetoscope on hand for the manufacture of the 25 additional machines contracted for on June 26. But much laboratory correspondence supports the idea that even at the time of the agreement the men most concerned with placing Kinetoscopes in the Fair were having serious doubts about being able to do it. This state of mind would have made the keeping of the machine at the laboratory less and less important. There is also substantial reason to believe that the 1891 Kinetoscope would have sufficed as a manufacturer's model for whatever work Egan contemplated. If not, then the exact dimensions, etc., of the Kinetoscope—a relatively simple mechanism—would have by now been familiar to a number of people at the laboratory.

In a note to Edison of May 15 Tate said:[3] "I hope we will be able to get a few before the exposition closes." Considering the fact that the Exposition had been opened only 15 days before this date and was to run to November 1, the possible note of sarcasm indicates considerable frustration. It perhaps

2 *Anthony's Photographic Bulletin* of May 13 made a similar remark.
3 "Motion Pictures, 1893."

also indicates at least the entertainment of the idea that Kinet-oscopes would not be available at all for the Fair.

On the first of June a correspondent was told[4] that the Kinetoscope would probably be ready in about five months—and indicates that the Egan agreement itself was either per-functory or a desperate recourse. Although Edison wrote Lyman Howe[5] that "a number of [Kinetoscopes] are being con-structed," this was apparently not true. Lombard said the same thing to Tate in a letter of June 27,[6] but the rest of this letter suggests that he was only trying to pacify Benson:

> In conversation with him [i.e., Benson] yesterday on the subject of "Kinetographs", I told him that twenty-five (25) machines were being built at the Laboratory, and would be sent here at the earliest possible moment. I told him furthermore that it was improbable that we would receive the full number during the World's Fair, but I thought in lieu of this we would be in a position to arrange for a con-tinuing interest in the matter with Mr. Edison when he himself saw how much injustice had he done us [sic] by his failure to carry out his part of the contract.

This failure by Edison again may be attributed in large part to his extraordinary preoccupation with ore-milling.

On July 5 Egan seems to have made a start of some kind on his work, for on that day John Ott gave him "fine material for tools used for 25 Kinetos."[7] On July 11 Tate wrote Benson:[8]

> I saw Mr. Edison about ten days ago and he told me that the 25 kinetographs [i.e., Kinetoscopes] will be ready about the end of this month . . .

"I saw Mr. Edison about ten days ago and he told me" does not seem designed to satisfy a man as eager as Benson. It reaffirms the view that by this time both Tate and Lombard were beginning to accept the notion that there would be no Kinetoscope business for them at the Fair. They also seemed bent on keeping this impression from Benson.

On July 31, a Monday, when the employees of the phono-graph works came to the job, they were not admitted and were

4 Letter book E1717 2/4/93 - 7/2/93

5 *Ibid.* This is the Lyman Howe of Wilkes-Barre, Pennsylvania who later became famous as a traveling lecturer.

6 "Motion Pictures, 1893."

7 The Precision Room notebook, E190-0-2.12.

8 "Motion Pictures, 1893." I am indebted to the Pitman Publishing Corpo-ration for a translation of this note.

told that they were laid off. In protest to what he considered the high-handed method of this, Ballou, the superintendent, resigned.[9] Edison promised to rehire them when the country was being run less like a "lunatic asylum" and went blithely off for a month at the Fair:[10]

> Thomas A. Edison left Saturday last [i.e., August 12] to join his family at Chicago. Mr. Edison and his father-in-law, Lewis Miller, of Akron, Ohio, who is President of the Chatauqua Assembly, have rented a house at Chicago and the families have been occupying it for some weeks. Mr. Edison and his family will return home on September 2d.

On September 6 a correspondent was told that the Kinetoscope would not be ready until the following summer:[11] on September 28 another was told that it would not be ready "for sometime yet."[12] But during these months work was being done on the machine and the model shown in Brooklyn on May 9 or a newer machine[13] was probably sent to Chicago and installed in the Edison exhibit there. This was in the gallery of the Electricity Building, but the directories which I have examined[14] do not mention it. The Electricity Building had been formally opened on June 1,[15] and although the *Chicago Herald's* May 21 detailed list of exhibits did not mention the Kinetoscope, the official catalogue did.[16] Johnson's *History of the World's Columbian Exposition*, page 394 of Volume 3, also noted its presence.

9 The Edison work week ended on Thursday. If the men had been told on Saturday, when they collected their pay for the previous week—but not their pay for Thursday, Friday and a half day Saturday—that they were laid off, they would have demanded the extra two and a half days' pay, and would probably not have left the premises until they got it. This matter is discussed in *The New York Herald* of August 1.

10 *Orange Chronicle*, August 19, 1893. Also letter book E1717 8/8/93 - 3/9/94.

11 Letter book E1717 8/8/93 - 3/9/94

12 *Ibid.*

13 The suggestion is that a few more Kinetoscopes may have come into existence at this time. A letter to a man in London on September 9 said that "There have been only a few manufactured as yet, the same being in use at the Laboratory."

14 The *Official Directory*, published by Conkey, 1893, and *Gems of the Fair*, 1893. The *Scientific American* account of October 21 said in the "southern end" of the Electricity Building. The photo reproduced in Ramsaye, *op.cit.*, opposite page 76, is irrelevant, since it shows only an office.

15 *Chicago Record*, May 27, 1893.

16 Page 28. Section J: "Electricity and Electrical Appliances, group 138A, #453: Edison, Thomas A., Orange, N.J., Kinetograph . . ."

The possibility is also strong that the Kinetoscope had arrived at the Fair in time for the Gooch lectures. Professor Hiram Gooch, Principal of the Preparatory School of Chicago University, initiated a series of lectures "upon the electricity department"[17] in the Agricultural Assembly Hall at 12 noon on July 10.[18] He gave a lecture every day except Sunday, at noon, and repeated the lecture on the corresponding day of each week for some time. He had done a preliminary series in the Administration Building from nine to ten A.M. which included tours of the Fair. He appears to have given the first of his regular series of lectures—on the Kinetoscope—on July 10.[19] He may have used the Kinetoscope—"Edison's last invention, the kinetograph"—for demonstration.[20]

6 · Preparations for Broadway

THE SAME UNLIKELY CHARGES TO THE KINETOSCOPE ACCOUNT which I noted in *The Edison Motion Picture Myth* continued into the period covered by the present work. Some of these were reasonable. But for February, March, April and May of 1893, when the Black Maria was presumably complete,[1] charges to the Kinetoscope account continued in a way we can only consider disproportionate to the facts. The charges for these months were $295.43, $281.01, $246.31 and $475.52 respectively. They are explained by no vouchers more "hard" than vouchers for telegrams, film, lamps, photographic chemicals and express charges. With the exception of a lens charge and a single Black Maria charge they are trivial.

17 *Chicago Inter-Ocean* July 9, 1893.

18 Just where in the Agricultural Building the "Assembly Hall" was is not clear from ground and gallery floor plans of the building in the guides to the Fair.

19 *Daily Columbian* July 12, 1893; *Chicago Inter-Ocean* July 9, 1893; *Chicago Times,* July 9, 1893.

20 *Chicago Inter-Ocean* July 9, 1893.

1 Although Randolph testified in Equity 6928 that some work had been done on the Maria in May of 1893, the building was nevertheless completed in February 1893. This has been taken as February 1 by other writers, in their desire to make history neat.

But with the signing of the Egan contract more substantial goods begin to appear, and as promptly as the next day, June 27, the following entry was made in John Ott's Precision Room notebook: "Work and Material for Twenty Five Kinetographs on Contract . . ." Although the charges to the Kinetoscope account for this month continued at the same substantial level as before, $253.76, still only one voucher explained this charge. The next month the precision room apparently began making the tips and dies for which the contract called. Vouchers for "sundries," "steel," "twist drills" and "chucks" help explain the smallest Kinetoscope charge in months, $123.68. These seem to indicate that at least Edison's part of the bargain was being kept. The steel voucher was apparently dated as early as July 5, for on that day the Precision Room notebook showed "Fine material for tools and for 25 Kinetos James Eagens [sic] contract . . ." In July too, for the first time in some months, what had been consistently called the "Kinetograph," but was actually the "Kinetoscope," was called by its proper name—"Kinetoscope." This was in a letter of July 7.

On this same day Benson wrote from Omaha:[2]

> Will you kindly advise me how the twenty-five kineto-graphs which were to be sent out to Chicago on trial, are getting along? You will also kindly advise me whether you think the contract can eventually be made with Mr. Edison for the handling of the kinetograph throughout the country. I think quite a business could be done in this . . . it seems to me that it would be hard for Mr. Edison to get a better combination . . .

Tate's answer on July 11 offered little solid encouragement, and revealed a man becoming rapidly disillusioned:[3]

> [I have your letter of the 7th] I saw Mr. Edison about ten days ago . . . he told me then that the 25 kinetographs will be ready about the end of this month but that we can have 100 more within 30 days thereafter. I think the time which he names for the delivery of the second lot is too short, but anyway I am going to . . . try to get the instrument although I believe we will have no difficulty in making the arrangements . . . to extend beyond the World's Fair . . .

[2] "Motion Pictures. 1893."

[3] This letter is a translation of Pitman notes at the bottom of the Benson letter. I quoted an excerpt from it on page 43.

This letter also described the elimination of H.E. Dick, Tate's *bête noire*, as a factor: "I do not believe that Mr. Dick will be successful . . . He has done nothing up to date and a short time ago he went to Mexico on some other business." Edison's optimism (if such it was) may have been justified by the start that Egan had made. Certainly John Ott was doing his part, although correspondents were told again and again that the Kinetoscope was not yet ready.[4]

August charges indicate that the manufacturing of the 25 Kinetoscopes was becoming sustained. A substantial total, $299.84, was entered and several vouchers indicate that Kinetoscope hardware changed hands. Vouchers for brass and Edison Phonograph Works material were drawn, and for the first time a charge was made to a slot mechanism.

On August 16 two copies of a "publication" containing "Edison Kinetoscopic Records" were received at the Library of Congress.[5] The fee for this deposit remained unpaid until October 5, when Dickson sent "2 cards with sample Edison Kinetoscope Records" to the Library along with the required fifty-cent fee. The cards he sent on October 5 must have been repetitions of the August 16 subjects, since the Library records no other entry than these two and records the October 6 payment and the copyright in the same space in which the August 16 deposit was recorded. We can only assume that the August 16 "publication," called a "book or form" in Library parlance, was compared with the October 6 deposit and the fifty-cent fee applied to that deposit.

"Fred Ott's Sneeze" has been called the first motion picture copyrighted.[6] But this October 6 entry pre-dates it, as I have pointed out elsewhere.[7] What the October 6 copyright was is obscure. Perhaps it was a barber shop subject (see page 56), or perhaps only now was Dickson getting around to copyright the *Phonogram* subjects of 1892 (see *The Edison Motion Picture Myth*, page 140).

4 Many letters in letter book E1717 2/4/93 - 7/2/93 show this.

5 Volume 23, page 113 of the 1893 *Copyright Register*.

6 By Howard Lamarr Walls, in his painstaking and valuable *Motion Pictures 1894-1912*, published by the Library of Congress in 1953.

7 In *Film Culture*, No. 22-23, 1961. I discussed this subject, dated it somewhat closely, and discussed the number of frames shot. I also quoted the *Harper's* article (see page 35).

The charge for September was $248.78, explained by only two vouchers, both for express. Thus, the Kinetoscope account seems to have been charged with more than $200 of laboratory overhead. It was during this month also that another pessimistic note was struck:[8]

> [The] Kinetoscope in all probability [will] not be placed upon the market before next summer. It is as yet too early for us to consider any proposition concerning its introduction to the public.

On September 9, as I have pointed out, a man in London was told that "There have been only a few manufactured as yet, the same being in use at the Laboratory."[9] Since "only a few" agrees with what we know about Kinetoscope manufacture since the Egan contract, we perhaps can assume that the man in London was being told the truth.

But this truth was not so apparent in the claims being made for Kinetoscope-phonograph combinations, and for the projection of sound motion pictures. These exaggerations had been made to the members of the Brooklyn Institute of Arts and Sciences on May 9, and it is not surprising that a request from the same group to actually see and hear such an instrument was evaded:[10]

> In reply, Mr. Edison directs me to inform you that he regrets that he cannot undertake to furnish a Kinetograph with Phonograph combined for use at an illustrated lecture which your friend, Prof. Hooper [the correspondent is again George Hopkins of *The Scientific American*] wishes delivered before the Department of Physics of The Brooklyn Institute of Arts and Sciences on Jan 23rd next. Mr. Edison is not yet satisfied with the operation of these instruments in combination, and until certain improvements are effected therein, he could not consent to public exhibition being made of the same.

We will see how these "certain improvements" were not made for some years—and not at all during the course of our history by anyone at the Edison laboratory. Edison's technicians' best efforts could manage only non-synchronized phonograph music accompaniment.

8 Letter book E1717 8/8/93 - 3/9/94.
9 *Ibid.*
10 *Ibid.* I quote this note again in the Chapter on the Kinetophone (see page 118).

In October there was a renewal of activity, and charges to the account so increased that they were too bald to cover only or much laboratory overhead. This charge, $778.10, was the highest in months, and can only indicate that now Egan or Heise or someone else did some solid work on the machines. But by this time the Chicago Fair had nearly expired, and Tate and his friends would have to depend on future business. On the last day of this month "Fred Ott's Sneeze" began its interesting career.

In November, work on the 25 Kinetoscopes was sustained with a $334.59 charge. This included a voucher for castings, although a substantial amount of brass charged in October was returned to stock unused, suggesting another Egan lapse.[11] During this month there was also an interest in what subjects were to be shot for the new machines. In a letter of November 4 Tate's assistant Thomas Maguire wrote that[12] "a photograph of the pup [i.e., the well-known dog "Phonograph" who was at the dog show then in New York City] displayed kinetographically would enhance the effect." The claims for Kinetoscope-phonograph combinations also continued their dreary procession:[13]

> . . . the Kinetograph . . . is now perfect. As you are probably aware, the Kinetograph is designed for use in connection with the Phonograph, and Mr. Edison is now at work on the latter instrument adapting it for use in combination with the former.

In December increased charges to chemicals were part of the month's charges of $252.51, which suggest an increased interest by Dickson in motion pictures. On December 16, the Hopkins request for a demonstration of the Kinetograph-phonograph noted above, refused before but apparently later acceded to, was again withdrawn. And on December 4 Egan was given an ultimatum:[14]

> Mr. Edison has just requested me to advise you that unless you come here tomorrow (Tuesday) morning and go to work on your contract and keep at it until it is finished he will put someone else on it to finish it up and charge it against you.

11 Letter book E1717 6/30/93 - 9/17/94
12 Letter book E1717 8/8/93 - 3/9/94
13 *Ibid.*
14 Letter book E1717 9/30/93 - 4/26/96, 12/2/96 - 1/31/98.

On December 7 and 9, respectively, *The Orange Journal* and *The Orange Chronicle* reported that Dickson had written an article for *McClure's* on the Kinetograph, but a search of *McClure's* discovers no such piece. Dickson and his sister Antonia had, incidentally, in the October issue of *Cassier's Magazine*, spoken of the motion picture work and were guilty of a curious distortion: "The kinetograph . . . is an instrument intended to produce motion and sound simultaneously . . ." "Kineto-phonograph" is intended, since a "Kinetograph" was never anything ·but a recorder of *motion*.

On December 16 *The Orange Chronicle* reported that Dickson had invented the "Photoret," a watch-size snapshot camera, to be followed with the same story in *The Orange Journal* of December 21 and *The Scientific American* of December 23.[15] On December 27 one of Egan's friends wanted to know if Egan was "drownded or not."[16] He was told that Egan was "at present employed at the Laboratory." On the same day that he was answered a theatrical man was told that he could see the Kinetoscope any day at the laboratory.[17] This is the first theatrical feeler I have seen.

Now the Kinetoscope entrepreneurs, with 1894 at hand and the May 2, 1893 order still not filled, arranged for Heise to complete the Egan contract.[18] Tate then made another payment on the machines, bringing his total to one thousand dollars:[19]

> I enclose herewith Cashier's check . . . drawn on the Chase National Bank of New York, to the order of F.R. Gammon,[20] for the sum of five hundred dollars, and endorsed by the latter payable to my order, and made payable to you by myself, the same being a payment to you on account of the purchase of Twenty-five Kinetographs now being completed . . .

During January of the new year Dickson's final revisions on the Kinetoscope seem to have been made. In January "Fred

[15] See Hendricks, *Beginnings of the Biograph* (pub. The Beginnings of the American Film, 1964) for a discussion of this Photoret matter.
[16] "Lab of T.A. Edison. Personnel. 1893."
[17] *Ibid.*
[18] This is clear from an entry in the Precision Room notebook, page 115.
[19] "Motion Pictures, 1894." Randolph pencilled a note at the bottom: "I have this check this makes $1000 received."
[20] This is the Gammon of the Raff and Gammon who became agents for the Kinetoscope, Kinetophone, and, finally, the first Edison-sponsored motion picture projection in 1896.

Ott's Sneeze" developed a bit further and, in the same month, another famous name in American motion picture history entered upon the scene: C. Francis Jenkins wrote to the laboratory for information concerning the Kinetoscope.[21]

February's charge to the Kinetoscope account, $334.18, exceeded January's, which had been $195.34. These suggest finishing touches: lenses, cabinets, locks and music wire (for the nickel-slot release?)

On February 13 Tate made Edison what was apparently the first post-World's Fair proposition for Kinetoscope exploitation. Since this proposition was directly participated in by Andrew Holland, Norman C. Raff, Tate, Lombard and Benson —all key figures in the beginnings of the American motion picture industry, I quote it fully here:[22]

Thomas A. Edison, Esq.,

Orange, N.J.

My dear Sir:—

The people with whom we have arranged to take hold of the active management of the Kinetograph business, so far as our interest in that business is represented by the machines that you have agreed to sell us, have authorized me to make a proposition to you. You are already aware that Mr. Andrew Holland is going to handle part of this business for us, and he will be assisted by Mr. Norman C. Raff of Chicago. Mr. Raff is a young man of independent means, wide business experience and unusual energy. He is well known to Mr. Benson and to Mr. Lombard.

We had a meeting several days ago and these people expressed the feeling that in going into the Kinetograph business they would handle it to much better advantage if they knew that their efforts would be recognised and would contribute towards the permanency of their work. They are all serious, capable men, and good for anything they undertake. The proposition is as follows:—

In consideration of the agreement we will first pay you a cash bonus of Ten thousand dollars, Five thousand to be handed to you upon signing the agreement, and Five thousand within thirty days thereafter.

Second. We will assume all the expenses necessary to complete your experiments on the Kinetograph by paying

[21] This was the eager, restless, ambitious man who later, in association with Thomas Armat, nursed the first Edison-sponsored motion picture projector, the Vitascope, to public view. Jenkins was now a government clerk, but had long been interested in the photography of motion. (See, for example, *The Photographic Times* of July 6, 1894.) A forthcoming work will document this story.

[22] From "Motion Pictures. 1894."

the salary of Mr. Dickson and the wages of the assistants that he will require in this work, together with cost of supplies used in connection therewith. In other words, we will assume this pay roll and other expenses and remit the same to you weekly.

Third. We will agree to make an arrangement with Dickson whereby his interest in the business will be provided for by us, so that you will not have to pay him anything.

Fourth. We will agree to order Kinetoscopes in lots of not less than Fifty, and to place our first order within ninety days after the date of the agreement.

Fifth. Kinetoscopes to be furnished to us on the basis of Labor & Material, plus 60% General Expense, plus 20% profit, to which is to be added a royalty of Twenty-five dollars per machine for yourself, on the understanding that these instruments are not to cost more than Sixty dollars each.

Sixth. We will pay you a royalty of Fifty cents each on all photographic strips sold for use in connection with Kinetoscopes and Kinetographs.

Seventh. When the experiments on Kinetograph [sic] are completed, and a satisfactory instrument produced, these instruments are to be supplied to us on the same basis of cost as Kinetoscopes, but are to bear a royalty to you of Fifty dollars each.

Eighth. We will agree that your royalties shall amount to not less than Ten thousand dollars per year, payable quarterly, we to have the right to make good on the fourth quarter any shortages in payments on the previous three, the agreement to lapse and all rights to revert to you in the event of our failure to carry out any of these provisions.

Please let me know at once if the above is satisfactory. These people mean business, and so far as experience and ability are concerned, you could not find better men if you hunted the world over for them. They thought that the amount of the bonus that I insisted upon was pretty steep, but I would not consent to present the proposition in any other form.

If it is agreeable I will have the agreement drawn and the money turned over to you within a week or ten days. I have no doubt that I could give you the whole Ten thousand dollars when the agreement is signed, and you will receive payment for the 25 Kinetoscopes just as soon as you are ready to deliver them. This, together with the bonus, would enable me to turn in to you $16,250.00, including the $1,000 already paid to you, within the next few weeks, and to relieve you of all expense connected with these experiments.

Yours very truly

[signed] A.O.Tate

Edison, having decided that his faithful servant Tate was expendable, wrote boldly across the face of the letter "No ans."

It is interesting to note that Dickson is carefully safeguarded by this proposal, and significant that Tate considered this an important ingredient in the sensitive job of keeping Edison happy. Perhaps he thought that Edison relied on Dickson's advice (which we know Edison did) and was placating Dickson. Certainly there is a strong suggestion that Tate would not otherwise have bothered about Dickson, whom he seems not to have liked. (See *The Edison Motion Picture Myth.*)

March charges to the Kinetoscope account were $418.41, and the character of these charges—"Scovill and Adams" (a prominent photographic supply house), "sundries," cabinets, lamps, etc.—indicate the readying of the machines for exhibition.

On March 6 the famous Austrian strong man Eugene Sandow, in the United States under the aegis of Florenz Ziegfeld, came out to the Black Maria for motion pictures. Many accounts of his visit appeared in contemporary periodicals, for example, *The Newark Daily Advertiser* of March 7, *The Orange Journal* of March 8, *The Electrical Review* of March 9, *The Orange Chronicle* of March 10, *The Photographic Times* of March 16, *The New York World* of March 18, and *Leslie's Weekly* of April 5 and July 17. The publicity was a big boost for the Kinetoscope. The *Orange Chronicle's* account is perhaps the most useful:

> The party arrived at the Phonograph works about 11, o'clock, and were there met by William K.L. Dickson, head of the photo-kinetographic department of the laboratory, and head of the electric ore milling department as well [Dickson must himself have supplied *The Chronicle* with this information] . . . Mr. Edison was not present when the party arrived, having worked all night and lain down at 7.30 in the morning for needed rest. He reached the building soon after 12 o'clock and was introduced to Mr. Sandow. Sandow had previously stated that he would charge $250 for coming out to give the exhibition, but would gladly come for nothing for the privilege of shaking the hand of Edison, the greatest man of the age . . . special pictures of various poses were taken . . . [One was] of Mr. Edison feeling Sandow's muscles with a curiously comical expression on his face . . . Sandow asked Mr. Cline [business manager of Koster and Bial's Music Hall in New York] if he would mind being "chucked" out of the door

54

> . . . Mr. Cline demurred but quicker than a flash Sandow
> caught him with one hand and sent him sailing through
> the air and out of the door . . . Sandow . . . said that he
> would have to bring out next time some man that liked to
> be "chucked" . . .
> Sandow and Mr. Cline came out again at noon yesterday
> and were met by Mr. Dickson. They were driven to the
> home of Mr. Edison in Llewellyn Park, where they spent
> an hour or more. After taking dinner at Davis's, they went
> out for a drive. Mr. Dickson then took his guests to his
> home on Cleveland street where the remainder of the after-
> noon was spent, Miss Antonia Dickson assisting her brother
> in entertaining and playing several selections on the piano.
> Last night Sandow was the guest of the Orange Camera
> Club at its dinner at Davis's and returned to New York
> on the 8.14 train . . .

A remarkable photograph was taken of this visiting group and
Edison, and is reproduced as Illustration 10. Additional stills
and film strips were reproduced in the Dicksons' *History of
the Kinetograph Kinetoscope and Kineto-Phonograph.*

The Sandow motion pictures, of which one is still widely
current (see Illustration 11),[23] show that the rate-of-talking
was considerably less than the 46 per second consistently
claimed (see page 6). The various accounts of the shooting
also give us interesting information about the Black Maria,
and are a further indication that the Kinetoscope business was
now being taken seriously. If Edison himself was not to become
involved, then at least he was permitting others to become so.
He was to sell three or four hundred thousand dollars worth
of Kinetoscopes, together with many thousands of dollars
worth of film, and he was not one to turn his back on such
bounty.[24]

Although the *Orange Chronicle* account of the Sandow visit
was the most charming, it was the *New York World* account
that brought the most lively reaction. A flood of inquiries
arrived. One correspondent was told that the Kinetoscope
would cost about $250 less battery and films, and that these
films—called "strips"—would cost $5 to $8 according to the
subject.[25] Another correspondent was told that:[26]

[23] I edited a print of this subject—along with a print of "Annie Oakley"—
for exhibition in the "Kinetoscope" models in the New Jersey pavilion of the
New York World's Fair for 1965.
[24] This amount was testified to by Edison himself in Equity 6928. He must
have been referring to gross retail returns.
[25] Letter book E1717 3/8/94 - 4/7/94
[26] *Ibid.*

After the 25 machines already sold are delivered, it will be six weeks before anymore can possibly be made. We are constantly making picture strips and will have a fine collection by that time.

A man at the General Electric Company was told that Edison "did not intend to organize any company," and "as soon as the machines are ready to be placed on the market . . . they will be sold to anyone . . ." Correspondents in Texas, Massachusetts and Washington, D.C., were told the same thing.

The week following the Sandow visit the famous Spanish dancer Carmencita posed in the Black Maria and this also became a popular subject (see Illustration 12).[27] And before the opening on April 14 of the Kinetoscope parlor at 1155 Broadway, the vaudeville contortionist Bertholdi, a barber shop scene, a highland dance, an amateur gymnast, a cock fight, an organ grinder, a trained bear subject and an employees' picnic (see Illustration 29)—among possibly others—were shot.[28] On March 11 the *New York Tribune's* Sunday edition had a picture story on the Kinetoscope and made the following wry comment: ". . . the chances are that this invention, while not the most important of [Edison's] many devices, will be one of the most interesting." Also on March 11, a New York physician asked permission to have his patients Kinetographed and was invited to bring them out.[29]

On March 17 Dickson got an estimate for tin coin boxes and tubes, presumably for Kinetoscopes.[30] Many correspondents were quoted the *circa* $250 price, but the date of delivery still was not set. In April a total of $586.89 was charged to the account. This included, for the first time, charges for celluloid cement—perhaps films were being spliced and looped, and for lunches. And this may suggest late work in preparation for the April 14 debut, which was now at hand.

[27] *Orange Journal,* March 8, 1894.
[28] Partly according to letter book E1717 6/30/93 - 9/17/94
[29] Letter book E1717 3/8/94 - 4/7/94: "As you are no doubt aware, the Kinetoscopic pictures can be taken only at the Laboratory . . ." Whether or not the physician ever took advantage of the offer is unrecorded.
[30] "Motion Pictures, 1894."

7 · Kinetoscope Parlors

ON APRIL 6 TEN OF THE TWENTY-FIVE KINETOSCOPES THEN IN existence were shipped by Colt's Express to Holland Brothers at 1155 Broadway (see Illustration 36).[1] This is established in the Equity 6928 testimony of Edison's bookkeeper, John F. Randolph:

> 16Q. [by Frank Dyer, the Edison attorney] Do your books show when the first commercial kinetoscope was shipped from the laboratory?
> A. Yes, sir.
> 17Q. Please state the date and to whom shipped, and how many were shipped.
> A. Shipped April 6, 1894, to Holland Brothers, 1155 Broadway, New York, 10 kinetoscopes, Nos. 1 to 10, both inclusive.

The bill for $2,500—ten machines at $250—was made out on April 12 to "A.O.Tate . . . 32 Park Place, New York."[2]

Sometime between April 6 and April 14[3] Dickson personally delivered the ten films for the debut—one film for each of ten machines. These are listed in the Randolph record as follows:[4] "Sandow," "Horse Shoeing," "Barber Shop," "Bertoldi [sic] (Mouth Support)," "Wrestling," "Bertoldi (Table Contortion)," "Blacksmiths," "Highland Dance," "Trapeze," and "Roosters." They were charged at $10 each and were paid for on the day of the opening.[5]

The legal record does not show the date of the opening and

[1] Letter book E1717 6/30/93 - 9/17/94. Andrew and George Holland were in the cattle-breeding business, with celebrated bulls in their stable. Formerly, according to Ottawa directories, they were "agents for the Smith Premier Typewriters" and "official reporters of the Senate."

[2] *Ibid.*

[3] The Randolph record is not clear on this point. The April 6 shipment was billed on April 12, but a lamp shipment on the same page was billed on April 11. The films for the machines were billed on April 14, but exactly when they were delivered is not indicated.

[4] In a further *Index* of early American films I will discuss each of these titles and, where possible, print a frame reproduction from each. There was more than one version of "Horse Shoeing," "Blacksmith," "Wrestling," "Highland Dance" and "Roosters."

[5] Letter book E1717 6/30/93 - 9/17/94

Norman C. Raff, recalling the event sometime afterward for Equity 6928 was vague:

> 40x-Q. [by Parker Page, the American Mutoscope and Biograph Company's attorney] Do you remember when you were first exhibiting machines?
> A. Yes, sir.
> 41x-Q. What was that date?
> A. As I stated before,[6] that was in April, '94.
> 42x-Q. Do you remember the date in April when you gave the first public exhibition?
> A. No, I don't know the exact date. I think it was the latter part of April.

Ramsaye places the opening on April 14[7] and Tate's account[8] is supported by the record, although no New York or New Jersey periodical which I have found has been specific.[9] We know, however, that April 14 is the correct date from the caption of the drawing of the 1155 parlor in the Dicksons' *History of the Kinetograph Kinetoscope and Kineto-Phonograph:*

> Interior of Kinetoscope parlor at 1155 Broadway, near 28th Street, New York, operated by the Kinetoscope Co., controlling the United States and Canada. The first Kinetoscope exhibition started in the world: opened April 14, 1894.

Tate's account, in his *Edison's Open Door,* describes the opening thus:

> We then decided to install ten of these [i.e., the original 25] in New York . . . in preparation for this I leased a small store, formerly a shoe shop, No. 1155 Broadway, on the west side near Twenty-seventh Street[10] . . . Here the ten machines were placed in the center of the room in two

[6] Raff had said that it was "about the month of April, to the best of my recollection."

[7] *Op.cit.,* page 88. Ramsaye's work seems to suggest that he got his information from a source additional to those he credits in his preface, for only Frank Dyer and Norman C. Raff among these appear to have been in a position to know this date. He may have gotten his information from the Dickson caption (see following). Raff, as we have seen, could not remember; Tate is not credited.

[8] In his *Edison's Open Door* (Dutton & Company, 1938).

[9] Unless we assume that the Sunday April 15 *New York World* advertisement of "Edison's Kinetoscope/1155 Broadway, near 27th St./On exhibition daily 9 AM to Midnight" indicates that a debut for the following day (Tate states that Monday April 16 was the day planned) was being announced. Judging from the advertising habits of these days this seems logical.

[10] Although the building at the southwest corner of Broadway and 27th Street is numbered 1155-1157, 1155 is four doors south of the corner. Raff had said "near Twenty-sixth Street."

rows of five each, enclosed by a metal railing for the spectators to lean against when viewing the animated picture. One ticket, at the price of twenty-five cents, entitled the holder to view one row of five machines. If he wanted to see both rows he bought two tickets.[11] On the right of the entrance door a ticket booth was erected. At the back of the exhibition room was a smaller room for use as an office and for repairing the films.[12] In the window there was a printed announcement or advertisement whose legend I cannot now recall, and a plaster bust of Edison painted to simulate bronze.[13] It was an excellent portrait but a few weeks later I received a message from Edison asking me to remove it. He thought its display undignified.

By noon on Saturday, the 14th day of April, 1894, everything was ready for the opening of the exhibit to the public on the following Monday. My brother, the late Bertram M. Tate, was to act as manager, and a mechanic to supervise the machines and an attractive young woman to preside over the ticket booth were to report for duty at nine o'clock[14] in the morning of that day. At one o'clock on this notable Saturday afternoon, after locking the street door, Lombard, my brother and I went to lunch. Returning at two o'clock, I locked the door on the inside and we all retired to the office in the rear to smoke and engage in general conversation. We had planned to have an especially elaborate dinner at Delmonico's, then flourishing on the south east corner of Broadway and Twenty-sixth Street, to celebrate the initiation of the Kinetoscope enterprise. From where I sat I could see the display window and the groups who stopped to gaze at the bust of Edison. And a brilliant idea occurred to me.

"Look here," I said, pointing towards the window, "Why shouldn't we make that crowd out there pay for our dinner tonight?"

11 This system was used fairly regularly in the well-established parlors of the larger cities, where banks of Kinetoscopes were used. But the regular nickel-slot arrangement was more practical for small installations, and much more common.

12 Film repairing was frequent and shipments of cement to Kinetoscope customers are often shown in the Raff and Gammon collection in Baker Library. Some customers sent their films to New York for repairing: on September 20, 1894, for example, a Boston customer was charged for repairs. These repairs often consisted of restoring damaged perforations.

13 This bust is shown in the drawing of the 1155 parlor on page 53 of the Dicksons' 1895 booklet—the caption of which dates the parlor's opening. The original is still in the library of the West Orange laboratory; it may have been the portrait bust referred to on page 153 of *The Edison Motion Picture Myth.* A possibly somewhat more realistic view of the 1155 parlor may be seen in *The Electrical World* of June 16, 1894.

14 This checks with the *World* advertisement and indicates an accurate memory (or accurate *aides mémoire*) for Tate, who was not likely to have had a copy of the *World* advertisement when he wrote his book.

They both looked and observed the group before the window as it dissolved and renewed itself.

"What's your scheme?" asked Lombard with a grin.

"Bert," I said to my brother, "you take charge of the machines. I'll sell the tickets and," turning to Lombard, "you stand near the door and act as a reception committee. We can run till six o'clock and by that time we ought to have dinner money."

We all thought it a good joke. Lombard stationed himself at the head of the row of machines, my brother stood ready to supervise them, and I unlocked and opened the door and then entered the ticket booth where printed tickets like those now in use were ready to be passed out. And then the procession started.

I wish now that I had recorded the name of the person to whom I sold the first ticket. I cannot recall even a face.[15] I was kept too busy passing out tickets and taking in money. It was a good joke all right, but the joke was on us. If we had wanted to close the place at six o'clock it would have been necessary to engage a squad of policemen. We got no dinner. At one o'clock in the morning I locked the door and we went to an all-night restaurant to regale ourselves on broiled lobsters, enriched by the sum of about one hundred and twenty dollars.[16]

On Monday a bill for six "Special Spiral Incandescent Lamps" at ninety cents each was sent to the new parlor. What these were for is uncertain. Perhaps they were some sort of a display: the Edison symbol of an electric dragon with green eyes, supplied to parlor operators, is plain in the drawing of the 1155 parlor and elsewhere in the literature.

The next week more than bulbs were needed and the parlor was also sent

1 Extra Shutter		1.50
1 " Roller		1.00
5 Films (Boxed) $10.00		50.00
		———
		52.50

[15] This was not true of the San Francisco parlor opening. *The Moving Picture World* of July 15, 1916 printed a statement dated June 1, 1894, identifying the first customer there:

This is to certify that Captain John F. Ryan, United States Government Diver (a Christian), was the first man who paid to see the Edison Kinetoscope west of Chicago.

[signed] HOLLAND BROS.

[16] Since the tickets were 25¢ each, this would mean that about 480 people saw the Kinetoscope at 1155 Broadway on this first day. Allowing a ten-hour run this would mean a rate of 48 per hour, with about two and a half minutes

These films, we know,[17] were repeats of five of the ten used for the opening, and suggest that of the ten original, the most popular were those of Sandow, the Barber shop scene, the Blacksmith shop, "Roosters" (now called a "cock fight") and one of the Bertholdi subjects. At the same time lamps as well as films needed replacing.[18]

On April 24, according to the William Pelzer notebook (see page 000), the "first Kinetoscope," presumably referring to the first after the original 25, was shipped. On May 1 this "first Kinetoscope" went to Chicago.[19] On May 3[20] preparations for the opening of the San Francisco parlor were implemented with the shipping of five Kinetoscopes at $250 each[21] to Holland in that city. The Chicago address, 148 State Street, was rented on May 5, and by May 26, 10 of the original 25 Kinetoscopes were on display there.[22] On May 14, according to the Baker Library collection, Andrew Holland's brother began his stay in Chicago (at the Hotel Vendôme, Oglesby Avenue and 62nd Street). We may thus assume that the Chicago parlor was not opened before May 14. This date is also a reasonable one for the machines to have arrived from New York.

On June 1, apparently, the San Francisco parlor opened under the management of Peter Bacigalupi (see page 59). This date comfortably allows transcontinental shipment beginning either April 30 or May 3 (see note 20). It is also supported by the

exhibition for each customer, ten films at about 15 seconds each. Tate's picture of congestion is thus, to put it mildly, somewhat overdrawn, and his "squad of police," hyperbole.

17 From the Randolph letter book cited before.

18 *Ibid.*

19 Letter book E1717 6/30/93 - 9/17/94

20 Randolph letter book cited above. May 3 is suggested but April 30 is a possibility.

21 Although Bacigalupi, the proprietor of the San Francisco parlor, said in *The Moving Picture World* of July 15, 1916, that these instruments cost him $500 each. Was Holland making 100% on the deal?

22 On that date *The Western Electrician* carried the following notice:

Ten kinetoscopes are on exhibition in Chicago at 148 State street . . . The kinetograph has not been seen outside of Edison's laboratory, but the kinetoscopes are on exhibition in New York and Chicago. The latter do not present any electrical novelties; the principle of the kinetograph is a marvel of photography, and is not electrical . . . For some time the novelty will be on exhibition for a small fee. There are ten views portrayed [i.e., one view for each machine], as a scene in a barber shop, a blacksmith's forge, wrestlers, etc. The best is a representation of a cock-fight, which is very spirited.

Moving Picture World report already quoted. We will see on page 78 how the San Francisco parlor was involved in one of the motion picture's first censorships.

By the end of May the New York parlor was staying open on Sunday[23] to accommodate the crowds. Now, possibly for the first time, it had the familiar "Souvenir Strip of the Edison Kinetoscope" of Sandow, ornamented in Dickson's heavy style (Illustration 11), as a lagniappe. On June 6 a parlor was proposed in Washington, D.C., but it did not open until October 6, when the vigorous Columbia Phonograph Company joined the motion picture business in the first move of its long career. By the same date (although I have found no specific information in either the Raff and Gammon archives or in Boston newspaper accounts) the Boston parlor opening at 169 Tremont Street was being planned. This parlor had a particular significance, for both James H. White, a resident of nearby Chelsea, Massachusetts, and Charles H. Webster, then in the employ of the New England Phonograph Company of Boston, began their motion picture careers at this place.[24]

By the first week in June, also, the new 150-foot capacity Kinetoscope had been projected, and, with it, both the Lathams and America's prize fight fans entered Kinetoscope history (see Chapter 10).

Although June records the manufacture of only 4 Kinetoscopes, July accounted for 46, August 39 and September 72.[25] Before the end of July, two more Chicago parlors had been opened—at 255 Wabash Avenue and 57 State Street, and both Asbury Park and Atlantic City were having openings.[26] Addi-

23 *New York Sun* May 20, 1894. The first open Sunday was May 20. *The New York Dramatic Chronicle* of September 10, 1894 said that at that time the parlor had gone back on a six-day schedule.

24 Webster, in his testimony in Equity 6928, said that the Boston address was 177 Tremont Street, but this may be an error. The Boston directory of 1895 lists "Kinetoscope Parlors, 169 Tremont Street," and the Baker Library correspondence verifies this latter address. White and Webster were mainstays of the Vitascope Company, Raff and Gammon's projection business. When that business closed, White went to the Edison Company, to become conspicuous there, and Webster joined Edmund Kuhn to form the International Film Company.

25 Item 12.13 of the legal file noted several times in this book. I called it a "private file" in *The Edison Motion Picture Myth* because part of the material seems to have been withheld by the Edison attorneys as prejudicial to their cause.

26 The addresses and cities are described in the Baker Library collection. The latter two are also referred to by local newspapers.

tional Kinetoscopes were apparently in operation at the California Midwinter International Exposition in San Francisco,[27] and what was described by *The Orange Journal* as the Kinetoscope's "first public exhibition in New Jersey," opened on July 8 at nearby Eagle Rock. This proved to be "the most popular feature . . . this season."[28] By August 16 a parlor had been opened in Brooklyn (see page 112). By August 9 the Kinetoscope invaded the Philadelphia area, for apparently the first time, with an exhibition on board the steamer "Republic":[29]

> Down to the Big Ocean/The Mammoth, Steam-Steered/ Palace Steamer/Republic/Has resumed her round trips to Cape May . . . /The Great Marvel!/Edison's Last Invention,/The Kinetoscope/has been secured for the/Palace Steamer/Republic/This marvelous reproducer of the scenes of every-day life in actual action is now among the attractions of the big boat.

On September 9 *The New York World* published the first Kinetoscope cartoon that I have found. This was "A Kinetoscope View of Alderman Parks," *i.e.*, sketches of a man before the Lexow Committee, which was then investigating civic corruption.

On September 27 a parlor at 144 East 14th Street in New York was opened.[30] By the *American Journal of Photography*'s October issue deadline, there was a ten-Kinetoscope parlor in operation in Philadelphia, although a search of Philadelphia papers has failed to reveal either its location or its debut date.[31] By October 2 another parlor was apparently planned for San Francisco.[32]

On October 3 five Kinetoscopes, numbers 156, 157, 158, 159 and 160, were sent to Washington along with seven films: "Caicedo," "Carmencita," "Barber Shop," "Barroom," "Bertholdi," "Blacksmith" and "Scotch Dance." On the same day

27 Volume 6 of the Baker Library collection has a letter from W.J. Holland from this Exposition. Holland complained that a strike was hurting his business.

28 *Orange Journal*, July 12, 1894.

29 *Philadelphia Bulletin*, August 9, and the same paper of August 10 and 11; *Philadelphia Times*, August 9 ("It is the only one in the vicinity"), and the same paper of August 10 and 11. Other *Times* notices appeared on August 19 and 26, and September 2, 9 and 16. The "Republic," which made regular runs to Cape May, closed its season on September 23.

30 Volume 6 of the Baker Library collection.

31 It may have been at 111 Chestnut Street, for on October 13 two films were sent to that address (*ibid.*)

32 Volume 1 of *Ibid.*

Kinetoscope 103, along with five of the original 25 (possibly the 1155 parlor was now replacing some of its machines with a new model), were sent to Baltimore[33] where a parlor under the aegis of the Columbia Phonograph Company was being opened.[34]

The Washington, D.C. opening at the Columbia Phonograph Musical Palace at 919 Pennsylvania Avenue was heralded on October 8. This parlor is of particular significance for us because it was here that C. Francis Jenkins saw his first Kinetoscope (see page 143). The *Washington Evening Star's* advertisement of October 8, 1894 was rhapsodic:

> It is here! Edison's Kinetoscope!!! Marvelous! Realistic! True to Life! The Most Wonderful and Interesting Invention of This Century of Science. The only actual and literal "Living Pictures" ever produced. Words fail to describe it—You must see it to Get an Idea of its Remarkable Qualities! Exhibition begins this Evening and Continues Day and Night . . .

Two and five more Kinetoscopes were sent to Boston and Chicago respectively, on October 8 and 9[35] and on October 12 another parlor at 527 Fifteenth Street in Washington was planned.[36] On the same day an additional five machines were sent to Chicago.[37] On October 13 five machines were sent to Cleveland, and the next day several more were supplied for apparently another New York City parlor.[38] The Kinetoscope was on exhibition at 130 Canal Street in New Orleans by October 16,[39] and by the next day at 70 Oxford Street in London (see page 112). By November 26 another New York parlor— in addition to those at 1155 Broadway, 39 Park Row (which may be the same as "the Times Building", which was at 41 Park Row at this time), 144 East 14th, 158 East 125th and the Times Building and the one mentioned above, whose address we do not know—was opened at 1436 Broadway, at the corner of 40th Street. This one was open from ten in the morning to twelve midnight.[40] By the first of February 1895 there

33 Apparently at 110 Baltimore Street, according to *ibid.*
34 Volume 1 of *ibid.*
35 *Ibid., loc.at.*
36 *Ibid.*
37 *Ibid.*
38 *Ibid.*
39 *New Orleans Times-Democrat,* October 16.
40 *New York Dramatic Chronicle,* November 26.

were additional parlors at 943 Broadway and 587 Broadway in New York. And a year later there was still another, at 1199 Broadway.

By the end of 1894 many additional towns in the United States had had Kinetoscopes debuts. The following list is representative. I have not invariably determined which of these exhibitions consisted of a full parlor and which of a single Kinetoscope, as was often the case: [41] Binghamton, N.Y., 9/5/94; St. Louis, 9/7; Cincinnati, 10/12; Albany, 10/15; 10 Grand Street, Brooklyn, 10/20; San Antonio, 10/22; 771 Broad Street, Newark, 10/22; Dallas, 11/2; Portland, Oregon, 11/2; Allentown, Pa., 11/5; Tacoma, Wash., 11/7; 10 Newark Avenue, Jersey City, 11/9; Denver, 11/10; Austin, Texas, 11/10; Jackson, Mich., 11/10; 206 South Spring St., Los Angeles, 11/10; Atchison, Kansas, 11/10; Waco, Texas, 11/12; 1154 Washington St., Boston, 11/12; Columbus, Ohio, 11/13; Montreal, Canada, 11/15; Paterson, N.J., 11/15; Sherman, Texas, 11/18; St. Paul, 11/19; 184 Woodward Avenue, Detroit, 11/19; Raton, N.M., 11/22; 266 King St., Charleston, S.C., 11/22; St. Thomas, Ontario, Canada, 11/24; Minneapolis, 11/26; Port Jervis, N.Y., 11/27; Helena, Mont., 11/27; Davenport, Iowa, 11/28; Pittsfield, Mass., 11/30; c. 12/1, Grand Central Palace in New York (with White and Webster—see page 00); Louisville, 12/1; #2 Stricklane Block, Bangor, Me., 12/3; Atlanta, 12/6; Memphis, Tenn., 12/6; 66 Bull St., Savannah, 12/6; Galveston, Texas, 12/8; 16 Park Place, Morristown, N.J., 12/10; Halifax, Nova Scotia, Canada, 12/11; Milwaukee, 12/13; Springfield, Mass., 12/14; Rochester, N.Y., 12/14; New Orleans, 12/17; Syracuse, N.Y., 12/19; Seattle, 12/19; Rutland, Vt., 12/19; Burlington, Vt., 12/21; 911 Oliver St., St. Louis, 12/21; 130 Clark St., Chicago, 12/22 (with Thomas R. Lombard in charge); and Omaha, 12/29.

A number of cities were showing the machine under the aegis of various agents of the Kinetoscope Company,[42] and any of a number of Holland Brothers agents.[43] These men paid the

[41] The Baker Library collection is the source of this information and the date after each name indicates the date on which either a film or a machine was shipped.

[42] For example, Tally and Bacigalupi in the West, and the Columbia Phonograph Company in Washington, Baltimore and Atlantic City.

[43] Baker Library collection, Volume 1.

Holland Brothers 5% on all Kinetoscopes, films and supplies they bought: Trajedes, Chaffee & Allen, Pike & Casterlin, Georgiades,[44] Mauro,[45] Blauvelt, Wallace, Sandlars, Pratt, Heyn, Stratton, Korn, Doring, B.A.Baldwin & Co., Maurice Moriarty, Harding, Wagner, Russell, Grosbeck, Brown & Clark, and Thomas and Pratt. The Kinetoscope Company itself, i.e., Raff and Gammon, apparently operated no parlor themselves.

Typical of the local sponsorships under which the Kinetoscope found its way into America's department stores, drug stores, hotels, barrooms, phonograph parlors, etc., in these months, was its introduction into Port Jervis, N.Y. This was apparently on December 13, 1894. James Joyce, the proprietor of the Clarendon Hotel in Port Jervis, was sent Kinetoscope 457 on December 12 for exhibition in the "public room" of his establishment. And on December 14 *The Port Jervis Union* sang the praises of the machine, its inventor and the enterprising local citizen who had brought "the greatest marvel of the age" to town:

The Kinetoscope at the Clarendon Hotel

The greatest of modern inventions is on exhibition at the Clarendon Hotel in this village. We refer to Edison's far-famed and marvelous kinetoscope. This wonderful mechanism is worth going a thousand miles to see, but the enterprise of Mr. James Joyce, the proprietor of the Clarendon, has made that sacrifice of time and money unnecessary by purchasing one of the machines and placing it on exhibit at his hotel where it may be seen by everybody for the small price of ten cents. The scene which is displayed in Mr. Joyce's kinetoscope is that of three blacksmiths working at an anvil. It is perfectly natural and life-like in every respect. Mr. Joyce has another series representing two boxers in a four round contest which will be placed on exhibition in due time. Two years ago the pictorial representation of motion would have been scouted as the wildest of impossibilities, the crazy emanation of a disordered brain.

[44] The reader is directed to the Ramsaye *(op.cit.,* pp 138 and 147ff) and Paul *(ibid,* p. 149 and *The Journal of the Society of Motion Picture Engineers,* November 1936) accounts of this man and his partner Trajedes. I have not added anything more to these accounts than I have already done (see page 115), since possible Ramsaye sources beyond those in Baker Library were not available to me and I have not considered the matter of English Kinetoscopes to be within the scope of this book.

[45] "At the same address [as Georgiades and Tragedes]", says Ramsaye on his page 138, as "one T. Mavro [sic. Ramsaye or his typist made "Mavro" out of "Mauro"], of whom we hear no more, who received and signed for the Kinetoscopes, film and other equipment."

This seeming impossibility has been converted into a reality by the wizard genius of Edison. As we remarked before the greatest marvel of the age is now on exhibition at the Clarendon Hotel.

The relative simplicity of the Port Jervis opening contrasted strongly with the splendor which greeted the Kinetoscope's arrival in Mexico City. Maguire and Baucus wrote Edison a précis of this fête on January 28, 1895.[46]

> We take great pleasure in writing you that our Parlour in the City of Mexico was opened Sunday, a week ago, at 6 P.M. by President General Diaz, and Mrs. Diaz and a large number of prominent people. A reception was given that lasted from 6 to 7:30 P.M. We quote from our agent's letter there, as follows:
>> "The President and Mrs. Diaz were so well pleased that they desire to see the Kinetoscope whenever we change views. We served a small collation at the end and everything went off smoothly and without a hitch. Everyone was deeply interested in the invention and thoroughly pleased."
>
> Many inquiries were made for pictures of yourself, which, unfortunately, we did not send in time, and President Diaz offered to loan a small one—the only one in the City of Mexico.
>
> We have sent them two of your large pictures and they have probably reached them by this time.

The Mexico City paper *El Monitor Republicano* of January 20 had the following to say (I have not corrected either the bad Spanish or the bad type-setting):[47]

[46] "Motion Pictures, 1895."

[47] This is from the Hemeroteca Naçional in Mexico City. A translation follows:

The Kinetoscope has arrived in Mexico.

The basement of a house in La Profesa Street, is actually exhibiting this marvelous machine, along with all Edison's inventions [sic]. The wizard of Menlo Park has been able to fix life clearly in this machine.

Imagine a kind of desk in which several spools turn, rolling and unrolling a narrow tape on which there are many photographs of real life scenes. A small motor is the motive power and on top there is a brilliant reflector illuminating the images through a lens to the eye.

The illusion is complete and the effect marvellous.

The images come to life before your eyes and move, walk and dance as if they were flesh and bone.

It is, in effect, a Liliput world—but with real life, because there seems to be a soul in the body of the little figures.

Photography aided by electricity has made this miracle possible.

The inventor has taken many images of the same subject and we will not describe his methods. These images superpose and change with great speed according to the variations of the camera. They are life-like motions

El Kinetoscopio ha llegado á México.

En los bajos de una casa de la calle de la Profesa, exhibese actualmente ese aparato prodigioso como todos los inventos de Edison, ese aparato en el que, el mago de Menlo Park, ha logrado sorprender y fijar la vida en sus más claras manifestaciones.

Figuraos una especie de pupitre en cuyo interior giran varios carretes, que vertiginosamente enredan y desenredan angosta cinta, que lleva fijadas innumerables fotografías de cualquiera escena de la vida real. Un pequeño dinamo es el generador del movimiento, y allá, arriba, un brillante reflector ilumina las imágines que el objetivo lleva á la retina del espectador.

La ilusion es completa, el efecto es pasmoso.

Veis cómo se animan los muñecos que pasan ante vuestra vista, los veis moverse, andar, bailar, son de carne y hueso, es en efecto el mundo de Liliput, pero con vida real, porque se antoja creer que hay alma en el cuerpo de aquellos pequeños séres.

La fotografía, ayudada de la electricidad, ha logrado realizar ese milagro.

El inventor, por quién sabe qué procedimientos, ha fijado multitud de imágenes de un mismo asunto, esas imágenes superpuestas y cambiando con la velocidad del relámpago

and are a succession of changes sometimes imperceptible, giving to the moving beings the signs of life that synthesize the Biologic phenomenon called life.

Through the Kinetoscope lens I saw a curious scene. A horse is being shod, and I can see how the nail is entering the horse shoe driven by the hammer. I can also see how the workman walks from the bench to the forge. On the other side there is a man stroking the horse and afterwards another rides him.

Everything is as natural and accurate as life itself.

I also saw the "Serpentine." This little doll is about 3 centimetres high, the same as the above picture. She extends her arms and we can see her, dancing and jumping and shaking her large mantilla, making fantastic clouds with it. Sometimes she smiles and we see her lips move as she wraps herself in her clouds of foam.

To obtain this effect it has been necessary in Edison's machine to take 1,800 images in the tape which passes before the eye of the spectator in half a minute.

This marvellous machine is only the beginning of another machine with which the genius of Edison will very soon astonish the world.

The Kinetoscope combined with the phonograph will be able to show us opera in our own homes, we will see the actors and singers moving and talking. We will thus be able to attend the theatre although we are far away. This is not anymore a dream.

These 2 machines are already invented, but are not yet combined. But the sorcerer who everyday surprises the world with his revelations has almost achieved the combination.

In looking at the Kinetoscope we cannot quite realize the difficulties that had to be overcome. More than 2000 images had to be taken in half a second [sic. "minute" is meant.] and this incredible speed is necessary to give the appearance of life.

segun las variaciones que el objetivo de la Cámara ha sorprendido, son los movimientos que constituyen la vida, forman esa sucesion de cambios imperceptibles á veces, que dan al sér animado los signos de la existencia, que en verdad sintetizan ese fenómeno biológico que llamamos vida.

Al través del lente del Kinetoscopio he visto una curiosa escena. Están herrando á un caballo y se ve cómo el clavo va entrando en la herradura impulsado por el martillo, cómo el obrero va del banco á la fragua; más allá un individuo acaricia al caballo, despues otro le monta, todo con la naturalidad, con la precision, con los detalles de la vida real.

He visto tambien bailar á la "Serpentina;" la muñequita tendrá unos tres centímetros, lo mismo que los del cuadro anterior; tiende sus brazos y se la ve danzar y lanzarse al vacío, agitando su manto, haciendo con él esas fantásticas nubes, esas olas, esos torbellinos de la "Serpentina" de veras; en algunos momentos se sonríe, en otros vuelven á agitarse sus lábios y á envolverse ella en sus nubes de espuma.

Para obtener ese efecto ha sido necesario allá en el aparato de Edison fijar 1,800 imágenes en la cinta, que pasan ante la vista del espectador en medio minuto.

Este aparato maravilloso no es más que el principio de otro con el que muy pronto el génio de Edison asombrará al mundo.

El Kinetoscopio adicionado del fonógrafo, podrá llevarnos á domicilio, *verbi gratia,* la representacion de una ópera; veremos á los actores y cantantes moverse, les oiremos hablar; á distancia asistiremos al teatro ó á alguna reunion, y esto ya no es un sueño, los dos aparatos ya están inventados, falta combinarlos y esto casi está logrado por ese *brujo,* por ese vidente que cada dia deja estupefacto al mundo con alguna de sus revelaciones.

Al ver el Kinetoscopio apénas nos figuramos la dificultad vencida; más de 2,000 imágenes fijadas, impresas en la película fotográfica en medio segundo, y esta velocidad increíble es necesaria para sorprender, para fijar la série de movimientos que forman la vida.

By the end of the first month of the new year the Kinetoscope had found its way into: Trinidad, Colorado, 1/3/95; a new parlor at 644 Market St. in San Francisco, 1/3; the Jordan Marsh Company, Boston, 1/4; Indianapolis, 1/5; Macon, Georgia, 1/8; Scranton, Pa., 1/10; Hot Springs, Arkansas, 1/14; Evansville, Indiana, 1/15; a new parlor in Baltimore, 1/17; Butte City, Montana, 1/7; a new parlor in Brooklyn at 291 Nostrand Ave., 1/18; Norfolk, Va., 1/31; Waterloo, Iowa, 1/31; Augusta, Ga., 1/31; and Kansas City, Mo., 1/31.

And in February: Morgan City, La., 2/5; Nashville, 2/7; Gimbel's store in Philadelphia, 2/7; Ottawa, Canada, 2/7; Duluth, Minn., 2/12; Lafayette, Ind., 2/12; Montgomery, Ala., 2/12; Richmond, Va., 2/20; Lawrence, Kansas, 2/25; and a new parlor at 203 Broadway in New York City, 2/5.

In March: Williamsport, Pa., 3/5; Niagara Falls, N.Y., 3/6; Chattanooga, Tenn., 3/14; Portage, Wisc., 3/18; Huber's Museum in New York, 3/23; and Watertown, New York 3/30.

In April: Jackson, Mich., 4/11; a new parlor at 13 Park Row in New York City, 4/9; Huntsville, Ala., 4/11; Monett, Missouri, 4/13; Great Falls, Montana, 4/15; Baker City, Oregon, 4/16; and Glens Falls, New York, 4/18.

In May: a new parlor at 278 South Main Street in Los Angeles, 5/3; Little Rock, Arkansas, 5/6; Utica, N.Y., 5/11; Schenley Park, a suburb of Pittsburgh, Pa., 5/14; Port Huron, Mich., 5/14; a new parlor at 722 Canal Street in New Orleans, 5/18; Lake Park, Minn., 5/18; Gardiner, Me., 5/18; 825 Market Street, Wilmington, Del., 5/18; Gloucester, N.J., 5/23; New Haven, Conn., 5/24; New Bedford, Mass., 5/25; Huntington, Pa., 5/29; and Madrid, Spain, 5/29.

In June: Augusta, Me., 6/5; Canastota, New York, 6/5;[48] Olympia, Washington, 6/19; and Tyrone, Pa., 6/28.

In July: Long Branch, N.J., 7/1; Salem, Mass., 7/9; Lincoln Park in New Bedford, Mass., 7/10; Hoboken, N.J., 7/12; Lynn, Mass., 7/19; Coney Island, 7/25 (see also page 000); Amherst, Virginia, 7/26; Cyrene, Wyoming, 7/29; and Riverside, R. I., 7/31.

The invoice book records in August show no additional shipments, and with the close of the season the Kinetoscope business had declined the point where there was very little left of it. Occasional refill orders from established locations—many of which had closed at the end of the summer season—formed the bulk of the business. A few customers wanted copies of the new Clark films (see page 137), but the September invoices show only a Steubenville, Ohio exhibition (9/14) and one at the Atlanta Exposition as new.

October records the introduction of the Kinetoscope into Pontiac, Michigan (10/22) only. And there were no new openings for the remainder of the year.

[48] See my *Beginnings of the Biograph* for an account of the possible special significance of this exhibition.

8 · *Summer Activity*

ON APRIL 2, WILLIAM GILMORE, WHO HAD BEEN INSULL'S SECRE-
tary (just as Insull had been Edison's), took up his duties at
the laboratory. Ramsaye reports that Gilmore was supposed
to start work on April Fool's Day, but quipped that he "wasn't
going to start anything on April Fool's Day." If Ramsaye's
research had been as facile as his credulousness, he would have
found that Gilmore's remark was specious, since April Fool's
Day in 1894 fell on a Sunday, and no one, not even at the
Edison laboratory, was expected to work on Sunday.

Soon after he arrived at the laboratory Gilmore began to
disagree with Dickson. This was apparent as early as April
24, when Gilmore decided that "Dickson's copyrights" should
be transferred to Edison.[1] This is the sort of matter that Edison,
immensely preoccupied with ore-milling,[2] left in the strong
hands of his new *chargé d'affaires*. The attorneys Dyer and
Seely were asked to prepare the transfer, and on May 9, after
having asked Gilmore to see Dickson about the matter, they
were assured that Dickson would see to it.[3]

On July 10 Dyer and Seely wrote Gilmore that the Librarian
of Congress had told them that "Mr. Dickson filed in all twenty-
one entries for copyrights" and asked for $10.50 for expenses
involved in the transfer.[4] On August 13 they sent the assign-
ment to Dickson for his signature, but were brought up short
on August 17 by Dickson's telling them that Edison wanted only
the motion picture copyrights. He was supported in this by
Edison:[5]

> Gilmore—Dixon [sic] is right have only Kinetoscope rec-
> ords transferred—and you better have Dixon furnish strips
> & copyright taken out on all strips up to date in my name

[1] Letter book E1717 4/13/94 - 8/27/95

[2] A letter of May 21, for example said: "I am engaged in a scheme now
that takes every moment of my time and will continue to do all summer . . ."
(ibid.) F.Z.Maguire, as we will see on page 112, was told on May 31 that
Edison was at the mine every day *(ibid.)*

[3] *Ibid.*

[4] Document files, "Motion Pictures, 1894. W.K.L. Dickson."

[5] *Ibid.*

The "Kinetoscope records" to date were only four: "No. 44,732Y—Edison Kinetoscopic Records, deposited October 6, 1893" (see page 47); "No. 2,887Z—Edison Kinetoscopic Record of a sneeze, January 7, 1894, deposited January 9, 1894" (see page 35); "No. 10,776Z—Edison Kinetoscopic Records, deposited April 9, 1894" (debut films?); and "No. 10,777Z—Souvenir Strip of the Edison Kinetoscope, deposited May 18, 1894"[6] (see page 61 and Illustration 11). The matter was settled on September 5, and Gilmore sent Dickson's assignment of these four subjects to Dyer and Seely for safekeeping.[7]

On April 24, the same day that Gilmore asked Dyer and Seely to initiate this transfer, the first Kinetoscope after the original twenty-five[8] left the Edison Manufacturing Company.[9]

April 24 is also the date of the first record I have found in the Edison archives with definite information about Tate's leaving the laboratory. A correspondent was told that[10]

> You better get Tate's proxy as I understand he has resigned from North American [i.e., N.A. Phonograph Company] and is going to Helena Montana to take a position in a Bank.

By May 5 *The Orange Chronicle* was calling him Edison's "former private secretary", and on June 1 he was given a farewell dinner at the Orange Club.[11] By May 30 he had appar-

[6] *Ibid.* The first of these series, as I have shown in *Film Culture*, Summer 1961, and in *Infinity*, December 1960, was for motion pictures overlooked by Howard Lamarr Walls when he searched the copyright records for his very valuable *Motion Pictures 1894-1912*. Here he called "Fred Ott's Sneeze" the first copyrighted motion picture. The second entry, January 9, is the *second* such that I have found. The third, for April 9, was possibly the second "Blacksmith Shop" and for the man-turning-somersaults—this latter apparently for a reproduction in *The New York World* of March 18, this year. The fourth entry was for the well-known Sandow souvenir strip (negative #6566A of the Edison archives and Illustration 11).

[7] Letter book E1717, 4/13/94 - 8/27/95

[8] Of which ten had been installed at 1155 Broadway (see page 56), 5 in San Francisco (letter book E1717, 6/30/93 - 9/17/94), and the remaining 10 at 148 State Street, Chicago, by May 5 (the Baker Library collection has a lease for these premises signed by a John Berry). *The Orange Journal* of June 21 indicates that as of that date these three parlors were still the only ones in America: "At present there are only twenty-five [Kinetoscopes] in the world—ten in New York, ten in Chicago, and five in San Francisco."

[9] According to an entry in William Pelzer's notebook (E190 43—3 in the Edison archives), "First Kinetoscope shipped by Edison Mfg. Co. to Jos. Steinberg . . ."

[10] Letter book E1717, 4/13/94 - 8/27/95

[11] *Orange Chronicle*, May 5, 1894. This item also reported that he "has gone to Helena," which we know is incorrect.

ently gone to New York, and, by June 6, to Boston.[12] On June 10, according to the *Chronicle's* account of the June 1 dinner, he was to have left for Montana. He may not have done so, however (his own account does not make this point clear),[13] as we know that for at least part of July his address was still 32 Park Place, which had been his address as of April 14,[14] and the *Chronicle's* personal notices, which took careful notice of his activities; failed to note his departure. Later he was to essay an entry into the affairs of the Kinetoscope Company (see page 85).

Like others before and after him, he was badly treated by Edison, and finally left the laboratory on May 1, 1894. His own account *(op.cit.*, page 291) is as follows:

> One morning, early in the year 1894, I found a note from Edison on my desk in the offices of the North American Phonograph Company which read:
> "Dear Tate. I want to put the North American Company into bankruptcy and sell phonographs direct from the factory regardless of the local companies. I enclose my resignation as President."
> That was all. I was appalled. I had had no previous information of this move. I could not reconcile it with the letter which Edison had given me for use in negotiating the three-year contract with the states companies, in which he stated that he would retain the office of President and protect their rights . . . and which still had more than a year to run . . . I knew that these companies had paid more than one million dollars for their rights . . . It was obvious that they would consolidate to vindicate these rights and the charge would be made, and it was made, that the three-year contract was a device specifically designed to disarm and weaken them. I clearly saw that eventually . . . Edison would be assessed not only for their original investment but perhaps also for damages . . . But beyond all this was the criticism to which I felt he would be subjected . . . I had met and intimately known the representatives of these . . . companies who in all instances were prominent in the business affairs of their respective localities. Beyond any written document, I had given them oral assurances of protection and had received and enjoyed their confidence. I visualized myself . . . facing a barrage òf questions to which the answers would be too crushingly humiliating for me to endure. I did not possess the moral courage . . . If Edison held to his decision only one course

13 Tate, *op.cit.*
12 Copies of wires in the Baker Library collection.
14 Baker Library collection.

appeared open for me to pursue, and [I went to Orange, talked to Edison, and he said:] "Well! I've been taking Insull's advice and your advice for years. Now I'm going to act on my own advice." . . . "Then there is only one thing I can do," I replied. "I shall have to resign." . . . "What's the matter with you, Tate? . . . Why are you going to make a damned fool of yourself? Aren't you getting salaries enough?" "That's not it," I replied, "The salaries are all right. I guess I'm a bit tired."

And on that note the interview ended . . . During the months that followed he made no further reference to the subject. I sent him my resignations and on the first day of May in the year 1894, exactly 11 years after I had entered it, I once again passed through Edison's Open Door . . ."

The amounts charged to the Kinetoscope account for May and June were up to previous standards, with May having a charge of $391.80 and June $214.00.[15] July, with only $95.78, had the lowest charge for some months. In August the figure was $112.08—still a low figure, and in September, with the Kinetoscope Company's new all-expense contract in effect, the charge plummeted to a meager $17.32. The International Novelty Company, Raff and Gammon's pre-Kinetoscope Company business name, had assumed the charges which had been made until recently to Tate,[16] and the Edison Manufacturing Company was charged with film production costs until the August 18 contract with the newly-formed Kinetoscope Company. The Edison Manufacturing Company, for example, was charged for twenty-our rolls of 1 9/16″[17] x 46′ film on May 15,[18] and for additional films from Blair on May 21.[19]

[15] Labor and Material Sub-Ledger No. 6 in the Edison archives. All these charges may be found in this ledger.

[16] The ten Kinetoscopes of April 12, the ten films of April 14, and two lamps of April 30 were charged to Tate, according to letter book E1717 6/30/93 - 9/17/94. The charge for five Kinetoscopes shipped to San Francisco, originally charged to Tate, was changed on May 3rd to the International Novelty Company (ibid.).

[17] This is the width of the film that Dickson got from Eastman these days and a size soon to appear in Kodak #2 film. The width of the Kinetoscope sprockets was 1 7/16″, or 36.5mm. This is very close to the width Dickson used in the earliest days of his Kinetoscope work, when he split the Eastman Kodak 2⅝″ film down the middle and got a width of 1.4″ or 35.56mm. Eastman was now apparently splitting the film for him. All these sizes, 39.1, 36.5 and 35.56 millimeters, show how closely the size of early motion pictures was dictated by the size of the film available. They also show how we arrived at our present 35mm. width.

[18] Ibid.

[19] Item 2.12 in what I have called the "private legal file" in the Edison archives: E190-0.292-2.1 to 2.47.

In June the *Century Magazine* article entitled "Edison's Invention of the Kineto-Phonograph," perhaps the best known of all periodical writing on the subject, appeared. It was written by Dickson and his sister Antonia, and carried two very interesting pen sketches by the skillful E.J.Meeker. These have been discussed in the chapters on the Black Maria and the camera. It was headed by the famous facsimile letter by Edison, which, although it is well-known to students,[20] is so definitive of Edison's opinion of his position in this area and so characteristic of his vainness, that I reproduce it here (Illustration 45). In it he made his familiar claims for 1887 beginnings and life-size projection, which I have discussed elsewhere.[21] But, with some years of boasting for sound projection, hour-long takes, color, and television ringing in the public ear, he now retreated somewhat: ". . . in the coming years . . . grand opera can be given . . . without any material change from the original, and with artists and musicians long since dead."

The *Century* article was also illustrated by the famous photograph of Edison with his Zeiss micro-photographic apparatus,[22] and three groups of frames from motion picture subjects: "Fencers" (the *Phonogram* subject of 1892—see Hendricks, *The Edison Motion Picture Myth*), "Hear Me Norma" (see illustration in the Dicksons' booklet), and the famous barber shop subject of the spring of 1893 (discussed apropos the dating of the Black Maria photograph on page 23). The sprocket holes had been carefully trimmed from all these frames.[23]

The *Century* article contained nothing significant that has not been discussed either elsewhere in these pages or in *The Edison Picture Myth*. It was highly valued by Dickson because

[20] It has been often reproduced. For example, in the Dickson, December 1933 article in *The Journal of the Society of Motion Picture Engineers*, the Dicksons' *History of the Kinetograph Kinetoscope and Kineto-Phonograph*, and in more than one film story of motion picture beginnings.

[21] Principally in *The Edison Motion Picture Myth*.

[22] Edison laboratory negative #s L40-L42. This photograph was also published in *Cassier's Magazine* of October, 1893, and in the Dicksons' *The Life and Inventions of Edison*, opposite page 300.

[23] Some have said that this was because Dickson did not want anyone to know how the film was propelled; and since secretiveness was often the order of the day with Edison, there is perhaps some truth in this. But sprockets and sprocket holes were well known at this time, and their use in the Edison laboratory machines was not novel. It also may have been because Dickson did not think that sprocket holes were "artistic."

of the *Century's* prestige, but as a source of exact information it is sadly lacking. Its interest, furthermore, to put it mildly, is not heightened by its grossly inflated literary style.

On June 14 a boxing match between Jack Cushing and Mike Leonard was photographed in the Maria (see Illustration 57). This was the first production effort of the new Latham Kineto-scope Exhibition Company (not to be confused with the Ki-netoscope Company of Raff and Gammon). Since this event falls squarely within the scope of the Latham section of this book, Chapters 10 and 11, I will not discuss it here. It should be said, however, that after the Sandow shooting of March 6 it was the first big Black Maria event, and was to be the last of comparable notoriety until the next Latham production—the Corbett-Courtney fight of September 7 (see page 100).

The motion picture was now firmly upon its way to capture another large section of the entertainment public—the fight fans of America. It had already captured the vaudeville public, whose taste had been catered to from the first by Kinetoscope subjects comprised almost exclusively of vaudeville turns. That there may have been artificial light planned for this fight film is even more significant (see page 97).

On June 16, the same day many New York papers carried the Leonard-Cushing story, an *Electrical World* article on "The Kineto-Phonograph" appeared. It carried the interesting Black Maria photograph already discussed, but little else that was new, and much familiar extravagance. But as *The New York World* of June 17 said, the exhibition of the Kinetoscope had become "one of the recognized sights of the town." Certainly it was becoming firmly entrenched in the amusement life of America.

Meanwhile, Kinetoscope manufacturing, in a lull after the production of the first 25 machines[24] got under way again, and in June the first 4 additional machines were turned out by the Edison Manufacturing Company.[25] In July a sizeable leap was made to 46 machines, and in August a total of 31 was made.[26] Dickson was no longer involved with ore-milling[27] and, with

[24] The reader may also recall that inquirers in the first weeks of the "Kinet-oscope era" were told they would have to wait 6 or 8 weeks for delivery.
[25] Item 2.13 of the legal file noted before.
[26] *Ibid.*
[27] The ore-milling letter books, heretofore a sure indication of Dickson's ore-milling activity, show no such activity in any of these months.

the Kinetoscope business now enjoying a mild boom, was allowed by the truculent Gilmore to devote a large part of his time to what had been a real interest for years. The laboratory was said to be "nearly closed" for the summer,[28] and motion picture activity became, after phonograph work, perhaps the most vigorous in the whole establishment.

This activity was, however, confined to the manufacturing of machines and film subjects, and experiments fell to a new low in July—$95.78. But this figure may not be realistic: Kinetoscope charges account traditionally obscured other expenses. So the July figure may represent an actual Kinetoscope expenditure, and may thus be substantial in comparison with what had gone before.

Parlors were opening throughout America—Atlantic City, Asbury Park, Brooklyn, two new ones in Chicago—in addition to those already in New York, Chicago and San Francisco. And new ones were being planned regularly.[29] New films were taken —for example, one of boxing cats (see Illustration 16)[30] and possibly of another dancing girl.[31]

On the morning of July 25 Dickson supervised the shooting of the trapeze artist Juan Caicedo in a novel use of Black Maria facilities (see Illustration 14):[32]

> . . . as it would have been impossible to stretch a tight-rope in the limited space of the building . . . the tight rope or wire was therefore stretched in the open air directly north of the building. It is the first time that any kineto-graph picture has been taken in the open air, and the results were looked forward to with interest.[33] Heretofore the success of the picture has depended largely on the interior inky blackness of the tunnel behind the figure or figures.

[28] Letter book E1717 4/13/94 - 8/27/95

[29] The Baker Library collection shows that new parlors were opened in July at 255 Wabash Avenue and 57 State Street, the Masonic Temple, in Chicago, and in Atlantic City—under the aegis of the Columbia Phonograph Company. The Asbury Park parlor is described in *The Newark Evening News* of July 17 (see page 000). *The Brooklyn Citizen* and *The Brooklyn Standard Union,* as we will see in Chapter 12, reported that the Brooklyn parlor had opened by August 16.

[30] According to *The Newark Evening News, loc.cit.*

[31] *The Atlantic City Daily-Union* of July 21 mentions "dancing girls." This may be carelessness, but on the other hand there is much to suggest that the first subjects of the dancer Annabelle had been taken by this time (see Illustration 00).

[32] *The Orange Chronicle,* July 28, 1894.

[33] The film of the employees' picnic (see Illustration 29) may have been a trial for this.

This appears, like the possible planning of light for the June 14 boxing match, to have been another significant event in the history of the American film. And knowing, as we do, that this film was a popular one,[34] the motion picture appears to have turned another corner on July 25, 1894.

Before the American motion picture had ended its first months of exhibition, it had also had its first brushes with the law. The first of these that I have found was with Senator James A. Bradley, the well-known founder of Asbury Park:[35]

> Senator Bradley has been shocked again, this time by the display of Carmencita's ankles in one of the series of pictures shown by the aid of "Wizard" Edison's latest invention, the kinetoscope . . . Founder Bradley said he would have to have a look at the pictures to see if they were the proper views for the people sojourning in the twin cities by the sea to witness without causing blushes to mount to their cheeks . . . on the night of the first day Founder Bradley and Mayor Ten Broeck went to the pavilion and proceeded to pass judgement on the pictures that Inventor Edison had so carefully prepared. The first picture shown the Senator and Mayor was that of the barroom and fight, and it was decided that the supremacy of the law over the rougher element had a good moral tone . . .[36]

> Then the exhibitor, pleased with his success as pleasing the powers that be [sic], thought that he would spring a great surprise upon the founder and the Mayor. He took a little tin can from a grip that he carried and placed a celluloid roll of pictures in the machine, at the same time remarking to the Senator, who had his eyes glued to the peep-hole: "Now you will be surprised, Senator. This is one of the best pictures in the collection."

> And the Senator was surprised, but not in the way . . . intended . . . The view was that of Carmencita in her famous butterfly dance,[37] and the Senator watched the graceful gyrations of the lovely Spanish dancer with inter-

[34] It appeared very frequently in the Raff and Gammon invoices now in Baker Library. We know, for example, from these records, that it was shown in Washington, San Francisco, Montreal, Chicago, Albany, London (England) and Huber's Museum in New York, as well as in the parlor at 1155 Broadway. There were also several re-orders for this subject, and Kinetoscope men did not buy a "pig in a poke," but viewed new subjects frequently, and decided very carefully on what they wanted.

[35] *The Newark Evening News,* July 17, 1894.

[36] This triumph of the law will be plain to anyone who examines the nine frames of this subject in *The Photographic Times* of January, 1895.

[37] Actually, Carmencita did not do a butterfly dance, but one of her own—which was considerably more distinguished than the serpentine and butterfly dances with which the vaudeville stage was ridden in these days.

est that was ill-concealed. But near the end of the series of pictures the Spanish beauty gives the least little bit of a kick, which raises her silken draperies so that her well-turned ankles peep out and there is a background of white lace.[38]

That kick settled it. The Senator left the peephole with a stern look on his face ... While he was trying to collect his scattered thoughts sufficiently to give full swing to his wrath Mayor Ten Broeck applied his eye to the peephole ... The Mayor also was greatly shocked and agreed with the Founder that the picture was not fitted for the entertainment of the average summer boarder, and the exhibitor was told he would have to send for some new views or shut up shop ...

"Boxing Cats," it may be reported, was brought down to Asbury Park at once, and the town's high moral tone remained unsullied.

The next month the censor's stroke fell more harshly—this time upon the Kinetoscope parlor at 644 Market Street in San Francisco. Secretary F.J.Kane, of the San Francisco chapter of the Society for the Suppression of Vice, arrested a Robert Klenck on August 15 for operating a Kinetoscope which was "alleged to be indecent." But Edison, sent the news by Lewis Glass, his phonograph agent, did not agree:

Mr. Edison has requested me to acknowledge your letter of the 18th instant, enclosing clipping[39] from the "Examiner," as to alleged indecent pictures being used in his latest novelty, the Kinetscope ... We don't understand how there can be any objection to any of the subjects introduced in the Kinetoscope, as they are all taken here at the Laboratory, and we have always been careful not to take anything that would be in any way objectionable to the Authorities, although certain religious people might object to some of the characters introduced ... We shall be glad to learn if any of the subjects introduced in the Kinetoscope are, in your opinion, absolutely improper ...

Thus, within four months of its public debut the motion picture had:

1, Captured the attention of the vaudeville public;

38 This Carmencita kick is, indeed, "the least little bit." It is shown at its apogee in Illustration 12. Surely Senator Bradley's innocence must have been tenderer than anyone else's.

39 This clipping, sent by Lewis Glass to Edison on August 18 has been lost, but I procured a copy of it from the San Francisco Public Library. This Gilmore letter to Glass, of August 28, is from letter book E1717, 4/13/94 - 8/27/95.

2, Captured the attention of a large section of the sporting public;

3, Had possibly had its first production planned with artificial light;

4, Taken its first shots in open air; and

5, Experienced its first censorship.

9 · Fall Motion Picture Production

THE CONTRACT BETWEEN EDISON AND RAFF AND GAMMON, EFFECTive on September 1, now came into force. The first major artistic event of the season, however, was not sponsored by Raff and Gammon, but by the Kinetoscope Exhibition Company, the Latham-Rector-Tilden venture. This event was the Corbett-Courtney fight which I discuss in Chapter 10. The bare facts are enough here. The Lathams had tried to match "Gentleman Jim" Corbett with Jim Fitzsimmons but had been unsuccessful. So on September 8, the anniversary of Corbett's fight with Sullivan (as a result of which he had become heavyweight champion of the world), Corbett met Pete Courtney, a Trenton heavyweight who was said to have "stood up against" Fitzsimmons for some rounds. They met in the Black Maria for six rounds of 1.16, 1.24, 1.12, 1.29, 1.23 and 50 seconds,[1] appropriate lengths for the Latham enlarged Kinetoscope. This fight served to focus, as no other event had yet done, national attention on the Kinetoscope and the motion picture.

Although Raff and Gammon's production schedule was nowhere nearly so spectacular as the Corbett-Courtney fight, it was nevertheless consistent and sometimes conspicuous. On September 13, the Glenroy Brothers, a comic vaudeville boxing team, met in the Maria for their boxing bout.[2] On September 20 a rats-and-terriers subject was shot.[3] On September 21, Layman, the "facialist," and another rats-and-terriers subject

[1] According to *The New York Herald* of September 8, 1894.
[2] Baker Library collection.
[3] *Orange Journal*, September 27, 1894.

were shot.[4] On September 22 the Glenroy Brothers apparently
returned, and still another rats-and-terriers subject was made.[5]
On September 24 the Maria's stage was host to Buffalo Bill and
an aggregation from his Wild West Show, which had just closed
a long run at Ambrose Park in Brooklyn.[6] Buffalo Bill was
shot in a rapid-firing demonstration and the Indians from his
company were shot in subjects later called "Sioux Indian Ghost
Dance," "Indian War Council" and "Buffalo Dance."[7] On
September 26 the Englehardt Sisters, lady fencers, were shot
in two subjects.[8] On September 29 the Kinetoscope Company,
deciding that the boxing business was the one that would
bring rich commercial returns, arranged for Hornbacker and
Murphy to meet for five rounds before the camera.[9] On Oc-
tober 1 a "Madam Rita" danced in the Maria.[10] October 6
was a big day: Walton and Slavin, comic boxers from "1492,"
a popular Broadway musical; a "pickaninnies" dance from
"The Passing Show," another musical; four "Arab" numbers
—"Mexican Knife Duel," "Lasso Thrower," "Sheik Hadj
Tahar," and "Hadji Cheriff" from the Wild West Show and
Cleveland's minstrel show (see Illustration 22); and another
Glenroy Brothers subject.[11]

The E.E.Cowherd letter, of possibly the week beginning
October 7, is very interesting in describing this atmosphere:[12]

> as pretty as can be.[13] I do not see why, but Mr and Mrs
> Dickson seem to take great interest in me, I suppose

[4] *Ibid.*

[5] *Ibid.* Also *Newark Evening News,* September 24, 1894.

[6] *Ibid.* Also *East Orange Gazette,* September 27 and *Orange Chronicle,* Sep-
tember 27.

[7] *Ibid.*

[8] Baker Library collection. These ladies were called the Englehardt sisters,
although there was only one Englehardt—the other being named Blanchard.
This is according to a receipt signed on September 26 in the Baker Library
collection.

[9] *Ibid.* The Hornbacker and Murphy fight is also listed in the undated
catalogue referred to on page 000 as a "Five Round Glove contest to a finish.
Price per set . . . $100.00. Or single rounds, each $20.00."

[10] Baker Library collection.

[11] *Ibid.* The October 16 balance sheet (see page 87) lists a number of these
subjects and dates various reimbursements therefor. Newspapers of Orange,
East Orange and Newark also refer to the taking of these subjects.

[12] I have referred to this letter in *Image,* September 1959. Cowherd appears
to have been a student at a New York electrical school who was also possibly
known to Dickson through Virginia friends, since Cowherd wrote that he had
seen a Virginia local newspaper at "Mr. D's."

[13] An intriguing fragment: the preceding sentences are missing.

on account of Mr. Shepherd.[14] In the afternoon they asked me to go to New York with them, as they were going to the Theatre there, but I declined, as I was not dressed well enough to go in a box with a man, as prominent to the world as Mr D. He promises to take me to Niagara Falls soon, when he is going to photograph the falls for the Kinetoscope. I shall go if he foots the bill.[15] My life is very pleasant as every fair day we have some theatre troupe out to act for the photo [sic]; Mr D always sends for me in time to see the performance. Last week we had 4 negro's from V[a]. who danced the old V[a]. break down for the photographing machine [possibly the "pickaninnies". G. H.]

Cowherd wrote his father again on December 8:[16]

. . . I think you do me an injustice by misconstruing my meaning as to my expenses. My board is $5.[00] per week since winter, and only was 4. per week for the first few weeks through Mr D's request of Mr Petit.[17] Now I have to pay full price, which is the cheapest can be had in the Oranges, that is fit for a *gentleman* to have. West Orange is only a new town built by the employees of Edison . . . the people charge what they like for board. I now get it one dollar cheaper than any one in the house, owing to Mr D's influence. I only get $8[00] per week now, as I do not work at night but very little. Our dep't has been shut down for the past week and I am the only one who has worked . . . Mr.D. allowed me to put in my time . . . Where my money goes to, is in necessary wearing apparel, of which I was very scarce. I can now save about $2[00] per week . . . if I keep my health, I will help you if you wish, or pay all my loans . . . I bought a very nice warm overcoat for 9.00 and a suit for $10.00. Mr D. cashed the check . . . I have been to N.Y. to the Theatre with ["one or two of [Dickson's] friends"] as a crowd, tickets & expenses by Mr D. He can get as many tickets as wants free, as theatre

14 I have not found who "Mr. Shepherd" was; local directory listings are inconclusive.

15 So far as I have determined, the first Edison-sponsored Niagara Falls excursion was in the fall of 1896—excepting a trip by Heise for Raff and Gammon in April of 1896. And the first such subject taken by Dickson was taken at the same time for the American Mutoscope Company (see Hendricks, *Beginnings of the Biograph*). This is probably a trip which was never seriously planned, considering the fact that such a trip would have involved the transportation of the ponderous Black Maria camera to the Falls. It is also possible that Dickson, who had obviously impressed Cowherd with his importance, was doing more of the same. The phrase "I shall go if he foots the bill" is poignant, in the light of the December 8 letter (see below).

16 "Motion Pictures, 1894."

17 This could be the Petit of U.S.Phonograph Company fame, who was later to be granted a significant patent (see page 158). This reference substantiates what that patent suggests: that Dickson and Petit were on friendly terms.

troupes are out here every day to be photographed for the kinetoscope.

I receive all the visitors for such purpose and see that they are attended to, look after the ladies with whom I have lots of fun, but for the time being of course, Theatre girls are a jolly set . . .)

On October 11 Luis Martinelli, a contortionist, was "taken" in the Maria. And on October 16 four subjects of the bronco-busting contingent of Buffalo Bill's Wild West Show were shot (see Illustration 25). They had received expense money on October 12 and were to receive a total of $85, which included transportation on the Delaware and Lackawanna Railroad for two horses.[18] On October 17 Professor Tschernoff's performing dogs were taken in two subjects—"Skirt Dance Dog" and "Somersault Dog."[19] On October 18 the Japanese tumbler Toyou Kichi was shot.[20] And on November 1 three subjects from the Broadway musical, "The Gaiety Girls"; Alcide Capitaine, a trapeze artist; and Annie Oakley were taken—the latter in apparently three subjects, only one of which must have been successful.[21] On November 26 two subjects of the Rixfords, an acrobatic team, were taken.[22]

Although the foregoing subjects are the subjects I have specifically dated in the 1894 Black Maria season, the following were also shot before the end of the year: several dance subjects by Annabelle (see Illustration 13); apparently four subjects of athletes in calisthenics; Armand 'Ary; another (than Madame Rita), oriental dancer, possibly "Miss Rosa"?—see page 126; Topack and Steele; two barroom scenes (one in existence by June 1894 and a new one made in December); a Chinese laundry scene (see Illustration 20); a Chinese opium den scene; a "Cupid Dance"; a fan dance; two Elsie Jones dance subjects; a fire rescue scene (see Illustration 24); a Japanese dance; an

[18] This information is from a receipt signed by Madden, their manager, in the Baker Library collection. I referred to this matter in *Image,* September 1959, but may have erred in my apportionment of this fee.

[19] *Orange Chronicle,* October 20, 1894.

[20] *Ibid.* Kichi is illustrated on pages 33 and 44 of the Dicksons' booklet, but there misnamed "Shiekh Hadji Tahar."

[21] This information is from *The Orange Chronicle* of November 3, 1894. I have refuted Ramsaye's dating of the "Gaiety Girl's" shooting on page 195 of *The Edison Motion Picture Myth. The Orange Journal* of October 18 announced an Annie Oakley visit for October 19, but this was apparently cancelled.

[22] *The New York Clipper* of December 8.

Indian club swinger; a gun spinner; five subjects from the Broadway musical "A Milk White Flag" (see Illustration 23); a Ruth Dennis (i.e., Ruth St. Denis) subject; an Arab "human pyramid"; an Arab "sword combat"; a trained bear subject (see Illustration 21); Waring and Wilson, from "Little Christopher Columbus"; a wrestling dog; a wrestling and a boxing match; and, possibly before January 1, 1895, a dentist scene in which Dr. Colton, credited with being the first to administer gas, was starred (see Illustration 26).

In addition to the manufacture of Kinetoscopes and the production of motion picture subjects, experimental work was being done. For example, there was work on a "New Model Kinetoscope Motor" and a "Model Armature" for such a motor.[23] In October, November and December there was also work on a film puncher, and a cutter and a printer. In November and December an additional cutter and puncher were under way.[24]

On October 30 Gilmore wrote to Raff in Chicago, who had complained on October 23 that things were a bit slow:[25]

> I have your letter of the 23rd. Arrangements have been made to enlarge the film department, and new apparatus is now being made for same. The apparatus necessary to do the work, has, of necessity, to be very accurate, and some time will be consumed in getting same out. Within the next month, however, I see no reason why we should not be in a position to turn out all the film that may be required.

Raff and Gammon, not satisfied, urged further diligence on Gilmore, who tried to pacify them further on November 7:[26]

> I have your letter of October 31st and in reply would say that we continue to steadily increase the output of our film department. Last week we turned out a total of 120 films, and we hope to continue to increase this output steadily right along. Another set of printing apparatus was only put into practical use during last week, and when this machine gets running as it should, I see no reason why we should not be in a position to increase our output ma-

[23] The Randolph letter book E1717 7/31/94 - 7/1/97, pages 39 and 54.
[24] Ibid.
[25] Letter book E1717 3/8/94 - 4/7/94
[26] Ibid.

terially. In addition to this, I have other apparatus being made, which will more than double the present output, but as I wrote you several days ago this apparatus necessarily has to be made very accurately . . . We are pushing ahead the work on this apparatus all that we can. You must also remember that this is an entirely new line of work, and necessarily it takes time to break in new help to do it in a systematic and thoroughly satisfactory manner . . .

I trust that our people here will soon be in a position to give you everything you want, not only in the way of films, but of machines, etc. . . .

That Gilmore was "doing everything possible" is unlikely. The ore-milling business was still uppermost in Edison's mind, and it was to remain so until late the next year when he said,[27] "I am getting close to the end of my mill biz & will soon be able to come back to work."[28]

That Gilmore's relation with Dickson was going from bad to worse is also certain. A particular deterioration seems to have occured not later than about November 10 and possibly not sooner than the deadline for the *Cassier's Magazine* article of December. Dickson did not claim projection in this article, whereas he did claim it in the late-1894 booklet. I have described elsewhere[29] the arrangement between Dickson, Raff and Gammon, and Albert Bunn, the printer of the Dicksons' *History of the Kinetograph Kinetoscope and Kineto-Phonograph*. I have said that Dickson's first claim for projection was made in this book, which appeared to have been "closed" about December 17. Although it is true that the book must have been closed on about that date, Bunn's note of November 10 to Raff and Gammon suggests that as of that date the text, and therefore the projection claims, had been completed:[30] "The Book is in hands & I am rushing it along—It is going to be a handsome & credible [sic] publication."

The phrase "The Book is in hands" suggests a completed text. Therefore Dickson, moving along with the Lathams in

27 "Elec. St. G.E. Co. 1895."

28 It is such remarks as these that have helped sustain the Edison legend of superhuman industry. There can be no doubt that Edison worked unusually hard, long hours, for many years; but there also can be no doubt that he was constantly aware of the hard-work legend that he was living.

29 In *Image*, September, 1959. A microfilm of my 40+-page research paper, published by the George Eastman House in connection with this study, contains my analysis of the Dickson-Bunn-Raff and Gammon matter.

30 Baker Library collection.

their projection efforts—at least a part of which pre-dated October 30, felt he should take a stand concerning projection. That he made this claim now adds to the impression that he began to see the end of his association with Edison. We can be sure that he was being constantly nettled by Gilmore, a man who was being given free rein at the laboratory, often to the frustration of other long-time employees.

Meanwhile Tate was having *his* trouble with Edison. He had left Edison because of the phonograph concessions matter, but was still, in spite of the World's Fair debacle, hankering after Kinetoscope profits. A letter he wrote to Edison on October 22, offering to settle the affairs of the Chicago Central Phonograph Company, appears to be antecedent to clearing the record for a *rapprochement* with Edison concerning the Kinetoscope.[31] It is interesting to note that Tate used the letterhead of the Kinetoscope Company in inquiring about the matter.

The North American Phonograph Company, of which Tate had been vice president, had failed in August, and Edison had forced it into bankruptcy. Tate was now assessing his prospects in the Kinetoscope business. A contract, found among Raff and Gammon's effects, appears never to have been implemented:[32]

> THIS AGREEMENT, made in duplicate this twentieth day of November, 1894, by and between THE KINETO-SCOPE COMPANY, . . . hereinafter called the "Company", and Alfred O. Tate, of the City of New York, State of New York, hereinafter called "Tate".
> WITNESSETH:—
> Whereas, the said Tate is desirous of purchasing from said Company certain Kinetoscopes and supplies therefor, and
> Whereas, the said Company desires to sell said Kinetoscopes and supplies therefor to the said Tate, upon the terms and conditions hereinafter stated, and
> Whereas, it is agreed that said Tate, may assign this agreement to a corporation to be formed within thirty (30) days from the date hereof, and that this agreement shall be as binding between said Company and said corporation as if originally made between them;
> NOW THEREFORE, in consideration of the premises and the covenants and agreements herein contained the parties hereto have agreed and do hereby agree as follows:

[31] *Ibid.* It will be remembered that the Chicago Central Phonograph Company was set up to handle World's Fair business and had been advanced $10,000 by Edison. It had repaid $8,207.

[32] Baker Library collection.

FIRST The said Company agrees to sell and deliver at the factory of The Edison Phonograph Works, West Orange, New Jersey, to the said Tate, or his assigns, at the prices and under the terms and conditions hereinafter specified, such Kinetoscopes and Kinetoscopic supplies as may be required by the said Tate, or his assigns, during the life of this agreement . . .

FIFTH The said Company agrees to deliver to the said Tate or his assigns, all films for which orders are given by the said Tate or his assigns (except such films as are reserved by said Company for its exclusive use), as soon as the same are received by the said Company from the manufacturer . . .

SIXTH The said Company, to the full extent of such control as they now or may hereafter acquire, over Kinetographs of Thomas A. Edison, agrees to make, or cause to be made for the said Tate or his assigns, films from subjects furnished by said Tate or his assigns, to such extent as such Company may be able to control or dictate the taking of subjects by the Kinetograph, and barring breakage or other accidents, and further agrees that such films shall not be used by it, or sold, or otherwise disposed of to others, but shall be held for the exclusive use and benefit of the said Tate or his assigns; provided, however, that said Tate or his assigns shall pay all expense of whatever nature attached to the production and taking of such subjects . . .

NINTH The said Company agrees that if it shall obtain for use, one or more portable Kinetographs or Cameras for photographing exterior views or scenes, it will place one of the said instruments under the direction and control of the said Tate or his assigns, it being, however, expressly understood and agreed that such direction and control shall relate solely to the selection of views or scenes to be photographed, at the expense of the said Tate or his assigns, and shall not by inference or otherwise indicate any right of ownership in said instrument on the part of the said Tate or his assigns and said Company is bound only to such extent as it may be able to control or dictate the taking of such subjects by the Kinetograph . . .

There is little evidence that Tate ever managed much in the Kinetoscope business, although he tried more than once to get into it.

Meanwhile the profits of the Kinetoscope Company appear to have been solid. Their net profit, for example, from September 1 to October 1 was $8377.13.[33] On October 12, in a burst of confidence, the majority stockholders assigned half

[33] Baker Library collection. This is from a balance sheet of April 22, 1895.

their prospective dividends to Raff and Gammon until the $10,000 paid at the time of the August 1894 contract had been repaid.[34]

An interesting abstract of the company's September 1 to October 16, 1894 finances is in the Baker Library collection. It lists office expenses, cash transactions, purchases from Edison, all film expenses in which the Hollands were involved, etc., and contained the following essential facts:

1. As of October 16, 1894 the Kinetoscope Company had paid Edison $7940 for Kinetoscopes and $369.35 for film subjects;[35]
2, As of October 16, 1894 the Kinetoscope Company had received $15,878.56 from customers;[36]
3, Such a subject as the "oriental dance" of October 1, costing $25, was relatively expensive. It was two and a half times the amount paid the lady fencers and equal to the amount paid a prominent vaudeville act like Walton and Slavin;
4, B.M.Tate, A.O.Tate's brother, was a talent scout for film subjects, whereas Fred Harvey was an agent for many of these artists.

With the close of 1894 the Kinetoscope business was not working out in the way Raff and Gammon had expected. Business was good for the first six months after public exhibition began, but they did not enter the field until September, and although the fall sustained itself, the end of the year brought difficulties. We will see in Chapter 14 how some of these were met—and some utterly defeating. From the first, too, Raff and Gammon were beset by domestic competition from the Latham cabal, and it is that story which should now be told.

34 *Ibid.*

35 It is easy to contrast this with modern motion picture production costs. Modern production may cost a million times as much, but in terms of viewer excitement, it is often difficult to credit an advance.

36 It is difficult, without an analysis of facts somewhat beyond the reach of the researcher, to decide what part of this is from the sale of machines and what part is from films.

10 · Latham Motion Picture Beginnings

AN ENLARGED VERSION OF THE KINETOSCOPE PRODUCED BY WOOD-ville Latham and his sons Otway and Gray (see Illustrations 52, 51 and 53),[1] and, to an undetermined extent by Enoch Rector and W.K.L.Dickson himself, also had some excursion.

It has not been possible to establish the date at which the Lathams entered the motion picture business. They appear to have been attracted to it after seeing the Kinetoscope on Broadway. The Latham sons Otway and Gray lived with their father at the Bartholdi Hotel, which still stands at the southeast corner of Broadway and 23rd Street,[2] just four blocks from the parlor at 1155 Broadway. Much publicity in New York periodicals preceded the opening of the 1155 parlor,[3] and the flashing electric dragon with green eyes and the bronze bust of Edison were a conspicuous addition to the Broadway *mélange* (see Illustration 36). But whenever the two Latham sons and their partner-to-be Enoch Rector,[4] saw the Kinetoscope, they were intrigued with it. It is obvious also, from a study of their

[1] It may be said here that Gray Látham's name has often been misspelled "Grey." I have seen several signatures by Gray, entries by his father in the family Bible, etc., and find that "Gray" is correct.

[2] We know that they were staying here in the fall (see page 150). Ramsaye (*op.cit.,* page 106) says it was the Bartholdi, but may have been inferring this from his knowledge of the fall residence. When Ramsaye wrote, all the Lathams were long dead. One of his sources, Leroy Latham, is not likely to have known it; but another, Enoch Rector, may have remembered. This residence may disagree with Otway Latham's testimony on December 10, 1897 in Interference 18461, in which he said that at that time he was living in the same "house" as his father. Edith Wharton said of the Fifth Avenue Hotel that it was the sort of a hotel one knew about but never knew anyone who stayed there; it can be said of the Bartholdi that it was the sort of a hotel one did not even know about.

[3] To name a few, *The Electrical Review* of March 9, *The New York Tribune* of March 11, *The Photographic Times* of March 16, *The New York World* of March 18, *Harper's Weekly* of March 24, *Leslie's Weekly* of April 5, and *The Photographic Times* of April 6. This is not to mention the considerable amount of pre-1894 publicity given the invention, and the avid interest Edison.

[4] I have no source on Rector except Ramsaye. I have been denied the examination of his personal effects, left after he died on January 26, 1957 at the advanced age of 94.

temperaments, that Broadway life fascinated them. They must soon have planned to go into the exhibiting business, since the Leonard-Cushing fight indicates extensive preliminary negotiation.

Woodville's own testimony three years later is not helpful,[5] and begins with a description of the 83 Nassau Street exhibition. Otway[6] merely said that Dickson showed him the Kinetoscope as a prospective customer, but failed to say when this demonstration occurred. Gray's memory,[7] insofar as the record is concerned, also began with the exhibition business, and Dickson's memory of seventeen years later is also not specific:[8]

[I] became acquainted with [Woodville Latham] in the early part of 1894 . . . then he [wanted to buy Kinetoscopes] and made such purchases . . . It was in my province to exhibit the machines to purchasers . . .

Three days later, testifying in the same case, Dickson also said:

[Gray and Otway] came to Mr. Edison's Laboratory . . . ["in the early part of 1894"] . . . to purchase some kinetoscopes . . . [I] met with them then and possibly three times after that during this deal . . .

It is possible that the Lathams visited the laboratory before the parlor opening, as much correspondence shows that many others were eager to get into the business.[9] Yet most of these correspondents were men already in some related business—phonograph concessionnaires, etc.—and there is little in the Latham history to suggest much pre-April 14, 1894 interest in the matter. This in spite of Woodville Latham's testimony later:[10]

The general principles of photography I began to study when I was fifteen years of age . . . [I read Dr. Draper[11]] many years before Mr. Edison's Kinetoscope was produced and before Anschütz . . . I clearly understood the conditions under which objects in motion could be photographed

5 On December 7, 1897, Interference 18461.
6 *Ibid.* December 12, 1897.
7 *Ibid.* December 10, 1897.
8 Equity 5/167, April 11, 1911.
9 Letters of January 20, 30, February 2, 8, 9 in letter book E1717, 8/8/93 - 3/9/94; letters of March 15, 16, 24, 28, 29, April 3, 4, 5 in letter book E1717, 3/8/94 - 4/7/94 and "Motion Pictures, 1894"; letters of April 7 and 12 in "Motion Pictures, 1894" and letter book E1717, 4/13/94 - 8/27/95, respectively.
10 Testimony on December 7, 1897 in Interference 18461.
11 John William Draper, an associate of Samuel F.B. Morse, was a photographer in the earliest days of the history.

... prior to the exhibition of the Kinetoscope; prior to my coming to New York, my information was that an instrument similar to the Kinetoscope had been exhibited at Koster and Bial's Theatre, if I mistake not, on Sixth Avenue.[12]

After having seen the new machines in operation in the 1155 parlor and at the West Orange laboratory (the weight of evidence suggests this was before May 24 of this year—see page 91), the Lathams[13] made their first important contribution to Kinetoscope history. They proposed the exhibition of prizefight films in an enlarged machine. Such films would enforce a considerably longer period of action than the customary ten-or-twenty-second films in the regulation Kinetoscope. And the perfectly obvious recourse—to enlarge the capacity of the camera and the Kinetoscope—was an important step forward in Kinetoscope fortunes.

I have discussed elsewhere the enlargement of the camera capacity (see page 96).[14] The enlargement of the Kinetoscope appears to have involved little more than the addition of spools to the spool bank. If the motor were thought to have needed additional strength perhaps the Kinetoscope motor ordered on

12 This is curious. Koster and Bial's Theatre, then at 117 West 23rd Street, was never on Sixth Avenue. But the Anschütz Tachyscope (see *The Edison Motion Picture Myth*) may have been displayed at various places in New York. There is some reason to think that it may have been at the Eden Musée some years prior to this time (see Ramsaye, *op.cit.*, page 182). Perhaps Latham was confusing this Anschütz apparatus with the Kinetoscope. The Chinnock Kinetoscope (see Appendix D) was too late.

13 I say "the Lathams" because it appears that the two sons of Woodville— and to a lesser extent the father in association with Enoch Rector (see page 150) and Samuel Tilden Jr. (see Appendix B, note 9), the intimacy of which I have not yet been able to assay, were the primary forces here. Considering Rector's later absurd claim for the invention of the loop (eagerly accepted by Ramsaye) his claims for early close association are weak. He also obviously exaggerated his part in the "difficult" construction of the one-hundred-fifty-foot capacity Kinetoscope.

14 This fact escapes—or is ignored by—Ramsaye. On his page 108 he says that "Both the camera and the viewing machine had to be given a new scope . . ." He goes on to say, under the influence of an Enoch Rector interview by his wife:

It made the prize ring and pugilism the major influence in the technical evolution of the motion picture for the entire first decade of the art . . . ["Rector's technical education now stood him in good stead"] . . . In order to get the prize fight into the limitations of the motion picture, Rector, working at the Edison plant, tripled the scope of the Kinetoscope, getting a capacity of one hundred and fifty feet of film, and then planned a prize fight of abbreviated rounds.

What "technical education" is necessary to add spools to a spool bank does not, on its face, seem considerable.

June 1[15] was the answer. But whatever was needed was sup-
plied, and on June 14, the first prize-fight for the new 150-foot
machine was filmed. Ramsaye *(op.cit.,* page 109) says "one
morning in July, 1894," and that the Latham combination was
called the "Kinetoscope Exhibition Company," and that it
"escaped the stricture of the prior Edison contract with . . .
The Kinetoscope Company." But as a matter of fact it was
not in July and the Kinetoscope Company contract was not
signed until two months later.

May 24 carpenter work on the Black Maria may have been
necessitated by this fight. We know that it had been planned
for some time. The somewhat elegant guard rails on the Maria
stage in the Carmencita film,[16] done away with for the somer-
sault of *The New York World* of March 18, 1894, may have
been thought inadequate for the robust action of a prize-fight
(see Illustration 12).

May 24 work may seem early for a June 14 fight, but there
is much suggestion of extended preparation for this event. The
New York Sun account of June 16 had reported that:

> Kid Levigne and Young Griffo, it is said, had been engaged
> at one time, and were willing until they went down to
> Orange and saw the twelve-foot ring in which they would
> have to fight. Then they backed out . . .
> Jack McAuliffe, it was said, had also been there with
> his partner, but they didn't get the real go into their
> sparring that was wanted to make a popular fight for pub-
> lic exhibition. Finally Mike Leonard and Jack Cushing were
> engaged . . .

And *The Orange Journal* of June 21 had had this to say:

> A number of attempts had been made . . . to get a good
> series of pictures, but they were not satisfactory. Finally
> Mike Leonard and Jack Cushing . . .

No legal testimony or Edison laboratory record notes this
June 14 production, but periodical references supply consider-
able information. The *Orange Journal* account of June 21
described the week's efforts, beginning, as *The Journal* reported,
on Monday June 11:

[15] The "private legal file" noted on page 73. Item 12.13 of this file lists a
Kinetoscope motor for June 1, 1894.

[16] See, for example, page 17 of *The History of the Kinetograph Kinetoscope
and Kineto-Phonograph.* A copy of the original Carmencita film is in the pos-
session of the author.

The pictures are about an inch square and close together. To make them with such a short exposure floods of light are needed, and the fighters were kept near at hand in Orange four or five days waiting for a clear morning sky. This came on Thursday . . .[17]

The World reported on June 16 that:

Since Monday Mr. Leonard, whose fame is world wide, has been walking about in his paddock coat, and Mr. Cushing, who is brave but unknown, had been eyeing him from a distance. They were waiting for a good day with such light and atmosphere as would best suit the kinetograph.

The *World* account continued:

Thomas A. Edison weighs about 185 pounds and has invented a machine called the kinetograph, which takes forty-six photographs in a second. Michael Leonard and Jack Cushing weigh 130 pounds each and are prize-fighters. Yesterday morning while they fought a prize-fight in real, solemn, bloody earnest Thomas A. Edison photographed them with his machine while he and six scientific friends looked on.

It was a very strange and unusual fight. The ring, only 12 feet square, was arranged in Edison's laboratory. It had to be a small ring so that the photographing machine might be able to take it all in. Such a fight has rarely been seen. Mr. Mike Leonard, the same who paid $60 for his paddock coat, said that he would not fight for $35, which was offered to him originally, but that he would fight for $150 and all his expenses. He insisted that any unfortunate who should be put up against him should receive $50 for his pluck and endurance.

The rounds were to last one minute only. That was necessary, as the kinetograph could not be arranged to work more than one minute at a time. There were to be six rounds, and between each round the men were to rest seven minutes while the men in charge of the kinetograph prepared it to receive new impressions.

In every second of every sixty-second round the marvellous kinetograph made forty-six photographs. It made a series of 16,560 photographs, in all measuring 900 feet in length. These photographs will be put into the kinetoscope, which will be divided off into separate rounds. The man who wishes to look will pay ten cents for each round, beginning with the first. The theory is that when in the first round he sees Mr. Leonard, to use his own language "pushing

[17] According to *The Report of the New York Meteorological Observatory of the Department of Public Parks, Central Park, New York City for the year 1894,* this is correct. Monday and Tuesday were overcast all day, and although Wednesday was clear in the afternoon, it was not clear in the morning. Thursday was clear all day.

Mr. Cushing in the face," he will want to see the next round and the next four. Thus he will pay 60 cents for the complete kinetograph of this strange and unheard-of fight . . .

The fighting began in earnest from the start. Mr. Leonard, who had put his paddock coat with the velvet cuffs on a chair where he could see it, felt that he of all the world's prize-fighters was to be the first to be made immortal, and Mr. Cushing, proud and ambitious as all young men should be, hoped that fame and the kinetograph would hand him down as a knocker-out of Mr. Leonard, if such a thing could be.

Each noble fighter had a trusty friend to act as second. Mr. Edison, in the good old days when he had very little money and a great deal of health, used to sit in the "mule pen" in Harry Hill's place in Houston Street to hear ladies sing and watch fighters fight. There he saw John L. Sullivan as a mere boy break the proud spirits of seasoned fighters, and beheld Paddy Ryan of the weak knees and shining locks sparring as well as he could. Mr. Edison was well fitted to supervise a prize-fight and see that all was fair and right . . .

Mr. Leonard, whose full name, Michael Wellington Leonard, was embroidered on his shirts and socks and stamped on his underclothes, remarked that it was a weird and unheard of fight and had many strange points about it; he doubted whether his new Brooklyn backer would like to see him in it, but he worried especially on account of young Mr. Cushing, against whom he had nothing, but whom he must severly punish in the interest of science and future ages.

Mr. Cushing, a man of few words and a very plain face, remarked:

"Mike, if you could fight like you can talk, Corbett and Sullivan would be dead and you'd be tried for murder."

The story as it proceeds will show why Mr. Cushing rued these words.

Mr. Edison and the six wise men whom he had invited had comfortable chairs, and at first discussed only the kinetograph, pretending that the fight was nothing to them. But as the battle went on they left those chairs, and their scientific manners vanished. Mr. Edison tossed his long locks out of his eyes and imitated every movement of the fighters. Sometimes he dashed his forehead farward [sic] as Mr. Leonard reached for Mr. Cushing's ear, and sometimes he twitched his mouth to one side as Mr. Leonard ducked to avoid Cushing's vengeance. All the six wise men did the same, and their excitement was proper and natural. The result of this kinetographic battle showed that a rest of seven minutes between one-minute rounds was a great and glorious idea. Instead of being only six rounds, it was six fights of one minute each.

The seven minutes between rounds enabled the heroic gladiators to recover their breath and start to work each time fresh and nimble as though nothing had happened. The ignorant should not despise the six fights because they only lasted a minute. Whoever has fought knows that one minute is a long time to keep at it.

Until the kinetoscope is in working order the true story of this fight will not be known, for Mr. Edison and the six wise men were too excited to remember just what happened, and the accounts of the two fighters vary. Mr. Leonard . . . said only this: "I hit him when I liked and where I liked. I'd hit him oftener, only Mr. Edison treated me right, and I didn't want to be too quick for his machine." .

"I generally hit 'im in the face, because I felt sorry for his family and thought I would select the only place that couldn't be disfigured. It's lucky the rounds lasted only a minute, for while I tried to spare him, of course I couldn't keep all my strength in."

Mr. Cushing, who has no paddock coat, but whose language is as simple and direct as that of Robinson Cruesoe [sic], said that in his opinion fighting in front of a photographing machine was no fight . . .

"I've got so in the habit of being tin-typed at Coney Island," he said, "that I felt as if I ought to keep a pleasant expression all the time. Once or twice while I was trying to get that expression on I went into a trance and Mike hit me, but he is not very strong. His tailor in Williamsburg charges him $3 extra for padding his shoulders, and that's what enables him to get a backer. But he's not muscular enough to fold towels in a Turkish bath." . . .

Mr. Leonard and Mr. Cushing went back to Brooklyn together.

To this *The Sun* of June 16 added a legal note:

Notwithstanding the fact that Justice Depue of New Jersey is holding together the June Grand Jury in Essex county to investigate a reported prize fight, something which was certainly meant to appear to be a fight to a finish took place in the grounds of the Edison laboratory at Orange on Thursday morning. Mike Leonard and Jack Cushing, both well-known fighters of Brooklyn, were the principals. Whether it was a contest of the character prohibited by law or not the patrons of Wizard Edison's kinetoscope will probably be able to judge in a few days. Perhaps the kinetoscope may be subpoenaed before the Grand Jury. If the whole undertaking was a success, the kinetoscope will be able to tell the story.

Except to confirm the story that the fight did actually come off, no one who could be found at the laboratory yesterday would tell about it. Mr. Edison, it was said, did not see it, as he was up in the mountains at Ogdensburg

experimenting with his electrical plant for the reduction of
iron ores. He has been there for six weeks, coming home
only to spend Sunday. W.K.L. Dickson has charge at the
Kinetoscape [sic] Works. These comprise two buildings in
the laboratory grounds. One of the buildings is used in
making the moving pictures and the other in preparing
and developing the films and for other purposes. It was
in these buildings that the pictures were made of Sandow
doing his acts of strength, of Carmencita in her dance, of
a barroom fight over a game of cards, and other pictures
of the series which are exhibited in the kinetoscopes in
this city, Chicago, and San Francisco . . .

The rules of the ring were remodeled to suit the kineto-
graph. That machine is arranged to take forty-six pictures
a second, and it had never before been capable of acting
continuously for more than twenty seconds. For taking
the pictures of the fight it was enlarged to a capacity of
2,760 pictures, or of one minute of exposures. The rules
for the fight, therefore, called for one-minute rounds. There
were to be six rounds, with seven or eight-minute intervals
between them while the films were being changed.

The manner of making the pictures is simple. A gelatine
film 150 feet long and about 1½ inches wide, with its ends
joined together into a band, is wound around among rollers
until it is all stretched out. A row of holes in one edge of
the band fits into the teeth of a sprocket wheel like those
used to drive the chains of bicycles. This wheel is driven
by an electric motor.

The band of film is thus passed rapidly along behind the
camera tube. The front of that tube is a circular shutter
having a slot in one side. The motor drives this also. It
turns around forty-six times a second, and every time the
slot comes around it allows a picture to be made on the
film. These pictures are about an inch square and close
together . . .

To make the fight interesting, it is said that Mr. Dickson
had a number of his friends present—New York business
men who like to see a [s]crap. It was fight from the word,
and in the sixth round Leonard is said to have dropped
his man. If it appears to have been well done in the pic-
tures it will be satisfactory to the public. It is said to have
been perfectly satisfactory to the spectators.

The pictures of each round will be mounted in a separate
kinetoscope, and if a fellow wants to see the fight to the
finish it will cost him six fees. It was learned yesterday that
100 new kinetoscopes are about ready for sale. At present
there are only twenty-five in the world—ten in this city,
ten in Chicago, and five in San Francisco.

The Orange Journal added a bit more—with the incorrect
information that there were only four rounds and the implied

exclusion of Edison as a spectator.[18] The *World's* account, full
of intimate, characteristic detail, strongly suggests that Edison
was there. *The Sun* excluded Edison from the spectators, but
this may have been as a favor to Edison, who did not want
himself to be thought of in connection with anything so vulgar
—and actually illegal—as a prize-fight. This was also to be
true of the Corbett-Courtney fight, which Edison surely at-
tended, although he later denied it (see page 108).

The technical facts of this fight are interesting. The camera
shot one-minute rounds, using, possibly, 138 feet (i.e., 3 x 46')
of film for each round. Three lengths would have necessitated
two splices. Although 150 feet was consistently claimed for
each round, such a length is unlikely: 50-foot lengths were also
claimed for regular Kinetoscope subjects, and there is a variety
of evidence indicating 46 feet for those (see Chapter 1). Shorter
lengths may have used, since, although the film that may have
been used was gotten in 46 foot lengths,[19] there would have
been a length needed for threading the camera. Dickson himself
said 42 foot lengths,[20] and a length, say, of 126 feet would allow
4 feet for threading the camera and a 3 x 42-foot length for
each round. This also corresponds more closely to the capacity
of the enlarged Kinetoscope and to the length of some of the
apparently complete Kinetoscope subjects now extant.[21] A
126 foot length would also correspond to what was said in the
Sun, World and *Orange Journal* accounts. 126 feet of film
would contain 2,016 frames of the approximately-35mm film
then used. These frames, flying by the camera gate at a rate
of 40 per second, would give about 50 seconds of exhibition:
each of the above periodicals said that the rounds were one

[18] The *World* and *Sun* accounts both describe 6 rounds, and two later film
catalogues offered 6 rounds of Leonard-Cushing film at $45 per round: first,
the Maguire and Baucus (see page 110ff.) catalogue of April 1897: *"Each* of
the above spirited boxing contests consists of SIX live rounds with "knock-out"
in the last," and second, an Edison catalogue of July 1901: "an actual six-
round contest between Mike Leonard . . . and Jack Cushing."

[19] On May 15, for example, approximately on time for the Leonard-Cushing
fight, 24 rolls of 46-foot film were delivered to the Edison Manufacturing
Company, according to letter book E1717 6/30/93 - 9/17/94. It may also be
remembered that Dickson had gotten 42-foot lengths the previous December.

[20] In his testimony in Equity 5/167 in 1911. See also Chapter 1.

[21] See my analysis of these lengths in a microfilm published by the George
Eastman House, of which the *Image,* September 1959 article was a conden-
sation.

minute long. The *Herald* lengths (see page 79) may have been pre-edited takes.

There is also a chance that auxiliary lighting was planned for this fight. Constant claims for such lighting had been made before. For example, in the florid language of the *Century Magazine* article of June 1894:

> The actors, when more than one in number, are kept as close together as possible, and exposed either to the glare of the sun, to the blinding light of four parabolic magnesium lamps, or to the light of 20 arc-lamps . . . supplied with powerful reflectors equal to about 50,000 candle-power. This radiance is concentrated upon the performers while the kinetograph and phonograph are hard at work storing up records and impressions for future reproduction.

Along with this must be set an account in *The Newark Evening News* of August 10, 1894: "In the Leonard-Cushing fight the men were compelled to pose until the lights were adjusted . . ."

Quite possibly, since this was Dickson's first serious prize-fight, he may have experimented with the use of artificial light. But if he used it, he afterward abandoned it, since in the film presumed to be the Leonard-Cushing Fight itself (Illustration 57) there is no lighting inexplicable by the sun.

11 · *The Latham Kinetoscope Parlor and the Corbett-Courtney Fight*

THE SUN'S "NEW YORK BUSINESS MEN WHO LIKE TO SEE A [s]crap," soon installed the Leonard-Cushing fight in a parlor at 83 Nassau Street in Manhattan. There appears to be little doubt that it *was* 83 Nassau Street. It was so stated by Woodville Latham in his testimony and concurred in by Otway. Enoch Rector also apparently agreed (see page 109 of Ramsaye, *op.cit.*). The date of the parlor opening is less certain. Woodville Latham testified that "my impression is that it was

in the month of July; it may have been the month of August."
His son Gray testified that *he* thought the opening was in the
latter part of July or the first part of August. Enoch Rector
said August (see Ramsaye).

It is logical that the machines for exhibition of the Leonard-
Cushing fight were not ordered until it was found that six
rounds had been successfully taken,[1] and thus that six machines
were needed—one for each round. Interesting in this connec-
tion are announcements for the Brooklyn Kinetoscope parlor,
appearing first in *The Brooklyn Standard Union* of August 16,
1894: "It is proposed to get a photograph taken of Mike Leon-
ard and Cushing . . ." and in *The Brooklyn Citizen* of August
18: "A complete picture of Mike Leonard knocking out Jack
Cushing will be ready in a few weeks." Since we know that
such a "complete picture" had long since been taken, then
perhaps business at 83 Nassau Street had begun to drop off,
and the Lathams were looking for new customers. It is less
likely that Maguire and Baucus gave this information to the
Brooklyn newspapers lightly: Leonard was a well-known
Brooklyn figure and the public was kept up-to-date with his
moves.[2]

It is also perhaps fair to assume that by this time, August
18, the 83 Nassau Street parlor had been open for some time,
since the Latham projection plans, apparently stimulated by
a falling off in Kinetoscope business, seem to have gotten under
way in September. This business apparently never flourished.
Rector's squadron of police "to keep order" was either Rector
or Ramsaye hyperbole. Indeed, if we are to credit Ramsaye,
the police of New York must have been kept busy these days
scurrying back and forth from one motion picture exhibit to
another, holding back the crowds. (We have seen how the
"crowd" at the 1155 Broadway parlor reached the astronomical

[1] The reader has probably noted that although *The World* and *The Sun* said
that six rounds were shot, *The Orange Journal* said four. Rector, speaking
through Ramsaye, said that the fighters "went about ten of the short snappy
rounds, of which the Kinetograph recorded six" (*op.cit.,* pg. 109). We must
conclude, however, in spite of the *Orange Journal's* statement, that six rounds
were shot. The April 1897 Maguire and Baucus catalogue and a July 1901
Edison catalogue offered six rounds. Dickson, furthermore, testifying many
years later in Equity 5/167, recalled that the Lathams bought six Kinetoscopes
for their parlor opening, and this would have put one round in each machine.

[2] For example, on June 18, *The Brooklyn Daily Times* had said that he had
"entirely recovered from his recent illness."

figure of 48 per hour.) The location of the Latham parlor may also have militated against its success. Then as now, customers in that neighborhood would have been mostly those employed there. On the other hand, countless thousands of visitors, both from other parts of the city and from out of town, came to uptown Broadway.

It is also likely that although the Leonard-Cushing viewers were getting three times as much film for only twice as much money, the ten cents required for *each machine*, a total of 60¢, inhibited the success of the Latham parlor. Fans were probably soon viewing only the knock-out round, and more and more often the other five machines remained idle.[3] The lack of variety also would have attracted only fight fans, of whom there were probably fewer downtown in New York than in uptown Broadway. There is little question also that the comparative obscurity of the fighters—Cushing was virtually unknown and Leonard had only the characteristic lightweight's reputation—contributed to the lack of success.

The 150 foot-capacity Kinetoscope was said by Gray Latham[4] to have been "supervised" by Otway. Rector, speaking to Ramsaye's interviewer, said *he* had made it. Given Rector's mechanical experience and Dickson's obvious close touch with the work, any Latham part in the planning or construction of the machines seems minimal. I have said that the addition of spools to the spool bank and possibly a stronger motor were all that was needed in this construction. I have nowhere seen or know the existence of any "formal" photograph or drawing of the enlarged Latham Kinetoscope.[5] No testimony or pioneer "memory" has given details. The reader may decide for himself the most logical arrangement. The film length would have to be increased approximately three and a half times, and its course would have to be changed in the transfer from one spool bank to the next. Possibly there were two such spool banks,

[3] This is also supported by the fact that the knock-out round of a fight was often the only one sold.

[4] Interference 18461, on December 10, 1897.

[5] There is a single probable "unofficial" exception. The photograph of the Tally Los Angeles parlor reproduced opposite page 428 of Ramsaye (*op.cit.*) and, apparently from Ramsaye, in the Deems Taylor, *et al.* "*A Pictorial History of the Movies* (Illustration 56) must show several of the enlarged Kinetoscopes. The machines are loaded with the Corbett films and the contour is different from that of the conventional Kinetoscope.

closely adjacent, with each bank half again as large as the one in the regular Kinetoscope model, with the movement from one bank to the other achieved by an oblique movement of the film.

<div align="center">* * * *</div>

To counteract bad business the Lathams, aided to an indeterminate extent by Enoch Rector and Samuel J. Tilden, Jr., brought the world's champion heavyweight, "Gentleman Jim" Corbett before the Black Maria camera. This was the most conspicuous motion picture to date, and it exceeded in notoriety all others for some time to come.

Since his title-winning fight with John L. Sullivan in New Orleans on September 7, 1892, exactly two years earlier, Corbett's handlers had been trying desperately to match him with another heavyweight of sufficient celebrity. The most recent candidate for this honor had been Pete Jackson of the British West Indies, and the two had come within a trice of a *dénouement* in Jacksonville, Florida shortly before.[6] But various states, including New Jersey and New York, had laws prohibiting such contests. Even the potential financial gain to all concerned was inadequate to counteract the pressure of society, whose gorge, then as now, occasionally rose at the idea of professional boxing.

Much had been said and written about the possibility of Corbett's fighting for the Black Maria camera, and press releases were flying about left and right. Typical of these was a report in *The Newark Evening News* of August 10:

THE BIG FIGHT AND KINETOSCOPE

There is a report that the people who control the Edison Kinetoscope have offered $15,000 for the Corbett-Jackson fight. The fight in such an event would have to be a private one. It was said the Kinetoscope people wrote to Corbett's manager, William A. Brady, and to Carson Davies in Chicago and asked to have the ring ten feet in circumference to suit their apparatus. Of course, the pugilists could not consent to this without throwing over ring rules bodily. Brady, it was said, replied that $15,000 would cut no figure at present because the Olympic Club of New Orleans, has

[6] All of this matter is most interestingly told in *The New York Sun* and *The New York World*. The reader is directed to these accounts for some of the sprightliest sports reporting in the history of American journalism.

already offered a purse of $35,000. Brady, however expressed a willingness to hear further from the Exhibition Company . . . Davies said "these men are going to fight on their merits, and, as I understand it, it would be impossible for them to do that under the Kinetoscope management. In the Leonard-Cushing fight, the men were compelled to pose until lights were adjusted and they had to rest over two minutes until the machine was fixed. No such arrangements would be satisfactory."

There has been more error recorded concerning this subject than any other with which I am acquainted. Chief among these is the statement, reiterated again and again, that this was the "first" fight film. These errors reached a climax in a recent article on this fight written by Leslie Lieber for *This Week* magazine,[7] and based, according to a letter from the author to me, on information furnished by Mr. Jimmy Jacobs. This *tour de force* contained nineteen errors in two pages.

I set down here large excerpts from the excellent account of the fight written by the reporter for Dana's *New York Sun* of September 8. This reporter accompanied Corbett from New York and back, talked with him many times, and wrote with charm and sophistication:[8]

> . . . at 8:15 o'clock yesterday morning the select party of sports began to arrive at the ferry entrance. A heavy fog hung over the North River, but as the sun's rays were slowly but surely burning through the mist, a successful trip was anticipated . . . Soon . . . Champion Corbett and his retainers hove in sight, followed by the usual curious crowd. The big pugilist was attired in a well-fitting suit of light checked cloth, an immaculate white shirt, standing collar, and black necktie in which nested a cluster of diamonds, while a broad-brimmed straw hat shaded his sunburned features. He carried a massive cane, and on the little finger of his right hand three big gold rings set with

[7] December 12, 1961.

[8] Other accounts I have read were those in *The New York Herald, The Newark Evening News, The Newark Daily Advertiser, The East Orange Gazette, The Orange Chronicle, The National Police Gazette, The Brooklyn Standard Union, The Brooklyn Daily Eagle* and *The Brooklyn Daily Times.* But these add little to the brilliant *Sun* report. The *Sun* account may have been written by Wilbur J. Chamberlin, Edward G. Riggs, Charles H. Fairbanks, or Erasmus D. Beach: Arthur Brisbane had left *The Sun* and gone to *The World* in 1890; Julian Ralph had left it in 1893; and Henry R. Chamberlin had left earlier this same year. Frank M. O'Brien, in his *The Story of the Sun* (George H. Doran Company, New York, 1918) said that "Dana liked Beach's [sports reporting] because the reader need not be a fan to enjoy it"—which applies well to this Corbett-Courtney account.

diamonds and rubies attracted the attention of the on-lookers . . . Close beside him walked big John McVey, who has assisted in the champion's training in his fights with Sullivan and Mitchell. Little Bud Woodthorpe, his private secretary, ran along behind lugging a suspicious-looking valise, and Frank Belcher, another attendant, carried several paper bundles. Several intimate friends were also in the champion's party, but Manager W.A. Brady was among the missing.

"Where's Courtney?" queried Corbett, when he stopped in front of the Delaware, Lackawanna and Western Railroad ticket office and lighted a black cigar.

"Oh, he's gone on ahead!" came the reply from a stout individual who seemed to be on the inside. "He took an early train, so as to get a good breakfast before facing the music."

"All right," said Corbett; "we'll wait a few minutes for Brady." By this time it had been noised about that the famous prize fighter was inside the ferry house, and hundreds of persons flocked down the dock to catch a glimpse of him. A policeman came up and extended his hand . . . :

"Where are you going, Mr. Corbett? Out on the road?"

"Oh, I'm just taking a little run out into the country," rejoined the big fellow, "and my friends here are going along, too, to see that I don't get lost."

"Ah, I see," mused the copper. "Well, I'm awful glad to see you looking so well, and I wish you luck." Then the blue-coat chased the small boys away with renewed vigor.

"Whew!" whistled Corbett. "That was a narrow escape. If that fellow had known I was going out in Jersey to knock out a stiff, he'd have made trouble, perhaps."

OFF FOR THE FIGHTING GROUND.

At this moment the managers of the concern which has charge of the kinetograph came into the ferry house and said that a start should be made at once for the battle ground. Bags and satchels were picked up, and the whole party swung onto the ferryboat Secaucus, bound for Hoboken. Manager Brady had been left behind at which Corbett seemed to feel a bit nervous. On the boat the champion was surrounded by a crowd of gaping men and boys, all of whom asked the question:

"Where's he going, any how?"

But Corbett never opened his mouth except to chat with THE SUN man about the prospects of his battle.

"This fellow Courtney," said he, "is big and lusty, although unknown to the sporting world. I never saw him before yesterday, and know nothing about him. These kinetograph people secured him and have offered a purse of $5,000 for a finish fight. It is stipulated that I must put the guy out in six rounds or I get nothing; for, as I under-

stand it, the machine is so arranged that a longer fight is undesirable. If I put the man out I get $4,750 and he will take the balance for his trouble. You can bet I'll do the trick, too, for it's too much money to let slip out of one's grasp."

By the time Corbett finished the above statement the boat had run into her slip and the short walk to the cars began. It seemed as if Corbett's coming had already been announced, for a crowd was waiting for him as he entered the depot. The party was just in time for the 8:45 train for the Oranges, and seats in the smoking car where the sports rode were at a premium.

The handlers of the affair were most mysterious. They told Corbett on the quiet that the utmost secrecy must prevail or the whole crowd would be "pinched" for aiding and abetting a prize fight, a violation of the New Jersey State laws . . . Then in . . . order to divert suspicion they suggested that the party divide into two sections and each leave the train at different stations. Corbett readily agreed to this, so when the Brick Church was reached, the Californian, accompanied by McVey, Belcher, and two friends left the cars and boarded a trolley car. At the next station, Johnny Eckhardt, Woodthorpe, the manager of the affair, and THE SUN reporter jumped out upon the platform and at once repaired to a neighboring restaurant to get a bite to eat.

CORBETT'S OPPONENT.

It was here that Pugilist Peter Courtney was discovered. He was a rather tough-looking citizen, with a bull neck, big shoulders, immense hands, and the proverbial thin legs. His eyes were small and set well back under his low brow. His jaws were square, and his nose looked as if it had taken many a good punch. Courtney was attired in an ill-fitting light suit, with a négligé shirt and a straw hat, the brim of which looked as if it had been doing business with a poll parrot. He carried a small black handbag and smoked a fat cigar. As the critics sized him up, they united in declaring him a "pretty hard-looking nut to crack," and one man ventured the opinion that a mallet blow squarely delivered on the top of his head would never phase him. Peter was as cool and unconcerned when THE SUN reporter approached him as if he had been on his way to a country picnic.

"I ain't no spring chicken," he declared, "and I don't think this here champeen will have such a picnic with me as he thinks. I was born in Pennsylvania and am 26 years old. A year and a half ago I went to Trenton to get a job, and that's how I got in the fighting business. There was a duck there named Ed Warner, and they said he was the champeen of Jersey. Well, . . . I just put this here Warner to sleep in just one round. Soon after that I did

up Jim Glynn in two rounds, Jim Dwyer in three, Jack Welch in four, and recently I went agin Bob Fitzsimmons, who couldn't put me out in four rounds . . ."

Courtney had with him several friends who were constantly telling him to keep a stiff upper lip, but such advice was unnecessary, as a cooler, more confident fighter could hardly be found. After breakfast a trolley car was boarded, and after an invigorating ride the brick buildings and tall chimneys of the famous electrical works were seen straight ahead. At the entrance to the laboratory the party was confronted by a high picket fence, through which a watchman scrutinized all hands. The managers of the fight soon explained matters, so that a big gate was swung back and the battle ground had been reached. Corbett and those who had left the train at Brick Church had not yet arrived; neither had Brady. But that cut no figure with Courtney. He walked around the grounds looking at everything in open-mouthed wonder, apparently oblivious to the fact that he was about to face a human cyclone that meant insensibility to him before the jig was up. Peter soon took a chair in the photographer's office and chatted quietly with his seconds . . .

"Ain't you afraid Corbett will knock your head off?" asked one of the workmen who stood around the fighters.

"Naw!" said Courtney. "He's got to hit hard to do that, for me nut is well set."

CORBETT ARRIVES.

"Here he comes!" shouted a small boy when the creaking of the big gate announced the arrival of the champion. Everybody shook hands with Corbett as he sauntered down the gravel walk to the place where his opponent was sitting.

"How do you do?" exclaimed Corbett, extending his hand to Trenton's pride.

"Howdy?" replied Peter in turn, as he looked the tall fighter full in the face.

"It's a nice day for this little affair of ours," remarked Jim, smiling grimly.

"Ain't it!" was the slow rejoinder, and Courtney turned on his heel.

"He looks like a tough customer," said Corbett, "and I think he'll take quite a punching."

The sun was now shining brightly, and the heat became so oppressive that everybody hunted for shady spots, while the fighters took chairs in a small wooden building where greasy workmen were pottering over all sorts of things electric.

THE BLACK MARIA.

Over at the Black Maria . . . several attendants were busy fixing the kinetograph, so that there might be no

slips or mistakes in photographing the impending struggle. The Maria, as the building in which Edison's wonderful machine is located is called, reminded everybody of a huge coffin. It was covered with black tar paper, secured to the woodwork by big metal-topped nails, and was the most dismal-looking affair the sports had ever seen. Inside the walls were painted black, and there wasn't a window of any description, barring a little slide which was directly beside the kinetograph and could be opened or closed at the will of the operator. Half of the roof, however, could be raised or lowered like a drawbridge by means of ropes, pulleys, and weights, so that the sunlight could strike squarly on the space before the machine.

The ring was 14 feet square.[9] It was roped on two sides, the other two being heavily padded walls of the building. The floor was planed smooth and covered with rosin. All battles decided in this arena must be fought under a special set of rules. A round lasts a little over one minute, with a rest of a minute and a half to two minutes between the rounds. Consequently, the smallness of the ring and the shortness of the rounds necessitate hot fighting all the time.

GETTING READY FOR THE BATTLE.

It was nearly 11 o'clock when the managers told the pugilists to get ready. Corbett prepared for the battle in the photographer's private room, while Courtney disrobed in a shanty just beyond. Corbett stripped in a jiffy, Woodthorpe untying his shoes for him and arranging his clothes over the back of a chair. When he was in the nude the champion presented a magnificent spectacle. Though a trifle fat, his wonderful chest and back development, and his long, sinewy arms showed that he was in pretty good trim. His legs were rather thin, as they always have been, but he showed there was great strength in them by the up-and-down movement of the muscles when he walked across the floor. He didn't put on his flesh-colored Jersey, or his blue trunks, such as he wears when he gives his sparring exhibitions, but he simply pulled on a red elastic breech-clout and slipped his feet into black fighting shoes. In other words, he made careful preparations for a fight and not a boxing bout for points. He was in excellent spirits, although worried considerably over Brady's absence. But when the hustling manager arrived later, with the excuse that he didn't wake up in time to catch the early train, Corbett evidently felt relieved.

Courtney, meanwhile, was getting ready, with the assistance of his friends. He showed that he was in the finest

9 *The World* implied the same size and said that "several workmen were building it, and Courtney watched every movement with interest." *The Newark Daily Advertiser*, *The New York Herald* and *The East Orange Gazette* agreed that it was a 14-foot ring (see Illustration 55).

possible shape, for his flesh was clear, his muscles flexible, and his body as hard as nails. He put on a pair of black trunks and the regulation fighting shoes. As he sat on a canvas cot bed, slapping the knuckles of his left hand with the fingers of his right, he looked like a typical prize fighter. His hair was cut close with the exception of a small pompadour that made Corbett laugh when he saw it. Peter was still self-possessed, and to all questions as to how he felt he had but one reply:

"First rate!"

Some of the spectators thought he looked pale around the gills, but big McVey, after talking with him, said:

"He's a dead game fellow and fears nothing!"

FIVE OUNCE GLOVES.

Woodthorpe's suspicious looking valise was now opened in Corbett's quarters and two sets of gloves were produced. One set were two ounces and the other five. Corbett put on a pair of the big gloves and playfully punched McVey in the chin to try them. Then he sat down and pondered.

"What's the matter?" asked the ever-anxious Brady.

"Why," answered Corbett, "I'm in a quandry. You see, each round lasts only a minute, and with these big bags on my hands I might not be able to put this fellow out. I'm thinking it might be well to put the small gloves on and be sure of doing the job clean."

At this a messenger was despatched to Courtney to ask him which gloves he preferred. The Trenton boy replied that it made no difference to him, that whatever suited Corbett was agreeable.

"I'm here to fight," said he, "and I'll put on big or small gloves, just as the champeen says."

. . . Still Corbett didn't know what to do. He argued that, as the rounds were so short and the rests so long, Courtney would have plenty of time to recover from heavy blows. He also explained that if Courtney succeeded in staying five rounds he (Corbett) would have to work unusually hard in the sixth round to put him out in order to win the purse. Jim had a strong leaning toward the small gloves up to within a short time before entering the ring, but Brady and McVey finally succeeded in driving the idea out of his mind.[10]

INTO THE RING THEY GO.

There was a half hour's delay now over some defect in the kinetograph, and the fighters sat restlessly in the quarters, while the sports wandered about the grounds waiting for the fun to begin. But at 11:40 o'clock the chief operator

[10] Corbett later said five-ounce gloves were first used but were changed because they were too big and covered the faces of the fighters from the camera.

said all was ready, and the march to the Black Maria began. Corbett and Courtney walked from their dressing rooms fully fifty yards across the yard to the entrance to the fighting house, while their seconds followed carrying towels, bottles, sponges, and pails of water. It was so warm that nearly everybody carried his coat over his arm and fanned himself with his hat.

The moment Corbett stepped into the ring, he stopped short and exclaimed: "My, but this is small. There's no chance to bring any foot movement into play here, that's sure. A fellow has got to stand right up and fight for his life." Then he examined the ropes and padding very carefully and tried the flooring with his feet, before taking a chair in the corner.

Courtney came into the building a moment or two later. He looked calmly at the arrangements, but made no comments. He smiled and nodded to those around him, as much as to say, "Watch me!" As he sat down he looked hastily at Corbett, and meeting the champion's steady gaze, he grinned a second or two and then scowled. There was still something the matter with the machine, and as the roof had been raised so as to let in the sunlight, the heat was overpowering. Both men began to perspire, and finally Corbett jumped up and drew his chair back into a shady place. Courtney, who never did anything until Corbett took the initiative, also changed his seat, and the seconds were kept busy fanning the men with towels.

EVERYTHING READY AT LAST.

At 11:45 o'clock everything was ready. The men were first requested to pose in fighting attitudes for an ordinary photograph [see Illustration 55]. Then the chief operator told them to get ready for the fight. John P. Eckhardt of this city was the referee and W.A. Brady held the watch. In Corbett's corner were his seconds, John McVey and Frank Belcher, with Bud Woodthorpe, bottle holder. In Courtney's corner were John Tracey and Edward Allen, seconds, and Sam Lash, bottle holder. Corbett weighed 195 pounds, he said, and Courtney 190. The men were ordered to shake hands and received instructions as to clinching. Then they went to their corners and waited for the signal to begin the battle. The operators were all ready now,[11] and when the word was given the kinetograph began to buzz . . .

[11] The *World* account said that at this point:

 . . . a nervous little man with a black moustache, a slight goatee and a linen duster, came out through a door at one end of the building and smilingly advised the fighters that they might cut loose.

Surely this "nervous little man" was Dickson.

AFTER THE FIGHT WAS OVER.

. . . the fighters, their seconds and friends hurried out of the Black Maria and were soon ready for the trip back to New York. Before leaving the laboratory Corbett was introduced to Edison's two sons, who seemed delighted to grasp the hand that did up Courtney.

Corbett was elated over his success, but he said that Courtney had really faced him but two rounds under Queensberry rules, or six minutes in all. He said he knew the public would give credit to Courtney for staying six rounds, but they would not consider that each round was of a minute's duration. Courtney at once claimed that he stayed longer than Charley Mitchell, as the Englishman was knocked out by Corbett in three rounds, but he soon changed his mind on that point . . .

The fact that there had been a fight at the laboratory was known by everybody, but the particulars were lacking. Corbett took a seat in the waiting room, and was immediately surrounded. One man walked coolly forward and touched Corbett on the lapel of his coat. Then he walked back just as coolly, while the crowd couldn't understand his audacity. The fellow, as Corbett explained, simply wanted to tell his friends that he had touched Corbett, but not financially, of course . . .

Corbett longed for the arrival of the 2 o'clock train. When it finally did roll into the station, Jim and his followers, together with Courtney, jumped into the smoking car and were soon on the ferryboat. They all gave a sigh of relief when they landed at the foot of Barkley [sic] street, out of the reach of Jersey justice. All hands repaired to Johnny Eckhardt's place, where lunch was served, and Corbett opened wine. Courtney by this time had recovered his former equilibrium, and after drinking several glasses of fizz as if it were beer he exclaimed:

"I tell you what it is, boys, this here stuff is liable to change your color if you take enough of it." Then he took another gulp, and at a late hour last night he had no idea of returning to Trenton . . .

But the champagne in Courtney's glass was barely flat before various papers reported that "Corbett may be Indicted" and that the Edison Kinetoscope "May Get Corbett in the Meshes of the Law."[12] The next day these "meshes of the law" extended toward Edison himself, when Judge Depue in Newark directed the grand jury to make a "searching inquiry" into the fight.[13] But Edison, subpoenaed along with Dickson,[14] told

12 *Jersey City News; Rochester* [N.Y.] *Post-Express.*
13 *Jersey City News,* September 11.
14 *Ibid.* September 12.

reporters with his customary facility that, "I was not there . . . I did not understand a prizefight was to take place . . . I should certainly not permit any fight to a finish in my place under any consideration."[15] Edison's denial, incredible as it was, enabled him to escape the law, for a careful search of subsequent issues of the Newark papers reveals no further notice of any action.

Corbett's autobiography, *The Roar of the Crowd*,[16] fails to recall the 1894 fight, and refers to the 1897 meeting with Fitzsimmons in Nevada as "the first time in the history of boxing, it was arranged that moving pictures should be taken of a fight . . ." Corbett's later account, however, in *The New Movie Magazine* of December 1930, recalls the 1894 fight in detail. But these details are sadly lacking in accuracy: 1, he fails to mention an initial fee; 2, he said he was playing in "The Naval Cadet" at the time, whereas it was "Gentleman Jack"; 3, at one point he places the Black Maria in East Orange and at another in Orange—neither of which is correct; 4, he says that the fight occurred on a Thursday; 5, he says that he reached "Orange" about 9 AM; 6, he says that the ring was eight feet square; 7, he says that there were long rests between rounds; 8, he says that they did not leave until late in the afternoon. But he convinces us, for all his romancing, that Edison was there:

> . . . Mr. Edison strolled out of the laboratory. Somebody said he had been working there for thirty-six hours without sleep on some improvement he was trying to perfect in the movie camera . . . but his face and eyes were as fresh as a boy's, and with the exception of the fact that his hair was somewhat rumpled he might have just [had ten hours sleep] . . . nothing awesome about him, nor high-hatty . . . He immediately became one of us, laughing and joking with us . . .

What a legend Edison lived! How he enjoyed it! How his worshippers delighted to preserve it! The idea of Edison working for thirty-six uninterrupted hours "on some improvement he was trying to perfect in the movie camera" is grotesque in a man who did not know a positive from a negative (see *The Edison Motion Picture Myth*). But he did know the difference between profit and loss, and when Kinetoscope profits began to fail, the new firm of Maguire and Baucus were among the first to feel his wrath.

[15] *Newark Evening News*, September 12.
[16] G.P.Putnam's Sons, New York, 1925.

12 · Maguire and Baucus

BEFORE THE SUMMER HAD PASSED THE FIRM OF MAGUIRE AND Baucus[1] had come to the fore. Early during arrangements for marketing the Kinetoscope, Colonel George H. Gouraud[2] had paid $10,000 as a 50% deposit on 100 machines. These he intended to sell in Europe, his natural bailiwick. But Gilmore, ever aggressive in the Edison interest, had heard that Maguire and Baucus were "making an arrangement with Colonel Gouraud to sell his machines" in the United States.[3] He told them that his "understanding . . . was that you were not to sell any machine in the United States and Canada, and I would advise that you came to some understanding with Mr. Raff in the matter."

But Maguire and Baucus pointed out to Gilmore on August 29 that:[4]

> . . . Mr. Raff . . . neglected the vital point of preventing the sale of the [Gouraud] machines before he left the city. We had an understanding with Mr. Raff concerning sale

1 Joseph D. Baucus, of this company, was a member of a Wall Street legal firm, but Frank Z. Maguire, his partner, not to be confused with Thomas Maguire (see page 33), had for some time been trying to involve himself more deeply in Edison affairs. On May 3, 1892, when with the Edison General Electric Company, he asked Tate for a job at the laboratory and was refused (letter book E1717, 12/31/91 - 3/9/92.) By June 8, 1893 he was employed by the Eastern Rubber Company, Trenton, New Jersey, but wanted to yet enter Edison's employ (letter book E1717, 2/4/93 - 7/2/93). He was again refused. On another occasion he invited Edison to go shooting on an island in Chesapeake Bay (a likely prospect!), and was among the first to inquire about Kinetoscope prices (letter book E1717 4/13/94 - 8/27/95). The date of the selling agreement with Edison is uncertain: we know that it must have been soon after May 31 (ibid) and before August 18, when Maguire and Baucus opened the Brooklyn parlor (see page 112).

2 Colonel Gouraud was, according to Dyer, Martin and Meadowcroft, Edison: His Life and Inventions (Harper & Brothers, 1929) at one time an associate of George Harrington, formerly Assistant Secretary of the Treasury. He went to England with Edison for telegraph tests, found favor with him, and represented his English interests in the electromotograph and later the phonograph. Before Samuel Insull came to America to be Edison's secretary, he had had the same position with Gouraud.

3 Ibid. The date of this letter is August 27, 1894.

4 "Motion Pictures, 1894." At this time, according to this letterhead, Maguire and Baucus were in business at 41-43 Wall Street. By the end of the next month they had become ensconced at 44 Pine Street.

of machines . . . in which arrangement we reciprocated in case they had orders for South America . . . One of our customers was seen coming from [Gouraud's] and we . . . found . . . that a price of $500 had been given . . . if we had not used our best efforts and secured the option, free machines would be out today. Parties would obviously rather pay 5 or 6 hundred dollars for a Gouraud machine with unrestricted territory than 300 for ours with restricted territory.

We explained our position . . . thoroughly to Mr. Gilmore last Friday. We have a telegram from Mr. Raff, stating that he will start for New York today. We are doing nothing until he comes . . . or without your approbation, but must say that we are powerless to prevent the machine going to the public if the short option we have is not taken advantage of.

Eager to get on record with their ideas concerning the European market, Maguire and Baucus wrote Edison himself the next day:[5]

. . . we would like to have a personal conference with you, and feel assured that we can meet any objections that you may have as to tying up any further territory . . . We do not intend to make the exhibition of the machines our chief source of revenue, but on the contrary merely as a method of advertising the machines, and in that way selling larger numbers than could otherwise be done. In other words, *we intend to make the selling of machines our chief business* . . . We do not ask you to tie up the territory for any long space of time, knowing that you will treat us fairly in the matter . . .

We have interested with us . . . Mr. Irving T. Bush, a young man under thirty years of age and a millionaire several times over . . . his purpose . . . is . . . to establish agencies in the various European countries which will enable us to market your new inventions as they are brought out . . . We intend to so handle this Kinetoscope business . . . that you will not hesitate to allow us to market all your future inventions that you may get out . . .

We propose putting in at least $20,000 now and propose establishing agencies in London, Paris, Berlin and Vienna as quickly as the machines can be furnished . . .

We are, Mr. Edison, as you know, both young men, and consider our connection with you the most valuable we have ever formed . . .

We would like very much to see you at the Laboratory at 11 o'clock on Sunday morning . . .

By September 10, according to corporation records in the New York City Hall of Records, Maguire and Baucus set up

5 *Ibid.*

the "Continental Commerce Company" at their 44 Pine Street office, and laid plans for Kinetoscope parlor openings in London and in Paris—this latter through Michael Werner, who will enter this history again as the maker of "bogus kinetoscopes" in Europe and as the business correspondent of Charles E. Chinnock (see Appendix D).[6] On September 29,[7] they ordered twenty-one films[8] for a London opening on October 17 at 70 Oxford Street.[9] This shipment was contravened on October 29, and six Kinetoscopes and films were ordered diverted to Werner at 85 Rue de Richelieu, Paris.[10] These Kinetoscopes were promised by November 10 and shipped, presumably, by the "S.S. Bretagne" on November 3.[11]

On October 1 Edison told an inquirer into the financial standing of Maguire and Baucus that:[12]

> I am not in a position . . . They are my selling agents for Kinetoscopes for Europe and other foreign countries, paying cash for such goods as they purchase from us. These settlements have, so far, been entirely satisfactory.

We have seen that there was a Kinetoscope parlor opened at 457 Fulton Street in Brooklyn in August. It is interesting to note that Maguire and Baucus, through an arrangement apparently directly with the laboratory or with the Holland brothers, were themselves responsible for this opening. There are "now

6 Ramsaye refers on page 138 to the "Werner Brothers," and says a Lionel Werner bought Kinetoscopes and, with his brother, set up a parlor in Paris in October at 20 Boulevard Poissoniere. This is where, he writes, Louis Lumiére first saw the Kinetoscope. This, however, is likely more Ramsaye romance, since nothing I have ever seen Lumiére has identified the location of the Kinetoscope parlor first visited. We know that there was more than one in Paris at this time; probably Ramsaye was unaware of this.

7 "Motion Picture Hist. Articles—Early." This invoice is, in parts, virtually illegible. I have set down here my best guesses.

8 These were as follows: "Horse Shoeing," "Cock Fight," "Barber Shop," "Wrestling Match," "Highland Dance," "Bar Room," "Armand Ary," "Bertoldi #1," "Bertoldi #2," "Ruth Dennis [i.e., Ruth St. Denis of later dance fame]," "Carmencita," "Anna Belle Sun Dance," "Anna Belle Serpentine Dance," "Anna Belle Butterfly Dance," "Boxing cats," "Wrestling Dogs," "Children Dancing," "Caicedo #1 with Pole," and "Blacksmith Shop.".

9 London Daily Graphic, October 18, 1894; London Daily Times, October 18, 1894.

10 "Motion Picture Hist. Articles—Early."

11 Considering it is outside the range of this book, I have not established the date of this Paris opening. Obviously it was after the "Bretagne's" arrival, and the "Bretagne," according to The New York World of November 1, 1894, sailed on November 1.

12 Letter book E1717 4/13/94 - 8/27/95

on exhibition in this city," said *The Brooklyn Citizen* of August 16, "Five scenes displayed by Messrs. Maguire and Baucus, the South American agents of the machine. The visitor peers down into the first of three oak boxes . . ."[13] Before the Kinetoscope Company made its arrangements, the Kinetoscope business was a morass of single operators, private parties, etc.— anyone who could afford to buy a machine. (The Eagle Rock, New Jersey (see page 62) enterprise and the steamship "Republic" exhibit (see page 62) appear to be cases in point.) Maguire and Baucus seem to have had some of the domestic market before they got their foreign concession.

On October 24 and 29 inquirers about the Kinetoscope business in South America were told to see Maguire and Baucus.[14] And on November 9 a letter from Maguire at the London office of the Continental Commerce Company (see page 000) at 70 Oxford Street (which was also a Kinetoscope parlor) gives a first ominous sound of the foreign competition that Edison failed to inhibit:[15]

> . . . There are several reasons why this business should be pressed to the greatest possible extent immediately. The principal one is the fact that we are going to have competition. We are doing everything possible for the success of the business, and are sparing neither money or time to make it a "go."
> . . . We open on the Strand today. There are at present in London about five Kinetoscope exhibitions, but we are getting all the swells, and in fact, I never before have seen such a fashionable crowd in a Kinetoscope exhibition. I received a note from the Secretary of the Prince of Wales, and expect shortly to have a private exhibition before him.
> From time to time we have had numerous promoters and other individuals in with offers to take a very large number of machines for exclusive rights in England, France, Germany and elsewhere. I find, however . . . that all want to get into the business without putting up any cash . . .

It will be seen from this report of the five Kinetoscope exhibitions then in London (including possibly three that were not

[13] This is somewhat confusing. Ordinarily there was one subject per Kinetoscope, and the *Brooklyn Citizen* account makes it clear that there were five subjects then on view at 457 Fulton Street: "Bertoldi . . . a Bowery barber shop . . . Annabelle in the serpentine dance . . . Carmencita . . . [and] the scene in a blacksmith shop." Perhaps the "3 oak boxes" is an error for "5 oak boxes", or perhaps the films were changed so that the newspaper men could see all the films on hand.

[14] "T.A.E. Personal. Friends. 1894;" letter book E1717 4/13/94 - 8/27/95.

[15] "Motion Pictures. 1894."

sponsored by Maguire and Baucus) that they were still apparently exhibitions of the "true" Kinetoscope, and the copies which were soon to appear (see page 133) had not yet arrived upon the scene. I have found no documentary evidence that Edison's reasons for not taking out foreign patents was a disinclination to waste money, though Ramsaye, with his ease at quoting conversation after the lapse of years, has remarked: [16] " 'How much will it cost?' Edison asked casually. 'Oh, about $150.' . . . 'It isn't worth it!' " Ramsaye also describes, in this connection, the Georgiades and Trajedes matter with his customary bravura (see page 65).

Maguire and Baucus regularly bought films from the Kinetoscope Company. On December 13, for example, they were sent "Kessel," "Oakley," "Carnival Dance," "Pas Seul," "Toyou Kichi," "Club Swinger," "Skirt Dance Dog," and "Lady Fencers." On January 9 they were sent posters—possibly to be used in connection with the Mexico City opening (see page 000), and on January 10 they were sent 250 lamps. Other substantial orders were placed on February 7 and April 18.[17]

On January 16 they placed a significant order: "6 Prize Fighting Kinetoscopes" and "2 sets 'Leonard Cushing' films."[18] These "Prize Fighting Kinetoscopes" are obviously those of enlarged capacity made by the Kinetoscope Exhibition Company for the display of several rounds of fight films. Thus Maguire and Baucus were enjoying a privilege denied to Raff and Gammon—the use of Latham films. I have found no indication, however, that this privilege extended to the Corbett-Courtney films. It is possible that the Kinetoscope Exhibition Company had decided that by this time[19]—and particularly since the sensational Corbett fight had appeared—the earlier fight had become *passé*. Yet we are left wondering why it was not therefore also allowed to Raff and Gammon. Perhaps the

[16] *Op.cit.,* page 76.

[17] This information is from invoices in the Baker Library collection. On February 7, 800 "World Supplements" were ordered. Unless this was connected with the promotion for the "Trilby" subjects later produced (see page 000) the reason for this is obscure. The *World* of the 17th had a full page of "Trilby" cartoons, but the issues of January 20 and 27, February 3, 10, 17, 24 and March 3, 10 and 17 seem otherwise quite irrelevant.

[18] "Motion Picture Hist. Articles—Early."

[19] This privilege was also granted later, in the projection era.

Lathams thought foreign exhibitions would not harm their business.

Maguire and Baucus soon met the competition they foresaw in their November 9 letter. George Georgiades and George Trajedes, having brought Kinetoscopes from the Holland Brothers and having taken them to England, entered into an arrangement with Robert W. Paul (see page 133) to copy the Edison-manufactured Kinetoscope for European sale, free of Edison restriction. Maguire, encountering these "spurious" machines, cabled Edison on January 17 asking him to permit the addition of his name to theirs "against users your name spurious machines quick give date our agreement with you."[20] Having secured no response, he urged the next day,[21] "Cable yesterday vital importance continent deal hangs on it parties using one genuine with four spurious machines must secure writ tomorrow morning answer quickly your joining us makes success absolute much at stake."

On the same day, W.S.Perry, a trusted Edison associate in the Edison Building on Broad Street, New York, sent Edison a note, enclosing the cables (which had been sent to the Broad Street building) and remarked that:[22]

> I shouldn't think it would pay for McGuire [sic] to enter into any law suit, but I don't know as that is my business.
> I fully agree with you in your remarks about lawyers . . .[23]

Edison apparently took Perry's advice, for, so far as I have found, nothing was done to help his European agents in their efforts to stop "the pirate who is infringing and making bogus Kinetoscopes in Europe.[24] Edison may have felt that such attempts would have been useless, since there was no patent protection in England for the Kinetoscope—a protection which he pretended to scorn, but which he sought eagerly and ruth-

20 "Motion Pictures. 1895."

21 Ibid.

22 Ibid.

23 We can imagine what these remarks might have been. Edison was deeply involved in litigation nearly all his commercial life, and litigation largely instigated by himself. Yet he never hesitated to derogate the very law and lawyers upon which he depended so heavily (see The Edison Motion Picture Myth).

24 Letter from Edison to Seligman and Seligman, February 28, 1895, letter book E1717, 4/13/94 - 8/27/95. See also page 133.

lessly. But Baucus, Maguire's partner on the home scene, was still hopeful of aid. And perhaps thinking that his own efforts might avail where his partner's had not, sent Edison a note on January 19 agreeing to save Edison "harmless from any and all costs and charges and expenses of any kind arising out of said action."[25] But there was neither help nor comfort.

It should be noted that Maguire and Baucus, like Raff and Gammon, paid for Maria productions. When they had an idea for a subject they arranged for it and set MB in monograph on the stage for identification purposes.[26] When Raff and Gammon made a subject they put the letter "R" on the stage.[27] Both these symbols were generally placed in the lower right hand corner of the stage.[28] We will see later how an additional means of differentiation was sought and not found and how the letter "C" was added for other subjects (see pages 129 and 137).

Maguire and Baucus also tried to get into the fight film production business. Quoting a source unavailable to us (or non-existent), Ramsaye says (op.cit., page 116) that a Hugh Behan "was employed at a contingent $3,000 a year to frame a fight between 'such first-class fighters as Corbett, Jackson, Fitzsimmons, M'Auliffe, Griffo, Dixon or Maher, and a suitable opponent.'" Ramsaye also states that Maguire and Baucus signed the contract—which was apparently never made final. But he does not date the proposal, nor does his language indicate Maguire and Baucus' position in the deal.

We have already noted the gala opening of the Mexico City parlor under the sponsorship of Maguire and Baucus, and we will see that before the month was out Raff and Gammon began to feel that Maguire and Baucus were making incursions upon their business.

[25] "Motion Pictures. 1895."

[26] For example, a Billy Edwards boxing film, which I incorrectly identified as a Glenroy Brothers film in Image, September 1959, has this symbol. And this symbol can also be seen at the lower right hand corner of the stage in the drawing of the Maria's interior in Antonia Dickson's article in Frank Leslie's Monthly of February 1895 (Illustration 9). It was also the object of speculation in the Maria photograph of c1905 (Edison negative #2974B), until my own work established its meaning.

[27] For example, the "Imperial Japanese Dancers" in the Image article.

[28] An interesting exception to this rule is in "Fire Rescue" (ibid.). It was apparently thought that an "R" in the lower right hand corner would have obscured important action. In "Fire Rescue" the "R" was placed in the lower left corner, reversed (see Illustration 25).

On April 19 Baucus, who was also a member of the firm of
Henry B. Gayley, Joseph D. Baucus and Matthew C. Fleming,
52 Wall Street, wrote Edison three pages of reasoning why he
believed that Edison had the right, under his contract with the
Edison United Phonograph Company, to use the Kinetoscope
in connection with the phonograph.[29] The Baucus effort was
apparently unsolicited and possibly more of the firm's court-
ship of Edison. Baucus' argument was meant to describe an
escape from Edison's agreement with the Edison United Phono-
graph Company. This was that, although Edison could not
ship Phonographs or Kinetophones abroad, he could neverthe-
less ship "toys." The Baucus argument revolved around the
problem of establishing that the Kinetophone was a toy. But
on August 20, 1895, Edison was enjoined from shipping Kineto-
phones abroad on the ground that they were *not* toys—and
considering their commercial use, this seems proper. "The ki-
netophone," said *The Orange Chronicle* of August 24, "was
acknowledged by both sides to the controversy to have the
same arrangement as the automatic phonograph, which was
admittedly within the terms of the contract."

Maguire and Baucus, long eager to become associated with
Edison, had succeeded in doing so, and remained some months
stormily connected. But when Kinetoscope sales fell off in the
spring of 1895 their business fell off, too. The April 19 letter
seems to have been an effort on their part to become involved
with another part of the Edison affairs—to replace the failing
peep-hole business. But Edison would have none of this, and
it was not until months later that Maguire and Baucus enjoyed
a revived film business. This was during that *mélée* of compe-
tition briefly prevalent in 1896 and 1897, before Edison, with
his August 1897 patent, set about to control the whole industry.
Then such small businessmen as Maguire and Baucus expired,
victims of Edison aggressiveness. But for much of the crucial
early period of the motion picture business in America, they
worked hard to gain a foreign market for the Kinetoscope and
its film. They gained this market, and have thus earned a place
in this record.

[29] "Motion Pictures. 1895."

13 · *The Kinetophone*

FOR YEARS EDISON THOUGHT OF MANY NEW PRODUCTS OF HIS laboratory as being only "improvements" on his phonograph. The motion picture camera was no exception. From the time of the first caveat, the Edison encounter with the motion picture problem was only an urge to improve his beloved phonograph:

> I am experimenting upon an instrument which does for the Eye what the phonograph does for the Ear, which is the recording and reproduction of things in motion, and in such a form as to be both Cheap practical and convenient[2]

For as many years as he claimed such "improvements" on his phonograph Edison also claimed—without having achieved —the *combination* of motion pictures and sound. Such claims were numerous; I referred to them rather fully in *The Edison Motion Picture Myth*. It will suffice to recall only a few here. First, as a typical example, after Edison had talked to Muybridge on February 27, 1888 *The New York World* of June 3, 1888 reported that "This scheme [i.e., the joining of the phonograph with the motion picture camera] met with the approval of Mr. Edison and he intended to perfect it at his leisure." And *The Scientific American* of June 20, 1891 reported that:

> The "kinetograph" is a machine consisting of a clever combination of a photographic camera and the phonograph, by which the words and other sounds of a speech or play are recorded simultaneously with the photographic impression of all of the movements of the speaker or actor.

On the occasion of the Brooklyn Institute showing of May 8, 1893, (which I noted before) the same excesses continued baldly:[3]

[1] See *The Edison Motion Picture Myth*, Chapter 2 and Appendix B.

[2] Bad grammar and the general perfunctoriness of the caveats—usually hastily written to circumscribe the field from others—should be noted. "Which is the recording and reproduction of things in motion" limits "what the phonograph does for the Ear," and this is not true. As George Parsons Lathrop said in *Harper's Weekly* of June 13, 1891, "[the motion picture camera] performs the same service in recording and then reproducing *motion* which the phonograph performs in recording and reproducing *sound*." The difference between *motion* and *sound* is crucial.

[3] *Brooklyn Standard Union*, May 10, 1893.

The kinetograph, Edison's wonderful new invention, by means of which a moving, living scene is brought before the eye, while the ear hears the accompanying sounds, was publicly exhibited for the first time anywhere[4] at the annual meeting of the Department of Physics of the Brooklyn Institute, which took place last evening. The instrument which was exhibited, however, only presented the moving picture without the noises accompanying.

The *Standard Union* reporter thus brings us down to date: up until the Kinetoscope era such a "clever combination of a photographic camera and the phonograph" had not been achieved. But as late as July 21, 1893, it was still being claimed, when *Science* of July 21, 1893 reported:

In this instrument a combination was made . . . so that at the same time that the motions of the moving object were seen, the accompanying sounds were heard . . . It has now been more fully developed and forms a part of the Edison exhibit . . .

On August 17, a laboratory correspondent, confused by these persistent claims, was told that the Kinetoscope *could* be used by itself:[5] the word "must" is more appropriate.

George Hopkins was delighted with the success of his May 9 demonstration at the Brooklyn Institute, and on August 22 he asked permission to demonstrate the Kinetoscope-phonograph combination on January 23, 1894 at the Institute.[6] He was told, as I have noted before, on September 9, 1893 that:

. . . Mr. Edison directs me to inform you that he regrets he cannot undertake to furnish a Kinetograph with Phonograph combined for use at an illustrated lecture which your friend, Prof. Hooper wishes delivered before the Department of Physics of The Brooklyn Institute of Arts and Sciences on Jan 23rd next. Mr. Edison is not yet satisfied with the operation of these instruments in combination, and until certain improvements are effected therein, he would not consent to public exhibition being made of the same.

As we have noted before, although Edison subsequently promised such a demonstration, he withdrew the offer on December 16.[8]

[4] "Public" here, the readers of *The Edison Motion Picture Myth* will remember, as differentiated from the May 20, 1891 exhibition to the delegates of the National Federation of Women's Clubs.

[5] Letter book E1717 8/8/93 - 3/9/94

[6] *Ibid.*

[7] *Ibid.*

[8] *Ibid.* The second Hopkins request was made on December 4.

We have thus Edison's own word that what he had been claiming as an actuality since 1888 or 1889 had still not been achieved in 1894. We also have, in "until certain improvements are effected . . . he would not consent to public exhibition . . . ," a reversal of the claims of the Brooklyn May 9 and the Columbian Exposition press releases.

On November 13 a correspondent was told that,[9] "the Kinetograph was designed for use in connection with the Phonograph, and Mr. Edison is now at work on the latter instrument adapting it for use in combination with the former."

Dickson's remarkable letter of January 3, 1894, enclosing a sketch made on April 26, 1892, contains no mention of a phonograph-viewer combination.[10] In his February 14 letter to Muybridge Edison also had failed to mention such a combination. That such a combination was the *raison d'être* for the Edison-Muybridge meeting in the first place, and that this communication (the first in several years) fails to refer to the matter, is particularly significant.

On April 5 a man in Cincinnati was told that although the Kinetoscopes already "made up" had been disposed of, "another lot is coming through" and there would be "no objection to your working this machine in connection with the phonograph."[11] Which is another indication that the phonograph viewer combination was not available at the West Orange laboratory.

It is interesting to note that another man planned such a combination in his promotion scheme for "The Flams," a musical planned for the Bijou Theatre in New York in the fall of 1894. On June 30, 1894 *The Dramatic Mirror* reported that:

> W.D.Mann, manager [of "The Flams"] . . . has conceived a novel advertising scheme . . . Edison's kinetoscope and phonograph are to be combined in a reproduction of the principal specialities and vocal features of the performance and the instrument will be publicly exhibited in the principal centers prior to the appearance of the play.

Whether or not the combination here describes the same mechanism is a moot question. Perhaps the Kinetoscope and the

9 *Ibid.*

10 This letter has been discussed on pages 128 and 129 of *The Edison Motion Picture Myth.*

11 "Motion Pictures. 1894."

phonograph were merely to be placed side by side—which, in a loose sense, would be a "combination." "The Flams," a musical farce in three acts, opened at the Bijou on November 26, 1894, but a search has revealed no further information about its manager's "novel advertising scheme."

Dickson and his sister made claims for such a combination in their well-known *Century Magazine* article of June 1894, but they seem to be confining such work to experiment. They claimed that "the most scrupulous nicety of adjustment has been achieved, with the resultant effects of realistic life, audibly and visually experienced." On June 16 *The Electrical World*, in the article already referred to, stated the situation as of June 1894 neatly:

> While the kineto-phonograph has not been brought to a sufficiently practical form for public exhibition, as has the kinetoscope, the experiments in the inventor's laboratory have been so successful that it is regarded only as a question of time, by those engaged in the work, when the apparatus will be perfected . . .

Antonia Dickson's *Leslie's Monthly* article of February, 1895 makes a nicer claim:

> The phonograph is now mechanically and electrically linked with a specially constructed camera . . . Thus, when reproduced, the minutiae of expression or gesture will be found to be harmoniously combined with their appropriate gradations of sound even to the delicate inflections of the lips in molding speech or song . . .

But this "delicate inflection of the lips" was not achieved on film for years, until sound-on-film was introduced with the variable-field and electronic eye method.

The November 20 contract between A.O.Tate and Raff and Gammon, drawn by people intimate with all conceivable aspects of the Kinetoscope business and eager to circumscribe all foreseeable areas of commercial value, made no provision for a Kinetoscope-phonograph combination. The Dicksons' booklet, *History of the Kinetograph Kinetoscope and Kineto-Phonograph* later the same year, only repeated the *Century Magazine* matter.[12] November's *Cassier's Magazine* continued the discussion of the motion picture work which had begun in the October issue, but added nothing beyond that with which we

12 See also *The Edison Motion Picture Myth* and *Image,* September 1959.

are already familiar through the *Century* article of June 1894.
Indeed, both the *Cassier's* piece and the Dicksons' *History etc.*
consist largely of reprints of the *Century* article. The *Century*
matter, incidentally, is also rehashed in *The Photographic Times*
of January, 1895.

The fairly well-known film showing Dickson playing the
violin before a large phonograph horn connected with an off-
screen recorder (Illustration 46) was clearly a part of the Dick-
son sound-synchronization experiments at the West Orange
laboratory at this time. This subject was shot in the Black
Maria, and the fact that it contains the familiar "R" of Raff
and Gammon places it not earlier than the fall of 1894 (see
page 79). Since it contains Dickson we can also be sure that
it was shot previously to April 2, 1895, when Dickson left the
laboratory. Efforts to arrive at a closer date have been fruit-
less.[13] But the film appears to belong to the time during which
Kinetophone experiments at the laboratory were close to
resulting in the first marketable machine.

This "first marketable machine" may have entered its gesta-
tion in 36 cents worth of castings bought from Hedges and
Brothers of Newark[14] sometime during the month of February
1895. Letter book E1717 7/31/94 - 7/1/97, the letter book in
which John Randolph entered his accounting matters, has a
charge for this amount to "sundries on Model Combining Pho-
nograph with Kinetoscope during February, 1895." Since the
charge is so small, it is possibly only for carfare. The March
and April charges, $2.79 and $1.95 respectively, stipulate that
very little was being done on the project.[15] A charge on April
4 for one foot of calfskin further supports this notion. Possibly,

13 William Jamison is said to have identified one of the two dancers as
James Duncan and other sources have identified the other as Hermann Fautz,
"a Newman boy." Since Duncan was not at the laboratory after April 5, 1893,
according to laboratory records, neither man is Duncan. The other sources
state that the "Newman boy" was killed on his 21st birthday by a trolley acci-
dent near the laboratory "last Wednesday night", March 28, 1893. But *The
Orange Chronicle* of March 25 establishes that "the Newman boy" was only 4
years old and the New Jersey State Department of Health fails to record
the death of a Hermann Fautz at any time between 1893 and 1899. Nor is any
Fautz in the photograph of what was meant to be all the laboratory workers
opposite page 284 of the Dicksons' book *The Life and Inventions of Edison*.

14 According to the Newark 1895 directory, William H. and Wallace M.
Hedges were brass founders and finishers at 10 Railroad Place.

15 Page 157 of the Randolph letter book cited above.

as Mr. Norman Spieden of the laboratory archives suggests, this was for use in belts for a pulley drive.

It is clear that such simultaneous taking and recording experiments as are shown in the Dickson film were abandoned as fruitless, and it was decided to insert a slightly altered model of the phonograph in the Kinetoscope case, and use sound as non-synchronized *accompaniment to* rather than *illustration of,* action. This consisted in playing dance or band records while a performer was seen in the film, and attaching ear-tubes for listening. Synchronization, even so far as only ensemble was concerned, was abandoned.[16] So far as speech or other non-musical sounds were concerned they were never seriously considered.

February, March and April charges in 1895 indicate that it was only during these months that Kinetophone manufacturing was planned. By March 4 the news in the trade about the new combination was beginning to hurt Kinetoscope sales: customers wanted to wait for the combination machine. As Raff and Gammon said to Gilmore on that date:[17] "[We must talk about the] large number of films which are going abroad . . . as well as the combination of the Kinetoscope with the Phonograph."

On March 16, 1895 *The Orange Chronicle* announced that:

> Within a short time the public will have another novelty shown them from the fertile brain of Thomas A. Edison and his gifted lieutenant, William K.L. Dickson . . . It is the connection of the kinetoscope with the phonograph in such a way that the two will work synchronously and the vocal expression exactly keep pace and follow the visual expressions . . . The apparatus bears little external difference from the kinetoscope, the only change being the protrusion from the top of the well-known rubber ear tubes of the phonograph. The synchronization . . . is attained . . . by a belt from one [of the instruments] to the other . . . With the new combination . . . the range of subjects is largely increased . . . It will for instance be possible to take a reproduction of an entire opera . . .

16 It was abandoned until 1908 when the Edison rigid shaft system of synchronization was conceived. By this system the phonograph was directly connected with the projector by, 1, a metal rod through the floor of the projection room, 2, another *the length of the theatre,* and 3, another to a phonograph behind the screen! This was issued as U.S. #1182897.

17 Volume 3 of the Baker Library collection.

This is familiar exaggeration, but is specific information (and the first publication thereof that I have found) on the slightness of the difference between the Kinetophone and the Kinetoscope.

This slightness is underlined by the fact that on April 11 Peter Bacigalupi, the San Francisco Kinetoscope parlor man, ordered "1 Phonograph attachment Kinetoscope, Complete with instructions for setting up 55.00 . . ."[18] The close resemblance of the Kinetophone to the Kinetoscope is immediately obvious in the illustrations in this book. As *The Photographic Times* of June 1895 reported, "The new machine resembles the kinetoscope closely."

The Bacigalupi order is the first such that I have found. An entry in the William Pelzer notebook (see page 60) records that the "first" Kinetophone was shipped to Raff and Gammon on April 15 and this may well have been the Bacigalupi Kinetophone. The Bacigalupi instrument may be the Kinetophone at the end of the row in the illustration of the Bacigalupi parlor (Illustration 41).

A discussion of the phonographs manufactured for use in the Kinetoscope may be found in Chapter 2. Certain litigation concerning the Kinetophone at this time has already been discussed in Chapter 12.

The next Kinetophone shipment I have found was to Richardson, an exhibitor in Austin, Texas, who was charged $400 on April 23 for a machine.[19] We may thus assume that the Kinetoscope price of $250 plus the "phonograph attachment" sold to Bacigalupi was upped $95 for the work done by the laboratory in setting up the device. Another invoice for two Kinetophones on April 25 was made out for 825 Market Street, Wilmington, Delaware, for a parlor which opened there on May 18. Two more were at the Atlanta, Georgia, parlor as of June 17, and at least one was at the Haunted Swing in Asbury Park, New Jersey, as of June 21.[20]

Phonograph records for the Kinetophone were regularly supplied. "Linger Longer Lucy" and "Pomona Waltz" were sent to the parlor at 243 Broadway on April 30; "Continental March" and "Irish Reel" were sent to the same place on an indeter-

18 Baker Library collection.
19 *Ibid.*
20 *Ibid.*, and *Asbury Park Journal,* June 21, 1895.

minate date; records apparently for a Kinetophone were sent to Tally at 278 South Main Street, Los Angeles on May 3;[21] more records were sent to Atlanta on May 4; more were sent to Little Rock, Arkansas to accompany the film "Fairies Dance" on May 6; "Jolly Darkies," "Vienna Beauties [?] Waltz," "Sleigh[?] Bells [?] Galop" and "Sawdust and Spangles" were sent to an unidentified customer on May 21; and additional records were sent to Olympia, Washington on June 19.[22]

We also know that only certain film subjects were favorites for record accompaniment in the Kinetophone. These included "Carnival Dance," "A Milk White Flag," and "Buck and Wing Dance" besides those referred to above.[23]

Only 45 Kinetophones were made and sold,[24] and, like Kinetoscopes, are correspondingly rare. Over a thousand Kinetoscopes were made and I know of only 6 in existence; of the forty-five Kinetophones made I know of only one, the subject of Illustrations 49 and 50.

In 1913, after many years of claims for synchronous photography and reproduction, the Edison laboratory publicly demonstrated sound pictures. But this was many years after the Kinetophone had disappeared from the market, and under patents other than Edison's. The Kinetophone's claim for distinction was that of compactness: the picture and the accompaniment were in the same box. The Kinetophone was thus an aesthetic as well as a technical advance in the history of the motion picture.

[21] This is the Tally who has often been credited with the first projection in Los Angeles. He was a travelling exhibitor.

[22] All these items are from the Baker Library collection invoice book.

[23] Items in *The Sunday Morning Star* of Wilmington, Delaware, May 26 and June 2, 1895 describe these.

[24] According to the testimony of James H. White in Equity 6928. This figure is supported by the private legal file referred to in note 25 of Chapter 7. This file may have been the basis for the White testimony.

14 · The Final Year of Glory

WITH THE BEGINNING OF THE NEW YEAR THE PROBLEM OF DETE-
riorating negatives had to be faced at once. Hundreds of prints,
in some cases, had been made from one negative, and processing
equipment did not allow the making of a new negative from
the old, or a new negative from a print. Thus a new, similar
subject had to be made when an old one wore out. A Galveston
customer was wired on December 29,[1] "Your film shipped except
Blacksmith negative broken cant get more," and on the same
day Thomas Lombard and was told that this same negative
had been "destroyed."[2]

Along with these communications may be set the following
note from Dickson to Raff and Gammon on January 8:[3]

> I beg to advise you of the necessity of throwing out certain
> negatives from your list—which you must have taken again
> immediately if you wish to keep the names on the list—
> We have had for the past several months much trouble
> with our *new punches* & whenever we used them the per-
> forations *"just missed* it" it wouldn't be so bad if the posi-
> tives suffered but the negatives of 2 of yr. best are n.g. So
> hasten to inform hoping to be on time . . . Now for the
> subjects to cut out of the list:—
> Kessell—Whirlwind gun spinning
> Rats & Terriers
> John R. Abell—Fancy Club [Swinger]
> L Bloom—The Tramp—Milk White Flag
> Miss Isabelle Coe—Widder
> Miss Rosa Oriental Dance
> Salem Nassar and Najid [?]—Sword Combat
> The last two are thrown out owing to faulty punches &
> as they are so good they should be taken again altho' the
> swords go too quick for the Kinetograph.

Considering the fact that many other subjects had been
taken, it is too much to beleve that another December 29 wire

1 Baker Library Collection.
2 *Ibid.*
3 *Ibid.*

from Raff and Gammon to the Edison Manufacturing Company was only coincidence: [4] "We will return to you both the 'Tramp' and the 'Widow' as neither of these are worth keeping." The "Tramp" and the "Widow" are on Dickson's list as being faulty because of the "new punch." I think we can assume from the language that Raff and Gammon use here that they were also photographically poor. They have not, indeed, endured. This is a sure sign that many prints were not made—itself an indication that customers did not particularly like them.

The suggestion in Dickson's letter is not of wearing out from use, but of inexact registration in the printer. Although the building of a camera is the most important step in motion picture production, a processing plant also needs much care and skill, and is often the difference between success and failure in the motion picture business. (Surely the excellence of the American Mutoscope Company's processing apparatus played an important part in the success of that company—see my *Beginnings of the Biograph.*)

A notation in a catalogue of uncertain date, of later this year,[5] has to say of "New Barbershop" that "The old negative having worn out, we have had a new one taken which is superior to the old one." This seems to agree with the "destruction" of 50% of the negatives described by Raff and Gammon in a February 18 letter to Maguire and Baucus and apparently attributed by them to poor registration in the printer:[6]

> Replying to yours of the 16th, inst., we have to say that it was not our intention to state in our letter to you that 50% of the *amount* paid you on account of Films suggested, was lost by reason of the breakage of Films, but rather that 50% of the number of Film subjects which we thus purchased an interest in, had been destroyed, according to the statement received from the Laboratory . . .
>
> It seems now, that some of the negatives which were reported destroyed are still available for making Films, and we are expecting an accurate and positive statement from the factory on this subject . . .
>
> If you will kindly refer again to our letter, you will find also that we did not charge the destruction of the nega-

4 *Ibid.*

5 This catalogue is reproduced by Ramsaye on his page 838, and there dated, with the author's remarkable assurance, October 1894. But it contains subjects we know were shot as late as the following May—for example, the Barnum and Bailey subjects.

6 Baker Library collection.

tives to the fact that you have ordered an excessive number of Films from the same, but we merely suggested this point with a view to ascertain whether that could account in any degree for the fact of breakage.

We have since been informed by Mr. Gilmore that the constant use of negatives increases the chance of destroying their usefulness, principally because of the edges wearing out by frequent running over on the large cylinders . . .

As I have shown, Kinetoscope production declined sharply soon after the first of the year. But work on processing apparatus took some attention. Work on a cutter, a punch and a printer continued through the first months of the year, according to John Ott's Precision Room notebook. The Kinetograph was repaired on March 22, but the punch proposed by Dickson in the following January 24 letter appears never to have been made. We can assume this, I believe, because no markings as are here described are visible in any known 1895 film subjects: [7]

> I have puzzled my cranium how to *re*mark film—& can not get there just yet—Yr plan of punching out wd be OK, but it will give perhaps a too decided white flash, & this wd have to be done at every 3d picture for 10 say so as to avoid the possibility of *cutting out* & rejoining
> R & G—o
> M.B—* or visa verso.
> I wd suggest yr doing this yrselves on receipt of goods punch out before delivering to yr parties M B doing ditto . . . Indel. ink stamp wd be the next only thing.

The problem here seems to be the need to keep Raff and Gammon films separate from those of Maguire and Baucus, in the minds of customers who want additional prints.

We have seen before how the Maguire and Baucus productions were marked within the subject itself by "MB" in monograph, and how the Raff and Gammon subjects were marked with an "R". An additional differentiation was now wanted. This was apparently for the reason that on some occasions these symbols were not used—as indeed they were not.[8] Maguire and Baucus, Raff and Gammon, and the customers of both wanted an easier way of identification. Trying to see the identifying symbol in the subject itself was often difficult, and since it was on an extreme edge, poor registration in the printer

[7] *Ibid.*

[8] For example, this symbol is not visible in the "New Barroom Scene" of the *Photographic Times* January, 1895 article.

often left it out entirely in many frames.[9] Furthermore, an identifying punch at the head of a subject would enable identification without the necessity of unrolling the film.

This identification would be useful also in reordering favorite films—particularly, as was often the case, when both Raff and Gammon and Maguire and Baucus produced nearly identical or similar subjects.[10] It would also be useful when subjects were produced in which it was thought that the presence of such a symbol would be deleterious to the effect. It is easy, for example, to make out a case for dispensing with the "R" in the "Dentist Scene (see Illustration 26)."[11] That the punch or indelible ink mark suggested by Dickson was not thought satisfactory is indicated, as I have pointed out, by the fact that no such holes appear in any known subjects of this time, and by the fact that the Maguire and Baucus symbol and "R" and "C" were used after this.

In February, Antonia Dickson's article appeared in *Leslie's Monthly*. I have already noted this, but a few items in this piece are worthy of setting down in this context. Miss Dickson errs in saying that the shutter of the camera "opens" and "closes." This is not true in the commonly accepted meaning of "open" and "close." The rapidly whirling aperture *passes* the film gate, but to ascribe an "opening" and a "closing" to it suggests a mechanical facility far ahead of science. She also repeats the matter of the "four parobolic [sic] manganese" lamps or "twenty arc lamps, supplied with powerful reflectors, representing a total of fifty thousand candle power." The use of artificial light in Maria shooting, either solely or as supplement to the sun, has yet to be established. Miss Dickson also speaks of projection, and on page 249 entitles a subject we know was actually the "Fairies Dance," as "The Gaiety Girls

[9] The reduction of the Billy Edwards film from 35 mm to 16 mm by the George Eastman House eliminated the "MB" in that film, and led me to improperly identify that film as a Glenroy Brothers subject in *Image* of September 1959.

[10] "Annabelle" is a case in point. Many "Annabelles" and "serpentines" were made in these months, and they were often scarcely distinguishable—even to their producers. The spring-of-1895 "Annabelles" are typical of this confusion.

[11] Which I place very late in 1894 or early in 1895. The reader may see additional frames of this subject reproduced opposite page 33 of F.A.Talbot, *Moving Pictures/How They are Made and Worked,* published by Heineman in London and Lippincott in Philadelphia in 1914. Talbot dates this subject, in his journalistic manner, "about 1891."

Dancing." The whole article is a demonstration that much of
the "literary" quality of the joint Antonia-W.K.L. efforts may
be attributable to Antonia, who grossly overwrites.

On February 5, Edison wrote a letter to Raff which shows
his rising pique with Dickson, his short-temper, his pseudo-
modesty, and his false claims: [12]

> I object to the little book gotten out by Dickson. The
> part about Dickson being a co-inventor in the Magnetic
> Separator etc, is incorrect, as there is no co-inventor in the
> Ogden business with Dickson or anybody else.[13] I have
> given Dickson full credit for his labours in my manuscript
> letter, and I object to lugging in outside things in a Kineto-
> scope book. Mr.Dickson will get full credit for what he has
> done without trying to ram it down peoples' throats, I
> have seen him and he will see you. I am not especially
> stuck on having my own photograph in the book. It looks
> too much like conceitedness and self-glorification on my
> part, and the public never takes kindly to a man who is
> always pushing his personality forward. Its the thing they
> want to know about and not the man for whom they do
> not care a D—— . . . Please say what you will do.

Gilmore shared this animosity toward Dickson, and on
February 28, Raff and Gammon found it necessary to reassure
him:[14]

> We have your favor of the 27th. instant, and see that you
> are laboring under a misapprehension of the facts. We
> have already given you assurance that we have no desire
> to, nor will we, have any dealings respecting the Kineto-
> scope and supplies for the same, with any of your employees.
> On the contrary, we wish to deal directly with you and Mr.
> Edison, and you may rest assured that we have not, and
> will not consciously, take any action or enter into any
> agreements whatever which may be inconsistent with this
> expression of our intention.
> The matter that you refer to, is of little or no conse-
> quence when the facts are explained. Mr. Dickson hap-
> pened to be in our office while on one of his trips to the
> City, and in the midst of a general conversation, [hap-
> pened] to mention that you were about to duplicate some
> of the old original subjects which had worn out or become
> useless. He stated that there would be a few dollars ex-
> pense in any instance in connection with the persons en-

[12] Letter book E1717 4/13/94 - 8/27/95
[13] I discuss this claim in *The Edison Motion Picture Myth.* Dickson had
considerably more to do with invention in "the Ogden business" than Edison
himself.
[14] Baker Library collection.

gaged in the scene and the properties necessary to make an attractive subject, and he remarked that he presumed it was understood that we were to pay these expenses. We stated that we expected to pay them, and this was the sum and substance of all that was said at the time, and we have had *no other talks or communications with Mr. Dickson on the subject.* It was by no means our intention to enter into any agreements with Mr. Dickson; nor even to arrange anything with him in connection with these subjects. We merely replied to the questions which he asked, and when your letter was received, referring, we supposed, to the matter of duplicating old subjects and the expense attached thereto, we merely stated in our answer that the matter had been brought up by Mr. Dickson, and that we expected to pay the expenses, or words to that effect. This is all there is in the whole matter, and the way in which the matter came up, was so informal and casual that we do not see how we could have well said less than we did, and it was certainly far from our mind to interfere with the regular course of our business with you or to enter into any agreements with your employees.

You can go right ahead on the duplication of these old subjects and charge the expenses up to us. If you have time to do so, you might advise us when the subjects are going to be taken, and we may have a representative on the ground. In any event, go right ahead whether we send a man over or not, as we know that you will do everything that can be done to make an attractive subject.

We trust you will understand that from now on, that we have no desire or intention or making any arrangements or having any agreements except with Mr. Edison and yourself, and should anything occur which should apparently contradict this, you will find after investigating the facts, that we have kept good faith and have done nothing intentionally inconsistent with what we have stated to be our desire and intention.

On February 14 Raff and Gammon wrote Benson that they could not declare dividends because, among other reasons, they had paid Edison $20,000 since the first of January. At the close of business on March 15, 1895 the assets of the Kinetoscope Company totalled $31,379.37. Against this there was balanced a "Dividend #1" for $5,000, a $25,794.31 gross profit on Kinetoscopes, $2870.91 on films, and $602.40 on batteries. Operating expenses to date had been $7283.37 and bills payable $6305.87. Stock on hand—Kinetoscopes, batteries, etc.—was valued at $8089.25.[15] The stockholders were told on March 20 that: "Our

15 *Ibid.*

business at this time is rather quiet, but we have considerable confidence in the Spring and Summer trade . . ." We will see that this confidence (if it actually existed) was misplaced, although Tate had been told several days earlier that "our business is picking up nicely, and last week we sold 17 machines."[16] On April 22 Tate was told that a $4,000 cash profit was expected.[17]

On April 29 Raff and Gammon wrote Benson that:[18]

> . . . if there is anything in indications . . . we are encouraged more and more every day to believe that we will be able to secure about all the concessions we intend to ask for [from Edison], and that our business will go forward after May 1st under much [more] favorable conditions and auspices than we have enjoyed heretofore . . .

The same letter included matter about the "screen machine" of the "Latham crowd" and its possible competition. One of the concessions asked from Edison was a reduction in the price of the Kinetoscope to $125.[19]

In May Raff wrote Lombard that "It is very likely that we will get machines hereafter for about 130.00 each . . . we hope . . . before the week is over. We need it because we have made but few sales during the past 90 days."[20] On May 14 Raff wrote Colonel James August (who had loaned Gammon $7940 to go into the Kinetoscope business in the first place) that "Our business, of course, has been quite small since the first of January [but] we are confident of making a very handsome showing at the end of the season."[21] The final new price for Kinetoscopes was settled upon by May 11: it was declared that the machine would be sold to Raff and Gammon for $127.50, who were not to resell it at more than $250, or $225 each in lots of 4.[22]

Throughout these months there was some activity in processing experiments at the laboratory in addition to somewhat perfunctory projection efforts. For example, beside the camera

16 *Ibid.*
17 *Ibid.*
18 *Ibid.*
19 *Ibid.* The Latham "screen machine" will be described in a later monograph.
20 *Ibid.*
21 *Ibid.* It must not be assumed that this letter was designed to mollify a disgruntled creditor. Gammon was punctilious about this debt and settled it neatly a few months later.
22 *Ibid.*

work referred to in connection with the shooting of "The Execution of Mary, Queen of Scots" (see page 137), a printing machine for a three-quarter-inch-wide film was made.[23] This apparatus may have been adjunct to the "Universal Machine for Taking and Projecting on Screen".[24]

A voice from abroad at this time shows how men over the world were getting into the motion picture business. On March 29 Robert W. Paul wrote Edison from London (see Illustration 44). This letter, like the Friese-Greene letters referred to in *The Edison Motion Picture Myth*, shed significant light on the early work of another English pioneer:[25]

> Dear Sir
> I have taken some interest in your Kinetoscopes here, and have found that a demand existed for a greater variety of subjects that [sic] at present available. I have therefore commenced to manufacture films representing recent scenes and events here, and shall be pleased to hear from you if you think that our mutual interests would be served by an exchange of films.
> I enclose for your inspection a small piece of the first film which I have made, thinking it might interest you, although I expect to attain even better results with a little practice.
> In case you decide to entertain this proposition, I shall be pleased to co-operate with you in stopping sundry attempts now being made here to copy your films—which, I take it, is an offence against the International Copyright Act.
>
> I am Dear Sir,
> Yours faithfully,
> [signed] ROBT. W. PAUL

The phrase "I have taken some interest in your Kinetoscopes" may be said to be an understatement. Paul had been manufacturing Kinetoscopes for some time when he wrote this letter and Edison's rejoinder on April 16 would have been less mild had he known this:[26]

> [I] have examined the sample of film you sent me . . . The original subjects, from which strips are made here, are

[23] Letter book E1717 7/31/94 - 7/1/97

[24] In addition to this "Universal Machine," an entry in the Precision Room book speaks of "Fitting up hand kineto for Hise [sic]." I assume a camera and not a Kinetoscope is meant here, since a hand Kinetoscope makes no sense whatever.

[25] Letter book E1717 4/13/94 - 8/27/95.

[26] *Ibid.*

> taken for account of other parties, who bear all expenses in connection therewith. I am not therefore in a position to make any such arrangement direct . . .

The film that Paul enclosed is extremely interesting (see Illustration 42). The sprocket holes are of the same size and location as those on the Edison film. This subject has been called the "first Kinetoscope film made in England." It is extraordinary that on the same day that Paul wrote Edison, March 29, Birt Acres was said (by Paul in a letter of July 23, 1924 to Ramsage) to have made *his* contract with Paul. A fuller treatment of this matter and its ramifications for the whole motion picture world is beyond the scope of this work. The projection efforts of both these men did, however, influence the American scene in 1896. This influence will be discussed in a later monograph.

On April 2, according to his testimony in Equity 5/167, Dickson resigned from the laboratory. Although Raff and Gammon must have known this immediately (as they must also have seen it coming) they were not "officially" notified by Dickson until April 26. They wrote him three days later as follows: [27]

> . . . We note your change of address after Monday the 20th, and also that you have resigned your position at the Edison Works.
> We certainly wish you every success and trust that your with-drawal from the Laboratory may not interfere with the work of making films and taking new subjects, as that would be very unfortunate for those of us who are in the Kinetoscope busines . . .

The Kinetoscope Company was eager to remain on the good side of Dickson, even though they must not let their Gilmore hand know what their Dickson hand was doing. More, they knew of Dickson's contact with the Lathams.

* * * *

Meanwhile, and since the year's beginning, various motion picture subjects were under way. When Raff and Gammon offered "New Barbershop" in a later catalogue and said that the old negative had worn out and that they were having a

[27] *Ibid.*

new one taken, they were describing a production of this January 17. On that day Dickson reported that "The Barbershop came off this a m Mr. Madden[28] brot out Party all went off OK."

A letter of January 21 suggests that the "Dentist Scene," heretofore placed either very late in 1894 or early this year, may have been shot shortly before January 21. Dickson wrote "Dentist is OK & sent down *new* Barber shop splendid goes down tomorrow . . ."[29] On the same day, Duncan C. Ross, "the well-known horse back broadsword athlete" was photographed:[30]

> Duncan C. Ross, the well-known horse back broadsword athlete, came out to Orange on Wednesday and appeared before the Edison kinetograph. He gave a fine exhibition of his abilities and used three fine saddle horses with military equipments sent for his use by Richard Coyne, of East Orange.

(On April 27 these "fine saddle horses" were apparently still at the laboratory and Gilmore was complaining.)[31] This Ross subject was the one later called "Gladiatorial Combat" in a Maguire and Baucus catalogue of April 1897 in the Museum of Modern Art Library. A list of films sent to Atlanta for the Cotton States Exposition in September of this year, and a list of films in the Museo di Storia delle Scienze in Florence, indicate that there were five rounds in this "Gladiatorial Combat."[32]

A list of April 18 suggests that only three subjects in addition to the new barber shop film, a new barroom scene, various Annabelle subjects and a subject of Guyer (called a "grotesque tumbler" in the Maguire and Baucus April 1897 catalogue), had been taken from the first of the year to that date:[33]

28 Billy Madden was, among other things, press agent for Buffalo Bill's Wild West Show. He brought out subjects for photography, and is visible at the ringside in the Billy Edwards film (see *Image, loc.cit.*) and at the fence in "Bucking Bronchos" (see Illustration 25).

29 The January 17 and 21 quotations are from the Baker Library collection. A catalogue said that the film showed "Dr. Colton, who first used gas for extracting teeth."

30 *Orange Chronicle*, January 26, 1895.

31 Baker Library collection.

32 The Atlanta list is in the Baker Library collection; the Florence list is in a Kinetoscope construction and publicity booklet.

33 Baker Library collection.

Apr. 18th, 1895.

STATEMENT

COST OF FILM SUBJECTS FROM
JAN.25th, TO DATE/.
LIST OF SUBJECTS TAKEN.

New Barber Shop
New Blacksmith Shop
New Barroom Scene
Dental Scene
Capt. Ross, Five Rounds
Guyer

Amount paid Edison in connection with above	– – – $11.25
" " Capt. Ross	– – – 125.00
" " Madden for services	– – – 65.50
Sundry small expenses	– – – 3.10
Cost of Annabelle Negatives	– – – 12.90

217.73

One-half of the above 108.86

The dates given for "Captain Ross," the "Dentist Scene" and the "New Barber Shop" are apparently incorrect: we have seen how these subjects were in existence by January 23. It is of course possible that the date here is only the *payment* date. But we know of the "New Barroom Scene," for example, that that subject was shot before the first of the year, since it was reproduced in the January issue of *The Photographic Times,* which had an editorial deadline of December 15.[34] We also know from a Raff and Gammon invoice that the Guyer subject was in existence by February 12.[35] The Annabelle subjects are still much confused and must wait further analysis.

In January or February two subjects of the boxer Billy Edwards were made and another cock fight. In March another "Scotch Dance" (another than the one in the first group of films sent to the 1155 Broadway parlor) was made (see Illustration 27). This one was of a company of dancers from "Rob Roy," a popular musical of the time. In April three scenes from the fantastically successful Du Maurier drama "Trilby" were shot. And at some time during these months three dances

34 This issue of the magazine specifically states that the deadline for the January issue was December 15, 1894.
35 Baker Library collection.

by James Grundy from "The South Before the War" were shot: a buck and wing, a cake walk and a breakdown. A wrestling match between the wrestlers Pettit and Kessler was also taken.[36]

On April 27 *The Orange Chronicle* announced the visit of the Barnum and Bailey circus to Orange. A street parade began at nine in the morning.[37] After the parade and before the matinee—at about noon—the following subjects were apparently shot:[38] "Dance of Rejoicing (Samoan Islanders) "; "Hindoostan Fakir and Cotta Dwarf"; "Paddle Dance"; "Short Stick Dance"; "Silver Dance"; two subjects depicting feats of strength by "Professor Attila"; feats of strength by "Young Weimer"; and an oriental dance by a dancer possibly named "Princess Ali."[39] My print of "Princess Ali" has a letter "C" on a small board at the front of the Maria stage (see Illustration 28); "Rob Roy" also had a letter "C". This may be an indication that these subjects were shot for the Maguire and Baucus foreign actuary, the Continental Commerce Company (see page 112).

On August 28[40] "The Execution of Mary Queen of Scots" was taken under the management of Alfred Clark[41] (see Illustration 31). It was not shot immediately outside the Black Maria as has been said,[42] but at an undetermined location in the West Orange environs.

[36] The reasons for dating these subjects as above are very complex. Some of the dates are specifically ascertainable from the Baker Library collection, but many are the result of considerations beyond the scope of this work.

[37] *East Orange Gazette,* May 2, 1895.

[38] This list is taken from various catalogues, invoices, and other sources.

[39] A subject by this title appeared for the first time in an invoice of May 14. It must not be confused with "Dolorita", a subject produced some time afterward. I assume this because the musicians accompanying Princess Ali are standing, whereas, according to an Edison catalogue of July 1901, Dolorita's musicians are seated. The dancer of "Princess Ali," incidentally, is shown in a photograph of a Barnum and Bailey group of performers in *Leslie's Weekly* of April 17, 1894.

[40] I deduce August 28 from a study of the weather reports of the time: Clark was waiting for the first clear day to do his shooting.

[41] The first note of Alfred Clark that I have seen was taken on January 2, 1895, when a Raff and Gammon letter refers to "Our Mr. Clark." A January 19 memorandum, also in the Baker Library collection, states that Clark took a steamer to Boston on company business. Clark's own account of his relations with Raff and Gammon is, like those of many other pioneers, tedious and confused. He cannot decide, for example, when he began to work for the Edison forces. He wrote these accounts chiefly for Edison Pioneers' investigators, and they are in the West Orange archives.

[42] It was said to have been shot in the Black Maria "yard" by whomever wrote the program notes attending this subject for the Film Library of the Museum of Modern Art.

"The Execution of Mary, Queen of Scots" is remarkable for several reasons. *First*, it contains the earliest example we know of "stop motion" in the motion picture. This was possibly the idea of Clark,[43] and this in spite of many claims for George Méliés, who did not touch a motion picture camera until months later.[44] The part of Mary was played by R.L. Thomae, secretary and treasurer of the Kinetoscope Company. Thomae places his head on the block, the camera is stopped, a dummy substituted, the camera started again, and the head of the dummy chopped off.

A *second* claim to fame for this subject is the fact that it appears that it may have been shot with a new, more portable camera than the one in the Black Maria. The locale, as I have said, was not just outside the Maria, but at some place far enough away from the laboratory to contain no sign of any laboratory building. A Clark letter of September 26, 1895[45] quotes Heise as saying that a new subject then being planned would be taken "in front of the high fence as heretofore," since "it would take too much time to move the kinetograph." Since the "Execution" was *not* shot in front of a fence it is possible that the camera was then, as later, thought to be too big to move, and another camera necessary. That another camera had been built—or was at least being built—is indicated by other records.[46] The film itself, moreover, shows at its right side, a black border inexplicable in any other way than that it occurred in the original taking; and no Maria subject before or since shows this border (see Illustration 31). "The Execution of Mary, Queen of Scots" was not the only "location"

[43] It was so claimed for him in a Chester Merrill Worthington article of May 1938 in *The Journal of the Society of Motion Picture Engineers*. Clark also must have claimed it for himself, for his wife once said to me "He invented that, you know", or something similar.

[44] This claim was implied by Bardeche and Brasillach in their *The History of Motion Pictures* (W.W.Norton & Co. and the Museum of Modern Art, New York, 1938). I also heard this claim made by the granddaughter of Méliés in a lecture in the Donnell Library in New York City on May 21, 1962. It has been supported by many who are fascinated with the idea of an omnibus changing into a hearse in the middle of the Place de l'Opera.

[45] *Journal of the Society of Motion Picture Engineers, loc.cit.*

[46] Projection efforts at the Edison laboratory included a combination taking-projection machine, and there will be discussed in a later work. Furthermore, a separate camera was apparently under way on March 18: a charge for "Making Duplicate Kinetograph" was entered in the Precision Room notebook on that date. And on March 22 a charge was made in the same notebook for "Repairing Kinetograph for Mr. Heise." (See Illustration 27.)

subject in these months, but it is the only one that has come down to us (see below).

Third, through the assiduity of Chester Merrill Worthington and the kindness of Mr. Clark, we have a photostat of a remarkable letter by Mr. Clark written on August 24, 1895: [47]

Voegeler
222 E. Houston St. City.

Dear Sir

As per your estimate given me on the 21st int you will please have. sent to me—addressed as follows
Alfred C. Clark
c/o Edison Laboratory
Orange. N.J.

the Costumes as below
Mary Queen of Scots
Headsman and Assistant
2 Noblemen of that period
6 Jackets & Armours & Shoes and 12 Helmets
2 Joan of Arc (white) one to be burned up
3 Peasants costumes 2 women & [?]
2 Priests and 1 Bishop

You are to send a man with them to dress the people.

You are to furnish also 2 dummies (straw) without heads—one of which will be returned to you and the other destroyed.

A large axe
and the Cross you showed me

The things are to be used on Wednesday morning Aug. 28th and will have to leave your store Tuesday morning early. Your man will go out Wednesday morning on the 8.10 train from the foot of Barclay St. He gets off at *Orange* Station and takes the trolley car to the laboratory [change in original] Any one out there will tell him the way.

As I understand it you will pack the costumes and properties in trunks so they will arrive safely and on their arrival will be placed in the care of your man.

As we also agreed—if Wednesday morning is a cloudy or stormy day you will let the costumes stay until the next *clear* morning, and do not send your man over if it is cloudy Wednesday, but wait until the next clear day as we will have no use for him

Yours truly
ALFRED E. [sic] CLARK

[47] This photostat is in the library of the Museum of Modern Art, New York. I have been denied access to the letter book itself by Mr. Clark's widow under circumstances which lead me to think that the original is no longer in existence.

Fourth, it was "The Execution of Mary, Queen of Scots" that Jean LeRoy claimed to have projected on June 6, 1894, more than a year before it was made! This claim was made some years later and has been cited many times as authority for LeRoy's pioneering.

In addition to the "Execution" we can assume that the "Joan of Arc" mentioned in a Raff and Gammon invoice of October 16 is the one for which Clark was ordering his costumes in the above letter. Four other subjects, "Indian Scalping Scene," "A Frontier Scene," "Duel between Two Historical Characters," and "Rescue of Capt. John Smith by Pocahontas," were described in Clark's letter book as having been "taken in a forest." The September 26, 1895 letter of Clark to Gilmore denies this,[48] but I have shown that "The Execution of Mary, Queen of Scots" was itself shot at some distance from the laboratory:

> I suggested that the scenes would look much better if they could be taken where there were some trees and shrubbery—where the men in the lynching scene could be strung up from a real tree. Mr. Heist [sic] thought it would take too much time to move the kinetograph, so we decided to take this in front of a high fence as heretofore.

In addition to these subjects Clark soon produced two films of the Leigh Sisters—an umbrella dance and an acrobatic dance, and a subject showing Lola Yberri in Spanish dances.[49] There is, incidentally, a possibility that Clark may have been an exhibitor. An invoice of November 16, 1895 in the Baker Library collection suggests this. And his address at that time was a good spot for a Kinetoscope exhibition: 39 Cortlandt Street, a very short distance up an arterial street carrying much of Manhattan's traffic from New Jersey.

But by this time the vaudeville-turn motion picture business was beginning to pall on the Ammerican public, and subjects of topical interest, such as the proposed Corbett-Fitzsimmons fight in Dallas on October 31, were eagerly sought by Raff and Gammon. They had tried for the privilege of taking this fight on August 19. On that date, they wrote Edison a letter both poignant and despairing—poignant because we know that by

[48] In the Edison Pioneers files in the West Orange archives.

[49] These subjects are listed on page 87 of Clark's letter book. A photostat of this page is in the library of the Museum of Modern Art.

September 12 Edison was already making the Corbett-Fitzsimmons cameras for Rector: [50]

> We beg leave to submit herewith our application to have the Corbett-Fitzsimmons contest, to occur at Dallas, Texas, in October, taken for us, in co-operation with you . . .
>
> We respectfully urge the following reasons in support of our application and our claim for preference: —
>
> 1. During our original negotiations with you, the men who afterwards controlled the Corbett-Courtney fight had not secured any rights and we presumed no machines were to be sold them or others pending our deal. We have understood since that they were to be limited to that fight and the one taken for them prior to that time, although, please understand us, we have no complaint to make against yourself.
>
> 2. —These parties have been in this business solely as exhibitors and only for their own profit and advantage, without any particular regard for your interests. That they did not hesitate to sacrifice you for their own ends, was abundantly proven when they laid their plans to make machines of their own and succeeded in discovering the method of making films, a process which we have all zealously guarded. They have not only brought out a so-called Screen Machine but they are now manufacturing an imitation Kinetoscope, as well as films, which they are offering to the public. On the contrary, we are not only exhibitors (having taken out a large number of machines for this purpose), but we are Sellers (which is of vastly more importance) and we have at all times, and are now, working directly for your interest . . .
>
> 3. It is true that the parties who now control the prize-fight machines, are not the same as the original parties, but the fact remains that they are *only exhibitors* and therefore have no incentive to advance any one's interest but their own, nor do they care for the future of the Kinetoscope . . .
>
> We have it from what we consider a reliable source that the Latham people are more or less interested in all movements thus far, except our own, to secure the Dallas fight, although we cannot vouch for the statement from personal knowledge.
>
> You will pardon us for recalling the fact, that at the time when the Latham people were seeking capital to establish their business of making Kinetoscopes, screen machines, films, etc., they would have induced the co-operation of the biggest amusement firm in America (viz: Jefferson, Klaw and Erlanger) and secured ample capital,

[50] On that date, according to letter book E1717 7/31/94 - 7/1/97, "8 lbs casting used in the four prize fight machines" were charged to the Kinetoscope account.

had we not discovered the scheme and stepped in to protect you and the business

We side-tracked this plan and induced Jefferson, Klaw and Erlanger to reserve their influence and capital with a view to joining us in some capacity, and making you a proposition with reference to your screen machine, when ready. Had it not been for this prompt action, there is no telling what the Latham people might not have accomplished and thus greatly injured you and us. If you now grant our application in re the Corbett-Fitzsimmons contest, you will not only be favoring us, but will also benefit the above mentioned firm, inasmuch as they claim to be able to control the taking of the Dallas fight by the Kinetograph, and we would co-operate with them in case you decide in our favor . . .

The result of an arrangement with us would be that, while you would be doing at least as well for yourself as under an agreement with others, and would be secure in whatever may accrue to you, the men who are really pushing the business of Kinetoscope sales will be benefitted and profited, and this again must surely redound to your benefit and increase the prestige of the general business.

All of which is most respectfully submitted with request for a reply at your earliest convenience.

Very truly yours,
[signed] RAFF AND GAMMON

By fall business had deteriorated to the point where only 17 Kinetoscopes were made in September, 2 in October, 9 in November, and 2 in December.[51] Raff and Gammon had been thinking about going into another business for some time, and now they were giving it additional thought.[52] They were also trying to sell the Kinetoscope business, and were guilty of the usual colossal exaggerations in the process:[53] "[The Kinetoscope business] has earned in the neighborhood of $50,000.00 . . . of net profits in but little over 1½ years . . ."

But shortly before December 8, 1895, an event occurred which was to lift them from the mirey clay and plant their feet once more on the solid rock. A Washingtonian named Thomas Armat announced that he had a new projector. Raff and Gammon saw it and it worked. We can now read joyous housecleaning between the lines of a letter of December 30:[54]

51 Item 12.31 in the legal file noted on page 73.

52 A letter of June 1 in the Baker Library collection indicates that they were organizing a telephone company, and one of November 22 indicates negotiations for the purchase of a business from an I.E.Blake of 412 West 13th Street, New York City.

53 *Ibid.*

54 *Ibid.*

For about a month now we have been in grave doubt as to the wisdom of continuing any longer. [We had better liquidate. We can realize, possibly, ten or twelve thousand dollars].

C. Francis Jenkins, the Life Saving Service clerk who had written to the laboratory many months before (see page 51), had developed a workable projector for Kinetoscope films he had gotten from the Washington parlor. Armat, a Washington real estate operator with a spare record of mechanical prowess, had gotten an interest in the new machine and was now representing to Raff and Gammon and sundry that it was his own. He wrote them that he had what they wanted—as indeed he did. Before the season was out the Vitascope (as the new projector was to be called) had a sensational opening in New York, and the Kinetoscope, America's first commercially successful motion picture exhibitor, was delivered its death blow. The Armat-Jenkins history is rife with tales of intrigue—but that is another story.

* * * *

With the passing of the next few years fewer and fewer Kinetoscopes were manufactured. Films for the new projecting machines were often supplied from the old Kinetoscope list. But by the end of the century, after only six years of business, Kinetoscopes had all but passed from the American scene. As a witness in Equity 6928 testified in 1900, "the Kinetoscope as a picture-exhibiting apparatus has practically disappeared from the market."

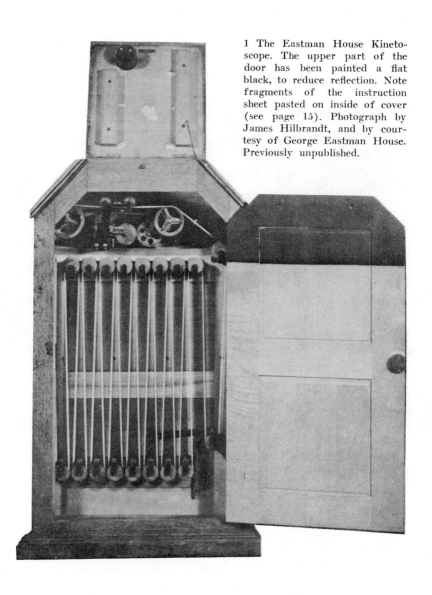

1 The Eastman House Kinetoscope. The upper part of the door has been painted a flat black, to reduce reflection. Note fragments of the instruction sheet pasted on inside of cover (see page 15). Photograph by James Hilbrandt, and by courtesy of George Eastman House. Previously unpublished.

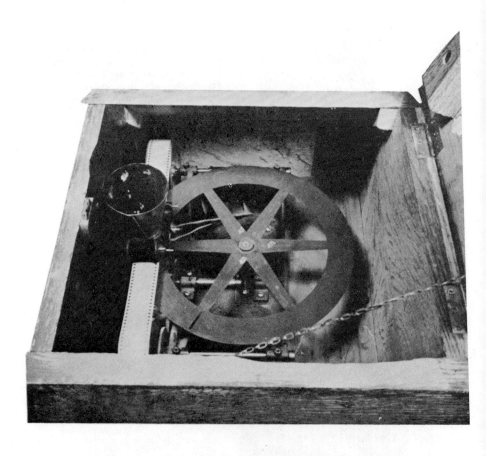

2 Close view of viewing apparatus of the Eastman House Kinetoscope. Note the "up" on the shutter, the velvet covered roller, and the black funnel through which the film was viewed. Photograph by James Hilbrandt and by courtesy of George Eastman House. Previously unpublished.

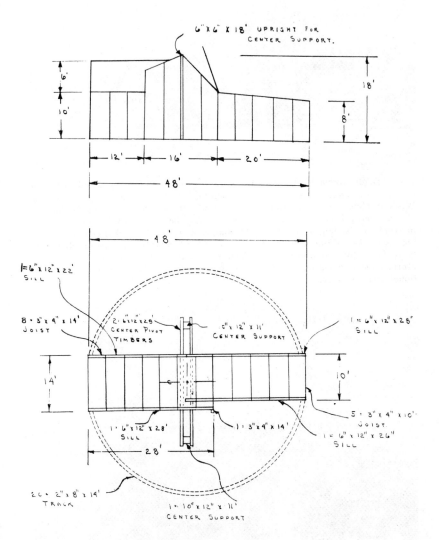

3 Analytical drawings made by William Brower, Sr., of the Black Maria, from the lumber purchased for the project (see pages 22-23). Here, for the first time, the Maria's dimensions are established to be 48′ (length) x 16′ (height) x 10′-14′ (width). Previously unpublished.

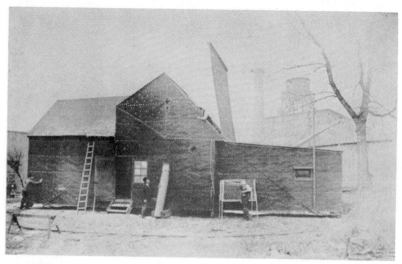

4 The Black Maria as of March 5-8, 1894 (see pages 23-25). Fred Ott is in the roof opening, Fred Devonald is holding his fighting cock, and, possibly, William Heise, has his hand on the great 10″ x 12″ beam supporting the Maria's central axis. At the extreme left may be seen a blacksmith standing in front of his shop on Lakeside Avenue, east of the 1889 photographic building (see *The Edison Motion Picture Myth*). Since this photograph shows the large laboratory building, it has been particularly helpful in establishing the Maria's location within the Edison grounds. Photograph courtesy of the National Park Service.

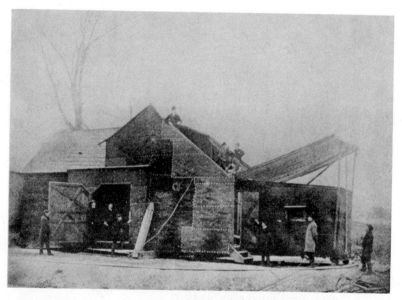

5 The Black Maria as of about January 1895, from the Dicksons' *History of the Kinetograph Kinetoscope and Kineto-Phonograph* (see page 25). The tree at the left here is at the right in Illustration 4). Dickson is third from the right in the group of four at the top of the Maria and Otway and Gray Latham may be numbers one and four. The new tar paper indicates the extent of the enlargement. Note also the power line entering the building at the right of the chimney hole. Photograph courtesy of the National Park Service.

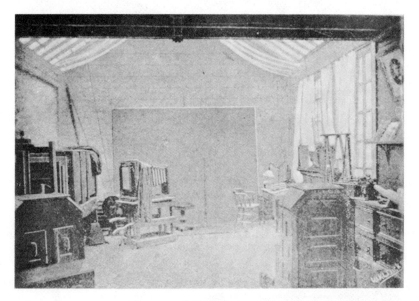

6 Interior of "1889 Photograph Building" (see *The Edison Motion Picture Myth*), from the Dicksons' *History of the Kinetograph Kinetoscope and Kineto-Phonograph* (see page 10). The Kinetoscope at the left may be the original manufacturer's model used for the Egan-Heise instruments (see page 34), and the instrument at the right may be one of these 25. Skylights and a large window facing south, Lakeside Avenue, are obvious. A photograph of Edison, various still cameras, a phonograph, a microphotographic apparatus (?), a drying drum (?), a head rest for portrait photographs, and a background screen for photography are also visible. Courtesy of the National Park Service.

7 Interior of the Black Maria, possibly taken on the occasion of an enlargement project. A pull-down back drop, possibly confused by a Fred Devonald daughter with a "screen" said to have been made by her mother can be seen (see *The Edison Motion Picture Myth*). Blocks to halt the camera can also be seen in the foreground. Courtesy of the National Park Service. Previously unpublished.

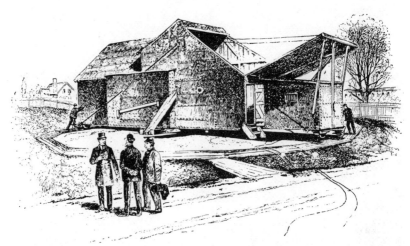

8 The Black Maria exterior, from *Frank Leslie's Popular Monthly*, February 1895. Dickson is apparently at left in the foreground group, Heise at the right (with his film box covered with black cloth) and possibly Charles Batchelor in the center. The long low building at the right distance is the Phonograph Works. Note the power line leading apparently to the power plant at the eastern end of the main laboratory building. Unpublished since 1895.

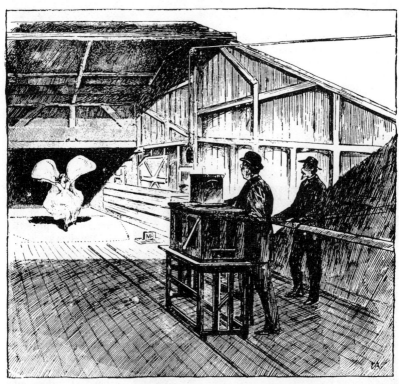

9 Drawing of Heise shooting an Annabelle Serpentine dance in the Black Maria from *Frank Leslie's Popular Monthly*, February 1895. The figure at the left is apparently meant to be Dickson, although Dickson's beard was never so long. Note the "M B" in monogram at stage right (see page 128), the door at the left (of Illustration 24), the power line to the outside, the track for the camera, the counter on the camera, and the handle for starting and stopping the phonograph (cf. Illustration 47). Unpublished since 1895.

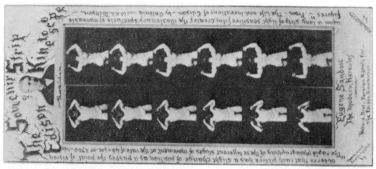

11 "Souvenir Strip of the Edison Kinetoscope," ornamented in Dickson's "Woodland" style (see page 61 and Illustration 38). Courtesy of the National Park Service. Previously unpublished.

10 From left to right: C. B. Cline (business manager of Koster and Bial's Music Hall, where Sandow was appearing); Sandow; John Koster (partner in Koster and Bial's); Edison; and R. T. Haines (manager of Koster and Bial's) in front of the background screen in the "1889 Photographic Building" on March 6, 1894 (see pages 52-53). Photograph by Dickson. From *Leslie's Weekly*, July 19, 1894. Unpublished since 1894.

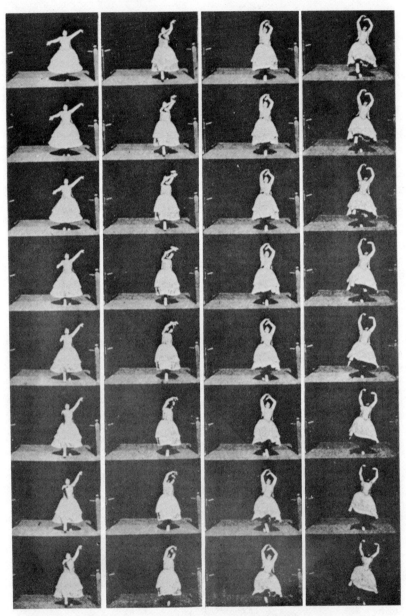

12 "Carmencita," from the Dicksons' *History of the Kinetograph Kinetoscope and Kineto-Phonograph* (see page 55). The earliest Maria subjects used balustrades with newel posts at right and left (see also Illustration 13). These barriers may be the same as those in The Phonogram subjects (see *The Edison Motion Picture Myth*). Courtesy of the Library of Congress. Unpublished since 1894.

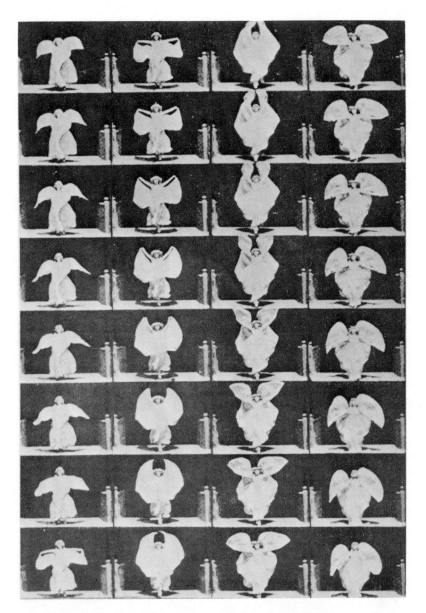

13 An "Annabelle Serpentine" shot early in the Black Maria 1894 production season. From the Dicksons' *History of the Kinetograph Kinetoscope and Kineto-Phonograph* (see page 82). The balustrades with newel posts are present, as they are in Carmencita's film (see Illustration 12). Courtesy of the Library of the Museum of Modern Art. Unpublished since 1894.

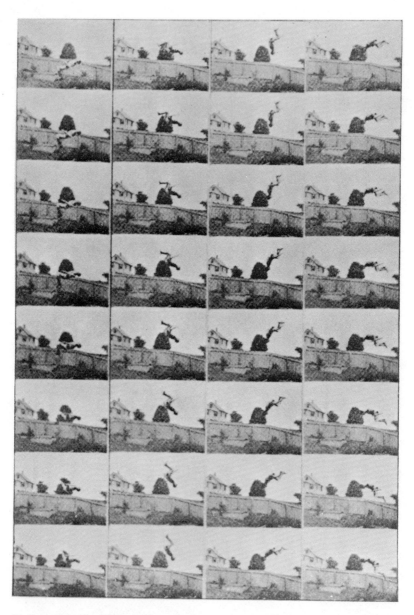

14 Juan Caicedo on the high wire outside the Black Maria on July 25, 1894. From the Dicksons' *History of the Kinetograph Kinetoscope and Kineto-Phonograph* (see page 76). Since Caicedo has a pole here, this is apparently the subject designated "Caicedo ♯1 with Pole." Courtesy Library of the Museum of Modern Art. Unpublished since 1894.

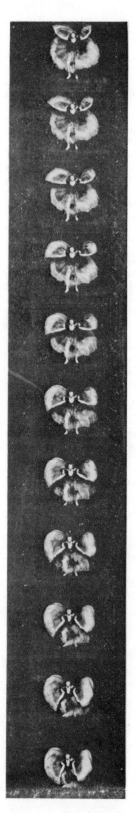

15 An Annabelle Serpentine dance shot possibly in the early fall of 1894, since neither the Raff and Gammon "R" or the Maguire and Baucus "M R" or "C" is present. The lack of a raised stage and the presence of apparently the same carpet as in Illustration 23 also suggests a shooting date near that time. Photograph from the author's collection. Previously unpublished.

16 "Boxing Cats," from the Dicksons' *History of the Kinetograph Kinetoscope and Kineto-Phonograph* (see page 76). The man in the middle is, we presume, Professor Tschernoff. A fulsome account of this match is also in the Dicksons' booklet. Courtesy of the Library of Congress. Unpublished since 1894.

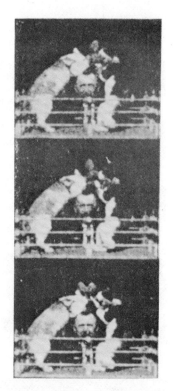

17 The Kinetoscope cross-section to be used in connection with "Directions for Setting Up and Operating the Edison Kinetoscope," beginning on page 15. The shutter is not, of course, in its proper place. Courtesy of the George Eastman House. Previously unpublished.

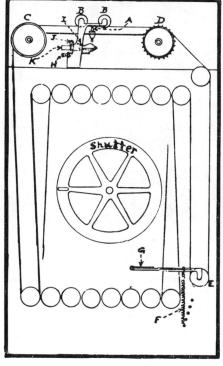

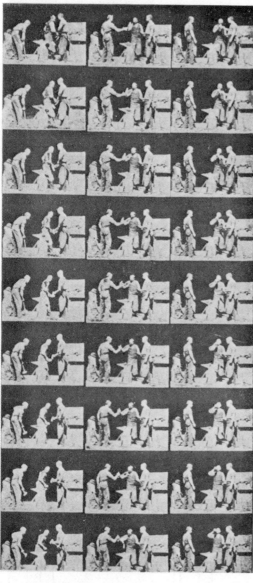

19 *(Below.)* "[Blacksmith #2]".
In the caption accompanying a
reproduction of these frames in
*The Journal of the Society of
Motion Picture Engineers,* De-
cember 1933. Dickson has said
that this subject was shot in ap-
proximately May of 1889, and,
in another place, that he himself
is the figure at the left. The
indistinctness of the photo-
graphs makes it difficult to sus-
tain or deny this claim. But we
know that it was not shot in
May of 1889, since at that time
a vertical-feed camera was still
considerably in the future (see
*The Edison Motion Picture
Myth*). The horse's stance and
gear suggest strongly that this
subject was shot at or near the
time of Captain Duncan C.
Ross' visit to West Orange (see
page 135). The light ellipse at
the lower left may be the Con-
tinental Commerce Company's
symbol (see page 129) or a
horseshoe.

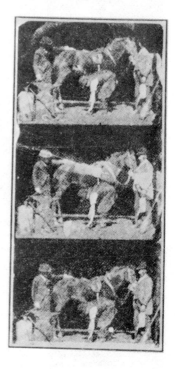

18 *(Above.)* "Blacksmith [#1]", from *The Photo-
graphic Times,* April 6, 1894 (see page 37). The
handing around of the bottle can be plainly seen
here. The relative banality of "Blacksmith [#2]"
(Illustration 19) is an indication of the increasing
casualness with which subjects were made as early
as the end of the first season.

20 A production still for "Chinese Laundry Scene" (see page 82). Courtesy of the National Park Service.

21 "Trained Bears" from the Dicksons' *History of the Kinetograph Kineto-scope and Kineto-Phonograph* (see page 55). The Dicksons called this "A Bear Party." This subject may have never found its way into Kinetoscope exhibition, since I have found no reference to it in newspapers or Raff and Gammon records. The camera points northerly here, and shows two houses on Alden Street in West Orange (long since demolished) and the high board fence upon which neighborhood boys were accustomed to gather to watch the proceedings (see also Illustration 25). Courtesy of the Library of Congress. Unpublished since 1894.

22 From left to right: Sheikh Hadji Tahar, Hadji Cheriff, Vincente Ore Passo, Pedro Esquibel (Esquizel? Esquirel?), and Dionecio Ramos (Ramon? Gonzales?) in a production still taken in the Black Maria on October 6, 1894 (see page 80). The names of Esquibel (?) and Gonzales (?) may be interchangeable. The Dicksons confused Hadji Tahar with Toyou Kichi (see page 82) in their *History*. From the original glass negative in the author's collection. Previously unpublished.

23 *Top:* "[Milk White Flag #2]" or "Band Drill", from *Image,* September 1959 (see page 83). Raff and Gammon's "R" at lower left is washed out.

24 *Middle:* "Fire Rescue Scene," from *Image,* September 1959 (see page 82). Actual uniformed fireman, smoke effects and full-shot techniques make this subject an advanced one. The Raff and Gammon "R" is again present at the left. The fireman at the left, playing a stream of water, suggested the presence of a far door in the Maria long before the *Leslie's Popular Monthly* illustration (see Illustration 9) established that such a door existed.

25 *Bottom:* "Bucking Broncho [Martin Riding]" from *Image.* September 1959 (see page 82). We know this is the Martin and not the Hammitt subject from newspaper accounts. These state that Hammit rode "El Diablo," which was black, and that during Martin's riding, Hammitt stood on the fence and fired his pistol. Note the legs of the boys on the fence in the rear, and Billy Madden, fourth from the left. The house dimly at far right distance still stands at the end of Babcock Place in West Orange.

26 "Dentist Scene" from Talbot's *Moving Pictures/How They are Made and Worked* (see page 83). The Raff and Gammon "R" can be clearly seen here at lower right, along with the giant tooth with which dentists were accustomed to adorn their offices. Gardiner Q. Colton is said to have been the "originator of nitrous oxide gas, anaesthetic for the painless extraction of teeth," and he was at this time practicing in New York.

27 "[Highland Dance #2]" (see page 136). Note the "C" for, apparently the Continental Commerce Company, indicating that this subject was shot for Maguire and Baucus' foreign distribution. Its unconventional proportions may suggest a wide-film camera (cf. page 138). Courtesy of the National Park Service. Previously unpublished.

28 "[Barnum and Bailey #9]" or "Princess Ali" (see page 137). As in "Carmencita," the right and left of this frame was decided upon as a result of the clockwise movement of the dancer; it was also noted that both tambourinists were, in this position, using their right hands. Photograph from the author's collection. Previously unpublished.

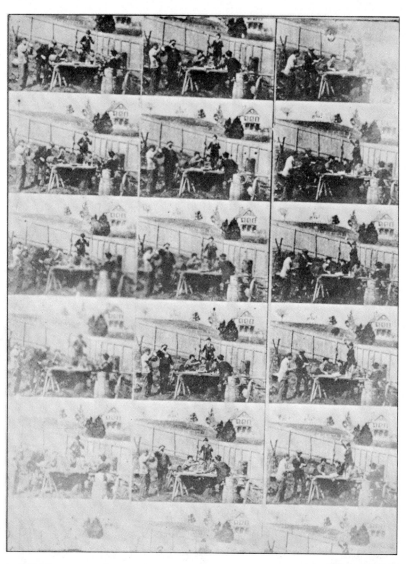

29 The "impromptu" "Employees' Picnic" described in the Dicksons' *History* (see page 55). The house at the extreme right here has been demolished, but the one in the distant center still stands (cf. Illustration 25). Courtesy of the National Park Service. Previously unpublished.

30 Alfred O. Tate from *The Phonogram,* October 1892. Courtesy of the Smithsonian Institution. Unpublished since 1892.

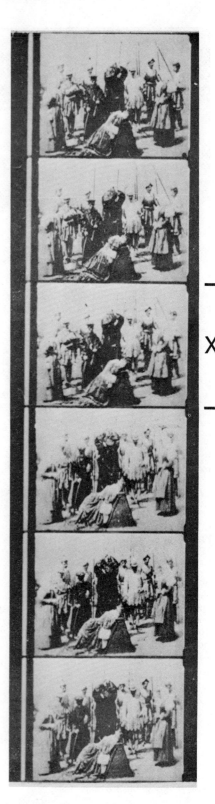

X

31 Stop-motion in "The Execution of Mary, Queen of Scots" (see page 137). After the camera had taken the photograph "X", it was stopped. Then "Mary" (played by Mr. Thomae of the Kinetoscope Company) went out of camera range, a dummy dressed in a similar costume was put in "Mary's" place, and the camera started again. While the replacement was being made the *dramatis personae* were supposed to hold their former positions rigidly, but it is clear that the spear bearers in the background did not do this. Courtesy of the Film Library of the Museum of Modern Art. Previously unpublished.

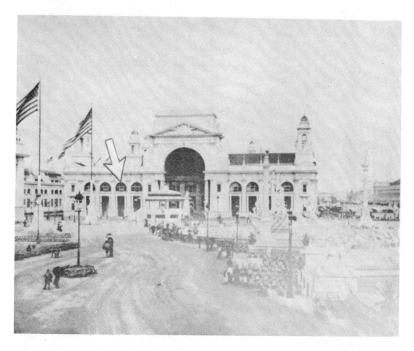

Above, 32: The Electricity Building at the World's Columbian Exposition, 1893, looking north (see page 40 ff). An arrow indicates the second floor space where the Kinetoscope was apparently exhibited. From *The Columbian Gallery*, published by Werner Company, 1894, in the author's collection.

Below, 33: A plan of the second floor of the building. An arrow indicates the space behind the four half-oval window where the Kinetoscope was apparently exhibited. From *The Official Catalogue.*

Above, 34: an aerial view of the New Jersey Pavilion and environs at the New York World's Fair of 1964-65. An arrow indicates the platform of the "Edison Kinetoscope" exhibition (see page 54). Courtesy W. Roy Cowan.

Below, 35: The three instruments on the south wall of the platform. These instruments were, exteriorly, only a rough approximation of the original Kinetoscope size, and, interiorly, quite unlike the original models. When this photograph was taken, September 29, 1965, signs indicating that the instruments were out of order (a frequent-to-typical circumstance) were on all three machines: two such signs can be seen in this photograph. From the author's collection. Previously unpublished.

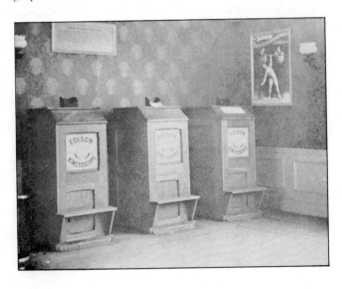

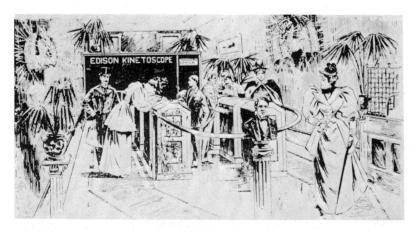

36 Drawing of the parlor at 1155 Broadway, from page 53 of the Dicksons' *History* (see page 57). The Dicksons wanted to give the effect of elegance in this parlour, and added palms, carpets, and waxed floors—none of which may have been there: it is difficult to credit the genteel patronage shown here. Note the incandescent dragons at right and left (see page 59) and the bronzed bust of Edison in the foreground (see page 58). Unpublished since 1894.

37 1965 photograph of the building at 1155 Broadway, New York, where the world's first Kinetoscope parlor opened on April 14, 1894 (see page 57). An arrow indicates the 1965 site of the 1895 parlor. Previously unpublished photograph in the author's collection.

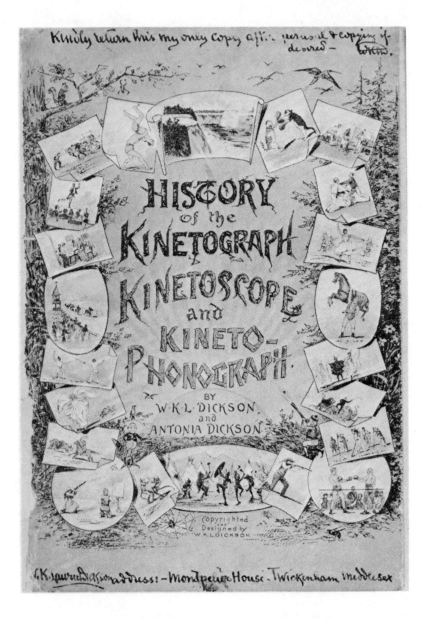

HISTORY of the KINETOGRAPH KINETOSCOPE and KINETO-PHONOGRAPH

BY
W.K.L. DICKSON
and
ANTONIA DICKSON

Copyrighted and Designed by
W.K.L. DICKSON

38 The cover of the Dicksons' booklet, *History of the Kinetograph Kinetoscope and Kineto-Phonograph* (see page 25). More or less exaggerated conceptions of a number of subjects may be seen here. Clockwise from the top: Niagara Falls, which may have been planned but was never shot (see page 81); "Boxing Cats" (see page 76); "[Blacksmith #1]" (see page 37); "Mexican Knife Duel" (see page 80); apparently "Carmencita," although Carmencita had no musicians (see page 55); a Sandow subject that was not shot (see page 53ff); apparently "[The Gaiety Girls #1]" (see page 82); a lion-taming scene that was not shot; "Trained Bears" (see page 55 and Illustration 21); "The Corbett-Courtney Fight," taken directly from the production still illustrated in this book (see page 100ff and Illustration 53); "Buffalo Bill" (see page 80); an Indian dance which could be either "Buffalo Dance" or "Sioux Indian Ghost Dance" but is unlike either (see page 80); a boxing monkeys subject, which may have been planned but was apparently never shot; "Annie Oakley" (see page 82); a lassoing scene with buffalo which was certainly never shot; "Annabelle #1]" (see page 82); a fencing scene, which may be intended for one of *The Phonogram* October 1892 subjects, since the fencers here are not Engelhardt and Blanchard (see page 80); a race track scene which was never shot; "Dentist Scene" (see page 83); Juan Caicedo (see page 76); a football scene which was never shot; and a wrestlers scene (see pages 56, 83). Dickson's inscription, "Kindly return this my only copy after perusal & copying if desired — WKLD. / W.K. Laurie Dickson address:- Montpelier House — Twickenham Middlesex," is somewhat poignant. He has now been dead for thirty years and his "only copy" was never returned. Courtesy of the Library of the Museum of Modern Art. Previously unpublished.

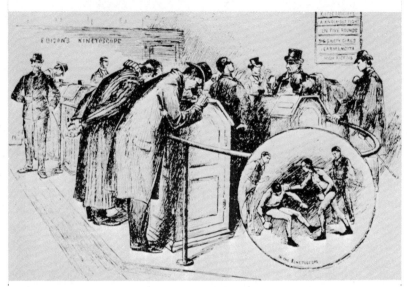

39 The caption of this illustration (in *Frank Leslie's Popular Monthly*, February 1895) called it a view of "The Kinetoscope on the Bowery, New York City." But New York City directories and Raff and Gammon records indicate no such installation. "High Kicking," on the right, may have been "Ruth Dennis" (see page 83). The skull walking stick held by the man at the left suggests that that drawing might be a portrait, but I have not found who it might have been. Unpublished since 1895.

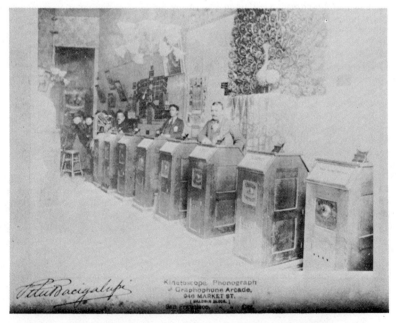

40 The Peter Bacigalupi parlor at 946 Market Street, San Francisco, in possibly 1894 (see page 60). One of the two outside men must be Bacigalupi. The instrument at the extreme left of the eight Kinetoscopes may be the one made into a Kinetophone (see page 124). Photograph courtesy of the National Park Service.

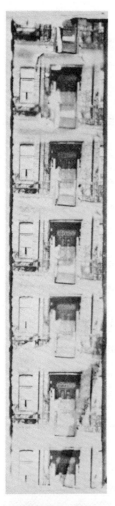

42 William Kennedy-Laurie Dickson as of, possibly, about 1898. From a glass copy negative made apparently by Dickson himself, now in the possession of the author. Note the break in the glass at lower right. Previously unpublished.

43 R. W. Paul (see page 133) from Ramsaye's *A Million and One Nights*, and 41, *above left*, the short strip of film he sent to the Edison Laboratory with his Kinetoscope proposition (see page 133). Courtesy of Simon and Schuster and the National Park Service respectively. Additional frames of this subject may be seen in Talbot, *Moving Pictures* (see page 129).

In the year 1887, the idea occurred to me that it was possible to devise an instrument which should do for the eye what the phonograph does for the ear, and that by a combination of the two all motion and sound could be recorded and reproduced simultaneously. This idea, the germ of which came from the little toy called the Zoetrope, and the work of Muybridge, Marié, and others has now been accomplished, so that every change of facial expression can be recorded and reproduced life size. The Kinetoscope is only a small model illustrating the present stage of progress but with each succeeding month new possibilities are brought into view. I believe that in coming years by my own work and that of Dickson, Muybridge Marié and others who will doubtlessly enter the field that grand opera can be given at the Metropolitan Opera House at New York without any material change from the original, and with artists and musicians long since dead.

The following article which gives an able and reliable account of the invention has my entire endorsation. The authors are peculiarly well qualified for their task from a literary standpoint and the exceptional opportunities which Mr Dickson has had in the fruition of the work.

Thomas A Edison

44 The famous autograph letter by Edison, written for *The Century Magazine* June 1894 article (see page 74), reproduced there and in the Dicksons' *History* (see page 25). Note Edison's misspelling of Marey's name, and the characteristic self-assurance which assigns "opportunities" to Dickson. From the author's collection.

45 "Dickson Experimental Sound Film" (see page 122). Frilling may be seen at the left of the two upper frames here, and the "electricity" markings described on page 48 of *The Edison Motion Picture Myth* at the left of the third from the top. Sprocket holes have been masked. Dickson is playing the violin (he was an accomplished amateur) in front of a recording horn for the Edison phonograph, and the top of the Raff and Gammon "R" is visible at the lower right (see page 128). The actual recording for this film may still be in existence at the Edison Laboratory. Courtesy of the National Park Service. Previously unpublished.

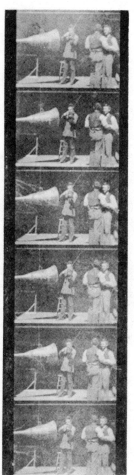

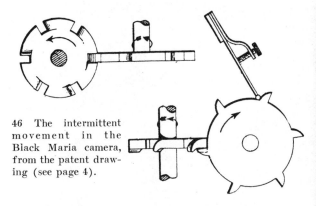

46 The intermittent movement in the Black Maria camera, from the patent drawing (see page 4).

47 *Below:* Drawing by Meeker of the Black Maria interior, from *The Century* Magazine, June 1894 (see page 8). The subject being shot here may be "Barroom [#1]". The recording apparatus is our clearest illustration of the attempts to create sound film. Such film, however, was not achieved. Heise is at the camera, with his left hand near the cut-off lever (for the phonograph?) and his right apparently close to the camera shut-off. It will be seen that the camera here, for journalistic reasons, is not in the center of the Maria as it actually was.

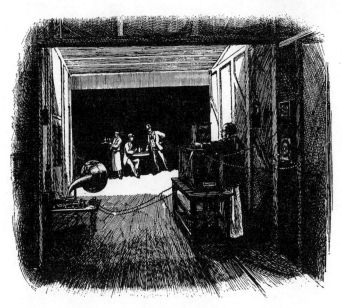

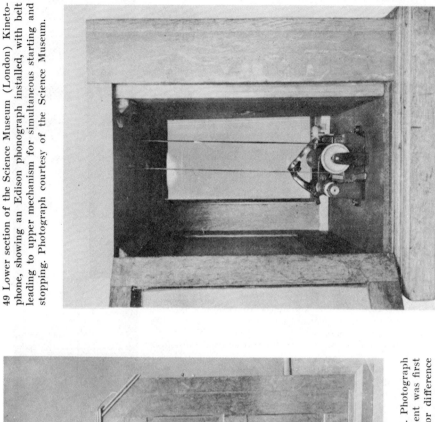

49 Lower section of the Science Museum (London) Kineto-phone, showing an Edison phonograph installed, with belt leading to upper mechanism for simultaneous starting and stopping. Photograph courtesy of the Science Museum.

48 The "official" Kinetophone (see page 118ff). Photograph taken possibly in April 1895, when the instrument was first being introduced. The slightness of the exterior difference from the regular Kinetoscope (see *Frontispiece*) is obvious. Photograph courtesy of the National Park Service.

52 Gray Latham, at possibly the time the Lathams were getting into the Kinetoscope business (see page 88). From the author's collection.

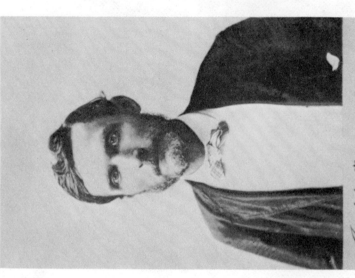

51 Woodville Latham, in a cabinet photograph by Judd, of Chattanooga, taken possibly about 1891 (see page 149). Courtesy of Miss Mary Abernethy. Previously unpublished photograph in the author's collection.

50 Otway Latham as of possibly the 1890s. From the author's collection.

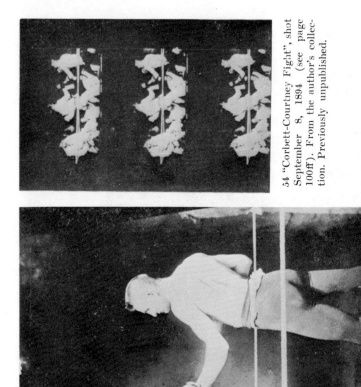

54 "Corbett-Courtney Fight", shot September 8, 1894 (see page 100ff). From the author's collection. Previously unpublished.

53 A production still of "The Corbett-Courtney Fight" (see page 109ff). Corbett is at the left. Note the padded walls of the Maria, and the ropes which were put up for this photograph. Courtesy of the National Park Service.

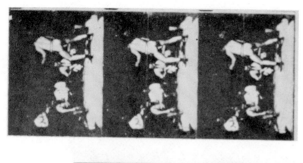

56 "Leonard-Cushing Fight," shot June 14, 1894 (see page 91). From the author's collection. Previously unpublished.

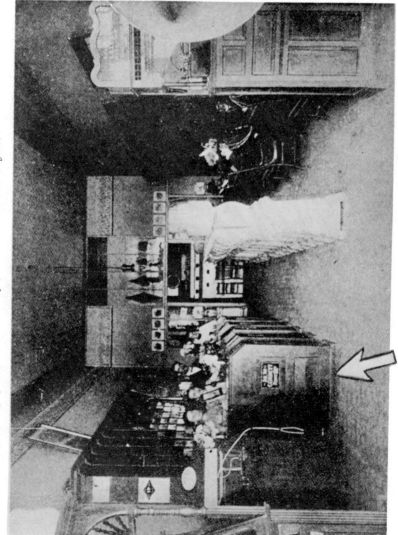

55 Photograph of interior of Thomas Tally's Kinetoscope parlor, showing phonographs at the right, Mutoscopes in the center, peep-holes for projection viewing (according to Ramsaye) at rear, and a row of Kinetoscopes at the left. Judging from its dimensions and the legend it bears "See the Corbett Fight . . ." the first of the instruments on the left must be the Latham enlarged Kinetoscope (see page 99). From Ramsaye, *A Million and One Nights*.

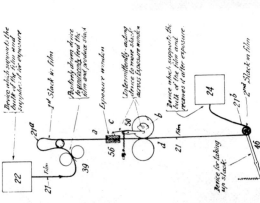

STRUCTURE OF CHINNOCK CAMERA.

58 Diagrammatic analysis of the Chinnock camera (see page 161ff). Drawn by the defendant's expert witness in the Motion Picture Patents Company suit, Equity 5/167. Courtesy of the National Archives. Previously unpublished.

59 Charles E. Chinnock (see page 161ff). Photograph by courtesy Mrs. Robert McCormick. Previously unpublished.

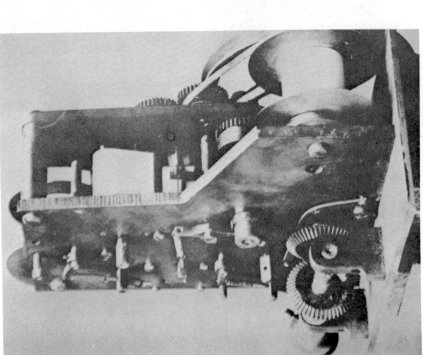

57 The Chinnock camera (see page 161ff). From the National Archives. Previously unpublished.

Appendices

APPENDIX A · *William Kennedy-Laurie Dickson*

William Kennedy-Laurie Dickson[1] (see Illustration 43) was born in August 1860, in France, the son of a Scotswoman born in the State of Virginia, and an Englishman. He came to Virginia with his mother and two sisters in 1879—apparently upon the death of his father—and settled in Chesterfield County, with or near his mother's relatives.[2] Soon after the death of his mother he moved to Petersburg, Virginia, where the directory listed him as an electrician, a subject in which he had previously evinced much interest. He described this interest in an 1879 note of application to Edison now in the West Orange archives. (See Hendricks, *The Edison Motion Picture Myth.*)

After about four years in Virginia, at the age of 23, he went to New York City, applied for a position at Edison's Goerck Street Works and within a year or so had advanced himself sufficiently to be placed in charge of certain testing procedures there.[3] At about this time also he had apparently become Edison's "official" photographer.[4] In 1886 he returned to Petersburg and married a local lady, Lucy Agnes Archer, traveled to Europe on a wedding trip, and returned to work with Edison, probably late in the same year. He was soon involved in the ore-milling work at the Edison plant, and after the move late in 1887 to the new laboratory in West

[1] See the more detailed biographical sketch of Dickson in Appendix A of Hendricks, *The Edison Motion Picture Myth* (University of California, 1961).

[2] As I have said in *The Edison Motion Picture Myth,* Dickson's mother's burial records in a Petersburg, Virginia, cemetery read: "Elizabeth Kenedy [sic] Dickson . . . Born Chesterfield Co., Va."

[3] This is shown in various Edison archives items, e.g., a letter of June 4, 1884, in which he is addressed as "Supt. Testing Room."

[4] See *The Edison Motion Picture Myth,* page 151.

Orange, was placed in charge of this work. He was also given a well-equipped photographic studio.

Late in 1888 he appears to have begun to contemplate the matter of motion pictures. By February 1889 there is evidence that he had come a little way along this road; this is indicated by the subject matter of the second motion picture caveat. By the end of the year he may have achieved the regular, rapid, intermittent photography of moving objects on the surface of a cylinder, although such subjects now extant were probably taken a year or so later.

In the fall of 1890 he set himself to achieve motion photography on a band of film, and by the following spring had achieved it. The length· of this film was probably not more than 40 inches and when it was shown in the Kinetoscope to reporters in May of 1891 it was looped and run over and over. Dickson then improved the Kinetoscope to such an extent that by the time plans were made for the World's Columbian Exposition it was regarded as a commercial possibility for display there. Delays in its manufacture, largely brought about by Edison's continuing pre-occupation with ore-milling and his disinterest in nearly anything which was not money-making, prevented its introduction to the general public until April of 1894. At that time a Kinetoscope parlor was opened at 1155 Broadway in New York City.

Soon Dickson became involved with the Lathams (see Chapters 10 and 11) and with Elias B. Koopman, Harry Marvin and Herman Casler (see Hendricks, *Beginnings of the Biograph)*—materially aiding the construction of the apparatus of both groups. He left Edison's employ on April 2, 1895, and helped form the American Mutoscope Company. He apparently designed the studio installations for this new company at 841 Broadway, and personally shot most of the subjects used by the company for the illustrious series of Biograph debuts beginning in September 1896 in Pittsburgh, Pennsylvania.

After a highly successful production and projection season, he went to Europe with his wife and sister Antonia on May 12, 1897, where he continued to supply foreign subjects for the American Mutoscope Company. Among these subjects were those he shot in Rome in the summer of 1898 of Pope Leo XIII, and, beginning late in 1899, of the Boer War in South Africa.[5]

After disassociating himself from the Biograph futures, possibly because of financial difficulties, he went into the experimental indus-

[5] The May 12, 1897 date is from *The Orange Chronicle* of May 15, 1897. The Leo XIII pictures were widely published by New York newspapers. The Boer War experiences are recorded in *Biograph in Battle* by Dickson himself (Unwin, London, 1901).

trial laboratory business, as his West Orange employer had done. His Virginia wife died about 1910. He remarried, adopted a son (who may have been killed in the Second World War) and died at the age of 75 on September 28, 1935, in his home in Twickenham, England.[6] He established himself as, possibly after Eadweard Muybridge, the single most significant figure in early American motion picture history.

APPENDIX B · The Lathams

Woodville Latham, Jr.[1] (see Illustration 52) was born in Hinds County, Mississippi on April 12, 1837,[2] when the Lathams apparently had a sugar plantation there. We know little of his early life. But for a time before the war's outbreak, he was "U.S. Storekeeper" in Long Branch, West Virginia: an envelope so addressed has been given to me by Miss Abernethy. After what was apparently a sound education at the University of Virginia he left that school to enlist in the Confederate Army. On October 5, 1861 he married Eliza Trudeau in East Baton Rouge, Louisiana.

His Civil War record was one of hard work and unusual loyalty. There is a suggestion in his National Archives war record that after the South's future had begun to decline sharply he volunteered for espionage work in the North. After an application from Charlottesville, Virginia, on October 9, 1862, for promotion to the rank of artillery captain, he achieved that rank on October 19, 1863, while Executive Officer of the Confederate States' arsenal at Columbus, Georgia. He had come to Columbus some time previous to September 18, 1863, and previous to the Columbus assignment had been an ordnance lieutenant in Richmond, Virginia. Many requisitions for fuel for his living quarters and horse forage in his neat, careful (but self-confident) hand can be seen in the National Archives record.

He signed his "parole of honor" on May 4, 1865, swearing not to participate again in armed rebellion[3]

6 This data is partly from family sources. The Biograph association he himself describes in testimony in 1911. The death date is from Somerset House, London.

1 His father, Woodville, Sr., was a resident of Culpeper County, Virginia, in the house called "Northcliffe," which is spoken of as a town by Ramsaye, op.cit., page 104.

2 According to his own entries in his father's Bible, kindly loaned to me by his niece, Miss Mary Abernethy, of Washington, D.C.

3 The National Archives record.

against the United States Government until I am regularly exchanged [he was now in a Winchester, Virginia, prisoner detention camp]. And that if I am permitted to remain at my home I will conduct myself as a good and peaceable citizen, and will respect the laws in force where I reside, and will do nothing to the detriment of, or in opposition to the United States Government.

Woodville Latham was discharged from service, incidentally, as a captain and not a major, as was later claimed for him by, apparently, his nephew LeRoy in conversation with Ramsaye.

(During the war, on January 25, 1863, his first son Percy was born in Orange County, Virginia, the Virginia county bordering Culpeper County on the south. Percy, who, like his brothers Gray and Otway seems to have become a problem to Woodville later in life (see the 1907 letter), is said to have "compounded Phenacitin." But this is not possible. Phenacitin was introduced into medical practice in Europe, in 1887.[4] It was accepted rapidly in the United States, but it cannot be said to have been invented here. The word "compounded", incidentally, is a misnomer: "synthesized" is more correct.)

Woodville's son Gray was born in Shelbyville, Kentucky, on April 25, 1867 (see Illustration 53), and his son Otway was born in the same place on March 22, 1868 (see Illustration 51). This is according to entries in the family Bible, although the death certificate of Otway, dated August 10, 1906, said he was 38 years, 4 months and 13 days old at the time of his death, and this would work out to a few days later than March 22, 1868.[5] What the family was doing in Shelbyville is uncertain. Perhaps Woodville was beginning the teaching career which was to bring him to West Virginia University in Morgantown, West Virginia in 1880. So far as I have found, however, there was no college in Shelbyville.

Ramsaye says that previous to this he was invited to become "the resident engineer in charge of [the Baltimore and Ohio Railroad] between Pittsburgh and Chicago" but preferred a teaching career. But the Baltimore and Ohio archives which would help to sustain (or deny) this were destroyed, I have been told, in the great Baltimore fire of 1904. The Patent Office records state that Woodville testified that he was a "railroad engineer"—whatever that means. Ramsaye also mentions Nashville and Chattanooga

[4] Smith, *Acetophenetidin* (Interscience Publishers, New York and London, 1958).

[5] The extant birth records of Shelbyville, which might substantiate the Bible entry, begin with 1911, according to a letter to me from the County Clerk of Shelby County.

sojourns in the pre-teaching years. The Nashville Directory for 1868-1882 lists only a "W.H.Latham" grocery in 1872 and 1874, but I have been unable to determine whether or not this is "our" Latham. The Chattanooga 1891 directory lists Woodville, Gray and Otway as "dlrs in mineral and timber lands" at "135 Richardson Building." A cabinet photograph of Woodville taken in Chattanooga—and most kindly given to me by Miss Abernethy—is reproduced as Illustration 52.

Woodville Latham's career as professor at West Virginia University gives a token of the self-assurance and irascibility evident in his later life. West Virginia University records reveal that several members of the faculty, supported by students who thought Latham too severe, also alleged that he drank too much, used profanity and generally undermined student morals. The Board of Regents agreed that he was irascible, and that there was some foundation for the drinking, smoking and "immorality" charge, but refused to ask for his resignation. His knowledgeability and essential worthiness seemed, to the Board, well-established.

Leaving Morgantown highly recommended[6] he took up a position in Oxford, in his native state of Mississippi, in the State University there. Here he remained four years.[7] He was Professor of Chemistry and Recording Secretary for faculty meetings in 1887 and 1888. His inventiveness is suggested by a letter he wrote while in Oxford, describing a filtering apparatus he had devised while in Morgantown. This letter was published in *The American Chemical Journal,* volume 9, 1887.

The next year he was in St. Louis. And, according to a Bible entry, his wife Eliza Trudeau Latham died in that city on February 8, 1890. The St. Louis directory for 1890 lists: "Latham, Woodville, Office 304 N. 8th," but in 1888, 1889, 1891 and 1892 fail to list him. Ramsaye quotes possibly Enoch Rector or LeRoy Latham and says that Otway, Gray and Rector were fellow-students at West Virginia University under Woodville, which would have placed their association pre-1885. Although West Virginia University Registrar records fail to mention any of these three, a letter from Woodville to his sister, Miss Abernethy's mother, states that both Gray and Percy were enrolled, and "Otty says his lessons to his

6 A brochure of references, apparently (if we may judge from the date of the last one) compiled by Woodville after he left the University, contains many glowing testimonials from highly placed men. This brochure was presented to me by Miss Abernethy.

7 According to a letter to me from the University of Mississippi Librarian, Miss Mahala Saville, of January 15, 1962. Miss Saville's source was the annual University catalogues and the *Historical Catalogue of the University of Mississippi 1849-1909.*

mother." Percy, however, is referred to in a library manuscript as being in a Woodville class, and Gray apparently was useful to his father in installing chemical apparatus in the school.

After the Chattanooga sojourn Otway—and possibly Gray— went to New York. Here Gray, according to Ramsaye, became employed by the Parke, Davis Company,[8] and Otway by the "Tilden Drug Company."[9] But Otway must have had this association immediately before Kinetoscope beginnings, since the 1895 directory lists him as "manager, 51 John, h. New Brighton, S.I." The 1893 directory lists Otway, the only one of our Lathams apparently in New York at that time, as "manager, 57 N. Moore, h. S.I.," and the 1892 directory lists him in "real estate, 134 W. 23d" of "Latham & Thompson, real estate, 134 W. 23d." In New York City, Ramsaye continues—apparently from Rector information, Gray and Otway accidentally met Rector, and the three of them decided to join Tilden and go into the Kinetoscope business. Their father Woodville had come to town, and the ensuing months are described beginning on page 88 of this book.

After being discharged from the Eidoloscope Company, the Latham motion picture projection enterprise, in about June 1896, Otway married Natalie Dole, a socially prominent New York woman, at All Souls Church in New York on June 22, 1896.[10] On October 17 of the same year Gray married Rose O'Neill, the "kew-pie doll" artist[11] (see Ramsaye, op.cit., page 177). By December 10, 1897, when he testified in Interference 18461, Otway had en-

8 Research for me by the Research Librarian of the Parke, Davis Company has failed to reveal any record of that employment. "Parke, Davis & Co., chemists" were at 92 Maiden Lane and 9 Cedar Street in New York for, at least, the years from 1892 to 1896, both inclusive.

9 Ramsaye calls it the "Tilden Drug Company." In the 1890s drug companies were not so called, but called "chemists." I have found only one listing in the New York City directories for such a company—"Tilden Co. chemists, 51 John." This was in the 1894-95 directory. Directories of several preceding following years fail to mention this company. It was apparently one of the fly-by-night business ventures of the wastrel nephew of the remarkable Samuel J. Tilden, Sr. Tilden Jr. had already succeeded (with, 1, the help of his brother George, 2, a $100,000 pool for legal fees put up by their creditors, and 3, a court packed by Governor Hill) in depriving his beneficent uncle and the people of New York City of the free library for which Tilden Sr.'s will had carefully provided. This will had given Tilden, Jr. the income from a $75,000 trust fund and had forgiven him and his family $300,000 in debts. But this was not enough. He and brother George set out to break the will and in 1892 succeeded in getting $454,005.19. Two years later, laden with debt, Tilden, Jr. assigned his rights in the estate to the National Hudson Bank of Hudson, New York, to meet financial obligations.

10 According to the family Bible, which has an inscription to this effect in a feminine hand—possibly Mrs. Otway Latham's or Mrs. Gray Latham's.

11 Ibid.

tered the advertising business and was living at 115 Madison Avenue. At the same time Gray testified that he was a "broker in merchandise" and lived at 170 West 88th Street.

When Otway died following an operation for duodenal ulcer on August 10, 1906, his father Woodville had been living in Washington, D.C., with his sisters.[12] Woodville's description of the operation on Otway, in a letter kindly loaned by Miss Abernethy is at once grim and colorful:

> Dear Ella & Mit [*i.e.*, Woodville's Washington sisters]
>
> I would have written last night if I could have done so. I can scarcely yet bring myself to believe that poor Otty is dead.—He had not been very well for some days, possibly for some weeks. He had been working hard on the real estate transaction he had in hand, & his indisposition was set down simply to work and worry.—On Tuesday last the "deal" was completed & arrangements were made to pay him his commission (something more than $15,000.00) on Tuesday next the 14th.—On Wednesday morning he was here in Gray's office & the offices of others whom he knew, in high spirits; but suddenly a severe pain struck him in the bowels; & happening then to be in the office of a Mr Brown, (a stock broker) next to Gray's, he was taken by Mr Brown to the latter's bed room next to his office where he remained till Friday morning, Gray being with him all the time, trying in conjunction with the house physician to relieve him.—On Friday, Dr ————,[13] one of the leading surgeons of the city was called in. At about 2 p.m. an operation was decided on under the impression that appendicitis was the cause of the pain. About 4 p.m. two long cuts were made the 2nd one large enough to admit the surgeons whole hand covered with a rubber glove. The appendix was found to be sound. This was after the first cut.—The second and larger cut was then made & the surgeon introduced his hand extending it up to the stomach in an exploration to determine by *feeling through the rubber glove* whether or not there was a tumor or something else to which the poor boy's pain could be referred. Finally a portion of the intestines was brought to view upon which was an ulcer, which had broken under the manipulation & from which a considerable quantity of green, ill-smelling matter issued.—The hole in the bowel was sewed up as were also the cuts that had been made, and the operation was pronounced a success & the surgeon expressed the somewhat confident hope that complete recovery would result.—Gray stood by during the entire proceeding— After the effects of the anaesthetic wore off Otway was in

[12] The *New York Herald* report of Gray's accident gave a Washington address for Gray's father, and Miss Abernethy remembers these days.

[13] I have excised the name of the surgeon: Woodville was not so delicate.

good spirits, & said he was free from pain except a little soreness. The operation had taken about 2 hours for its performance, which brings us to about 6 P.m. Friday evening. The D^r then said to Otway that Gray & everybody else except the nurse must leave him for an hour to get a little nap.—Before the hour had ended they were called up by the nurse who reported that he was sinking. Before the D^r & Gray reached the bedside he was dead.

Otway's widow, Natalie Dole Latham, separated from him and committed suicide in Paris on March 7, 1909.[14]

On March 25, 1907, Gray Latham, divorced from his wife, Rose O'Neill Latham, who was then living abroad, closed a real estate deal in downtown New York and boarded a Broadway trolley northward. At Tenth Street he missed his footing and fell off the car and fractured his skull. He died in St. Vincent's Hospital on April 3, 1907. The May 20, 1907 inquest said that his death had been caused by a fracture of the skull caused by "accidentally falling while alighting from a north bound electric car . . . when said car was in motion."[15] The circumstances of this accident are still in dispute. Gray may have been celebrating too enthusiastically for his own good. Our impression of his habits suggest this, as does Miss Abernethy's charming phrase—"the Latham men were always light on their feet."

Woodville, separated from the children upon whom he had spent so much of his heart and substance, had reduced Otway's remains to ashes. He now performed the same service for Gray.[16]

After the death of his sons Woodville apparently remained in New York City, taking up, for at least a time, the occupation of door-to-door selling. Ramsaye describes this in a condescending manner on his page 297. A letter given to me by Miss Abernethy and dated November 30, 1910, exactly a year before Woodville's death, gives us an intimate glimpse into his life and state of mind at this time:

My dear Mit:—
I rec'd today at 2Pm your letter without date, but mailed last night at 11 o'clock.—I am sorry you have been unwell. I think if you had tried the witch-hazel jelly it would have given you some relief. It is good for more things than any remedy I know of.
I thank you for the egg sauce receipt. It is 3^30 Pm now

[14] An interesting account of this is in *The New York Sun* of March 8, 1909.
[15] *The Coroner's Day Book,* which I examined on June 24, 1960, in the New York City Hall of Records.
[16] According to Miss Abernethy, who remembers her mother—Woodville's sister—telling her that Woodville took his son's ashes to the Hudson River and scattered them there.

& I am going out presently to get some eggs so as to see if I can make it. I have not eaten much today & this is the only thing my mouth waters for. The weather here for some while has been excerable [sic], & I have suffered in consequence a good deal—finding it difficult to dress & undress myself & even to walk about my room. I am relieved somewhat today but the weather is still threatening. I feel it "in my bones".—Of course it was impossible for me to go to St. Luke's yesterday. [see note 18 below. G. H.]

Woodville had a final hour of glory in 1911 when an investigator for the Motion Picture Patents Company discovered him living at 227 West 116th Street and procured the testimony in the 1911 case often referred to in these pages. It has been said that the Motion Picture Patents Company gave him a "pension" after this, but when he died on November 30, 1911, a few months later,[17] the expenses of his final illness and funeral seem to have been paid by relatives.[18] At any rate, his remains were reduced to ashes in New York and mailed to Washington to his sister, Miss Abernethy's mother. Miss Abernethy recalls carrying the tin box containing Woodville's ashes in her lap as she and her mother made the trolley trip to the cemetery—the last of three fittingly melodramatic endings to the Lathams.

Gray and Otway have left little contribution to the beginnings of the American motion picture apart from the energy and helpfulness they inspired in their father. But Woodville gave intelligence, direction and enthusiasm to the work on the Latham-sponsored Kinetoscope and projector. And although he seems to have done less invention than he claimed (or than has been claimed for him), these qualities aided significantly in the creation of America's first "official" public motion picture projection venture. His Kinetoscope work was also an important factor in arousing public interest in motion picture entertainment. Thus the Lathams—and principally Woodville—deserve a solid place in this record.

[17] According to the inscription on the gravestone in Rock Creek Cemetery in Washington, D.C., which I visited in June of 1960. The New York newspapers, so far as I have found, failed to note his death.
[18] According to Miss Abernethy, who has been very helpful in this work. St. Luke's Hospital records show that he had had three admissions there in 1910 (see November 30, 1910 letter above) and 1911, the last stay lasting from September 13, 1911 to November 21, 1911, nine days before his death.

APPENDIX C · *The Ford Museum Camera*

I said in *The Edison Motion Picture Myth* that:

> . . . Edison correspondence . . . shows that a camera was
> being built for the purpose of the law suit [in *circa* 1905]
> . . . It is clearly this reconstructed camera which is now in
> the collection of the Ford Museum in Dearborn, Michigan
> . . . [But the Ford Museum camera is not entirely spurious.]

Information uncovered since this writing among the mass of uncat-
alogued material at the West Orange laboratory strengthens the
idea that this camera is more nearly entirely spurious than I had
thought. The J. Edgar Bull reference to a "reconstructed old cam-
era"[1] was the case in point. I had expected that the discovery of
the correspondence between Bull and Dyer, Edison's general coun-
sel, relating to this "reconstructed old camera," would obviate the
difficulty. But unfortunately the language of these letters is am-
biguous. And the difficulty is increased by the fact that many of
the letters refer to matter discussed in face-to-face or telephone
conversations, thus leaving no written record.

With the decision of the judge of the Circuit Court of Appeals
on March 10, 1902, the original Edison infringement suit had gone
against him. Judge Wheeler, in that suit, said:[2]

> It is obvious that Mr. Edison was not a pioneer in the
> large sense of the term, or in the more limited sense in which
> he would have been if he had also invented the film . . .
> Undoubtedly Mr. Edison . . . met all the conditions neces-
> sary for commercial success. This, however, did not entitle
> him . . . to a monopoly of all camera apparatus . . .

Reacting to this decision with the resilience customary to those
with substantial bank accounts, Edison looked about him late in
1903 for a new basis for reopening the case. He found such a basis
in a re-issue of the camera patent #12037, and he opened a suit
for the infringement of this patent in the United States Circuit
Court of the Southern District of New York. This suit was Equity
8289. He had previously sought a writ of *certiorari* from the United
States Supreme Court on the March 10, 1902 decision, but had

1 Hendricks, *op.cit.*, page 111.
2 I quote this decision more fully on pages 174-75 of *The Edison Motion
Picture Myth*.

been denied.[3] Bull, the new attorney,[4] suggested that the new suit should be based on an intermittent movement of the reel(!). He wrote Dyer on November 28, 1903 to that effect:[5]

> I urge upon you the desirability of having, as soon as possible, a demonstration made with the old apparatus, or apparatus like it, to determine the presence or absence of slack, as its presence would broadly differentiate from the prior art in the direction of both forms of defendant's apparatus, and, as far as I know, all other practical forms of moving picture machines.

But Dyer immediately replied that this would be impossible, as the intermittent movement of the reel was a "quite impracticable function"—a great understatement, and that "Edison shows a belt . . . for driving the sprocket wheels when the latter are released. If the reel moved intermittently this belt would be superfluous."[6]

An additional letter from Dyer on December 1 from the same file suggests to Bull that he try to get information from Dickson, "who is still in England."[7] He also said the following, bringing the matter of the "reconstructed old camera" immediately down to earth: "I have unearthed the original exhibits and find that the early camera is very fragmentary, but appears to be exactly like the patent." This letter appears to settle the matter, since neither the Ford Museum camera or anything like it was an exhibit in Equity 6928, but only the horizontal feed camera.[8]

[3] Defendant's Brief in the present case. This denial was recorded in 186US, 486.

[4] J. Edgar Bull was a prominent patent law expert and a long-time member of the firm of Gifford and Bull, New York. He appears not to have been, however, a member of any of the principal law associations, and efforts to locate his heirs (and possible additional material) through these media have failed. His *New York Times* obituary listed no survivors. His father was a professor at New York University, but inquiry there was fruitless.

[5] From the West Orange archives, X E 190-44 11.

[6] *Ibid.*

[7] This is curious. Herman Casler had said in his testimony in the previous case that Dickson, although no longer an employee of the American Mutoscope and Biograph Company, was still a director of that company. And Dyer was to say on January 11, 1904, in another letter to Bull, that the suit would be also effective against that company. We cannot be expected to think that Dickson would succour the enemies of his company. This proposal is typical of the self-assurance with which the Edison steam-roller moved in these early years of legal harassment.

[8] Edison Museum accession #E5477, illustrated in *The Edison Motion Picture Myth.*

Meanwhile Edison re-issue patent U.S. #12038, for film,[9] was pushed through the Patent Office by fair means and foul and the Edison forces reopened the case thereon.[10] The American Mutoscope and Biograph Company had filed a demurrer, and Judge Hazel, Bull wrote Dyer on December 17, 1903,[11] gave the Biograph attorney a time extension "to file an additional memoranda [sic] . . . Hazel as a judge is not very steadfast in his opinion, but I hope we will have the reissue granted . . . before he can decide the case one way or the other . . ." As I have said, the patent did not issue until January 12, but by January 8 Hazel had overruled the Biograph demurrer.

Meanwhile, models for use in the new suit were being built. These were built after U.S. #133394 issued to Waterbury on November 26, 1872, for a "Photographic Camera"; and after U.S. #284073 issued to Schlotterhoss on August 28, 1883, for "Photographic Exposing Apparatus." These had been cited in the case already in progress on re-issue patent #12037. It was decided to demonstrate before the court that they were irrelevant to the new Edison patent. Edison's expert witness testified on May 3, 1905

[9] The re-issue patent for the camera, #12037, had been applied for on June 10, 1902, after the anti-Edison decision of March 10, 1902. It had been allowed promptly on September 30, 1902. Section 4916 of *Revised Statutes* of the United States Patent Office states that:

> Whenever any patent is . . . invalid, by reason of a defective or insufficient specification, or by reason of the patentee claiming as his own invention or discovery more than he has a right to claim as new, if the error has arisen by inadvertence, accident, or mistake, and without any fraudulent or deceptive intention, the Commissioner shall, on the surrender of such patent and the payment of the duty required by law, cause a new patent . . . with the corrected specification, to be issued to the patentee . . .

Bull said in his brief that the difference between the line in the first application: "The film is suitably treated for developing and fixing the pictures, when it is ready for use in an exhibiting apparatus" and the line in the record: "The film is suitably treated for developing and fixing the pictures when positive prints therefrom . . . can be used in an exhibiting apparatus" was an "obvious and immaterial error."

[10] Dyer told Bull on December 12, 1903, that his "Washington contact" had seen the Examiner and had been assured "that the application can be put through without delay." On December 19 he wrote that the Examiner had "promised me the new re-issue application would be promptly allowed by him." On December 23 he was able to report that "Examiner Chapman . . . has passed the case to issue." The patent issued on January 12, 1904, and Edison had what he wanted—the legal basis for a new infringement suit. A personal relationship of this kind between an applicant's attorney and a Patent Office Examiner does not qualify for the legal definition of fraud and collusion. But from our perspective, and the standpoint of good ethical practice, each of these terms seems appropriate. Certainly no such thing would be done now in the Patent Office.

[11] X E 190-44-11.

157

to this effect. But he perjured himself when, in answer to the opposing attorney's question, "Have you ever constructed or attempted to construct an apparatus like that in the Waterbury patent?" he answered, "I certainly have not." Obviously the Waterbury model had been found to be practical within the sense of the patent, and the Edison attorneys were of course not going to tell anyone about this. Bull, eager to move ahead, asked Dyer on January 6 how the work on these models was progressing and was told that it was coming slowly.

The next item in the correspondence file directly relevant to the "reconstructed old camera" is an invoice dated March 11, 1904, for: "1 350' Negative Film, No Charge/Above film used in making picture of Mr. Heise[12] operating the first motion picture camera buildt [sic]."[13] The "first motion picture camera buildt" and certainly, according to everything any Edison witness ever said, similar to or identified with the horizontal-feed apparatus now on display in the Edison Museum in West Orange and illustrated in *The Edison Motion Picture Myth*. But there was no tension in this machine, and Bull spoke to Dyer some time later[14] of "the tension . . . as it was when we were photographing the camera in action." Assuming the 350' film described in the invoice of March 11, 1904 to have been the one referred to in this letter of March 15, 1905, showing Heise "operating the first motion picture camera buildt," we are faced with the inescapable conclusion that the Edison Museum machine was added to later, as I have suggested on page 190 of *The Edison Motion Picture Myth*.

On January 28, 1905, Bull wrote to Dyer that "the test of the model like the drawings of the patent in suit had been made and pictures successfully taken."! Dyer replied on January 30 that this was incorrect: that such pictures had not been taken and could not be taken until the machine was boxed in. And his language, furthermore, neatly excludes the possibility of the camera used for the trials being anything other than newly-made at this time: "A machine like the drawings of the patent has been made but no pictures have been taken with it, nor can they be taken since the machine is not boxed in."[15] The significant intermittent of the apparatus described in the patent is present in the Ford Museum camera, supporting the position that the Ford Museum camera is

12 Cf. pp. 99-100, *The Edison Motion Picture Myth*.
13 Excluding, of course, the early cylinder apparatus. This horizontal-feed device was called the first by all witnesses in Equity 6928, including Edison himself.
14 X E 190 file in the West Orange archives.
15 *Ibid.*

the one referred to as having just been built—or a camera like the one just built. If not identical, why was not the Ford Museum camera (given to Henry Ford about 1928) used for the trials, and not another built? This intermittent, incidentally, was described by Dickson in his 1911 testimony.

A most interesting sidelight on this intermittent (apparently gotten in the first place, as I have said on page 186 of *The Edison Motion Picture Myth*, from Hiscox' *507 Mechanical Movements*) is seen in the application for a "Series Photographic Camera" filed on July 16, 1895, and issued as U.S. #560424 to A.N.Petit on May 19, 1896. The intermittent described in this Petit application is a virtual parallel to that described in the Edison patent. Petit was closely connected with the laboratory and with Dickson in particular, as we have seen in the matter of the E.E.Cowherd letter (page 80). Dickson had left the laboratory three months earlier, and was certainly not amicably disposed toward the laboratory or its capitalizing on an invention he regarded as his own. May he not have suggested to Petit that he utilize this intermittent in a patent of his own?

The trials on the newly-built camera were apparently first held on Sunday, February 26, 1905.[16] Additional correspondence concerns the subject matter and the quality of the films exposed in the "model like the drawings of the patent in suit." That the 350' subject of the March 11, 1904 invoice was of a different camera than the one used for these trials is confirmed by the following sentence in a letter of March 16, 1905 from Dyer to Bull: "I have not critically examined the film showing the interior of the old camera . . ." It seems conclusive that language such as "the model like the drawings of the patent in suit" does not indicate an old camera, but one recently built. Dyer's "very fragmentary" exhibit from the first case was apparently the horizontal-feed camera used by Heise in the March 11, 1904, invoice subject, and another camera, or "reconstructed old camera," was built for the case now pending. Thus, the Ford Museum camera must be the "reconstructed old camera," *built*—and not "reconstructed" in any proper sense—in apparently early 1904 for this case.

Later references to "the old camera" may seem to indicate the feeling on the part of the writer that the camera being used for the trials was indeed an "old camera." But the specific statement in the January 30, 1905, letter, "A machine . . . has been made",

16 The March 12 letter said "Are you aware of the fact that you never sent me the film taken Sunday before last?" Since March 12 fell on a Sunday in 1905, "last Sunday" would be March 5, and "Sunday before last", February 26.

indicates that the use of the word "old" is rhetorical, and that at this time this camera was being thought of as old in design—in contrast to the current cameras with which all parties concerned were familiar, and that the word "old" was being used in a comparative sense. The present Ford Museum camera case adds credence to this position. It is of a "stylish" mahogany design quite unlikely for any of the early, rigidly functional motion picture work at the West Orange laboratory. No effort was spent in any of these early years to make any apparatus "beautiful," and surely the Ford Museum camera case is "beautiful."

The E.J.Meeker drawing of the Black Maria camera as it was shortly before June 1894 further indicates this (see page 26 and Illustration 48). This careful drawing bears many signs of at least partly on-the-spot sketching, and shows a plain case similar to those used for the Kinetoscope. The *Electrical World* drawing of June 16, 1894, seems to have been taken from the Meeker drawing, as a later drawing in *Cassell's Family Magazine* seems to have been taken (with considerable embellishment) from the *Electrical World* version. (I have discussed this matter in Chapter 3). The careful drawing by "EA" in *Frank Leslie's Popular Monthly* (see Illustration 9) adheres closely to the Meeker drawing, although it also must have been sketched on-the-spot. (What a fuss Antonia Dickson must have made about getting these right!) A sketch by Dyer at the bottom of a letter of May 15, 1905, is unilluminating.

In his May 9 letter Dyer said that "our very earliest cameras made use of a continuously operating sprocket between the film feeding mechanism and the take-up reel." On May 16 he wrote Bull that the machine which he then described "was constructed late in 1894 or as early as 1895 [sic]." On the sketch at the bottom he added "First machine without loop/Used Oct '94/Change made in 1894 or '95." His sketch is so inaccurate that I do not reproduce it here. And his statement that the "First machine" was "Used Oct '94" is so entirely wrong that it must be disregarded: many thousands of feet of film had been shot by October of 1894. The patent drawings preclude the possibility that he was referring to the first loopless camera as of October 1894, which is another example of the overriding confidence, perfunctoriness and bluffing which characterized much of the Edison legal methods. This perfunctoriness was referred to in the Defendant's Brief in this case (Equity 8289, U.S. Circuit Court of Appeals for the Second Circuit) as follows:

> It is highly significant of the perfunctory manner in which complainant has conducted his case that [the plaintiff's expert witness, saying that the old Edison camera could take at least twenty pictures per second] should

have apparently never read the testimony of his fellow expert, Mr. Dyer [who said in Equity 6928 that seven per second was too slow, but in the present case] his views had undergone a complete revision [and he said the speed could be] 7 per second.

This looseness did not stand up in court, as did neither the looseness of the earlier suit (see *The Edison Motion Picture Myth*, page 37). Judge Ray had ruled against Edison by March 26, 1906. Bull called Ray's opinion "fool reasoning" and "messy," and had predicted that it would be "a weak one [on whatever side it is written]." The Edison attorneys could have waited for a Judge Platt, Bull wrote Dyer on February 5, but Platt would have been even "worse" than Ray. Undaunted, the Edison legal forces rolled forward and continued to harass the whole industry until the Motion Picture Patents Company was overthrown by the United States Supreme Court (see Note 13, page 163).

* * * *

The present day visitor to the Edison exhibit at the Ford Museum will see a polished hardwood, ornamented box *circa* 23½" x 18¼" x 17½". The left side of the box (facing the lens) slides upward by means of an engaged handle. It reveals a mechanism which, although it may contain elements of the Black Maria camera, certainly contains many elements which have nothing to do with the Black Maria. It also contains many elements which must have been assembled for legal purposes. See illustration in *The Edison Motion Picture Myth*.

He will see a long brass-tubed telescopic lens for critical focus (marked "3 in 12°/R.& J.Beck") and will look in vain for a suggestion of such a lens in the Meeker or "EA" drawings. He will see film reel elements quite beyond science for 1894. He will see the suggestion of a seat for a counter, in a hole through the top of the box, but he will have difficulty in coinciding this arrangement with the Black Maria camera sketches. He will see a heavy iron L-shaped base plate with many holes in it—some used and some unused. This plate he may ascribe to the original camera: certainly such a plate would have neither been lightly discarded (after use in an earlier camera) or lightly made (for legal purposes). But who will say that it could not have been used in one of a myriad other places in the laboratory?

As he faces the camera from the rear, he will see the ends of two shafts, one of which may or may not have been intended for use with a crank. He will also see brass posts for power inlet, but will have difficulty seeing how such power could have operated the

mechanism, since there is no provision made inside for a connection. If he examines the gears he will find them virtually perfect, and will have no difficulty whatever in excluding them from the Black Maria camera or from any but the sparest use in *any* camera.[17]

APPENDIX D · *The Chinnock Kinetoscope*

Charles E. Chinnock (1845-1915, see Illustration 60), formerly an Edison associate but now bitterly disenchanted, also tried *his* hand during these months with a considerably different sort of peep-hole exhibitor.

On May 5, 1911, Joseph F. McCoy, then employed by Thomas Edison, testified as follows in Equity 5/167:

> [In '95, '96 and '97 I was] connected with William Wilson of Philadelphia, who was operating automatic phonograph and motion picture machines. Among the machines which were exhibited by us in Philadelphia, Atlantic City, and other places in the United States during this period, were machines for the direct view exhibition of motion pictures, known as the Chinnock Kinetoscopes, which were manufactured and sold by Charles E. Chinnock of Brooklyn or New York. These machines were well known to everyone connected with the business of exhibiting motion pictures, and were somewhat extensively sold and used, at least in the eastern part of the United States. They were advertised and pushed to a considerable extent, and I believe that everyone of prominence in the business knew that such machines were being marketed and used, and these facts are still known to the trade generally.

It is the story of this Chinnock Kinetoscope and the motion picture camera which supplied it with which this Appendix is concerned.

The Chinnock contribution may be said to have begun when Chinnock visited a Kinetoscope parlor. This parlor must have been the one at 1155 Broadway.[1] It is also likely that Chinnock felt an

[17] I am grateful to Mr. Frank Davis, Curator of Communications at the Ford Museum, for having noticed the condition of these gears. Mr. Davis and I have had many pleasant talks about the Edison apparatus at the Ford Museum. He is a notable exception to many museum curators, who sometimes great outside study with an almost petulant skepticism—particularly when that study may vitiate the strength of an exhibit.

[1] Chinnock himself (in his May 9, 1911 testimony in the case cited) said that this was "in the spring of 1894." Since the 1155 parlor was the only one operating in the spring, and since it is natural that Chinnock, although he may be slightly in error concerning the time, would have wanted to see the Kinetoscope as soon as possible, I assume both spring and 1155 Broadway.

urge to compete with Edison for more than commercial reasons. He must have felt considerable rancor about the Patent Office decision in Interference 13569—Edison vs. Chinnock vs. Wheeler.[2] This is whether or not he knew that the pro-Edison decision in the case had been largely the result of Dickson testimony which we can only assume was perjured.[3] Chinnock was also a man of vigorous enterprise. He turned to a fellow member of the Brooklyn Chess Club, Frank D. Maltby, the owner and operator of a machine shop at 18 Columbia Heights in Brooklyn,[4] and asked Maltby to build a motion picture camera.

Maltby had begun business in, possibly, May of 1893.[5] His establishment was a characteristic part of the great scientific revolution then sweeping America—automating industry far beyond the capacity of society to consume the products of that automation.[6] His shop on Columbia Heights was a typical example of many such throughout America at the time. The Edison laboratory at West Orange was perhaps the most prominent example of these. Each gathered unto itself a collection of machinists, designers, etc., equipped to handle proposals such as this one by Chinnock.

Chinnock visited the shop, talked over the matter with his friend Maltby and, "shortly after June or July," repaired to Madison, New Jersey for the summer. While at Madison he sketched plans for the camera. He also worked on "the idea of showing . . . a Kinetoscope that I had partially figured out."[7] That he instituted the work on the camera at the Maltby shop in September 1894 appears certain. According to the testimony of one of Maltby's employees, Henry C. Lohman, shop workmen were just starting to build the camera when he first saw it, and this was one-and-a-half to two months after he began working at Maltby's, which was, he said, "the latter part of July or fore part of August, 1894."[8] Chinnock himself said that it was before October 1, and Charles Pearson,

2 This was for an "Improvement in Systems of Electric Lighting." Chinnock's application had been filed on December 9, 1886 and Edison's on December 12, 1883. It was settled in favor of Edison on March 28, 1893.

3 Page 155 of *The Edison Motion Picture Myth.*

4 According to the testimony in the case cited. The 1895 Brooklyn directory lists Maltby's shop at 18 Columbia Heights; the present site is occupied by the Squibb laboratories.

5 According to his testimony in *ibid.*

6 This late-19th-century crisis in over-supply is said by many to have been a major cause of the 1893 depression.

7 This is according to the Chinnock testimony on May 9, 1911. That the sketches were made in Madison is also indicated by the testimony of Chinnock's son Alvah.

8 May 11, 1911 in case cited.

who startéd work at Maltby's in September or October, appears
to have done his first Maltby work on the Chinnock camera.[9]
When the work started Chinnock was secretive about what it
was. Maltby[10] testified that Chinnock

> seemed to be a little reticent at first explaining what it was,
> but after he got it started, I said to him "I know what
> you're making", he says, "What is it?" I said, "You're
> making a picture machine". "Well", he says, "keep it to
> yourself".

The camera took about two months to build.[11] It was a most
interesting machine (see Illustration 58). Although its use of the
loop was its relating characteristic in the Motion Picture Patents
Company suit, Equity 5/167, it contained other interesting points.
It was brought from the basement of the Chinnock house in
Brooklyn when the Independent Motion Picture Company, one of
the many motion picture makers being crushed by the Patents
Company trust, had become aware of these early Chinnock opera-
tions.[12] The Patents Company suit alleged infringement of the
Latham patent, which had now, through the Biograph Company,
become the property of the Patents Company.[13] The Independent
Motion Picture Company case had been handled by a Chicago
attorney, but the New York firm of Kenyon and Kenyon entered
the case on the side of the defendant, and their associate Eyre
knew of Chinnock's work.

When Chinnock was approached by Eyre he looked in his base-
ment and found his 1894 camera. Eyre then located Maltby in
Battle Creek, Michigan and the others, who had become dispersed.

The testimony concerning the camera is substantial and consist-
ent. The camera had: 1, a positively-driven feed below the film
support to feed the film and produce a slack; 2, an intermittent
below the exposure window to move this slack across this window;
and 3, a slack or loop below this intermittent with a spring arm
to take up the slack so that the film would be drawn firmly through

[9] Chinnock and Pearson testimony in *ibid.*
[10] *Ibid.*
[11] According to the testimony of Chinnock, Charles O. Pearson, William
Edge, Maltby and, by inference, the testimony of Robert T. Moore, Herbert
C. Barnes, James W. Lahey and Alvah Chinnock.
[12] *Ibid.*
[13] The Patents Company litigation ended in 1916 when the United States
Supreme Court held, in a distinguished opinion, that although a patent is a
legal monopoly of the patentee for the use of an invention, a combination of
patents constitute a trust and is therefore in violation of the law. Judge
Learned Hand had, incidentally, in one of the early eloquent opinions of his
career, pointed the way to this high court decision.

164

the intermittent and into the take-up device. Jesse W. Smith, the defendant's expert witness testified that:

> [If present exhibit were new, with shutter, lens, light-tight box, operating to take 10-30 pictures per second on a strip of film] and that in taking such pictures the machine was adjusted so that when the clamp or platen was released the lower . . . rolls would take up substantially the entire loop or slack that had been formed above the clamp or platen while the same was clamping the film, [it would contain] every substantial feature of the Latham apparatus and operated on the same principle.

The majority of the court agreed with this opinion. The single dissenting judge, however, had this to say:[14]

> The Chinnock camera, assuming it to have been completed and operative prior to the Latham invention . . . does not anticipate for reasons similar to those just above stated [i.e., no sprockets, regular advance, etc.] regarding the Marcy[15] camera. The film is advanced by continuously driven friction rolls, and is arrested and released by a clamp intermittently operated . . . There is also a pair of friction rolls below the exposure opening; they are of a greater diameter than the upper rolls and revolve at a higher speed but are arranged to slip over the film when it is clamped. The function of these rollers is to pull down a certain amount of film and they are, therefore, made larger in diameter and are driven at a higher speed. With the addition of these rolls, the Chinnock device is substantially similar to the Marcy device. It does not have the essential features of the Latham invention, as before pointed out, viz., the loop of slack film produced by the film-feeding mechanism operated by continuously rotating sprockets together with an intermittently operating sprocket which feeds the slack across the exposure window . . .

The presence and location of the loop in the Chinnock camera were described by a number of witnesses who had to do with its construction. First Chinnock himself:[16]

> There is a gate with an opening in it . . . that corresponded with the size of the pictures. This gate was clamped in by a cam or moved out by a cam and would spring in at certain intervals and hold the film a certain length of time; while these pictures were taken the film was being drawn off the reel and it would then be held while the

14 From page 3414 of Volume 6 of the complainant's record.
15 Sic. *I.e.*, Jules Étienne *Marey*, the distinguished French physiologist and motion picture pioneer.
16 Equity 5/167.

picture was taken and the film would form a loop or a length which would correspond with the length of the picture . . .

Then Charles O. Pearson:[17]

> The film runs down from a reel mounted on top of the camera, between 2 feeding rollers over a frame in between the clamp, then it runs back to lower pair of feeding rollers which travels faster than the upper rollers so that while the clamp held the film tight a loop was formed on the top and when the clamp is released the loop was taken up by the lower rollers . . .

Then William Edge:[18] "I remember the loop more distinctly than anything else. The loop formed up there just before the movement that stopped the pictures." Then, William A. Hollman:[19]

> . . . he [i.e., Chinnock] showed me some difficulty he had in the breaking of the film and that's why I suggested the releasing of the tension . . . from the supply roll . . . he came in to the office very downhearted after consulting with my partner Mr. Maltby and not getting any relief to overcome the breaking he appealed to me, saying, Mr. Hollman what do you know about this, I thought he was joking and answered him Not Much, as I did not know what he really meant. After explaining to me what his troubles were I suggested the relieving spring . . .

Finally Maltby himself:[20] "There was a loop formed between the delivery reel and the stop plate . . ."

The testimony regarding the loop is presented fully because it was significant in overcoming the alleging of the Latham patent infringement—an historic occasion in motion picture history. Many claims for priority have been made for a film loop between the feed reel and the film gate in motion picture cameras.[21]

The Chinnock camera was an effective camera because it did what it was intended to do—make motion pictures for the Chinnock Kinetoscope. This Kinetoscope is described by Chinnock:[22]

> The kinetoscope was modelled after the plan of the kinetoscope that I saw as a boy with the exception that my

17 *Ibid.*
18 *Ibid.*
19 *Ibid.*
20 *Ibid.*
21 Ramsaye gives Rector the credit on his page 125. The Patents Company gave the credit to Latham, but the credit for this suggestion is very beclouded. The loop was used by Marey and Friese-Greene and was probably introduced into the Latham work by either Lauste or Dickson.
22 *Ibid.*

kinetoscope had photographs, whereas the others that I
refer to were simply painted. My kinetoscope consisted of
a drum mounted on a shaft, the shaft having a groove cut
longitudinally from end to end . . . that forced the drum
to travel from end to end and back again to the original
position. On this drum was wound a canvas having on the
face of it the photographs . . . No. 1 picture would run
spirally around this drum and would be an inch wide and
the groove in the shaft was an inch wide, consequently
when the drum started to revolve and the peep hole re-
volved in the reverse direction each picture would come
before the eye . . . [The electric light was] Intercepted
by the shutter . . . In the form of a cylinder, a duplicate
of the drum only larger, in diameter and very much nar-
rower in width, the width being sufficient to cover the eye
so that it would be possible only to see one picture at a
time looking at it naturally.

The wide excursion of the Chinnock Kinetoscope is established.
Joseph F. McCoy had stated that the Chinnock Kinetoscopes were
"well known to everyone connected with the business of exhibiting
motion pictures, and were somewhat extensively sold and used, at
least in the eastern part of the United States." George Scull, prom-
inent in Motion Picture Patents Company affairs, agreed with this.
But in spite of this extensive use I have been unable to find a
Chinnock Kinetoscope, and so am unable to illustrate it here.
But the reader is invited to examine three patents which describe
similar apparatus: Brown, U.S. #552410; Demeny, British #15709
of 1892 and 12794 of 1893; and Hough, British #9881 of 1895.
Hough is the man who had much to do with the exploitation of
the Edison Kinetoscope in Europe, and who infuriated Edison by
imitating it (see page 169).

The Chinnock Kinetoscope was being used regularly early in
1895 to show motion pictures taken by the Chinnock camera. Pro-
duction of these subjects began before Christmas of 1894 and
continued well into 1895. Chinnock said that many people saw
these motion pictures before Christmas of 1894; Robert T. Moore
(a nephew of Chinnock who was also a boxer in one of the sub-
jects) said that his subject was shot "about the middle of Novem-
ber"; Alvah Chinnock said that it occurred "positively" before
Christmas; James W. Lahey, the other of the two boxers, said that
it was in the fall of 1894: "It might have been the latter part of
November or in December"; Herbert C. Barnes said "I saw pictures
. . . before cold weather of winter of '94."

The films were developed at the Chinnock house at 157 Sixth

Avenue in Brooklyn.[23] The James Lahey testimony indicates this:
". . . A rear room on top floor and from that rear room there were
two small rooms or a passage they had a sink in each one and
a closet in the back, a ward robe." Alvah Chinnock said that the
printing was done on the roof of the Sixth Avenue house, and
Robert T. Moore told of watching Chinnock develop the pictures.
Chinnock said that the photographs were cut into 12-inch strips
for developing, each length numbered, pasted on paper which was
also numbered, and then pasted on a strip of canvas and wound
around the drum of the Kinetoscope.[24]

It appears that the first "official" Chinnock subject was the
boxing match mentioned above. It was shot on the roof of a
building at the rear of 1729 St. Marks Avenue, Brooklyn.[25] Accord-
ing to the Lahey testimony a fence was built on the roof "to afford
us privacy in taking pictures, and a platform for the subject we
wanted to take, and right across from the platform we had a small
house built." This "small house" was apparently for the camera,
like the house built for the Biograph camera on the roof of 841
Broadway (see my *Beginnings of the Biograph*). Lahey further
testified that "[we "sewed together"] a large piece of cloth . . .
and [used] hooks to hang it up." This must have been a back-
drop. The camera was in a wooden case painted black, and had
an overall weight of 40 to 50 pounds[26]—an interesting contrast to
the ponderousness of the Black Maria machine. It was apparently
usually operated by Chinnock himself.[27]

The source of the film for the pre-Christmas boxing subject is
obscure, but with the production season described by Chinnock
as beginning in January, the film was bought from Charles W.
Smith, a "mercantile photographer," who ordered it on January 8,
1895, from Eastman. It was in the form of 15 spools of 50-foot
film 1 31/32" wide.[28]

23 Stenographic errors in the record occasionally made this 167 Sixth Avenue.
An examination of the Brooklyn directories of the time shows 157 to be cor-
rect. The house is still standing. I spoke to the owner on October 18, 1962, and
was told that there was a sink in the top floor rear, but I did not examine it.
 24 *Ibid.*
 25 I visited this address on May 27, 1957, and found that all structures
possibly dating from this time had disappeared. 1721 was previously a laundry
and extends back to the property line, which seems to exclude the possibility
of any rear building being still in existence.
 26 James W. Lahey testimony in *ibid.*
 27 Chinnock testimony in *ibid.*
 28 This is according to Charles Smith's testimony and an Eastman stipula-
tion, in *ibid.* The Wyatt Brummitt data (see my *The Edison Motion Picture
Myth*) shows that Eastman billed Smith for 15 rolls of 1 31/32" x 50' film
on January 9, 1895; 2 rolls of 2" x 100' film June 4; 6 rolls of 2" x 50'

Although the boxing pictures were processed at Chinnock's home, later films were processed in a laboratory set up beneath the stage where the subjects were shot.[29] This developing room, Lahey testified, had a dark room and several porcelain sinks.

Later productions were of the Claflin sisters,[30] a "boxing bout of McDermott and somebody else I can't recall his name,"[31] a dancer named May Jewell,[32] a cock fight,[33] a "couchee Couchee dance,"[34] a subject called "The Gamesters,"[35] one called "Casey at the Bat,"[36] a blacksmith shop,[37] and one of Ruth Dennis,[38] who had been photographed in the Black Maria a few months before.

A recent satisfying collaboration of the Chinnock venture is contained in a letter Miss St. Denis wrote on February 18, 1959, to Mr. George Pratt of the Eastman House. I quote excerpts from this letter through the courtesy of Mr. Pratt and by permission of Miss St. Denis:

> All I can remember of my first "motion picture experience" . . . is the following:
> Our scene is a roof top, I think in Brooklyn. My mother and I . . . had been summoned by someone making pictures that had motion. For many years out of this brief but momentous occasion, I kept a few frames of the print of this dance that was taken at that time . . .
> My hair was brown, and curled to my shoulders. Of course we had no music, so mother must have provided the accompaniment by humming some Spanish tune or something approximate.
> Anyway, this event did take place and I do remember it . . .

Mr. Pratt, asking Miss St. Denis for her memories of the Black Maria, recalled to her what must have been the Chinnock production at 1721 St. Marks Avenue in Brooklyn. It was apparently not

film June 18; 6 rolls of 2″ x 72′ film August 23; 12 rolls of 2″ x 90′ film October 29; and 12 rolls of 2″ x 72′ film November 16.

29 Chinnock testimony in *ibid.*

30 Lahey and Chinnock testimony in *ibid.* The *Boston Evening Transcript* of August 12, 1895, referred to the Claflin Sisters as dancers "of the skirt and kicking order." I have not investigated the itineraries of these Chinnock performers to determine whether or not they coincide with this testimony.

31 Lahey and Charles Chinnock testimony in *ibid.*

32 Lahey and Charles Chinnock testimony in *ibid.*

33 Chinnock testimony in *ibid.*

34 Lahey testimony in *ibid.* Maltby called this an "Egyptian Muscle dancer."

35 *Ibid., loc. cit.*

36 *Ibid., loc. cit.*

37 Maltby testimony in *ibid.*

38 Charles E. Chinnock and Lahey testimony in *ibid.* Lahey called it a dance by "Ruth St. Dennis [sic]." Miss St. Denis had become, by the time of this 1911 testimony, a famous dancer under the new name.

the Black Maria shooting at all: her memory of "Brooklyn" *may* not exclude the Black Maria, but "roof top" surely does.

Chinnock made other cameras and other Kinetoscopes and continued production possibly through August of 1895. He said that he made three cameras, one of which went to England in June of 1895 to Justin Hough. Hough had already begun to imitate the Edison Kinetoscope, and was now in the process of patenting a Kinetoscope of his own. This Kinetoscope was too close to the Chinnock apparatus to have been only a coincidence.

Hough and Werner—who also got a camera from Chinnock for use in France—were themselves, according to Chinnock's testimony, taken in a motion picture subject. I have not included it in the above list since it seems likely that it was a test, just as the Dyer and Waterman test described on page 157, the Dickson and Heise film illustrated in *The Edison Motion Picture Myth,* and the Marvin and Casler film illustrated in *Beginnings of the Biograph,* were also tests. Alvah Chinnock wrote the Werner and Hough agreement, and this was signed on May 3, 1895.[39] This agreement activated the North American Kinetoscope Company, which exhibited the Chinnock Kinetoscope.

Chinnock testified that his Kinetoscope was soon being exhibited on the Iron Pier in Coney Island and "after 15 or 16 years was actually working." But the first Chinnock Kinetoscope was placed in the saloon of a Val Schmidt on Fulton Street near the Brooklyn Bridge in Brooklyn.[40] It took in $40 in three days, of which 30% was given to Schmidt.[41] The next machine was placed in King's Hotel in Canarsie. Another was placed in Gerkins, a cafe at the corner of Church and Cortlandt Streets in New York City. Several others were placed in Manhattan in Huber's Museum, in the Eden Musée (see page 90), in the Putnam House Hotel at Fourth Avenue near Madison Square Garden, and in Bader's Hotel on Cortlandt Street near the ferry.[42]

There can be no doubt that the Chinnock-sponsored motion picture venture, though isolated, was a positive contribution to the beginnings of the American motion picture. Several effective cameras were built and a number of subjects taken and exhibited widely during the first crucial years. And there can be no doubt also that these exhibitions materially added to—and satisfied public demand for—motion picture entertainment.

[39] Alvah Chinnock testimony in *ibid.*
[40] According to Chinnock's testimony. The Brooklyn directory for the year ending May 1, 1895 lists no saloon under the name of Val Schmidt, but locates a "Valentine Schmidt, barkeeper" at home at 509 Marcy Avenue.
[41] Lahey testimony in *ibid.*
[42] *Ibid., loc. cit.*

Index

[1] I have tried to make this an exhaustive list of all motion picture subjects known to have been shot for the Edison and Chinnock Kinetoscopes, for experimental or miscellaneous purposes by Edison, or, insofar as this work is concerned, for projection by Edison. Not all the subjects listed were used. The problem of nomenclature has been enormous, and my reasons for creating new titles and parts of titles (which I have always put in brackets) are too complex for discussion here. Every unbracketed title is one I have found in contemporary material: some of these I have left intact, others I have added to—particularly, when this was known, the names of the participants. A later *Index* willfurther analyze these works and their nomenclature.

[2] I have not yet determined, as I stated on page 47, what these "Records" were. Surely some are titles elsewhere in this list.

182

Beginnings of the Biograph

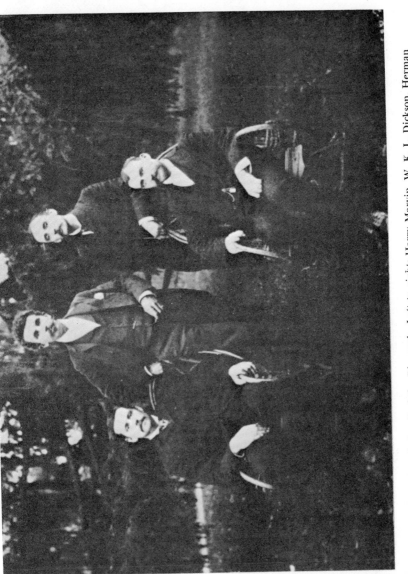

The "four fathers" of the Biograph. *Left to right*: Harry Marvin, W. K. L. Dickson, Herman Casler and Elias Koopman on the lawn of "The Evergreens," Marvin's mother-in-law's house on North Peterboro Street in Canastota, New York, September 22 1895. (The top of "Sep." and "2" can be seen here.) (*See page 22*). From the author's collection.

BEGINNINGS
of the
BIOGRAPH

The Story of the Invention of the
Mutoscope and the Biograph and Their
Supplying Camera

by

Gordon Hendricks

The Beginnings of the American Film
New York, New York
1964

To the vision of those who founded
and the devotion of those who sustain
THE REFERENCE DEPARTMENT
OF THE
NEW YORK PUBLIC LIBRARY

Preface

THIS IS THE SECOND IN A SERIES OF BOOKS DESIGNED TO INVESTI-
gate the beginnings of the American film. The first, *The Edison
Motion Picture Myth,* discussed the work at the Edison West
Orange laboratory up to the fall of 1892, and a forthcoming
book will continue that story—the story of the Kinetoscope—
to the beginnings of Edison-sponsored projection. The present
book takes up the story late in 1894, in New York City and
Syracuse, when W. K. L. Dickson's contact with Harry Marvin,
Elias Koopman and Herman Casler resulted in a remarkable
motion picture camera, a projector and a peep-hole exhibiting
machine. It is the story of the work of these men into the
season of 1896-97 that forms the substance of *Beginnings of
the Biograph.*

I have been substantially helped in this work by several im-
mediate descendants of Casler, Dickson and Marvin: the Misses
Elsie and Allene Archer, grandnieces of the first Mrs. Dickson;
Messrs. Harry and Roger Casler, sons of Herman Casler; and
Mrs. Marguerite Marvin Smith, daughter, Mr. Robert Marvin,
son, and Mrs. Kenneth Marvin, daughter-in-law, of Harry
Marvin.

I am again heavily in the debt of Mr. Beaumont Newhall,
Director of the George Eastman House in Rochester, New
York, for his continuous intelligent encouragement, and to
Messrs. James Card and George Pratt of the Eastman House.

I am also grateful to Mrs. Ethel Bitzer, widow of the famous
Billy Bitzer, early Biograph cameraman and projectionist, who
has very kindly allowed me to quote freely—for the first time
—from her late husband's notes.

I am also grateful to Mr. Arthur Steiger of the Museum of
Modern Art for his enthusiastic help, to the Film Library of

the Museum for allowing the use of early film, and to Mr. Bernard Karpel, Librarian of the Museum, for the free use of the Library's Biograph material.

I am grateful to others who have helped me in the preparation of *Beginnings of the Biograph*: Messrs. E. D. Carter and P. J. Federico of the United States Patent Office; Mrs. Helen Chariton, Librarian of the Canastota Public Library (who brings graciousness and enthusiasm to a job which must be often frustrating), Mr. and Mrs. Kirk Delano of Canastota for many kindnesses, Miss Alice Dailey, and Messrs. James Chapman and Harry Swanker of Canastota; Mr. William Finn, Jr., of Clifton, New Jersey; Dr. Sidney Foreman of the United States Military Academy Library; Messrs. H. A. Pierce (Mr. Pierce's gift of time and material has enriched my study) and Earl Fish—both of Syracuse (I remember with nostalgia an evening at the Liederkranz Club in Syracuse with Mr. Pierce and Mr. Fish); Mr. Henry J. Lanier, Jr., of the Chemical Bank New York Trust Company; Mr. Eugene Ostroff of the Smithsonian Institution; Miss Genevieve Oswald of the New York Public Library; Miss Frances C. Seguin, Madison County Recorder of Deeds, Wampsville, New York; Mr. Alfred Sergio of the Brooklyn Technical High School; Mr. George Tracktir of Pictorial Laboratories, New York; Miss Marjorie F. Williams of the Niagara Falls Historical Society; and to others whom I may have omitted.

I am also grateful to the following for the use of copyrighted material:

> The Society of Motion Picture and Television Engineers for quotations from their *Journal*.

> Simon and Schuster, New York, for quotations from Terry Ramsaye's *A Million and One Nights*.

I hope that this book will help illuminate, with a minimum of error, a beclouded subject. I have tried to reduce such error by presenting as many original sources as possible, so that the reader may see how I have reached such conclusions as I have —and may, if he feels so impelled, form his own differences. Much remains to be done, but I hope that *Beginnings of the Biograph* will be another step.

G. H.

Contents

Illustrations

1 · The Beginnings

THE BIOGRAPH WORK WAS ONE OF THE MOST IMPORTANT IN THE history of American film origins. It resulted, some years later, chiefly through the work of D. W. Griffith, in much of the art of the motion picture. In this way it is the most significant of all.

W. K. L. Dickson,[1] after giving his skill and industry to the commencement of the "Edison" motion picture, left Edison on April 2 1895 and soon found himself with Herman Casler, Harry Marvin and Elias Koopman, engaged in the fortunes of the American Mutoscope Company. From this company came the Mutoscope, Biograph, and many of the blessings of art and industry with which we are familiar.

Claims for preëminence in the initiation of these blessings have been made for Edison (by himself and the many who ascribe all famous acts to famous people), for Marvin (chiefly by himself and his descendants), for Casler (chiefly by his descendants), and for Dickson—whose case has not been examined until now. Dickson himself has not helped his case by vacillation between his own case and Edison's (see *The Edison Motion Picture Myth*).

Dickson was excluded from the official record of the patents by the necessity for being legally detached from Biograph invention. If he had not been so detached, Edison's attacks

[1] See Hendricks: *The Edison Motion Picture Myth*, University of California, 1961. See also Appendix B of this book.

would have been even more virulent than they were: as it was, they harassed the entire young industry for many years with subterfuge after subterfuge. But if Dickson had been the patentee of the devices upon which the American Mutoscope Company based its fortunes, he, because of his former association with Edison, may have been quite prevented from using these patents. The sturdy young Biograph organization would have been nipped in embryo.

But after Edison's death in 1931, Dickson made his claims more freely. And in 1933, when asked by the Society of Motion Picture Engineers to set down his own story of what had happened at the Edison laboratory, he ended his account with an unequivocating claim for the invention of the Mutoscope. He said that he had initiated the Biograph venture and he appears to be correct. His chronology is inaccurate but his intent is clear:[2]

> In conclusion, when I left Mr. Edison's laboratory in 1895, having accomplished the problems assigned to me, I joined my friends Messrs. H. N. Marvin, E. B. Koopman, and Herman Casler to carry out a new method of reproducing motion by means of a pack of cards, which I had devised shortly after I had left Mr. Edison. This device we called the "Mutoscope."

Dickson's claim to have devised the Mutoscope is supported by Harry Marvin. Marvin's memory is recorded on page 211ff. of Terry Ramsaye, *A Million and One Nights* (Simon and Schuster, New York, 1926):

> Some time in 1894 or early '95, about the time that Dickson was growing uncomfortable in his seat at the Edison Laboratory, if one is to judge by the evidence of subsequent dates, he wrote a letter to Marvin concerning the Kinetoscope and the possibility of some small simple device which could be made to show cheaply the final punch and knockout of a prize fight. . . .

[2] *Journal of the Society of Motion Picture Engineers*, December 1933. An editor's note in this issue contains two errors: first, the "K.M.C.D." is said to be "sometimes known" as "the Biograph Co." and "was formed in the summer of 1896," but the "K.M.C.D." was formed in 1895 (see page 24) and "K.M.C.D." and "Biograph Co." are not interchangeable terms; second, the note follows other errors in saying that the "first commercial showing was on Oct. 13, [sic] 1896, at Hammerstein's Olympic Music Hall" (see page 48).

It seemed to be Dickson's idea that a little novelty of some sort could be made for popular sale. In line with this he evolved and suggested to Marvin a method of putting pictures on a book of cards, the pages of which would be flipped to present the successive pictures and an illusion of motion to the eye. To illustrate it, Dickson made up an experimental pack of cards and drew a series of crosses in varying positions on them. When the cards were thumbed the cross seemed to whirl and dance.

Marvin tinkered with the idea a bit and improved on Dickson's hand drawn pictorial effort of a whirling cross, by stamping the cards with a rubber stamp bearing a figure "1." It gave a better image.[3]

Marvin was then, in 1895, associated with Herman Casler, a machinist from the Edison General Electric Company at Schenectady, in the Marvin & Casler Company of Canastota, New York, devoted to the making of machines of various types.[4]

Marvin passed along the idea to Casler, who worked out the notion of making the pack of cards into a whole wheel of cards bearing pictures, to be turned by a crank and presenting a long sequence of action.

Dickson, Marvin, and Casler were all sure that this idea had a fortune in it. But it was going to need financing for the building of the machines required. The peep show Kinetoscope was prospering,[5] and here there appeared to be a possibility of a device which would eliminate the costly batteries and films of the Edison invention.

Marvin chanced upon his friend, E. B. Koopman of the Magic Introduction Company, 841 Broadway, and engaged him in a street conversation on the project.[6] Koopman was

[3] My study of Marvin had led me to believe that the story of his contribution to the motion picture loses nothing in the retelling. The "improvement" described here seems dubious.

[4] This sentence is a *tour de force* of error: 1, the proposal could not have been made in 1895 since a Mutoscope had already been built in November 1894; 2, to call Casler only a "machinist" is a gross understatement; 3, Casler was in no sense "from the Edison General Electric Company," since he had worked only several months in Schenectady and by 1895 had for at least two years (at the time of a January 10 1893 patent application he was a resident of Syracuse) been living in Syracuse, where he still lived well into 1895: it is much more proper to say that he was "with" the noteworthy C. E. Lipe Company—as he was, in a sense closely similar to that in which Dickson was with the Edison laboratory; 4, several months were still to come before the Marvin and Casler Company came into existence (see page 44)—it had not yet been dreamed of when the Mutoscope and motion picture camera ideas were born.

[5] Ramsaye contradicts his own source here. The Raff and Gammon/Kinetoscope Company records in the Baker Library of Harvard University are filled with complaints beginning early in 1895 of the failing Kinetoscope business. It was this failing that led Raff and Gammon and others to strain toward projection.

[6] Again, since Marvin is telling the story for Ramsaye, he would make Koopman *his* friend. But there appears to be no reason for Marvin to have known

4

thrilled with interest. He had a flair for novelties. He was then engaged in the promotion and sale of his own patented pocket lighter and lamp [see page 32], a pocket savings bank, and various other devices. Also he had been selling[7] a top kinetoscopic machine called the Viviscope, an improved Zoetrope[8] into which various bands of printed pictures could be inserted. This had educated him to the motion picture idea.[9]

Koopman watched Marvin flick the little book of cards with the spinning, dancing figure "1" on it, and then and there agreed to finance the project.[10]

The K.M.C.D. Syndicate was formed,[11] taking its name from the founders, Koopman, Marvin, Casler, Dickson.

Ramsaye's account, though full of error, seems to have come directly from Marvin, who would certainly have been in a position to know—and to have been very much interested in knowing—what the origin of the Mutoscope proposal was. Given Marvin's inclination to credit himself with possibly more work than he did, there seems to be no reason for his crediting Dickson with the Mutoscope idea unless Dickson deserved to be credited.

The Elias Koopman[12] idea of using the Mutoscope as a means of showing machinery in motion, and thus selling it to

Koopman except through either Dickson or Casler, whose "Photoret" Koopman was handling. (See page 21.) Furthermore, the Magic Introduction Company, at this time, was not at 841 Broadway, but at 321 Broadway. The business had not moved to 841 Broadway even when the American Mutoscope Company set up its office at that address some months later.

[7] But had not invented. The patent was W. C. Farnum's, issued October 15 1895 as U.S. #547775. The movement of the picture bands in this apparatus was intermittent, and accomplished by the novel and interesting means described in the second paragraph of the printed patent. The reader is also directed to an article on this device in the *Scientific American* of June 20 1896 which illustrates this "Viviscope." Although the *Scientific American* calls the toy "ingenious," it fails to credit Farnum with its invention, and merely mentions Koopman, 33 Union Square, New York, as its manufacturer. I have been unable to find a Viviscope in any of the large toy collections I have examined.

[8] Not at all a Zoetrope. The essence of the Viviscope was that its pictures were presented by an intermittent movement, while a chief characteristic of the Zoetrope was its lack of intermittency.

[9] Much more likely he had been "educated to the motion picture idea" by the Kinetoscope, which, by the time Koopman met Casler with the Mutoscope proposition, was well known in New York.

[10] How fortunate it was for the American film industry that Marvin happened to have the little book of cards with him!

[11] Not until many months afterward (see page 24).

[12] Koopman was a suicide in 1929 (see the *New York Times* of August 24 1929)—leaving behind a real contribution to the beginnings of the American film.

manufacturers for their sales forces, appears to have come into the Biograph story at an early date. The first notice of it I have found is the *Canastota Bee's* account of the August 5 1895 first "official" Biograph motion picture production (see page 20).[13]

> [The Mutoscope] is as portable as a hand satchel and the cost of its manufacture so low that it will come into popular use. It will be of incalculable value to agents who wish to show customers the actual workings of intricate machinery and will amplify the scope of instruction in technical schools. . . .

The Bitzer notes (see page i) also support this:

> William Kennedy Dickson was the sponsor of what was then known as the Mutoscope. . . . The first pictures we took[14] were of looms weaving material, so the salesmen could show the merchant how the material was made. . . . The salesman carried a box which he attached by a wire to the electric light . . .

Bitzer, incidentally, called Dickson "America's First Moving Picture Cameraman," and had considerable admiration for him:

> I myself had little or nothing to say [about the Canton, Ohio, September 18 1896 subjects—see page 41], as I was merely the man who ran the camera for Dickson whom I looked up to . . .
> He was a french Canadian [sic] scholarly, a gentleman a musician and a swell man to work with . . . In the short time I was with him he treated me swell.

Koopman, seeking to find a man to build a camera to take the pictures and a viewer to show them, naturally turned to those he knew to be versed in the art. Conspicuous among these was Dickson—widely known as the man who had developed the Kinetoscope and the camera supplying the pictures therefor. He knew Dickson personally, having promoted the Photoret (see page 4).[15]

13 *Canastota Bee*, August 10 1895.

14 Bitzer, of course, was not in Canastota on August 5 1895, but he must have been on the scene in New York City from the first, being already in the employ of the Magic Introduction Company.

15 It appears that Dickson claimed a larger part in the invention of the Photoret than may actually have been his. In an article in the *Orange Chronicle* of

But Dickson was deeply involved with Edison, and must certainly have felt that motion picture work elsewhere would have been a serious violation of his obligation to his employer. Furthermore, Gilmore, Edison's truculent *chargé d'affaires,* had not yet become too obnoxious to Dickson—possibly since the Latham intrigue was still in the future at this time—and Dickson could not foresee that an association with another company would be as desirable as it later turned out to be. At any rate Koopman turned—probably with the hearty recommendation of Dickson himself—to the other Photoret designer, the young Syracuse inventor-mechanic, Herman Casler.

Casler was at this time employed in the remarkable machine shop of his relative C. E. Lipe, at 208 South Geddes Street in Syracuse.[16] He had spent several months working as, apparently, a mechanical draftsman for the Edison General Electric Company in Schenectady (see Appendix A). It was at the Lipe shop that Casler met Harry Norton Marvin,[17] another young Syracusan graduate (in 1883) of Syracuse University, who called himself an "electrical engineer" and who had met Dickson in New York soon after his graduation. This may have been while they were both engaged in the work of putting New York's power lines under ground.[18] It was Marvin who had intro-

December 16 1893, it was said that "W. K. L. Dickson . . . has invented a singularly ingenious contrivance entitled the 'Photoret'," whereas Herman Casler had filed a patent application on March 1 1893 for what appears to be the same device. This patent issued on November 28 1893. Casler's own records, however, indicate that both Dickson and Koopman may have felt Dickson to be half responsible for the Photoret, since the Casler notebook (see page 28) has regular entries indicating that Casler and Dickson shared the Photoret royalties equally. A May 4 1895 entry, for example, made while Casler was visiting New York, indicates that he got half the royalties, which amounted to $7.28 for the first quarter of 1895.

16 See illustration 1. This shop was a middle-sized edition of the experimental laboratory-machine shops spread throughout America in those days—Edison's being a big-sized edition. Charles E. Lipe moved into the shop in February 1880, seven years after graduating from Cornell as a mechanical engineer. The Geddes Street building was called "a cradle of industries," and the reader of *Syracuse and Its Environs* (see page 13) will perhaps be inclined to agree. Rarely has so much been accomplished in so little a space.

17 In answer to examination in Equity 6928 Casler said: "My relations with Mr. Marvin began, I think, as early as 1891 or 1892, while Mr. Marvin and myself were connected with the Edison General Electric Company of Schenectady." Perhaps Casler's use of the phrase "my relations" suggests that he knew Marvin before the Schenectady days, but was only then having concourse with him. Surely their paths may have crossed in Syracuse before this.

18 See Hendricks, *op. cit.* Although Marvin told Ramsaye (*op. cit.* page 211)

duced Casler to Dickson, it is safe to assume, in the summer of
1891 or 1892.[19]

But Casler was now back in Syracuse working in his rela-
tive's shop and had already become involved in the intricate
matter of patent applications. He made such an application for
a toy having to do with manipulating balls into pockets, filed on
January 13 1893 and issued on November 28 1893 as U.S.
#509362.[20] This is the same day upon which the Photoret patent
was issued as U.S. #509841. The Photoret was the only photo-
graphic matter that had concerned Casler seriously, apparently,
prior to the Koopman proposal, but he seems to have had a
remarkable grasp of materials. His acquaintance with the
shutter problem in the Photoret may have helped his under-
standing of "instantaneous" photography, although it is easy
to believe that much of what he learned about motion pho-
tography he learned from Dickson.

He may not have seen the Kinetoscope when he began his
work on the camera, which may seem strange in view of the
fact that he was in New York City in November of 1894. He
said in his Equity 6928 testimony that:

> My impression is that I saw the Kinetoscope after I com-
> menced the construction of the mutograph [and] I never
> knew very much about the kinetoscope, and what informa-
> tion I did gain of it was from newspaper articles and con-
> versations with Mr. H. N. Marvin and Mr. Dixon [sic].

The Kinetoscope was in Syracuse as of December 19 1894, and
Casler may have seen it then. It was also in Canastota for five
days beginning June 5 1895 at the Twogood House.[21]

The work on the viewer began in the fall, with a camera in

that he met Dickson in 1887, Dickson himself said that it was during the under-
ground work. This is much more likely: Marvin wrote a letter to Insull in 1885,
asking for a recommendation from Edison, and there is no other conceivable
Marvin-Edison relationship. Insull's favorable answer was on July 28 1885 and
is in letter book E1730 12/27/84-9/21/85 in the Edison archive.

[19] Casler testified in Interference 18461 that he had met Dickson in the sum-
mer of 1891 or 1892. We know that Marvin knew Dickson well. They spent a
vacation together in Clifton Springs, New York (see Hendricks, op. cit., page
153) and each many times claimed the other's friendship.

[20] It had been allowed on May 5, but possibly Casler's financial status was
such that the final $20 fee for the issue was more than he could manage at the
time.

[21] Canastota Bee, June 8 1895.

immediate prospect. The result of this work was the remarkable Mutoscope, the only serious threat to the Kinetoscope ever built (see illustration). It outlived the Kinetoscope (which virtually disappeared from the market after six years of life) and persists in many places today.[21] This machine will be described more fully in Chapter 7. It had many interesting ancestors in the card-flipping metier,[22] but the Biograph realization of the principle involved in this card-flipping is easily the most proficient of all.

2 · The First Camera

PATENT OFFICE INTERFERENCE #18461 IS THE SOURCE OF MUCH information concerning these first months. By November 10 1894 Casler testified that a Mutoscope had been built at the Lipe shop. Although the card-flipping principle of the Mutoscope was far from new, the Mutoscope is replete with adroit applications of this principle. It also shows much mechanical ingenuity.

When he had gotten the model built, Casler apparently went down to New York from Syracuse to show it to Koopman, who was planning to promote it. This is suggested by the following testimony of Harry Marvin, given in the Interference:

> A [to question 8]. Mr. Cassler [sic] started active operations to produce this machine [i.e., the first camera, or "Mutograph"] immediately after an interview in this city [i.e., New York] between Cassler, M. [sic] B. Koopman and myself, at which interview it was arranged that Mr. Koopman should furnish certain moneys to assist in developing the invention, and at that time I remember that I stated to Mr. Koopman that in my opinion Mr. Cassler would be able to have the construction under way in about six weeks or by Christmas time.

21 At this writing, for example, July 1962, I know of the existence of Mutoscopes in Hubert's Museum on 42nd Street in New York City and in Asbury Park, New Jersey.

22 These ancestors will be described in a projected work on the "pre-history" of the motion picture.

In his answer to question 9 Marvin placed this visit to New York City about the 10th or 12th of November 1894. Thus we can assume that the first Mutoscope was shown to Koopman at this time, and when he saw it he agreed that work on a supplying camera should begin at once.

Immediately upon returning to Syracuse, Casler began to work on the patent application for the Mutoscope, and a few days later, on November 17, the application was signed and witnessed. The official filing date was November 21 1894. I quote from the second paragraph of this application:

> My object is to produce a device for exhibiting pictures, photographs, or similar likenesses so arranged that by successively bringing them into the line of vision they will show the changing positions of the body or bodies and reproduce to the eye the acts of the performers . . .

It will be seen that the language here suggests no such use as was contemplated by Koopman, i.e., the photography of machinery, but confines itself to what appears to be entertainment.

Not later than the first week in December 1894 Casler began to build the camera which was to supply photographs for the Mutoscope (see illustration 2). This is supported by the statements of two associates. First Marvin, who testified that Casler told him he was building or designing the camera the first week in December, and second John Pross (later to become significant in motion picture history as the designer of a widely-used shutter) who said in answer to question 13 that "[Casler had been in] New York City, and upon his return he told me that he was going to build a camera for taking pictures of moving objects."

Casler himself testified that the planning of the camera had begun somewhat earlier. He said that a letter from Koopman of November 15 1894 "refers to a taking machine which I had entered into a contract with Mr. E. B. Koopman to build." Whether the contract to build the camera was separate from the contract to build the Mutoscope, was signed only after Koopman had seen the Mutoscope, or whether reference is made here to a contract which provided for both machines, we cannot know.

Casler also referred to a Koopman letter of November 28 in

which reference was made to "work . . . on a camera and an exhibiting device known as the Mutoscope." He also dated sketches of the camera as November 30 and a letter from Koopman on the same subject as December 1. But he was able to *prove* only a date of "on or about December 12th, 1894":

> Q. 4. State whether you ever conceived of the invention set forth in your last answer, and if so, when?
> A. I conceived of the invention set forth in the answer on or about December 12th, 1894.
> Q. 5. What enables you to say that you conceived of the invention here in controversy on or about December 12th, 1894?
> A. My own memory and a photographic negative showing a set of Patent Office Drawings for an Application for a Patent on a boring and facing machine filed by C. E. Lipe, December 14th, 94, which negative shows sketches of shutter partially covered by the Patent Office drawings. This sketch of shutter and calculations shown on the negative were made to demonstrate the comparative light values of a shutter of a suitable size for a machine I was designing at that time, and a shutter of the size supposed to be in use on Edison's machine. I had working or shop drawings of the machine on exhibition which drawings bear date of December 94, and show shutter shaft located so as to require a shutter of the diameter as shown in the sketch by the photographic negative referred to.

These sketches, Casler also said, were made in his Syracuse home. This was at 471 Shonnard Avenue.[1] Casler also said that the drawing was "used for reference . . . in making detail drawing of the different elements of the machine, and that:[2]

> it was [designed] to begin the work upon the elements first conceived, and to furnish drawings which would explain my wants fully to the workmen and at the same time enable several workmen to be occupied in the manufacture of the machine at the same time.

John Pross was asked later:[3]

> Q. 25. When, according to your recollection, did Mr. Casler show . . . you the drawing . . . ?
> A. Sometime before Christmas, 1894.

[1] I photographed this house in November of 1961. It is only a very short distance from Geddes Street and an intersection only a few blocks from the Lipe shop at 208 South Geddes.

[2] Answer to questions 90 and 94 of direct examination.

[3] *Ibid.*

Q. 26. In what month?
A. December.
Q. 27. What enables you to say that it was the month of December, 1894, and before Christmas, that Mr. Casler showed you [the drawing]?
A. I took a vacation and did not return to Syracuse until the 2d day of January, 1895.

If we can assume that Pross began his vacation not later than Christmas Eve, and Pross himself said in answer to Question 42 that his vacation began about December 22, then the working drawing of the Mutograph, or the first Biograph motion picture camera, had been made by December 24 1894. There is no reason to believe, however, that it was not made when Casler said it was made, i.e., "on or about December 12, 1894."[4]

The actual work on the camera itself, according to testimony by Casler, began the first week of January 1895. This varies somewhat from the testimony noted before, but was given in the same Interference:

Q. 96. Give the names of the men who worked on this machine?
A. C. W. Cornelius, C. S. Grannis, Thomas Casey, Charles Fauth, J. Ryan, L. E. Munsey. These are all that I can recall to mind now . . . [A to Q. 98:] I [superintended the work] and the foreman of the shop . . . Perry Phelan . . . [A to Q. 99:] [It was commenced] The first week in January, 1895.

Charles S. Grannis stated in answer to Question 24 that he commenced working on the camera "About the beginning of the year 1895."

Casler produced a number of bills for tool steel, iron castings, brass castings, mahogany drop-forged handles, shafting, etc., which he identified as material for the camera. He also produced memoranda of the workmen's time. These bills began on January 5 and continued on January 12, 19, 26, February 2, 9, 16, 23, March 2, 9, 16, 30 and April 6 and 13. On March 2, however, the camera was in condition to be tested:[5]

4 He said he was also working on a ribbon-inking machine for the L. C. Smith Company of Syracuse. Mr. Kenneth W. Greb, a patent engineer of the Smith-Corona-Marchant Company (successor to the L. C. Smith Company), showed me a group of ribbon-inking patents used by the company which he stated was exhaustive. Likely Casler was working on the machine of U.S. #479351 to Dennis.
5 The post-March 2 bills, according to Casler's testimony, were for such items

Q. 102 [by Casler's attorney, E. M. Marble]. You say you commenced the construction of the machine you described [i.e., the first camera] in the first week of January, 1895; when was said machine completed . . . ?
A. On or about March 1, 1895.[6]
Q. 103. How are you enabled to state that this machine was commenced in the first week of January, 1895, and completed so as to . . . perform . . . on or about March 1, 1895?
A. By my memory, and bills rendered by C. E. Lipe for the work done on the machine, the dates on working drawings and the operation of the machine by me on or about March 1, 1895, in the presence of Mr. H. N. Marvin, Mr. E. B. Koopman, the foreman of the shop;[7] Mr. Perry Phalen and other workmen in the shop. I remember that Mr. Phalen was present and that he left the employ of Mr. Lipe about the 2d day of March, 1895,[8] and that Mr. Koopman was present at the running of the machine on the 2d day of March, 1895, as he promised to be.

This March date was an important one in Casler's career, and it is easy to accept his memory concerning it. As I have said above, however, the camera was almost certainly operable some days before this. The testimony of the Lipe shop foreman, Perry Phalen is convincing:[9]

Q. 16. When was the construction of this machine commenced, if you remember.
A. The latter part of 1894.
Q. 17. When was it completed; I mean the machine part of it?
A. February 15th, 1895.
Witness asks:
Q. 18. You mean the machinery part of it, not the case?
A. Yes.
Q. 19. What enables you to state that the machinery part

as the mahogany in the camera case (see page 52), and therefore not essential to the test. See also Perry Phelan's answer to Question 18 below.

[6] Again, as in his "on or about December 12, 1894" answer, Casler is using a phrase directed by his attorneys. Instead of stating specifically as he did in the next question that the machine had been completed by March 2 he says "on or about March 1." Actually, of course, it is proper to assume that the test described in his next answer was not held until it was certain that the camera could operate, and this could have been known only by tests made prior to the March 2 test.

[7] This is typical of the kind of stenographic errors which must be identified as errors if the testimony is to be properly read. Since Phalen was foreman of the shop the semi-colon is an error.

[8] This is corroborated by Phalen's own testimony and also by John Pross.

[9] *Ibid.*

of Casler's Exhibit First Machine was completed Feb. 15th, 1895?

A. The last of February I was to leave the shop; there was a new man coming in to take my place; there was a lot of rice-huller machinery on the floor;[10] this machine was running on top of one of those rice hullers, driven from a counter shaft on another, and the 15th of February I started to get those rice hullers out of the way in to the storehouse; I had Mr. Casler move this machine down to another part of the shop and run it down there while I was moving the rice hullers; then after I got the rice hullers moved, in the course of a week, the machine was brought back to its original place and run again down there where the regular test was made; we generally built from 50 to 100 rice hullers in a lot, and when they were under construction we were pretty crowded for room.[11]

The coming of Koopman to Syracuse to see the camera was an event of importance to all concerned, and we can be sure that Casler would not have invited Koopman to witness a test which he did not believe would be successful. (See also Marvin testimony in answer to question 29 below). Much hinged on it. Although Koopman had been favorably impressed by the Mutoscope in New York City the previous November, that apparatus was virtually useless without a camera to supply it. The machine of the March 2 1895 test was the heart of the Biograph fortunes, just as the "Black Maria" camera was the heart of the Edison-Dickson motion picture fortunes, and the Geneva cross camera of the February 26 1895 test the heart of the Latham fortunes.[12]

[10] *Syracuse and Its Environs* by Franklin Henry Chase (published in New York and Chicago by Lewis Historical Publishing Company, Inc. in 1924) says on page 439: "The coffee and rice hulling machines of the Engleberg Huller Company were manufactured in the Lipe Shop from 1888 to 1897."

[11] This remarkable building (see illustration 1) still stands at 208 South Geddes Street. As of December 12 1956 it was occupied by the Syracuse Color Press. The wooden frame building at the right (connected by a two story brick structure enclosing the present main entrance) is said to have contained the drafting room in Casler's time.

[12] The reader may note a remarkable coincidence: the American motion picture came into being as a result of work progressing in various places at the same time. At the same time, quite possibly to the day, that Lauste was testing the Latham camera in the shop at 35 Frankfort Street in New York City, Casler was testing his camera in the shop at 208 South Geddes Street in Syracuse. Neither man knew of the other's operations; Dickson would have been very quiet about what he knew concerning Casler's implementation of his card-flipping suggestion. The historian, from his eminence in time, can put all of these developments in perspective.

14

Film was not used at this March 2 1895 test. A roll of paper was used. This is established by the testimony of Casler, Pross and Marvin—Marvin's being particularly explicit.[13]

> I remember that during the latter part of the month of February, 1895, the strip of blank paper was run through the machine in the same manner that it was intended that the photographic film should be run through the machine. The paper ran through the machine in a satisfactory manner, and by an inspection of the machine and paper I was able to determine that the various elements of the mechanism were properly performing their respective functions. I remember that these tests were made while the foreman Perry Phalen, was still employed at Mr. Leip's [sic] shop, and I know that Mr. Phalen left Mr. Leip's employ on or about the first of March, 1895.[14]
> Q. 28. You have testified to have had an interview at one time, in connection with Mr. Casler, with Mr. E. B. Koopman. State whether Mr. Koopman was present at any trial of the machine referred to during the latter part of February, or on or about the first of March, 1895?
> A. Mr. Koopman was present at a test of the machine during the latter part of February or on or about the first of March, 1895.
> Q. 29. How many such tests did you see on or about that time?
> A. I cannot remember the exact number, but to the best of my recollection the machine was tested as above described a dozen or more times at about that period.

The camera had now to be encased and film boxes made. A bill dated March 9 1895 for mahogany indicates this (see page 52). Bills in March and April suggest finishing touches or modest alterations. Casler also testified to this effect.

From the March test onward the camera or Mutograph was tested "repeatedly" and first used as a camera with film to photograph objects in motion "about the middle of June, 1895."[15] The camera was pointed out a rear window of the

13 Answer to question 27 in the Interference.
14 The reader will understand how a test in the presence of Phalen could have occurred a day after Phalen had left Lipe's employ. This is easily explained—and even made more logical—by the fact that March 1, Phalen's last day was, logically, Friday. The test would then have been on Saturday the 2nd of March, and Phalen may well have been eager to see how the test went off. This is also a logical day for Koopman's visit.
15 Casler answers to questions 111 and 112 in the Interference.

Lipe shop and photographed a mock boxing match between Casler and Marvin.[16] As John Pross testified:

> X-Q. 86. Did you ever witness the operation of the machine "Casler's First Machine," in the taking of pictures of moving objects?
> A. I did.
> X-Q. 87. Where did that occur and when?
> A. That occurred in the back yard of Charles E. Lipe's, camera being placed in the shop, and the picture was taken through an open window, along about the fore part of June, 1895.

The illustration in this book (4) *may* be an existing specimen of this rare film and thus a specimen of the first subject shot by the Biograph's first camera. The locale is improvised exactly as it would have been at the rear of the Lipe shop.[17] Casler, assuming this to be the June 1895 subject, was 28 at the time and Marvin 33—neither impossible for the men in the photograph. Efforts to establish the ages of the men in the photograph were impracticable; efforts to establish even the season from the weeds in the foreground, at the New York Botanical Society, were also unavailing. This photographic series was found in the effects of Herman Casler after his death in 1939. It is difficult to understand why it would have been thought significant enough to preserve if it did not have a special significance to Casler. Most significantly, however, it is difficult to establish an *occasion* for such a subject unless it was the June 1895 production. The answer may lie in the record of Interference 18461. Casler produced "Casler's Cross Exhibit, First Film," which was the boxing match shot in June 1895. It seems logical, considering Casler's habit of preserving items significant in his work, that the illustration may be the June 1895 subject. Casler's statement that he operated the camera himself for this test may, of course, be rhetorical. Or he may have set the camera in motion and then hurried outside (cf illustration in *The Edison Motion Picture Myth* of Dickson and Heise).

16 Marvin answer to question 33.
17 The locale is not possible for the Canastota Canal Street shop: 1, the window in the right distance did not exist near the East North Canal Street shop; 2, the slanting wooden roof cannot be explained by the East North Canal Street structure; and 3, there were no such trees near the East North Canal Street building (see illustration 5).

3 · Motion Pictures in Canastota

BY THE TIME OF THE JUNE TEST OF THE MUTOGRAPH, HARRY Marvin had induced a number of Canastota, New York, businessmen to underwrite his electric rock drill.[1] This enabled him to remove his business from its crowded, shared quarters at the C. E. Lipe shop in Syracuse to Canastota, a village some 20 miles east.

This was a logical move. Marvin's connections in Canastota were extensive, and, after the manner of small towns, business and social at the same time. His wife, the former Oramella Tackabury, had lived there for some years. Her wedding to Marvin had been a big social event of 1882: the chancellor of Syracuse University had, according to the *Canastota Bee* of September 20 1882, performed the ceremony. Her mother (her father was now dead) lived on North Peterboro Street in "The Evergreens"—perhaps the second most pretentious house in town (the first belonging to Milton A. Delano, U.S. Representative from the district, and father of Kirk Delano, with whom I have had many pleasant conversations).

The men who were the financial backers of his Canastota business were also friends of the family, and eager to help a local boy get ahead. Patten, titular head of the new company and president of the State Bank of Canastota and vice president of the Canastota Savings and Loan Association, was later to become disillusioned. He felt, I have been told, that the Drill Works failed because Marvin became too preoccupied in the new motion picture business.

In moving to Canastota, Marvin took over what was known as the old match factory on East North Canal Street, and asked

[1] U.S. #395575 for "Electro Magnetic Rock Drill," issued January 1 1889. Edison was interested in this and planned at one time to market it under his own name. (See the *Western Electrician* of April 12 1890; *Electrical Engineer* of December 17 1890; letter of May 21 in letter book E1717 4/14/91-6/13/91 in the Edison archives.)

his friend Casler to join him in the new establishment as shop superintendent. An acre of land was bought on June 12 1895 for $600. Along with it came the "one thirty five horse Porter Boiler and fixtures belonging to same and also all shafting belonging to said boiler and building on said premises."[2] It was Casler's job to appraise the machinery and decide what would be useful for the work of the new manufactory. This new manufactory, incidentally, included a "Muto. room," where Casler could, in his spare time, work on motion pictures.

The Casler notebook (see Chapter 4) shows that his work on the motion picture stopped sharply after June 27, and June 28 shows entries for the Canastota appraisal. On June 29 he received a hundred dollar check from Koopman and charged the "Muto." account 25¢ for cartage. The *Canastota Bee* of June 29 refers to "car loads" of machinery, and the moving from Syracuse was done by the New York Central Railroad, whose main line ran through Syracuse and Canastota. The 25¢ was apparently Casler's estimate of that proportion of the cartage cost attributable to motion picture apparatus. The *Bee* of August 10 said that a five ton dynamo received on August 7 at the Drill Works "was moved from the railroad by Daniel F. Moyer on a truck of his own construction that has a capacity of carrying over ten tons."

The new place was apparently officially opened on Monday, July 1 1895, for an entry in the Casler notebook reads: "1—2—3—4—5—6/Marvin Drill Co. Works." This is the first time this title appears. That the new location was to contain facilities for motion picture work is indicated by notebook entries of July 8, 13, 22, 25, 26 and 27, etc. (see page 29). That this work may have been kept *sub rosa* is indicated by the purchase of a "Lock Muto Door" for 75¢. Additional purchases indicate film processing and the setting up of a dark room on or about July 22.

The original movement to Canastota had been described by the *Bee* of June 29 1895:

> The by-laws of the Marvin Electric Drill Co. have been changed so as to have its office and principal place of busi-

2 This quotation is from the deed recorded in the office of the County Clerk of Madison County in Wampsville, New York.

18

ness changed from Syracuse to this village . . . Two car loads of machinery for the new works were unloaded yesterday.

On July 27 the *Bee* reported that the "old match factory," had been remodelled for the Marvin Electric Drill Company, and was "being filled with fine machinery." A rare photograph of the new installation in the old match factory may be seen in the illustration section of this book (5); possibly taken by Casler himself, since it was found among his effects.[3]

By July 20, in spite of Casler's preoccupation with the Drill Works (or perhaps because of it?), W. K. L. Dickson had become installed as a guest of Marvin in the house on North Peterboro Street, where Marvin and his wife now lived with "Grandma" Tackabury. The *Bee* of July 20 said: "Mr. William K. L. Dixon [sic] of Orange, N. J., is the guest of Mr. and Mrs. H. N. Marvin." He must have been there on the previous Wednesday evening (July 20 1895 was a Saturday) July 17, when the Marvins had a lawn party under the same magnificent evergreens which formed a backdrop for the famous "K.M.C.D." photograph of September 22 (see frontispiece), and which still persist. The *Bee's* account of this affair, irrelevant to our history, is nevertheless charming, and evokes the local social atmosphere in which the Marvins were immersed and into which Dickson must have enjoyed plunging:[4]

> A very pleasant lawn fete was held at the home of H. N. Marvin, North Peterboro St., Wednesday evening. The grounds were beautifully illuminated with colored lanterns and a tent was erected in which a most amusing farce entitled "A Proposal Under Difficulties" was cleverly pre-

[3] Via Harry Swanker, a Canastota resident, who preserved Casler's effects for some years. Casler apparently had a 5 x 8 camera, according to his notebook, and later a 4 x 5 camera. This photograph is 4 x 5, and the notebook shows purchases of 4 x 5 plates. I have been denied the use of Swanker's effects by Fletcher Newberry, the Canastota mortician who came into possession of Swanker's effects upon his death.

The reader may still find the camera station of this photograph by climbing to the tow path of the Erie Canal, directly opposite the site. The building is no longer in existence, having burned several years ago, but its L-shaped concrete site was plainly visible as of November 1962, the date of my last visit.

[4] This enjoyment is amply supported by our knowledge of Dickson's Orange social life (see biographical sketch in *The Edison Motion Picture Myth*). Mrs. Kirk Delano also remembers that Dickson was quite a figure about town with his slight goatee, pendulous watch chain and his singing in the Marvin's church. (!)

sented by Mrs. F. G. Bell, Miss Sayles, and Messrs. Harry Weed and Irving Lennox. The young ladies of the physical culture class of the academy gave the flower drill, which was a feature of the commencement exercises, to a delighted audience. Refreshments were served with the result that the organ fund of Trinity church is increased by about $12.

Dickson may have stayed with the Marvins through the September 22 meeting: the *Bee* later remembered him as being "formerly of this village"—a memory which likely would have had its inception in an extended stay. On September 7 the *Bee* reported that he and his wife both were at "The Evergreens," but although Dickson may have stayed through August and the September 22 meeting, his wife, by that time, had gone to Geneva, New York.[5] The *Bee* of August 24 said that Mrs. Marvin and family had gone to Lewis Point for ten days, and this description seems not to include Harry. Possibly the two men were "batching it" at "The Evergreens." Dickson may also have stayed through October and November, since the *Bee* of November 2 reported that he had his hand severely burned while taking a flash light picture on November 1, and although he was not mentioned as being present, he was nevertheless at the November projection (see page 22ff). (We would know a bit more about Dickson's movements if we could examine the Saratoga papers, since he apparently spent some time in Saratoga this summer; but I have been told that what was probably the only run of Saratoga newspapers of this time *in existence*— has been destroyed by the Library of Congress.)

Dickson's Canastota summer was highlighted by two significant events in the Biograph story. The first of these was his taking of "Sparring Match, Canastota, New York"[6] on August 5.

Herman Casler testified in Interference 18461 that the film used in the November 1895 projection was "a sparring match which was photographed in Canastota." This match occurred behind James Mahan's machine shop on West Center Street in Canastota at noon on Monday, August 5 1895. This building still stands next door to the Canastota Public Library (see

[5] *Orange Chronicle,* September 21 1895.

[6] This is the Library of Congress copyright title. So far as I have been able to discover this subject is lost; the Library of Congress has apparently no film or frame reproduction from it.

illustration 8). A Sanborn-Perris map of November 1895 shows it on the north side of West Center Street, just west of the jog. The same map gives it a 4 H.P. engine but no lights—corresponding to Harry Marvin's testimony that a calcium light was used for the November 1895 projection. The *Bee's* account[7] is most interesting:

A WONDERFUL MACHINE

A Canastota Invention that beats Edison's
Greatest Effort.—A Successful Test.

The machine invented by Herman Casler, of Syracuse, now connected with the Marvin Electric Drill Company was given a trial at Mahan's machine shop at noon Monday. Mr. Casler's invention is upon similar lines as that of Edison's kinetoscope, but having a much more rapid movement and making a picture seven and one-half times as large.[8] The invention consists of two machines each totally unlike the other. One, the kinetoscope [sic] is for taking the views which are afterwards presented in the other machine called the kinetograph [sic]. These are the names now used by the Edison people but the Casler machines when put on the market will be known as something else.

A platform was erected in the rear of the machine shop and Photographer H. J. Dobson, of Syracuse, soon arranged the kinetoscope for photographing two boxers, engaged in a sparring exhibition. The boxers were experts, Prof. Al. Leonard and his pupil, Bert Hosley.[9] For more than one minute they went at each other in a scientific manner and both received several hard blows in the encounter. The kinetoscope clicked along at the rate of sixty exposures a second and at the end of one minute had taken 3,000 pictures as the encounter progressed. These views will be mounted on a long ribbon and when placed in the kintograph [sic] made by Mr. Casler will magnify many times and will reproduce the contest to anyone looking into the machine. The points of superiority in the new invention are that the kintograph is as portable as a hand satchel and the cost of its manufacture so low that it will come into popular use. It will be of incalculable value to

7 August 10 1895.

8 We can only assume that this refers to the square inches of surface difference between the Edison frame and the Casler frame. My frames of Biograph film have shrunk a little but still measure $2\frac{5}{8}''$ x $2''$. The Library of Congress copyright deposits measure $2\frac{11}{16}''$ x $2\frac{1}{8}''$. The Edison frame, established by Dickson, was *c*, $1''$ x $\frac{3}{4}''$.

9 A Casler notebook entry of August 15 1895 (see page 27) indicates that Hosley and Leonard were paid 50 cents each for their services. I have found no appropriate directory entries for these two men.

agents who wish to show customers the actual workings of intricate machinery and will amplify the scope of instruction in technical schools. It will also be in demand for parlor amusements, the views being easily adjusted and may be purchased as stereopticon pictures are now obtained from supply houses. A stock company composed of New York capitalists has been organized to place it on the market.

Mr. Casler has also invented a camera that can be carried in the vest pocket which has produced perfect results and will be sold by the Magic Introduction Co. at $2 each. It has a capacity of fifty ribbon exposures[10] and can be transformed into a camera with four plate exposures.

A Fort Plain paper adds little except interpolation by the reporter and indicates that the event was neither personally covered by a Fort Plain reporter nor were the persons concerned personally interviewed.[11]

For some time before I realized that "H. J. Dobson" must have been a pseudonym for Dickson, I puzzled over who this might be. The *Bee's* "Photographer H. J. Dobson, of Syracuse" and the Fort Plain paper's "H. J. Dobson, an expert photographer from Syracuse" were a mystery. A search in Syracuse city directories for ten years previous to and ten years following the event failed to reveal any H. J. Dobson at all and no photographer whose name remotely resembled it. My search of photographic periodicals for all these years—from roughly 1860 to 1905—revealed nothing. A search of the records of the Syracuse Camera Club (of which, incidentally, Herman Casler's relative, C. E. Lipe had been a member) was also unavailing.

Persistently the language of the *Bee* account obtruded itself. It was characteristically Dickson's—and Dickson's only. The careful distinction between the *taking* machine and the *viewing* machine was one he had made more than once, and the confusion between the two was apparently the cause of some frustration to him. Still the *Bee* erred: ". . . two machines

[10] The "Photoret" (see page 4) had a celluloid plate and six pictures. A "Photoret" is in the Eastman House in Rochester, N. Y. Although Herman Casler's son, Harry, has a "Kombi" camera, with a 25 exposure roll film, there is no evidence that Herman invented it. (See illustration 21ff.)

[11] A clipping from this paper is in the Herman Casler scrapbook now in the possession of his son, Harry Casler, and has been generously photostated for me. Although the paper is not identified in the scrapbook, the heading "Fort Plains' 'Edisonic' Native," and the opening line, "Canastota correspondent in Utica Press," indicates a Fort Plain paper.

each totally unlike the other. One, the kinetoscope is for taking the views which are afterwards presented in the other machine called the kinetograph."

Surely "H. J. Dobson" was a *nom de plume* for "W. K. L. Dickson," and used to avoid public awareness that our hero was now linking his future with the Biograph entrepreneurs.

Two additional motion picture subjects may *possibly* also have been shot at about this time, in the milieu closest to Koopman's heart, i.e., motion pictures of machinery (see page 4).

We do not know whether or not Dickson remained in Canastota until November but we do know that he was visiting the Marvins on Sunday, September 22, when, presumably after a hearty Sunday dinner after services at Canastota's Trinity Church, the four Biograph men gathered on the Marvin lawn and were photographed. This famous photograph is reproduced in this book as a frontispiece and in Ramsaye, *op. cit.,* opposite page 211.[12] It shows the four men in characteristic poses: Koopman self-conscious; Marvin and Dickson a bit pompous; Casler modest and unassuming, but with a kind of selfassurance some may find lacking in one or two of the others.

Surely these men gathered to talk over Biograph plans. It would have been no trouble for Casler to be there—he lived only half a block away. And Dickson was likely already a Marvin house guest. But Koopman would not have made the 6 hour trip[13] from New York City merely to have Sunday dinner and a chat. Exactly what they talked about is conjectural. But within two months the Biograph future took a decided turn toward success, and the August 5 sparring match was thrown on a screen at the Mahan shop.

Casler describes this achievement thus:[14]

12 A copy of this photograph is now in the possession of Harry Marvin's daughter, Marguerite Marvin Smith, and has "G. D. Dunn, Canastota" and this date inscribed on its verso.

13 Today this trip takes, via the Empire State Express, about 5 hours and a half. An examination of old time tables indicates that in the 1890s it took only slightly longer.

14 In his testimony in Interference 18461. This Interference was to decide priority for the loop (among other things) in a *projecting* machine. Then, to prove priority, the Casler forces had to show the use of the loop in such a machine as they had already established was in existence before the other claims. This was the Mutograph, or camera. They thus had to prove the use of this *camera* as a projector. Although it is difficult to say that this camera was not

Q. 114. Where did you use this exhibit as a projecting machine?

A. At the shop of Thomas Mahan,[15] in Canastota, N. Y.

Q. 115. Please name the persons who were present when you used it as a projecting machine or some of them?

A. Myself, H. N. Marvin, W. K. L. Dickson, E. B. Koopman, Thomas Mahan, W. J. Casler[16] and others.

X-Q. 178. What was the result of that exhibition, with relation to its satisfactory character?

A. Very gratifying to all parties present.

. . .

X-Q. 187. Was the film of the boxing match [of June 1895] the film that you used in November, 1895, when you state you first projected objects in motion on Casler's First Machine [i.e., the camera]?

A. It is not.

X-Q. 188. What film did you use at that time?

A. We used film which represented a sparring match which was photographed in Canastota.

Charles S. Grannis (see page 11) testified in the same Interference:[17]

A. I saw the machine used for projecting pictures on a screen.

Q. 39. When was that?

A. In November, 1895.

Q. 40. Where?

A. At Canastota, New York.

Q. 41. Who were present at that time you saw it so used?

A. Mr. Marvin, Mr. Casler, Mr. Dickson, Mr. Mahan and myself.

Q. 42. How many times did you see it so used; that is, how many nights or days?

A. One night only.

Marvin testified in the same Interference:

Q. 34. . . . When did you first see said exhibit used for projecting pictures of moving objects upon a screen?

A. During the month of November, 1895.

used also as a projector at some time in these early months—in spite of obvious difficulties and the Bitzer memories noted on page 58—the addition of a light, the placement of a mirror to reflect that light, and the addition of a condensing lens all seem somewhat incredible.

[15] It will be noted that Casler erred in calling Mahan "Thomas," (he should have been James) just as he may have erred in including Koopman among those present at the November projection (see Grannis answer below).

[16] Herman's brother.

[17] It will be noted that Grannis does not mention Koopman, as neither does Marvin. I am inclined to believe that Koopman may not have been present and that Casler's memory was incorrect. This question is perhaps specious, however, as the projector was soon taken to New York City.

Q. 35. State the circumstances attending such exhibition or exhibitions, and where they were given?
A. The exhibition was given at the shop of Mr. Mahan, in the village of Canastota, New York. On this occasion the machine was located within the shop and the lens pointed out of a window. The screen was stretched on a support outside. A calcium light was used and the exhibition was very satisfactory. The exhibition took place at night. There were a number of people present, including Mr. Casler, Mr. W. K. L. Dickson, Mr. Mahan and others. The pictures exhibited were pictures of a boxing match . . . the pictures were exhibited on a number of different occasions during the month of November.

Another Marvin answer gives us a hint as to why the Mahan shop was used for the November projection: "The machine was driven by means of a belt connected to a counter-shaft, the counter-shaft being driven by the line shaft of the shop in which the machine was used." The Mahan shop apparently had more convenient facilities for using the apparatus than the Drill Works.

Meanwhile a patent for the Mutoscope was issued on November 5 as U.S. #549309. This instrument was to become a mainstay of Biograph profits for years to come (see Chapter 7). Its significance to the four men at this time may be seen from the fact that they named the new company the "American Mutoscope Company" and not the "American Mutograph Company" or the "American Biograph Company." The American Mutoscope Company was the immediate descendant of what was known as the K.M.C.D. combination.[18] Application for a hand-held version of the Mutoscope was also filed by Casler on November 14 1895. This issued as U.S. #614367 on November 15 1898, after a division on May 26 1896 and a renewal on March 2 1898. It apparently had little excursion: I have never seen an example of it in any of the several large toy collections I have examined. It is described in a *Scientific American* article of October 23 1897.

It now remained to raise money to go into the motion picture business in a big way, and this was more money than any of the four had. But arrangements were soon made to secure a

[18] Much has been made of this "K.M.C.D.," particularly by Ramsaye. Dickson testified in 1911 that it never had any legal definition and was a term loosely applied by the four men themselves to their combination.

loan from the New York Security and Trust Company (Ramsaye says the Empire Trust Company), and the American Mutoscope Company entered upon a new phase of its rich, varied career.

4 · The Dickson Contribution

THE PICTURE OF A MAN OF CASLER'S EXPERIENCE CREATING THE first Mutoscope is not incredible. Given a stimulus from Dickson, the history of the art, and Casler's high-grade mechanical skill, it is not illogical that there should be such a culmination of the card-flipping tradition in this man.

But the picture of Casler inventing the Biograph camera or the Biograph itself is not so credible. A hand motivated card-flipping machine is nonetheless only a card-flipping machine and a man with Photoret experience and Casler's skill might have almost solely designed it. But a machine to supply a card-flipper with suitable photographs is quite another matter. We are led to the belief that the Biograph camera must have been largely the result of the skill and experience of W. K. L. Dickson.

This position also seems to have been taken by Harry Marvin—via Ramsaye:[1]

> The experimenters of Canastota set out to reinvent the art of making motion pictures. They had as a guide Dickson's knowledge of some things that might be done, and also, of equal importance what must not be done if they were to escape infringement on the Edison patents and the inevitable consequences to be dealt out by his active legal department.
>
> They decided to build a machine which would take much larger pictures than the Edison camera with its little one inch film . . .
>
> Theoretically, at least, the invention of the . . . camera was left to Herman Casler. Too many ticklish legal points might have been involved if Dickson had been too closely connected with the work, in view of a possible contention of borrowing from his Edison experience . . .

[1] Ramsaye, *op. cit.*, page 213ff.

Ramsaye did not like Dickson[2] and is not likely to have given Dickson more credit than he deserved.

Dickson was a man who could build original, successful motion picture apparatus on command. The mechanical ingenuity which designed the "Black Maria" camera and other significant instruments was now turned toward the problem of supplying the Mutoscope with photographs. And such a supplier was brilliantly forthcoming.

Everyone conceded Casler's early contact with Dickson, and the record indicates that this contact concerned advice on how to build a camera. That Casler got such information and advice from Dickson seems clear from his testimony in the Interference which I quoted before:

> This sketch of shutter and calculations shown on the negative[3] were made to demonstrate the comparative light values of a shutter of a suitable size for a machine I was designing at that time and a shutter of the size *supposed to be in use on Edison's machine.* [my italics]

Since the details of "Black Maria" camera were part of a secret as closely guarded as those of the Book of Thoth, the historian must conclude. that Casler got his crucial shutter information from Dickson. Supposition concerning the "Black Maria" specifically—or motion picture camera generally at this time— would have almost surely swum into the Casler ken via Dickson. We also know that the 1896 Biograph subjects were shot at a rate similar to the regular "Black Maria" camera rate (see page 56)—too remarkable a parallel for coincidence. In his

[2] It is impossible to escape this impression. Both Muybridge and Dickson, foremost figures in the history of the beginnings of the American motion picture, seem not to have been Ramsaye's "sort." I have discussed this anti-Muybridge bias somewhat in *The Edison Motion Picture Myth.* Ramsaye's less-than-cordial feelings toward Dickson are less obvious than his rancour toward Muybridge, but are nevertheless clear, it seems to me, in such passages as the following from his page 184: "In after years on the witness stand . . . Dickson testified that [he left the Lathams because of] his disapproval of the personal conduct of Grey [sic] and Otway Latham. He held that they were a trifle fast. There is indication that Dickson never did like Broadway. He has been living in England and France nearly thirty years." This identification of the conduct of a man who did not like this "Broadway life" with a dislike for America, considered in conjunction with the condescension toward Muybridge, may also suggest an anti-British feeling in Ramsaye.

[3] Casler had been describing a photograph of a boring and facing machine patent of C. E. Lipe, filed November 14 1894, and containing a sketch of Casler's ideas.

answer to cross question 71 in Equity 6928 Casler also disavows experiment with the rate-of-taking, which is nearly a *sine qua non* for serious motion picture camera design: "I never did any experimental work with the idea of determining just how many pictures were necessary to give a satisfactory reproduction of a scene." Since the sturdiness of a camera would increase in geometric progression as the rate-of-taking increased, this is surely significant.

We know also, for example, that Dickson sent Casler a copy of the Friese-Greene patent.[4]

One has only to stand in delicious recoil in front of the Mutograph in the Smithsonian Institution and compare that instrument with the Photoret—which was the apparent limit of Casler's photographic experience to date—to decide that the dominant hand in the Biograph camera work was Dickson's.

This conclusion is supported by the entries in the Casler notebook.[5] The entries in this notebook cover the period from March 5 1895 to apparently the end of August 1895. It is filled with sketches and notations incidental to, or irrelevant to, motion picture apparatus. Its motion picture sketches and notations are of shutter ideas, joins, picture areas, breaking devices, ratchets, Mutoscope picture shapes, photographic chemistry, time charges, snapshot photography, electrical switches and connections, pulley sizes, etc. But it contains only matter peripheral to the mechanism of a motion picture camera, and leads us to think that it was with only such matter that Casler was concerned at this time.

On "May 2-95"—page 54[6]—Casler went to New York. He must have returned to Syracuse on Sunday night, May 5, since an entry on page 58 lists ten hours work on the "Muto" and a $43 "expenses N. Y." These New York pages, 54-58 both inclusive, have very interesting notations. On the trip down,

[4] Dickson's copy of this patent, with significant passages marked, is now in my possession.

[5] This is a small *circa* 4″ x 6″ red, calf-skin, vertically hinged, graph-lined notebook originally of 60 leaves (three have been torn out) plus buff-colored end papers and a half-pocket in front (in which I found a two-cent stamp). This notebook is now in the possession of Roger Casler, who very kindly loaned it to me for study.

[6] I.e., the verso of leaf 27. These pages are unnumbered in the original. I have merely counted the pages and indicate my count for possible future students.

for example, pages 54-55, Casler sketched lens foci. On the bottom of page 55 he simply noted "May 3-95/New York." On page 56 he carefully drew a Mutoscope card with a profile drawing of a man's head and what may be a brief sketch of a camera punch—but not means for its activation. On page 57 an electrician's drawing[7] of the wiring for a camera, with a full-front elevation of the lenses and shutter.

On the same page is a notation of the Photoret account for the first three months of 1895:

> HC Dr 7.28
> ½ Royalty on
> 104 Photorets
> Quar End Apr 1/95

This suggests that Casler shared Photoret royalties evenly with Dickson.

On Sunday May 5 (page 58, verso of leaf 29) Casler visited Dickson in Orange: "May 5-95/Sunday—Orange." It may have been partly a social day but the absence of sketches on this page do not convince us that Biograph technical matters were not discussed. Two days before, incidentally, Mrs. Dickson had left for a visit to her brother in Richmond, Virginia[8] and the two men may have had the place to themselves.

When Casler returned to Syracuse the notations continued as above. An occasional entry concerning film and photographic chemicals suggests the impending June trial of the camera. The move to Canastota is recorded in several pages suggesting the tooling of a shop. For example, on page 93:

> Files
> 1 Doz. 8" Hf round Bastard
> 1 " 8" Flat Mill
> 1 " 10" " "
> 1 " 10" Flat Bastard
> 1 " 12" Round "
> 1 " 10" " "
> 1 " 10" Square "
> 4 " Assorted Handles

[7] The suggestion here is that this sketch is not Casler's: lead pressure and softness and "style" suggest another hand. I am familiar with Dickson's hand and am also hesitant about identifying this sketch with Dickson.

[8] *Orange Chronicle,* May 4 1895.

The first part of the notebook suggests that the word "Muto" refers to work on the Mutoscope, "Cam" refers to work on a camera and "App" refers, possibly, to work on patent applications. But the sketches of June 10 and such notations as those of June 13, 26 and 27 clearly relate to film feeds—a non-Mutoscope matter—and suggest that later in the book the word "Muto" described Casler's motion picture work as distinct from his work for the Electric Drill Company. The notation on page 97, "Lock Muto Door," and the charge on page 104 to "Muto 1 Broom 35¢" confirm this.

The notebook is full of interesting information too copious to describe here in detail. On April 28, for example, which was a Sunday, Casler and John Pross hired a rig and went photographing. They took snap-shot cameras (or camera) and visited the country surrounding Syracuse: Fayetteville, Chittenango, Cazenovia, etc. The previous Friday Casler had bought film for this occasion and later recorded that he tried "instantaneous" (one fifth second) photography on 5″ x 8″ plates (pages 50-52). It is deeply characteristic of Casler that he should fill even his leisure time with activity related to his work.

As I have noted on page 20 other notebook notations concerned the August 5 1895 shooting. Others recorded the names of various persons from whom Casler was to get material, information or help. Another records the date of Casler's first Schenectady work for Marvin (see page 6). Others record remittances from Koopman, salary from Marvin ($90 a month), and many mathematical calculations—chiefly algebraic and arithmetical—which indicate Casler's solid and facile way with fundamental mathematics.

Conjecture as to the interpretation of many of the drawings and notations in this notebook I will leave to a more experienced man than myself. I have consulted two or three experts and there appears to be disagreement—except as to the incidental-to-a-motion-picture-camera character of the notations. In some the notebook seems to contain bits and pieces—but *central* bits and pieces[9] of Herman Casler's thoughts from March

[9] Central, because it is incredible that Casler would have carried *two* notebooks with him. We know that he often wrote in this one while holding it in his hand (pages 32, 46-48 show this contrast) and, from the time charges, etc., that it was a diary of his work.

to September 1895. They establish that he was involved in Biograph fortunes to some time in June and sporadically thereafter to about August 21 1895. It also establishes, it appears to me, that the execution of the Biograph apparatus was neither largely nor to a considerable extent the work of the keeper of this notebook—else why is there not a single reference to a distinguishing, crucial part of this apparatus?

Photographic reproductions of three pages of suggestions Dickson made on September 3 1895 for color projection (which are now in my possession) are not relevant to this history, since none seem to have been utilized in Biograph apparatus.

5 · The First Season in Business

THE FIRST ITEM IN PLANS TO ORGANIZE A COMPANY WAS TO transfer all patent rights to such a company and use these rights as security for a loan of $200,000 from the New York Security and Trust Company. The company was organized as the American Mutoscope Company in Jersey City, New Jersey[1] on December 27 1895 for:[2]

> The Manufacture and sale of photographic, mutographic and mutoscopic implements and appliances, implements and apparatus in any manner connected therewith, or for projecting the same, and the using the same for exhibition or other purposes, and the selling or leasing or otherwise disposing the same, or the right to use the same.

The capital stock of the American Mutoscope Company was $2,000,000, divided into 20,000 shares with a par value of $100 each. The attorneys who drew the papers, as organizing stock-

[1] The laws of New Jersey, since altered, made it much less expensive to incorporate in New Jersey than in New York where the business actually was. Thus a Jersey firm of attorneys here, as frequently elsewhere, acted as figurehead officers.

[2] From a *True Copy* of the Certificate of Organization made for me by the Hudson County Clerk on January 22 1957.

holders, each received 2 shares of stock. The remaining 19,996 shares went to a George A. Lauman of Greenwich, Connecticut, who held the stock until it was transferred to Casler, Marvin, Dickson and Koopman as sole stockholders. The Certificate of Incorporation was filed on December 30 1895 and on January 3 1896 the American Mutoscope Company officially commenced business.

On January 13 Marvin and Casler assigned their patent rights to the new company and all four men agreed to assign rights issued "at any time hereafter" to the company. As of this date these rights consisted of 1, Casler's U.S. #549309 (the Mutoscope patent); 2, Casler's application of November 14 1895 (the hand-held Mutoscope); and 3, Marvin's application of November 14 1895 ("improvements in Mutoscope"). The great Mutograph camera application was yet to be filed (on February 26 1896) and the application for the projector— called a "Mutopticon" in the patent records but soon to be called a "Biograph"—was filed on the same date.[3] On the same date the American Mutoscope Company assigned the rights thus received to the New York Security and Trust Company.[4]

> as security for the payment of two hundred Thousand dollars ($200,000) represented by four hundred certain negotiable bonds of the said American Mutoscope Company dated January 15th, 1896 . . . secured by a certain mortgage from the American Mutoscope Co. to the New York Security and Trust Co., which mortgage bears date the 15th day of January, 1896 . . .

By January 24 1896, according to a letter from John T. Easton, 150 Nassau Street, Counsel and Secretary of the new company, "machinery and appliances" were being put in: "in", presumably, the sixth floor (see page 59) of 841 Broadway.[5]

[3] From the *Transfers of Patents*, Volume J-52 in the Federal Records Center at 8th and D Streets, S.W., Washington, D. C. The word "Biograph" was, of course, by no means new. For example, as early as 1879 there was a British publication named *The Biograph and Review*. The word itself, of course, is a combination of two Greek forms, "bio" meaning "life," and "graph" meaning "to write."

[4] *Ibid*. This matter is recorded in Liber 174, page 435 of the *Transfers of Patents*.

[5] The New York Security and Trust Company papers in this case were very kindly made available to me, at some inconvenience, by Mr. Henry J. Lanier, Jr., assistant vice president of the New York Trust Company. Mr. Lanier's civilized kindness was a bright spot in my research.

Negotiations, however, were in the offing for the establishment of a plant in Hoboken, New Jersey, at 1013 Grand Street.[6] On February 26 the details of the Mutograph camera and "Mutopticon" were so far advanced as to enable Casler to file applications for these instruments, to be issued, respectively, on July 18 1899 as U.S. #629063 and on January 22 1901 as U.S. #666495. On March 21 Casler and Marvin went to New York on business—presumably to meet Koopman and Dickson.[7] Marvin took another trip to New York City about May 16,[8] but apparently Dickson and Koopman, being on the spot, were chiefly responsible for the 841 Broadway installations. It is likely that the roof stage (see illustration 10), the processing rooms, etc., were chiefly of Dickson's arrangement: Koopman's experience in such matters was comparatively small. The Marvin Electric Drill Works was also taking much Marvin and Casler attention,[9] and so long as the New York end of the business was in good hands there was no need to divide their attentions.

As of June 3 1896 Dickson was installed in the new address. On that date he wrote Raff and Gammon a dictated letter on the letterhead of the "Porter Air-Lighter Company"—a Koopman interest.[10] The address of this company, according to the

6 A letter dated March 13 1896 in the New York Security and Trust Company files sends the minutes of the bondholders' meeting to the Suburban Land and Improvement Company of New Jersey, which was to install at least part of the Hoboken plant.

7 Canastota Bee, March 21 1896.

8 Ibid, May 16 1896.

9 Although the first drill was not turned out until November 1895, (Canastota Bee, November 23 1895) the business picked up somewhat. For example, the Bee of March 7 1896 said that the company had "a force of seventeen men," and on June 1 1896 that Marvin had gone to Cripple Creek, Colorado, to install a drill in a gold mine. On July 11 the Bee said that this trip took five weeks. On July 25, however, the business took a slump, and the Bee reported the Drill Works closed. It was not to reopen until November 14 1896.

10 This letter is in the Baker Library, Harvard University. After leaving Edison's employ Dickson joined Llewellyn Johnson, an Orange friend, in the Portable Electric Light and Power Company, which was designed to exploit a Dickson patent for a bicycle lamp for mining and other purposes. This company, according to the Electrical Engineer of May 8 1895, had "offices in Watts Street, this city [i.e., New York]." The Porter Air-Lighter Company was listed in the New York City directories for the years ending July 1 1896 and July 1 1897 at 841 Broadway—with no previous listings. For the year ending July 1 1898 it was listed at 28 Waverly Place. The memory of Mr. Billy Bitzer (whose notes were made available to me through the kindness of his wife) informs us that the Porter Air-Lighter Company was a Koopman Company, controlling, in Bitzer's words, a "chemical substance which was applied on gas jets to keep

letterhead, was 837-841 Broadway. Possibly Dickson was only using the letterhead: he may have been concealing his business. But he shed this camouflage (if such it was) on June 23 and wrote Raff and Gammon a thank-you note for their loan of a Kinetoscope and phonograph for the lawn party of one of his Orange friends. He wrote this letter on the letterhead of the "American Mutoscope Company/837-847 [sic] Broadway/. . . Cablegrams & Telegrams/MUTO/Telephone 1180-18th St."

By this time the photographing of subjects on the roof stage may have gotten underway. This roof stage rotated (see illustration 10) through a 90 degree angle to accommodate the variance of the sun's rays. The reader who visits the roof of 841 Broadway at the present time will be able to closely approximate the location of this stage. He will also see, on the southeast corner of the roof, a galvanized iron shed, where, legend has it, motion picture equipment was kept.[11] The camera house, a considerably different building, was placed on a track and could be moved away from or toward the stage—as in the "Black Maria"—also of Dickson's design. The *Scientific American* of April 17 1897 describes it:

> . . . a floor of steel I beams which carries a series of three concentric steel tracks. Upon this rotates a massive frame, at one end of which is a stage supplied with the necessary scenery, and at the other end a corrugated iron house in which is located the mutograph. The stage is bolted to the frame but the house travels upon a track and may be moved to or from the stage as required. The frame carrying the stage and house rotates about the smaller circular track located beneath the house, and may be swung around so as to throw the light full upon the stage at any hour of the day.

On this stage, on the distinctive rug with its seven-patterned

the yokels from . . . blowing out the gas at night. . . . This patent was taken up by all the hotels. . . . When the yokel would blow out the gas it would instantly relight itself."

[11] Conjecture as to the disposition of the steel framework of the stage or the iron of the camera shed in relation to present structures is interesting but inconclusive. That the stage was between the south, 13th Street parapet, and the stairwell roof opening (then and now glass-covered, but now somewhat altered) may also be seen from a photograph of "Cam. B. tripod extended" in the author's collection of photographs.

design and border,[12] the dancer Annabelle may have been the subject of the first "official" production of the 1896 season.[13] Two "skirt dances," a "tambourine dance" (see illustration 14) and a "flag dance" were taken. These would have seemed to Dickson, steeped in "Black Maria" tradition, to be a good start.[14] "Sawing Wood" was another subject. At about the same time four subjects of the strong man Sandow were shot: "Sandow (no sun)", "Sandow (Sun)", "Sandow (Breathing)", and "Sandow (no Breathing)." What I presume to be "Sandow (Breathing)" and "Sandow (no Breathing)" are now in my possession. The latter is the same as the first, with several frames cut out which show deep breathing movements.

The Sandow subjects had a premonition in the *New York Clipper* of April 4 1896:

> Charles B. Jefferson is about to organize a vaudeville company, headed by Eugene Sandow, which will open its season probably in August. Mr. Jefferson has signed a five years' contract with Sandow.

I will show on page 39 that, contrary to all previous writing on the subject, the American Mutoscope's projector—née the Mutopticon, later the Biograph—made its world public debut on September 14 1896 at the Alvin Theatre in Pittsburgh, and as the closing number on a Eugene Sandow bill. These four Sandow subjects may well have been taken at the time negotia-

[12] This rug can be seen often in Biograph subjects: in the 1896 "Annabelles," for example; in a "Sandow"; in the subject illustrated by four frames captioned "Akrobatik Tänzerinnen im Variete" in Zglincki, *Der Weg des Films* (Pub. Rembrandt Verlag, Berlin, 1956) but not identified there.

[13] Previous subjects copyrighted by the Company—"Sparring contest taken at Canastota," "Threshing Machine" and "Engine and Pump"—all appear to have been taken in Canastota. We know that the first of these three was shot on August 5 1895 in Canastota, and the spectacle of a threshing machine—a logical part of Canastota in summer—being dragged onto the roof of a New York skyscraper is something less than credible. "Engine and Pump" is also a logical companion piece to "Threshing Machine." The 1902 catalogue (see page 45) describes it as a steam engine—the customary motive power for a threshing machine in those days. These two latter subjects were probably an attempt to satisfy Koopman's desire for machinery subjects. They may also have been only experimental.

[14] These titles are taken from a remarkable ledger in the collection of the Museum of Modern Art, approximately 5⅜" x 14⅜", which lists by number— but only approximately chronologically—the American Mutoscope film subjects from 1 to 1100. The cover of this notebook bear the legend "List of subjects/ Feet-Copyright/Scott" and seems to be a record of 1902 and 1903 copyrights, with negative and positive film lengths.

tions were under way for including the new projector in the show. The third, "Sandow (Breathing)", may be seen in a remarkable series of drawings in the *New York Herald* of February 7 1897 in which Sandow is shown turning a somersault. (We know that this is the "Sandow (Breathing)" title from the 1902 catalogue.) Although the first two Sandow subjects were numbered 12 and 13 and the latter two 37 and 38 in the Museum of Modern Art notebook, I have placed them together. It is possible, of course, that this variation in numbering indicates a later shooting date, but the notebook shows other subjects widely spaced in numbers which were clearly shot at the same time.

"Trilby and Little Billee," a scene from the sensationally successful melodrama "Trilby" then enjoying a run in New York, may also have been shot at a later time, as was "Hard wash,"[15] "Watermellon [sic] Feast" (see illustration 00) and "Dancing Darkies"—all of which were apparently shot at the same time. Also shot at 841 was "United States Flag," but probably only shortly before the projection debuts, since it seems most appropriate for those.

Numbers 7 and 8 in the notebook are, respectively, "Union Square and Fourth Avenue" and "Union Square—New York." The scenario of the first may be read in the *New York World* of February 7 1897, and of the second in the 1902 catalogue:

> A most interesting view of Union Square as it appeared in 1896, showing the old style trolley cars rounding Deadman's Curve[16] at Broadway and Fourteenth Street, and the old style cars of the Fourteenth Street crosstown.

This latter subject is somewhat more interesting than ordinarily because of the camera station—apparently a window in the 841 Broadway building. We know from the Bitzer notes that the American Mutoscope Company had its offices on the sixth floor of this building, but the window of this subject is lower.

On June 6 two more subjects, "Carriage and Bicycle Parade on Boulevard" and "Bicycle Parade on Boulevard" were taken.

15 Often confused with an Edison imitation of this subject.
16 So-called because of the number of accidents occurring there: it was necessary for cars to turn this corner without stopping.

The only bicycle parade on the Boulevard (i.e., Broadway north of Columbus Circle) in 1896 was on June 6.[17]

Shortly before July 18 (see note 19 below) the camera, with probably Dickson at the controls (as he had been up to now)[18] went down to Atlantic City and shot 16 subjects: "Shooting the Shutes [sic] Atlantic City," "Shooting the Shutes Atlantic City," "Sea Scene," "Boys Bathing at Atlantic City," "Atlantic City Bathers," "Taken from Trolley Atlantic City," "Fire Engine at work,"[19] "Taken from Trolley,"[20] "Bathers and Life Boat Atlantic City," "Group of Bathers Atlantic City" (see illustration 15), "Getting off Trolley Atlantic City," "Buses leaving Depot—Atlantic City," "Atlantic City Boardwalk," "Wrestling Pony and Man," "Wrestling Ponies" and "monkey's Feast." These are numbered 17, 18, 19, 20, 21, 22, 23, 24, 30, 31, 33, 34, 102, 42, 43 and 32 respectively. The Library of Congress copyright deposit for "monkey's Feast" as well as its numbering—32, between "Group of Bathers Atlantic City" and "Getting off Trolley Atlantic City"—indicate an Atlantic City setting. Two monkeys are shown being persuaded to perform

[17] See, for example, the *New York Herald* of June 7 1896.

[18] The Library of Congress copyright deposits for many of the 1896 American Mutoscope subjects consists of a small card upon which is mounted a frame reproduction of the subject intended for copyright. These frames are preceded and followed, with only slight variations, by handwritten titles, partly in Dickson's hand and partly another's—which Mrs. Bitzer has said was not her husband's. The Atlantic City subjects bear the same inscription, with Dickson filling in the appropriate date. Logically the cameraman would be the best and possibly the only person qualified to supply such data. Many of these deposits have been lost.

[19] The *Atlantic City Daily-Union* of July 18 1896 reported: "Agent Stewart of the American Ball Nozzle Company gave an exhibition of the possibilities of the patent ball nozzle this morning at North Carolina Ave. with the view of having it introduced into the fire department in this city. A States engine was used to force the water and was run at its highest speed. . . . The test was witnessed by Chief Whippey, ex-chief Lackey, Lewis Evans and other prominent members of the fire department. The exhibition was photographed for a kinetoscope by the Edison company and will be reproduced in the Boardwalk in a few days."

Since no such subject was used in the Kinetoscope I have assumed this to be an American Mutoscope Company production, with the visitors keeping Biograph plans *sub rosa*. It is numbered 23 in the Museum of Modern Art notebook, and is sandwiched between numbers 22 and 24, which are both Atlantic City subjects. Its stress on the American Ball Nozzle Company sponsorship also strongly suggests the Koopman idea of industrial use for the Mutoscope. Bitzer remembered Koopman's association with a "Ball nozzle." Ramsaye, *op. cit.*, page 215, is also interesting in this connection.

[20] This and the former trolley subject were mounted camera subjects, predating most others.

by a handler, whose arm may be seen reaching into a small canvas-walled enclosure bathed in bright sunlight.

Possibly on the way to or from Atlantic City via Philadelphia on the Pennsylvania Railroad the following subjects were shot: "Train coming out of Station Philadel. Penn.," "Penn. R.R. at New Brunswick, N. J.," "Penn. R.R. near Philadelphia Penn." "Pennsy. Railroad Cliffs,"[21] "Pennsy. Railroad near Haddonsfield [sic]" and Penn. Rd. Limited Express." Although the latter subject is numbered 100 in the Museum of Modern Art notebook I have placed it on this shooting excursion because of its subject matter. It was chosen as the basis of the well-known *Scientific American* illustration of April 17 1897 (see illustration 12) in which Casler (who was almost certainly not present) and Dickson are shown. (It is incorrectly identified as the "Empire State Express" on page 5 of the Griffith and Mayer book, *The Movies,* published by Simon and Schuster in 1957.)

About a month later Dickson, with the Biograph rapidly approaching its public debut, visited Buzzard's Bay, Massachusetts, and photographed both "Stable on Fire"[22] and eight subjects showing the famous actor Joseph Jefferson in scenes from his celebrated stage hit, "Rip Van Winkle." It will be remembered that Jefferson's son Charles was the promoter of the Sandow show with which the new projector was to make its public debut, and certainly this excursion was arranged by Charles. Several of these subjects are in my collection and show the outdoor setting described by the 1902 catalogue. The large boulders and scrub pine characteristic of the locale are all plainly visible. These subjects are listed in the Museum of Modern Art notebook as "Rips Toast," "Rip Meeting the Dwarf," "Exit of Rip and Dwarf," "Rip Passing over the Hill," "Rip's toast to Hudson and Crew," "Rip's Twenty years Sleep," "Awakening of Rip" and "Rip leaving Sleepy Hollow." We know the approximate shooting date for these subjects from an item in the *Orange Journal* of August 29 1896:

[21] In Jersey City, New Jersey, showing the cut and bridge near Journal Square.
[22] Identified as having a Buzzard's Bay locale by the 1902 catalogue, although no local paper describes its taking. Local papers also failed to note the taking of Joseph Jefferson subjects. Those I examined were the *New Bedford Morning Mercury* and the *New Bedford Evening Standard.*

> William Kennedy-Laurie Dickson[23] of Cleveland street
> is visiting his friend, Joseph Jefferson, at his home at
> Buzzard's Bay. Mrs. Dickson and Miss Antonia Dickson,
> A.C.O., have returned from Saratoga.

Hurrying back to New York, Dickson shot three events of the visit of Li Hung Chang, the Chinese diplomat just returning from the coronation of Nicholas II of Russia. This distinguished visitor docked on Friday, August 28 1896, and was escorted to the Waldorf, where he arrived "shortly after three o'clock."[24] On his way through the streets Dickson photographed "Li Hung Chang"—Fourth Avenue and Broadway" (the copyright record says Fourth *Street*). The next day the visiting diplomat met President Cleveland at the Whitney residence at Fifth Avenue and 55th Street and Dickson shot "Li Hung Chang—5th Ave and 55th Street." The next day, Sunday, Chang visited the nearly-completed Grant's Tomb, laid a wreath on it, and was immortalized in the Biograph subject "Li Hung at Grant's Tomb."

Soon, if we may judge from the Pittsburgh debut on September 14, Dickson began a trip to that city via West Point, where he shot two subjects called "West Point Cadet Cavalry" and two entitled "West Point Cadet Drill."[25] Proceeding to Niagara Falls (cf page 000) he shot eleven subjects of that Mecca of all early motion picture cameramen. Again no local newspaper notice appeared which would enable us to date these subjects more closely.[26] These subjects are consecutively numbered 60 to 71, both inclusive, in the Museum of Modern Art notebook and are as follows: "Canadian Falls Table Rock,"

[23] About this time Dickson began the hyphenating of his second and third names. He had hyphenated these in his autograph in a copy of *The Life and Inventions of Edison* given by his wife to a Saratoga friend in August of this year—"a gift to my Charlotte—Instinct with the love and gratitude of her vital friend Lucie Agnes Archer Dickson Saratoga, N. Y. Aug./96" (!) This book was kindly made available to me by Mr. William Finn.

[24] *New York Herald*, August 29 1896.

[25] The West Point archives, which I examined on March 26 1958, have no record of such a visit. Neither the *Superintendent's Letter Book*, 3/1/96-3/1/97, nor Volume 10 of *General & Miscellaneous Letters received*, 6/1/97-cl/10/97, has any record of any arrangements for such a visit.

[26] I perused the *Niagara Falls Daily Cataract*, the *Niagara Falls Gazette* and, with the hope that someone familiar may have stayed at the famous Cataract House, the register of that place for the period from May 1 1896 to November 3 1896. There was no relevant entry.

"Canadian Falls Table Rock No. 22,"[27] "Falls from Michigan Central Ry. No. 23," "American Falls, Luna Island," "American Falls, Goat Island No. 25," "American Falls from American Side No. 26," "Niagara Gorge from Erie Railroad," "Lower Rapids Niagara Falls," "Pointing Down Gorge Niagara Falls," "Taken from Trolley in Gorge Niagara Falls," "Upper Rapids from Bridge," and "Panorama of Am. & Can. Falls taken opp. Amer. Falls."

These American Mutoscope Company Niagara Falls subjects contain complex problems of inter-identification. I think, for example, that "Am. Falls, Luna Island" does not show Luna Island, but should properly be entitled "Am. Falls [from] Luna Island." A similar change should be made in "Am. Falls, Goat Island No. 25." Detailed analyses must wait for the *Index* of these early subjects now in preparation.

6 · The Debuts

WE MAY SURMISE THAT DICKSON AND HIS STRONG-BACKED ENTOU-rage, leaving Niagara Falls, boarded a Baltimore and Ohio train at Buffalo with camera and projector and traveled to Pittsburgh for the September 14 debut at the Alvin Theatre. There is, of course, no way of knowing that the Niagara Falls shooting was part of the Pittsburgh trip, but since we know that the camera was in Canton, Ohio (see page 41ff), this arrangement seems logical.

The Alvin Theatre debut was little heralded. Indeed, the whole pre-October 12 Hammerstein's Olympic career of the projector was so little noted in New York that every writer has failed to note it, and designates the October 12 performance as the debut. My own search of the *Dramatic Mirror* led me to Pittsburgh and was the first notice I had seen of the

27 Cf following subjects. I do not know what this "No. 22" means, unless, as appears likely, it means that 26 or more subjects were taken on this visit to Niagara Falls (or on this trip out of New York) and that this subject, number 22 of the series, was one of the 11 of the 26-plus which were shot thought suitable for use.

American Mutoscope Company's projection plans. On September 12 that periodical, speaking of the Sandow "Olympia" said: "The company . . . includes . . . the Biograph, a new invention in the moving picture line." The *Mirror* also spoke of the Pittsburgh opening of the company and a search of the Pittsburgh papers revealed announcements of the new show. These were in the *Pittsburgh Post* and the *Pittsburgh Press* of September 6 1896. Each of these, however, failed to mention the Biograph. Another *Pittsburgh Press* note on the show on September 8 also omitted the Biograph, and a display advertisement in the same paper on September 13 listed all the features of the show but still did not mention the new projector.

On the next day, however, September 15, the *Press, Post, Commercial Gazette* and *Chronicle Telegraph* all reviewed the Biograph appearance. The *Post's* account is perhaps the most lively, although the *Press* said it was "well received" and the *Commercial Gazette* said that it was "heartily applauded . . . [and] Mr. Jefferson's lips moved so naturally that one could almost imagine he heard the words that he seemed to utter." The *Chronicle Telegraph* gave a foretaste of what was to come in saying that the Biograph "seem[ed] to be the best . . . [in the] new process of photography." It was this superior performance of the American Mutoscope Company's machine that enabled it to successfully endure. The *Post*[1] said:

> Manager Kirk, of the Alvin, sprung a surprise on the big audience last night at the close of the performance by the Sandow troupe. He has secured a machine which produces the same results as the cinematographe, vitascope or biographe [sic], as it is variously called. Mr. Kirk's instrument is a "biographe," and he got it because he didn't believe in being behind the times. The biographe shows a picture nearly twice as large as the similar machines in the other houses, and the impression is clear-cut and distinct. Trilby came back to life through it last night, bounced into the studio and jumped on a table at Little Billee's elbow. After kicking off her slippers and revealing her beautiful feet she borrows a cigarette of Billee and then they fall to, as the story goes. The machine has an extensive repertoire, and will show every night this week . . .

The Biograph played only one week—through Saturday, September 19—at the Alvin. But before it traveled down to

[1] Of September 15, 1896.

Philadelphia for another week's run at Gilmore's Auditorium, Dickson took the camera to Canton, Ohio, to shoot some of the most significant of all early Biograph subjects.

At this time in Canton William McKinley, Republican candidate for President of the United States, was obeying Mark Hanna's orders and confining himself to "front porch" pronunciamentos affecting the problems of the day. His brother Abner is said to have had stock in the American Mutoscope Company[2] and may have arranged this production. The trip to Canton could have been made in a day (the subjects were shot late in the morning and early in the afternoon).[3]

At any rate we know that the shooting occurred on Friday, September 18, since that is the only day all summer that the Elkins Cadets and the Americus Club visited Canton. These were organizations photographed on September 18. The *Canton Evening Depository*[4] said on September 18:

> The Americus Club of Pittsburgh arrived at 11:45 . . . 350 men . . . all dressed in white plug hats, decorated with elegant badges and carrying red, white and blue umbrellas . . . The Elkins cadets in uniform, one hundred in number . . . were headed by . . . a colored lad as drum major. The uniforms consisted of a West Point suit, with the exception of white duck trousers. Each cadet carried a spear with a yellow streamer.

These details may be observed in the illustration of "The Americus Club" in the 1902 catalogue, and in the description of "Parade Elkins Cadets" in the same publication.

Productions numbered respectively 72, 73, 74, 75 and 76 in the Museum of Modern Art notebook were shot in Canton, Ohio on September 18 1896 as follows: "McKinley at home—Canton—O.," "Parade American [sic] Club of Canton—O.," "Parade Canton O. showing McKinley in carriage," "Parade Elkins Cadets" and "Parade Sound Money Club Canton—O."

[2] According to Ramsaye. But I have not seen Abner McKinley's name in the New York Security and Trust Company papers, so whether or not the Canton shooting had Abner's intervention is conjectural.

[3] On the other hand, since Bitzer does not seem to remember the Pittsburgh exhibit—and he was certainly nevertheless in Canton (see page 42)—it is possible that Dickson only supervised the Pittsburgh opening, and was not concerned with the remainder of the week.

[4] A microfilm of which I read in the New York Public Library. It had been kindly loaned for my purpose by the Ohio Historical Society—the Canton Public Library not giving help to out-of-town researchers.

By far the most important of these was the first: "McKinley at home—Canton—O." This was later called "Major McKinley at Home" in accounts of the Hammerstein showing,[5] and merely "President McKinley" in the 1902 catalogue. In the Library of Congress copyright deposit of November 11 1896 it was called "Wm. McKinley Receiving Telegram Announcing His Election." This is a canard, however, since we know from the scenario in the *New York Herald* that the November 11 subject described there is the September 18 subject, and McKinley was not elected until November 3. In any case he received the news of his election long after dark on election night. This *New York Herald* February 7 1897 scenario is as follows:

> For instance, I have learned through the mutascope [sic] that Mr. McKinley, the President elect, toes out like a ballet girl when walking. His clod crushers are quite respectable in size, too, if anybody should ask you. In the machine one can readily see that he is not a reckless pedestrian. He is slow and methodical, and is careful where he puts his feet.
> He is represented as walking on the lawn at his residence, bareheaded and with his silk hat in his hand. You can tell that it is a hot day by the looks of him. Down the lawn comes a young man, reckless and full of speed and importance. Mr. McKinley stops, puts on his hat, takes his glasses from his waistcoat pocket and adjusts them to his eyes, and slowly reads the telegram. From the expression of his face it may be judged that the telegram is a harbinger of victory. Having read the telegram with apparent satisfaction to himself he returns it to his secretary, takes off his hat with his left hand, and with the right brushes the hair from his forehead, and, accompanied by his secretary, resumes his walk across the lawn, evidently discussing the good news just received.

The *New York Herald* of October 12 1896 reproduced four frames from this subject.

Billy Bitzer's account of this visit to McKinley is interesting.

> Mrs. McKinley was seated upon the porch, back in the corner, as the President came out of the door with his secretary, George B. Cortelyou, who handed him the notification papers. The President looked at it, and then took off his hat and wiped his forehead with his handkerchief. That

[5] For example in the Olympia program and the *New York Clipper* of October 17 1896.

was all. Not much, was it? But it was what the public wanted. A picture which could go down for posterity, like we said. The first time a President had been photographed in action. There is a thrill in that!

Now as I said, Mrs. McKinley had been upon the porch while all this was going on, and then when it was all over she was gone. Gone like a wraith! How she got from place to place I never knew. She was an invalid. She could not have left by herself, but the President was most considerate of her in her affliction, and he ran things so smoothly that her coming and going was hard to detect.

We were invited into the house for Luncheon, where once more presided Mrs. McKinley. She chatted a bit, but not much, for it was plain to see here was a woman who besides being delicate, was old fashioned enough to leave the talking to the 'men folk.'

I myself had little or nothing to say, as I was merely the man who ran the camera for Dickson, whom I looked up to . . .

After luncheon we again went out upon the lawn taking more pictures, and as the sun left us we had to discontinue. All was so pleasant I could have worked on forever . . .

After "Olympia" closed in Pittsburgh on Saturday, September 19, (we can be sure of the names of only three subjects shown in Pittsburgh, either "Rip's Toast" or "Rip's Toast to Hudson and Crew," "Stable on Fire" and "Trilby and Little Billee") the Biograph was taken to Philadelphia, where it opened a week's run at Gilmore's Auditorium. The *Philadelphia Bulletin* of September 19 announced it thus:

> [Sandow] will appear in a thrilling play written especially for the purpose of displaying [his] wonderful powers . . . There will also be an exhibition of the biograph, the embodiment of the highest improvements and advances in that new and marvellous field of science—the picture making of moving objects.

The *Philadelphia Times* of September 20 announced

> . . . [four scenes] . . . among them being three scenes from Rip Van Winkle, acted by Joseph Jefferson, and the visit of Li Hung Chang to the tomb of general Grant, which will afford the general public the opportunity of witnessing one of the most interesting incidents of the Viceroy's visit to America.

The Philadelphia press reaction to the Biograph cannot be

called enthusiastic. The *Times* of September 22 merely said that it was "thoroughly appreciated" and the *Bulletin* of the same date said that it "caused the audience to wonder where marvels of invention will stop."

From Philadelphia, where it closed on September 26, the company went to the Columbia Theatre in Brooklyn and opened on Monday, September 28.[6] Here also the reviews were either non-existent or unspectacular. The show closed in Brooklyn on Saturday, October 3 and reopened for a final week's run at the Grand Opera House in Manhattan at 23rd Street and 8th Avenue.[7] It was decided to close the show at the end of this week because, as the *Herald* of October 6 said, it was "unprofitable financially."

Meanwhile Dickson, possibly remaining in upstate New York after the Pittsburgh closing (or taking the Niagara Falls subjects *after* the Pittsburgh closing?) had taken another subject—which was to be second most popular in the resplendent Hammerstein debut of October 12, and far more popular than "McKinley at Home" afterward.

The *Canastota Bee* reported on September 26:

> Mrs. E. B. Koopman of Mew [sic] York, has been the guest of Mrs. H. N. Marvin several days this week. Mr. Koopman and Mr. W. K. L. Dickson of New York, passed Sunday at the pleasant home of Mr. and Mrs. Marvin.

Sunday was September 20, the day after the Pittsburgh closing, which may suggest that both Koopman and Dickson were on their way home from Pittsburgh/Niagara Falls. On October 3 the *Bee* had an even more interesting account:

The Wonders of Photography

> Very few people in Canastota are aware of the powers of the mutuscope [sic], a remarkable little instrument manufactured by Messrs. Marvin & Casler of this village. By it the movements of any rapidly moving objects can be reproduced with the greatest accuracy. When Li Hung Chang was in New York a few weeks ago a series of views was taken of himself and his retinue of attendants passing through Broadway. His celestial highness was greatly pleased with the reproduction of his procession and he was

6 *New York Herald*, September 27 1896; *Brooklyn Eagle*, September 27 1896.
7 *New York Herald*, October 4 1896.

doubly delighted when Mr. Marvin presented him with one of the instruments. Last Wednesday one of the machines was used to photograph the Empire State express and fast mail as they were scooping water at Palatine. The Empire State was taken at 12:13. The train had just passed the pump house and was tossing the water high in the air on either side when the mutuscope, taking forty pictures a second, was set in motion. The train had previously been telegraphed of what was to be done and therefore everybody aboard was astir. The engineer shook his hat, the cooks waved their aprons and passengers dangled handkerchiefs to the breeze. The fast mail was taken a short time after.

These September 30 subjects, together with three more taken shortly afterward to satisfy public demand (prints having a very short life and duping being unused by the Biograph people), comprise five titles in the notebook: "Empire State Express No. 1," "Empire State Express No. 2," "Chicago fast mail NYC. R.R.," "Train taking Water NYC. R.R." and "Empire State Express No. 3."

The first and third appear to be the *Bee* subjects. The report is specific about the "fast mail" (we know it was a "Chicago" fast mail from contemporary time tables) and there appears to be no other reason for the Nos. 1, 2 and 3 in the Empire State Express titles, except that they should describe a chronology. Thus "No. 1" would have been shot on September 30, and "Nos. 2" and "3" after: 1, the October 12 debut, 2, after the first negative had begun to wear out, and 3, before December 18 1896 when "No. 3" was copyrighted.[8] "No. 3" is also the subject copyrighted on July 25 1902 and is now in the film collection of the Library of Congress. "No. 1," which made the great debut sensation, seems to be the subject reproduced opposite page 297 of Ramsaye (from a mutoscope reel of undescribed origin). "No. 2," not having been copyrighted or reproduced in any known place, is lost to us—although its locale may be seen in the Ramsaye reproduction of his "Empire State Express." "Train taking Water NYC. RR.," although not copyrighted until February 4 1897, was shot at the same time

8 We know it was "No. 3" which was copyrighted from the 1902 catalogue, which reads: "81 Empire State Express": "81" is the notebook number of "No. 3." The catalogue also says it was shot near Canastota, and the background clearly shows a different locale than the September 30 subjects. This is the subject of the illustration (18) showing the Biograph in a theatre.

as "Empire State Express No. 3," since the copyright deposit shows the same locale.

"Parade of First Brigade" and "United States Flag," numbers 82 and 83 in the notebook, appear to be the last subjects shot before the debut.

There was a press screening before the Monday, October 12 opening at Hammerstein's Olympia in New York, but I have not determined exactly when it was—a customary time would have been Saturday, October 10. Although I have found no notice of such a preview, not to have had one under the circumstances would have been virtually unprecedented, and Bitzer's description of his experience at the press preview eliminates any doubt that one was held. It was at Hammerstein's, according to Bitzer, and the picture was too high on the screen:[9]

> It struck me that I had the picture a little high on the screen at the press preview. I had the coffin very slightly tipped forward with a piece of wood under its back and had been afraid to tip it much further lest its vibration would topple it over into the audience below and there wasn't much space for bracing it anymore (with the little magic lantern (stereopticon) with which I projected the title slides of the several pictures between the pictures) which I had placed in front of the Biograph a little lower down and to the side. There were also a couple of large bulky rheostadts [sic] on the floor with their wires leading to them lying about the glass title slides I had in my pocket . . . taking the next one from my right pocket and shifting . . . then showing one in the left pocket couldn't make any mistakes there as the shown ones were pretty hot. an electric switch was also on the floor had no place to hang it without mutilating the booth and, I had hung some cheap maroon colored drapes the color I selected to match the covering on the balcony rail . . . on either side of the front of this booth to prevent the occupants of the booths on either side from peeking in . . . a couple of fire pails filled with sand a big box I brought the film down in a stack of tools and a WOOD SAW to operate the machine required both hands one foot and sometimes my nose. The modus operandi was thus. The full reel of film . . . I would adjust evenly when the upper large brass pully its diameter being about 10 inches as compared to the 3 in core diameter of the core of today with the eight or ten pictures upon the diameter across the reel measured two feet on account of the core supposedly required . . . after adjustment, the

[9] Obviously Bitzer, a highly intelligent man, intended this writing only as an *aide memoire*. I have preferred, however, to make no changes—thinking that such changes might involve injudicious interpretation.

reel upon the pulley I would keep it covered with a couple of damp Towels as it was not well to thread the machine completely until about ready to run their being a long stretch between the reel and where it came to the first set of pulleys and if left too long in the air the film along this section would try to curl up like a hose so just before the finish of the act ahead of the Biograph[10] I threaded the film over the wooden pulleys clamped the rubber webbed driving belt on over the film made the long lower loop which was also about two feet long (all this was required on account of the bulkiness of the contraption) and led it over another series of rollers and gripped it on to the take up pulley. Threw on the main switch then in a smaller switch on the front 25 ampere hand feed Colt Lamp it used 3/8 inch carbons both upper and lower and lower carbon being the same size. put first slide into position The America Biograph with its spread eagle. the next slide and the first picture slide . . . then . . . the Biograph Lamp which was also a 25 amp Colt hand feed lamp. and jumping down (there was a single step in this booth (to raise the rear chairs higher than the front ones when in general use) to the front lamp I would put on the slide and then step back up to the big upright coffin muttering a prayer and giving it a final hard look. I would gingerly start the somewhat large motor controller my left hand reaching up to help guide the film at its start My right hand when she got up to speed quickly clutched at a rod which controlled the picture upon the screen. as the beater cam movement which pulled the pictures down into position was uneven pictures would gain or lose in the aperture frame the lever which operated a friction drive disk controlled this my foot would push down the pedal which opened the light gate. I had hung a mirror in a wooden frame on the front drape at an angle which enabled me to intermittently observe how the film was feeding on. if it was trying to creep toward the edge of the feeder pully. I would give a push back with my forehead or nose which would straighten it out enough to finish that 1 minute picture had to keep my eyes pretty well glued to the screen however or the picture would start riding up or down) a black leader between the picture and "bang" off went the motor control and with a jump at the big reel on top to stop its momentum when the reel was full. (and say as it piled up on the take up reel I used to slap a monkey wrench onto one of its spokes to help it take up as its diameter increased) then pull the next slide out of my pocket down to the slide lantern (the reason I say down I had it on a board one end resting on the balcony rail the other on a chair . . .

10 We can only assume that the whole new Hammerstein's bill was being previewed or that Bitzer is eliding his regular projection experiences into those of the preview.

48

There was also a Sunday night October 11 "concert" at Hammerstein's Olympic,[11] and the machine may have been shown again. But the Biograph made its "regular" debut on Monday, October 12 1896. This has often been called the "public premiere," but we have seen that it was not. The original program (a photostat of which has been kindly given to me by Harry Casler) billed the new projector as follows:

THE BIOGRAPH

Invented by Herman Casler of Canastota, N. Y.
The "dernier cri" in the art of reproducing light and motion,
The Biograph presents this week the following views:

Stable on Fire.
A vivid picture of the rescuing of live stock and carriages from a burning barn.
Niagara Upper Rapids.
American side, taken from Goat Island Bridge.
Trilby and Little Billee.
The studio kissing scene from Du Maurier's immortal story.
Joseph Jefferson.
Toast scene from Rip Van Winkle. "Here's your good health, and your family's, and may they live long and prosper." The words of this famous toast can almost be heard, so realistic is the effect produced by watching the speaker's lips.
A Hard Wash.
From sunshine to storm in a Darktown home.
Niagara, American Falls.
Taken from Goat Island, showing Luna Island and small falls in the foreground. This is the most realistic reproduction of "America's Greatest Wonder" ever shown. Not only the overpowering effect of Niagara's tireless rush of seething waters is vividly reproduced, but every detail, even to the swaying of the trees in the foreground, can be observed.
Empire State Express. 60 miles an hour.
In the distance the locomotive is seen taking water from a track tank while running at full speed, the spray thrown out on both sides of the engine being distinctly visible.
McKinley and Hobart Parade at Canton, O.
Note the antics of the now famous racoon which is

[11] *Dramatic Mirror*, October 17 1896. New York's blue law prohibited Sunday theatrical performances, so "concerts"—qualifying in a very loose sense as "cultural" and not "theatrical" events—were consistently arranged.

carried upon a pole alongside of the banner bearing
Mr. Hobart's portrait.
Maj. McKinley at Home.
The Republican candidate after receiving a hopeful
message from New York headquarters, walks across
his lawn to meet a New York audience.

The next day's newspapers were rapturous. The *Press,* the
Herald, the *Morning Advertiser* and the *World* reviewed it
with enthusiasm. The McKinley subject was highly topical.
The whole country was at a fever pitch over the tireless cam-
paign efforts of the magnificent William Jennings Bryan, who
traveled thousands of miles during the summer campaigning
for free silver, with somewhat prim punctuations by his rival
McKinley from a Canton front porch. Nearly all the conserva-
tive business interests of the country (which at that time meant
nearly all business) and nearly all the press vigorously sup-
ported McKinley. Although New York was Democratic and
was to give Bryan a majority in the November 3 election, at
Hammerstein's Olympia on the evening of October 12 1896
Bryan "wasn't in it." The *Dramatic Mirror's* October 24 account
is one of the most expressive:

> The house was crowded and the picture of McKinley
> set the audience wild. Seldom is such a demonstration seen
> in a theatre. The entire audience rose to their feet, shout-
> ing and waving American flags[!], and it was several min-
> utes before they settled down quietly to enjoy the rest of
> the performance.

This enthusiasm was certainly not dampened by the "paper"
in the house, which included a number of Republican big-
wigs, according to the *Press* and the *Morning Advertiser* of
October 13: Judge Clarence Meade (Chairman of the Repub-
lican National Committee), Charles W. Hackett, Dwight Law-
rence, General Horace Porter, R. S. Fox, General Fred
McLewee, Charles F. Wilbur, Thomas L. Hamilton (Secretary
of the Republican National Committee), S. A. Perkins, Mat-
thew S. Quay, Richard Quay, Cornelius Bliss, J. H. Manly,
General Powell Clayton, General Osborne, General Scott, S. S.
Dukes, Colonel H. L. Sewards, Fred Gibbs (Republican Na-
tional Committeeman) with one hundred followers, Colonel
J. W. Black with one hundred and fifty members of the Com-

mercial Travelers' Sound Money League, General C. H. Collis, F. H. Wilson, Maurice Eckstein, ex-assemblyman Halpin, Arthur Heacock, Fred B. King, Judge William R. Day of Canton, and a large body of New York Central Railroad men headed by Daniels, the General Passenger Agent. The latter group, presumably, came to see the New York Central's crack train, the Empire State Express, bear down upon the audience. But most came to see their hero, William McKinley, and managed to give the Biograph the most sensational motion picture debut since April 23, when the Edison aegis had helped to make the Vitascope a sensation at Koster and Bial's.

Billy Bitzer, who apparently operated the projector on this night, gives a first-hand account of his experiences:

> After the Press Preview I began to figure how I could tilt the machine more as I said before the picture was a bit too high on the screen, couldn't tip it enough as the top would hit the ceiling. There was[n't] any mechanism right near the top of the box so I literally took a saw and cut the whole top of the Box off a centre partition piece included and nailing a couple of wooden braces on it sort of protruding feet extending forward down to the corner of the floor and balcony rail (incidentally cluttering things up more) I really made the coffin steadier. But I also knocked the whole clumsy delicate (which combination it was) mechanism out of alignment and the dumb thing would not run a picture without (buckling the film) when I tried it out after sawing the top off. and had it wedged in the desired position anyone else could have been secured to run that threshing machine world would never have heard, (later) [of] Billy Bitzer Griffiths cameraman after repeated adjustments in which all suggestions even from H. N. MARVIN (who was another swell fellow by the way) nothing helped much. The dog film which I had for testing purposes would run one time next time it wouldn't. I finally said let me alone and I will have it running in time for the show. We had a fellow named Jack Miller he got a job with the Mutoscope as a contact man guess you would call him a location getter today was he officious he sure tried to tell me how to get the machine to run. the reason I mention him was that when Mr. Marvin finally pulled him away from me, saying let him alone he'll fix it all right. Millers parting shot was if it fails tonight Hammerstein will throw you right out of the window down onto Broadway and he locked me. I imagine two powerful open arc lamps, a hank of Nitro Glycerine (the film) big as a roll of garden hose and flimsy cotton woolen nap curtains and

me alone wasn't room for another man and he couldn't do a thing if there was . . . The show went off fine and when the last picture finished The Empire State Express the applause cheers stamping and pounding on the booth door I almost collapsed I thought the whole back of the machine had blown up or fallen off, such was the nervous tension I was under. (P.S. I had never run a public show before) . . .

The Biograph showed pictures larger[12] than the Vitascope and very much superior photographically (not to say topically) to that which any projector before had done. For these reasons it sustained its popularity through two enthusiastic weeks at Hammerstein's. It went down to Koster and Bial's on October 26 where it remained until January 18. From Koster and Bial's it opened its sensationally long run[13] at Keith's Union Square. At Koster and Bial's, the Vitascope bailiwick, it was clearly much more successful than the earlier machine—even in a time when it no longer had the intrinsic advantage of novelty. And at the close of November the Biograph was the only one of the major projectors still running at a big New York theatre.

As the year waned, the American Mutoscope Company roof studio at 841 Broadway and its cameramen (by now including one or more beside Dickson), were turning out subjects weekly to satisfy an eager public. On election night, November 3, the Biograph threw its views on an enormous outdoor screen (called the "largest ever made" by the *World* of November 8 1896) stretched on the front of the *World* building. And on December 28 the projector opened its first major out-of-town run in Philadelphia at the Bijou[14]—the first in a long series of highly successful runs in various American theatres, where it soon outstripped other projectors in popularity.

[12] See page 20. This larger picture has been said to have been designed so that Mutoscope photographs, viewed by direct light and printed by contact, could be more easily seen (see page 63). But this is debatable, since the Mutoscope pictures, although viewed by reflected light and not by direct light *through* the picture as in the Kinetoscope, were nevertheless magnified. Also, surely Dickson, Casler, *et al.*, must have fully appreciated the value of larger pictures for theatrical reasons.

[13] It began its Keith's run on January 18 1897, and closed (with only a four-months' hiatus) on July 15 1905, after eight and a half years—an incomparably long run in the history of the American theatre to that date.

[14] *Philadelphia Inquirer*, December 29 1896.

7 · The Camera, the Mutoscope, and the Biograph

THE PROBLEM OF DESCRIBING THE CAMERA BUILT BY CASLER beginning late in 1894 and ending in February 1895, is, fortunately, much less complicated and uncertain than many of the problems of this work. This is due largely to two reasons: first, Herman Casler's sense of orderliness, which has left us photographs of this camera, and second, his statement in Interference 18461 on March 24 1897[1] that the camera was "completed on or about March 1, 1895 . . . the only [motion picture camera] . . . constructed prior to March 24, 1897." Our concern, therefore, is with only one camera—the Mutograph to which we have already referred.

This camera is illustrated in this book (3) as it appeared apparently on January 20 1898 or shortly before[2] and as it now appears in the Smithsonian Institution. I identify the Smithsonian mechanism with the machine of the 1898 photograph from many identical details and no apparent exception to an exact similitude of parts. The additional fact that the case of the first camera that Casler built was mahogany[3] and that the Smithsonian camera case is also mahogany[4] is interesting.

There are, of course, differences irrelevant to this identification. For example, the driving wheels in the end of the Smith-

[1] Quoted and repeated on November 14 1899 in Equity 6928.

[2] It was on this date that Casler, testifying in Interference 18461, referred to described and exhibited photographs of the camera. The formality of the mounted cabinet photographs reproduced here suggests their preparation for the lawsuit.

[3] He stated in Interference 18461 that post-March 1 1895 bills for the camera (which had been questioned because they were dated after the camera was said to have been in operation) were for such items as mahogany for the camera and film cases.

[4] According to an examination made by Dr. William L. Stern, Curator, Division of Woods, Smithsonian Institution, through the courtesy of Eugene Ostroff, the Smithsonian's Curator of Photography.

53

sonian case have been altered from the earlier version. This alteration appears to be exactly that of the *Scientific American* artist of April 17 1897 (see illustration 12), which shows the motive power of the camera supplied from a motor mounted on top and powered by storage batteries. The pulleys to the shaft of the motor appear to be the same, with the power feed of the storage batteries being varied by the rheostat in Dickson's right hand,[5] and a shifter-fork to start the camera in his left.

Casler's own description of the camera's operation in the February-March 1895 trials, may be set down here as authority[6]

> I operated the machine successfully using a strip of paper, drawing the same from a spool and passing it between the driving drum and friction roller thereby feeding the paper toward the tension device thence through the tension device and between the felt covered friction roller and its mate, thence between the driving drum and lower friction roller to a winding up spool, the machine operating as described, driving drum and friction roller serving to feed the paper through the tension device until said tension device would arrest the movement of the paper when the feeding mechanism would proceed to form a loop in the paper between the same and the tension device. While tension device was thus arresting the movement of the paper the felt covered roller and its mate were acting to hold the paper taut until the tension device should release the paper, thereby allowing the felt roller and its mate to draw the paper through the tension device and removing the loop formed between tension device and feeding mechanism, felt covered roller and its mate operating to draw the paper downward through the tension device as fast as the feeding mechanism fed the paper through until the tension device should again grip the paper and arrest its movement when the loop would be again formed repeating the operation just described. The paper after passing between the felt roller and its mate was run between feeding drum and lower friction roller with the loop between said rolls and the felt covered roller and its mate. The paper being led from the feeding drum to the winding up spool. The period of rest of the paper being varied at times by the adjustment of the friction device.

[5] It seems clear that the subject illustrated is the "Pa. Rd. Limited Express," with the addition of the camera and its operators. The dress and moustache of the operator, together with the impression that Dickson took the subject, indicate Dickson as the man at the controls. The other man in the sketch is almost certainly meant to be Casler. Furthermore, these two were, as the American Mutoscope Company's letterhead said, the "technicians" of the Company.

[6] In answer to question 109 of Interference 18461 on January 20 1898.

It will be noted that Casler does not describe the intermittent device other than to speak of "arresting the movement of the paper [until] the tension device should release the paper." Nor does he discuss the rate of operation—an aspect of the machine with which he said he had not concerned himself. It was nevertheless built to function as high as 50 to 60 frames a second, according to testimony—although it was regularly used at approximately the rate of Dickson's "Black Maria" camera.

The camera application had been made on February 26 1896 and was even now in the Patent Office, from which it would issue as U.S. #629063 on July 18 1899. The details of this device were crucial to the successful evasion of the claims of the Edison camera. The Edison application had yet to issue, but until it did issue its details would have been known to Dickson, and it was at Dickson's instance that the American Mutoscope Company camera was given its distinctive tension device. These Dickson-suggested essential differences enabled the company to sustain its patents for some years, and until the Biograph fortunes were soundly established on the American scene.

The film was held stationary before the gate during exposure and was fed by an eccentric cam. During this stationary period holes were punched on either side of the film with the film in the same position in reference to the holes at each punching. The exposures were somewhat irregularly spaced on the film but, in printing, holes were punched in advance on the positive film, and the negative and the positive film run together through a printer. Lines 29 to 58 of page 3 of the printed patent, U.S. #629063, describe this process:

> . . . it is necessary that some means shall be used for marking the position of each view on the strip or film accurately, so that the views of the prints . . . may be registered accurately when subsequently mounted separately. The marking of the film for this purpose I effect by punching two holes in the film each time a new length of film is fed forward. Upon the [intermittent], upon either side . . . is mounted an arm . . . carrying a punch . . . arranged to punch a hole through the film each time the [intermittent] vibrates . . . The holes thus punched are punched each time at the instant when the exposure is made and are always in precisely the same position with respect to the center of the view. In printing from the negative strip made in the

camera after the pictures thereon have been developed a sensitized strip upon which the positives are to be printed is first run through the camera or through a similar punching mechanism, so as to have the holes punched at the same distance as are the holes in the negative strip. When the positive and negative strips are placed in the printing-frame for printing,[7] the registration-holes are kept in registry while printing is going on by means of dowels or similar devices.

The Patent Office tried to decide, with the Declaration of Interference of 18461 on January 23 1897, among the patent applications of Casler, Latham and Armat. Armat had filed his application on February 19 1896, Casler on February 26 1896 and Latham on June 1 1896. The issue in controversy was defined by the Office as follows:

> In a picture exhibiting apparatus for giving the impression to the eye of objects in motion . . . a picture carrying strip or film, a tension device . . . means for intermittently moving the film . . . and mechanism for feeding the film . . .

All these qualifications but the first—"In a picture exhibiting apparatus"—were easily met by the Biograph camera. The statement of the Examiner of Interferences in his decision of June 14 1899 states the case exactly: the camera was not intended to be a projector.

But the American Mutoscope Company was eager to pre-date Armat and Latham in the use of a projector, and Casler testified that he added a mirror to reflect the light, pegs for film, a new lens and an arc light and used the camera for projection in November of 1895. He would thus qualify for that part of the Interference limiting the issue to an *exhibiting* apparatus. His testimony as to how this was done was derided by some in the case, but the Bitzer notes may support such a use.

These notes convey the idea that before the projection through transparent film was tried, attempts were made to project Mutoscope pictures by reflection. This was unsuccessful, he says, by comparison with direct light through film:

[7] A photograph of an early Casler printer is in my possession. It shows a rather timid-looking Casler behind two vertical boxes, from the smaller of which a bellows and lens point to the other. Each contains feed and supply reels.

So we took out of our big bulky 1st camera a few parts of the mechanism that interfered with the incorporation of a mirror into which we shot at right angles the rays from an arc light . . . and the effect with this wide film was magnificent . . .

Bitzer's description of the camera itself is also interesting:

. . . the motor alone a General Electric 2½ horse power which was mounted atop . . . on a special 2″ x 4″ wood frame work weighed 200 lbs which resembled a . . . Iron Safe laid upon its side in fact the housing . . . were cast iron and its base plate a big . . . affair with 3 ring holes one front 2 back through which its adjustable legs which resembled the old freightcar coupling pins in size and weight to raise the camera ⅛ of an inch to get more sky-line on the photo image on the film required 2 men a monkey wrench was needed to tighten the bolt which held this front foot rigid all this atop a turn table and lower stand the total weight of camera with its heavy inner mechanism its stand film 2 23/32 wide film and speed of 320 ft per minute Pictures taken at 30 per second required a husky built mechanism which you can readily visualize . . . the somewhat massive beater movement to pull down this film . . .

This camera had been built by the Marvin and Casler Rock Drill Co [sic] at Canastota, NY and was already on the 6th floor of the Hackett Carhardt [i.e. "Carhart"] Building 841 Bway and 13th St when I got my job with the American Mutoscope Co, there was also a large dark room for developing film a smaller room to print the film and a small enclosed experimental machine shop . . .

Marvin's testimony of the camera-turned-mirror-projector was self-assured:

A calcium light was procured, and the rays of light from this source were directed into the machine by means of a condensing lens, and were directed upon a mirror so placed as to reflect the rays of light at or about right angles and through the lens in the front of the machine, the film bearing the pictures being carried out in front of the position that the film occupied when the machine was used as a camera.

Casler's description was specific:

Assuming that the end of the case carrying the shutter to be [sic] the face of the machine, the light was placed at its left-hand side and just a little forward of a vertical line

passing through the center of the oscillating shaft, the rays of light coming from the lamp and striking the small mirror, placed at an angle of 45 degrees to the axis of the lens, said mirror being placed directly in front of the place of exposure of the film when the machine is used as a camera, the angle of the mirror being such as to deflect the rays of light from the lamp, causing the same to pass through the lens, which is placed or screwed in the opening in the front or face of the camera where the shutter revolves, the pegs being so attached to the frame of the camera to carry the film forward and toward a lens a short distance as soon as it passes through the tension device, thence downward in a vertical line passing between the mirror and lens, thence drawn backward away from the lens to the felt-covered roller and its mate, and thence through the machine . . .

Casler's statement that "the light was placed at . . . the left-hand side [of the shutter] and just a little forward of a vertical line passing through the center of the oscillating shaft" cannot be said to closely parallel Marvin's "the rays of light were directed into the machine." Casler's careful designation of 45 degrees for the angle of the mirror does not coincide with Marvin's "at or about right angles." Casler fails to mention the condensing lens referred to by Marvin, and Marvin merely mentions a "lens in the front of the machine," without stating that this lens would have to be a different lens than the camera lens—a crucial matter.

Paper 48 of the Interference is a motion to compel Casler to produce this camera-turned-projector. The Assistant Commissioner of Patents denied this motion, saying that it was not "within the power of the Patent Office to enforce such an order." The failure of Casler to produce the machine may have been because it could not be taken out of operation. Although, considering the importance of the action and the fact that several newer cameras were by now in existence, it also may have been because an examination of the machine would have revealed no such marks as may have been left by the placing of an arc light, pegs for film and new lenses. An examination of the Smithsonian camera is inconclusive.

We of course cannot know that this camera was *not* used as a projector at the Canastota November 1895 projection. The Bitzer descriiption seems convincing but may apply to another

time. (The summation of the Examiner of Interferences is interesting in this connection.) It may be said that nearly every camera inventor tries at one time or another to use his camera as a projector: this was true of Friese-Greene, Marey, Jenkins and of the horizontal-feed camera in the Edison Museum (see Appendix E of *The Edison Motion Picture Myth*).

If the plans for mirror projection did not actually include the 1895 camera—as Casler, Marvin and Bitzer said they did —they at least concerned a projector distinct from the projector used for the 1896 debuts. After the attempt to project Mutoscope pictures was found to be unsatisfactory, a tall, erect mirror projector—according to Bitzer—was built and used at 841 Broadway projections for prospective customers.

Bitzer's description of the difficulties he had at the October 12 projection I have already noted. His description of the mirror-projection matter is also interesting:

> Canastota was informed and became furiously busy building the mechanism for a projector which was shipped to New York and when assembled on the 6th floor 841 Bway looked more like a Wright Bros first flying machine than anything I can now think of. Skeleton frame work of wooden two by fours from the floor 7 foot up. 2 x 4 braces ran out at an angle from the top of frame to floor (same as stage scenery is braced) more 2 x 4 front and back end and additional projecting 2 x 4 pieces to hold the projecting arc lamp which we stuck to shooting its ray into a mirror which in turn reflected the beam of light through the film We were a bit timid about having this open arc lamp in between the celluloid wide film and having the film run over or under it So it was put out on the side. We made the mirrors of copper plates about 4 inches square which we had not only solid silver plated but they were also hand . . . burnished to secure a perfectly flat surface, and I got quite a kick out of going back to some of my old cronies of silver smith days[8] having the copper plates made at a considerable expense for some mysteriouss new patent until I got a perfect no distortion one. (I was always a show off) ordinary mirror glass gave a double reflection would also crack with the heat. when this freak looking Biograph projector with its wheels bulky eccentric cam and friction pull down pulleys friction discks [sic] and all was ready . . . we would run the machine which was enclosed in canvas duck curtains. which curtains I would by

[8] Bitzer was, according to his widow, formerly a silversmith for Gorham and Company.

the way wrap about the entire piece of machinery each night tie with rope and seal the tie knots in the ropes and initial them so that no one could look at the machine during the night. I was always the operator and every time the film would run off the pulleys or rip and tear. I got the blame. Koopman would snarl at me what did you do to it, etc. it was running all right let it alone. get out. and I actually had that happen. after the group had gone he would look for me out on the 6th floor fire escape once and would ask me what I thought caused it to buckle. These were all the Biograph projection previews we ever gave on the 6th floor 841 Bway none any where else until Casler sent down the new machine which I called coffin shaped.[9] this had the arc located directly behind the aperture opening and between [sic] the wide films in an wooden box asbestos lined. shooting its ray directly through the film no more mirrors with the right angle arc.

A photograph of an upright rough wood frame projector with supporting 2″ x 4″ braces may be this mechanism (see illustration 19). The photograph is somewhat unclear, but unused holes and other markings on the wood, in juxtaposition to the arc, may suggest the installation of mirrors. It is difficult not to believe that Bitzer, who was so intimately acquainted with the matter, would not have known the mechanism of the projector used for the previews at 841 Broadway which he describes. Perhaps later in 1896 the mirrors were removed and the light allowed to pass directly through the film. Bitzer's description of the Hammerstein showing (which he calls the "first," indicating that he either did not want to contradict Ramsaye or that he did not know of the out-of-town appearance of the Biograph) indicates that the tall 2″ x 4″ braced projector was the one used on October 12 1896. This tall projector is closely similar to the apparatus described in Casler's patent application of December 10 1896, issued September 27 1898.

* * * *

The second commercial use to which the product of the American Mutoscope Company's camera was put was the Mutoscope itself (see illustration 2). This instrument apparently had been projected before the Biograph and seems always to have been the project closest to Koopman's heart. Throughout

[9] Bitzer's memory here is interesting. The asbestos-lined arc housing projector of the *Scientific American* (see illustration 18) and the Smithsonian was apparently preceded by the tall, non-mirror projector (see illustration 19).

the years of our history the company had great expectations for the Mutoscope, and many were realized. Actually it may have been the Mutoscope itself which was responsible for the decision to use a wide-film camera. The Mutoscope photographs were to be seen by reflected light and low magnification. Thus it needed larger photographs and larger film. (Some years later Harry Marvin tried to obviate this lighting difficulty for the Mutoscope by installing an electric light inside the machine— the patent for this apparatus was issued as U.S. #614738. It is interesting to note that to this day the Marvin descendants, confusing Harry's electric light machine with the basic Mutoscope, claim that he *invented* the Mutoscope. "He invented the Mutoscope, you know," one of them told me.)

The Mutoscope expectations, however, do not seem to have been realized until beginning early in 1897—outside the range of this history. Ramsaye says (*op. cit.* page 216) that it was "ready for the market" at the beginning of the winter of 1895, and that by the beginning of 1896 it was hurting the Kinetoscope business. But the Kinetoscope business had been hurt beyond hope of recovery in 1895 by screen machines and/or the expectation thereof, and the Mutoscope was in no position to hurt anything until 1897. This in spite of the model which, according to Casler, had been built by November 1894 (see page 8), and the attempts to project Mutoscope pictures described by Bitzer.

Bitzer's account of Mutoscope beginnings gives us a backstage look into the difficulties of arranging the cards:

> ... Herman Casler Mutoscope Reels were like taking stacks of playing cards and mounting them upright on end over a round wood block . . . the first ones were hand assembled and it was a sort of Chinese puzzle to squeeze [them] around . . .
>
> We wore elastic arm bands to keep shirt sleeves up in those days and some were round with a cotton or silk webbing covering we got the idea by punching a round hole through the cards and putting an opened sleeve rubber through the holes and then fastening the rubber together again this would hold the cards in a circle it could be stretched over the wooden huge spool and *metal flanges* could be made to clinch the cards on the side . . .

The current press, then as now, took little notice of arcade entertainment. No contemporary periodical that I have found,

for example, had noticed the Broadway debut of the Kineto-scope and it was apparently the same with the Mutoscope. I have found no reference to any Mutoscope parlor opening in any of these first months of its career.

The first public notice of the Mutoscope I have found was taken in the *New York Herald* of February 7 1897:

ANOTHER "SCOPE."

This Time It Is the Mutoscope
and the Newcomer Has
Many Claims.

AMAZING PHOTOGRAPHY

Forty Large Pictures in a Second,
Showing Every Degree Of
Action or Motion.

DONE BY TURNING A CRANK.

Queer and Fantastic Effects Obtained
by Reversing the Usual
Order.

And now comes the mutoscope. Do you want to see your-self in action? Do you want to see how you look in anger when you step on a tack in your bare feet, or in joy when you hear that your mother-in-law cannot pay you a visit? The mutoscope will accommodate you.

The life picture by the mutoscope is pretty much like that seen in other scopes, except in the matter of pressing a button and letting the scope do the rest. You work your own passage in the mutoscope by simply turning a crank. If you are enthralled with any particular pose of any par-ticular picture, you can stop the crank and study it. It is here that the mutoscope differs from its fellows in the pictorial machinery field.

It is operated by hand and requires no motor, battery or attendant; so simple is it that a child can operate it . . .

Photographic prints from the series of pictures thus ob-tained are mounted in consecutive order around a cylinder standing out like the leaves of a book.

When this cylinder is slowly revolved, the picture cards being held back by a stop, and allowed to snap past the eye one by one, as one thumbs the leaves of a book, an apparently moving picture is the result, and it is difficult to realize that the picture is not endowed with life.

In the operation of the mutoscope the spectator has the performance entirely under his own control by the turning of the crank. He may make the operation as quick or as slow as fancy dictates, or he may maintain the normal speed at which the original performance took place; and if he so elects the entertainment can be stopped by him at any point in the series and each separate picture inspected at leisure[10] . . .

The fact that the machine can be run slowly or stopped at will is where its attraction comes in. To the physiologist and the anatomist this will prove an endless source of delight. For instance, I have learned through the mutascope [sic] that Mr. McKinley, the President elect, toes out like a ballet girl when walking. His clod crushers are quite respectable in size, too, if anybody should ask you. In the machine one can readily see that he is not a reckless pedestrian. He is slow and methodical, and is careful where he puts his feet . . .

ALL TOPSY TURVEY

By far the most amusing features [sic] of the mutascope, if not the most instructive, is the capacity for reversing the usual order of things.[11] Take, for instance, the curve at Union Square at the noon hour. In the natural order of things, crowds are seen hurrying to and fro. Vehicles of every description are moving in all directions . . .

Now take out the picture wheel and reverse it. "Slam, bang!" go the cars around Dead Man's Curve, all running backward. The gripmen stand on the rear platforms with solemn faces, running their cars crawfish fashion around the curve, and, strange to say, although the pedestrians are all walking backward, every one of them succeeds in getting out of the way . . .

Altogether the newest "scope" is a very interesting machine, and if the hopes of the inventor are realized, it will in time be adopted in the general portrait work of photograph galleries, and as a means of describing motion in drawing and painting. It may also be used instead of working models in all mechanisms.

The next notice of the Mutoscope that I have found was taken by the *Scientific American* article of April 17 1897, to which I have already referred:

[10] Harry Marvin's electric light Mutoscope soon eliminated this facility.

[11] This process was familiar to operators and inventors long before. It was familiar, for instance, to Dickson. A letter of June 24 1893 (in letter book E1717 2/4/93-8/3/93 in the Edison archives) tells a correspondent who suggested the reversal of motion pictures that: "The experiment . . . has already been tried . . . and the effect is certainly very strange and peculiar. Apart from this, however, I [i.e., Tate] cannot see that it can be made to serve any useful purpose.

Perhaps the most novel of the three machines [after the projector and the camera] is the mutoscope . . . which, on account of its compactness, simplicity of operation, and the large size of its pictures, is certain to win great popularity. In this machine the bulk, the complicated mechanism, and the motor of the biograph are replaced by a simple, box-like apparatus, no larger than the cover of a sewing machine. The enlarged pictures, 6 x 4 inches in height,[12] are mounted in close consecutive order around a cylinder, and stand out like the leaves of a book . . . In the operation of the muto-scope the spectator has the performance entirely under his own control by turning a crank which is placed conveniently to hand. He may make the operation quick or as slow as fancy dictates,[13] or he may maintain the normal speed at which the original performance took place, and if desired he can stop the machine at any particular picture and inspect it at leisure. Each picture is momentarily held in front of the lens by the action of a stop attached to the roof of the box, which allows the pictures to slip by much the same way as the thumb is used upon the leaves of a book.

The *New York Herald* the next day, April 18 1897, quoted largely from this *Scientific American* article, and reproduced several of its illustrations. However it added nothing to our knowledge of the Mutoscope as its contemporaries saw it.

The *Scientific American* illustrations are the first I have seen of the new Mutoscope. The Casler collection is curiously lacking in photographs of these earliest machines. It contains only photographs of the projecting Mutoscope[14]—which is apparently the earliest of the Mutoscope photographs; an "Ornamental wood cabinet and pedestal mutoscope"; a wood cabinet table model; a portable model in a leather case; a multiple-view Mutoscope; and the cast iron model so widely known

[12] The *Scientific American* has exaggerated the size of the Mutoscope pictures —unless reference is made to the magnified images. Casler testified that these photographs were printed by *contact* from the negatives. This size would then by no more than about 2 23/32 inches. The Mutoscope frames in my own collection are this size.

[13] This convenience of the first Mutoscopes disappeared with the appearance of the electric light Mutoscope. In this machine, after an allotted period of time, the light went off. It is easy to see that the reasons for this time limit were commercial.

[14] This device utilized arc light with either direct or alternating current and was said, according to a *Clipper* advertisement of September 11 1897, to be the invention of "the Well-Known Pioneers in the Art of Moving Photography, Mr. William Kennedy Laurie Dickson and Mr. Herman Casler." Dickson later suggested the use of an acetylene light.

now. All these developments are beyond the range of this history and formed no part of the American Mutoscope Company fortunes until many months later.

Casler's own account of the Mutoscope operation may be recorded here as authority:[15]

> The mutoscope consists of a series of photographs of objects in motion, attached to the surface of a drum or arbor. The photographs normally stand in a radial line from the center of the drum. At the rear of the picture bearing drum is a worm gear which meshes with a worm on a shaft, which carries the operating crank at the front of the case. By turning the crank, the drum is caused to rotate slowly and as the drum rotates, a portion of the pictures are bent backward by a detent which swings on a stud at the top of the case. As the drum continues to rotate, the pictures are slowly carried forward until upper edge [sic] passes the detent, when they snap forward, and assume their normal position. Thus one by one the pictures are momentarily held in view and then spring forward, thereby bringing the succeeding picture to view. A lens set in the front of the cabinet serves to magnify the pictures. A tilting mirror at the top of the case reflects the light downward through an opening on the photograph below. As soon as the hand is taken from the crank, a spring causes the crank shaft to rotate backward a portion of a revolution, which causes the worm to disengage from the gear, allowing the reel of pictures to run backward. The reel is carried backward by the spring tension in the photographs and in doing so, the detent swings on the stud in such a way as to take up but very little space between the pictures.

Herman Casler testified in Equity 6928 that the Mutoscope was "brought out" in 1896—and before the Biograph. Assuming "brought out" to mean a public—if not necessarily a commercial—appearance, this would place the Mutoscope pre-September 1896. Casler, however, must refer to the time when the Mutoscope *design* had been settled upon, although the Marvin gift to Li Hung Chang (see page 44) may indicate that some Mutoscopes had been made by that time.

It is quite possible that it was decided that the Mutoscope's public appearance should wait until the Biograph had ap-

15 This quotation is from a lecture given by Casler some years later in Syracuse, New York. It was copiously illustrated by a variety of glass slides. Both Casler's original text for this lecture and the slides themselves are in my possession.

peared. Else, it may have been thought, the same pictures seen for five cents in the Mutoscope as were seen in the Biograph for the price of a theatre ticket would inhibit the Biograph's success. After the Biograph had caught on the Mutoscope could be safely introduced and might also be useful in penetrating parts of the world where the Biograph, with its relatively high expense and importability, might not go. Manufacturing may have begun in 1895, but the Mutoscope was apparently not presented to the public until early in 1897. It is also obvious that until motion picture production got well under way there would have been no photographs to show in the Mutoscope. This could agree with Casler's "1896," but not with Ramsaye's "1895." It also agrees with Bitzer, who said that the Mutoscope was made "when we had enough [motion pictures]." Its first appearance was probably in a parlor in New York City, but exactly when and where is uncertain. As late as May 1898, the *Photographic Dealer* was still saying: "We have no doubt that these machines *will become* very popular. [my italics]."

But by the end of 1896, the first year of general projection in America, the Biograph was forcing other projectors out of business by its excellence. As a local exhibitor said on December 22:[16]

> The man I had worked up on Tennessee was almost ready to close [with the Edison-sponsored projector] but went to Atlanta and there saw the Biograph and that settled it.

The Mutoscope and the Biograph were supplied with motion pictures of high quality for many years—a backlog of work and experience upon which a large part of the motion picture industry of America was founded and upon which, in 1908, D. W. Griffith seized and developed an art.

[16] From a letter in the Baker Library, Harvard University.

ILLUSTRATIONS

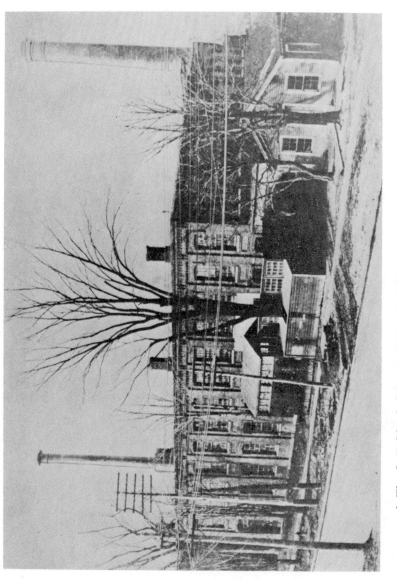

1. The C. E. Lipe building at 208 South Geddes Street in Syracuse, New York, late in the 19th century. "Old timers" at the present business believe that the right hand construction necessitates a pre-1900 date, and as of May 3 1895 this portion of South Geddes was unpaved (*Syracuse Daily Courier*, May 3 1895). Since it appears to be paved here, this photograph would date between 1895 and 1900, with a tendency, considering the not-quite-new appearance of the paving, toward the latter part of the period. (*See page 6*). From the author's collection, by courtesy of Mr. H. A. Pierce. Previously unpublished.

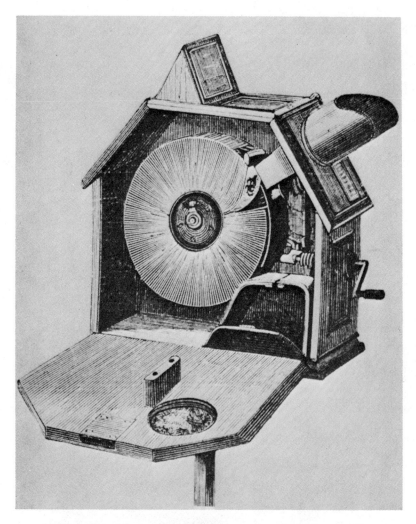

2. The earliest known version of the Mutoscope, from the *Scientific American*, April 17 1897. No example of this version is known to be extant. It may have been never mass-produced, but used only for demonstration within the premises of the 841 Broadway establishment. *(See pages 59ff)*.

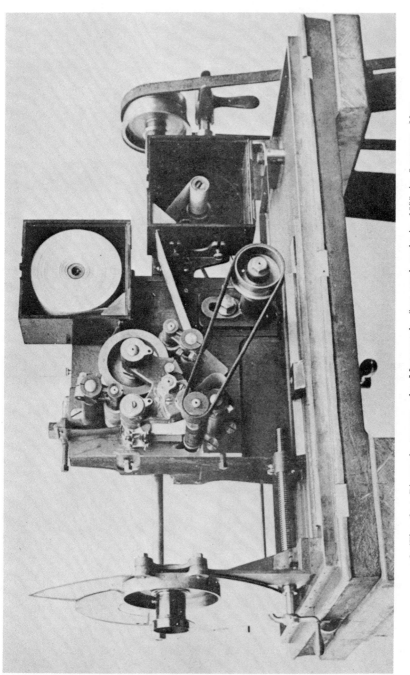

3. The first Biograph camera, the Mutograph, first used early in 1895 in Syracuse, New York (*see pages 8ff*). This camera may be seen in illustrations 11 and 12 as it is now and as it was used. From a previously unpublished photograph in the author's collection.

4. Herman Casler *(left)* and Harry Marvin "sparring" for the Biograph camera at, possibly, the rear of the C. E. Lipe shop at 208 South Geddes Street in Syracuse, New York, in June 1895. This *may* be the earliest Biograph subject extant, and the first actually shot with the first camera. *(See page 15)*. Background details eliminate the East North Canal Street Canastota address and appear also to eliminate a James Mahan Machine Shop site *(see page 19):* the high window in the right rear is inexplicable from contemporary maps, as is also the board fence. From a previously unpublished photograph in the author's collection.

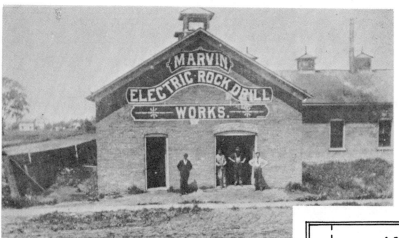

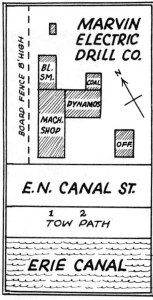

MARVIN
ELECTRIC
DRILL CO.

BOARD FENCE 8'HIGH

BL. SM.

COAL

DYNAMOS

MACH. SHOP

OFF.

E.N. CANAL ST.

1 2
TOW PATH

ERIE CANAL

5 (above). The Marvin Electric Rock Drill Works on East North Canal Street in Canastota, New York as of, possibly, the summer of 1895—when the occasion for such a photograph seems appropriate. From a previously unpublished photograph in the author's collection.

6 (right). A sketch of a detail of a Sanborn-Perris map of 1895 showing the location of the Marvin Electric Rock Drill Works, with camera positions for photographs 5 and 7 indicated by the figures 1 and 2, respectively.

7 (below). The site of the Marvin Electric Rock Drill Works as it appeared in November 1961 from virtually the same point of view. The building was destroyed by fire several years ago. Previously unpublished photograph in the author's collection.

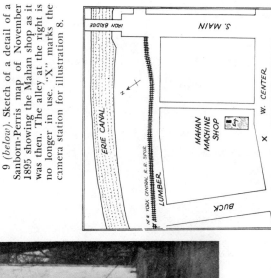

9 (below). Sketch of a detail of a Sanborn-Perris map of November 1895 showing the Mahan shop as it was then. The alley at the right is no longer in use. "X" marks the camera station for illustration 8.

8 (above). The James Mahan Machine Shop on West Center Street in Canastota, New York as of November 1963. The August 1895 sparring match (see page 20) and the November 1895 projection (see pages 22-24) both occurred at the rear of this building. Photograph by W. W. Sharpe of Canastota, previously unpublished.

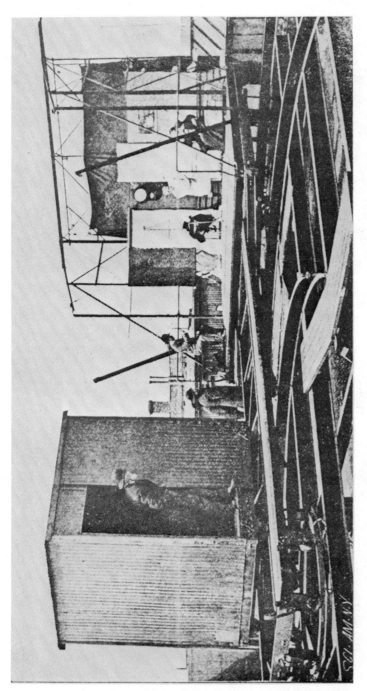

10. The movable roof stage at 841 Broadway late in March 1897, from the *Scientific American* of April 17 1897 (*see page 33*). The subject being shot here is "Love's Young Dream," copyrighted on November 11 1902. I have identified none of the people. It is unlikely that the man at the left of the stage is either Wallace McCutcheon or Frank J. Marion, but the man leaning from the camera house *could* be Harry Marvin's father, Daniel.

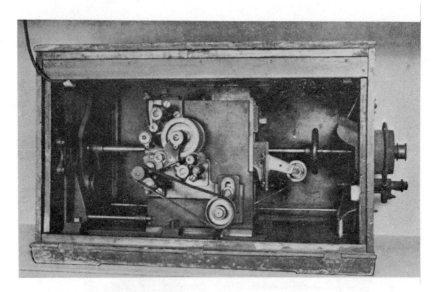

11 *(above)*. The first Biograph camera, or Mutograph, as it is today in the Smithsonian Institution *(see page 52)*. Film boxes and film are of course lacking, and a vitreous enamel electric light bulb socket has been placed at the right. By courtesy of the Smithsonian Institution. Possibly previously unpublished.

12 *(below)*. The first Biograph camera as it was being used to shoot "Penn. R.R. Limited Express" *(see page 37)*. A man obviously intended to represent Dickson—although somewhat smaller than life—has his left hand on the shifter fork which starts the camera and his right on the switch that controls the power. Casler watches at the right as the train comes into camera range. From the *Scientific American* of April 17 1897.

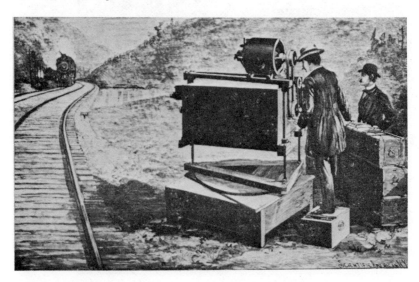

13. The Dickson copyrighted title for this subject was "Oh! that Watermelon," although the Biograph production book called it "Watermellon [sic] Feast," and the 1902 catalogue called it "A Watermelon Feast." It was shot in the summer of 1896 on the roof stage at 841 Broadway (see page 35). "A Hard wash," a juxtaposed Biograph subject, shows the lady and child on the right and the tub in the center in a "pickaninny" bath. An Edison imitation of "A Hard wash" has often been confused with the Biograph subject. Courtesy of the Museum of Modern Art, previously unpublished.

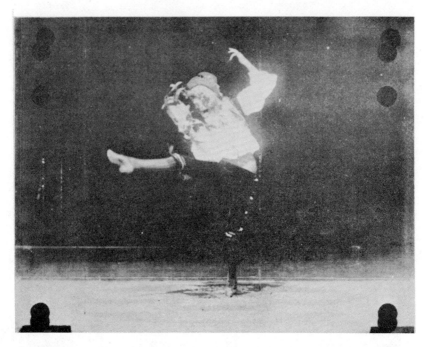

14 *(above)* and 15 *(below)*. The copyrighted title of the upper of these two Biograph 1896 subjects *(see page 34)* is "Tambourine Dance—Annabelle" (although the deposit card omits the hyphen) and of the lower, "Showing Group of Bathers, Atlantic City Beach" (although Dickson used a hyphen instead of a comma in his original request for copyright. *See page 36).* Random punches are visible in the Annabelle subject, as is the distinctive rug of the 841 Broadway roof stage. From the Library of Congress, previously unpublished.

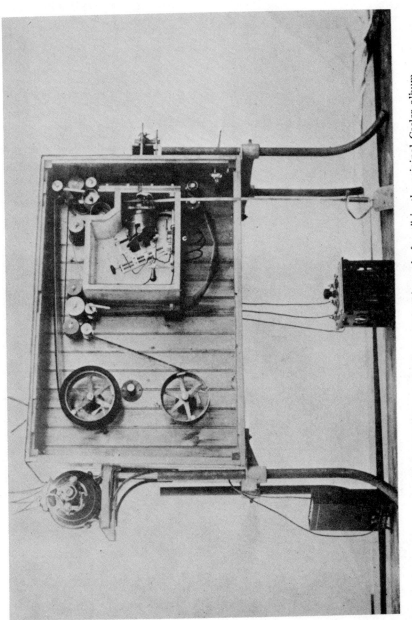

16. The first "official" Biograph, designated "Biograph, front" in the original Casler album. This apparatus may be seen as it is now and as it was used in illustrations 17 and 18. From a previously unpublished photograph in the author's collection.

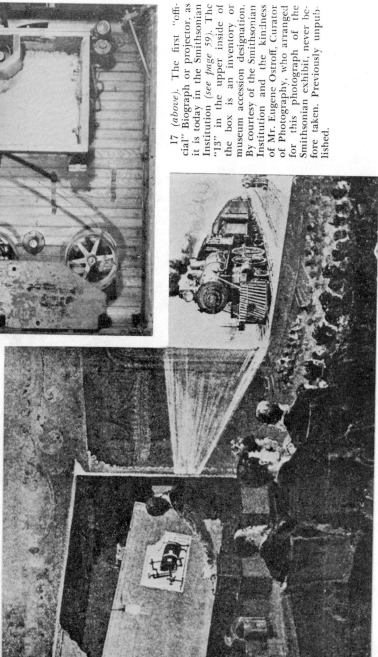

18 (*below*). The first "official" Biograph as it was being used in, apparently, Keith's Union Square. The cutaway projection booth reveals a technician with his hand on the controls, a watering can and a basket of waste (film?) beneath the projector. The proportions of the projector are somewhat attenuated here. (See *illustration 16*). The subject being shown is "Empire State Express No. 3." From the *Scientific American*, April 17 1897.

17 (*above*). The first "official" Biograph or projector, as it is today in the Smithsonian Institution (*see page 59*). The "13" in the upper inside of the box is an inventory or museum accession designation. By courtesy of the Smithsonian Institution and the kindness of Mr. Eugene Ostroff, Curator of Photography, who arranged for this photograph of the Smithsonian exhibit, never before taken. Previously unpublished.

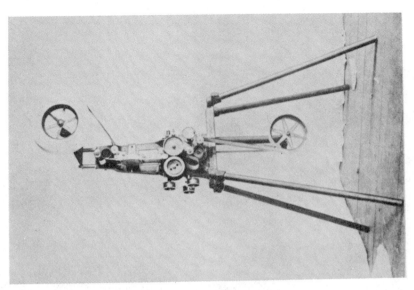

19 (*left*) and 20 (*right*). The exact position of these two projectors in the early Biograph days is uncertain. (*See pages 58ff*). These machines are indexed in Herman Casler's album as: "Project. mch. front" and "Electroscope. front." An "Electroscope" figured in somewhat later projection history and may have been named from this mechanism. From the author's collection. Previously unpublished.

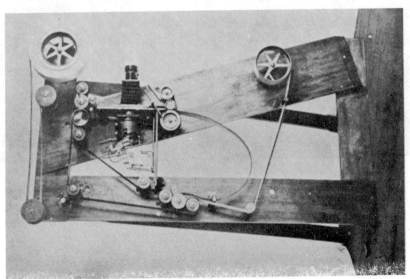

21. Dickson and Casler. 22. Dickson

23. Koopman (?) and Dickson. 24. Dickson and Casler.

See Appendix C for a description of these photographs.

Appendices

APPENDIX A · *Herman Casler*

Herman Casler was born in Sandwich, Illinois, on March 12 1867, the son of former Fort Plain, New York residents.[1] The family returned to Fort Plain where Herman was educated in the public schools.[2] He early showed considerable interest in mechanical subjects.[3] He married Fanny Ehle of Fort Plain in 1894 and apparently in 1889 moved with his wife and mother to Syracuse, New York. He became employed in the shop of his relative, Charles E. Lipe at 208 South Geddes Street in that City.[4]

Late in 1891 he entered upon a short period of employment at the Edison General Electric in Schenectady. He was back in Syracuse not later than early in 1893,[5] resumed his work at the Lipe shop and filed, on March 1 1893, his first photographic patent application. This issued on November 28 1893 as U.S. #509841, and was marketed by Elias B. Koopman's Magic Introduction Company as the "Photoret" (see page 4). This device may have been jointly invented with W. K. L. Dickson.

Late in 1894 his association with Koopman and Dickson, encouraged by Marvin—a Schenectady associate and fellow Syracusan—led him into the motion picture business. He built the

[1] This date is from Casler family sources. The County Clerk of De Kalb County, Illinois, writes me that birth records in that place do not start until 1877.

[2] Not, as has been said, in the Clinton Liberal Institute. His wife attended this school.

[3] According to his Fort Plain landlord, transmitted to me by Herman's son, Harry, who was told that while still a boy Herman devised mechanical apparatus.

[4] According to the testimony in Interference 18461.

[5] A patent application is dated January 10 1893 and lists him as a resident of Syracuse. A mechanical drawing of the Marvin electric drill in my possession is dated September 17 1891. This is called the "first work for H. N. Marvin" in Casler's notebook.

remarkable "Mutoscope" card-flipping device for showing pictures of motion—and filed an application for a patent therefor on November 21 1894. He began to build a supplying camera for this device at about the same time. This motion picture camera was called the "Mutograph" and was finished by February 1895, successfully tested with paper on March 2 1895, and with film in June 1895.

In association with Marvin he moved to Canastota, New York, in June 1895, as superintendent of the Marvin Electric Rock Drill Company—a concern already in existence at the Lipe shop in Syracuse. (This concern was organized for the manufacture of electric rock drills based on Marvin's patent, U.S. #395575, although there is reason to believe that the first drill—after the model—was not built until the company reached Canastota.) In Canastota in 1895 Casler, in association with Dickson, took the first "official" Biograph motion picture subject. In November of 1895 projection was achieved by possibly both the camera and a separate apparatus called at first the "Mutopticon" but soon called the "Biograph."

Late in 1895 the American Mutoscope Company was formed among Casler, Marvin, Dickson and Koopman, and the manufacture and processing of motion picture subjects was begun at 841 Broadway, New York, and elsewhere during the summer of 1896. In September and October of 1896, the Biograph—apparently partly the design of Casler—had auspicious public debuts. Along with the Mutoscope it became a mainstay of the fortunes of the American Mutoscope Company.

In 1896 Casler and Marvin formed the Marvin and Casler Company of Canastota for the manufacture of the apparatus used by the American Mutoscope Company. Additional arcade-type machines,[6] a popular boring-head and other tools were also made. This company continued business until 1923—although it had been sold in 1919 to the Watson Products Company of Canastota. In 1923 Casler resigned from the company and founded the Production Engineering Company of Canastota, which was assigned some of the Casler patents and which continued the manufacture of some of his devices.

He retired in 1926 but continued as a consultant to "a number of companies."[7] These included, according to his sons, the Rem-

[6] For example, a palm-reading machine which "read character" by outlining the contours of the palm, and a name plate machine which stamped letters on a strip of aluminum.

[7] The phrase of the *National Cyclopedia of American Biography*, volume 36.

ington Rand Corporation. He was prominent in Canastota civic affairs until his death in that village on July 20 1939. After Muybridge, Dickson and Eugene Lauste he seems to be the most significant contributor to motion picture invention in the United States.

APPENDIX B • *W. K. L. Dickson*

William Kennedy-Laurie Dickson[1] was born in August 1860 in France, the son of a Scotswoman born in the state of Virginia and an Englishman. He came to Virginia with his mother and two sisters in 1879—apparently on the death of his father—and settled in Chesterfield County, with or near his mother's relatives.[2] Soon after the death of his mother he moved to Petersburg, Virginia, where the directory listed him as an electrician—although he had previously evinced much interest in the subject.[3]

After about four years in Virginia, at the age of 23, he went to New York City, applied for a position at Edison's Goerck Street Works, and within a year or so had advanced himself sufficiently to be placed in charge of certain testing procedures there.[4] At about this time he had also apparently become Edison's "official" photographer.[5] In 1886 he returned to Petersburg and married a local lady, Lucy Agnes Archer, traveled to Europe on a wedding trip, and returned to work with Edison probably late in the same year. He was soon involved in the ore-milling work at the Edison plant and, after the move late in 1887 to the new laboratory in West Orange, was placed in charge of this work. He was also given a well-equipped photographic studio.

Late in 1888 he appears to have begun to contemplate the matter of motion pictures. By February 1889 there is evidence that he had come a little way along this road.[6] By the end of the year he may

[1] See the more detailed biographical sketch of Dickson in Appendix A of Hendricks: *The Edison Motion Picture Myth*, University of California, 1961.

[2] As I have said in *The Edison Motion Picture Myth*, the inscription on Dickson's mother's gravestone in a Petersburg, Virginia, cemetery reads: "Elizabeth Kenedy [sic] Dickson . . . Born Chesterfield Co., Va."

[3] In a note of application to Edison of 1879 and now in the West Orange archives, he describes this interest. (See Hendricks, *op. cit.*)

[4] This is shown in various Edison archives items, e.g., a letter of June 4 1884 in which he is addressed as "Supt. Testing Room."

[5] See Hendricks, *op. cit.*, page 151.

[6] The subject matter of the second motion picture caveat indicates this (see Hendricks *op. cit.*, page 31).

have achieved the regular, rapid, intermittent photography of moving objects on the surface of a cylinder, although such subjects now extant were probably taken a year or so later.

In the fall of 1890 he set himself to achieve motion photography on a band of film and by the following spring he had achieved it. The length of this film was probably not more than 40 inches and when it was shown to reporters in the Kinetoscope in May 1891, it was looped and run over and over again. Dickson improved the Kinetoscope to such an extent that by the time plans were being made for the World's Columbian Exposition in Chicago it was regarded as a commercial possibility for display there. Delays in its manufacture, largely brought about by Edison's continuing pre-occupation with ore-milling and his disinterest in nearly anything which was not certainly money-making, prevented its introduction to the general public until April 1894, when a Kinetoscope parlor was opened at 1155 Broadway in New York City.

Soon Dickson became involved with the Lathams and with Elias B. Koopman, Harry Marvin and Herman Casler—materially aiding the construction of the apparatus of both groups. He left Edison's employ on April 2 1895 and set about entering the motion picture business on his own. He soon accomplished this with the American Mutoscope Company. He apparently designed the studio installations for this new company at 841 Broadway, New York, and personally shot most of the subjects used by the company for the illustrious series of Biograph debuts beginning in September 1896 in Pittsburgh, Pennsylvania.

After a highly successful production and projection season he went to Europe with his wife and sister Antonia on May 12 1897, where he continued to supply foreign subjects for the American Mutoscope Company. Among these subjects were those he shot in Rome in the summer of 1898 of Pope Leo XIII and, beginning late in 1899, of the Boer War in South Africa.[7] After disassociating himself from the Biograph futures—possibly because of financial difficulties—he went into the experimental industrial laboratory business himself, as his West Orange employer had been. His Virginia wife died about 1910. He remarried, adopted a son (who may have been killed in the Second World War) and died at the age of 75 on September 28 1935 in his home in Twickenham, England.[8]

[7] The May 12 1897 date is from the *Orange Chronicle* of May 15 1897. The Leo XIII pictures were widely published by New York newspapers. The Boer War experiences are recorded in *Biograph in Battle* by Dickson himself (published by Unwin, London, 1901).

[8] This data is partly from family sources. The Biograph association he himself describes in testimony in 1911. The death date is from Somerset House, London.

He established himself as, possibly after Eadweard Muybridge, the single most significant figure in early American motion picture history.

APPENDIX C · A Note on the Kombi (?) Photographs of Casler, Dickson and Koopman (?)

I have determined neither the place nor the time for the Kombi (?)[1] photographs of illustration numbers 21, 22, 23 and 24.

The most logical place, the roof of 841 Broadway, is almost certainly not correct. None of the roof details: skylight, ironwork (which cannot be fitted into the stage ironwork—see illustration 10), parapets, are proper. And an examination of hundreds of contemporary photographs of the Union Square area turned up no building appropriate to the one in the right background of number 22.

Other Koopman addresses for these years—96 Church Street and 321 and 371 Broadway—are also inexplicable. 96 Church Street would show St. Peter's directly across Broadway, which it does not, and St. Paul's churchyard at the right, which it does not. 321 Broadway is one door north of Pearl, which would pass directly through the building shown across the street. And the parapet in the photograph as well as the juxtaposition of the skylight to the edge of the roof eliminate 371 Broadway. There is no iron work at present on the roofs of any of these buildings, and, of course, any conjecture about what building might be in the background of number 22 is irrelevant—since the roofs themselves are impossible.

The only other locale possible, Syracuse, is eliminated by the fact that that city did not have any buildings as high as ten stories until 1897.[2] This is too late for these photographs, since Dickson had gone to Europe by that time, and it is much too early for his

[1] In *Image*, December 1959, Beaumont Newhall says the Kombi pictures were $1\frac{1}{8}$″ in diameter and breadth, while my originals of this series are clearly not less than $1\frac{3}{16}$″ and possibly, taking shrinkage into account, $1\frac{1}{4}$″.

[2] According to a letter to me from Mr. Gerald J. Parsons, Head of the Local History and Genealogy Department of the Syracuse Public Library.

next visit, 1911, when he returned to testify in Motion Picture Patents Company litigation.

I can only conclude, therefore, that these photographs were shot at a location other than a Koopman or American Mutoscope Company roof, and at a time somewhere between 1893-plus, when the Kombi camera (if such these photographs are) swam into the Casler-Dickson-Koopman ken,[3] and before May 12 1897 when Dickson sailed for Europe.

If it is a somewhat dilapidated sunflower that Dickson is pinning onto Casler's lapel in 24, then we can readily believe that cool weather in the fall of 1896—in the final analysis the most logical time for the series—must be the time: a sunflower was the campaign symbol of William McKinley—its yellow symbolized that candidate's stand for gold, and that campaign ended with Election Day in 1896. It is not difficult to imagine that all of these men would have been McKinley men. 21 may have resulted from a desire that there should be a close-up of a handshake, and when it was found that the hands would be out of the frame, the two men decided to shake hands higher up. Surely this is a natural explanation of the curious gesture, as well as an easy explanation for Dickson and Casler's amusement.

The notebook Casler holds in 24 is too small for the notebook of Chapter 4. Furthermore, assuming an 1896 shooting date, that notebook would have been filled and out of date; and it does not, as a matter of fact, contain any notations possible for this period.

[3] The Kombi may have, indeed, inspired Casler/Dickson to develop the Photoret (see page 5). It was introduced at the Chicago 1893 Fair and, according to Newhall, *loc. cit.*, became very popular.

Index

The Arno Press Cinema Program

Dickinson, Thorold and Catherine De la Roche. **Soviet Cinema. 1948.**

Dickson, W. K. L., and Antonia Dickson. **History of the Kinetograph, Kinetoscope and Kinetophonograph. 1895.**

Forman, Henry James. **Our Movie Made Children. 1935.**

Freeburg, Victor Oscar. **The Art of Photoplay Making. 1918.**

Freeburg, Victor Oscar. **Pictorial Beauty on the Screen. 1923.**

Hall, Hal, editor. **Cinematographic Annual, 2** vols. 1930/1931.

Hampton, Benjamin B. **A History of the Movies. 1931.**

Hardy, Forsyth. **Scandinavian Film. 1952.**

Hepworth, Cecil M. **Animated Photography: The A B C of the Cinematograph. 1900.**

Hoban, Charles F., Jr., and Edward B. Van Ormer. **Instructional Film Research 1918-1950. 1950.**

Holaday, Perry W. and George D. Stoddard. **Getting Ideas from the Movies. 1933.**

Hopwood, Henry V. **Living Pictures. 1899.**

Hulfish, David S. **Motion-Picture Work. 1915.**

Hunter, William. **Scrutiny of Cinema. 1932.**

Huntley, John. **British Film Music. 1948.**

Irwin, Will. **The House That Shadows Built. 1928.**

Jarratt, Vernon. **The Italian Cinema. 1951.**

Jenkins, C. Francis. **Animated Pictures. 1898.**

Lang, Edith and George West. **Musical Accompaniment of Moving Pictures. 1920.**

L'Art Cinematographique, Nos. 1-8. 1926-1931.

London, Kurt. **Film Music. 1936.**

Lutz, E [dwin] G [eorge]. **The Motion-Picture Cameraman. 1927.**

Manvell, Roger. **Experiment in the Film. 1949.**

Marey, Etienne Jules. **Movement. 1895.**

Martin, Olga J. **Hollywood's Movie Commandments. 1937.**

Mayer, J. P. **Sociology of Film: Studies and Documents. 1946.** New Introduction by J. P. Mayer.

Münsterberg, Hugo. **The Photoplay: A Psychological Study. 1916.**

Nicoll, Allardyce. **Film and Theatre.** 1936.

Noble, Peter. **The Negro in Films.** 1949.

Peters, Charles C. **Motion Pictures and Standards of Morality.** 1933.

Peterson, Ruth C. and L. L. Thurstone. **Motion Pictures and the Social Attitudes of Children.** Shuttleworth, Frank K. and Mark A. May. **The Social Conduct and Attitudes of Movie Fans.** 1933.

Phillips, Henry Albert. **The Photodrama.** 1914.

Photoplay Research Society. **Opportunities in the Motion Picture Industry.** 1922.

Rapée, Erno. **Encyclopaedia of Music for Pictures.** 1925.

Rapée, Erno. **Motion Picture Moods for Pianists and Organists.** 1924.

Renshaw, Samuel, Vernon L. Miller and Dorothy P. Marquis. **Children's Sleep.** 1933.

Rosten, Leo C. **Hollywood: The Movie Colony, The Movie Makers.** 1941.

Sadoul, Georges. **French Film.** 1953.

Screen Monographs I, 1923-1937. 1970.

Screen Monographs II, 1915-1930. 1970.

Sinclair, Upton. **Upton Sinclair Presents William Fox.** 1933.

Talbot, Frederick A. **Moving Pictures.** 1912.

Thorp, Margaret Farrand. **America at the Movies.** 1939.

Wollenberg, H. H. **Fifty Years of German Film.** 1948.

RELATED BOOKS AND PERIODICALS

Allister, Ray. **Friese-Greene: Close-Up of an Inventor.** 1948.

Art in Cinema: A Symposium of the Avant-Garde Film, edited by Frank Stauffacher. 1947.

The Art of Cinema: Selected Essays. New Foreword by George Amberg. 1971.

Balázs, Béla. **Theory of the Film.** 1952.

Barry, Iris. **Let's Go to the Movies.** 1926.

de Beauvoir, Simone. **Brigitte Bardot and the Lolita Syndrome.** 1960.

Carrick, Edward. **Art and Design in the British Film.** 1948.

Close Up. Vols. 1-10, 1927-1933 (all published).

Cogley, John. Report on Blacklisting. Part I: The Movies. 1956.

Eisenstein, S. M. Que Viva Mexico! 1951.

Experimental Cinema. 1930-1934 (all published).

Feldman, Joseph and Harry. Dynamics of the Film. 1952.

Film Daily Yearbook of Motion Pictures. Microfilm, 18 reels, 35 mm. 1918-1969.

Film Daily Yearbook of Motion Pictures. 1970.

Film Daily Yearbook of Motion Pictures. (Wid's Year Book). 3 vols., 1918-1922.

The Film Index: A Bibliography. Vol. I: The Film as Art. 1941.

Film Society Programmes. 1925-1939 (all published).

Films: A Quarterly of Discussion and Analysis. Nos. 1-4, 1939-1940 (all published).

Flaherty, Frances Hubbard. The Odyssey of a Film-Maker: Robert Flaherty's Story. 1960.

General Bibliography of Motion Pictures, edited by Carl Vincent, Riccardo Redi, and Franco Venturini. 1953.

Hendricks, Gordon. Origins of the American Film. 1961-1966. New Introduction by Gordon Hendricks.

Hound and Horn: Essays on Cinema, 1928-1934. 1971.

Huff, Theodore. Charlie Chaplin. 1951.

Kahn, Gordon. Hollywood on Trial. 1948.

New York Times Film Reviews, 1913-1968. 1970.

Noble, Peter. Hollywood Scapegoat: The Biography of Erich von Stroheim. 1950.

Robson, E. W. and M. M. The Film Answers Back. 1939.

Weinberg, Herman G., editor. Greed. 1971.

Wollenberg, H. H. Anatomy of the Film. 1947.

Wright, Basil. The Use of the Film. 1948.